Turner on the Loire

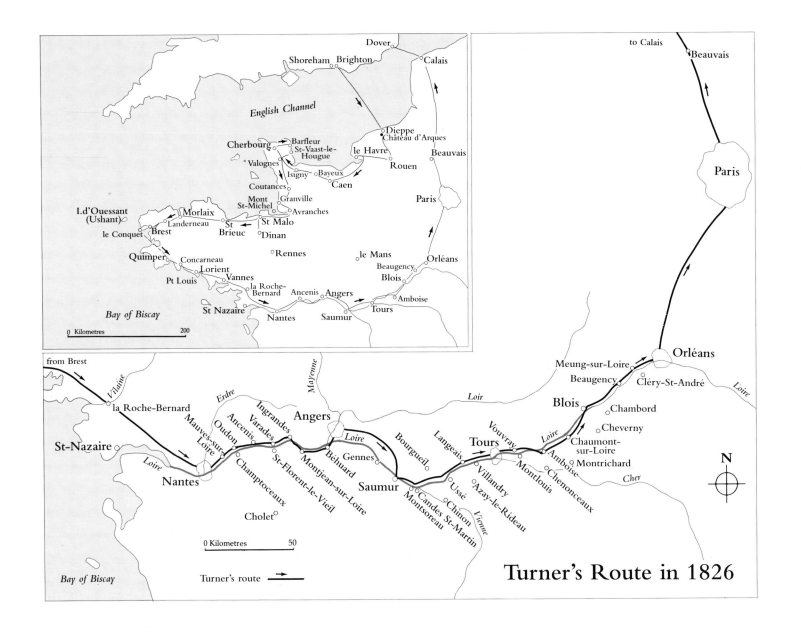

Turner's Route in 1826

Inset map (top)

Dover
Shoreham · Brighton
Calais
to Calais
Beauvais

English Channel

Barfleur
St-Vaast-le-Hougue
Cherbourg
Dieppe
Château d'Arques
le Havre
Valognes
Isigny · Bayeux
Rouen
Beauvais
Coutances
Caen
Mont St-Michel · Granville
Paris
Avranches
Paris
I.d'Ouessant (Ushant)
Morlaix
Landerneau
St Brieuc
St Malo
le Conquet · Brest
Dinan
le Mans
Quimper
Rennes
Orléans
Concarneau
Beaugency
Lorient
Blois
Pt Louis
Vannes
la Roche-Bernard
Ancenis · Angers
Amboise
St Nazaire
Nantes
Saumur
Tours

Bay of Biscay

0 Kilometres 200

Main map (bottom)

Paris

to Calais
Beauvais

Orléans
Meung-sur-Loire
Beaugency
Cléry-St-André
Loire

from Brest
Mayenne
Loir
Blois
Chambord
la Roche-Bernard
V'ilaine
Cheverny
Erdre
Ingrandes
Angers
Loire
Chaumont-sur-Loire
Varades
Vouvray
Montrichard
Mauves-sur-Loire
Ancenis
Loire
Bourgueil
Langeais
Tours
Amboise
Cher
St-Nazaire
Oudon
Béhuard
Gennes
Montlouis
Chenonceaux
Nantes
Champtoceaux
Montjean-sur-Loire
Saumur
Villandry
St-Florent-le-Vieil
Candes St-Martin
Ussé
Azay-le-Rideau
Montsoreau
Chinon
Cholet
Vienne

Bay of Biscay

0 Kilometres 50

Turner's route →

N

Turner's Route in 1826

IAN WARRELL

Turner on the Loire

TATE GALLERY PUBLISHING

Exhibition supported by

GlaxoWellcome

Published by order of the Trustees 1997
to accompany the exhibition at the Tate Gallery
30 September 1997 – 15 February 1998
and touring to two museum in France from March
to September 1998. First venue: Musée du Château in
Nantes 13 June – 14 September 1998

Published by Tate Gallery Publishing Ltd
Millbank, London SW1P 4RG

ISBN 1 85437 218 1

Designed and typeset by Harry Green

Frontispiece map by John Flower

Printed and bound in Great Britain by
Balding + Mansell, Norwich

FRONT COVER: *Scene on the Loire* c.1828–30 (fig.60, detail)

Abbreviations

B&J Martin Butlin and Evelyn Joll, *The Paintings of
 J.M.W.Turner*, revised ed. 1984

R W.G. Rawlinson, *The Engraved Work of J.M.W.Turner,
 R.A.*, 2 vols. 1908, 1913

TB Turner Bequest, as catalogued by A.J. Finberg,
 *A Complete Inventory of the Drawings of the Turner
 Bequest*, 2 vols., 1909

W Andrew Wilton, *The Life and Work of
 J.M.W.Turner*, 1979

Contents

Sponsor's Foreword

Glaxo Wellcome is pleased to support this exhibition, which traces the journey through north-western France of one of Europe's most important and influential artists. We would like to congratulate the Tate Gallery on bringing together a fascinating collection from around the world in *Turner on the Loire*.

Glaxo Wellcome has a full and varied programme of support for the Arts. As well as supporting unusual and innovative exhibitions, we encourage young people to take part in, and learn about, performance and visual art. Through our support, we hope to give them – and you – the opportunity to take a fresh look at the Arts.

This is our first major association with the Tate Gallery. We are delighted to support the Gallery in its centenary year and hope that this exhibition will enable visitors to the collection to see an unfamiliar – but highly rewarding – aspect of Turner's work.

We hope you enjoy the exhibition.

Foreword

Turner's views of the Loire are undoubtedly the most familiar images of the great French river. Whereas the two sets of views he produced of the River Seine have to some extent been eclipsed by the later paintings of that river by the Impressionists, the small, brightly painted scenes that Turner created of the Loire and its riverside towns remain unchallenged by the works of any later artist of stature. Turner's achievement is all the more remarkable in that his views of the river were not the result of an extended painting campaign, and instead resulted from the briefest of passages up the Loire at the beginning of October 1826, which it now seems took him scarcely two weeks.

Although the set of twenty-one finished views that were afterwards engraved have rightly been celebrated in considerations of Turner's achievement as a graphic artist, it is perhaps in the less fully resolved, private studies that we find a more immediate sense of his impressions of the Loire. Chief among these compact and frequently experimental works must be the marvellous study of *St-Florent-le-Vieil* (fig.76), which exudes a contemplative stillness, and is in every way as radical a response to a particular setting as the much later painting *Norham Castle, Sunrise* (c.1845, Tate Gallery).

This exhibition, and its catalogue, represents the most complete opportunity of studying the Loire views since Turner's death, providing the first detailed outline of the route Turner actually took in 1826. Earlier discussions of the tour have not examined the significance and consequences of Turner's route across northern France before he arrived on the Loire. It is especially in this area that Ian Warrell, the curator of the exhibition, has put forward a number of exciting new identifications. Not least among his findings is the rediscovery of the only oil painting Turner made of a Loire subject, which effectively disappeared from all records after it was first exhibited in 1829. We are grateful for the Worcester Art Museum for agreeing to lend this work which was last exhibited in this country in 1912.

Although the focus of the exhibition falls on the many Loire sketches in the Turner Bequest here at the Tate Gallery, it would not be possible to do full justice to Turner's achievement without the very generous support of a numbers of institutions and private collectors who have kindly lent their treasured possessions, few of which have been exhibited in the past. Most of these drawings were once part of the set of twenty-one engraved Loire subjects, which has not been seen together since it was in the collection of Charles Stokes in the early 1850s; thirteen of this original group have been reunited for this exhibition. The largest group of the finished designs is now to be found in the Ashmolean Museum in Oxford, where they form the centrepiece of Ruskin's great gift of 1861. We are, therefore, especially grateful to the Visitors of the Ashmolean Museum for consenting to lend us nine of these works, plus a further four related studies. There are a further nine Loire subjects at Oxford that are now considered too fragile to be exhibited again, but fortunately we are able to illustrate the entire series in the following pages.

It would have been difficult to mount this exhibition and realise such a comprehensive catalogue without the committed support of Glaxo Wellcome plc. *Turner on the Loire* is Glaxo Wellcome's first major involvement with the Tate Gallery, and we hope that we will be able to work with them just as fruitfully on future exhibitions.

Finally we are delighted that the exhibition will be shown subsequently in two museums in France. The Musée du Château in Nantes, which has recently purchased one of Turner's views of the city, will be the final venue.

NICHOLAS SEROTA
Director

7

Acknowledgements

This catalogue and the exhibition it accompanies have been several years in the making, during which I have been fortunate enough to receive expert advice and assistance from both sides of the Channel, as well as from the other side of the Atlantic. Without the guidance of the following people I really could not have arrived at many of the conclusions presented here. I am, therefore, greatly indebted to each of them for their help: Nicholas Alfrey; Belinda Arthur; Iain Bain; Anthony Bailey; Andrew Barlow; Sylvain Bellenger; Fr Berquet; Christian Borde; Michael Bott; Frances and Martin Butlin; Andrew Clayton-Payne; Christiane Chenesseau; Madame R.Claudel; Malcolm Cole; Melva Croal; Dr Patrice Crossay; Richard Davies; James Dearden; J.L. Delalande; Salima Desavoye-Aubry; Dominique Deschere; Helen Dorey; Louise Downie; Harriet Drummond; Anthony Dyson; Claude Fagnen; Elizabeth Fielden; Geneviève Gascuel; Sophie Gillot; Antony Griffiths; Sophie Grossiord; Bruno Guignard; Gérard Guillot-Chene; Debbie Hall; Annette Haudiquet; John Heath; Annie Henwood; Robert Hewison; David Hill; Evelyn Joll; Mrs H.E. Jones; Patrick Jourdan; Marie-Hélène Jouzeau; Richard Knight; Mr and Mrs Van Auken; Martin Krause; Susan Lambert; René Le Bihan; Eric Lee; Patrick Le Nouëne; Philippe Le Stum; Pierre Leveel; Lowell Libson; Loveday Manners-Price; Sir Edwin and Lady Manton; Frances Miller; Edgar Munhall; Jane Munro; Griselda Munro-Ferguson; Charles Nugent; Robyn Paisey; Ivonne Papin-Drastik; Jean-Paul Pasquette; Judith Ann Peacock; the Pessereau family of Tours; Guy Peppiatt; M.-C. Poutre; Michèle Prevost; Ph.-G. Richard; Duncan Robinson; Marie-Françoise Rose; Sidney F. Sabin; Philippe Serisier; Janet Skidmore; Dr Kim Sloan; R.J. Stanley; Anne Steinberg; Philip Stevens; Karen Taylor; Richard P. Townsend; Dr Raymond Turley; Rosalind Mallord Turner; O. Valles; Henry Wemyss; Dr Selby Whittingham; Stephen Wildman; Sarah Wimbush; Andrew Wyld; James Yorke. I would also particularly like to thank M. le Maire de Cherbourg and his staff at the Archives Municipales, for their help in tracing the previously unknown record of Turner's visit to Cherbourg.

Each of the Turner Scholars to have worked here at the Tate Gallery since 1988 has in some way helped shape my ideas for this project. The valuable contribution made by Peter Bower's ongoing work on Turner's papers can be found in Appendix B, but I am also grateful to Dr Maurice Davies, Gillian Forrester, James Hamilton, Dr Jan Piggott, Dr Cecilia Powell and Eric Shanes.

The involvement of the Ashmolean Museum was the real key to this exhibition; without its works we would have been able to tell only half the story. I should, therefore, like to thank the following people for their support from the outset: Judith Chantrey; Dr Catherine Whistler, Prof. Christopher White, Dr Jon Whiteley. In addition, Colin Harrison has provided encouraging words and useful information at many stages.

Among the people I need to thank individually is Prof. Luke Herrmann, himself formerly a Keeper at the Ashmolean, and an earlier cataloguer of the Loire drawings. Prof. Herrmann has kindly allowed me to use the set of photocopies of the Stokes-Cooper Notebooks given to him by Kurt Pantzer. These offer vital clues to the early provenance of hundreds of Turner watercolours, including the Loire series, and are at last to be published by Martin Krause of the Indianapolis Museum of Art.

In America my research has greatly benefited from visits to the Yale Center for British Art, where discussions with Patrick Noon and Scott Wilcox were of especial help. I should also thank Julia Marciari Alexander, for her scholarly assistance and hospitality, both in Paris and at New Haven. At the Worcester Art Museum in Massachusetts, I was fortunate to receive the expert guidance of James Welu and Rita Albertson when looking at the Turner painting in detail. Our good luck in being able to borrow the picture has been greatly assisted by the patient ministrations of Nancy L. Swallow.

My colleagues at the Tate Gallery in many departments have made an important contribution both to the exhibition and its catalogue. In particular, I should like to thank Rosie Bass, David Brown, Ann Chumbley, Juliet Ireland, Andy Loukes, Anne Lyles, Brian McKenzie, Tessa Meijer, Andrea Nixon, Heather Norville-Day, Sue Smith, Kasia Szeleynski, Sarah Taft, Joyce Townsend, Piers Townshend, Andrew Wilton and Calvin Winner. Throughout the planning stages of the exhibition I was sustained in the Exhibitions

Department by a combination of indefatigable tenacity and verve from Ruth Rattenbury, Carolyn Kerr, Emmanuelle Lepic and Sarah Tinsley. Similarly, I could not have received more encouragement from Celia Clear, managing director of Tate Gallery Publishing Ltd. The volume has been produced by the exacting and effortlessly professional team of Sarah Derry, Harry Green, Colin Grant, Tim Holton and Susan Lawrie, who have saved me from numerous inconsistencies. I hope others will agree that they have done a marvellous job.

The participation of Glaxo Wellcome plc has been very much appreciated. On the basis of comparatively little evidence, they placed their wholehearted faith in the exhibition. I have greatly enjoyed working with their corporate events manager Claire Jowett.

Three people deserve special thanks. At the Louvre, Olivier Meslay has proffered much vital information about the French background (and indifference) to Turner's visit, which it was hoped would take a more tangible form here. I have benefited immensely from the wisdom and tact underlying our many discussions. The following pages demonstrate that Nantes held a special place in Turner's journey, and I could not have navigated my way through the local records without the diligence and knowledgeable research of Bertrand Guillet, at the Musée du ducs des Bretagne at Nantes. Lastly, but not least, Stephen Tate has made an invaluable contribution to the process of unearthing the 1826 route.

Finally, the exhibition could not have been realised without the kindness of its lenders, who have helped with numerous enquiries and graciously consented to part with their treasured possessions for a considerable part of a year.

Introduction

Of the splendid engravings which adorn this costly volume, it is scarcely possible to speak with adequate praise. These alone, in our judgment, would be sufficient to raise the character of British art to the highest pinnacle of fame. The genius of the painter, and the skill of the engraver, have here united to produce the realization of perfection in the pictorial and graphic arts'.[1]

So wrote the critic of the *Gentleman's Magazine* in December 1832 when he reviewed the twenty-one views of the River Loire that had just been published as illustrations to the 1833 edition of *Turner's Annual Tour*. While this seems exceptionally high praise for a small book of topographical prints, the critic was not alone in commending Turner's newest works. Indeed, his opinion was representative of many contemporary critics who had hitherto routinely mocked the artist's best efforts in the Royal Academy exhibitions, but who were at last forced to concede a triumph to Turner by the magnificence of the Loire series.

The twenty-one Loire engravings have since become among Turner's most celebrated images, the sequence brilliantly condensing the thrill of travelling through the historic region, with its riverside towns, its steep cliffs and its once powerful châteaux, all of which the artist bathed in his most atmospheric effects. The history of Turner's visit to the Loire region in 1826 and the subsequent process of making these works, and the watercolours on which they are based, form the subject of this publication and the exhibition it accompanies.

The 1833 edition of *Turner's Annual Tour* proved to be the first of three volumes containing views of French river scenery, and was followed in 1834 and 1835 by two more devoted to the River Seine, again with about twenty engravings in each book. Each of these volumes included text by Leitch Ritchie, a popular writer, who specialised in volumes of travel and romance. Throughout the nineteenth century it was the small black and white prints after Turner's designs, rather than the actual watercolours, that reached a huge audience as a result of being frequently republished, and it may not be an exaggeration to claim that they have been reprinted more often than any other group of designs by Turner. In fact, the success of the designs was such that

even during his lifetime rival publishers, both in England and in France, created their own pirated versions of some of the Loire images.

The engraved views of both rivers represent only a fraction of a much larger body of work from which Turner selected the subjects most useful to his publication. In the case of the Loire series, for example, the twenty-one published views are part of a group of more than eighty finished drawings and colour sketches on blue paper, many of which have been identified for the first time as a result of the research for this project. Most of the unpublished material is less fully resolved than the set of engraved views and was therefore less commercially saleable. Nevertheless, about ten of these more private studies of Loire scenes were sold to one or two loyal collectors towards the end of Turner's lifetime or soon after his death. One of these men was Charles Stokes, who in May 1850 also acquired the complete set of finished compositions from which the engravings were made. With these exceptions, however, the rest of the Loire group remained in Turner's own collection, ultimately becoming part of his bequest to the nation.

After Stokes the majority of the original drawings for the engraved subjects were owned for a short time by John Ruskin, who echoed the critic of the *Gentleman's Magazine* in believing that there might be some beneficial qualities for the future of British art in the example provided by Turner. This was certainly the motive that prompted him to donate his group of Loire views to the museums at Oxford and Cambridge in 1861. He also championed the series in his writings, to the extent that individual drawings from the set have rarely been reproduced or exhibited without an accompanying quotation from Ruskin, even where his observations are sometimes at variance with what can actually be seen in the works themselves. Indeed, because the later reprintings of the Loire and Seine series generally included commentaries by Ruskin, his opinions had, until recently, become the orthodox way of looking at these French subjects. Inevitably, the popularity of his writings on Turner encouraged others to hold the series in the same kind of esteem. Thus, it is not surprising to learn that Turner's French drawings have been among the most regularly copied of his compositions (they are only exceeded in volume by those based

on his views of Venice) and continue to be some of the best-known depictions of the Loire and the Seine.[2]

Apart from the long shadow cast by Ruskin, the impression left by some of the late-nineteenth century texts accompanying the group of Loire views is distinctly muddled as to exactly when, and with whom, Turner visited the river, and was for a long time in need of closer examination and correction. This began in 1939 with A.J. Finberg's monumental biography, which rightly identified the year 1826 as that in which Turner's tour of the Loire took place but mistakenly conflated it with an earlier journey to the Meuse-Mosel region.[3] Despite the bold beginning made by Finberg, it is only during the last thirty years that there has been a concerted effort to re-examine Turner's life and art. As a result of this resurgence of interest, the Loire drawings in the collections at Oxford and Cambridge were catalogued respectively by Luke Herrmann (1969) and Malcolm Cormack (1975). But it was not until the second half of the 1970s that a proper study of the Loire and Seine views was conducted by Nicholas Alfrey.[4] His pioneering work on both series subsequently provided the foundation stone for the important exhibition *Turner en France*, held in 1981 at the Centre Culturel du Marais in Paris. The catalogue for that exhibition, richly illustrated with many hundreds of sketches dating from 1802 to 1845, has remained the most useful overview of Turner's interest in French scenery. Although some of the conclusions reached there are challenged in the present publication, Alfrey's essay in that volume represents the first well-reasoned discussion of the processes that resulted in the Loire series, and has been followed by all subsequent writers on these works.[5]

Because Turner created the Loire and Seine drawings as complementary sets, to be engraved and issued in the same format, there has been a natural tendency to discuss them as one entity – the 'Rivers of France' – within which group comparisons between the two rivers tend to be weighted in favour of the more progressive views of the Seine. For example, the contrast with the varied viewpoints of the steamer-laden Seine, has given strength to the idea that those of the Loire are repetitive in their compositions and conservative in what they present of modern life on the river. If there is an element of truth to these assumptions, a fuller knowledge of Turner's actual experience during his 1826 tour, combined with an awareness of the sites he was depicting, suggests not so much the limitations of the set but rather the inventive alchemy that Turner brought to his sketching materials. This is all the more remarkable in that, for the Loire series, he was only able to draw on the sketches gathered during his one hasty passage up the river in 1826, which were often compara-

tively slight, whereas the Seine drawings benefit from Turner's much greater familiarity with that river, which he had explored several times on his way to and from Paris, and at least once specifically with the *Annual Tour* project in mind. It must also be noted that the much greater number of Seine scenes means that the emphasis inevitably falls on them. There is a further obvious disparity between the number of Loire and Seine views and the length of each river, so that the distance between Orléans and Nantes is charted in only twenty-one views, whilst the shorter course between Melun and the Channel is given more than forty, with the viewpoints often overlapping.

A final distinction between the two sets lies in the way they were actually painted. The set of Loire views was one of the first groups Turner created on blue paper, and, as one might expect, there are some inconsistencies in the handling and the degree of finish, suggesting that he was still investigating the way his media worked with its support. These range from simple washes of colour over pencil outlines to highly detailed accumulations of gouache (also known as bodycolour). In the 1834 Seine series, however, there is a greater homogeneity of approach to the finished designs, which tend to be more jewel-like in their densely applied surfaces. The second group of Seine subjects for the 1835 volume is further distinct in returning to a looser handling of paint, which required that the engravers translating Turner's images thoroughly understood his individual shorthand.

In order to explore fully the quite distinct factors behind each series, it has seemed more profitable to pursue separate studies of both the Loire and the Seine, rather than to lump them all together in one complete volume; a second exhibition and catalogue devoted to the Seine will follow in 1999. In the case of the Loire there have proved to be rich rewards from a concentrated examination of the context surrounding Turner's visit to the region, both in terms of providing a better understanding of his relationship with his contemporaries and, more obviously, in setting out the route taken during his only extensive tour of north-western France.

The structure of this publication adopts a roughly chronological framework, placing the visit to France in context in the first section before examining Turner's actual route in detail in the next. Both of these reveal the originality of Turner's itinerary, which, as well as the voyage on the Loire, took him through Brittany, at that date a still largely unknown region untapped by landscape artists. A final third section traces the consequences of the tour in Turner's work during the following years. Included in this latter part of the book is a discussion of the only oil painting that Turner produced of a Loire scene,

which 'disappeared' after it was first exhibited in 1829 but which is here re-identified for the first time since then. Previous studies of Turner's French subjects have not examined the nature of the reception meted out to his engraved views by the critics, even though it sheds an important light on Turner's critical fortunes at the beginning of the 1830s. A final chapter documents the history of the Loire drawings and studies after Turner's death, and briefly considers the influence the designs may have had on subsequent generations. There are also various appendices at the back of the book to complement the main text, the most important of which provides a checklist of the touched proofs of the engraved versions of Turner's views of the Loire. This is essentially an updated version of W.G. Rawlinson's notes in his 1913 catalogue, and although this appendix is necessarily incomplete, it is hoped it will provide more recent information for future scholars and print-lovers.

The Background
to the 1826 Tour

Turner and France in the 1820s

At the end of August 1826 Turner set out on a journey that was to take him on a long circular tour of north-western France. He was then fifty-one and very much at the height of his powers. Travelling by land, sea and river, he covered well over fifteen hundred miles by the time he returned to London in October, but, other than the general urge to acquire more reference material, there is little documentary evidence to suggest that he had a definite goal in making this journey. Some of the contemporary concerns which may have influenced his decision to undertake this trek are considered in the following essay, which precedes the more detailed discussion of the route he took. This tour, which incorporated Normandy, Brittany and the River Loire, comes at the mid-point of the fourteen-year period during which Turner travelled most frequently in France. Between 1819 and 1832 there were probably only five years in which he did not specifically visit or pass through the country. As a result of this he built up an encyclopaedic collection of quick pencil notations of French towns, landscapes, boats and costumes in his densely filled sketchbooks.

It had not always been so easy to travel to France. For much of Turner's youth Britain had been at war with its neighbour, so that the French coast, though it lay but twenty miles away, must have seemed both inaccessible and actively forbidding. Perceptions of the French were inevitably coloured by a deeply ingrained antipathy to Catholicism, but more explicitly by the bloody events of the Revolution, which, as characterised by the Terror of 1793, even radical British sympathisers, like Wordsworth and Blake, found difficult to support.[1] Similarly, the rise of Napoleon was watched from Britain with an awe tempered by a righteous distrust that continued to shape European politics for decades afterwards. The repercussions of his attempted dominance of Europe find echoes in Turner's watercolours and paintings right up to the late works of the 1840s.

But it was to Italy, rather than to France, that Britons of all classes aspired to travel. Long before he was able to go there himself, Turner would have been fully conversant with many of its famous monuments, either through the classical evocations of the Roman Campagna by Claude Lorrain or as a result of seeing the sketches and watercolour drawings of Italy by John Robert Cozens.

He had been encouraged to study these works in the mid-1790s at the home of Dr Thomas Monro, who also paid him to copy them in collaboration with Thomas Girtin. The rich associations and impressions Turner was able to call up of Italy make a striking comparison with the paucity of information, visual or otherwise, he would have had about French history and culture before his first visit there. This is partly a reflection of British taste, which for over a century had looked to Italy as the model of a civilised culture, a sentiment that gave rise to the institution of the Grand Tour.[2]

French artists had, nevertheless, made a considerable impact on the arts in Britain during the first half of the eighteenth century, but the impetus given to the patriotic ideal of a distinctive British School had tended to obscure this important infusion by the time Turner was labouring at the Royal Academy schools in the 1790s. What he knew of French art would have been at second-hand, culled from engravings, although, because Claude-Joseph Vernet was admired and collected by the British gentry during the Grand Tour, he seems to have known examples of that artist's shipwreck scenes.[3] Apart from his copies of Cozens, the majority of the works that Turner copied from Dr Monro's collection were of Italian subjects, but it is possible that the doctor also had a small selection of French views. This can be deduced from two previously unidentified watercolours in the Turner Bequest, which are typical of his style around 1794–5, both of which depict towns on the River Loire (figs.1 and 2). The lack of traditional finish suggests that they were undertaken as an exercise akin to the act of making monochrome copies after Cozens. Regrettably, it has proved impossible to identify the sources for these works, but they must have been partly derived from prints or sketches by a now-unknown artist.[4] That they should both be Touraine scenes is perhaps not surprising, for the region had strong links with Britain during the first half of the eighteenth century. In his study of the behaviour of Grand Tourists Jeremy Black has demonstrated that many young travellers went to Angers, Blois and Tours in order to 'learn French and acquire expertise in some of the attributes of gentility, such as dancing, fencing and riding, without, it was hoped, being exposed to the vices of the metropolis'.[5]

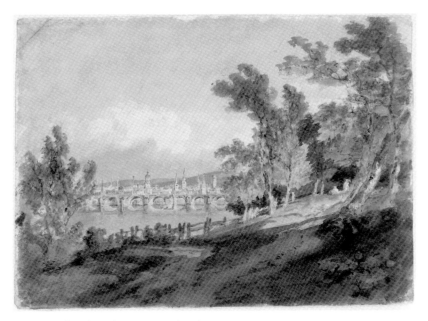

FIG 1 *Tours from the north-east c.1794–5* (cat.1)

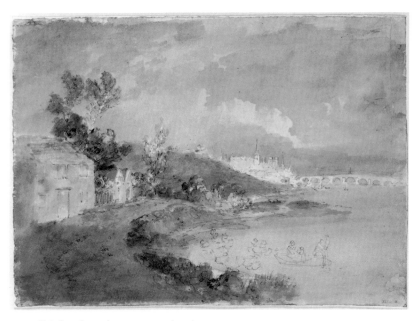

FIG 2 *Blois from the south-west c.1794–5* (cat.2)

The first of these watercolours is a view from the right bank of the River Loire, looking across to Tours, where the spires and towers in the quarter round the old cathedral of St-Martin rise up behind the stone bridge of 1765. The place from where the view is taken would have been on the main route between Tours and Orléans, so the picturesque track and framing trees are likely to have been invented by the young Turner, perhaps added to a straight-forward topographical depiction of the city, which would have been a useful exercise in composition for a budding landscape artist.

The other watercolour is even more obviously an incomplete study, with its exposed pencil lines and areas of blank paper, but was interesting enough to induce Ruskin to include it in the selection from the Turner Bequest that he made available to the public at the National Gallery. Though Ruskin titled it simply 'Town and Bridge', it is actually a fascinating representation of Blois from the west, in many ways anticipating the composition Turner was later to complete for the set of Loire illustrations (fig.129). Tucked away behind the falling slope, the buildings and bridge of Blois are sufficiently distinctive to be recognised, even though they have not been fully realised. By contrast, the vernacular architecture on the left produces a puzzling effect, seeming much more

English than French, and it may also have arisen from Turner's attempt to design a new image from separate elements.

Along with the rest of his generation, Turner's first opportunity to travel to France came in 1802 during the fourteen months of peace that followed the Treaty of Amiens. However, unlike most of his contemporaries, who stayed in Paris or close to the Channel, Turner set off for the Alps in the company of a gentleman-amateur called Newby Lowson, travelling there via Châlon-sur-Saône and Lyons. After completing a thorough exploration of Savoy, the Val d'Aosta and central Switzerland, they returned to Paris, where the ambitious young artist drank deep from the masterpieces in the Louvre, assembled there from all over Europe as a result of Napoleon's campaigns.[6] Turner made over five hundred sketches during his three-month tour, which served as the basis for numerous oil paintings and watercolours during the following years.

It was just as well that his method of collecting potentially useful compositions was already so effective, for it was to be another seventeen years before he again stepped on French soil. This did not occur until 1819 when he made his momentous first journey to Italy. His keenness to get to Rome, however, seems to have resulted in very few sketches of his journey through France, but these

are sufficient in number to mark out his course through Calais and Beauvais to Paris, whence he largely retraced his 1802 route as far as Lyons, before crossing the Alps through the Mont Cenis Pass. Several months later, at the beginning of 1820, this was also his route home.

With the exception of these rather breathless, cross-country gallops, Turner did not become a regular visitor to France until the 1820s. By that date the Channel coast had been visited by many of his contemporaries, who had begun to explore the area soon after the Battle of Waterloo had brought an end to the years of conflict in Europe. In contrast, it was not until 1817, two years after travel on the continent was once again permissible, that Turner made his first foreign tour since 1802. This was not to Italy, as one might have expected. Instead, he explored Belgium and the Rhine, drawn there by the heightened topical interest in the famous battleground.[7] The prevailing jingoistic mood passed Turner by, so that, unlike many of the celebratory depictions of the French defeat that were exhibited in London at the Royal Academy and the British Institution, his 1818 picture of Waterloo (Tate Gallery, B&J 138) followed Byron's example in considering the individual tragedies involved in the great moments of human history.

By 1821, when Turner decided to revisit Paris, northern France was already becoming an adjunct to the middle-class tours of Britain, and was promoted through a string of published narratives recounting the opinions of travellers and the incidents they had met with during their journeys. Other volumes adopted a dry antiquarian approach, attempting to classify the appearance and behaviour of the unfamiliar cousins across the Channel in works such as Richard Brinsley Peak's *The Characteristic Costumes of France* (1819). For Turner, as a maker of sets of topographical views, perhaps the most significant publication would have been Frederick Nash's *Picturesque Views of the City of Paris and its Environs*, which first appeared in 1820. The beautifully engraved illustrations for this work stand comparison with the best contemporary prints based on Turner's own designs, and his familiarity with some of the engravers involved would have ensured he was aware of it, and perhaps encouraged him to think of making his own visit.

Although Paris was the goal of many short excursions from Britain, the focus of contemporary attention fell more specifically on the architecture and scenery of Normandy. Its fishing towns, built around solid Gothic churches or ruined castles, appealed greatly to the widespread taste for the picturesque, and could increasingly be found to have the modern comforts that British visitors expected at coastal resorts, such as Weymouth, Brighton or Margate.[8] Dieppe and nearby Rouen attracted numerous artists, so that from around 1820 onwards the London exhibitions were rarely without depictions of at least one of these places.[9] The fascination for the 'old fashioned' qualities of this area was neatly expressed by the urbane William Hazlitt a few years later, during his visit to Dieppe in 1824: 'In France one lives in the imagination of the past; in England everything is on the new and improved plan'.[10] Though time sometimes seems to have reversed these sentiments, this was a common perception among those travelling from England to France. Even for those visiting the area from Paris, the antiquated traditions provided a pleasurable jolt.

Turner's itinerary in 1821 reflected the new-found popularity of Normandy. Starting from Brighton,[11] his tour took him to Dieppe, Rouen and up the Seine to Paris. While there, he visited the cemetery of Père Lachaise, perhaps on the recommendation of John Soane, who had been there two years earlier.[12] At the Louvre he made a group of thumbnail copies of many of the paintings by Claude Lorrain, an artist he had strangely omitted from his studies in 1802.[13] He also made sketches at Abbeville, which was one of the other northern towns most often favoured by British topographical artists.[14]

During his journey he almost certainly came across the set of lithographs of Normandy that was being published by Isadore Taylor and Charles Nodier. Entitled *Voyages pittoresques et romantiques dans l'ancienne France*, the first plates of this important publication had been issued early in 1820, and in subsequent years the work was to include designs by Richard Parkes Bonington. That Turner discovered the prints for the first volume on Normandy is apparent from a note in one of the sketchbooks he used on the tour, which refers to the various prices for impressions of a 'Normandy French Work'. There is a possibility that he may have met some of the men responsible for producing the prints, as he also recorded some comments on the technique of lithography.[15]

If the evidence of his sketches suggests he spent most of his time in the Louvre looking at Claude's depictions of classical harbours, there is reason to think that he also came across works by Jean-Antoine Watteau. The early eighteenth-century French artist had already made a deep impression on his sensibility, as can be seen in paintings such as *England: Richmond Hill, on the Prince Regent's Birthday* of 1819 (Tate Gallery, B&J 140). At the Royal Academy the year after his tour to Paris, he exhibited only one picture, a small figure subject called *What you Will!* that alludes to the alternative title of Shakespeare's play *Twelfth Night*, a tableau from which is presented to the viewer (private collection, B&J 229). Typically, the title was a pun by Turner on the name of Watteau, whose deliciously insubstantial confections, characterised by silken costumes worn in bucolic glades, were the obvious inspiration for the picture.[16]

Turner's continuing involvement with several different series of topographical engravings at the beginning of the 1820s, and an ultimately successful attempt to secure the patronage of George IV, ensured that it was not until 1824 that he was able to make another visit to France. This came at the end of a much longer tour through Belgium and along the rivers Meuse and Mosel. Until very recently the details of this tour had been mistakenly confused with those of the 1826 Loire journey, but it is now clear that one of the reasons for the tour was a commission for a view of Dieppe from a Mr John Broadhurst.[17] Though Turner already had numerous useful sketches of the port from three years earlier, he made a long detour from Calais to Dieppe, via Abbeville, after he had completed his wanderings in the Ardennes and the Rhinelands, and Mr Broadhurst's painting duly appeared at the Royal Academy exhibition of 1825 (fig.169).

Turner was travelling through France at the beginning of September in 1824 but chose not to visit Paris. This was the year of the famous 'English Salon', when the grand rooms in the Louvre that were given over to the biennial show of the latest paintings were invaded by a sizeable (if random) group of works by British artists.[18] Admittedly, one or two of the 'British' artists were actually based in Paris, such as Bonington, but the significance of this event was immediately recognised on both sides of the Channel, causing much excitement in the art world. In fact, the cultural exchange that took place in this display was symptomatic of the period as a whole, where the usual patterns of influence were temporarily reversed. As the historian Alfred Cobban perceptively remarked, 'Normally, in the history of art and literature, inspiration has come from France and spread to the rest of Europe; but the French spirit has been too self-contained and insular, and the French too unwilling to read foreign languages, for much to be accepted back in return.'[19] But by the mid-1820s Byron and Scott had rapidly become as popular in France as they were in Britain, and it was natural that, where poetry had led the way, painting should follow. The chief beneficiary of exposure at the Salon was John Constable, who was only a year younger than Turner but had still not been officially embraced as a member of the Royal Academy. His involvement in the Salon exhibition had come about through the French dealers John Arrowsmith and Claude Schroth, who had bought several works from him and commissioned others with the intention of capitalising on the current Anglomania. Constable's paintings, which included *The Hay Wain* (National Gallery), had also been shown briefly at Schroth's gallery in June, and Turner must have known of the interest they had provoked.[20] At this stage in his career Turner acted as his own

dealer and had already established a reputation for sharpness in business that would have deterred even the most enterprising dealer from approaching him with an offer to promote his pictures, although Turner would surely have welcomed the chance to show his work abroad.

He next returned to France in 1825 at the beginning of his tour through the Netherlands and the Rhine, arriving at Boulogne, where he made his first sketches of the town, and concluding the tour at Calais.[21] Earlier that year Charles X had been crowned at Reims, but this was to prove only a short, troubled reign, culminating in his abdication after the July Revolution of 1830. Turner would have had good cause to be interested in French politics because he was acquainted with the Duke of Orléans (later crowned as Louis-Philippe), whom he had known during his periods of exile at Twickenham between 1800 and 1817.[22] While there is little reason to think that they remained close associates, this personal connection may have meant that Turner followed news from France with more interest than most.

And so we come to 1826, the year of the Loire tour. Up until this point very few of his visits to France had been devoted exclusively to French scenery. The most significant tour in this respect had been that in 1821, but the sketches he made that year had not afterwards given rise to any exhibited or engraved works. Although five of his foreign journeys had taken him to France, his knowledge of the country was confined to the stretch of coast between Calais and Dieppe, the routes from these places to Paris, and the well-worn corridor south from there to the Alps. The 1826 tour is therefore his first proper survey of northern France. It was also the longest journey he had undertaken for several years.

Now that the outline of this tour has been established, it is clear that Turner's interest lay just as much in the picturesque towns and ports along the northern coast as in the River Loire. Coasts and rivers were of especial interest to him in the first half of the 1820s, both in his own work and in that of his contemporaries. This was a period in which he contributed illustrations to various sets of engraved topographical views, the most important of which was *Picturesque Views on the Southern Coast of England*.[23] He had worked on this series since 1811, producing a total of forty watercolours, and although designs were included by other artists, his work was the real core of the publication. In May 1826, three months before he set off for France, the project finally came to an end. The conclusion of this frequently problematic publication was a great relief for its architect and chief engraver, W.B. Cooke, who had been forced to tolerate and accommodate Turner's increasingly unreasonable demands. In spite

of this, the two men seem to have arrived at an understanding that they would produce a second set of views charting the rest of the British coast.[24]

Among Turner's peers the French coast was just then providing the subject of a clutch of illustrated volumes. From 1823 the Paris-based publisher and dealer J.F. d'Ostervald had begun to produce plates to illustrate the *Excursion sur les côtes et dans les ports de Normandie* by Noel-Jacques Lefebvre-Duruflé. Some of these derived from watercolours by Frederick Nash, which were exhibited in London at the Old Water-Colour Society in 1825.[25] That year had also seen the publication of G. Reeve's book, *The Coasts and Ports of France from Dunkerque to Havre de Grave*. There is a remote possibility that these works could have contributed to Turner's decision to investigate the Channel ports, but their existence as competition for the same market certainly did not deter him from conceiving his own scheme, which was first advertised as 'The English Channel or La Manche' in January 1827.[26] It is important to note here that this advertisement strongly implied that the 'Tour on the Northern Coast of France' during the summer of 1826 had been specifically undertaken in connection with the new scheme, although the actual circumstances behind this project will be examined in greater detail below (see p.158).

Even more important to Turner's repertoire of subjects than coastal views were his pictures in oil and watercolour devoted to river scenery. During the years between 1805 and 1819 he had produced an ambitious series of paintings that celebrated the Thames valley in much the same way that it had been evoked by eighteenth century Arcadian poets like James Thomson.[27] The potency of rivers as symbols of a nation's power has been examined at length by Simon Scharma, and it is perhaps a measure of Britain's increasingly confident perception of itself that there had been steady growth in the vogue for views of the Thames and other rivers during Turner's working life.[28] Indeed, Turner's attempt to develop a distinctive British type of landscape painting was inseparably bound up in his Thames series.[29]

At a time when rivers were also the natural highways across Europe, it is not surprising that Turner and other artists should have utilised the unity of a voyage along a particular river as the framework for a set of views. Turner's journey up the Rhine in 1817 resulted in fifty-one watercolours, which he sold soon after the tour to Walter Fawkes. Several of these subjects were repeated for other patrons, and their success led to the advancement of a scheme in 1819 to produce and publish another set of thirty-six Rhine views. This project was also to have involved a collaboration with W.B. Cooke and the publisher John Murray, but ultimately came to nothing.[30] It does, however, represent the germ of the idea of a series of volumes illustrating the rivers of Europe that only later began to take shape in the views of the Loire and the Seine.

Turner's other engraving projects structured around rivers met with mixed results. One series started in 1815 and was intended to chart the rivers of Devon, but never really got off the ground, and its few engraved subjects were only published much later in the 1820s.[31] More successful were the mezzotints of *The Rivers of England*, based on the exquisite watercolours Turner began to paint for the series in 1822. However, only sixteen of his designs had been published by 1827, when a quarrel with its publisher, again W.B. Cooke, brought the project to an end.[32]

Even if Turner had not then actually envisaged producing a comprehensive publication devoted to the rivers of Europe, his interest in the Rhine, the Seine, the Meuse and the Mosel in the first years of the 1820s suggests he realised the potential value of this kind of subject matter. In retrospect, it is easy to see that in 1826 the Loire was logically the next major river for him to explore. It is the longest river in France, and its countryside is steeped in associations with the course of British history. At that time, however, it had not received the kind of attention from travellers and artists that had begun to transform the northern coast. A set of views of Touraine by Isidore Dagnan had appeared in 1819, and one or two volumes by other French writers or artists had appeared focusing on the picturesque qualities of the region in 1823 and 1824, but there do not seem to have been any English books devoted to the Loire prior to Turner's visit, and no views of the river had appeared before that date at any of the London exhibition venues.[33] Among Turner's colleagues at the Royal Academy there was one artist who had already visited the Loire. This was George Jones, who prior to becoming an Academician, had been a Captain in the Montgomeryshire Militia. He had passed between Orléans and Tours on his way to Bordeaux in 1817 (fig.3).[34] However, though Turner and Jones were certainly well acquainted by 1826, the period of their close friendship did not come until slightly later, so in this case it is unlikely that Turner would have known anything of Jones's visit nearly ten years earlier.[35]

The dearth of topographical material about the Loire was remarked on by Sir Walter Scott in 1822, when he was writing his novel *Quentin Durward*. Indeed, the lack of useful illustrations forced him to piece together and invent much of his description of Louis XI's château of Plessis-lès-Tours.[36] Scott's book appeared anonymously in 1823 and was almost immediately a success in France, with British sales picking up as a result. The generalised descriptions of the Loire region and of Liège, where the dramatic events of the second half of

the novel occur, created widespread interest in these places, but it seems unlikely that Turner knew the book, or that it was one of the reasons for his visit to Tours. Unlike Stendhal, or Henry James more than fifty years later, Turner did not wander the streets of the capital of Touraine with *Quentin Durward* 'in his pocket'.[37] By 1826 he could have known who the author was, since the collapse of many printing companies at the end of 1825, including that in which Scott was involved, had forced 'the Author of Waverley' to reveal his identity. Ironically, Turner actually had a personal connection with Scott,

ably in 1828, visiting Plessis-lès-Tours and focusing on other details of use to his historical subjects (fig.5).[40]

One of the young literary pilgrims in search of the settings of Scott's novel was the American poet, Henry Wadsworth Longfellow, whose tour in October 1826 actually coincides with Turner's. The precise dates of both journeys can only be surmised, but it is probable that they would have passed, going in opposite directions, somewhere near Amboise on 9 October, perhaps both spending the night there.[41]

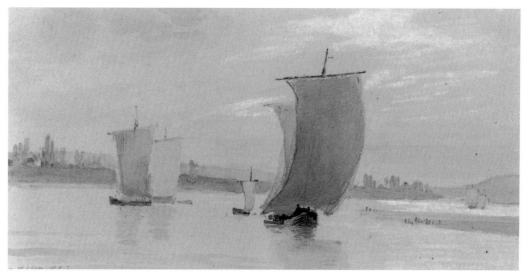

FIG 3 George Jones, *View on the Loire, near Blois* 1817, pencil with watercolour and gouache on coloured paper
The Visitors of the Ashmolean Museum, Oxford

having worked on a set of landscape watercolours to illustrate the author's *Provincial Antiquities and Picturesque Scenery of Scotland* between 1818 and 1826.[38]

While Turner did not apparently see the potential popularity of subjects related to Scott's book, the opportunity was seized by other artists, and an illustrated edition was already being discussed in the year of his tour. It was probably this year that Bonington produced his watercolour depicting the meeting of Quentin Durward and the disguised Louis XI, which occurs in the very first chapter of the novel (fig.4). This was engraved five years later in the complete edition of Scott's works published by Robert Cadell, for which Turner also contributed vignettes and landscape designs.[39] Bonington's friend Eugène Delacroix also made a visit to Tours in connection with *Quentin Durward*, prob-

The various factors outlined above should go someway to suggesting a context for Turner's 1826 journey. However, because Turner's motives can sometimes only be gauged from the existing results of his actions, it remains unclear that he had any immediate aim in making the tour. The tours of 1824 and 1825 had been structured around research for paintings which had afterwards been bought by Mr Broadhurst, but none of the new works he exhibited at the Royal Academy in 1827 suggests a reason for his extensive travels on the continent during the previous year. As so often with Turner, conclusions must inevitably be tentative in the face of his inscrutability.

The most authentic indication we have of his proposed itinerary comes from his closest friend and ally, his father, whom the artist relied on as a factotum

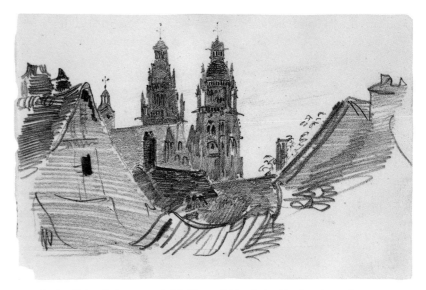

FIG 5 Eugène Delacroix (1798–1863), *The Towers of Saint-Gatien, Tours* ?1828, pencil *Metropolitan Museum, New York*

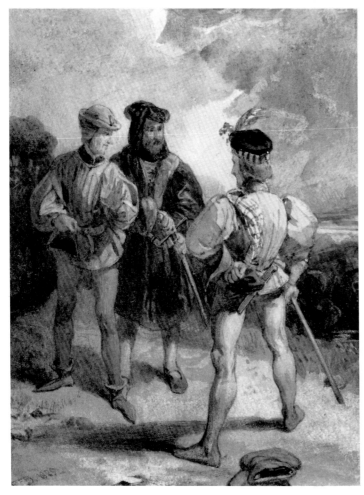

FIG 4 Richard Parkes Bonington, *Quentin Durward and the Disguised Louis XI* ?1825 or 1826, pencil and watercolour. *Private Collection (courtesy of Richard Feigen, New York)*

and personal secretary. But using the information arising from him as a means of understanding the tour has tended to compound the problems rather than clarify them. For it seems that, before leaving London in 1826, Turner gave his father the impression that he intended to visit Ostend, even though this would have meant revisiting the port he had passed through during his tours of both 1824 and 1825. It may be that the elder Turner, then in his eighties, simply mis-remembered what he had been told, since it is unlikely that Turner would have

wanted to keep his father in the dark about his actual movements, especially if he wanted his letters forwarded to him at specific pre-agreed locations, as seems to have happened when he was travelling. Whatever the reason, the absence of sketches of Ostend in any of the books that can be related to the tour suggests that he had resolved on an entirely different direction before he actually left England at the end of August.

The suggestion that Ostend may have been part of the tour was the chief cause of the confusion with the 1824 journey. This mistaken conflation of the two jour-neys arises from a reference to Ostend in a letter that Turner wrote to his great friend James Holworthy at the beginning of December 1826.[42] Without time for a proper examination of all the evidence, Turner's biographer, A.J. Finberg, linked this letter with the sketches of Ostend in the 1824 *Rivers Meuse and Mosel* sketch-book as proof that Turner had indeed been there in 1826.[43] However, in the letter to Holworthy Turner does not actually admit he has been in Ostend.

In fact, the misunderstanding between the Turners about Ostend arose simply because the artist failed to write at regular intervals to let his father know where he was. Whether he told his father he meant to be at Ostend or not, this proved to be a bad time to loose contact. For on Tuesday 19 September there was an enormous explosion in the powder magazine just to the south of Ostend, which

flattened some parts of the town and lifted the roofs of a village three miles away. The reports in the British newspapers on the following days wrote of up to 1,300 barrels of powder, each weighing 50 kilograms, which were thought to have been set off by the spark from a lighted pipe, something that *The Times*'s xenophobic journalist considered highly probable, given that 'the Flemish would hazard any danger rather than be deprived of their pipes or segars'.[44] For William Turner, Senior, it must have come as a considerable shock to hear that forty people were feared dead and that mangled carcasses and single limbs had been flung out to sea by the force of the explosion. He must have fretted alone during the following weeks hoping for some news of his son, and after a month, thinking the worst, he apparently aired his fears and (as Turner put it) 'contriv'd to stir up others in the alarm'.[45] Thus, on 20 October the *Hull Advertiser and Exchange Gazette* carried the following editorial note:

We are truly concerned to hear that fears are entertained for the safety of J.M.W. Turner, Esq., R.A., the celebrated artist. It is known that he was to be at Ostend at the very time when the late dreadful explosion took place, and no letters have been received from him since.[46]

It was to this brief passage that Turner referred wryly in his letter at the end of 1826, and although the report did not reach Holworthy's quiet retreat at Hathersage in Derbyshire, it could easily have been seen by some of Turner's London associates. For, though the *Hull Advertiser* was essentially a local paper, it was widely available in the metropolis through a number of printers and coffee houses. As luck would have it, none of Turner's friends need have worried, for on the day of the explosion he was at least three hundred miles to the west in Brittany, on his way to Morlaix.

Preparing for the Tour

Before attempting to trace the route Turner took in 1826, it is worth pausing to consider what preparations he made before setting out. Unlike some of his other journeys, the notes in the surviving sketchbooks provide very little information about practical details, such as what items of clothing or other luggage he took with him. Similarly, there are no lists of the money orders that he must have cashed as he made his way through France.

During the first half of the nineteenth century travellers in France were required to register at their point of arrival. Most visitors also carried passports with them, although this was not absolutely necessary. Turner had obtained a passport prior to his first visit to France in 1802, but appears not to have sought further official documentation in London until his journey to Venice in 1840, so there is no record of him applying for a passport in 1826.[1] None the less, he would have needed some form of identification. This is clear from the narratives of other visitors to France at exactly this period, which recall the problems they encountered with soldiers and other local officials, who were suspicious of foreigners and often demanded to check their papers. Among those who travelled on the Loire in the years after Turner, Leitch Ritchie, Elizabeth Strutt and William Callow were all made to show their papers, although in view of the political unrest in 1832 at the time that the first two made their visits this is hardly surprising.[2]

If asked to explain his presence, Turner would clearly have needed to be able to understand and to be able to reply in French. Anyone who has travelled at all knows that it is possible to get by with only a smattering of the native language, but for official matters it is much more vital to be able to communicate effectively, which prompts the question, how well did Turner speak French? A sketchbook of 1799 contains notes which have led some scholars to conclude that he had only a very limited knowledge of the French tongue.[3] Further compounding this perception are the numerous misspelt names appended to his topographical sketches. Instead of referring to the maps he took with him, he may have occasionally resorted to eavesdropping on his fellow travellers in order to identify the name of a specific town. This certainly explains some of his errors, which occur from a near-phonetical transcription that indicates he must have had some idea of the principles of French spelling, even if its finer points eluded him. This does not prove he could not speak the language, only that his proficiency was perhaps somewhat limited. In this, however, he would not have been alone. John Sell Cotman (1782–1842), for example, made three visits to Normandy with very little understanding of the language.[4]

On other journeys Turner had sought out useful information about what to see and where to go before setting off, but this must have proved a problem with the 1826 tour, simply because there were no standard English guidebooks on the area to consult. His own knowledge of the region he was to cover was slight, and limited to the Normandy coast. Once in France he would have been able to improvise a route, and it was presumably to this end that he acquired the map of Brittany (fig.6).[5] However, the direction he followed through Brittany, for example, can be attributed to two specific factors. The most important was the route taken by the diligence, the large and most comfortable of the various forms of public transport available to travellers (fig.115). The regular service this provided between the main cities by the mid-1820s was well established, and because the lumbering vehicles arrived and departed from very central locations in every large town, they were of great convenience.[6]

A second factor is the set of prints of the chief French harbours produced after designs by Nicholas-Marie Ozanne (1728–1811), examples of which Turner could have found in the print shops before he set off or once he was in France. Having trained in Vernet's studio, Ozanne followed in his master's footsteps as a royal marine painter, and had reached a position of some eminence by the 1780s, most notably for the *Plans, Dessins et Vues des Ports du Royaume*, which were commissioned from him by Louis XV. The group of prints would have had obvious appeal to Turner in its depictions of ports. Though he was perennially interested in harbour subjects, as we have seen, this type of material was very much in his mind at that date. It was, after all, only a couple of months since the conclusion of the *Picturesque Views on the Southern Coast of England*, which had included many port scenes, while the first part of the *Ports*

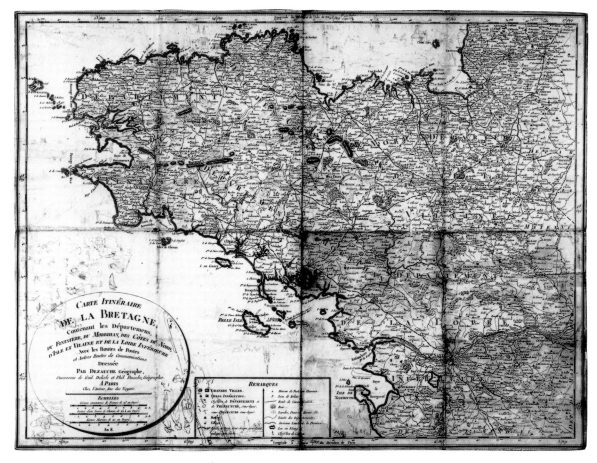

FIG 6 *Map of Western France – Brittany and the Loire* 1799–1800 (cat.10)

of England had appeared a few months before on 1 April. It is perhaps no coincidence that almost all of the places visited by Turner in Brittany had been previously recorded by Ozanne. Indeed, his sketches of the small port at Morlaix actually replicate one of Ozanne's engraved views (fig.7). Thus, it is possible that Turner may have been partly dependent on Ozanne's images as a means of deciding where to break his journey round the coast.

Selecting Materials

By 1826 Turner was already a well-practised traveller, and his method of gathering visual material had settled into a fairly established pattern. On most of his recent explorations he had taken with him sketchbooks of complementary sizes. In the smaller ones he made numerous sketches of a subject from every possible viewpoint, his eye and hand reacting as one to a motif. The larger sketchbooks, on the other hand, provided the space for him to record a more assimilated composition. This neat process breaks down completely with the 1826 tour, and it seems that this was the first time Turner travelled with an assortment of different types of paper, choosing each sheet according to his own purposes. Among the bundle he took with him were a few loose sheets of white wove paper with an 1816 'Ivy Mill' watermark, some of which was also bound up as a sketchbook.[7] He also took some of the Whatman paper he had

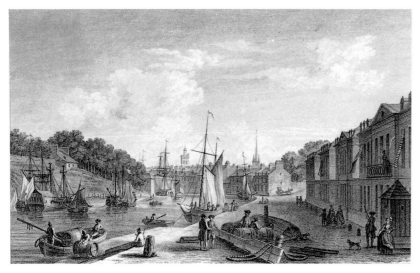

FIG 7 Nicholas-Marie Ozanne, *Le Port de Morlaix. Vu du Quai de la Manufacture de Tabac*, engraved by Yves Le Gouaz *c*.1776, line engraving. *Département des Estampes, Bibliothèque Nationale, Paris*

bought in bulk back in the 1790s.[8] But the most significant addition to his repertoire of support materials were the sheets of blue paper made by Bally, Ellen and Steart at the De Montalt Mill, near Bath. Peter Bower has determined that this type of coloured paper had probably been in production only for a short time, beginning some time after 1821.[9] The evidence of 1823 and 1824 watermarks on some of the sheets used for the Loire series demonstrates once again how keen Turner was to be at the forefront of new developments, experimenting happily with the latest materials.

One of the main attractions of the blue paper was that it provided a warm even tone on to which Turner was able to project his more considered compositions, the blue acting almost as the mid-tone on a colour keyboard. A comparison with the sketchbooks of some of the earlier tours reveals that this is not greatly dissimilar from his established method. In Rome in 1819 or on the Meuse in 1824, for example, he had used his largest books to make detailed sketches over a washed-in grey ground, choosing only later to work some of these compositions up in colour.[10] So the toned blue paper served not just as an aesthetic reference point but was also a means of saving time, as Turner no longer had to prepare his sheets with washes. The paper was immensely practical in that one sheet could be folded into sixteen smaller sections each measuring about 14 x 19 cm (5¹/₂ x 7¹/₂ in). This bundle was then easily carried in a

pocket and could be repeatedly folded over until the sheet was covered with sketches. The Loire tour may be the first extended use of this paper, but Turner resorted to it continually over the following decade, utilising it both for sketches and finished views of East Cowes Castle, Petworth House, the East Coast of England, the South Coast of France on his 1828 visit to Italy, and the rivers Seine, Rhône, Meuse and Mosel. In all he used over a thousand small sheets, sometimes sketching on both sides.[11]

While travelling in 1826, Turner made several outline sketches in pencil that he went on to work up in watercolour and gouache. Generally these are the less finished subjects, but he may also have done this for some of the images that were later engraved (figs.34, 107, 116, 121 and 124). Looking closely at the blue paper, it is obvious, even to the naked eye, that several different types have been used. The differences result from the varying presence (or absence) of red and black fibres when combined with the basic make-up of the paper. As a result of a survey of these sheets, made in collaboration with Peter Bower, it has been possible to group the works from several identifiable types; this has also resulted in the discovery that some of the drawings are on paper with an 1828 watermark and must postdate the tour (see p.238). Regrettably, because many of the finished works at the Ashmolean Museum are currently stuck to their mounts, it has not proved possible to establish whether they are on the same papers.

The adoption of this new sketching material did not prevent Turner's use of more traditional sketchbooks. Generally, only three sketchbooks have been definitely linked with the tour, as a result of which it has seemed that the tour began at Morlaix and ended, after the voyage up the Loire, at Paris.[12] However, it is probable that the tour is documented in a further four books, most of which have been dated '?1830' or associated with other tours to France in the late 1820s. As mentioned above, one of the books is made up of paper watermarked in 1816 at Ivy Mill (TB CCLV; cat.5). Appropriately, this English paper seems to have been used in the first book Turner worked in, its pages recording his presence at Dieppe and Rouen. The next book is more tentatively connected with the tour, but its contents chart the journey from Rouen, via Le Havre, to Caen and Isigny, which would have been a logical direction for Turner to pursue (TB CCLI; cat.6). Once again, this is a cheap, laid paper, probably English, that Turner must have taken with him. On his foreign journeys he invariably sought extra supplies of paper from local sources, something that he had first done in 1802, but it is perhaps a measure of how little serious thought Turner had given to the tour that he had exhausted these small books so soon after his arrival in France. Thus, the laid paper of the next book in the 1826

sequence was made by a French maker, but so far it has proved impossible to recognise the watermark. This book begins at Cherbourg and is full of views of the Cotentin peninsula (TB CCL; cat.7). There may be a missing book at this point in the tour, as there seems to be nothing to document Turner's progress from St-Malo to Morlaix, where he began another of the French-made volumes, which this time was covered in oily parchment that he inscribed 'Morlaise to Nantes' (TB CCXLVII; cat.11; Appendix A, p.231–3). The journey on the Loire from Nantes was documented in two more books made up of French paper, the first covering the distance as far as Saumur, and the second allowing him to set down his impressions from Tours until he arrived in Paris (TB CCXLVIII and CCXLIX; cats.12 and 26; Appendix A, pp.233–7). One last book, with an 1822 watermark, records a journey to the Channel coast via Beauvais and Calais, concluding with the cliffs at Dover, which may chart the final stage of the tour (TB CCLVII). Although this resembles the books used on the Loire, it is actually made up of one of the English laid papers that was specifically made for export.

Another detail of the tour that has been misrepresented is the question of whether Turner travelled alone or in the company of Leitch Ritchie, the author of the text accompanying *Turner's Annual Tour*, which took its published form as *Wanderings by the Loire* (see below, p.193). With the exception of his 1802 and 1836 Alpine tours, it was Turner's general practice to travel without companions, but somehow a tradition grew up that the two men conducted their survey of the region at the same time. To some extent, it was Ritchie's fault that this impression was created. Though his narrative never directly states that he travelled with Turner, it makes numerous references to Turner's works, and cleverly insinuates that the two men had been companions, recording their travels with pen and pencil.[13] The finely balanced ambiguity of this literary device was, however, widely misinterpreted and had become a fact by the time the Loire engravings were reprinted in the second half of the nineteenth century. By that stage Ritchie's full original text, with its many clues about his own journey a few years after Turner's, had been jettisoned. The most valuable piece of internal evidence is that Ritchie claimed to have carried with him some of the engravings based on Turner's designs, which would hardly have been possible if they were both exploring the river for the first time together.[14]

The actual dates of Turner's movements during the tour have proved difficult to establish, and, once again, previous attempts to interpret the existing evidence have not always proved reliable. Aside from the clue that he had been to France in the summer of 1826, already noted in the advertisement of

January 1827, there are actually several dates inscribed in the tour sketchbooks. The earliest of these is 23 August, which appears in the last of the three Loire books.[15] This has been assumed to record a transaction at the London print dealers Colnaghi's immediately prior to Turner's departure,[16] but its inclusion in a book so late in the tour, and moreover one that he used in Paris, must throw this into doubt (see p.156). A more reliable date appears towards the end of the *Morlaise to Nantes* sketchbook, where Turner has written 'Nantes = 1/2 October', but unfortunately this incipient diary was not continued.[17] Tracking Turner down in the official records on the other side of the Channel has met with a similarly fragmentary picture, but has brought to light documents that prove he visited Dieppe, Cherbourg and Brest during his journey; the dates and documents are discussed in the following outline of the tour. From these documented appearances it is possible to work out a likely route that lends support to the inscription at Nantes, but after that fixed point the dates of Turner's visits to the towns along the Loire as presented here are purely conjectural.

There has also been much speculation as to exactly when Turner painted the set of Loire subjects, producing a variety of opinions but with most scholars concluding they were created several years after the tour, probably only a short time before the set of engravings for his *Annual Tour* went into production.[18] This opinion is thrown into question by the actual use of the sheets of blue paper for on-the-spot sketches and by the lack of a uniformity of style across the series, even among the group of published subjects, suggesting perhaps at least two working campaigns on the material. In the majority of the colour sketches, the handling of paint and the wiry pen work is most similar to the series produced at Petworth, which is now dated to the autumn of 1827.[19] On the other hand, not all, but the greater part of the group of finished works seems to have been produced a few years later, as is most obviously clear in the sophisticated vignette of Nantes (fig.29). In the following discussion of Turner's route, sketches and finished subjects are intermingled, but the differences between them should be readily apparent.

Apart from a handful of views, which must have been developed over the pencil notations that Turner made directly on to the blue paper, most of the set relies on preliminary ideas in the 1826 sketchbooks. His development of this material would not necessarily have needed to be focused on the final *Annual Tour* scheme. In 1826 and 1827 he was still largely unaccustomed to the behaviour of his colours on the new blue paper and would have enjoyed the opportunity of experimenting with its effectiveness. It can, at least, be deduced with

some certainty that he had produced a group of colour sketches before he left for his 1828 visit to Rome or, at the very latest, soon after his return in early 1829, for one of these studies was the source of an oil painting he exhibited at the Royal Academy that spring (figs.67 and 179). The types of paper he used also play an important part in helping to date the works. Some of the sheets are watermarked with the dates 1823 or 1824, but there are also works in the series with an 1828 watermark. The use of the same type of paper for views of a specific place, coupled with exactly the same range of colours, indicates that these designs were produced in the same painting session, worked on by Turner in batches, much as he did with the watercolour 'beginnings' he was also creating at this time for the series of *Picturesque Views in England and Wales*.[20] For example, all the views of Orléans are painted on a pale blue paper with an 1824 watermark, using a predominantly red palette (see figs.142–50).

The Loire views appear to represent the first time Turner used his blue paper for studies painted predominantly in gouache, that is the opaque form of watercolour that has been thickened with Chinese white, also known as body-colour. In the best of these studies and finished drawings the brightly coloured paint sparkles against the warm ground, relying on the paper to act as sky or water, or to supply atmosphere. Nicholas Alfrey has pointed out that the series is notable for 'a succession of concentrated moments in which Turner goes well beyond naturalism in search of poetic effect'.[21] It is important, however, to stress that the first of the groups of works on blue paper began life as personal memoranda and were not intended to be seen by the public. They are part of the same investigative tendency that led Turner repeatedly throughout the 1820s to set himself new technical challenges, especially in relation to the process of seeing his designs translated from colour into black and white line engravings. Having produced a set of informal Loire studies sometime around 1828, he returned to the blue paper once the idea for a set of engravings provided a specific project, possibly utilising one or two of the already existing designs. Significantly, the three sets of views of French rivers, beginning with those of the Loire, were to be, with one exception, the only group of his works sent to the engravers as gouache drawings on blue paper, thereby presenting special problems for the team of men who were to interpret them.[22]

Turner was heavily dependent on his sketchbooks when working up the views in colour, but because the tour had not been planned specifically around collecting data to furnish a series of engravings there are obvious limitations to the material, which Turner stretched as resourcefully and as ingeniously as possible. For example, sometimes a page covered in tiny thumbnail sketches resulted in as many as three colour works (figs.59–63). The nature of his experience on the river meant that he was often forced to adopt a low viewpoint, which exaggerates the scale of the cliffs, although this was also a characteristic throughout his career of his presentation of subjects that combine a river scene and an architectural subject.[23] But even without knowing that the sketches would be used as the basis for future works, Turner was already thinking pictorially, and frequently compressed a panorama on to one sheet or one page-opening (fig.45). The final format of his colour designs is much closer to a square than to a panoramic landscape and this inevitably also affected the way he presented his motifs. He tended to conform to the rule: 'The nearer a shape approaches to the square form, the more a landscape-painter is tempted to exaggerate the height of things to fill up his composition and get things in, on each side.'[24] Something that derives from his training in the topographical tradition is a preference for a general view or distant prospect of a town. The view of Blois, in particular, demonstrates his ability to present an informative overview, which is actually the result of cleverly concealed artistic licence, as a contemporary photograph from the same spot reveals (figs.127 and 129). The notes below on the various towns at which Turner stopped reveal other sleights of hand in the actual details of what he recorded. This is best accounted for by his innate sense of what would be best in any design. For, as one of Turner's biographers Philip Hamerton perceptively remarked, 'the intensely strong personality of the artist subordinated truth to imagination, and led him to substitute what he imagined for what he saw'.[25] While this is true, most of the sites sketched by Turner will be easily recognised by those who choose to visit them.

NOTE

Although the presentation of the drawings to the public after Turner's death is discussed below, it needs to be stated here that many of the sheets have become discoloured because they were unremittingly exhibited during the late nineteenth century. Sadly, there is little that can be done to restore the damage from over-exposure to daylight, and it is for this reason that some of the works are now considered too fragile to exhibit.

The Tour through North-Western France in 1826

Turner's Route

At the end of August 1826 Turner set off from London, leaving his father with the impression that he would shortly be in Ostend. However, rather than heading east to cross the Channel at Dover or at one of the other ports in Kent, he journeyed south towards Brighton. But if he stayed there, he successfully managed to evade the local press, who published weekly lists of the celebrated arrivals to the town. Brighton would have been a convenient place to start his tour, since it offered a regular steampacket service to Dieppe. Furthermore, passports could be readily obtained near the Chain Pier before boarding one of the boats. There was, however, a temporary breakdown in the usual service at the end of August that year while two of the boats underwent maintenance work.[1] Nevertheless, a third boat, the *Quentin Durward*, continued making the crossing during these weeks. Turner was already familiar with the seaside resort and its facilities, but may have decided to avoid the town altogether and perhaps instead travelled straight to Shoreham, a few miles to the west, since the first sketches which can definitely be related to the 1826 tour are a group of views of the church of St Mary de Haura and the adjacent harbour, which were made on one of the folded sheets of Ivy Mill paper (fig.8). Turner's presence in Shoreham could indicate that he embarked directly from there for France or simply that he made an excursion there from Brighton while waiting for a steamer. Either way, he actually began his French tour that year at Dieppe.

Dieppe and Rouen

His arrival in France at Dieppe can be ascertained from his answer to the inquiries of a bureaucrat much later in the tour. For, after arriving at Brest in Brittany, he seems to have been asked the standard questions about where he had disembarked and where he was heading, to which he replied Dieppe to the first query.[2] Even without this useful piece of information, one can surmise from the views of Dieppe on the first pages of the *Rouen* sketchbook that he arrived there (cat.5). These are taken from the cliffs of Le Pollet to the east, which was a viewpoint he had sketched in 1821 and 1824.[3] As we shall see, this book can be firmly linked with 1826, as its sketches are unique among those Turner made of Rouen

FIG 8 *Studies of Shoreham church and harbour* 1826 (cat.3)

in showing the cathedral without its spire. This indicates, as A.J. Finberg rightly noted, that the 'date of the book must therefore be between 15 September 1822, when the spire was destroyed by lightning, and 1827, when the work of erecting the new spire was begun'.[4] Because none of Turner's other visits to France in the mid-1820s included both Dieppe and Rouen, it seems reasonable to conclude that this book charts the beginning of the 1826 tour.

At the end of August 1826 Dieppe was bustling because of the presence there of Marie-Caroline, the Duchesse de Berry. This was the first of her annual visits, which were to make the town, with its newly built bathing facilities, the French equivalent of Brighton for the fashionable set. Royal-spotting was, if anything, more popular than it is today, and interest in the Duchesse drew many English as well as French visitors. None of this is evident in Turner's sketches, which concentrate on the picturesque port. After the thorough survey he had made of the quaysides in 1824, he chose only to make general views over the town. The discovery of the ruins of Château d'Arques, just outside Dieppe, on that earlier trip seems to have encouraged him to return there in 1826. To visit it entailed a gentle walk of about four miles up the River Béthune. Once there, he recorded the fortress from the north-east on one of his sheets of blue paper (fig.9), but he may also have sketched on the pieces of Whatman paper that he had brought with him. However, his survey was rather cursory because he had made so many sketches two years before.[5]

From Dieppe he travelled swiftly on to Rouen. This initial goal may have been one of the factors that caused him to depart from the plans he had announced to his father. One incentive would have been the dramatic loss of the cathedral's spire since his last visit in 1821. More particularly, his interest in the building may have been heightened by David Roberts's *View of Rouen Cathedral*, which had appeared at the Royal Academy earlier that year. This was only Roberts's first exhibit, which meant that his picture was hung in the relative obscurity of the School of Painting. In spite of this, it was seen by Turner, who is known to have drawn it to the attention of Sir William Allan.[6]

For his own sketches of Rouen he generally adopted viewpoints outside the city, which allowed him to observe the diminished cathedral from a distance and, once he had climbed Mt-Ste-Catherine to the south-east, from above. One of these sketches (fig.10) looks down on the city from almost exactly the same spot that John Sell Cotman had selected a few years earlier on his explorations of Normandy.[7] That this also happened at Dieppe, Château d'Arques, Coutances and Avranches can most probably be attributed to the coincidence of two artists seeking the same type of picturesque subjects, since there are not known to be any direct links between them at this stage, although some of Cotman's French subjects had recently been sold or exhibited in London.[8]

From Rouen to Cherbourg

Turner's *Rouen* sketchbook is the only book from the 1820s made up of 1816 Ivy Mill paper and provides very few clues as to where he went after leaving the city.

FIG 9 *Château d'Arques from the east* ?1826 (cat.4)

FIG 10 *Rouen from Ste Catherine's Hill* 1826 (cat.5)

At the back of the book a sheet of the same paper has been attached, although it has been trimmed and was clearly never part of the original sequence. On this sheet is a view of Mont-St-Michel, which was formerly one of the loose pieces of paper on which Turner sketched the western side of the Cotentin peninsula. There are very few pieces of this particular type of paper, and the smaller pieces can often be neatly arranged to make larger sheets. As a group they reflect the tour as outlined so far, but there are no sketches to cover the route from Rouen to any of the sites to the north or east of Mont-St-Michel.

One solution for this omission lies in a small notebook, which was catalogued by Finberg as the *Caen and Isigny* sketchbook and dated 1830 (cat.6).[9] Because the paper of this book was made in England, it is very likely that it was used in the early stages of a tour and was brought to France by Turner himself. The title given to the book by Finberg is not an accurate reflection of the full scope of its contents. A more useful description of the progress recorded in its pages would be 'Rouen, Le Havre, Caen, Bayeux and Isigny'. The early pages of the book especially, showing the quays at Rouen, suggest that Turner filled the book during the 1826 journey. However, before rushing to make this conclusion, it should be noted that the style of the sketches is different from the sketchbooks more firmly associated with the latter part of the tour. In fact, there are tremendous discrepancies in the handling of the pencil from page to page of the book, so that while some sketches deploy the same sharp lines found in the views of Rouen, others are either vague or much blunter, almost resembling scribbles. Some of this may be attributed to circumstances such as Turner's hasty pace across Normandy or to the paper, which was very cheaply made. There is the further possibility that the book can be read from back to front, thereby recording the journey in the opposite direction, but against this it has to be said that there are similar stylistic problems in associating the book with the material resulting from Turner's visit to Guernsey in 1829. Rather than dwelling on this problem at length here, it seems useful to give some idea of the route these sketches imply if a date of 1826 is accepted.[10]

There are several views of Rouen close to the front of the book, but, as the central spire of the cathedral is not shown in any of them, it is not possible to use this as a means of dating the book more securely. From Rouen Turner seems to have taken a diligence to Le Havre, as there are no sketches of the country in between. In contrast, there are several views of places in the vicinity of the port at the mouth of the Seine, including the light-towers at Ste-Adresse.[11] Among the pages bearing these sketches are notations of stormy cloudy skies passing over the sea.[12] By calculating back from the fixed dates we

FIG 11 *Views of Bayeux* 1826 (cat.6)

have of Turner's known movements later in the tour, it is possible to see these as recording the beginnings of the mighty gales that lashed the Channel coast at the end of the first week of September in 1826.[13]

At Le Havre Turner may have stayed at the New York Hotel, for he inscribed its name at the bottom of a sketch that he afterwards used as the basis for a watercolour (Indianapolis Museum of Art, W1048).[14] If that watercolour was painted in 1827, as suggested below, this would help to date the sketchbook more securely to 1826. There are then very few sketches until the large group of studies and jottings that he made at Caen.[15] The city was rich in subject matter for any artist interested in religious or vernacular architecture, and had already been visited by one or two of Turner's younger contemporaries. From Caen he kept close to the coast, sketching at Luc-sur-Mer and St-Aubin-sur-Mer before stopping at Bayeux. It was there, while setting down a general study of the cathedral, that Turner recorded one of the most charming inscriptions in any of his notebooks (fig.11). The comment suggests his sketching had attracted the attention of the locals, who, on discovering

Turner's innocent purpose, must have said, 'Take all you like Home with you – All Normandy'.

Cherbourg and the Cotentin Peninsula

If this was indeed Turner's route across Normandy in 1826, as seems probable, it brought him within a short diligence ride of Cherbourg, the port at the tip of the Cotentin peninsula. He arrived there on Saturday 9 September, as is made plain from the records that all hotel owners were obliged to submit to the

Confirmation of Turner's presence in Cherbourg can also be found in what Finberg titled the 'Coutances and Mont St Michel' sketchbook, the first of those Turner bought while in France (TB CCLI). Like the *Rouen, Le Havre, Caen, Bayeux and Isigny* book, this has been more often related to the later visit to Guernsey. In this case there should be absolutely no doubt that this book records the 1826 tour, for on the inside front cover Turner inscribed the words 'Cherbourg Dimanche', which would indicate that he began this book on Sunday 10 September, the morning after his documented arrival there. Surpris-

FIG 12 *Cherbourg: the Fort au Roule* 1826 (TB CCL f.59v.)

FIG 13 *St Vaast-la-Hougue* 1826 (TB CCL f.53 verso)

authorities in Cherbourg.[16] In this newly discovered document he gave his usual guarded account of himself, recording his name as 'Turner, William', and admitting to '50' years, although he was actually a year older. For the question about what kind of work he did, the answer given is 'Rentier', meaning someone of independent means. Not surprisingly for a traveller from 'Angleterre', he opted for the reassuringly familiar-sounding Hôtel de London. The final column of the ledger allowed the official to make observations. That beside Turner presumably notes his reply to an enquiry about the purpose of his visit, to which he responded evasively, 'pour de promener'.

ingly, he made very few sketches actually in Cherbourg; those he did are of the Fort du Roule from below in the port (fig.12).[17]

The stormy weather of the previous few days had probably forced him to abandon a steady survey up the peninsula, so that, in order to make amends, after leaving Cherbourg, he pursued a leisurely meander around the east coast before wandering across country towards Coutances and Granville. In contrast with the *Rouen, Le Havre, Caen, Bayeux and Isigny* sketchbook, there is little order to the sequence of sketches, and it is apparent that Turner set down his observations after opening the book at random. The tour along the coast took

him east to Barfleur and then southwards to St-Vaast-la-Hougue, where he discovered seventeenth-century fortifications protecting both sides of the small fishing port (fig.13). He stopped next at Valognes, making a simple profile sketch of the church of St-Malo, which is of some interest in that the church has since been rebuilt after it was badly bombed in 1944.[18] He also made another more detailed study of the church in the *Rouen* sketchbook, although the sketch has been previously identified as a view at Evreux.[19] This new identification is of great importance in helping to knit together the early sections of the tour more convincingly.

At Valognes he may have waited for a diligence or some other form of transport to take him the twenty miles or so to Coutances, most probably arriving there a couple of days after leaving Cherbourg, perhaps on Wednesday 13 September. Perched high above the surrounding country, Coutances has served as the religious and judicial centre of the region for centuries. Like Cotman before him, Turner was captivated by its appearance and made numerous outlines of its distant silhouette (fig.14), as well as studies of individual buildings.[20]

FIG 14 *One of four views of Coutances on a sheet folded into quarters* 1826 (cat.8)

FIG 15 *The cathedral at Coutances from the south-west* 1826 (cat.7)

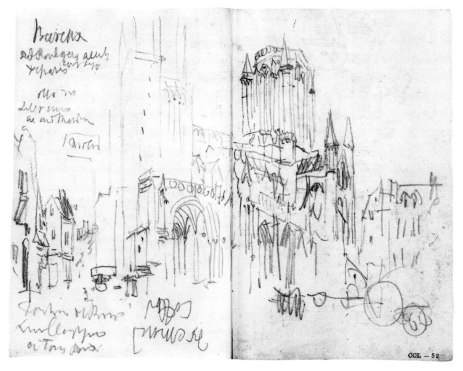

The views of Coutances, in fact, represent his most extended survey of any of the places he had visited on the tour up to that point. Although he clearly paid some attention to the Renaissance church of St-Pierre, he concentrated much more intently on the grandeur of the cathedral, transcribing its solid spires and galleries and noting the breathtaking beauty of the lantern-tower over the transept crossing, which ensures the graceful interior is bathed in light, even on a dull day (fig.15). The other architectural feature to catch his eye at Coutances was the remains of an ancient aqueduct to the west of the town, from where he made several detailed views. Though none of these is known to have been given more elaborate form as a finished watercolour, this was a view that many other artists depicted in the following years.[21]

Turner's next significant break from his journey came at Granville, further south, on the west coast of the Cotentin peninsula. It was then just a small fishing port, built around the church of Notre-Dame on the rocky outcrop that projects into the sea (fig.16). Beyond it lie the Iles Chausey, which were quarried for their brown granite in order to construct the buildings on Mont-St-Michel. Turner would have found the siege of 1793 still vivid in local memory, as Stendhal did nearly a decade later. This event had resulted in the defeat of the uprising by Chouan troops, who had remained loyal to the monarchy. Later in the tour Turner was to come across other sites important in the resistance against the revolutionary forces.

Throughout his tour across Normandy up to this point, as well as recording the appearance of the places he visited, he made numerous studies of people, noting their activities and their costumes, which, in the case of the women, often involved stylised regional headgear.[22] Although these figure studies are often little more than rough jottings, they served exactly the same skeletal function as any of Turner's other sketches, and could be given flesh and blood as the need arose.

After Granville Turner stopped briefly at Avranches before making his way on to Mont-St-Michel. One of the pieces of Ivy Mill paper records the view of the distant monastery island from the terrace at Avranches (fig.17), and, because this is still a popular viewing place, it is no surprise to discover that Turner's view echoes a drawing that Cotman had made a few years earlier.[23] Mont-St-Michel was to become perhaps the most popular Normandy subject, after Dieppe and Rouen, for the next generation of topographical watercolourists. It was especially valued for the mirage effect produced at sunset, when the island seemed to hover magically above the sea.[24] The unpredictability of the tides gave the otherwise picturesque island an element of the sublime, as

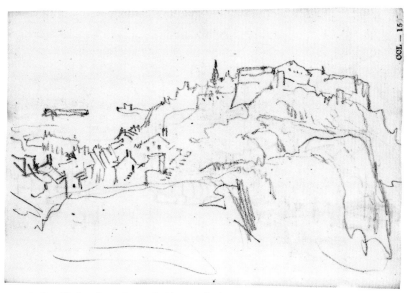

FIG 16 *Granville from the north-east* 1826 (TB CCL f.15)

FIG 17 *View from Avranches, looking towards Mont St Michel* 1826 (cat.9)

Brest

Turner's stay in Brest is another of the few parts of the 1826 tour that can be precisely dated and is documented here for the first time. The municipal archives at Brest include a register of travellers, which records his presence there on Saturday 23 September.[30] The entry for that day, where his name is listed as 'Turner, Mallord', indicates that he was travelling from Dieppe. When he left the next morning another entry in the register lists his name as 'Turner, Joseph' and his stated goal as Lorient. Whether he arrived on the Friday evening and was unable to register until the following day is not clear.

Brest has always been one of the most important French ports, provided as it is with the great advantage of a huge natural harbour, formed by the meeting

strictly restricted (much as it is today) for reasons of military security. This may have been the reason Turner made so few sketches during his short visit. Just as other artists travelling in France in this period were invariably accused of spying, the act of sketching in such a sensitive area was in danger of being mis-interpreted by wary soldiers. In spite of this, Turner managed to jot down the principal forms of the port, including the Tour Tanguy, and he also made three outline sketches of the château, one of which was to prove the basis for a large oil painting (fig.22; see below, fig.173).

Elsewhere in Brest, he made a sketch of the church of St-Louis, which is of some documentary interest, in that the church was destroyed by Allied bombing during the last war (fig.23). Begun in the late seventeenth century, the

FIG 22 *Brest: the château from the quayside, with the masting machine* 1826 (cat.11)

FIG 23 *Brest: the church of St-Louis* 1826 (TB CCXLVII f.14)

of several rivers. The most striking feature of the town is the fortress guarding the mouth of the Penfeld river and the military buildings which line the quays. Built as part of Richelieu's project to strengthen the French ports against Eng-lish or Dutch invasion, the extent of this immense seventeenth-century com-plex can best be understood from depictions by artists such as Jean-François Hue or Nicholas Ozanne, who both adopted the principles Vernet had brought to the genre of the port scene.[31] Travellers of the first half of the nineteenth century were greatly impressed by the bustle of the port with its extensive arsenals, workshops, magazines and barracks, although access to the area was

church was apparently not finished until the nineteenth century. As much of Turner's sketch is suggested only in outline, it is not possible to say whether building work was complete.[32]

From Brest Turner made a short detour to Le Conquet, taking in the ruins of the abbey at the Pointe de St-Mathieu, the furthest point west of any of his travels on the continent.[33] The order of the sketches in the book suggests that this excursion took place after his survey of Brest and before he continued his journey south. Since this involved a round trip of nearly forty miles, it would have taken the best part of a day, which may have replaced his declared inten-

tion on 24 September of moving directly on towards Lorient. The trip would have required him to come through Brest a second time, where he could have found a diligence to take him on to Quimper. However, another alternative would have been for him to have sailed south from Le Conquet, but this possibility does not seem to be borne out by the identifiable sketches, although a couple of sheets have been ripped from the book at this point.

At Le Conquet he recorded the outline of the island of Ushant, but in annotating his sketch he was uncertain which of the group of islands actually was Ushant. His sketches of this part of the journey are slight and it seems surprising that he felt able to think of them as useful source material for any of the views of the Channel coast that he was to propose back in London four months later (see p.158). No doubt the site held associations for him, as for most Britons at this time, for there had been a famous naval battle there in 1788, when the British fleet was led by Admiral Keppel.

Quimper

Once again, Turner covered a considerable distance before he made his next group of sketches, which are of Quimper. Depending on the date of the preceding excursion, he must have reached the town on either 25 or 26 September. It is at this point that the systematic use of the sketchbook breaks down, so that there are four groups of sketches of Quimper interrupted by views of Lorient and Nantes. Turner's initial concern was for the obviously picturesque elements of the small town, such as the cathedral of St-Corentin, the western facade of which he recorded across both sheets of a page-opening (fig.24). Characteristically, the architectural sketch remained incomplete once he had absorbed enough of the pattern of the building to be able to replicate it if the need arose. At this date the towers of the church were finished off with decorated galleries and short pyramidal spires that were removed in the 1850s when the existing stone steeples were constructed. Around the foot of the towers can be seen a number of small houses, which also reappear in two further sketches a few pages on in the book. During the second half of the nineteenth century the houses were demolished as part of the vogue for preserving important Gothic monuments; at that stage the preservation of heritage had not yet embraced secular architecture. One of the sketches shows the cathedral facade, with the timber-framed houses of the Rue Kéréon on the left. Over these Turner has made a list of places that lay on the route through Brittany from Quimper to Paris, which suggests that Turner was considering other places worth visiting. He may have observed them listed at the coaching inn. Among

FIG 24 *Quimper: the cathedral of St-Corentin* 1826 (TB CCXLVII ff.22v., 23)

the sketches of Quimper one view of the Rue Kéréon, with the tops of the cathedral towers, is inscribed 'Rue de Bouchery'.[34] As Turner only rarely made this kind of annotation, this may suggest the area of the town in which he stayed.

The name Quimper has its derivation in the Breton word *Kemper*, meaning 'confluence', in this case that of the rivers Odet and Steir, but, having been

FIG 25 *Breton peasants dancing ?c.1826–8 (cat.45)*

delivered to the centre of the town, Turner was only able to discover the attractive views of the town to be had from the banks of the Odet once he had explored the area surrounding the cathedral. Many pages after the initial group, the sketchbook includes two distinct sets of outlines of the bishop's riverside palace, looking up the Rue Ste-Catherine to the cathedral. The emphasis falls alternately in these two groups on the cathedral and then the Bishop's Palace. There is also a more distant view from downstream, close to the port, where the spires of the cathedral appear above the other buildings.[35] While Turner chose not to develop this as a watercolour, it was to prove a popular viewpoint with artists such as Ferdinand Perrot, Eugène Boudin and Myles Birket Foster, among many others.[36]

The distinctive costumes worn by the people of the Quimper region also caught Turner's eye, for, as well as portraying them incidentally in one of his sketches of the cathedral, he made a page of studies, showing the characteristic

features of both male and female attire.[37] One figure wears a broad-brimmed hat, with a short jacket and trousers gathered at the knee, and there is a small study of a woman in a striped dress. Although these notes are somewhat minimal, Turner had often paid special attention to the local costumes of the places he visited, sometimes devoting whole sketchbooks to this kind of observation on his earlier tours.[38] However, in the late 1820s, instead of making coloured notes in sketchbooks, Turner painted them on the sheets of blue paper that he was also using for collecting topographical material. For example, a year after the Loire tour he made many figure studies during visits to East Cowes Castle and Petworth House.[39] Although it has sometimes been dated slightly later, there is a pen and gouache study which relates to the figure noted in the *Morlaise to Nantes* sketchbook (fig.25).

In this apparently spontaneous scene a group of figures dance in an open place near a Breton church to music provided by a drummer and a fiddler. Nowadays these traditional costumes are almost exclusively associated with the religious festivals known as 'pardons', many of which occur in August and September, and it may be that Turner happened upon one of these celebrations during his journey. The lively humour of the scene is certainly well observed, but the lumpen quality of the figures is also typical of those found in the set of *Picturesque Views in England and Wales*, which Turner was creating at exactly this period and which were often criticised. The critic of the *Spectator*, for example, remarked that 'Turner's models must certainly be a collection of Rag Fair dolls'.[40] While it is easy to see the truth of this sort of comment, images such as this were essentially unfinished sketches, made solely for Turner's own amusement as mementoes of the people he encountered or as records of the hospitality he enjoyed.

Lorient

After staying at least one night in Quimper, Turner was back on the road again. Assuming he left Quimper in the morning, quite possibly that of Wednesday 27 September, he could have been in Lorient later that day. It is interesting to note that he was at this point tantalisingly close to the small village of Pont-Aven, which was to become such a haven for later nineteenth-century artist-visitors to Brittany. At this date, other than the tranquillity of the mills beside the stream, there would have been nothing distinctive to cause Turner to stop there. However, the diligence route from Quimper to Lorient would have gone through Quimperlé, and therefore bypassed both Concarneau and Pont-Aven, thus denying Turner the chance to sample the picturesque qualities of either

place. Although the emphasis of Turner's tour tended to revolve around the major ports of western France, it must have been frustrating to pass through so much unfamiliar countryside without the secure knowledge that the places he was seeing were the most interesting. It has been remarked by other commentators, writing about other tours, but it is worth reiterating that, where there was no deeply rutted route worn by previous travellers, Turner seems frequently to have been lacking in curiosity or apparently in such a rush that he missed some of the real treasures of the countries he visited.

Once at Lorient he made only a handful of sketches, many of which appear scrappy.[41] As at Brest, this may have been a result of an intimidating military presence, causing him to sketch furtively, and perhaps explains the preponderance of general views, rather than the kind of individual details he executed at other centres. The port had grown up rapidly during the second half of the seventeenth century after Louis XIII had given the land to the Compagnie des Indes, whose first attempts to found a base at Port-Louis on the other side of the Scorff estuary had at first not met with success. During the eighteenth century the company thrived on the silks, teas, spices and other luxury goods that passed through the port until the loss of the French colonies in the second half of the eighteenth century. By the time of Turner's visit in 1826 Lorient had become a free port, increasingly involved in the fishing industry, but its former wealth had enhanced its appearance, providing it with elegant buildings and

FIG 26 *Lorient from the south* 1826 (TB CCXLVII f.87)

FIG 27 *Vannes: the Chapelle of St-Yves* 1826 (TB CCXLVII f.29v.)

quaysides, something of which can be seen in the painting of Lorient by Jean-François Hue.[42] Turner's sketches focus on the most eye-catching features, such as the long regular lines of the Magasins des Ventes, and the tallest structure, the Tour des Signaux, which served as a lighthouse (fig.26). Lorient, however, does not really seem to have held his attention as much as the interesting patterns formed by the symmetrical citadel of Port-Louis across the water. This had been chiefly constructed in the seventeenth century at the time of the Catholic League, but its development had been stunted by the commercial success of Lorient. The sketches suggest that Turner either crossed the roadstead by water to get a closer look at the seventeenth-century fortifications, or that he simply walked downriver from Lorient on the same side. His views of Lorient are often taken from the south, looking back up the estuary, but because they are scattered randomly through the second half of the book it is impossible to reconstruct his precise route, especially now that Lorient has been rebuilt after the destruction of the last war.

From Lorient Turner made another headlong dash eastwards, which meant that he passed straight through the attractive town of Auray without seeking out its distinctive features. This was a period when there was beginning to be considerable interest in the megalithic alignments and dolmens of this area, particularly in those at Carnac, and other travellers were already making a

point of stopping off at Auray to study these ancient monuments.[43] Perhaps the weather was bad, or perhaps Turner simply did not know of their existence. It is certainly regrettable that he missed this opportunity, since he had earlier shown a great interest in the stones of Stonehenge, although this may have been partly as a result of the associations the burial site had with British history.[44]

At Vannes he would scarcely have needed to leave his seat in the diligence to make his only record of his visit there. Presumably the diligence stopped to let down and pick up passengers opposite the Hôtel de Ville in the Place Marchais, and while it was doing so Turner made his view of the north side of the square, focusing on the seventeenth-century facade of the chapel of St-Yves, which lies outside the ancient ramparts (fig.27). Attractive though this building is, the omission of any identifiable sketches of more important buildings, such as the cathedral of St-Pierre, or even of the picturesque streets overhung with half-timbered houses, confirms that Turner cannot have spent very long here.

La Roche-Bernard

The next group of sketches depicts the banks of the River Vilaine, which Turner crossed at La Roche-Bernard. After a long day's travelling this would have been a convenient place to spend the night, perhaps that between 29 and 30 September. There were inns on either side of the river, which until 1839 had not been spanned by its first suspension bridge. Before he was ferried across the Vilaine, Turner made sketches from the right bank looking across to the cluster of buildings around the small chapel, with its little spire, showing their relationship to the landmark group of rocks beside the river (fig.28). The town was then a well-established port, founded on the export of goods from the region, but it was its setting that appealed to travellers. Some years after Turner's visit, Stendhal (Marie Henri Beyle) stayed here on his journey through western France, and declared it to be 'one of the most beautiful natural scenes that [he had] ever encountered'.[45]

The diligence appears alongside the rocks in the last of the four sketches of La Roche-Bernard, apparently waiting to carry Turner up the main street and on towards Nantes. As the coach covered the forty miles of heathland, Turner's eye was caught by his first distant view of the River Loire, looking down on it as it began to merge indistinguishably with the sea. The two quick sketches on page 47 verso of the book are very slight, and it has not been possible to recognise the identity of the church spire and windmill, which appear in the lower of the two outlines of this view, although they could be those of St-Etienne-

FIG 28 *La Roche-Bernard from the south-west* 1826 (TB CCXLVII f.85v.)

de-Montluc. It is, in fact, only Turner's almost illegible inscription of the word 'Loire' that provides a general clue as to where he was when he made it, but the annotation vividly communicates his excitement as he approached the great river for the first time.

Nantes

Turner would have been able to see the towers of the cathedral of Nantes as the road from Savenay dropped down towards the shipyards along the Loire, and once he was on the waterfront itself, the city would have seemed to stretch out across the river in front of him, connected from one bank to another by a series of bridges spanning the many sandy islands at this point. Since Turner's visit the island structure of the city has become obscured by the blockage of the smaller arms of the river and by the diversion of the course of the main stream away from the city centre. This was partly a result of the silting up of the river, which was already a concern in the 1830s.

There are so many sketches and watercolours of Nantes that it is clear Turner stayed there longer than he had allowed himself in many other towns. Towards the end of his *Morlaise to Nantes* sketchbook he wrote 'Nantes = 1/2 October',[46] presumably indicating the time he had spent there, but if this was intended as the beginning of a more ordered record of his journey, it actually went no further. Allowing for the time it would have taken him to travel from

Brest, where he is recorded on 24 September, to Nantes, even with the detour to Le Conquet, it is quite possible that he arrived in Nantes on the last day of September. The first two days of October would then represent full days devoted to intensive sightseeing, making it possible that it was not until Tuesday 3 October that Turner began his ascent of the Loire. Certainly, the volume of visual information that he gathered is a testament both to his industry and to the attractions of Nantes itself.

In 1826 Nantes was a large city with a population bordering on 80,000 inhabitants, and was (with the exception of Rouen) by far the largest place Turner had visited since leaving London. For some time it had been enjoying a period of tremendous prosperity as a result of its thriving port, which was within easy reach of the Atlantic. During the last thirty years of the eighteenth century there had been a great building boom, with whole neighbourhoods rebuilt in the latest fashionable styles, particularly at the western end of the city. Much of this prosperity was founded on a long tradition of what was euphemistically termed the 'ebony trade'. This involved transporting slaves from the Guinea coast to the Antilles, where sugar cane was bought to bring back to Nantes. It was there refined before being transported up the Loire. All of this was brought to an end, however, by the Revolution, which abolished the slave trade, thereby forcing Nantes to develop other industries. However, the river remained a vital transportation route for commercial products.

When making his sketches of Nantes, Turner seems to have opened his book indiscriminately, choosing to fill in the spaces around his earlier sketches. If, however, one assumes that the first sketches in the sequence were those first executed, there is a strong possibility that Turner may have begun his survey by leaving the diligence before it arrived in Nantes itself. By doing this he was able record his impressions as he gradually approached it on foot. But, for the purposes of this essay, it is perhaps easiest to begin with a consideration of his views of the château of the Dukes of Brittany, which lies at the heart of the city as a solid reminder of Nantes's long history.

Although there were earlier fortifications on the site, the existing château was largely built in the fifteenth century during the reigns of Duke François II and his daughter Anne of Brittany. The château had in 1598 been the location where Henri IV had signed the famous Edict of Nantes, which brought greater freedom to Protestants. Until the nineteenth century the waters of the Loire lapped against the southern side of the ramparts, as can be seen in Turner's pencil sketches, and particularly in the two gouache designs of the château from the river (figs.29 and 30). The foregrounds of both watercolours are filled

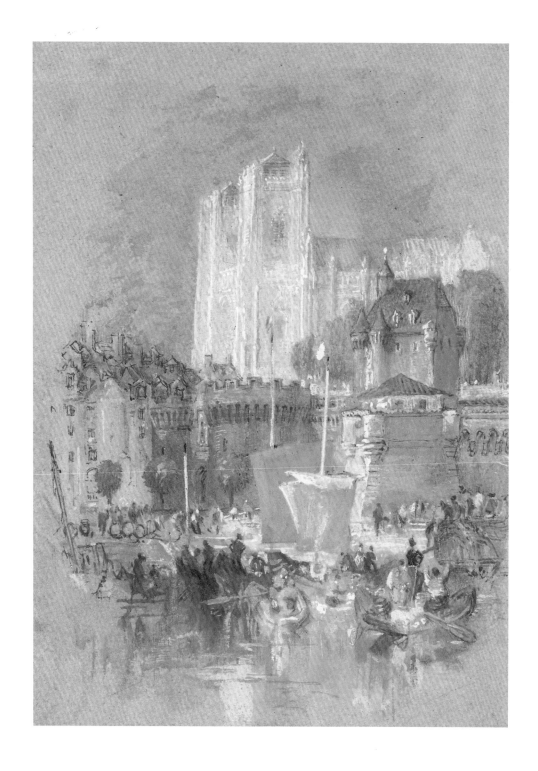

FIG 29 *Nantes* (frontispiece vignette for *Turner's Annual Tour*) *c.*1830–1 (cat.107)

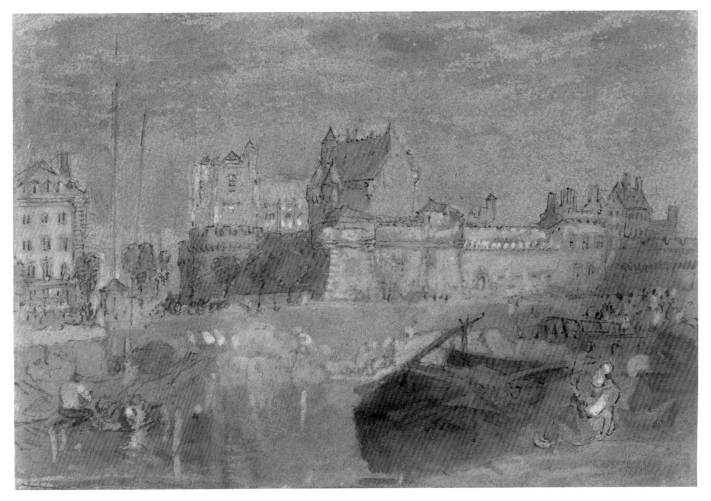

FIG 30 *Nantes: the château and cathedral from the river c.*1828 (cat.46)

with the bustling incidental life of the river, which is not surprising, as this was the point from which traffic set off upriver or to which travellers were brought from inland. In fig.30 it is possible to see the dark form of one of the Loire barges, which appear repeatedly in Turner's set of Loire views.

In these watercolours the emphasis falls on the Tour du Port, with the Grand Logis above and the Tour des Jacobins beyond. However, when he came to make the vignette of this scene, Turner departed from strict topographical accuracy and compressed the essence of this view. Not only does this mean he displaced the Tour des Jacobins in order to bring into view the entrance to the château between the Tour de la Boulangerie and the Tour du Pied de Biche, but he has also brought the cathedral of St Peter and St Paul much closer than it is in reality, so that it towers over the scene. For the purposes of his design, this sleight of hand produced a wonderfully concentrated image, which brilliantly distils the essential ingredients of his more factually straightforward view.

FIG 31 *Nantes: the château from the river* 1826 (TB CCXLVII f.38)

No area is wasted, as each element contributes to the total impact. If anything, it is perhaps too busy, but the happy juxtapositions of colour and the contrasting patterns of light and shade make it a remarkably sophisticated work. For example, the brilliant white stonework of the cathedral ensures that the viewer's eye is drawn upwards, thereby unifying the whole. As already noted above, despite their apparent spontaneity, many of the set of Loire views on blue paper were made some years after the tour, including this subject, which in its engraved form served as the frontispiece to the whole series. Between 1826 and 1839 Turner became deeply involved in the production of small book illustrations, chiefly in this borderless vignette form, for editions of the works of Samuel Rogers, Lord Byron, Sir Walter Scott, John Milton, Thomas Campbell and Thomas Moore.[47] The view of Nantes has the same jewel-like qualities found in those he produced for the 1830 edition of Samuel Rogers's poem *Italy*, although none of those watercolours were painted on blue paper.[48]

Among the Turner drawings that Ruskin gave to the Fitzwilliam Museum there was a view of the château from further up the river (fig.32).[49] This appears to show the battlements between the Tour du Port and the Tour de la Rivière, with the Grand Logis constructed by Anne of Brittany rising above. The right-hand side of this design, above the riverside building, should include the Saddlery, built at the end of the eighteenth century, which at the time of

Turner's visit was being used as an armoury. Indeed, the château continued to serve its traditional function as a military stronghold and prison for some time afterwards which meant that its interior was inaccessible; the unfortunate Duchesse de Berry was held there a few years later after the uprising of 1832.

The side of the château facing the town can be seen in fig.33, with the light falling on the projecting form of the Tour du Fer à Cheval. The northerly entrance to its right was reached by crossing the bridge, which has since been destroyed. By the time of Turner's visit the moat had been filled in and turned into a kitchen garden. His colour sketch communicates the commanding presence of the fortress, which makes the contrast with the scene of maternal tenderness in the foreground all the more touching. The other figures are weighed down by the goods they have collected from the riverside down towards the left, where masts can be seen.

A little further to the north of this spot can be found the first of two spacious tree-lined promenades, the Cours St-Pierre and the Cours St-André, which were set out in the eighteenth century. These are reached by climbing up a flight of steps between statues of Arthur III (1393–1457) and Anne, Duchess of Brittany and Queen of France (1476–1514). In Turner's depiction (fig.34), which was also engraved, the gap between the statues has been greatly reduced to assist in the compression of picture space. On the right, under the elm and linden trees, the ranks of the national guard are being drilled, although the abandoned drum in the foreground suggests that they have finished marching. Among the figures on the left is a man wearing a yellow jacket and a cap, supported by a walking stick, who seems to be begging (this detail is clearer in the engraving). Otherwise, there is a holiday mood to the figures in this and the other two views of the Cours St-Pierre (figs.35–6). As one of Turner's days in Nantes would have been Sunday 1 October, it is very likely that these are a fair reflection of what he actually saw. Fig.36, for example, perfectly captures the sense of a Sunday promenade in a provincial city, with its mixture of colourful uniforms and well-dressed women wearing a wonderful assortment of stylish hats. Turner has also nicely structured the scene so that we appreciate the contrast between those showing themselves off and those who have come to watch. In the distance the form of the château can be made out, while the building on the right is the unfinished cathedral, which remained without a north transept and chancel until it was completed in 1893. Since there are no views of the Cours St-Pierre in Turner's sketchbooks, he must have jotted down his compositions in pencil straight on to the blue paper, working them up in colour later.

What is especially interesting is that the presence of so many soldiers does

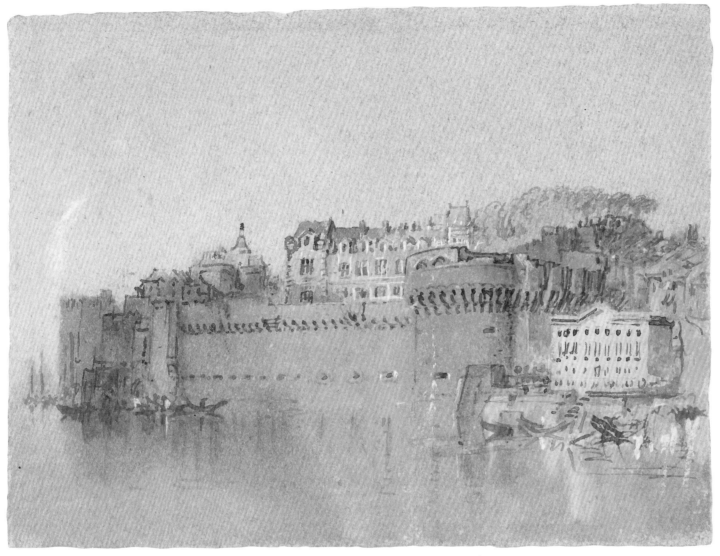

FIG 32 *Nantes: the château from the river c.1826–8 (see p.218)*

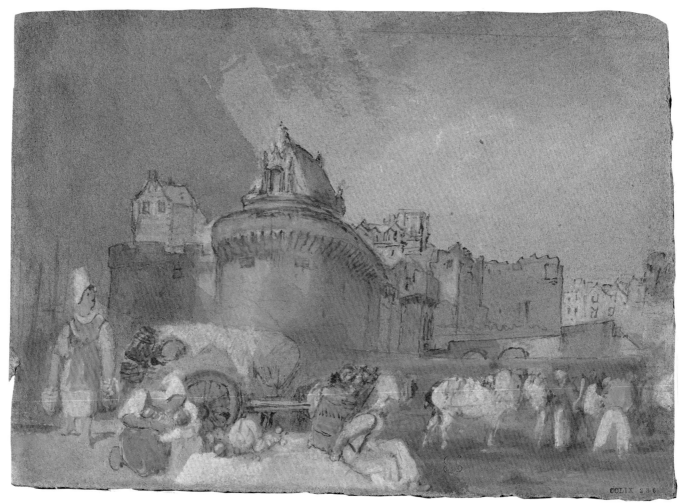

FIG 33 *Nantes: the château from the east c.1826–8 (cat.47)*

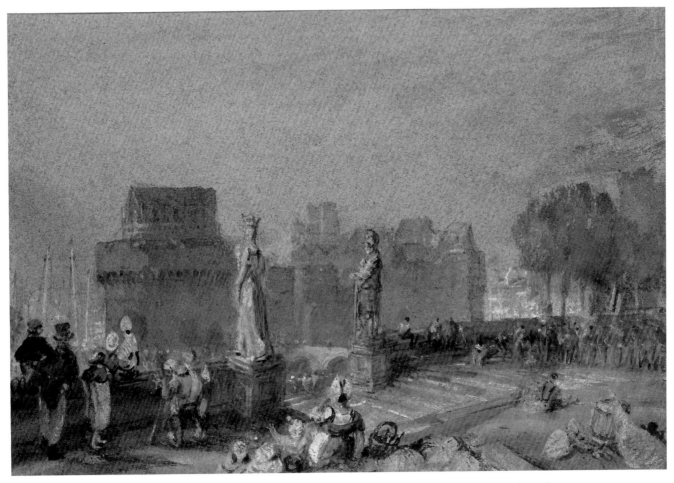

FIG 34 *Château de Nantes from the Cours St-Pierre* (engraved for *Turner's Annual Tour*) c.1828–30 (cat.108)

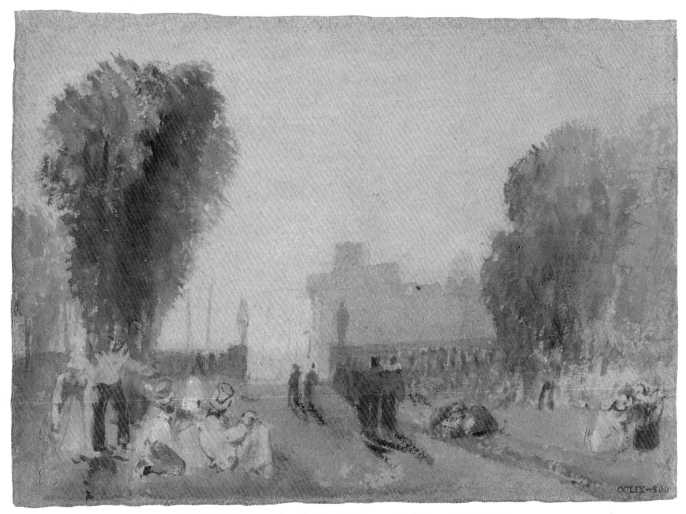

FIG 35 *Nantes: promenade on the Cours St-Pierre, near the château c.1826–8 (cat.48)*

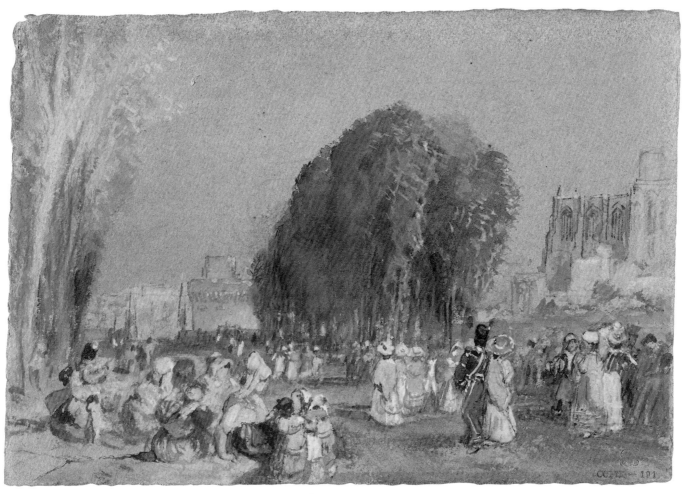

FIG 36 *Nantes: promenade on the Cours St-Pierre c.1826–8 (cat.49)*

not seem to have prevented him sketching, as it may have done elsewhere. Another of the figure studies on blue paper is closely related to this group, both in terms of its subject matter and the paper on which it was painted, which is of the same type (fig.39). This shows the interior of a café on the mezzanine or first floor, the 'Caffé premier stage', according to the signboard. Through the semi-lunette window can be seen a building with dormer windows, which could very easily be one of those lining the quays of Nantes.

Because of the city's wealth, its quays had become handsomely decorated with grand buildings, many of which were constructed on the Ile Feydeau as private residences for prosperous merchants. An idea of the island's character can still be gained, but it is now firmly attached to the north bank, and traffic and trams run where once was water. Turner made two detailed sketches of this central area of the city in pencil on blue paper, which he worked up in pen and ink, with some touches of colour. The first of these is a view looking across the old Pont de l'Aiguillon (also known as the Pont de la Poissonnerie), which linked the Quai Flesselles on the north bank of the river with the Quai Duguay Trouin on the Ile Feydeau (fig.37).[50] On the right it looks as if an impromptu market is taking place at the end of the bridge, where a group of figures gesture animat-

edly. The asymmetrical tower seen over the rooftops is that of the Tour du Bouffay, which, like the main fortress, was built by the Dukes of Brittany and at the time of Turner's visit served as both belfry and clocktower (it was destroyed in 1848). In his study of Turner's use of perspective Maurice Davies used this work to demonstrate how Turner frequently places the viewer at the wide end of a kind of funnel-like perspective, so that the eye is drawn deep into the picture space along a gradually narrowing road or across a bridge.[51] In this case Turner has deployed both devices, inviting the viewer to follow the course of the Rue de la Poissonnerie, leading into the Ste-Croix quarter.

Further down this arm of the Loire, named after the Bourse which stands at its western end, Turner made the second of his pen-and-ink views (fig.38). This was taken from the southern end of the Pont Feydeau, looking back upstream towards the Bouffay tower and the cathedral. On either side the long regular quays retreat into the distance. Among the buildings on the immediate right is the 'Temple du Goût', built for the shipowner Guillaume Grou. As well as architectural details, such as the arched doorway, Turner has noted the ornamental ironwork decorating this and other facades on the Ile Feydeau. The eye is also caught here by the vertical stroke of colour further down the Quai

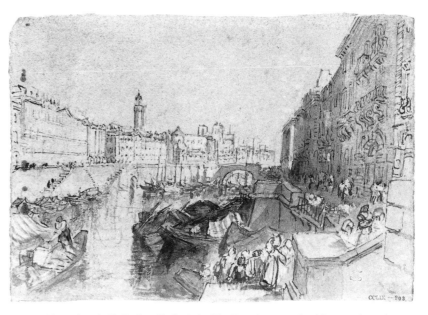

FIG 37 *Nantes: the Pont de l'Aiguillon, looking across to the Quai Flesselles, with the Tour du Bouffay above* ?1826 (cat.51)

FIG 38 *Nantes, from the Ile Feydeau (the basis for* The Keepsake *watercolour)* ?1826–8 (cat.52)

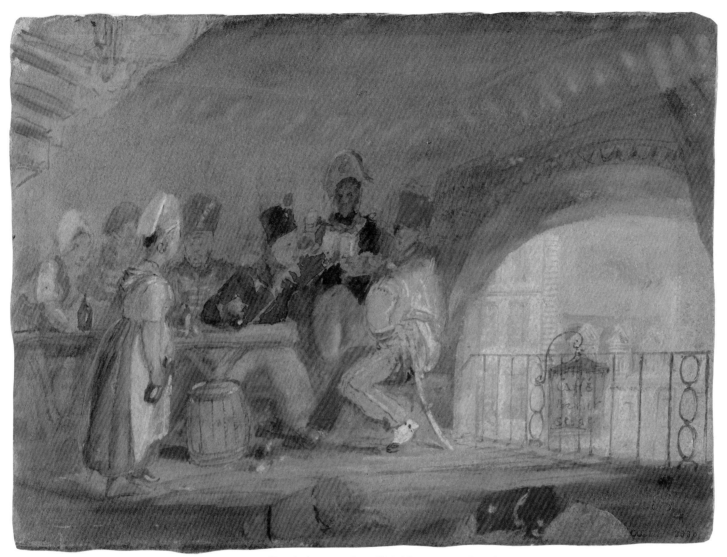

FIG 39 *Soldiers drinking in a café, possibly in Nantes c.1826–8 (cat.50)*

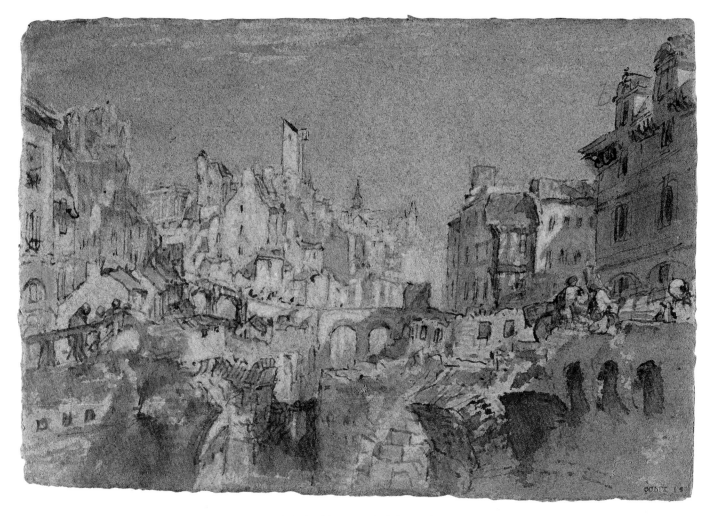

FIG 40 *Nantes: the banks of the River Erdre, looking north* ?1826–8 (cat.53)

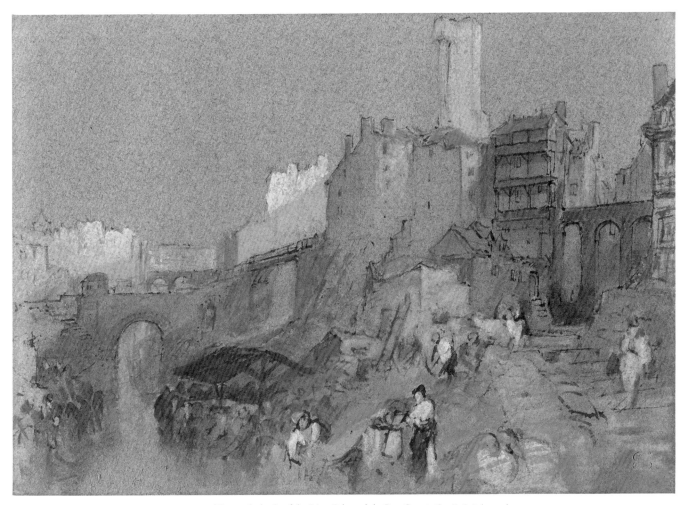

FIG 41 *Nantes: the banks of the River Erdre and the Pont Sauvetot ?c.1826–8* (cat.54)

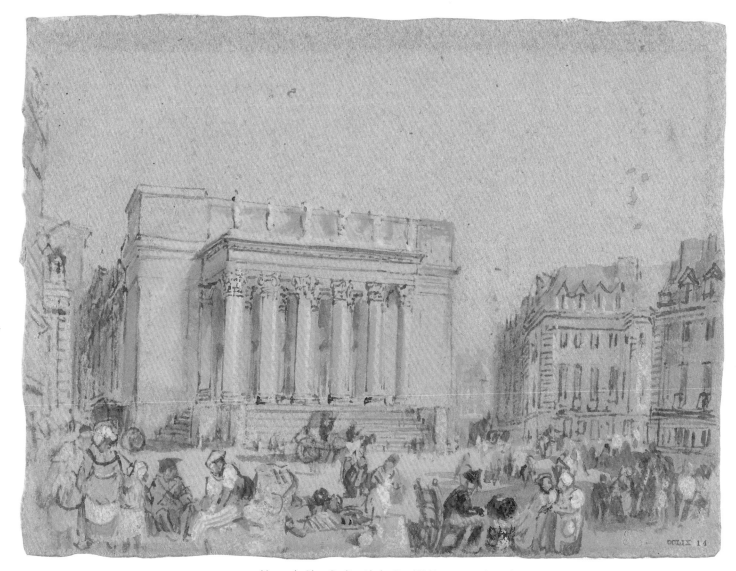

FIG 42 *Nantes: the Place Graslin with the Grand Théâtre c.1826–8 (cat.55)*

Duguay-Trouin, which indicates so effectively the place at which the road across the island broke through.

On the opposite bank can be seen the Quai Brancas, which was predominantly built to the designs of the local eighteenth-century architect Jean-Baptiste Ceinerary. About halfway along, directly below the Bouffay tower, there is a small opening at water level, indicating the confluence of the River Erdre with the Loire. The main river is full of incident, and, as in the preceding view, Turner utilises the perspective lines of the flight of steps going down to the boats in the right-hand corner to draw the viewer into the image. As a composition, very few of Turner's other views of Nantes compare with the richness of this scene, which manages to combine the modern life of the city with its historic monuments. It is, therefore, not surprising that this was a view Turner repeated on a larger scale when he was developing some of the Loire subjects as illustrations for *The Keepsake* annual (see p.184, fig.180).

From this arm of the Loire Turner ventured into the heart of the city, following the course of the River Erdre upstream. For the first of his two colour sketches of this area he chose a viewpoint looking north to the shot-tower known as the Tour à Plomb or the Tour Sauvetot (fig.40). The flow of the river here appears to be very confined, so that it almost resembles a stream, which has meant that the correct identity of this view has sometimes been questioned.[52] In the foreground, lit from the right by the same raking morning light that catches the dormer windows above, are the remains of an old bridge. In the distance, clustered round the tower, are the buildings of the Bourgneuf quarter, with the spire of a church, possibly St-Similien, beyond. This area was completely transformed later in the nineteenth century, and there are remarkably few views by other artists with which to compare it, making Turner's sketch all the more interesting.[53] The other view (fig.41) was taken from much closer to the Tour à Plomb, and looks back down towards the Loire. To the right are the arches of the Pont Sauvetout (or Pont de l'Arche-Sèche). These scenes are unexpectedly picturesque for depictions of a bustling nineteenth-century city. The figures and the covered washing-place by the river introduce the idea of traditional labour, but there is also evidence of building work taking place, perhaps connected with the circus which later occupied this site.

Moving up the hill into the St-Similien quarter, Turner made a hasty record of the view over the city towards the cathedral in his sketchbook,[54] but he paid much more attention to the area constructed in the late eighteenth and early nineteenth century by Jean-Joseph-Louis Graslin, a wealthy financier. The focal point of this piece of urban development was the Place Graslin, with its neo-classical theatre, all of which was designed by Mathurin Crucy (1749–1826), who is best remembered for the Théâtre de l'Odéon in Paris.[55] At Nantes Crucy made a major contribution to the physical structure of the city, designing new public buildings and open spaces which conferred great style and elegance. The Place Graslin, in particular, was considered by many guidebooks to be 'the most beautiful quarter of Nantes',[56] and when Stendhal stayed in the city in 1837, he especially enjoyed the view from his hotel, which looked out towards the theatre, or Salle de Spectacle.[57] The view he had cannot have been greatly dissimilar to that in Turner's watercolour (fig.42). While Stendhal tended to be condescending towards much of what he saw on his journey through western France, he was compelled to make favourable comparisons between Crucy's architecture and that of Paris, which makes it all the more ironic that Turner's view has until now been listed as the 'Place du Carrousel' in Paris (see cat.55). Turner worked this colour sketch up from pencil notes made on the spot, but it is odd that he has given the facade of the theatre only six statues of the muses and six columns, finished with Corinthian capitals, when the building actually has eight of each. To compound this, one of the pencil sketches (fig.44) reveals that he had actually sought to differentiate for himself between the number and type of columns on this building and those of the Bourse (which had ten columns with Ionic capitals). During Turner's stay in Nantes the theatre had a bill made up of a melodrama, a vaudeville comedy and Spontini's three-act opera, *Fernand Cortez*, but although Turner is known to have enjoyed the theatre, we can never know if he attended any part of the evening's entertainment.[58]

Another colour sketch of the Place Graslin, which has previously been catalogued as a view of Dijon or a 'North Italian Town', seems to be based on a confused outline in the *Morlaise to Nantes* sketchbook (fig.43).[59] This is a view from the Rue de Breda Gresset, but much of the left-hand side of the image has been invented, including the balustrade. Another puzzle is the Italianate church tower, appearing from behind the theatre, which inexplicably has its basis in the pencil sketch. Contemporary prints do not include this feature, and in those where a tower is present, it is actually on the right of the facade, not the left.[60]

From the Place Graslin it is just a short walk down to the Bourse, another of Crucy's buildings (fig.45). Standing close to the river, Turner made a sketch of its facade, then he continued the panorama to his right in a second sketch across the top half of the page, showing the Bains Publics, the Pont Maudit and the Quai de l'Hôpital on the opposite bank. Remaining on the north side of the Loire, Turner made a handful of sketches of the quays that stretch westward towards the shipyards known as the Salorges, but generally the sketches

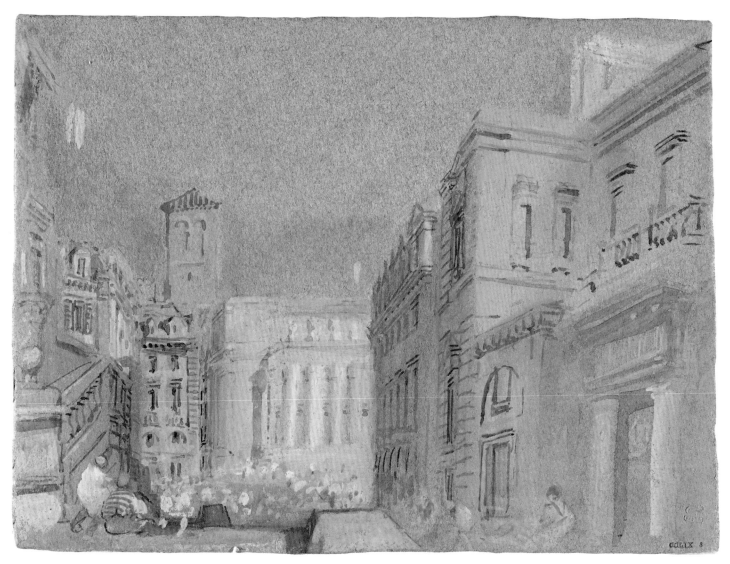

FIG 43 *Nantes: the Théâtre and Place Graslin from the rue de Breda Gresset c.1826–8 (cat.56)*

FIG 45 *Nantes: the Bourse and the Ile Feydeau, and (above) a subsidiary sketch across to the Ile Gloriette* 1826 (TB CCXLVII f.55v.)

FIG 44 *Nantes: the portico of the Théâtre Graslin, with a sketch of a Loire barge* 1826 (TB CCXLVII f.68v.)

tend to look back towards the city.[61] The first of his coloured sketches of this area looks upriver to the Bourse, where the forms of the allegorical statues standing on its peristyle give its outline an irregular pattern (fig.46). One of the uncatalogued sheets of blue paper in the Turner Bequest has much the same composition in pencil, and it is possible that Turner elaborated his colour sketch from that work.[62] In the colour version he has moved his view-point further away from the quayside so that the viewer seems to hover over the river. Even the introduction of a kind of platform in the left-hand corner fails to clarify this part of the image. The sails and masts of boats on the right, however, underline that this is a riverside scene. Some of these would have

been the three-masted vessels known as *chasse-marées*, which were common around the Brittany coast (fig.48).

Another of the colour sketches, which has otherwise been identified as 'Havre', shows the Salorges itself, with a ship on the stocks and a forest of masts indicating the intense commercial activity on which Nantes thrived (fig.47). In the foreground three figures struggle as they load or unload a barrel. The quays extended several miles to the west, and many visitors made a point of walking their full length, before returning back over the hills above.[63] It is the view from towards the end of this quay that Turner painted in fig.49. The tranquillity and openness of this design is characteristic of so many of the Loire subjects, but here there is very little specific topography to weigh the scene down. Very subtly, Turner uses the diagonal line of the mast and sail to draw the eye towards the white towers of the cathedral in the distance, which appears above the warm ochre colours of the Ile Gloriette and the Prairie au Duc on the right. Ruskin, who briefly owned this sketch, marvelled that 'though containing hardly half-an-hour's work [it] is so first-rate that I would have given *anything* for it'.[64]

Having completed his scrutiny of the north bank, Turner crossed the five or six principal bridges that linked its shores to the south bank via a series of islands, making sketches of some of the bridges as he went. That of the Pont de

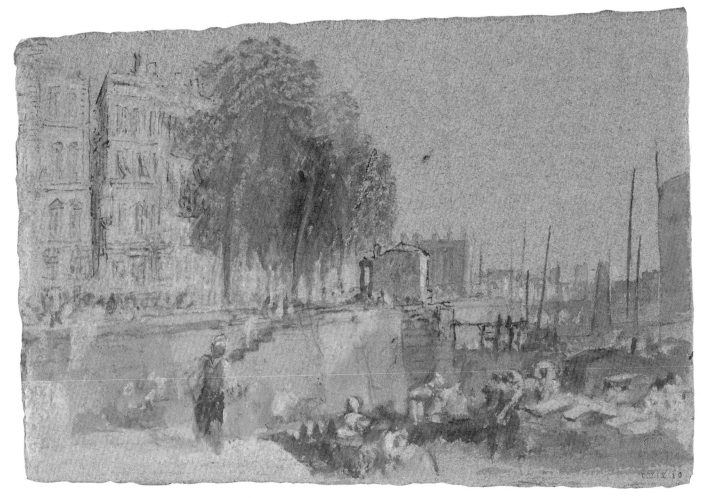

FIG 46 *Nantes: the Quai de la Fosse, with the Bourse in the distance c.*1826–8 (cat.57)

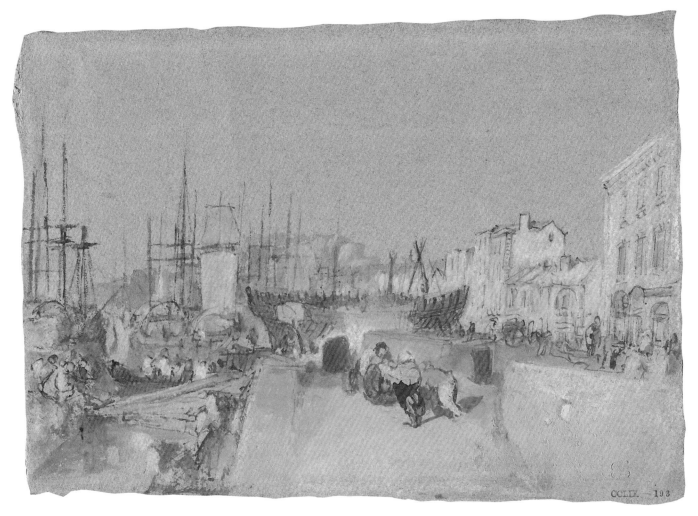

FIG 47 *Nantes: the shipyards (or Salorges) c.*1826–8 (cat.58)

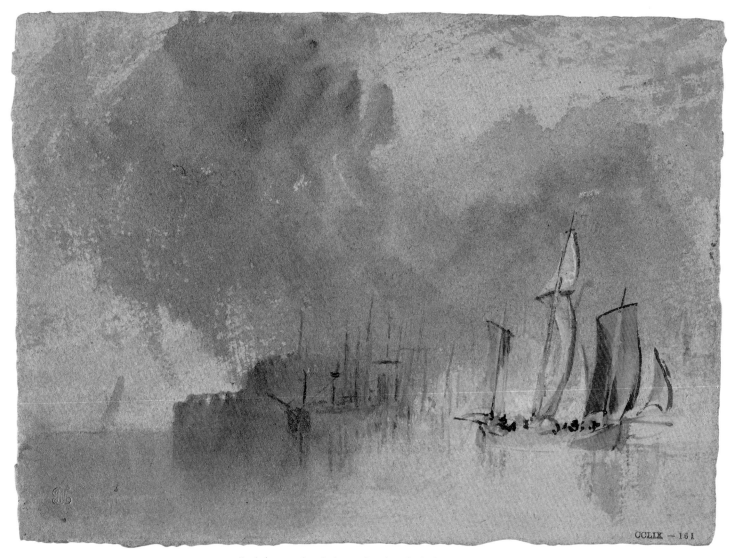

FIG 48 *A chasse marée and other vessels under a cloudy sky* c.1826–8 (cat.59)

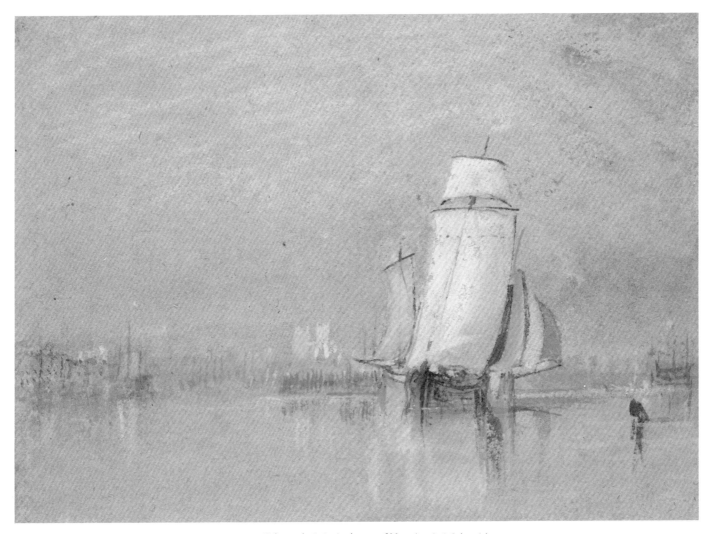

FIG 49 *Calm on the Loire (to the west of Nantes) c.*1826–8 (cat.60)

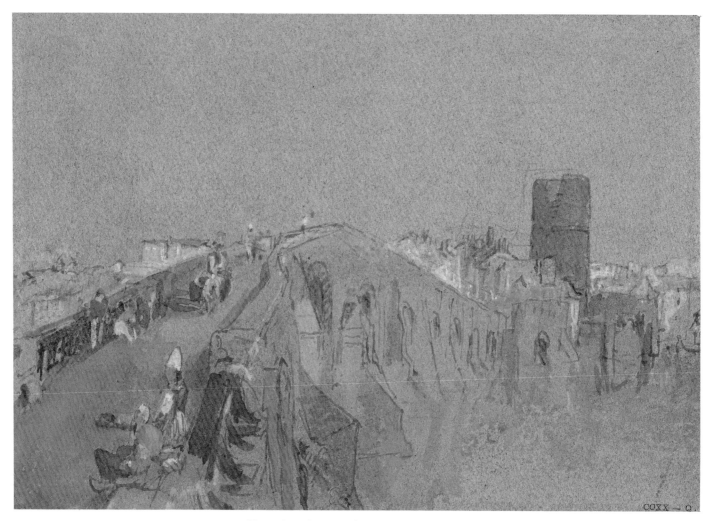

FIG 50 *Nantes: the northern approach to the Pont Pirmil c.1826–8 (cat.61)*

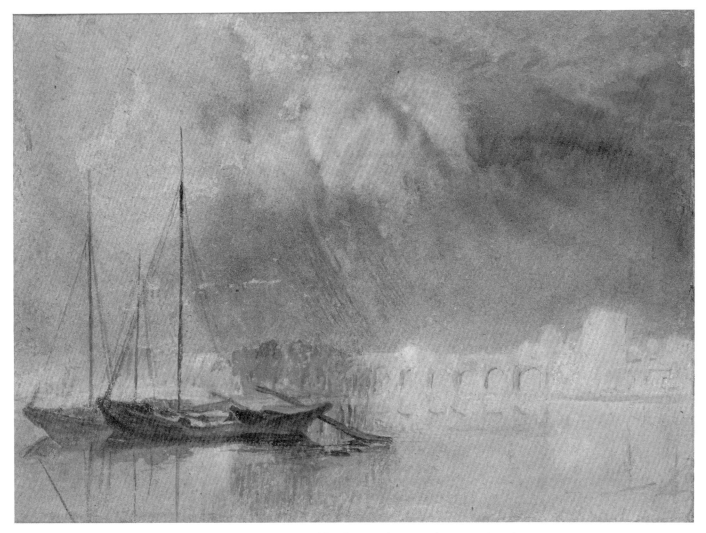

FIG 51 *Nantes: the Pont Pirmil from the river, under a stormy sky c.1826–8 (cat.62)*

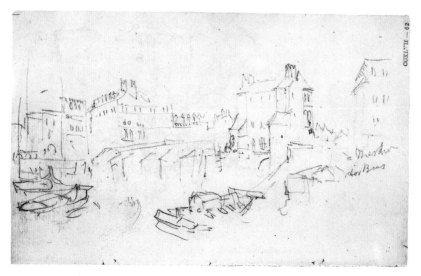

FIG 52 *Nantes: the Pont de la Belle-Croix from near the Poissonnerie* 1826 (TB CCXLVII f.62)

la Belle-Croix could very easily have served as the basis for a colour sketch amplified with figures (fig.52). Turner has even made a note to remind himself of what appears to read 'Market for Bees' on the right, although the chief market on this quay was for fish.

The bridge to which Turner devoted most attention was the Pont de Pirmil, which joined the last of the islands with the southern bank of the Loire. Given that this bridge spanned the Loire itself, rather than one of its subsidiary streams, it is perhaps not surprising that Turner sought it out as a subject. Because the islands had not then been intensively built on, the bridge could be clearly seen by travellers approaching from either direction, whether they were coming upriver from Paimboeuf or down from Angers. It was readily identifiable because of the tower of the ruined Château de Pirmil and the buildings at its southern end.[65] Although they have not previously been identified as views of Nantes, two of the colour sketches on blue paper show the bridge, both of which relate to pencil sketches, so that it is most likely they were created after the tour, perhaps around 1828. The first is a view from the north end of the bridge, where, in the foreground, the main stone body of the structure is briefly concluded by a couple of arches with wooden railings (fig.50). On the other side is the remains of the tower, which Turner has made higher and narrower than in his on-the-spot sketch. To the left, the white building is the Hôpital St-Jacques, while the bridge itself is peopled with figures wearing

colourful local costumes, only one of whom can be found in the pencil sketch. The curving perspective of the bridge is skilfully realised, and, once again, the viewer has been lifted up and out to the right in order to appreciate the slope of the bridge as it falls towards the other bank. Technically, it is interesting to note how Turner applied a very broad area of colour for the stonework, which, after he had defined the crisp lines of the bridge, also served as its reflection.

The second sketch of the Pont de Pirmil adopts a viewpoint from a little further downstream (fig.51). When Ruskin owned the view he considered it to be of Angers, but the shapes of the buildings on the right are recognisable as those of the bridge at Nantes.[66] The real subject here, however, is the downpour from a sudden shower, neatly dividing the sky along a darkening diagonal line, which concludes in the solid colour of the Loire barges, throwing the lighter form of the bridge into sharp contrast.

From Nantes Upriver

After at least two days in Nantes Turner still had blank pages in the *Morlaise to Nantes* sketchbook. However, at this point, probably on 3 October, he began a new notebook before beginning his voyage up the Loire. The new book was similar in size to its predecessor, but without a skin cover, and was subsequently labelled by the artist 'Nantes, Angers, Saumur' (cat.12; Appendix A, pp.233–5). The first sketches are again of the Théâtre Graslin and the Bourse, suggesting that Turner's hotel was in this fashionable quarter. By this stage he had already made himself familiar with the château and the Ile Feydeau, but he continued to sketch their outlines, perhaps as a way of killing time while he waited for his boat to depart.

It is a matter of great interest what sort of boat conveyed Turner up to Angers, but one which has not previously received any consideration. There were, in fact, two alternatives: sail or steam.[67] The distinctive appearance of the Loire barges, with their beautiful white square sails, meant that Turner made numerous sketches of them during the course of his time on the river, as he would of anything that was unfamiliar. It is perhaps the abundance of these sketches that has led to the assumption that this was Turner's own means of transport. While this remains a possibility, albeit one that would have consumed a great deal more of Turner's time and thereby slowed him down considerably, there was also another method of climbing the river to Angers.

Since the early 1820s the rivers of France had begun to be plied by British- and American-made steamboats. These were most evident on the Seine, where by 1826 there were twenty-six steamers serving the lower reaches of the river.[68]

By contrast, steamers were only introduced to the Loire in June 1822, when a boat called the *Loire*, with British-built machinery, made a voyage from Nantes to Paimboeuf and then up to Angers.[69] The wooden hull measured 25 metres and it was authorised to carry up to 250 passengers. In March the following year the *Loire* and another boat, the *Maine*, were put into service on the stretch of river between Nantes and Angers, while a third boat, the *Courrier*, ran a regular service to Paimboeuf. Later in the spring of 1823 the *Nantais* became the first steamer to sail upriver as far as Orléans. The number of boats and companies involved in exploiting the river proliferated in the second half of the 1820s, so that at the time of Turner's visit steam travel was beginning to become an established feature of river life.

By 1826 Turner would certainly have been well used to steamboats as a result of those he saw on the Thames, although at this date he had not begun to rely on them for the regular excursions to Margate that became so important in the last two decades of his life. One of the steamers, the *Lord Melville*, appears in his watercolour of the Tower of London, which predates the Loire tour.[70]

He was just as keen to record the steamboats he saw on the Loire, but, perhaps because they were not as novel as the more traditional craft, which were unlike the vessels of any other river,[71] he made comparatively fewer sketches of them. An unfinished broadside view of one of the steamers towards the front of

FIG 54 One of the Loire steamers ('Bateaux à Vapeur en Fer') from an advertisement issued by the Compagnie Générale des Remorqueurs de la Loire (detail)
Chambre de Commerce et d'Industrie du Loiret

the *Nantes, Angers, Saumur* sketchbook (fig. 53) has been annotated by Turner, presumably with its name, which appears to read 'Louis Guib...'. This must be the steamer *Louis Guibert*, which was constructed by Auguste Guibert during 1826 and ran on the estuary route downstream from Nantes. Guibert built many of the Loire steamers, including both the *Loire* and the *Maine*. It must have been one or other of these steamers that Turner boarded on his journey to Angers[72]. Sadly the local papers for the beginning of October give no timetables for the steamers which would help confirm the the details of Turner's voyage, but it is most likely to have taken place on 3 October and for the purpose of this essay we will assume that he travelled on the *Loire* boat.[73] The other pencil sketches of a steamer in this book occur among the views of St-Florent, which lies about half way between Nantes and Angers (fig. 74). This would be a natural point for the *Loire* to pass its sister-ship the *Maine*, which would be on its return trip downriver.[74]

Further support for the idea that Turner travelled on a steamer comes from his sketches, which were made in quick succession as the boat pushed steadily upstream against the current. In these it often seems that before Turner had finished sketching his subject from one viewpoint he was offered other ways of

FIG 53 *A Loire steamer: the* Louis Guibert 1826 (TB CCXLVIII f.5v.)

viewing it, which encouraged him to begin afresh.[75] Furthermore, there is a unity of approach to the views between Nantes and Angers that suggests they were all made in the course of one long day. The voyage would have taken about fourteen hours, depending on stops included in the schedule. Like the sketches executed during the tours of the preceding two years, Turner's thumbnail impressions run down the page in a fairly systematic order, so that it is possible to chart almost exactly the route taken by his boat.[76] He had used the *Morlaise to Nantes* sketchbook for a few pages in much the same way at Morlaix, but, other than that, this is his only sustained employment of this characteristic method of collecting visual information on the 1826 tour.

Another, perhaps stronger reason for assuming that this part of the journey

was transacted during the course of one day lies in the lighting effects that Turner created (or quite probably recreated) when he came to execute the colour sketches and finished designs based on his pencil outlines. Beginning with a sunrise beyond the dramatic cliffs at Mauves (fig.60) and concluding with the late afternoon sunlight on the walls of Montjean (fig.81), this part of the Loire series reflects the sun's journey towards the west as clearly as it records Turner's movement in the other direction.[77] This point will become clearer from the following discussion of individual works.

By the time that Turner produced his third set of French river views in 1835, he had fully assimilated the steamers into his river landscapes, even treating one of the vessels as his main subject.[78] But, for the Loire views, the steamer merely

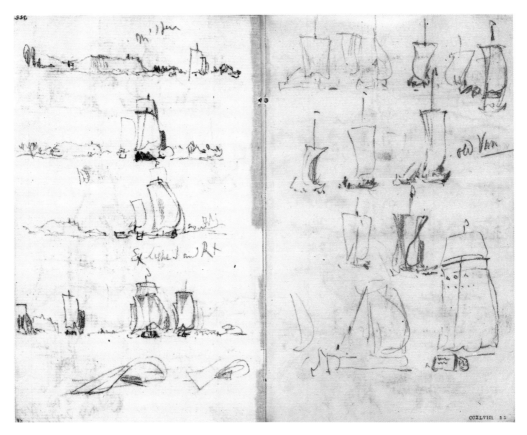

FIG 55 *Studies of Loire barges under sail near Montjean-sur-Loire* 1826 (TB CCXLVIII ff.22v./23)

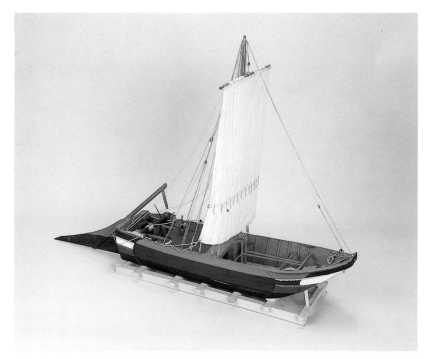

FIG 56 *A model of a Loire barge (gabarre). Musée du Château, Nantes*

provided the means of seeing the countryside, and Turner refrained from introducing it in order not to disturb the quiet mood of the group.

Since Turner made such an extended study of the appearance of the Loire barges, known locally as *chalands* or *gabarres*, it is perhaps appropriate to examine their distinctive qualities before following Turner's progress upriver (figs.55–7). The design of the boats had evolved slowly over the centuries and was popularly thought to owe something to the Viking boats that had made their way up the Loire in the ninth century. Most boats measured about 22 metres in length, supporting a single mast of considerable height in the centre. This carried the huge square sail and a smaller pennant above. The bows of the boat rose up to create a broad poop area, behind which the cargo was stored. At the stern a large rudder, or *piature*, had been developed to minimise the effort required to steer the boat. It was a common sight to see several barges tied together, each having a particular function in the convoy, with the various positions having specific names. The barges were entirely at the mercy of the wind on their upriver journey, and were usually forced to progress in short bursts, often trav-

elling very few miles a day. Another problem was the shallow waters of the Loire, which posed a real danger for mariners, as even these flat-bottomed boats could run aground on sandbanks.

From the Coteaux de Mauves to Oudon

Turner's steamer journey would have begun very early in the day. The sun had not appeared above the horizon when he left Nantes, so that in the grey dawn the buildings would have appeared to have no substance or detail, and this is how he sketched them. Before long his steamer had joined the main stream of the Loire, and it was at this point that the sun rose above the water, causing Turner to note a 'Curious effect' as its rays caught the cathedral towers.[79] Although it was not among the set of finished subjects, one of Turner's most evocative views of the Loire is the colour sketch he made looking back towards Nantes (fig.58). This panorama embraces many of the most important elements of the Loire journey: a group of ancient buildings lying alongside the river, in this case the towers of the cathedral on the right; the high masts and the light-catching sails of the Loire boats strung together in convoy; the distant arches of a bridge, perhaps that of the Pont de la Madeleine; and, on the far left, a steamer issuing a plume of smoke from its tall chimney. The balance of this ensemble is given further strength by the deployment of the complementary colours blue and orange, one of Turner's favourite combinations. He had made quick sketches of this view as it began to appear through the morning river fog. In early autumn the mist sits low on the Loire before it is dispelled by the warmth of the sun.

For a while he continued to record the receding prospect of Nantes, until, ahead of the boat, the landscape began to rise up on the north bank of the river, dropping sharply down into the water as a vertical cliff a little beyond the village of Mauves. The sublime qualities of this spot were partly obscured in the 1840s by the construction of the Paris to Nantes railway, but it is still possible to see why Turner was so impressed by the schist rocks and their relationship to the river.[80] From the three pages of sketches that he made here he later developed two of the watercolours that appeared in the published record of the tour (figs.59–62).

The first of these shows the morning sun beyond the silhouetted flat headland to the east of Mauves, whose church spire can be seen on the left (fig.60). Ruskin, along with most subsequent commentators, thought this effect was actually a sunset, an error that Turner realised often affected the correct understanding of many of his works. He apparently said to Mary Lloyd, one of the young

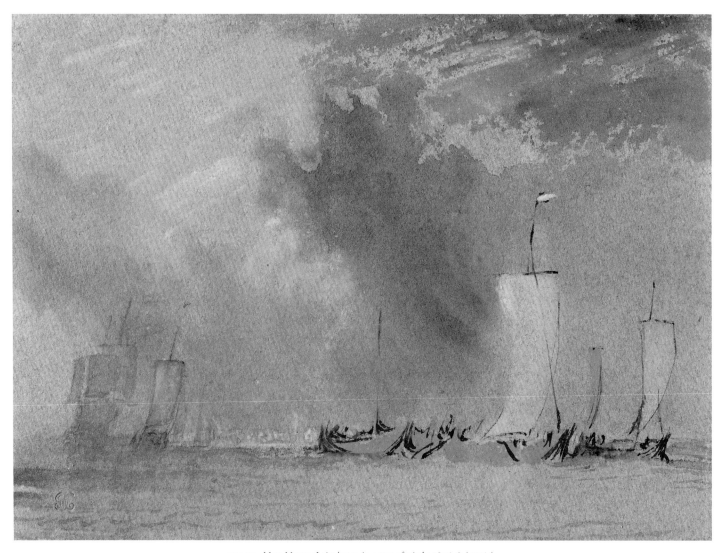

FIG 57 *Near Nantes: Loire barges in a gust of wind c.1826–8* (cat.64)

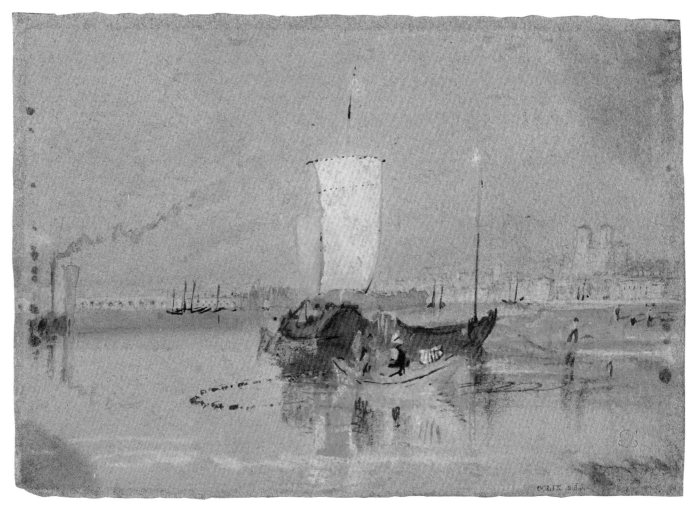

FIG 58 *On the Loire, looking west towards Nantes c.1826–8* (cat.63)

ladies he met through Samuel Rogers, 'People talk a great deal about *sunsets*, but when you are all fast asleep, I am watching the effects of *sunrise* far more beautiful; and then, you see, the *light* does not fail and you can paint them.'[81] However, if Ruskin was wrong in his interpretation of this scene, he was surely right to consider its dappled sky and warm colours 'priceless' and possibly 'the best of the Loire series'.[82]

Once past the rugged *coteaux*, or 'cliffs', the morning light began to warm the dark earthy colours of the stone, producing in Turner's image an echo of the reddish-orange sail-cloth on the left (fig.61). An indication that the season depicted is autumnal can be found in the line of birds preparing to migrate. As in some of the Rhine views of 1817, Turner savoured a composition which

allowed him to contrast the natural sublimity of this rocky outcrop with the dainty appearance of the village glimpsed in the distance. Despite the reflective stillness of the Loire, it is an image where nature continues to disturb and awe the viewer. Perhaps in order to heighten the sense of the sublime, Turner added a tiny white house below the cliffs on the right during the process of engraving this subject (fig.211).

The riverside *coteaux*, which continue for some miles between Mauves and Oudon, provided two further views for the engraved set, as well as three colour sketches, and it has sometimes been remarked that the inclusion of so many views of these headlands gives a false idea of the character of the river.[83] There is even more force to this assertion if one also includes the other drawings of

FIG 59 *Views of the Coteaux de Mauves, and the distant outline of the Château de Clermont* 1826 (TB CCXLVIII ff.9v., 10)

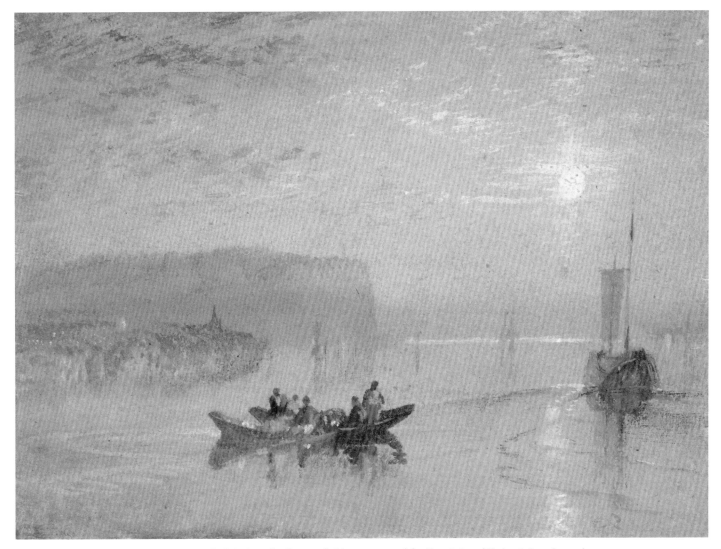

FIG 60 *Scene on the Loire* (near the Coteaux de Mauves; engraved for *Turner's Annual Tour*) *c*.1828–30 (cat.109)

buildings perched on the *coteaux* between Mauves and Montjean. Although Turner had tended to place a motif at the centre of his image and view it from below since his early tours of Britain, in this case it was perhaps an inevitable reflection of his actual experience on the Loire, which did not allow time for him to get off the steamboat in order to explore alternative viewpoints. But it

is also worth stressing that the development and inclusion of so many images of the lower reaches of the Loire indicate how deeply Turner was affected by what he saw that October morning. As Ritchie noted in the letterpress accompanying the engraved views,

Here Turner was in his element; he rioted in beauty and power; and if to the

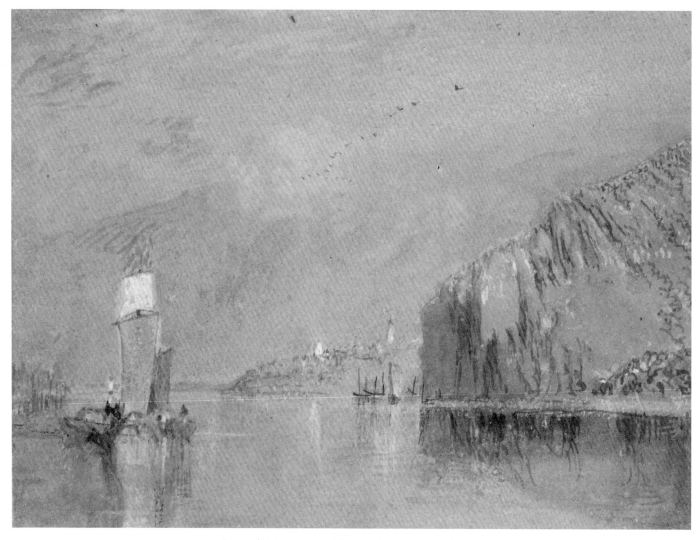

FIG 61 *Coteaux de Mauves* (engraved for *Turner's Annual Tour*) c.1828–30 (cat.110)

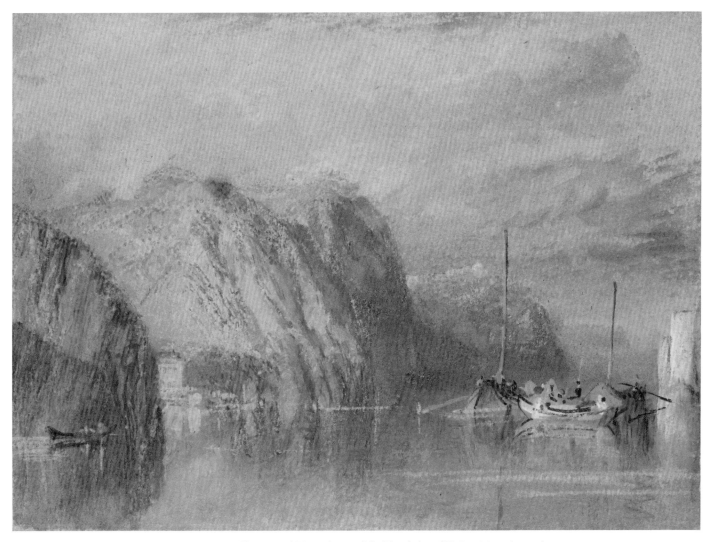

FIG 62 *Between Clairmont and Mauves* (engraved for *Turner's Annual Tour*) *c.*1828–30 (cat.111)

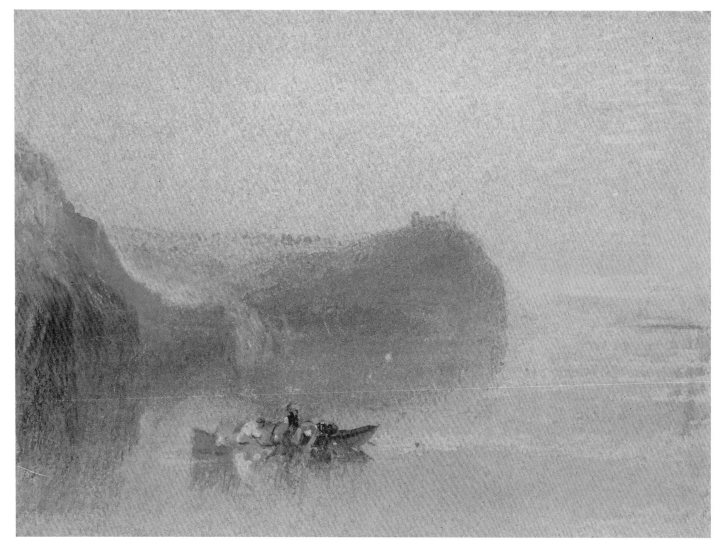

FIG 63 *Scene on the Loire; a distant view of the Château de Clermont c.1826–8* (cat.65)

cold in soul and imagination his paintings may seem defective in mathematical accuracy, they will be identified at a single glance with the originals by all who can *feel* genius, and who are capable of seeing in nature something beyond its outward and tangible forms.[84]

What is perhaps most remarkable about this group of views, aside from their number, is the inventive way Turner was able to create them from what are really only a string of simple outlines. The sketches on page 9 verso of the sketchbook, for example, provided the seeds for three of these more elaborate watercolours. Technically the most complex of the group is that showing several of the *coteaux* just downstream from the château of Clermont, which can be seen on the eminence to the left of the mast (fig.62; this detail became much clearer in the subsequent engraving). The positioning of the barges in the right-hand third of the composition forms a natural resting point for the eye after it has travelled across the distinct colour zones that divide up the image. On top of the sunlit hills Turner has applied touches of gouache to suggest clouds of smoke rising from the stubble being burned off after the crops have been harvested.

He developed another distant view of Clermont from a slight sketch on page 10 of his notebook (fig.63), this time creating an image of absolute restraint, pared down to the bare minimals of form and colour, except in its treatment of a boat full of fishermen. Despite his expressed admiration for other specific examples of the series, it was this watercolour that Ruskin kept back for himself when he donated the Loire views to Oxford in 1861. He retained it for another fourteen years and, even after he had finally relinquished it, continued to discuss it in print and in his lectures. During the lecture he gave in 1883 he stated, 'It is one of the Loire series, which the engravers could not attempt, because it was too lovely; or would not attempt, because there was, to their notion, nothing in it.'[85] As with fig.60, Ruskin has misled others into seeing this as a sunset scene, but the viewer is, in fact, looking upriver towards the east. The soft yellow of the gouache used for the sunrise is especially close to that also found in a number of the Petworth studies of the sun, which were painted in the early autumn of 1827.[86] Of all the Loire series, Turner must himself have been especially pleased with this work, for he subsequently began a large-scale watercolour based on it (see p.185, fig.184).

As his boat drew closer to the château of Clermont, he made a number of general sketches showing its western, southern and eastern façades, to which he appended more detailed sketches of its architecture (fig.64).[87] The red-brick building had been constructed in the seventeenth century by René Chenu de Clermont for the Prince de Condé, although he is thought not to have lived

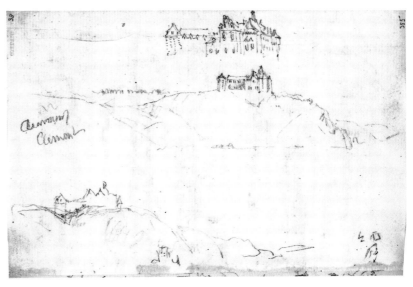

FIG 64 *The Château de Clermont from below to the west* 1826 (TB CCXLVIII f.10v.)

there. During the Revolution it had been confiscated and used as an observation post by the Republican troops, its lofty position commanding the Loire for some distance in either direction. When it was subsequently put up for public sale, it was acquired by Baron Louis-Marie Juchault des Jamonières (1769–1842), in whose family it had been before the Revolution. He was still living there at the time of Turner's visit, proving a generous host to the writer Elizabeth Strutt and her party during her voyage down the Loire a few years later.[88]

Although the pencil sketches demonstrate that Turner knew exactly what the château looked like, this is not apparent from his treatment of the building in his finished watercolour, where its ordered classical lines are presented as irregular and dilapidated, rather like the castles he had sketched on the Rhine (fig.65). There does not seem to be a simple solution to this discrepancy, for if Turner was here intending to evoke the destruction caused during the revolutionary period he was seriously at fault. In fact, if anything, the military use of Clermont had ensured its preservation. Similarly, other areas of the design do not support an underlying associative message; the boatmen, for example, only seem to make the common point that modern life continues under the ruined walls of the past.[89] The sunlight in the image comes yet again from the east. By this stage in his voyage it must have been some way into the morning, but it is just about plausible for Turner to include a lone

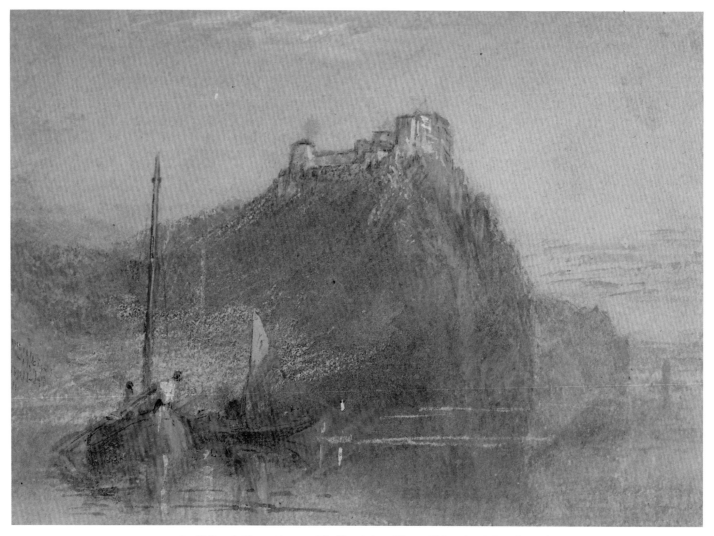

FIG 65 *Château de Clermont* (engraved for *Turner's Annual Tour* as *Clairmont*) *c.*1828–30 (cat.112)

star lingering in the northern sky. On the right, beyond the Clermont *coteau*, the distance begins to melt into a golden glow around a sloping headland that meets the water further down as a vertical line. Although this could be thought to be a generalised way of depicting the riverside cliffs, comparison with fig.67 reveals that Turner was already introducing the next location on his journey. At the top of this distant silhouette is the apparently inconsequential detail of a slight protuberance, which was derived in both colour works from the same pencil sketch.[90] Such attention to minor detail is espe-

cially noteworthy here, making the inaccuracies in the presentation of Clermont all the more intriguing.

The features that can only be glimpsed in the view of Clermont come into much sharper focus in the next colour sketch in the series (fig.67). This beautifully composed image has not previously been associated with the Loire, despite the characteristic boats on the right. Its warm earthy colours led Ruskin to catalogue it as a view of the 'Coast of Genoa', and others, following this lead, have seen it as a happy 'alliance of southern light and brilliant bodycolour'.[91] However, this is the same low autumn sunshine that illuminates the other views in this series. As the light streams across the image from the right, the application of a graduated wash of blue to the upper left-hand corner makes the rest of the sheet seem even more dazzling.

From this viewpoint it looks as though the image depicts a ruined fortress overhanging the river. Yet what appeared at first sight to be an ancient ruin was soon discovered by travellers on the river to be a group of modern follies. These can be seen more directly in Turner's second colour sketch of the subject, made from further upstream (fig.68). Like the great strongholds it imitates, this fantasy seems to rise up from the water in serried ranks of battlements, terraces and turrets.

In 1826, when Turner saw these follies, they would have been startlingly new, since they had only been created in the preceding years (in fact, work may still have been continuing). He annotated his pencil sketches with the word 'Folls',

FIG 66 *Views of the Folies-Siffait and the tower at Oudon* 1826 (TB CCXLVIII ff.11v., 12)

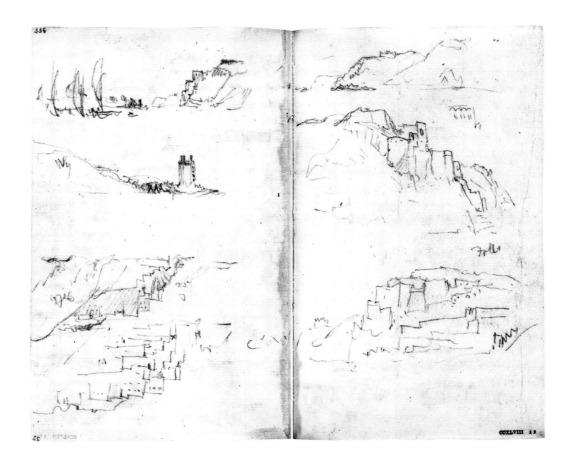

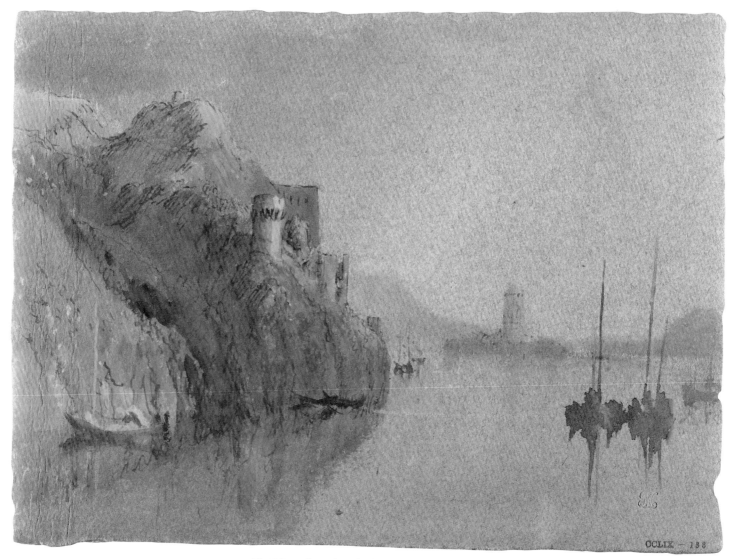

FIG 67 *The Folies-Siffait, with Oudon beyond, from the west c.1826–8 (cat.66)*

but it is a matter of fruitless speculation whether his linguistic skills were sufficiently good to allow him to enquire further about them. The writer of the 1829 guidebook for travellers using the steamboats between Nantes and Angers was rather bemused by the follies and began by describing them as Italianate in inspiration, but then rapidly warmed to their exoticism, comparing them with the Seraglio gardens of the Sultan Mahmoud.[92] Much more censorious was the travel writer Elizabeth Strutt, who exclaimed that 'it required some ingenuity to mar so effectually by art, all that was meant by nature to be so grand and simple'.[93] She

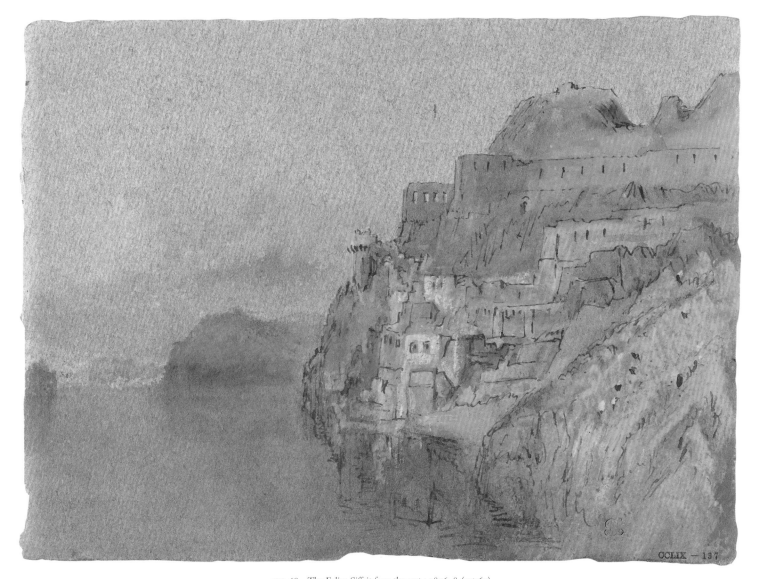

FIG 68 *The Folies-Siffait from the east c.*1826–8 (cat.67)

was, however, able to establish from her fellow travellers that the follies had been constructed over a period of ten years by Maximilien Siffait, partly as a means of ornamenting the grounds of his house above the river at La Géradière but, more importantly, as a widely praised act of charity. When work began on the Folies-

Siffait, the region was deeply affected by agricultural hardship, leaving many of the local workforce without either food or labour, but, by building the follies, Siffait is reputed to have employed fifty families at a cost of 200,000 francs. Though not impressed with the results, Elizabeth Strutt was forced to concede

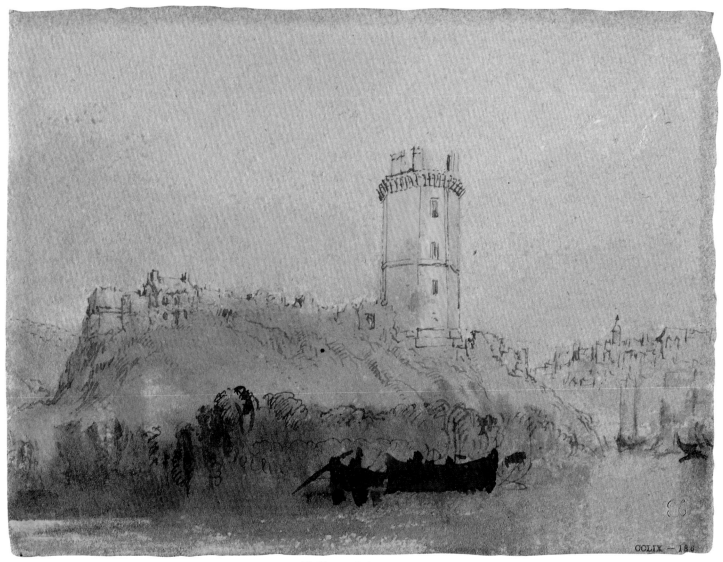

FIG 69 *The Tower at Oudon* c.1826–8 (cat.68)

that a man who was willing to do this 'may be allowed to build after any design he pleases'. Originally from the north of France, Siffait had made his money as a shipowner at Nantes and was among the earliest steamboat entrepreneurs, his company's boats competing for the Nantes-to-Paimboeuf route.[94]

Although Turner's watercolours appear to be the only contemporary record of what the follies looked like in the early 1820s, they were not reproduced in the 1833 volume, where these curious buildings were mentioned only briefly in Ritchie's account. While noting that the word folly tended to have a pejorative meaning, signifying anything odd or without function, Ritchie questions whether these monuments deserved such opprobrium for the confusion they caused in the viewer who at first thought them ancient:

> But where, after all, is the real difference between the tower of Oudon [seen beyond] and its modern rival? In a little while they will both be a heap of ruins. The former will be traced by the yet unborn antiquary to the Francs or the Romans; and the latter classed with the monuments of antiquity, whose origin is lost in the night of ages. Alas for human pride! Is our noblest edifice any thing else than a folly?'[95]

That Turner would have agreed with such sentiments is clear from the occasional poetic outbursts that accompanied some of his pictures. Whether he made this connection for himself is not known, but it is especially interesting that fig.67, which makes exactly this juxtaposition between old and new, was the only Loire subject Turner developed as an oil painting (see below, p.181, fig.179). Certainly, Ritchie's prophecy has been partly fulfilled by the subsequent history of the follies, which were neglected and choked by the rampant growth of ivy and briars, so that they look like a lost city, but in recent years they have been designated a site of architectural interest, and work has now begun to clean away the accretions of time.

Oudon

The tower of Oudon, which indistinctly haunts the distance of fig.67, was also sketched from several closer viewpoints, subsequently resulting in another of the colour sketches on blue paper (fig.69). The present octagonal tower dates from the late fourteenth century, although the site had been fortified for at least four hundred years before that. Because of its position on the borders of Brittany, the tower always played an important defensive role and was also the point at which tolls were collected from passing travellers. In his watercolour Turner has omitted all but one of the three bands of the local white stone known as *tuffeau* that encircle the tower and thereby form a contrast with the darker

stone used for the rest of the building. The smaller towers above the balustrade at the summit do not seem to have been topped by the peaked roofs they now possess, which were added later in the nineteenth century.[96]

Champtoceaux to Ancenis

Across the river from Oudon, and just a little way upstream, lies the village of Champtoceaux. Little now remains of the important fortress of Châteauceaux, which was originally established on the site during the Gallic era and which the Dukes of Brittany and the Counts of Anjou fought over during the Hundred Years' War. The spectacularly extensive views from the top of this escarpment reveal why it was so bitterly contested, but Turner, confined to his boat, was only able to appreciate the views from the river. At water level his interest was caught by a series of arches at the foot of the *coteaux*. Appearing like a truncated bridge, for which it has often been mistaken, this structure was formerly a fortified toll station, built in the thirteenth century. As he was carried past, Turner made sketches of each profile of the *péage*, thinking through several of the compositions that he later developed in colour on blue paper (figs.70–72).[97] On one of the sketches looking down the river he wrote 'Chatx', but this appears to have been intended as a contraction of the word *châteaux*, rather than an abbreviation of 'Champtoceux'. It is therefore somewhat perplexing that, when fig.72 was engraved in *Turner's Annual Tour*, it was given the title 'Chateau Hamelin'. An attempt to correct the error was made by Ritchie, both in his text and in the list of plates at the front of the book, where the image is recorded as 'Chanto-ceau'.[98] Some explanation is required for this confusion. It is most probable that the origin of Turner's title lies in the Château de la Hamelinière, which is situated less than three miles to the south-east of Champtoceaux. Perhaps someone disembarked from Turner's boat, stating the château as their destination, and Turner, overhearing this but not comprehending the context, assumed they were referring to the settlement he had been sketching. He made no written record of the name 'Hamelin', but it somehow remained with him, as did so much other detail that was not committed to paper until required many years later. Ironically, in this instance, if he had referred to his map of Brittany (fig.6) he could very simply have found the misremembered name.

It should be noted that the three views of Champtoceaux are the first in the series that focus on the left, or southern, bank of the river, which provided Turner with potential problems in the lighting of his subjects. For example, there was a danger that detail could be lost in the shadows cast by the *coteaux*. To some extent, however, what Turner went on to produce was determined by the way he

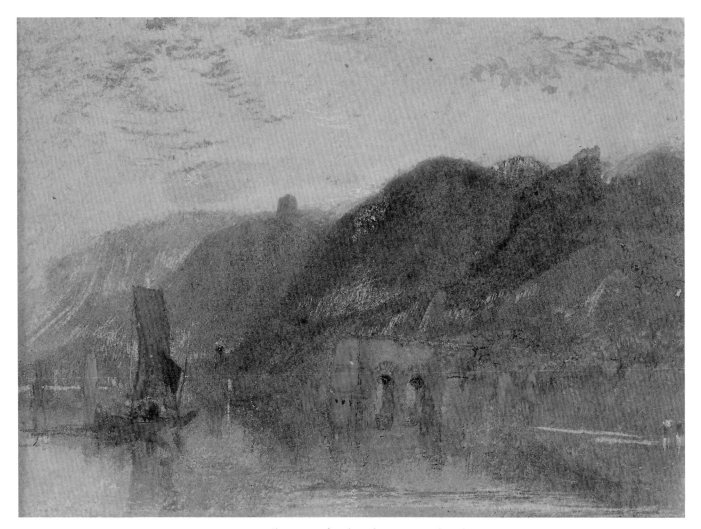

FIG 70 *Champtoceaux from the north-west* c.1826–8 (cat.69)

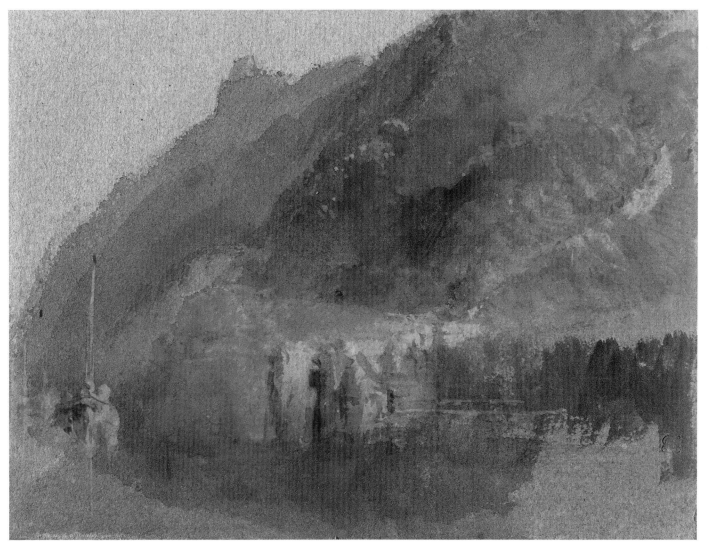

FIG 71 *The ruined* péage *at Champtoceaux, from the west c.*1826–8 (cat.70)

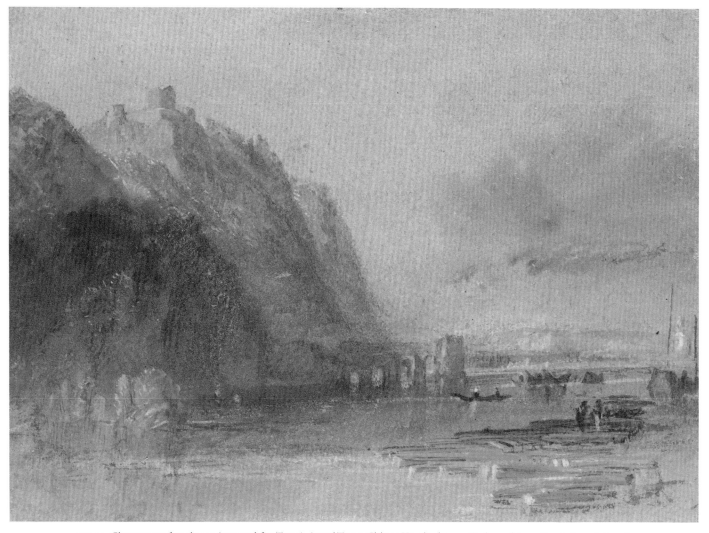

FIG 72 *Champtoceaux from the east* (engraved for *Turner's Annual Tour* as *Château Hamelin, between Oudon and Ancenis*) *c*.1828–30 (cat.113)

had seen this spot. Although the river is very wide here, his sketches suggest that he sailed close under the *coteaux*, which would have prevented him seeing their outline against the sun. As a result, rather than creating a *contre jour* effect, Turner resolved the problem by making the *coteaux* themselves the subject of his images, particularly in the inventive composition of fig.71, where the long perspective of the river is cramped into the left-hand edge of the sheet. Each of these views is illuminated by light from the south or south-east, which rakes across the hillside or catches the top of the château crowning the riverbank.[99] As well as the *péage*, each view includes the generalised outline of this small château at the end of the village street, which is still privately owned. Turner was content to leave this

building indistinct, much as he had done in the watercolour of Clermont (fig.65), choosing not to make a precise transcription from his sketchbook notes. The technique of fig.72 also compares with the Clermont view in its use of scratching on the surface of the paper. All of the Champtoceaux subjects include the traffic of the river, the most memorable of which is the snaking raft of timber in the engraved view. When this watercolour was translated into black and white, Turner deftly drew the viewer's eye deeper into the picture space by introducing a group of birds flying in V-formation downriver, towards the west (fig.208).

During the few miles between Champtoceaux and Ancenis Turner only recorded the rocky outline of the Coteau de Pierre Meslière and the line of windmills at St-Géréon. By then the outline of Ancenis was clearly visible, spilling down a gentle hillside to the towers of its riverside château. During the following years, the small wharf at Ancenis became the point at which passengers coming by steamer from Angers would be transferred to a second boat to complete the journey downriver, a procedure that sounds highly risky in some accounts.[100] Although Turner's boat came in close enough for him to make a page of sketches of the river front, he does not seem to have landed (fig.73). Beyond Ancenis, as the boat rounded a bend in the river, he was able to see the Château de Juigné (privately owned).

It was at this point that Turner interrupted his topographical studies to scrutinise the form and construction of the Loire boats. A sharp contrast is effected on one page of his sketchbook where the traditional *gabarre* is juxtaposed with three

FIG 73 *Views of Ancenis and the Château de Juigné* 1826 (TB CCXLVIII ff.15v., 16)

FIG 74 *Three views of a steamer, a Loire barge, a figure, with views of St-Florent-le-Vieil* 1826 (TB CCXLVIII ff.17v., 18; cat.12)

sketches of one of the new steamers, seen advancing, retreating and in profile (fig.74). As suggested above, the presence of a steamer at this point in the book implies that Turner passed the sister-ship to his own vessel, travelling downstream from Angers, before he reached St-Florent-le-Vieil. The three depictions of the steamer recall the naval tradition of representing the different sides of a ship, a tradition that Turner had honoured in his painting of the *Victory*.[101]

St-Florent-le-Vieil

The journey up the Loire to St-Florent-le-Vieil must have taken the whole morning, and perhaps the first part of the afternoon, with the steamer moving

at a steady pace of about four miles an hour. Thus, if we continue to assume that Turner later reproduced in watercolour and gouache the effects of light he had observed while travelling, it is entirely appropriate that in his views of St-Florent-le-Vieil the sun appears to be high in the sky, its rays streaming down at an acute angle (fig.75). In effect, Turner must have had to squint into the sun in an attempt to discern the detail with which to fill in the more readily observable outlines. The problem was inevitably exaggerated by the setting of this attractive village, which is perched on Montglonne, another stretch of the *coteaux* lying along the southern bank of the river.

The site is one of historic significance dating back to the seventh century,

when a Benedictine abbey was built to commemorate St-Florent, who had lived there as a hermit three hundred years earlier. Most of the remaining abbey church dates from the first years of the eighteenth century, but there were also substantial alterations to its fabric many years after Turner's visit. The chief interest of the village, however, resides in the famous part it played in the history of the Vendéan uprising. As one of Turner's contemporaries put it, St-

Florent was 'a name big with interest, and written in streaks of blood on the memories of all'.[102] The rebellion by those loyal to the monarchy began in the nearby region and spread to St-Florent on 12 March 1793 as a reaction to the execution of local priests and a general dissatisfaction with the means of con-

FIG 75 *St-Florent-le-Vieil* (engraved for *Turner's Annual Tour*) *c.*1828–30 (cat.114)

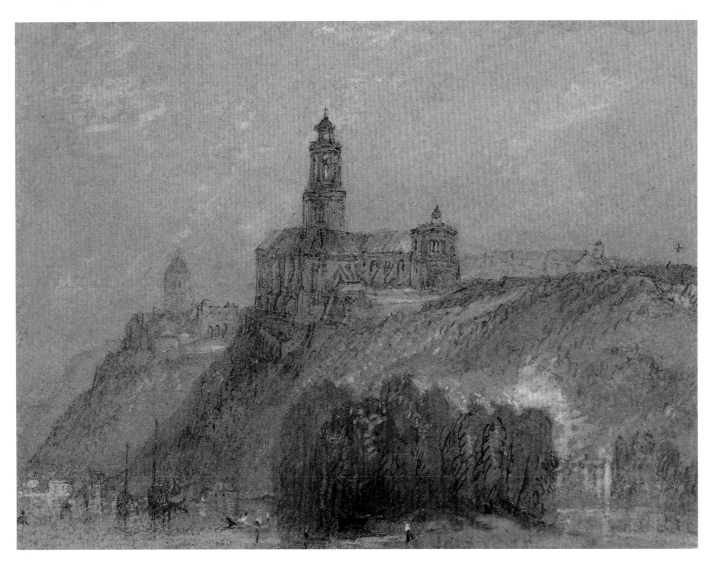

scription into the revolutionary army. This outburst of protest began a war in the area that was only superficially brought to an end by a number of treaties two years later.[103] A measure of the continuing loyalty in the region can be gauged from the ease with which the Duchesse de Berry was able to stir up the people in 1832 in support of her campaign against Louis-Philippe, the so-called citizen-king. The crucial event for St-Florent during the first Vendéan uprising was the desperate crossing of the Loire by more than 80,000 people following the loyalist defeat at Cholet on 17 October 1793. Although fatally wounded, the loyalist general Charles de Bonchamps prevented his troops from enacting their revenge on the 5,000 Republicans they had captured and imprisoned in the abbey church. Sadly, his act of clemency was not followed by the revolutionaries, who killed more than 2,000 local people at the foot of Montglonne during the Terror the following year.

First-hand accounts of the uprising were translated and published (anonymously) by Sir Walter Scott in 1816, so it would have been possible for Turner to know of the awful events.[104] Furthermore, the heroism of the loyalist forces was still a subject for artistic representation, and only a year before Turner's visit the sculptor Pierre-Jean David d'Angers (1788–1856) had completed his monument showing Bonchamps raising his hand to stop the slaughter of the revolutionaries; it was installed in the church on 11 July 1825.[105]

In spite of the widespread currency of these historic resonances, it has to be said that Turner's images of St-Florent lack any obviously significant details that would indicate the artist had intended his designs to evoke any link with the events of 1793–5 (figs.75–6). Both views focus on the abbey church, with the tower and ruins of the seventeenth-century Chapelle du Sacré-Coeur to its left (this latter building now houses the Musée d'Histoire Locale et des Guerres de Vendée). It is only in the view from the west, which was afterwards engraved, that Turner departed somewhat from his sketches to create a much more extensive monastic building, leading along the top of the ridge from the facade of the abbey church, although this could have resulted from a vagueness in this part of the drawing. At the end of the plateau he has included a small figure praying in front of a crucifix, which may perhaps refer to the hermit existence led by St-Florent. That this detail was deliberately introduced is apparent by making a comparison between the pencil notes and the colour sketch, in all of which it is possible to see the tall column erected to commemorate the visit of the Duchesse d'Angoulème in 1823 (replaced by another structure in 1828). The process of overseeing the engraving of this subject encouraged Turner to rework other areas, to which he added many incidental details (see p.244–5, fig.206).

The colour sketch (fig.76), on the other hand, is a perfect example of Turner's ability to strip away anything that was not essential to his image. It is as though he has attempted to paint the transforming action of light itself, as it begins to give shape and body to the towers on the hillside. As in the famous series of views of Norham Castle, which are composed in much the same way, there is the sense of revelation in things seen for the first time. Working almost entirely in monochrome – Turner's palette could scarcely be any more restrained – the result produced is a kind of negative effect. The viewpoint selected for this sketch is significantly different from that in the engraved design, indicating that it was not intended as a preliminary study for the more finished work, and that it served a different function for Turner. It was more probably begun as a variant design, of the kind identified as 'colour beginnings' or 'colour explorations' by Eric Shanes in his recent study of the watercolours.[106] A similar spare use of colour in the engraved view suggests that both works may have resulted from the same painting session. While this remains the most valid interpretation, there is something so complete about this image that it is difficult to imagine what more Turner could have added. As in the views of Clermont and Montjean (figs.63 and 82), it seems that Turner sometimes sought a means of expressing the exalted sensations given by the first impression of a place, rather than simply representing it more corporally. The 'unfinished' results seem to have been sufficient for his own purposes, even if he needed to treat other subjects more elaborately for public consumption.

As the boat sped past St-Florent, Turner continued to sketch its diminishing outline, interspersing these sketches with a view of the feudal castle at Varades on the other side of the river. Like the majority of the sketches that Turner subsequently used as the basis for watercolours, this is only a slight pencil outline. The resulting colour work, however, is a marvellous expansion of the humble motif, brilliantly suggesting the almost imperceptible flow of the river, as it gently disturbs the glassy reflections, so typical of the Loire (fig.77).

Ingrandes

A little further upstream Turner came across Ingrandes, whose importance lay partly in the salt trade, but more importantly in its position on the actual border between Brittany and Anjou. The town was known as 'la ville aux deux nations' because the border effectively cut the town in two down its main street. Ritchie noted that the 'view of Ingrandes from the river gives you the idea of a city – one hardly knows why. As you approach nearer and nearer the illusion diminishes, and you are at last greatly amazed to find so magnificent an

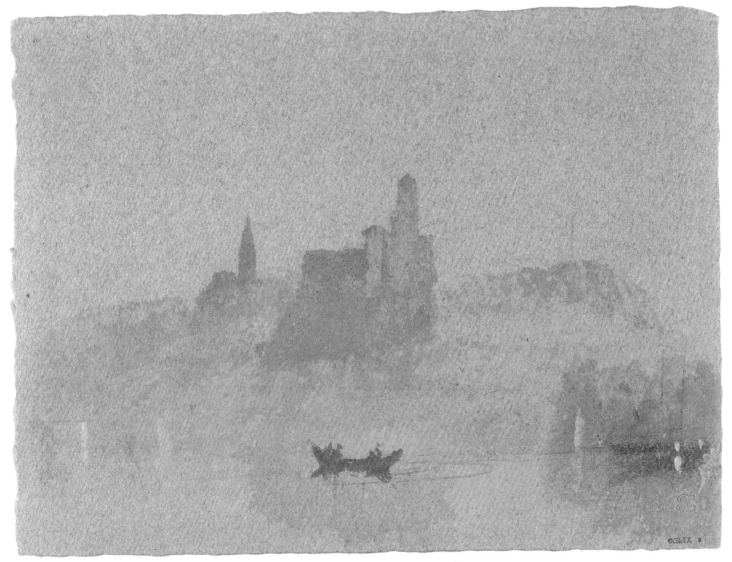

FIG 76 *St-Florent-le-Vieil c.*1826–8 (cat.71)

object degenerated into a snug and compact little town of twelve or thirteen hundred inhabitants.'[107] One of Turner's sketches gives some idea of exactly this effect, with a line of buildings starting with the church on the right and tapering off down the hillside towards a windmill. The sketch in question falls on page 17 of the *Nantes, Angers, Saumur* sketchbook, a few pages earlier than the page with views identified by Turner as Ingrandes. In order to record the panoramic view, he turned his book so that his sketch is parallel to the book's spine (rather than at ninety degrees from it). This proved to be the basis for

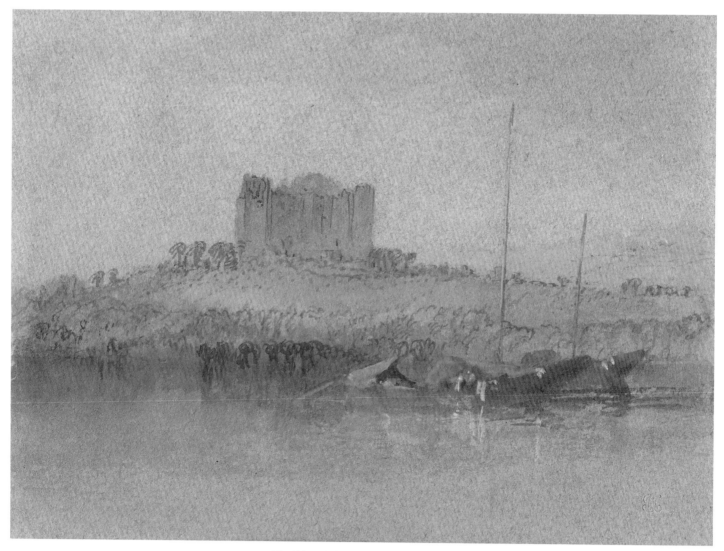

FIG 77 *The Château de la Madeleine, Varades c.*1826–8 (cat.72)

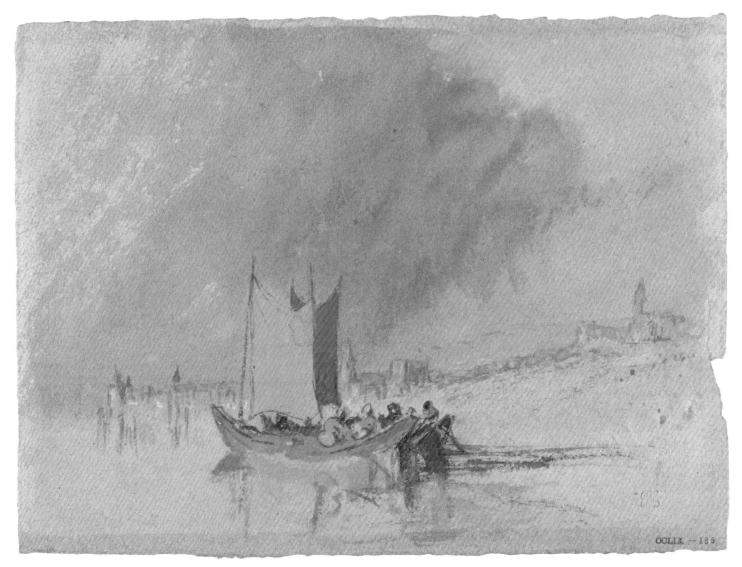

FIG 78 *Boats on the Loire, possibly near Ingrandes c.*1826–8 (cat.73)

another watercolour in the series, although in this case Turner did not follow his sketch slavishly (fig.78). The architecture in this work does not relate exactly to the pencil sketch, but the key elements are set out in much the same way, while the emphasis of the composition actually falls on a group of small boats. In Turner's mind the boats were very much identified with this part of the river; sketches of them face the other views of Ingrandes.

Montjean-sur-Loire

From Ingrandes, as the river curves away to the south-east, it is easy to see the outlines of Montjean, which occupies the next hilly eminence on the left bank. The four or five pages Turner covered with sketches of the town are of especial documentary interest in that the town has since been almost com-

pletely rebuilt and little of what he saw remains (fig.79). Turner began to make sketches of Montjean on page 20 of his book, continuing on the next right-hand opening, then turning that page over to sketch on its back, before returning to fill the preceding left-hand page. The distant prospect of Montjean is also the background to the sketches on page 22 verso.

It is perhaps clearer in Turner's pencil sketches than in his colour views of Montjean that the town straddled three hills, one each for the ruined château, the old Romanesque church of St-Symphorien and the convent of the Cordeliers. The convent had been converted before the Revolution into

FIG 79 *Views of Montjean-sur-Loire* 1826 (TB CCXLVIII ff.20v., 21)

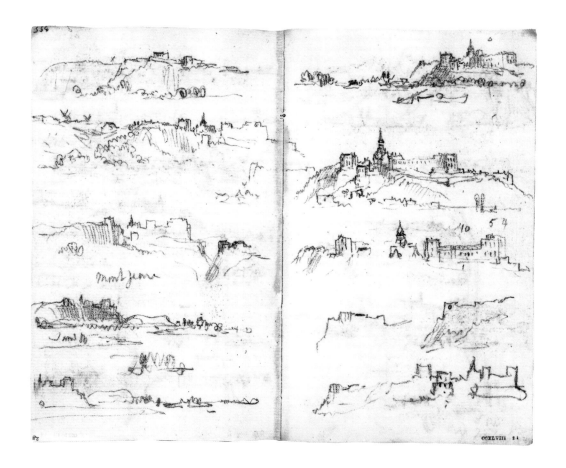

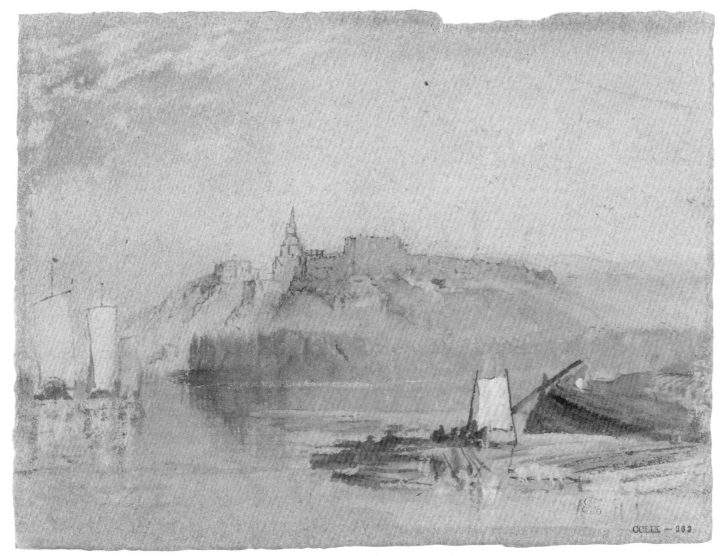

FIG 80 *Montjean-sur-Loire c.*1826–8 (cat.74)

a state prison, with the monks serving as jailers. The château, meanwhile, was a casualty of the Vendéan wars, when the Republicans destroyed much of the rebuilding work that had taken place during the previous century. Views by other artists show that Turner was accurate in his topographical depictions of the site.[108] Ritchie particularly praised the beauty of Turner's engraved subject (fig.81) but emphasised that Montjean was 'still more remarkable in nature than in [this view], since it rises in that imposing manner from a dead level. There is also a fishing hamlet at the base con-

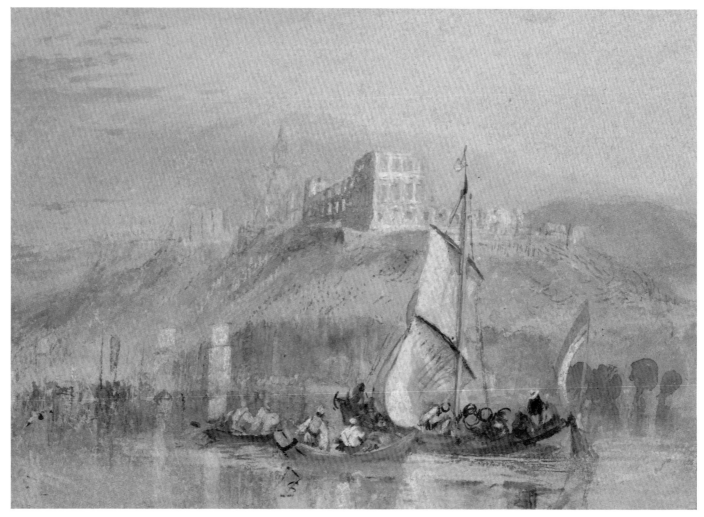

FIG 81 *Montjean-sur-Loire* (engraved for *Turner's Annual Tour*) *c.*1828–30 (cat.115)

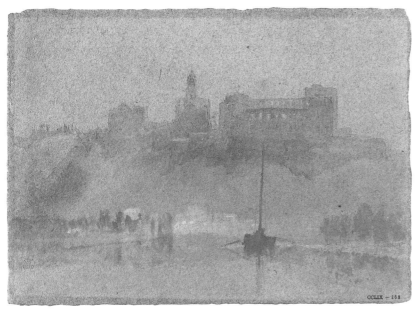

FIG 82 *Montjean-sur-Loire c.1826–8 (cat.75)*

cealed by the trees, which, contrasting with the magnificent ruins above, adds to their effect.'[109]

The reason Montjean was later so radically transformed lies in the growth of the quicklime industry, which may already have been evident at the time of Turner's visit. Just a few years afterwards, in 1832, the keen-eyed Miss Strutt remarked on the ugly appearance of the quarries and mines on the left bank immediately to the east of Montjean, which, like most nineteenth-century travellers, she was glad to leave behind for the more picturesque qualities of the ruined town.[110] As a result of this industrial work, Montjean expanded very rapidly in the mid-nineteenth century, apparently producing 40,000 tonnes of quicklime each year from sixteen furnaces, which was then shipped downriver, thus making the town a port of some importance.[111] As the town prospered, it swept away the remnants of its historic past, so that by 1864 the roofless church and the château walls had been cleared to make space for a new church.

In the sketch at the top of page 21 of the *Nantes, Angers, Saumur* sketchbook Turner included a small circular form in the sky, which, because of its position to the south of the ruins, most probably represents the sun (fig.79). This is confirmed by the two colour sketches and the finished watercolour view, which develop the theme of a building seen against low afternoon sunlight that had found such consummate form in the view of St-Florent (fig.76). In the finished view of Montjean the low afternoon light falls through the ruins of the old convent, and its western facade shimmers cool and pale. Perhaps to vary the range of effects, Turner transformed this image when it was engraved by introducing the rising moon to the left of the ruined château, so that it cast its reflection down on to the still waters of the Loire (fig.205). This is a highly poetic touch and was perhaps an effect he observed as his boat drew nearer to Angers later that day.

Each of the three watercolours of Montjean emphasises the mass of the ruins by setting up juxtapositions between the citadel and the tall masts and sails of the *gabarres*. In the first in this series (fig.80) there is the additional pictorial 'rhyme' between the sprawling group of buildings and the raft of timber alongside a barge in the foreground. These vessels, filled with barrels or towing felled plantations of wood, give a vivid sense of the vital part played by the river as a highway for local produce.

The afternoon must certainly have been drawing to a close as Turner's boat

FIG 83 *Views of villages beside the Loire, including la Possonnière, Savennières, the island of Béhuard, la Pierre Bécherelle, and the cliffs near Bouchemaine 1826 (TB CCXLVIII ff.23v., 24)*

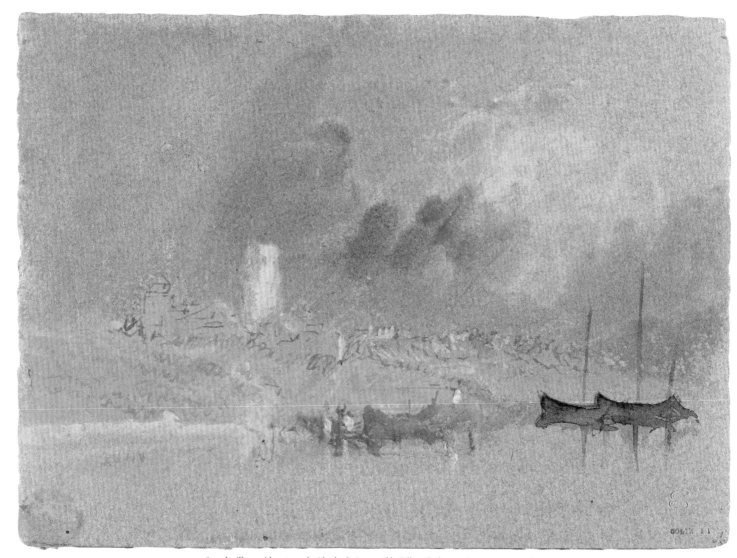

FIG 84 *A village with a tower beside the Loire, possibly Béhuard, close to Angers c.1826–8 (cat.77)*

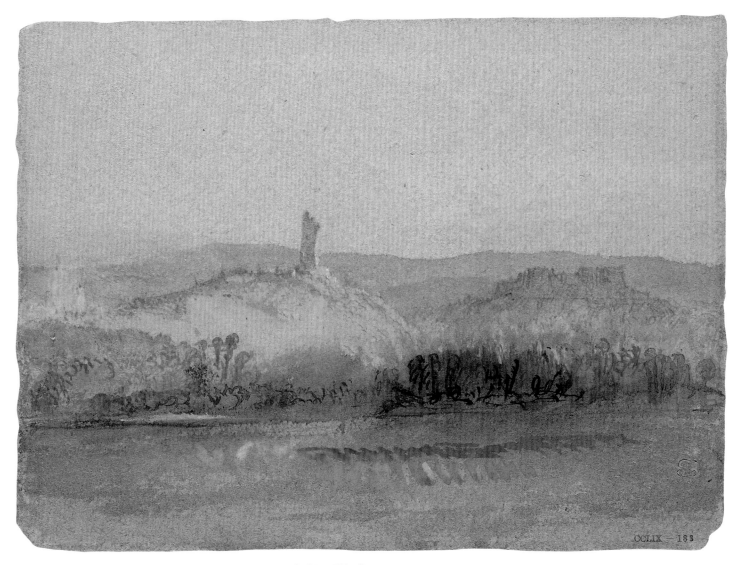

FIG 85 *La Pierre Bécherelle, near Epire c.*1826–8 (cat.76)

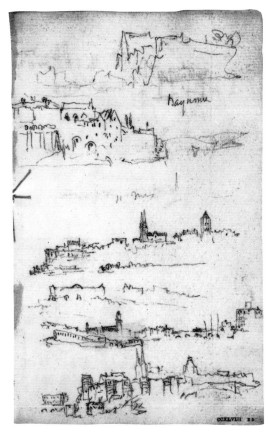

FIG 86 *The convent of la Baumette and distant views of Angers
from the south 1826 (TB CCXLVIII f.25)*

made its way past the villages of La Possonnière and Savennières, before skirting the historic island of Béhuard. During this part of the journey he continued to sketch the windmills, towers and rocks alongside the river, sometimes also noting their names (fig.83). Once again, the compulsive act of setting down as many quick impressions of what he saw later proved the seed for works in colour (figs.84 and 85). The second of these shows the group of freestanding rocks close to the village of Epire, known as La Pierre Bécherelle. On the right of this watercolour study it appears as though there is a large building, but this is explained by the fact that Turner seems to have misinterpreted the details of his pencil sketches.

Just a mile or so east of Epire the north bank of the Loire becomes the right

bank of the River Maine, the two rivers meeting close to Bouchemaine. There are very few sketches to record Turner's approach to Angers, which lay just off the Loire up the Maine, although it is clear that he looked out eagerly for his first sight as it began to rise from the horizon, the towers of its cathedral signalling an end to the voyage (fig.86). Two quick outlines record the convent of Baumette just downriver of the city, but any attempt to follow the last stages of this journey must have been curtailed by the rapid approach of evening, which drew Turner's long day of sketching to a close. Since leaving Nantes he had covered nearly fifty sides of his new book, filling them with more than one hundred and eighty sketches. As we have seen, this tremendous productivity bore fruit in the group of more than twenty drawings and colour sketches that went on to make such an important contribution to the flavour of the set of published Loire views.

Angers

Turner had only been able to obtain a general idea of Angers at the end of his long day afloat on 3 October. Consequently, he spent the following day (or possibly even two days) making a much more thorough survey. As the capital of the province of Anjou, the city has a long history which was richest in the Middle Ages. The foundations of this strength were set down by the Foulques dynasty, who, through the creation of a number of impregnable fortresses along the Loire, also secured the neighbouring province of Touraine. At the beginning of the thirteenth century Blanche of Castile, who was Louis IX's mother, began a new castle at Angers on the raised site on the left bank of the Maine, the outer structure of which has remained largely unchanged. By this time the city had spread across the river to the quarter known as Doutre (from 'd'outre-Maine') where religious foundations, such as the abbey of the Ronceray and the Hôpital St-Jean, had grown up to minister to the poor, the sick and the orphaned. As well as the new château, Blanche of Castile erected huge fortified walls to encircle the city. It was further protected on its waterfront by great bastions from which chains were stretched across the river to prevent the passage of enemy boats. Even though the population had continued to expand in the following centuries, reaching 30,000 in the late 1820s, these walls had remained in place, determining the scope of the city, and preventing its outward development. In 1807, therefore, Napoleon decreed that the walls should be demolished, setting in motion the period during which Angers gradually reinvented its outward character by erecting Haussmann-like boulevards along the lines of the old battlements. Nearly twenty years after Napoleon's order, however, it is

clear that there was still a huge amount of work to do, for Turner's sketches record a city still bound in by its medieval past. In the 1820s the two halves of the city were linked by only one bridge, but the remnants of the old Pont de Treilles, built by the Plantagenet king, Henry II, could still be seen, providing a picturesque motif for many artists.[112]

The conclusion of the steamer voyage from Nantes meant that Turner had already enjoyed spectacular views of the city walls on both banks of the Maine. Other travellers arriving by coach from Les Ponts-de-Cé or Saumur were not so fortunate and complained that the approach by road gave no idea of the attractive river outlook. From its river aspect the city was, and still is, dominated by the spires of its cathedral and the massive walls of the château, and it was in this quarter that Turner began his explorations on the morning after his arrival. After

the stylish modernity of Nantes, he must have been struck by the contrast with Angers, which in many ways was still almost entirely medieval in character.

The order of sketches suggests that he was anxious to return a little way downstream in order to make a proper general view of the city. However, the first page-opening in the sequence is devoted to the Tour St-Aubin and the facade of the cathedral of St-Maurice (fig.87). Both buildings reflect the long tradition of Angers as a religious centre. It had been a bishopric since the fourth century, but the current cathedral dates chiefly from around 1148 onwards. The west front has been much modified during its history, and shortly

FIG 87 *Angers: the west front of the Cathedral of St-Maurice, with a study of the Tour St-Aubin* 1826 (TB CCXLVIII ff.26v., 27)

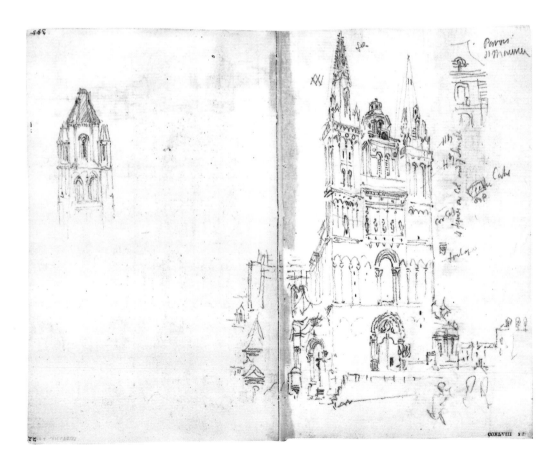

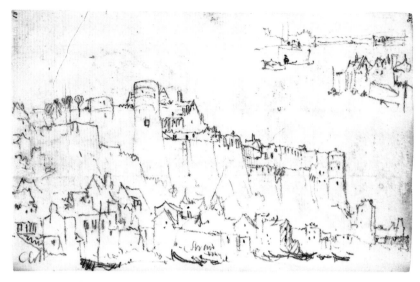

FIG 88 *Angers: the walls of the château above the Porte Ligny, from the other side of the River Maine* 1826 (TB CCXLVIII f.30v.)

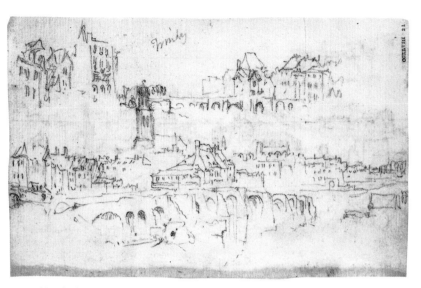

FIG 89 *Two sketches at Angers: the Pont des Treilles from the left bank, with the tower and church of La Trinité, and (above) the main bridge at Angers further downstream* 1826 (TB CCXLVIII f.31)

after Turner's visit was again reconstructed as a result of a fire in 1831 at its upper level.[113] Perhaps the most interesting feature is the Galerie St-Maurice at the third storey, where there are eight niches, each containing a carved figure, one of which represents the cathedral's patron saint. Surprisingly in such a deliberate study, Turner's sketch is not accurate in every detail. Thus, there are only five sculptures in the sculpture gallery. But his observations are conveyed in a more attentive manner, and with more style, than the architectural sketches he had made earlier in the tour at Coutances or Quimper (figs.15 and 24).

From the cathedral he walked down to the River Maine, staying on its left bank. Once he was past the perimeter walls, he made a sketch of the quayside Hôtel du Roi de Pologne,[114] but his real energies were reserved for a group of well-composed views of Angers taken from the south, where its immense spread proved too large to encompass within a single sketch. As he got older, Turner increasingly favoured a grand general view of a town or city, rather than the picturesque fragments he had sought out as an adolescent. Both in the preparatory sketches and in the finished views for *The Rivers of France* series, the move towards this overview is quite marked, with the third group of views, of the Seine around Paris, being particularly characterised by plunging views down on to the river, with its towns and bridges. Arriving at this sort of

prospect required Turner to make a lengthy perambulation of his chosen subject, seeing it from all sides.

In one of the first studies in the Angers series he attempted to make a panorama, beginning at the extreme left with the western walls surrounding the Doutre district, and then moving across the page towards the church of La Trinité, but at this point he ran out of space and was forced to continue the rest of his view in the space above, culminating in the bulk of the château on the right.[115] After making sketches from a point close to the ruined Pont de Treilles (fig.89), it seems that he crossed the river and began to circumnavigate the ancient walls, all the time looking back towards the château and the cathedral. Pages 31 verso to 36 verso of the book chart his movement from the Tour de Haut Chaine around the western walls to the Tour de Basse Chaine.

The views in the notebook are not the only record he made of Angers from this side of the river, for there is also a series of pencil sketches on some sheets of the same blue paper used for his colour sketches. Because the blue paper is such a strong background colour, it is often difficult to see Turner's pencil work clearly, which makes these works difficult to reproduce. However, a selection is included here (figs.90–92 and 95; see also cats.13–16, 19 and 21–2). Many of the group were identified by Nicholas Alfrey, who was the first to conclude

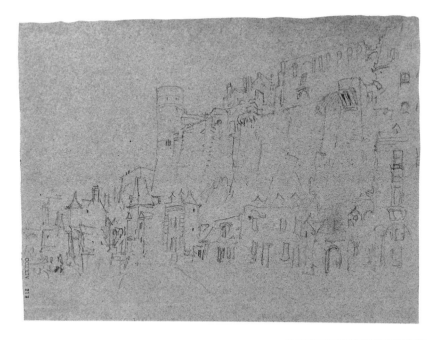

FIG 91 *Angers: the ruins of the Pont des Treilles, with the cathedral, from the right bank of the Maine* 1826 (cat.23)

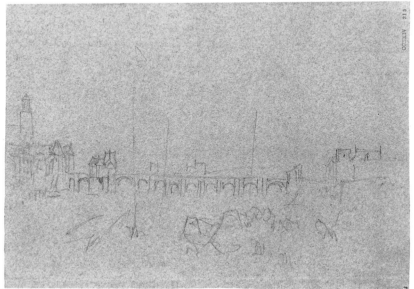

FIG 90 *Two views of Angers: the Tour de Moulin of the château from below; and the Grand Pont, with the tower of La Trinité on the left* 1826 (cat.20)

FIG 92 *Angers: the towers of the château* 1826 (cat.17)

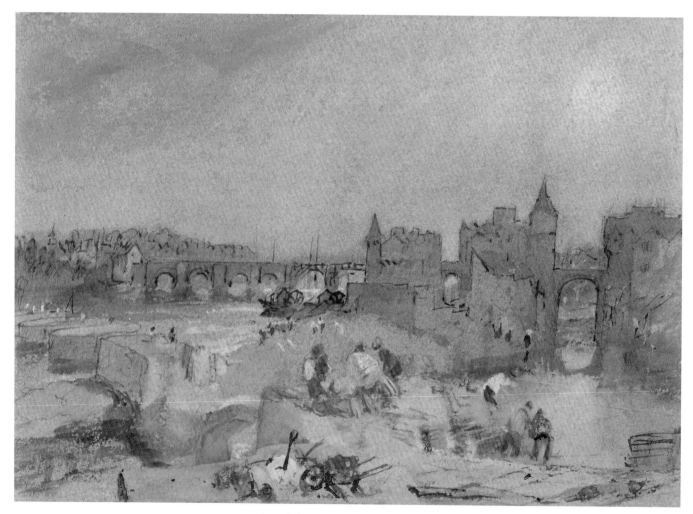

FIG 93 *Angers: looking south down the Maine c.*1826–8 (cat.78)

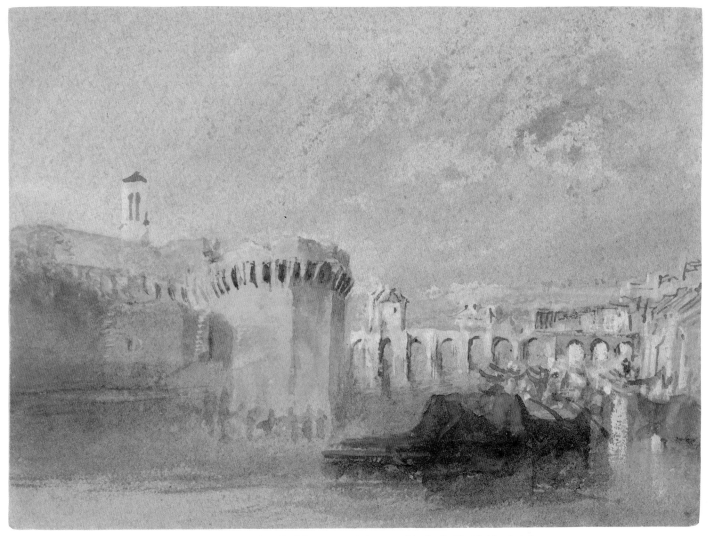

FIG 94 *Angers: the walls of the Doutre, with the tower of the church of La Trinité c.1826–8*

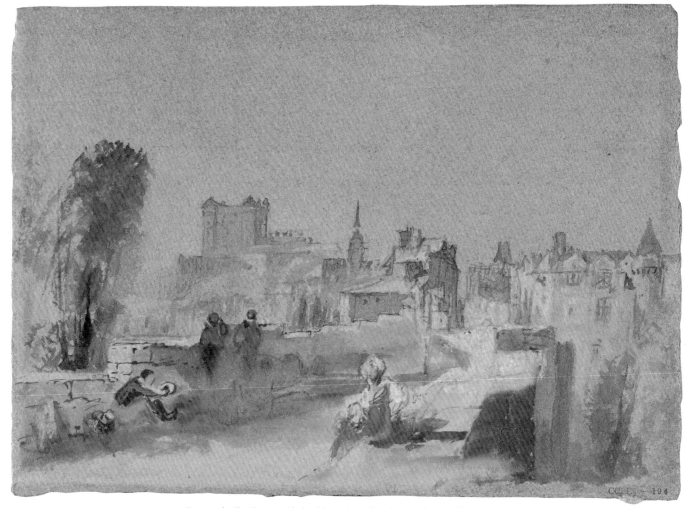

FIG 99 *Saumur: the Ilot Censier, with the château above, from the Pont des Sept Voyes c.1826–8 (cat.80)*

although two of the views are on paper that may be part of a batch with an 1828 watermark, suggesting they were developed from other missing sketches.[124] In the first of the series (fig.98) it is possible to discern fairly readily the pencil work in the lower-left corner of the image, which Turner presumably intended to develop as foliage growing from below the bridge parapet. Working over the structure of his sketch, he gave shape and body through the application of gouache and fine pen lines. Although Turner exploited the silhouette of the château as the focus of the design, the emphasis he intended has become exaggerated as a result of the discolouring of the paper where it has been overexposed to daylight. The subject of the view is the Pont de la Croix-Verte, the first of the six old bridges across the river, which were being superseded in the mid-1820s by the completion of a new, more direct route, a little

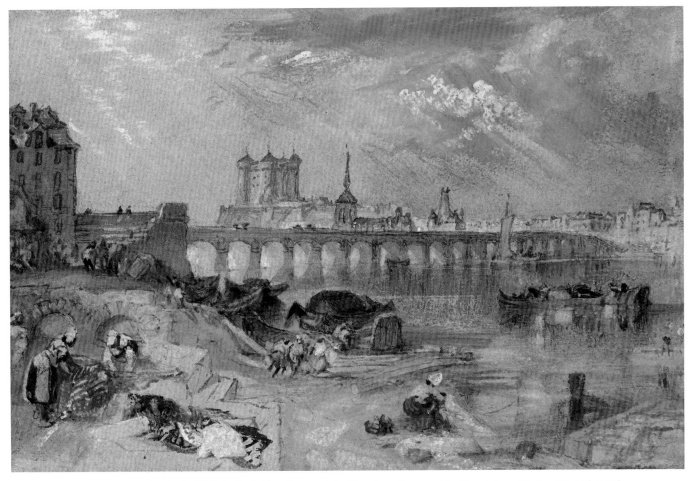

FIG 100 *Saumur from the Ile d'Offard, with the Pont Cessart and the château beyond* (engraved for *Turner's Annual Tour*) *c.*1828–30 (cat.116)

way downstream. A second colour sketch shows the Ilot Censier, with the tur-reted Maison de la Reine de Sicile on the right, from the end of the Pont des Sept Voyes (fig.99).[125] Since most other artist-visitors to Saumur concentrated on the château and the main arm of the river, which flows between the Ile d'Offard (then the Faubourg des Ponts) and the main quayside of Saumur, Turner's selection of less obvious subjects is doubly interesting. As in the colour sketch of the Pont Pirmil at Nantes, these views of the medieval bridges employ a daring perspective that sweeps across the plane of the image to embrace the viewer, thereby breaking down, as Maurice Davies has observed, 'some of the rectilinearity of standard perspective without necessarily breaking its rules'.[126] In the first of these Turner found a complementary interest to the view itself in the two boys fishing from the wall. He was renowned as a fisher-

man among his friends and would therefore have been especially keen to know what type of fish the children hoped to catch from the Loire.

As a contrast to the picturesque forms of the ancient bridges, Turner moved on to make a pencil sketch of the more modern Pont Cessart on page 43 of his book.[127] Taken from the Quai du Gaz, to the west of the bridge, this is another of his two-part panoramas that continues above the main sketch at the point

where lack of paper had forced him to break off. The lower half of this sketch served as the basis for the view of Saumur published in *Turner's Annual Tour* (fig. 100). When painting this watercolour, Turner allowed himself many slight variations from the primary source material in the interests of providing a tighter design. For example, in the finished drawing the château is taller and placed on a higher position, the spire of St-Pierre has been moved further to

FIG 101 *Sketches at Saumur, and (below) a distant view of Saumur from the east, with the 'Château de Souzay'* 1826 (TB CCXLVIII ff.41v., 42)

the left, and the pitched roof of the Hôtel de Ville is much more drawn up than it appears in the sketch. More significant, however, are the changes he introduced to the bridge itself, which should only have the '12' arches he recorded in his book. This change of emphasis resulted from treating the house and steps on the left of the image as though they are on a different plane to the bridge, whereas they should be all of a piece. Inaccurate though the details may be,

they contribute to the grand effect, which is heightened by the light reflected through the arches from the water. It is also a rare instance of Turner suggesting the full width of the Loire. Despite making an accurate note of the actual number of arches, he was at least consistent in adding more arches to his other representations of the Pont Cessart (see figs. 103 and 181).

Turner was always capable of introducing groups of figures to enliven a simple

FIG 102 *Saumur from the east, with Notre-Dame des Ardilliers in the middle distance, and (below) Saumur from the Ile d'Offard* 1826 (TB CCXLVIII ff. 43v., 44)

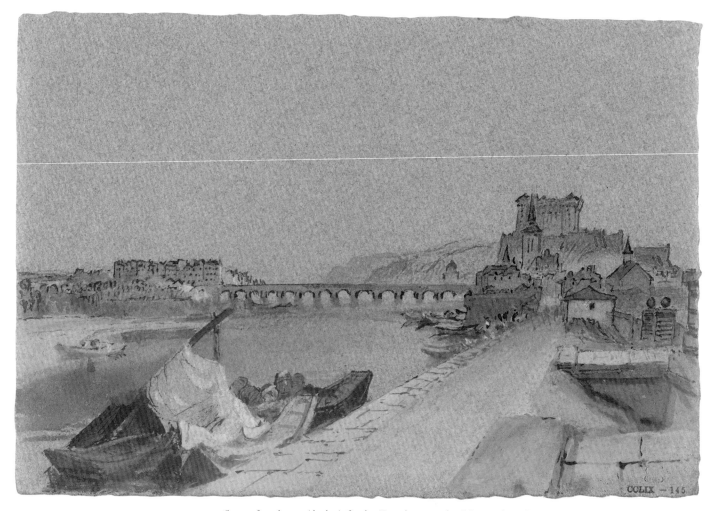

FIG 103 *Saumur from the west* (the basis for the *Keepsake* watercolour) ?*c*.1828 (cat.81)

outline sketch. In fig.100 the quayside is peopled with men hauling loads of timbers, much like the flotilla seen in the view of Champtoceaux (fig.72). The more immediate foreground is given over to the women, who seem to be stretching out sheets of washing but this is probably another solecism on Turner's part, for the quay is not known to have been used in this way.[128] Yet it is in this kind of incident that Turner reveals something of what he had absorbed during his trav-

els. Like other travellers, he may have observed that women washing at the riverside was a 'constant and always pretty feature in the landscape of the Loire'.[129]

Nearly all of Turner's views of Saumur include the squat block of the château presiding over the town. Ever since the fourteenth century, when it was painted in miniature to illustrate one of the months in *Les Très Riches Heures du Duc de Berry*, its silhouette had provided an attractive focus for artists.[130] By the time of

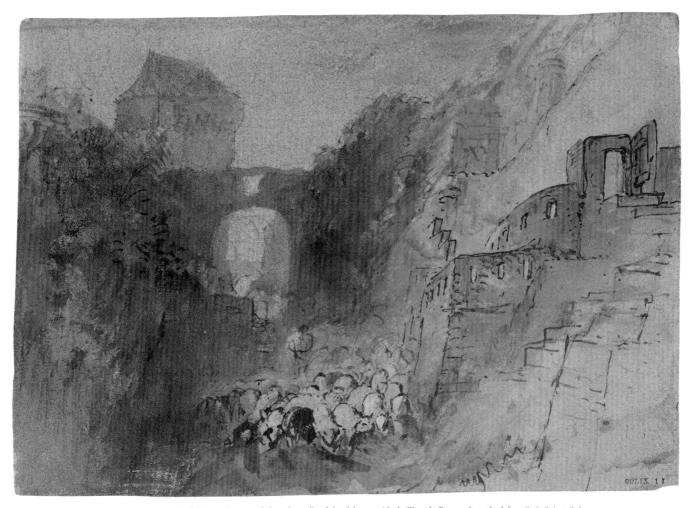

FIG 104 *A herd of sheep at Saumur; below the walls of the château, with the Tour de Papegault to the left c.1826–8 (cat.82)*

Turner's visit, its structure had been substantially changed by the collapse of the western range, and by its subsequent use as a prison and barracks. The corner towers then were conical, but they were not pointed as they are today (fig.102). Most of Turner's sketchbook views of the château were taken from the Ile d'Offard or from immediately below in the Place St-Michel, but another of the sheets of blue paper indicates that he walked some way to the west in order to capture a more distant prospect of the town (fig.103). He may have been drawn along the southern bank by the famous military riding school, which had been designated the principal national Ecole de Cavalerie only the previous year. His view must have been made from close to the parade ground, the Place du Chardonnet, and there is the suggestion of its outer walls in the lower right-hand corner. Following the route back into Saumur, the eye first passes the

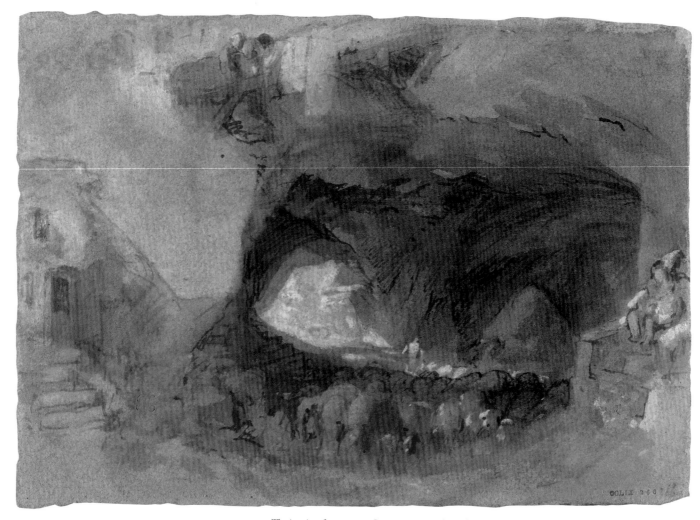

FIG 105 *The interior of a cave, near Saumur c.*1826–8 (cat.83)

church of St-Nicholas on the right, then rises to the spire of St-Pierre, which partly obscures the western facade of the château. Beyond the bridge can be seen the dome of the church of Notre-Dame-des-Ardilliers, which Turner would have recognised as an imitation of Sta Maria della Salute in Venice. A few years after the tour Turner reworked this view on white paper as an illustration for the popular *Keepsake* annual (fig.181).

In the town under the château Turner walked the very streets that were to prove so fruitful to Balzac as a setting for his novel *Eugénie Grandet*. Given the pronounced fashion for all things English during this period, it is interesting to speculate whether Balzac would have seen one or other of Turner's engraved views of Saumur, the later of which appeared in France in 1833 while he was working on the novel. Since Balzac's text mentions Sir Francis Chantrey's portrait of Lord Byron and Richard Westall's illustrations for *The Keepsake*, it is worth at least considering this as a possibility.[131] The sleepy bourgeois town

FIG 106 *Parnay, looking west towards Saumur* 1826 (TB CCXLVIII f.47v.)

evoked so well by Balzac can also be found in a view of Saumur which is identified here for the first time (fig.104). This shows the Tour de Papegault to the east of the church of St-Pierre, with a shepherd driving his flock back into town. Again, topographical accuracy was not Turner's chief concern, and it is only loosely based on the view recorded on the inside back cover of the *Nantes, Angers, Saumur* sketchbook.

The dome of Notre-Dame-des-Ardilliers drew Turner to the eastern outskirts, which had grown up as one of the chief centres for the manufacture of rosaries after the Protestant sympathies of Saumur had been suppressed in the seventeenth century. The three or four sketches Turner made of the view westwards from alongside the church and its adjacent hospice suggest that he considered creating a more finished image of this subject, although this does not seem to have been effected. His exploration continued further up the south bank, taking him on foot to Souzay, Parnay (fig.106) and towards Montsoreau and Candes-St-Martin.[132] This would have been, by Turner's standards, a fairly leisurely ramble that allowed him to climb up above the river and to make views looking back towards Saumur. No visitor to this area can ignore the 'troglodyte' dwellings carved into the limestone cliffs, some of which are faced with elaborate buildings constructed from the chalky *tuffeau* stone. British visitors were intrigued by these houses and their inhabitants, which can be found

along the entire length of the river but are especially numerous and fine on the stretch close to Saumur. It is, therefore, not surprising to find several representations both of the interiors and the exteriors among Turner's sketches. On one of his sheets of blue paper he developed the scene of an open cave, which, to judge from the numerous barrels, served as a store for makers of the renowned Saumur wines (fig.105). It is also possible that some of the informal subjects Turner painted on blue paper showing groups of figures in interiors may record this part of his journey, where he could have sampled the local hospitality and conducted some pleasurable research into the various vintages.[133]

Montsoreau and Candes-St-Martin

The *Nantes, Angers, Saumur* sketchbook comes to a close with some fragmented views of Souzay and Parnay, and others of the windmills perched on the cliffs above, but this was not the end of Turner's observations on this part of the Loire. One of the views published in his *Annual Tour* records the scenery a little further to the east of these villages at a point before the river bank reached Montsoreau (fig.107). An unremarkable sketch on page 37 of the notebook may have provided the basis for this drawing, although it is also possible that Turner worked in colour directly over a pencil outline, as he had done elsewhere. In the process he created yet another of the glorious sunrises that suggest a better title for the set of published views might have been 'Mornings on the Loire'.[134] The rising sun bathes the whole scene in a golden glow, and as its sparkling light falls across the river, it creates a swathe of gently broken reflections. In the distance the eye is drawn to the outline of the church at Candes-St-Martin, but the angle of the view means that its silhouette is conflated with that of the château of Montsoreau, which at that date was right on the river's edge. When the image was engraved, Turner added two boats in the lower left-hand corner, but they were not drawn to the same scale as the rest of the image, resulting in the impression that the road is much higher than it is in reality.[135] The title that appeared on the finished engraving was 'Rietz, near Saumur', which has caused some confusion, since the named place cannot be found on a map. However, as with the erroneous title at Champtoceaux, there is an element of truth to Turner's classification, for it seems that the traditional name for Montsoreau was 'Rets'.[136] Although this point has not previously been made, the topography here is of some note, for the subject of the view is actually the confluence of the Loire and the Vienne. Turner underlines this most subtly by allowing the sunlight to fall at exactly the point where the two rivers merge just opposite Candes-St-Martin.[137]

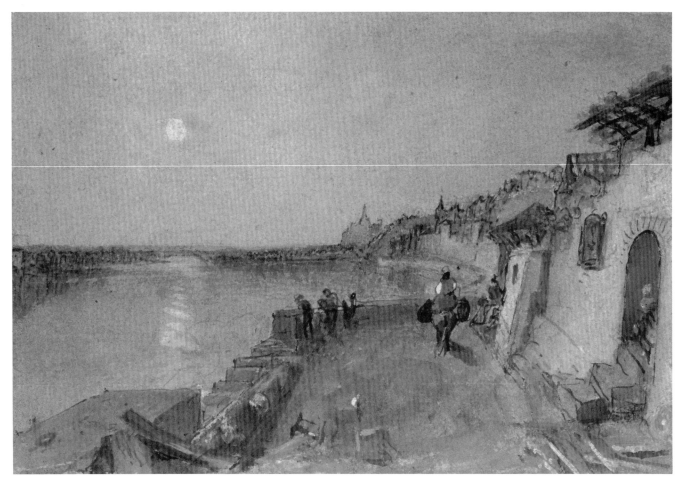

FIG 107 *The junction of the Loire and the Vienne near Montsoreau and Candes St-Martin*
(engraved for *Turner's Annual Tour* as *Rietz, near Saumur*) *c.*1826–30 (see p.228)

A Dash through Touraine

Since the excursion to Montsoreau effectively marks the end of the second Loire sketchbook, it is impossible to know precisely what Turner did next. There are two distinct possibilities. Firstly, he might have retraced his steps to Saumur, whence he could have boarded the diligence to Tours. Alternatively, since he would not have wanted to waste time on a fruitless detour, he could have paid someone at Montsoreau to row him across the river, where he could have continued a mile or so to Chouzé-sur-Loire, which was one of the post-stops on the diligence route.[138]

Although the next sketchbook in the series was not begun until he was within sight of Tours (cat.26; Appendix A, pp.235–7), he did not fail to document this part of the journey altogether. On a sheet of paper that he folded into smaller sections he made a series of thumbnail sketches of the ancient buildings visible from the diligence, beginning with 'Chouzay' (fig.108). A tiny

FIG 108 *The Château at Langeais from a folded sheet of sketches of the châteaux between Saumur and Tours, including Ussé, Chousay and Langeais* (detail) 1826 (cat.24)

FIG 109 *A folded sheet with sketches of the châteaux of Cinq-Mars-le-Pile, Luynes and Tours Cathedral* (detail) 1826 (cat.25)

outline indicates that he saw the fantastic towers and battlements of Ussé across the river, followed soon afterwards by the village of St-Patrice and the solidly imposing château at Langeais. The diligence paused long enough there for him to make a slightly more elaborate sketch, but he was soon travelling on through Cinq-Mars-la-Pile (or '5 Marses' as Turner's inscription would have it), where he noted the two cylindrical towers of the ruined château, as well as the mysterious structure to the east of the town dating from the Gallo-Roman period (fig.109). From there it was just a short distance to Luynes, which was swiftly recorded before it too was left behind.

To the modern visitor, who lingers over the abundant architectural, historical and horticultural attractions of these celebrated châteaux, it must seem surprising that Turner should choose to give them barely a second glance. Furthermore, his route on the north bank of the Loire meant that he was also unable to visit the châteaux of Azay-le-Rideau and Villandry, which have since come to epitomise the charms of the region. Admittedly there is a frenzied quality to Turner's sketches, which suggests he was anxious to catch whatever impressions he could while pressing on still more urgently towards Tours. The most likely cause of this haste is that he was making this part of the journey early on Saturday 7 October, having spent the previous day in Saumur, and that he intended to be in Tours for Sunday.

Tours

When the city began to rise from the horizon, it appears from Turner's sketches that he dismounted from the diligence, making a slower approach on foot. In the related watercolour views of Tours from the west, the sun sits high over the cathedral towers (fig.112), suggesting that Turner arrived there only a few hours after he had seen the sunrise at Montsoreau.

He began his new sketchbook by observing the rock-face dwellings at La Guignière, close to the 'Pont Mort'. This bridge crossed the tributary stream, the Choisille, which flows into the Loire to the west of St-Cyr. In the watercolour showing the route running along the north bank towards the city, he included a group of houses beside the road, and while he probably invented them from his recollections, the styles he used for the stepped and turreted roofs are typical of the region. Both the road and the adjacent waterway are busy with traders and other traffic, leading the eye inevitably towards the long Pont de Tours, which lies parallel to the picture plane. This elegant, fifteen-arch structure was built from 1765 onwards to a design by Mathieu Bayeux (1691–1777). Of the Loire bridges constructed during the first half of the eighteenth century, which

include those at Orléans and Saumur, that at Tours was widely considered the finest. French and English commentators were quite partisan in the comparisons they made between it and the new Waterloo bridge in London.[139] As we have seen, Turner had already drawn the bridge about thirty years earlier, in the mid-1790s (p.15, fig.1), so he may have had a sense of *déjà vu* when its majestic form began to appear in front of him. He cannot have looked at it very intently, for in the sketch on page 6 of his book he mistakenly recorded that it had '16 arches', and there are further interesting discrepancies in the number of arches in his watercolours and the engraved views based on them.[140]

view that could not fail to impress the visitor. The two prominent towers down-river from the bridge, though now several streets away from each other, were once part of the great basilica of St-Martin, constructed in the eleventh and twelfth centuries, and demolished, as a result of neglect, between 1797 and 1802.

Apart from views of the city, the other early pages of the Tours sketchbook show that Turner was interested in the small flat-bottomed sloops that plied the river alongside the Loire barges. Working from his pencil notes, he made a second, closer view of the bridge, where the focus is on one of these boats under a cloudy morning sky (fig.113). There is so little precise detail given to

FIG 110 *The church of St-Cyr, looking across the Loire to Tours* 1826 (TB CCXLIX f.6v.)

FIG 111 *Tours from the northern end of the Pont de Tours* 1826 (cat.27)

Whilst there were considerable differences of opinion about the supposed attractions of Tours itself, almost all commentators agreed that the views of the city from the right bank of the Loire were incomparable. Perhaps the young Balzac overstepped the bounds of impartiality when he described this aspect of his birthplace as 'the finest view in the world, equal to that of Naples'.[141] Yet, the city certainly has a welcoming grandeur in the sketches Turner made from the heights of St-Cyr (fig.110). Spread out on the other side of the river and punctuated by numerous towers and the looming mass of the cathedral of St-Gatien, this was a

the distance that it is not surprising that Robert Brandard's engraving of the image bears very little relation to the architecture Turner was attempting to recreate (see p.242, fig.200).

Once he reached the northern approach to the bridge, Turner paused to sketch the hemispherical Place de la Tranchée, which is decorated by four toll pavilions and large stone vases on the balustrades of the bridge (fig.111). He then climbed a little way up the gentle slope above this area, from where he was able to concentrate the panoramic view within the framing banks of the

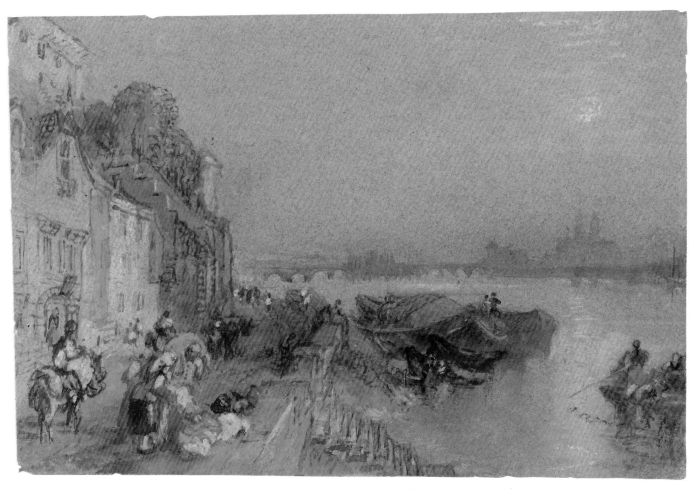

FIG 112 *Tours from the west* (engraved for *Turner's Annual Tour*) c.1826–30 (cat.117)

roadway, an effect that is much more pronounced in the gouache study than in the original pencil sketch on which it is based (fig.114). If Turner had been wary around military placements earlier in his journey, he seems to have been less cautious in Tours. Though he actually made no sketches of soldiers in his notebook, members of the national guard in their blue and red uniforms are introduced to his coloured views and can be found marching in file across the bridge or on duty in the market place. A few years later Ritchie noted that, despite the very forceful presence of the troops at the entrance to the city, no proper check was made by them of those passing by, so that anyone could enter unnoticed, something that is borne out in the fact that none of the records at Tours have been found to contain any indication of Turner's visit in 1826.[142] Thus, we have no documentary evidence to confirm the precise dates of his visit, nor information to indicate where he stayed. To the suggestion above that he was there over the weekend of 7–8 October it is possible to add that he may have lodged at the Hôtel d'Angleterre in the Rue Colbert. This *auberge* was situated opposite the Gothic abbey church of St-Julien, and the reason for assum-

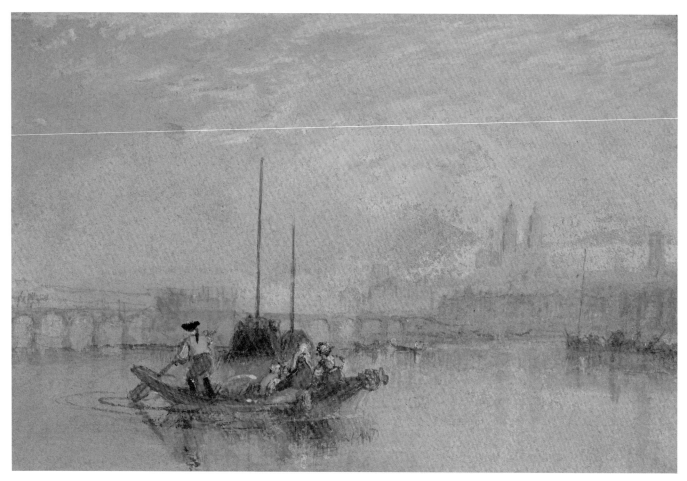

FIG 113 *Tours* (engraved for *Turner's Annual Tour*) *c.*1826–30 (cat.118)

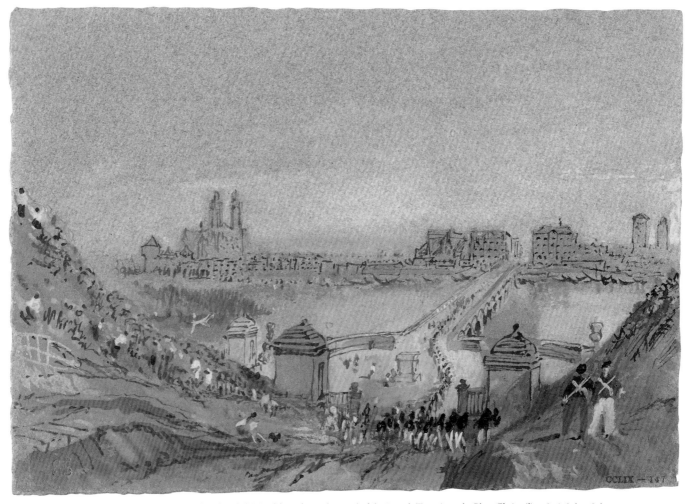

FIG 114 *Tours from above the Place de la Tranchée at the northern end of the Pont de Tours (now the Place Choiseuil) c.1826–8 (cat.84)*

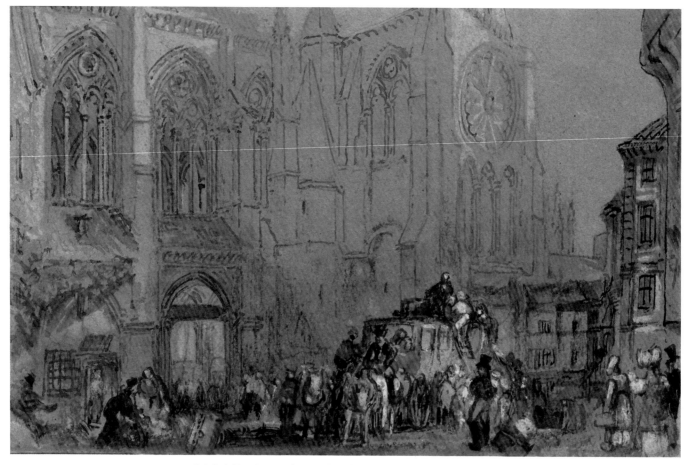

FIG 115 *St Julien's, Tours* (engraved as *St Julian's* for *Turner's Annual Tour*) *c.*1826–30 (see p.228)

ing that Turner stayed there lies in the atmospheric nocturnal scene he created of a diligence preparing to depart from the court outside the church (fig.115). During the 1820s Turner made several evocative and dramatic representations of his own travels, so that it is possible that this drawing serves the same function, evoking his own departure from the city or perhaps simply recording his presence at the hotel, from where he was able to survey the adjacent comings and goings.[143] After the Revolution the Benedictine church had been sold off and was thereafter used as a stables and store for the hotel, something that shocked some British visitors. In the early 1840s, however, these 'base uses' were brought to an end, when the state intervened in the form of Prosper Mérimée,

who, as Inspector General of Historic Monuments, set about restoring this and many other neglected religious buildings.

The external view of St-Julien is another of the finished Loire series for which there is no preparatory sketch, although Turner made several jottings while inside the church (fig.116). Of the other artists who depicted the building during its secular period, Samuel Prout, Frederick Nash and Alexander Jules Noel chose to make their views of the interior, where the differences between its past grandeur and its current humdrum function are the overriding theme of their picturesque images.[144] In contrast, by selecting an exterior scene that also allows the viewer glimpses though the open door and windows,

FIG 116 *The entrance to the church of St Julien's, with a diligence 1826* (TB CCXLIX f.45v.)

Turner suggests more subtly that the function of the building has changed, revealing in one of his most animated foregrounds the cause for this, and at the same time documenting a vital part of contemporary life. Even in the now distorted sepia colours of the drawing, it is possible to appreciate how skilfully Turner established a Rembrandt-like series of different light sources, with three flares illuminating the various activities of the groups of figures. Inside the church the vaults and pillars are thrown into relief by a further, hidden light source. Discreetly looming above the chaos of the coach departure is the ghostly form of the church itself, lit by pale moonlight. In its juxtaposition with the coach this occupies much the same role that Turner later gave to the redundant hulk of the *Fighting Temeraire*, and it is treated with much the same dignity.[145] Just as in the 1839 painting of the *Temeraire* (National Gallery), Turner seems both to lament and embrace change; he communicates the excitement of a departure from a foreign town as dawn is breaking, while a former Catholic church lies desecrated and empty.[146] Turner was particularly keen to create exactly the right effect in the engraving of this subject, and made many painstaking corrections to the proofs prior to its publication in *Turner's Annual Tour* (see p.192).

Elsewhere in Tours Turner sought out the most striking architectural land-

marks, acting here, as elsewhere, as part-reporter and part-conscientious tourist. The towers of the old cathedral had fascinated him from the other side of the river, but he made only one sketch of them once he was in the city itself. This is on another of the loose sheets of paper that he had utilised for his approach to Tours and shows the Tour de l'Horloge from near the Place du Grand Marché (fig.117). The area around the towers contains many historic buildings, including the house mistakenly associated with Louis XI's hangman, Tristan l'Hermite, who had been one of the characters in Scott's *Quentin Durward*. It seems that Turner,

FIG 117 *Tours: the Tour de l'Horloge from the Place du Grand Marché 1826* (cat.28)

unlike Delacroix and other contemporary tourists, did not discover the picturesque facade of this building or, if he did, he made no sketches of it. He did, however, produce another view of this part of the city when painting the series on blue paper, and this is now the only documented Loire subject to remain untraced. All that is known of the drawing, which was last recorded at its sale in 1937, is that it depicted a 'A street scene, with a crowd of figures'.[147] If it was not based on the view from the market place, it is possible that the subject of the missing drawing was the much praised Rue Royale (now Rue Nationale), which, like the new bridge at Tours, had been created in the eighteenth century as part of the improvements to the route between Paris and Spain.

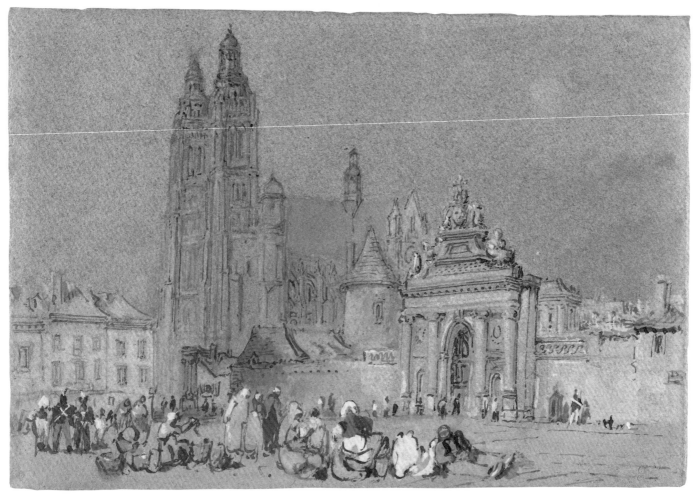

FIG 118 *Tours: the cathedral from the Place de l'Archevêché c.1826–8 (cat.85)*

Over in the eastern quarter of the city Turner investigated the distinctive appearance of the existing cathedral of St-Gatien, whose twin lantern-topped towers can be seen for miles across the neighbouring countryside. Working on the same sheet of paper that he had folded into sections to chart his journey into Tours, he made a fairly detailed study of the southern tower, recording the second only in outline (cat.25). These structures were completed much later than the rest of the building in the early sixteenth century, but, as a result of the revolutionary purges, the many niches across the surface of the facade had been denuded of their sculptures. From his viewpoint immediately in front of the cathedral Turner moved into the Place de l'Archevêché, which provided him with a slightly more oblique angle. His second sketch of the cathedral, this time in colour (fig.118), includes a grand Baroque archway leading into the Bishop's

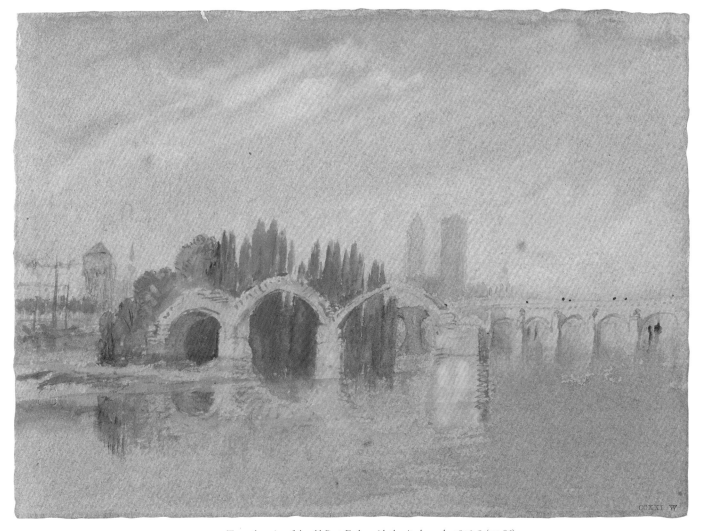

FIG 119 *Tours: the ruins of the old Pont Eudes, with the city beyond c.1826–8 (cat.86)*

Palace. The upper part of this entrance has since been replaced by a much simpler use of classical embellishment. The time of day evoked by Turner is the end of the afternoon, as the foreground figures clear away the market produce they have been selling. Above them the moon rises faintly over the Bishop's Palace (now the Musée des Beaux-Arts).

Whereas Longfellow, Delacroix, Stendhal and Henry James made their excursions from Tours with *Quentin Durward* very much in mind, if not actually in their pockets, Turner does not seem to have undertaken the common literary pilgrimage to Louis XI's château, Plessis-lès-Tours, to the south-west of the city.[148] Instead, he concentrated on a group of sites on its eastern peripheries, immediately adjacent to the river. The first of these was the ruined bridge constructed in the eleventh century by Eudes II, Comte de

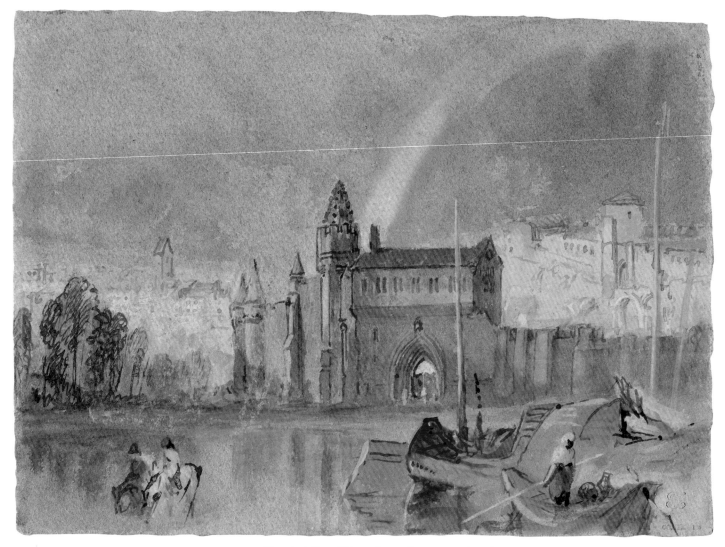

FIG 120 *The ruined abbey of Marmoutier, near Tours c.1826–8 (cat.87)*

Blois.[149] Although only three arches were then standing, this had formerly crossed the river from near the Château de Tours to the suburb of St-Symphorien on the north bank. It was from the latter that Turner made a pencil sketch in his notebook, but in the colour work he developed from his on-the-spot record, he left a crucial area blank (fig.119). This was the area above the ancient bridge where the towers of the cathedral should rise to dominate the Tours skyline. Even though their outline is faintly indicated in pencil, this omission must have been one of the factors that contributed to the work being miscatalogued as a view of Trier. Consequently, it is the towers of the old cathedral, rather than those of St-Gatien, that act as specific landmarks,

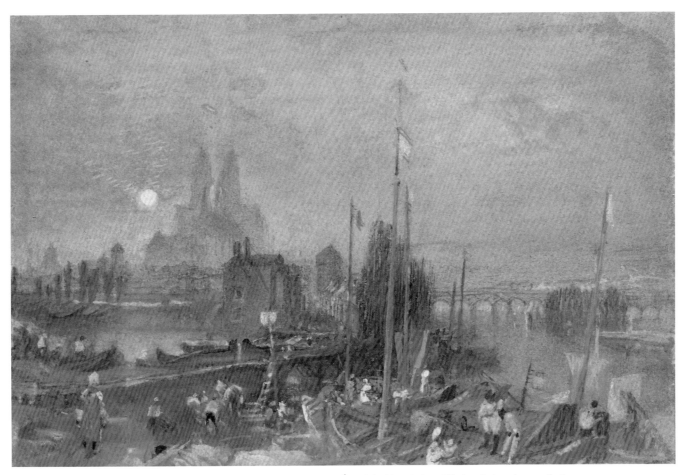

FIG 121 *The canal of the Loire and Cher, near Tours* (engraved for *Turner's Annual Tour*) *c.*1826–30 (see p.228–9)

assisted on the left, beyond the isle of poplars, by the Tour de Guise and the Logis du Gouverneur.[150]

A little further upstream on the right bank of the Loire lie the remains of another formerly great Benedictine abbey, that of Marmoutier, which was founded by the early followers of St Martin and became one of the most pow-

erful religious houses in the Christian world. Turner made only one pencil sketch at Marmoutier, showing the gateway to the ruined complex. While this was already becoming the standard view recorded by most artist-visitors, the lack of other sketches by Turner suggests that he may have made this excursion by boat.[151] There are several reasons to conclude this was the case, the most

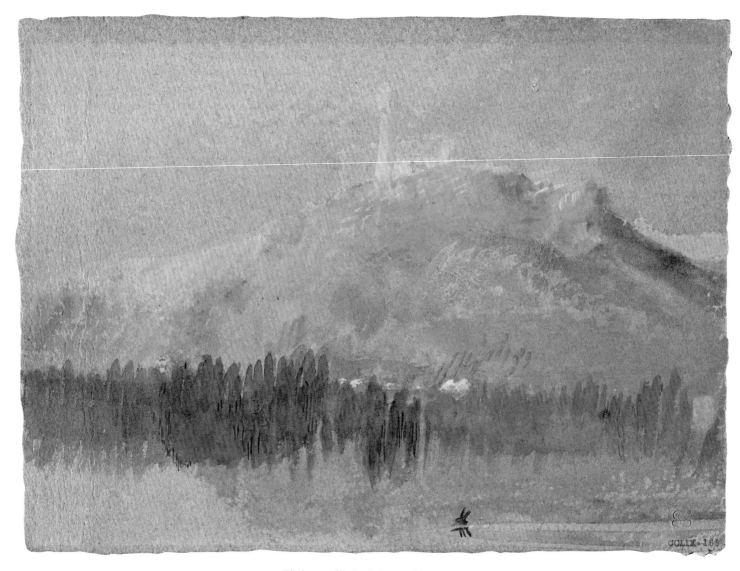

FIG 123 *The lantern of Roche-Corbon, near Tours c.1826–8 (cat.88)*

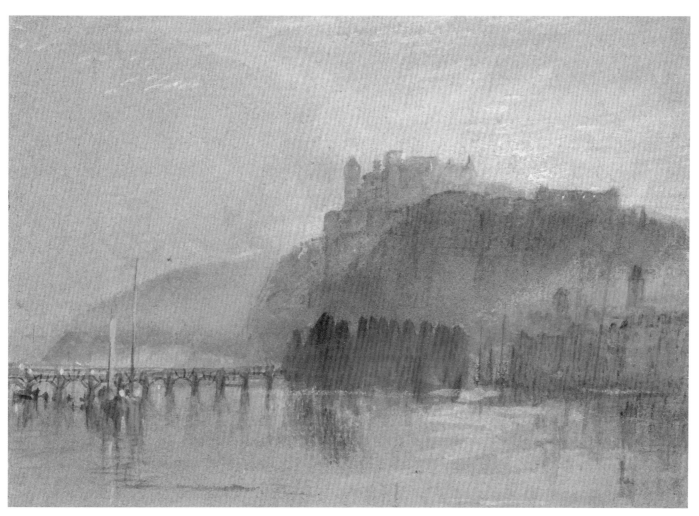

FIG 124 *Amboise* (engraved for *Turner's Annual Tour*) c.1826–30 (cat.119)

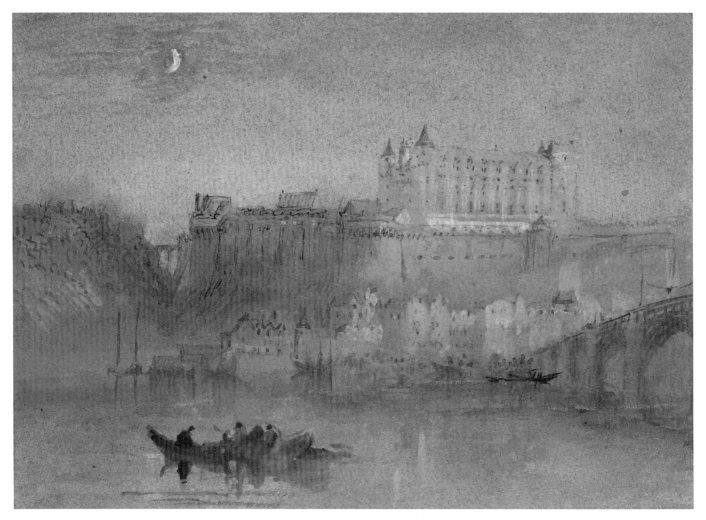

FIG 125 *The bridge and château of Amboise c.1826–30 (cat.89)*

talked of his tours as his summer 'flights', in effect likening himself to a migratory bird.[159]

From Roche-Corbon, where the diligence would have paused briefly, he passed under the Château de Moncontour, which Balzac later hoped to make his ivy-covered retreat from Paris.[160] Shortly afterwards he saw the church tower and roofs of the famous wine centre of Vouvray, and then, as the road swung down towards the south-east, he began to make sketches of Montlouis-sur-Loire on the opposite bank of the river.[161]

Amboise

Turner made no further sketches after Montlouis-sur-Loire, but the first of his coloured views of Amboise shows the town from the west as it is seen by a

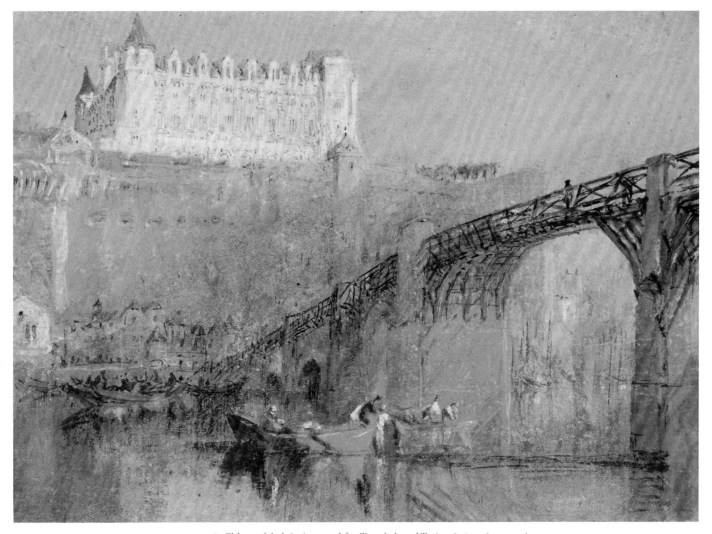

FIG 126 *Château of Amboise* (engraved for *Turner's Annual Tour*) *c.*1826–30 (see p.229)

traveller approaching on the road from Tours (fig.124). In the discussion up to this point the lighting effects present in the watercolours have been used as a means of piecing together an outline for Turner's journey, but the three views of Amboise present something of a dilemma. Two of the colour views show the château illuminated by early evening light, just after sunset, with a crescent moon rising (figs.125 and 126). By contrast, in the view of Amboise from the west the sun is hidden beyond the towers of the château and has barely begun its daily journey. One could conclude from this that Turner stayed at Amboise over night and saw the rising sun as his diligence was returning to the road on the northern bank of the river. The amount of time Turner spent in Amboise, as suggested by his pencil sketches, appears to have been very brief. Indeed, unless there are missing sketches, he covered only one page-opening of his

sketchbook with views of Amboise. This could have been at the end of the day, as darkness was falling. It is also possible, to judge from the letters describing Longfellow's contemporary visit, that the clear autumn weather had begun to break up at about the time that Turner would have got to Amboise.

The principal subject sketched on page 16 verso could, therefore, with considerable ingenuity on Turner's part, have served as the basis for the two evening scenes. He was, of course, also fully capable of inventing his own effects, so these speculations are ultimately unanswerable. However, the consistency with which Turner recreated the appropriate lighting effects earlier on this journey suggests that this may also be the case in these three views. The afternoon light already noted in the view of Roche-Corbon supports the possibility that he arrived at Amboise at the end of the day. Significantly, of the three drawings, only one is especially close to the pencil sketch in the *Loire, Tours, Orléans, Paris* book, and this is the most self-consciously poetic in its lighting effects (fig.125). Furthermore, unlike his view of the cathedral at Tours (fig.118) or that of Blois (fig.129), where the moon is shown to be almost full, in this view of Amboise it is simply a sliver, although the slanting sunset light is the same as in the other view of the château. Perhaps Turner added this detail to strengthen the empty area to the left of the fortress. Its presence certainly gives greater weight to the little bridge by the Porte des Lions. The two comparative subjects of Tours and Blois are quite likely to have been painted over the pencil notes Turner made on the spot, and the lack of preparatory sketches suggests this may also be the case for the other views of Amboise. Notwithstanding Turner's inventiveness and his incredible visual memory, there is insufficient material in his sketchbook to furnish the powerful image of the château towering above the ancient bridge, with the roofs of the town seen through one of the arches (fig.126). The bridge had partly collapsed in 1789 and had then been repaired in wood rather than stone, just as it is represented by Turner. While there are discrepancies in the height and length of the bridge as it appears in Turner's various depictions of Amboise, the rather creaky-looking supports and balustrades were apparently not an exaggeration, for a few years after his visit Elizabeth Strutt noted that the structure was in a 'dangerous and ruinous state'.[162] To make the view, Turner selected a spot on the Ile de St-Jean, although the artfully framed image gives the impression that he was actually below the bridge in a boat. Visitors to the actual spot will discover that the bridge has gone and that the road into Amboise now crosses further downstream.

Because of its commanding outlook on to the Loire, the northern facade of the château was the most frequently depicted aspect of Amboise, and there are numerous depictions of it also made from the Ile de St-Jean.[163] But while these views may be more strictly accurate, none of them conveys so dramatically the brooding might of the fortress, which is further emphasised by the light elegance of the medieval palace sitting on top of the dark ramparts. Turner suggests the fine stonework of the Logis du Roi by painting this part of the château in pure gouache. This was a distinction he retained and underscored in the engraving based on this work (see fig.197).

During the fifteenth century Amboise had been the chief royal palace of the line of kings from Charles VII to his grandson Charles VIII. The naturally high site meant it was virtually impregnable, but it also required that huge towers with spiral ramps had to be constructed to allow horses to climb up bearing provisions from the town. That on the left in Turner's view is the Tour des Minimes, or de Cavaliers. During the reign of Louis XII the royal seat was moved to Blois, but new life came to Amboise with the accession of François I in 1515. In an attempt to rival other Renaissance princes, he persuaded Leonardo da Vinci to move there from Italy at the end of 1516. The Manoir du Clos-Lucé, where Leonardo lived and died, was not a fixture on the tourist itinerary in the early nineteenth century, so it is not surprising that, in spite of its obvious interest, Turner missed it. He would, however, have had special reason to be interested in the château, for since 1821 it had been owned by the Duke of Orléans, who was later to reign as Louis-Philippe. Turner had known the duke during his two periods of exile in England (1800–1808 and 1815–17), when he was a near neighbour of the riverside retreat Turner had built for himself at Twickenham. The duke's presentation to Turner in 1838 of a gold snuff-box, encrusted with diamonds, betokens the endurance of a loose connection between the two men, but there is insufficient documentation to reveal whether they were in contact during the 1820s.[164] It is, anyway, unlikely that the duke would have been in residence at the château at the time of Turner's 1826 visit, as it was only on his accession four years later that it was restored as a summer residence for the royal family.

The more distant view of Amboise at sunrise was also engraved for *Turner's Annual Tour*, where the unresolved silhouette of the château was given a more precise, if not necessarily a more accurate, outline (fig.198). But it is particularly noticeable that Turner omitted the famous ornate Chapelle St-Hubert on the western flanks of the ramparts and that he exaggerated the scale of the tower at the north-west corner. As is often the case in the Loire series, Turner has concentrated on producing an effect based on very little topographical

material. In translating the image into the linear medium of a print, he was far more insistent on changes to the darting rays of the sunrise than he was on architectural detail.

After leaving Amboise by the north bank route, he continued to sketch the image of the castle on its steep hill until it diminished to a barely discernible block on the horizon, but, as noted already, none of these pencil sketches adopts the same view as the engraved subject. Once again there are very few sketches to chart the journey between towns, and, whether Turner walked or took another diligence, he apparently found little he felt compelled to record. The blankness representing the twenty miles covered is broken only by two thumbnail outlines of the château of Chaumont: one can be seen in fig.136, the other is on page 17 verso. Chaumont is another of the great castles lining the banks of the Loire. It was refashioned in much of its present form during the fifteenth century, although it is most famous for its connection with Catherine de Médicis and Diane de Poitiers in the following century. More recently, in 1810, Madame de Staël had been a reluctant exile at the château, complaining to her fellow guests that, in spite of the magnificent views over the Loire, she preferred her gutter in the Rue du Bac. Only three years before Turner's visit, the château had passed into the possession of Baron d'Etchegoyen, who neglected it in favour of another of his residences; thus the building would have been inaccessible, even if Turner had been on the same side of the river.

Blois

The approach to Blois on the raised levee from the west formed the subject of one of the two views of the town that Turner later included in his *Annual Tour* (fig.129). Its composition is very similar to the unfinished watercolour, dating from the 1790s, which was discussed above (fig.2). We can assume that the sight of Blois, with its distinctive bridge, made him recall the earlier work and provoked him to seek out the approximate viewpoint for himself. Once again, there are no preparatory notes for this subject in the sketchbook, where none of the general views of the town is taken from the west, so it is most probable that the outlines of the image were composed on the spot. Alternatively, he could have created the drawing back in London through a conflation of the earlier watercolour and the knowledge he had gained as a result of his visit.[165]

In front of the motif, he would have discovered that it was necessary to retreat to a considerable distance in order to gain a position from where the buildings of the town could be set out in a way that articulated both their individual features and the recession of space between them. This was some-

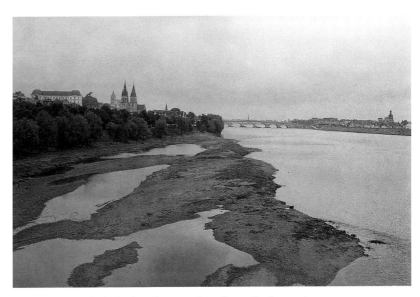

FIG 127 *Blois from the bridge above the river to the south-west* October 1996

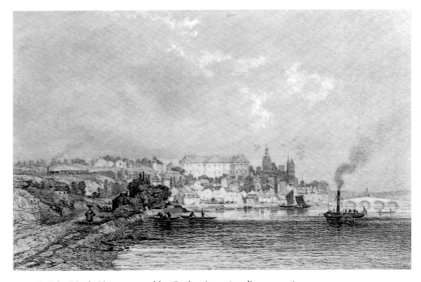

FIG 128 Jules Noel, *Blois*, engraved by Outhwaite *c.*1845, line engraving
Musée du château de Blois

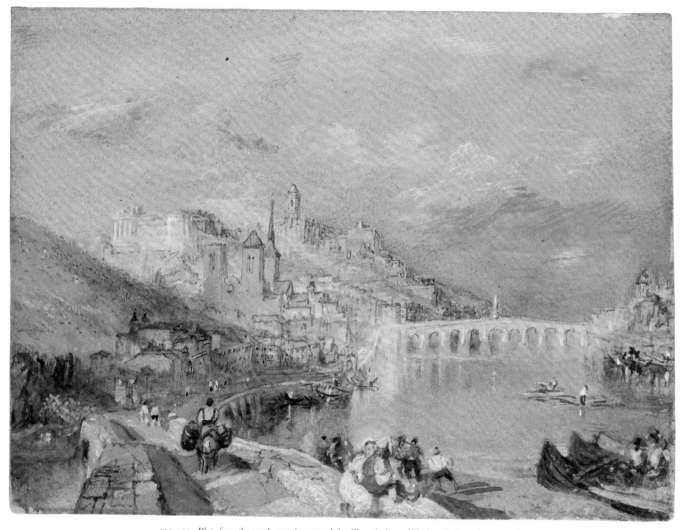

FIG 129 *Blois from the south-west* (engraved for *Turner's Annual Tour*) *c.*1826–30 (see p.229)

thing he had not been able to achieve in his unfinished watercolour, where they appear muddled by being bunched together. The only problem with attempting to make the buildings more distinct from each other was that it required him to stand so far away from his subject that their details become unclear. As the accompanying photograph of Blois demonstrates (fig.127), the triumph of the finished work is that he has managed to compress and tele-

scope the elements of the panorama into an incredibly compact space, without greatly distorting the sense of the actual place in the process. The view even includes the church of St-Saturnin in the Quartier de Vienne on the far right, which is not present in the earlier work. Here the eye is sent swiftly into the centre of the design by the device of the road that fans out towards the foreground. As a result of this sweeping curve, the viewer is able to see the dis-

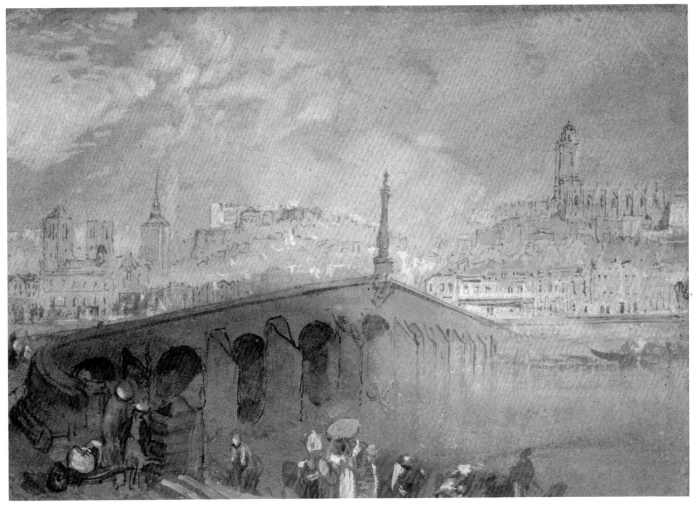

FIG 130 *The bridge at Blois: fog clearing c.*1828–30 (see p.223)

tant bridge as if parallel to it, which would actually require being in the middle of the river. Through this cunning distortion, however, Turner is able to divide the composition so that the bridge and the rising moon have equal weight with the town.

The bridge had been constructed over a hundred years earlier, between 1717 and 1724, to a design by the esteemed architect Jacques Gabriel (1666–1742),

who also designed the Bishop's Palace at Blois (now the Hôtel de Ville). Gabriel's structure has eleven arches, with an obelisk sited on the upstream side over the wide central arch, and even though Turner dutifully made a note of this in one of his pencil sketches (fig.131), he shows only nine arches in the view from the west. Another reason for selecting this viewpoint was that it meant that the famous château was clearly visible, something that visitors have

FIG 131 *Blois: the Pont Jacques-Gabriel. 'Glorious Effect of Sun Rise and Fog' 1826 (TB CCXLIX f.19v.)*

FIG 132 *Blois: the Cathedral of St-Louis, the Bishop's Palace and other buildings to the east of the Pont Jacques Gabriel 1826 (TB CCXLIX f.46)*

FIG 133 *The Façade des Loges of the Château de Blois, with a subsidiary sketch of the church of St-Vincent-de-Paul 1826 (TB CCXLIX f.20v.)*

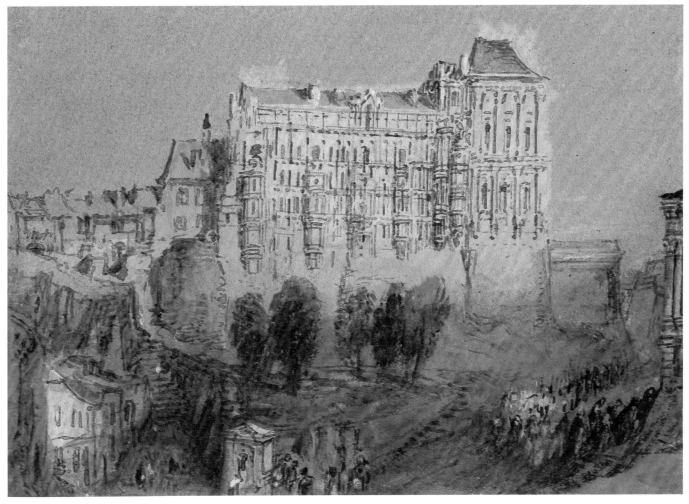

FIG 134 *Blois: the Façade des Loges of the château* (engraved for *Turner's Annual Tour* as *Palace at Blois*) *c*.1828–30 (see p.229)

often found a shortcoming of the town when looking at it from other sites on the riverside. The imposing white facade on the left dates from the seventeenth century and was actually the last part of the château to be built. Below this to the right are the towers and spire of the abbey church of St-Laumer, now more commonly known as St-Nicholas, which in Turner's day had only one of its western towers finished in a pyramidal roof. To the right of the spire is the cathedral of St-Louis and, to its right, the Bishop's Palace.

Most of these buildings can also be seen in the view looking across the upstream arches of the bridge (fig.130), which grew out of a group of sketches that Turner made near the southern bridgehead. Some of the sheets include only a general outline of the town on the opposite bank, whilst others are fairly accurate transcriptions of specific buildings or architectural details. One reason for this fragmented investigation can be found on page 19 verso which Turner annotated with the words, 'Gorgeous Effect of Sun Rise and Fog' (fig.131).

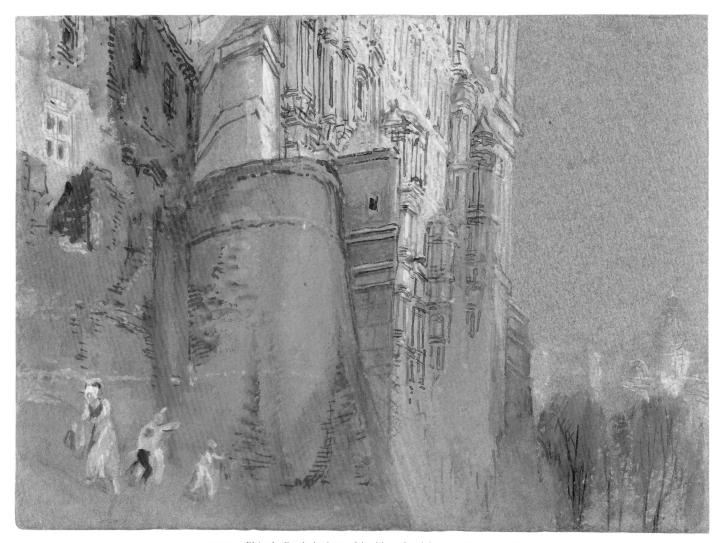

FIG 135 *Blois: the Façade des Loges of the château from below* c.1828–30 (cat.90)

Presumably he was limited in what he could see by having to sketch through vapour. Earlier in the journey Turner had already observed the looming towers of Nantes Cathedral, as they miraculously appeared above the mists that frequently settle over the Loire during the autumn and winter months. A week or so later, on another early morning, it is clear from the rising curly lines above the bridge in the pencil sketch that a similar fog obscured much of Blois. When recreating this effect in gouache, Turner resorted to red colour to outline the principal forms depicted, thereby strengthening the contrast with the swirls of white gouache lifting from the town. There are very few other works in the Loire series where he deployed this technique. The transition from red to a dark pen work on the bridge is especially subtle, as is the foreground shadow, which effortlessly directs the eye to the slightly ethereal buildings above. The design could have served very happily as the basis for one of the engravings in the *Annual Tour* set, even though the figures have not been fully resolved. What may have deterred Turner from selecting it is that the viewpoint presents only the shoulders of the château, as it were, and not its face.

In order to inspect the château more closely, Turner explored the area directly below the celebrated northern façade, and it was perhaps inevitable that the other engraved view of Blois should have been developed from the sketches he made there (figs.133 and 134). With the exception of the great, open, courtyard staircase, the Façade des Loges is perhaps the most remarkable aspect of the building, demonstrating so tangibly the impact of the Italian Renaissance on French design at the beginning of the sixteenth century. It was built by François I within the remaining spaces of Louis XII's palace, and projects daringly out over the gardens below. Whereas the actual architecture retains the Northern preference for asymmetry across its façade, Turner introduced a more classical regularity in his depiction. This may have arisen because he had not recorded the correct rhythm of the façade's embellishment in his general sketch, having instead selected and studied individual elements.[166] The finished view also includes, on the left, the exterior of the thirteenth-century Salle des Etats-Généraux, but again Turner's compressed depiction results more from memory than close scrutiny. On the right is a flank of the Gaston d'Orléans wing, added between 1635 and 1640 by the brother of Louis XIII, who had been confined at Blois to prevent his plotting against the king. The imposing façade of this wing, designed by François Mansart, is seen more clearly in fig.129.

Turner had developed this drawing from the sketch on page 20 verso (fig.133). As well as his outline of the château, he added at the bottom of the sheet a quick sketch of the church of St-Vincent-de-Paul, in effect just swivelling round to the

right from where he stood in the Place Victor Hugo (as it is today) to see its façade and cupola. This Jesuit church had been secularised during the Revolution, but during 1826 it was restored as a place of worship. Turner included the suggestion of its three-tiered façade on the right-hand edge of his design, but added a little more of the building in the final engraving (fig.196). While he had shown an atmospheric moonrise in the other engraved view of Blois, the day has literally and symbolically come to a close in this scene, as is indicated by the procession of monks accompanying a coffin with candles and tapers.

The sketch of St-Vincent-de-Paul was also mistakenly utilised by Turner in a second view of the Façade des Loges (fig.135). Nicholas Alfrey has aptly described this subject as 'a Renaissance casket mounted on a huge splayed plinth of rough stone' and rightly noted the influence of Piranesi in the nature of the composition.[167] Standing immediately under the Salle des Etats-Généraux, close to one of the thirteenth-century foundation towers, Turner looks along the façade to the south-west. At the end of this perspective is the indistinct form of a church that is derived from the sketch of St-Vincent-de-Paul just mentioned, although the church tower has also been thought to be that of a Capuchin monastery afterwards a funerary chapel, which was moved from the spot in 1853.[168] In the foreground a group of figures make their way up the steep hill towards the Place de Château.

Unlike many of the other châteaux Turner had seen during his journey, that at Blois had been open to the public since 1810. In spite of this, it seems that Turner did not make any sketches of its eastern façade or its courtyard. The most likely reason for this could be the presence there of the local gendarmerie. Alternatively, but less plausibly, he may, like his associate Ritchie, have considered the building only a 'magnificent ruin', of which the Gothic parts were of little interest beside the austere beauty of the seventeenth-century wing.[169] It must be noted, however, that Turner's journalistic approach almost always impelled him to record as much as possible for future use, regardless of the prevailing taste in architecture, and that the courtyard, had he seen it, would have been an obviously attractive subject, as is evident from the contemporary views by George Jones and Thomas Shotter Boys.[170]

From Blois to Beaugency

After staying a night at Blois, Turner pressed on with renewed vigour towards Orléans. At this point in the sketchbook his method of making notes on consecutive pages is less consistent. Consequently, it is difficult, and very probably impossible, to know how he made this stage of the journey, whether on foot or by coach.

From the two pages of sketches he made between Blois and Beaugency one might conclude that he travelled on the right bank of the river, since this was the route along which the diligence passed. One of these pages includes a tiny sketch of Chaumont from the east, below which there is an imprecise, but

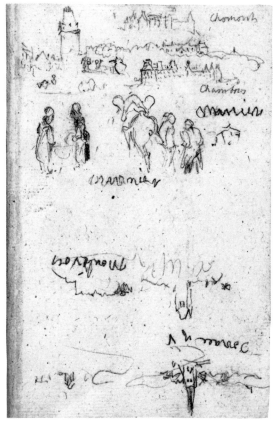

FIG 136 *Views of the Châteaux of Menars, Chaumont and Chambord, with the tower of the church at Montlivault 1826*
(TB CCXLIX f.24v.)

recognisable view of Ménars, the château briefly owned by Madame de Pompadour in the mid-eighteenth century (fig.136). After her death her brother, the Marquis de Marigny, made various improvements, which included the erection of a pagoda to the east of the château, and it is this imitation of William Chambers' pagoda at Kew that can be seen on the right in Turner's sketch.

Immediately below the outline of Ménars is a slightly larger jotting of a château that Turner identifies as 'Chambors'. Since he would have found it impossible to glimpse the fairy-tale silhouette of the château of Chambord from the road near the river, Turner would have needed to cross the river and walk a considerable way to see it. The fame of Chambord meant that Turner was certain to know that it lay between Blois and Beaugency, but he may have been ignorant of how to get there. Most travellers hired carriages at Blois to make this excursion, but it seems extraordinary to imagine that Turner would have undertaken the lengthy detour into the park surrounding François I's hunting palace in order to produce such a trifling record of his efforts. Furthermore, the way the building is drawn is too imprecise to assume that it does actually represent the great round towers of Chambord. Another sketch at the other end of the same page records the silhouette of the church at Montlivault, as it is seen from the north, across or close to the river. This village is not half a mile upriver from Ménars (but on the opposite bank), and the sketch indicates that, even if Turner made an attempt to see Chambord, he later rejoined the principal route to Beaugency.

Beaugency

Beaugency had grown up around the tall donjon erected by Raoul I, who was seigneur at the end of the eleventh century. It subsequently figured occasionally in the history of France, but perhaps its most significant moment came during the Hundred Years' War, when it was eventually liberated from the English by Joan of Arc in 1428/9. By the early nineteenth century it had become a sleepy market town surrounded by vineyards. Indeed, it is interesting to note that, when Ritchie was making his tour of the Loire in order to write the narrative that accompanies Turner's engravings, he was told by his fellow travellers that there was nothing in Beaugency to detain him. This opinion is strikingly at odds with the attractive qualities found in Turner's views.

If other travellers found Beaugency lacking in interest, the old town offered Turner exactly the ingredients he most liked in a view, even if he was under a misapprehension that it was called 'Boujancy'. He experimented in his compositions with the much-repaired form of the old bridge, stretching it diagonally across the picture space in the view he selected for his *Annual Tour* (fig.138), and used its many arches to close down the right-hand side of his more direct presentation of the town (fig.137). This latter subject derives from page 26 verso of his sketchbook, where he first drew the left-hand half of the composition up to the medieval Château Dunois, but then ran out of space, and continued the rest of the buildings below the main sketch. Not surprisingly, in bringing the two halves

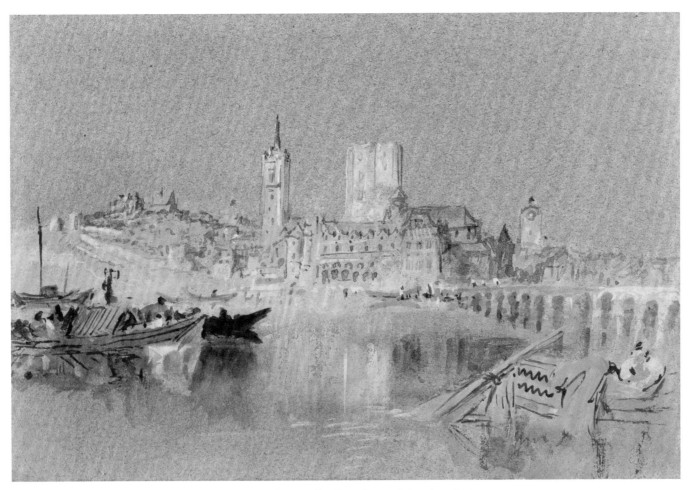

FIG 137 *Beaugency from the south-east c.1826–30 (cat.91)*

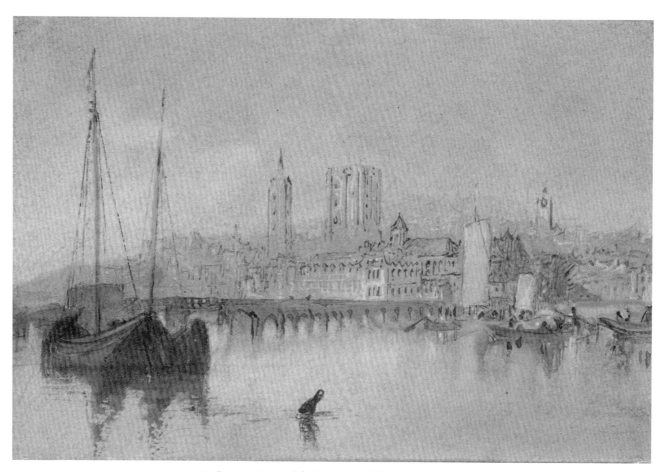

FIG 138 *Beaugency* (engraved for *Turner's Annual Tour*) *c*.1826–30 (see p.229)

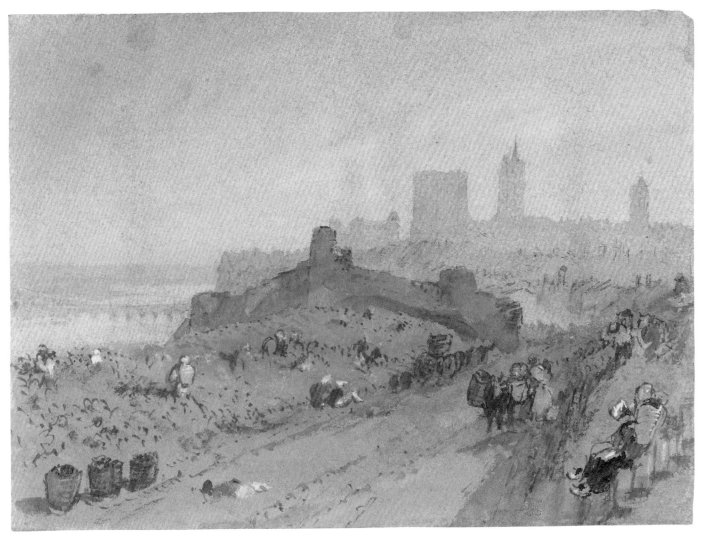

FIG 139 *Beaugency from the north-east c.*1826–30 (cat.92)

FIG 140 *Beaugency from the south-east (and an additional sketch of the towers of Notre-Dame, Paris)*
1826 (TB CCXLIX f.28)

of this view together, Turner found it necessary to compress his information, not always observing the correct spaces or proportions. Thus there should be a wider gap on the left between the Porte Tavers and the Couvent des Ursulines to its right. The next landmark is the belltower of the church of St-Firmin, which had been otherwise destroyed during the Revolution. On the river front below this is the Tour du Diable and the abbey, with the Romanesque church of Notre-Dame behind. Finally, to the right, above the bridge, can be seen the Tour de l'Horloge.

In each of Turner's colour views of the town its towers are lit by afternoon sunshine or are silhouetted against glowing western light. Although the distance from Blois was scarcely more than 19 miles, not allowing for diversions from the direct route, this would have been a natural place for Turner to stay overnight, allowing him to rest before he pressed on to Orléans the following day. The three drawings are among the most evocative of the Loire series, vividly suggesting the quiet, traditional ways of those living on and beside the river, a form of contemporary existence that was soon to be transformed. Only a few years later the celebrated 'Inextinguishable' steamers were to establish a regular service past the town, followed thereafter by the railway, which marked the demise of the old life of the riverboats.

In the third view of Beaugency, looking back towards the town from the Orléans road, Turner adopted a viewpoint just beyond the dilapidated ancient ramparts to its east (fig.139). Though apparently spontaneous, this study derives from two incisive outlines in the sketchbook, one of which is on a page that also includes a number of sketches of heavily laden carts, as well as a quick study of one of the grape-pickers, who in the colour design are shown resting after filling their baskets. Turner could very well have recorded these observations from the diligence as he departed from the town, as has been suggested,[171] but the lazy atmosphere of the colour sketch suggests that he is more likely to have watched the passing vehicles as he sat by the roadside, observing the local farm workers at the same time.

Orléans

Nowadays Orléans can be reached from Beaugency in much less than an hour, but even in 1826 the journey cannot have taken Turner much more than two or three hours, depending on the means of transport he selected. Because his sketches of Orléans begin on the Quai Neuf, on the south side of the river, there is the possibility that he could have travelled upriver by boat and disem-

barked on the busy quayside. Alternatively, the trembling urgency of the sketches of the distant towers of Orléans on page 29 of the sketchbook implies that he was travelling by coach, being jolted by its irregular motions as he doggedly attempted to record his impressions. From the diligence he could, however, have found a way of crossing the river before arriving in the city in order to sketch its most alluring prospect.

The diligence route would have taken him through Meung-sur-Loire and St-Ay, and there are indeed recognisable sketches of the church and château at Meung (fig.141). The village, incidentally, later became a retreat for the painter Ingres in the mid-1850s. From either the road or the river Turner could not have failed to notice the basilica at Cléry-St-André. Its lofty nave and chancel rise imperiously over the surrounding countryside and were in themselves sufficient reason why Turner should have considered the building noteworthy. But had he been interested in medieval French history, either for its own sake or in the popularised form of Scott's fiction, he would perhaps have known that the church was where Louis XI was buried. Probably ignorant of this, he nevertheless thought the church of enough interest to discover its name, with which he annotated the sketch.

Once at Orléans, Turner covered nine sides of his sketchbook with views of the city, concentrating especially on the long parade of towers on the right bank.[172] Since three of the sheets in the sketchbook are devoted to architectural fragments, it is a revealing indication of the tightly focused nature of his sketching process that Turner was subsequently able to create a group of eight colour views of Orléans. So purposeful was his method of setting down useful visual information that there was really no waste material. In fact, all of the colour subjects derive from the general views or smaller details recorded in the sketchbook. When working from his sketches there were some inevitable distortions of scale, although this tendency can be explained by the need to concentrate the wide river front on to such small pieces of paper.

The sketches on page 29 verso and page 30 were the starting point for three colour sketches of the city from the left bank (figs.142–4). Presumably, Turner hoped to include a view from the river in his *Annual Tour* but eventually selected a view of the city streets around the cathedral as more characteristic of Orléans. The first of the series is the most westerly viewpoint along the Quai Neuf, with the sky bathed in gentle morning sunshine (fig.143). Here, the foreground is alive with incident that Turner invented or furnished from memory, including the charming gesture of the small girl pointing towards her dog. If Turner had been carried upriver by boat, he could have disembarked here, but,

in any case, he would have been drawn to this spectacular viewpoint, encouraged, no doubt, by the plethora of contemporary prints by local artists showing the city from roughly this spot.[173] The river front he presents covers a distance of well over a mile and is set out largely as it is seen on the spot, with few of

FIG 141 *Sketches of Meung-sur-Loire and a distant view of the Basilica of Cléry-St-André* 1826 (TB CCXLIX f.28v.)

the spatial contractions that can be found in some of the other Loire scenes. The buildings depicted are, from the left, the Hôpital Général and the Hôtel Dieu, the belltowers of the churches of Notre-Dame de Recouvrance and St-Paul, followed by the Tour du Beffroi, and the twin towers of the cathedral of Ste-Croix. To the east of the cathedral is the spire of St-Pierre-le-Puellier, and in the far distance, hovering over the bridge, is the collegiate church of St-

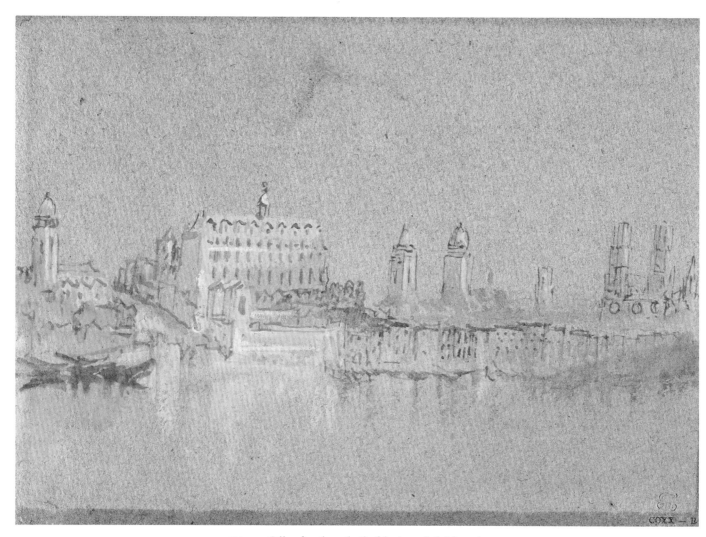

FIG 142 *Orléans from the south side of the river c.1826–8 (cat.94)*

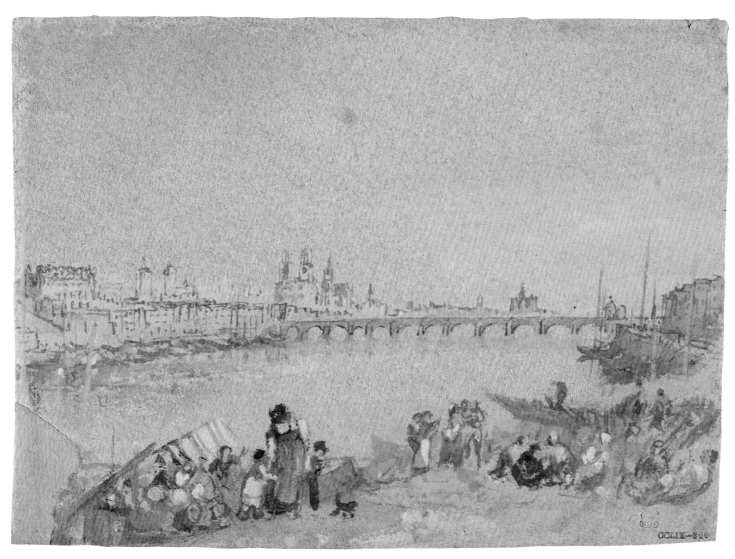

FIG 143 *Orléans from the Quai Neuf c.*1826–8 (cat.93)

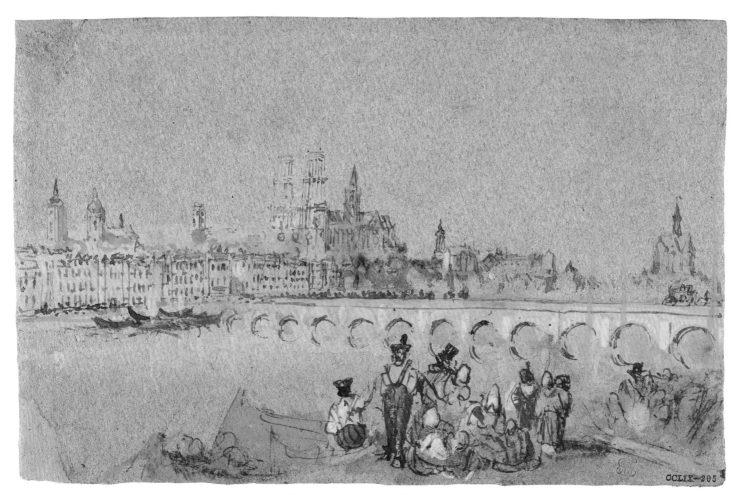

FIG 144 *The bridge and cathedral at Orléans c.1826–8 (cat.95)*

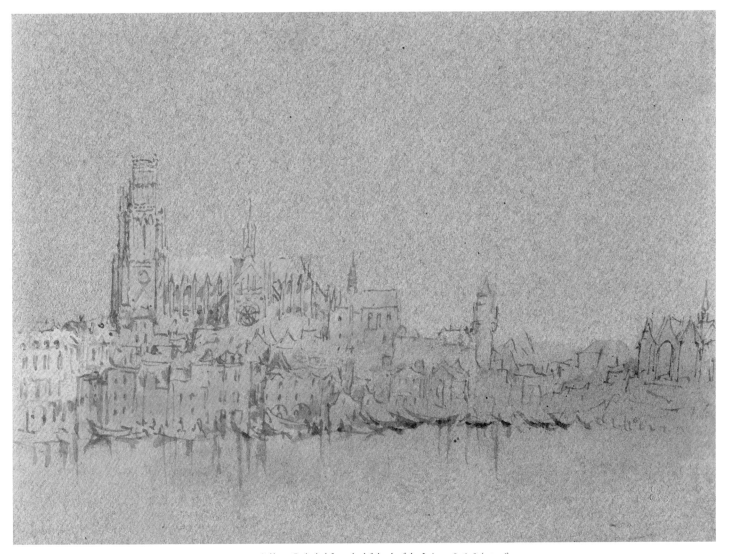

FIG 145 *Orléans Cathedral from the left bank of the Loire c.*1826–8 (cat.96)

Aignan. Once again, despite making an accurate record of the number of arches on the Pont Royal, Turner elected to create a much longer bridge, with twelve instead of nine arches. This is undeniably lighter and finer than the actual structure, and is further proof, if it were needed, that Turner would always sacrifice fidelity of detail to grandeur of effect.

In the other two colour sketches the full panorama is broken up into sections, each of which retains the central group of buildings around the cathedral. The view in fig.142 was exhibited throughout the nineteenth century as part of a group of views on the Meuse and was only correctly identified by Nicholas Alfrey in 1981.[174] Most of the buildings are easily recognisable from the first view of the right bank, but, following the sketchbook outline, the Hôpital Général in the centre has been given greater prominence and a cupola on the

middle of its roof. On the far left is the tower of the church of St-Laurent, the height of which Turner has exaggerated in making the transfer from the sketch on page 29 verso. The right side of each building is highlighted by a dash of white gouache, which is again indicative of morning light. This effect was something that Ruskin remarked on, noting that 'the tenderness of the few simple touches and hues that produce it may be studied with never-ending gain'.[175]

The third colour sketch is a nearer view of the Pont Royal, with the cathedral as the focal point (fig.144). In its treatment of the architecture of this important building this sketch is far less cursory than the previous subject, so

FIG 146 *Studies of Orléans Cathedral: the spire over the crossing and the southern tower, with a separate sketch of part of the west front* 1826 (TB CCXLIX ff.32v., 33)

that the flying buttresses between the west front and the transept are readily discernible, and the sky can be seen through the open stonework of the galleries crowning the towers. Because the colour range is so restrained in this group of views of Orléans, one is especially aware of the red pen work. Examples of a similar use of this outline can be found in the views of the Folies-Siffait, and in those of Oudon and Blois (figs.67–9 and 130). But these are the exceptions rather than the rule in the Loire series, for generally Turner adopted a softer outline, preferring to blur the demarcation points between objects.

As in the first view along the Quai Neuf, the foreground activity contributes substantially to the vitality of the scene, so that the group of soldiers mingling with some of the boat women seems to connect to the long chain of figures on the bridge behind. Perhaps, as in the view of Tours (fig.114), Turner was suggesting the arrival of the rest of their regiment. Another swiftly drawn incidental detail is the carriage below St-Aignan on the right, which is nicely framed by the masts of some of the Loire barges. Unlike the other views in this group, this is apparently an afternoon subject, as is clear from the brightness of the bridge and the western faces of the towers on the left.

Turner's fourth view of Orléans from the south side of the river is based on page 31 of his sketchbook (fig.145). Although this pencil sketch did not provide him with the left-hand half of the cathedral, to the west of the rose window, he was able to cull this information from other sketches, including the detailed study of one of the towers on page 32 verso (fig.146). In order to place greater emphasis on the cathedral, Turner gives it a dazzling clarity of light and line, especially in contrast with the surrounding buildings, which are swathed in a pinkish-grey wash, so that their forms are much less distinct. He also introduced an anchoring compositional device that draws the eye down a diagonal line from the top of the cathedral towers, over the diminishing peaks, to the remains of St-Aignan on the right. To ensure that the rhythm of this device worked in his image, he exaggerated the height of the Tour Blanche between the two more important buildings.

Although it is generally only the upper levels of the cathedral that are seen in Turner's views of Orléans, he also painted a view of the west front, which, in its irregular cropping of the building, is more like a modern snapshot than a nineteenth-century topographical view (fig.148). This original way of presenting the cathedral has also obscured a correct identification of the building depicted (see cat.97). Some of Turner's contemporaries were of the opinion that there was insufficient space around the cathedral to allow proper consideration of its imposing facade. However, the strangeness of Turner's study arises

FIG 147 *Orléans: the Place de l'Etape, looking towards the Théâtre, the Hôtel Dieu and the cathedral c.1826–8* (cat.98)

not so much from his inability to get far enough back to make a general view, as from the way he pursued his observations on the spot. For example, his sketch on page 33 (fig.146) is devoted exclusively to the central and southern doors of the west front, perhaps because other parts of the facade remained incomplete. This seed for the present work was supplemented by the sketch on the reverse of page 33, which provided the buttresses and spires of the southern transept on the far right.

From the Place Ste-Croix in front of the cathedral Turner walked north to the sixteenth-century mansion, the Hôtel Groslot, which since 1790 had been the town hall. This historic building is constructed from patterned red and black bricks, and is considered the finest Renaissance building in the city. It was here that François II died, attended by his wife Mary Stuart. Instead of making any record of this important civic palace, Turner stood with his back to it and made a pencil sketch of the view across the Place de l'Etape towards the theatre, with the towers of the cathedral soaring above. As at Nantes, he was greatly interested in the new theatre, then scarcely thirty years old. His finished view includes a crowd of figures, with men on horseback and stylish carriages, implying the

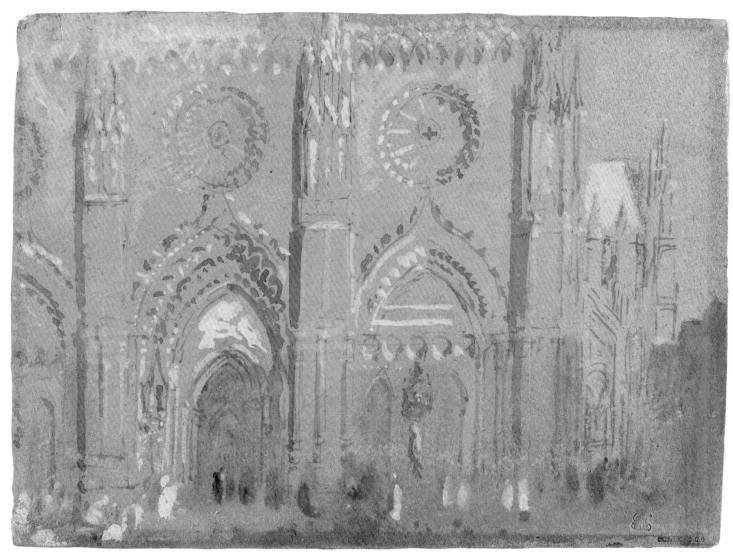

FIG 148 *Orléans: the west front of the cathedral c.*1826–30 (cat.97)

FIG 149 *Orléans: the Théâtre, the Hôtel Dieu and the cathedral, from near the Hôtel Groslot* (engraved for *Turner's Annual Tour*) c.1828–30 (see p.230)

FIG 150 *Orléans: twilight over the Place du Martroi c.1826–8 (see p.224)*

arrival of some important person, but this procession is making its way to the Hôtel Dieu (rather than to the theatre; fig.149). The picturesque eccentricity of the exaggeratedly tall mansard roof on this old building, aligned with the cathedral towers, provides a contrast between Gothic and classical styles.

The same pencil sketch served as the basis for another view (fig.147). Although the pen work to some extent resembles that in the on-the-spot views of Nantes (figs.37 and 38), this is actually a very good example of Turner's ability to invent a completely new viewpoint from the information gleaned on the spot. As Ruskin suggested, it is almost as if it was sketched slightly later in the day than the preceding subject.[176] Essentially it is the same scene, but Turner has moved, in his imagination at least, further north from the Hôtel Groslot. Comparison with contemporary depictions of this spot by Orléans-based artists show that the buildings on the left are largely invented,

FIG 151 *Gien on the Loire* 1828 (TB CCXXIX f.3; *Orléans to Marseilles* sketchbook)

although they are characteristic of this area of the city.[177] Furthermore, Turner has omitted the pitched roof behind the facade of the theatre, which would have been more evident in profile.

The last of the series of views of Orléans in the sketchbook was also transformed by Turner's infallible ability to instil life into the barest outline composition (fig.150). Where the preceding views of the cathedral both show its towers glowing in the radiant afternoon, the view of the Place du Martroi is imbued with the gentler effects of early twilight, as the moon climbs gradually higher in the sky. To the left of the cathedral is the onion-domed tower of the church of St-Pierre, a little to the east of the Place du Martroi, while on the right, at the head of the Rue Royale, is the Pavillon de la Chancellerie. On the other side of the square, beyond the figures clearing away the daily market, can be seen a statue of Joan of Arc, which has since been moved to the Quai Fort-des-Tourelles and was replaced by another sculpture in 1855. Perhaps the most telling detail is the inclusion of the diligence on the right, seemingly ready to depart on its way northwards. There are no sketches of the countryside between Orléans and Paris, and it is surely not being too fanciful to assume that Turner may himself have taken a diligence from the Place du Martroi at the end of his day in the city. He would then have been in Paris by lunchtime the following day, most probably Saturday 14 October.

This was not, however, the last time he saw this part of the River Loire, for in 1828 he paused at Orléans on his way south towards Italy. One of the sketchbooks he used on that tour also contains a view of the attractive town of Gien further upriver (fig.151). It is perhaps significant that Turner chose not to develop this sketch as part of the Loire series, even though there is sufficient information from which to create a colour work. Presumably he preferred to keep his experience on the Loire in 1826 distinct from the later visit.

Paris

Although Turner had visited Paris three times before, he covered nearly twenty pages of his sketchbook with views of the most famous sites (also making scrappy notes on sheets of the Whatman paper he had brought with him from London).[178] Most of these views are fairly elaborate studies, sketched with simplicity and directness. It is as though Turner had not seen them before. A reason for this could be that, because of the success of Frederick Nash's set of views of the city, he was aware of its potential as material for more developed works. After sketching the principal buildings of the Ile de la Cité and the Louvre, he made another visit to the famous gallery itself. Since he had last been there he had rebuilt his own gallery at Queen Anne Street. With this in mind, he seems to have been interested in the way the grand spaces of the Louvre were illuminated, and made studies both in the sketchbook and on his sheets of blue paper (fig.152).

In Paris he would have found letters waiting for him and would no doubt

FIG 152 *The Grande Galerie in the Louvre, Paris* ?1826 (cat.29)

have been amused to learn of the alarm he had caused by suggesting at the outset of the journey that he might go to Ostend. He also seems to have monitored the state of his business affairs. This is clear from the inscription at the end of the sketchbook, which has often been used as the starting point for the tour, although if this really were the case one would expect to find the information in one of the earlier sketchbooks in the sequence. What Turner actually wrote reads as follows: '23 Augt / 1826. Colnaghi Junr. set of Libers'. The most likely interpretation of this note is that he had heard of a recent transaction involving a set of the mezzotints in his *Liber Studiorum*, either from a letter or from one of the sons of Paul Colnaghi, who occasionally had cause to visit

Paris in connection with their work as print-dealers.[179] In 1826 the elder son, Dominic Paul, was made a partner in the family firm, so it is possible that he was in Paris on business. His younger brother, Martin, though less involved with the firm, had apparently commissioned a painting from Constable five years earlier as a companion to the family's Turner.[180]

During his stay in Paris Turner may have met up with the young Scotsman, H.A.J. Munro of Novar (1797–1864), who was to become one of his most important patrons during the next twenty years. Munro was apparently also acquainted with the artist's great friend James Holworthy, to whom Turner wrote later in the year with news of Munro's increasing confidence following his tuition in 'French manners'.[181]

From Paris Turner had a number of options for his homeward journey. The route has not been documented before because the Loire tour effectively ends with the Paris sketches. However, there is a sketchbook that charts a hasty return journey from Paris to the English coast (TB CCLVI). The book is made up of laid paper bearing an 1822 watermark and includes a series of sketches of Beauvais, Calais and the coastline near Dover. Depending on how long Turner spent in Paris, he could have been in London before the end of October, possibly even in time to make a payment on 25 October to a fund to which both he and Sir John Soane contributed.[182]

Back in London, his father would have been relieved to see him after such a lengthy absence, although news of Turner's safety must have reached home before his own arrival. To follow Turner's own metaphor, he could now rest his 'wings' after his long journey. The act of transforming his functional transcriptions of the unfamiliar places and people lay ahead. But if the voyage up the Loire had formed a fitting and memorable climax to the long journey through Normandy and Brittany, it was to be some time before Turner was able to make good use of his Loire material.

In the Wake
of the 1826 Tour

Exploring The English Channel

The first opportunity Turner had of developing sketches from the 1826 tour came about three months later, at the beginning of 1827, but the project that he envisaged at that stage was concerned with the French coast, rather than the Loire. The idea came about as a result of a bitter quarrel between Turner and W.B. Cooke.

After the conclusion of their work on the *Picturesque Views on the Southern Coast of England* in May 1826, negotiations began with a view to continuing the series all the way up the east coast.[1] But just before New Year's Eve 1827 Turner visited Cooke's print-rooms, where a fierce argument took place over the terms under which the project was to continue. Turner apparently demanded that the sum of twelve and a half guineas, which they had agreed for the *East Coast* views, should be applied retrospectively to the earlier group of drawings; this would have resulted in Cooke paying him a further two guineas for each *Southern Coast* drawing, in addition to which Turner wanted twenty-five sets of India proofs of all of the new designs.[2] This suggestion seemed both ungracious and insensitive to Cooke, who had barely managed to weather the crash of the financial markets during the early part of 1826.

A flurry of heated correspondence ensued, in which Cooke pointed out Turner's unreasonable expectations of profit from the projects associated with his name. He pointed specifically to the *Provincial Antiquities and Picturesque Scenery of Scotland*, the *History of Richmondshire* and James Hakewill's *Picturesque Tour of Italy*, for which there was 'considerable doubt remaining whether they will ever return their expenses, and whether the shareholders and proprietors will ever be reinstated in the money laid out on them'.[3]

Cooke's letter also refers to a comment that Turner made under his breath during his visit on 30 December, which several of those present also heard. From Cooke's account it appears that what Turner mumbled was, 'I will have my terms! or I will oppose the work by doing another "Coast"!' That this was a very real threat and not just an idle boast is readily apparent from a letter from a completely different source that followed a week or two later. For on 16 January the publishers John and Arthur Arch wrote to William Miller inviting him to engrave designs for a new work:

During last summer J.M.W. Turner took a journey along the coast of France, and in consequence, he intends publishing a work of twelve Numbers, to be called 'The English Channel or La Manche', to consist of views taken by him on both sides of the Channel in the manner of the Views of the Southern Coast.[4]

The Arch brothers proposed to publish the series for Turner, in effect consolidating their recent investment in the *Southern Coast*, the final stages of which they had supported through the press. They suggested that Miller might like the chance to engrave a landscape and a vignette, offering him fifty guineas for the full plate and a sum 'in proportion to its work' for the vignette. As well as issuing a prospectus for the series, the Arches placed an advertisement in the *Examiner* during the following week. This largely repeated the information in their letter to Miller, but added that the series was 'to consist of Views taken by [Turner] from Dunkirk to Ushant, and places adjacent; together with others, on the opposite Shore of England, but varying from those in the recent Publication of "Picturesque Views on the Southern Coast of England"'. The letterpress was to be made up of 'short descriptions in English and French', and it was proposed that the first part would be issued in June. Each part was to contain three landscapes and two vignettes.[5] Both the subject matter and the proposed means of presentation indicate that this was a deliberate attempt to create a larger audience for Turner's work by capitalising on the current French fashion for all things English.

News of the project quickly reached W.B. Cooke, whose brother George wrote to Miller at the beginning of March. Deeply sickened by Turner's behaviour, he warned Miller to proceed with caution:

Should you engage with him, let me advise you not to agree to some outrageous terms as to Proofs to be retained by the artist (instead of the engraver who builds his fame). You will have the friendship not to name the substance of this to anyone; but do not suffer him to rivet his Chains on your fine talent, be ready to engrave, but not enchained.[6]

Presumably the Arch brothers approached other engravers as well as Miller, but there is insufficient documentation to determine whether they secured the

FIG 153 *Dieppe from the east* ?1826–7 (cat.30)

FIG 154 *Dieppe: a view down the Grande Rue from the quayside* ?1826–7 (cat.31)

services of any of these men. It seems probable that one or two plates were begun, but ultimately the scheme came to nothing. No engravings were actually published, and no watercolours have hitherto been identified as relating to the project. What form the designs may have taken has caused scholars to speculate that they may have been painted on the small sheets of blue paper, although the advert in the *Examiner* hints that they were to resemble those of the *Southern Coast*.[7] The prominence given to vignettes should also be noted; if issued, they would have constituted the most substantial group of Turner's works in this form prior to the publication of Rogers's *Italy*.

In January and February 1827 Turner was busy with his annual series of lectures on perspective at the Royal Academy. At the same time he was at work on five paintings for the Royal Academy exhibition,[8] so it could perhaps be thought that he did not actually have any spare time to produce watercolours for *The English Channel*. There are, however, a number of views of the north coast of France in the Turner Bequest and elsewhere, which provide a solution to this unexplained lack of any material. Most of these were grouped together by Finberg, with some unrelated blue paper studies, in section TB CCXX.[9] The majority of the group are views of Dieppe and Château

d'Arques. Nearly all are about 17 x 24 cm (6¹/₂ x 9¹/₂ in), but the edges of each sheet have washes overlapping from other designs, which reveals that they were actually painted on bigger pieces of paper that were only later divided. Piecing these fragments together, it is possible to determine that one of the views of Château d'Arques was painted immediately above a simple wash study of an island with a tower (figs.156 and 168). It is this latter sheet that suggests most strongly that these views were painted early in 1827, because the subject is derived from a pencil sketch that Turner made at St-Vaast-la-Hougue during the second week of September 1826 (fig.13).[10] Another sheet, showing Calais from the sea, can be seen to relate to the oil painting *'Now for the Painter', (Rope.) Passengers going on Board*, which Turner exhibited at the Royal Academy in the spring of 1827 (figs.171 and 172). Against this hypothesis, it has to be noted that the views of Dieppe and Château d'Arques could suggest an earlier date, since at least one of the views of the quayside is based on the sketches of 1821, while some of the studies of the ruined château resemble the notes resulting from Turner's perambulations around its remains in 1824.[11] However, Turner had systematically labelled and organised his sketchbooks in 1824 so that he would be able to draw on ear-

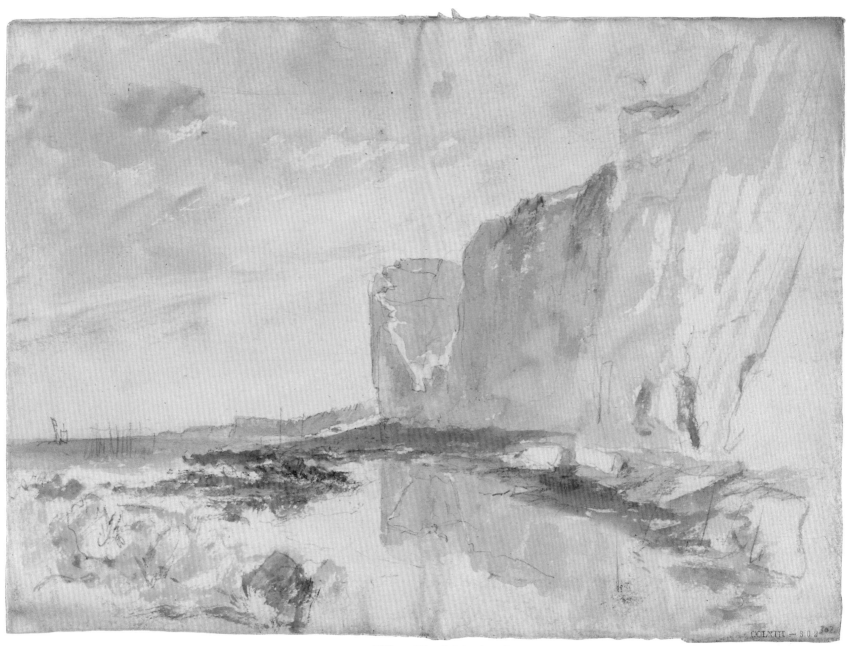

FIG 155 *Cliffs near Dieppe* ?1826–7 (cat.32)

lier material, and the crisis provoked by his row with Cooke would have been the ideal time to cast about for suitable material utilising this new system.[12]

As well as those in the Turner Bequest, there are three further views of Château d'Arques, which are clearly related in size and handling to this group (figs.158 and 159).[13] Not previously identified as a French scene, and dated much earlier, one of these is closely based on the pencil sketch on blue paper that Turner made of the castle during the 1826 tour (fig.9). The tremendous popularity of Dieppe and the nearby ruin would have meant that both sites recommended themselves as subjects for the proposed series of French Channel subjects.

It appears that Turner kept the twelve studies in the bequest together as a distinct group, for this is how they were found by his executors, whose official note on the parcel states that there were originally eight more sheets in the group.[14] These were removed by Ruskin in the 1850s, when he was attempting to impose his own order on the bequest. He wrote on the wrapping containing the works, 'There are one or two in this parcel that some people might like. I consider them all done in some careless or sickly state of mind, and have therefore put all aside, except one, taken out for an example, and seven, too large, put elsewhere, leaving here 12.'[15] He actually owned a similar work himself, which he shortly afterwards presented to the Fitzwilliam Museum, Cambridge, but he clearly had some reservations about the quality of the group. Nevertheless, he was surely right to recognise the frantic haste in which they had been painted.

The identity of the other eight works mentioned by Ruskin, seven of which seem to have been larger, can be tentatively surmised from the subject matter of a group of colour studies catalogued by Finberg in section TB CCLXIII. One of these is much the same size as the Dieppe views and seems to show the cliffs close to the town (fig.155). There are also two groups of views of Granville and Mont-St-Michel, which relate to the 1826 pencil sketches (figs.160–65). The Mont-St-Michel studies are all on the same type of paper and may have begun life as a sketchbook, since several of them have studies on both sides, including that on the verso of fig.163 showing a figure trying to lead a frightened horse away from the rising tide. The colours Turner used are more like sugared confectionery than naturalistic effects, and recall Henry Crabb Robinson's objections to the 1825 picture of Dieppe:'We know Dieppe, in the north of France, and can't easily clothe it in such fairy hues.'[16] In the watercolours of Granville Turner selected the view from the north-east, looking over the rooftops of the

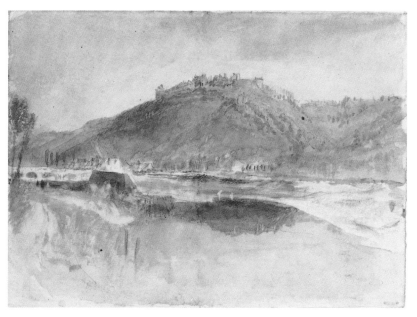

FIG 156 *Château d'Arques from the north–east* ?1826–7 (cat.33)

old town, with the sunset beyond the Pointe du Roc. This small series uses the basic structure in the pencil sketch as the starting point for a set of variations on the sunset theme, each sheet creating more fabulous effects. These larger works, however, are more assured than the group of Dieppe studies and may have been produced slightly later.

If it is now clear that Turner did embark on a set of studies for *The English Channel* as a result of his 1826 sketching tour, it is worth considering whether he also produced any finished works for the series. In fact, there are at least three French subjects, sharing roughly the same dimensions, which could relate to the project. The size of the sheets of paper is an important consideration because within many of Turner's topographical series the pieces of paper he selected were much the same throughout the group, give or take a few centimetres.[17] Two of the potential *Channel* subjects were listed in Andrew Wilton's 1979 catalogue as part of a section devoted to 'Finished watercolours, derived from the "Rivers of Europe" project', which also included the French subjects published in *The Keepsake* annual. Wilton suggests there that the drawings that Heath published in his 'Annual' were part of what was intended to be a longer series of 'picturesque views in France'.[18] Though there are some similarities

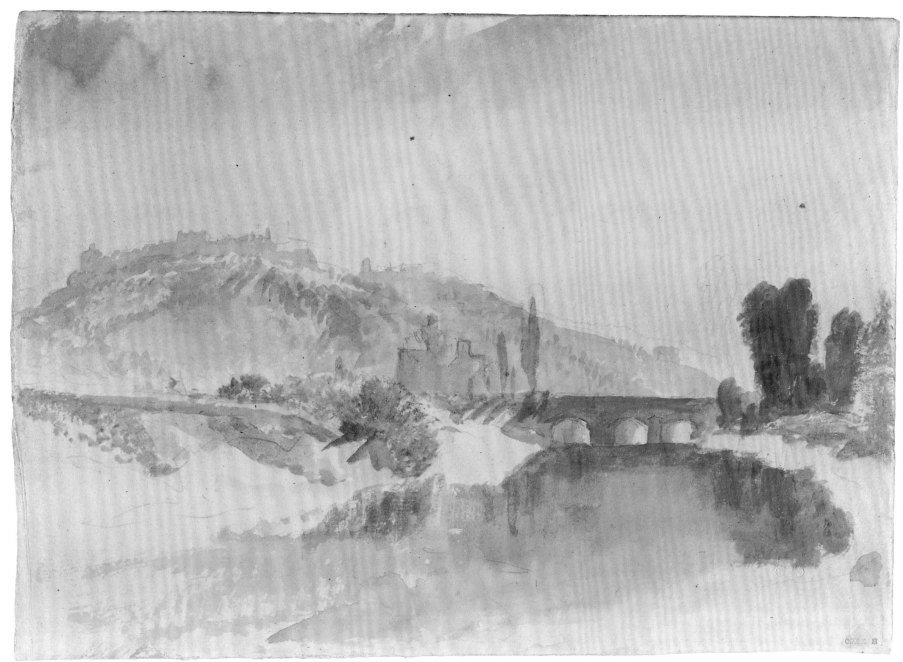

FIG 157 *Château d'Arques from the south-east* ?1826–7 (cat.34)

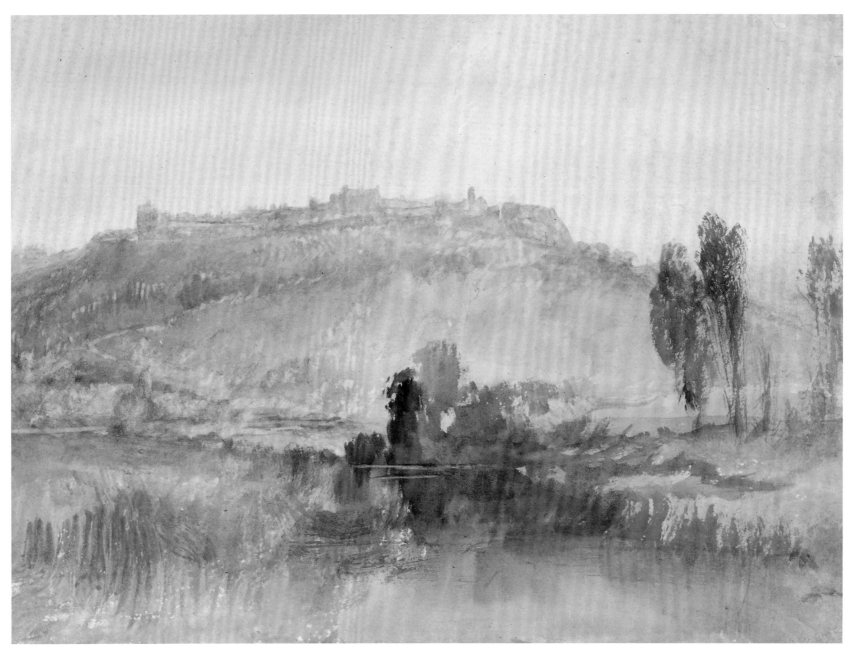

FIG 158 *Château d'Arques from the east* ?1826–7 (cat.35)

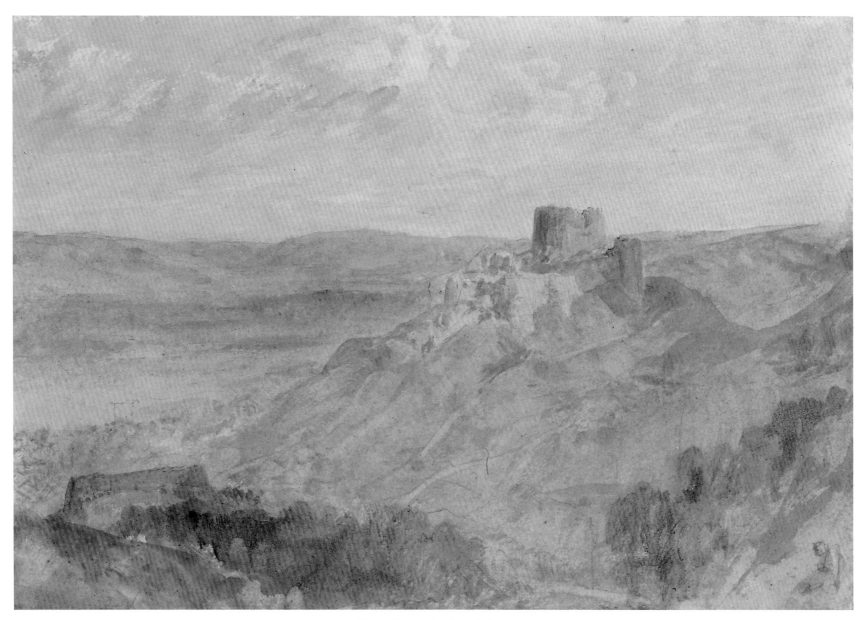

FIG 159 *Château d'Arques from the west* ?1826–7 (cat.36)

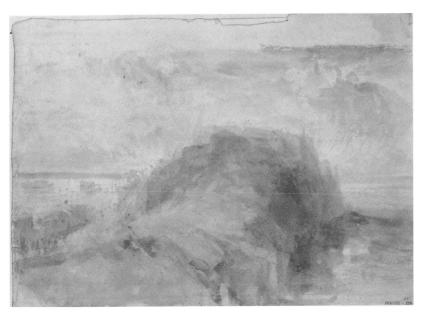

FIG 160 *Granville* ?1827–8 (cat.41)

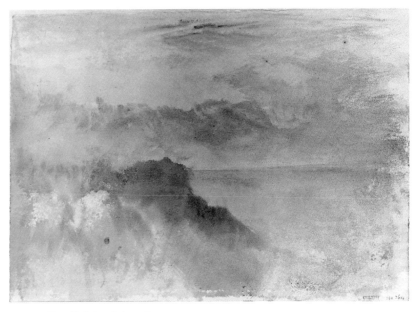

FIG 161 *Granville* ?1827–8 (cat.42)

with *The Keepsake* watercolours, those works are much larger than the two works probably connected with the *Channel*.

The first is a view of *Granville*, this time taken from the beach to the north of the town (fig.166).[19] As in all of the finished views associated here with the *Channel* series, the foreground teems with figures, in this case members of the fishing fleet and their families, wearing the distinctive costumes of Normandy that Turner had observed during his tour. In the distance, silhouetted faintly by the sun, is the outline of the old town, for which Turner was indebted to a sketch on one of the loose sheets of Ivy Mill paper that he took with him in 1826.[20]

The second watercolour, a view of *Le Havre* in the Indianapolis Museum of Art, is also based on a pencil outline, this time from the *Rouen, Le Havre, Caen, Bayeux and Isigny* sketchbook.[21] Again the scene is full of activity, sometimes clumsily delineated, which has led some scholars to question whether Turner could have painted this scene, although it is characteristic of his work in every other way. It was thought that this watercolour provided the design of one of the engraved illustrations in the 1834 edition of *The Keepsake* annual, but another work has been identified as a more likely source.[22]

FIG 162 *Granville* ?1827–8 (cat.39)

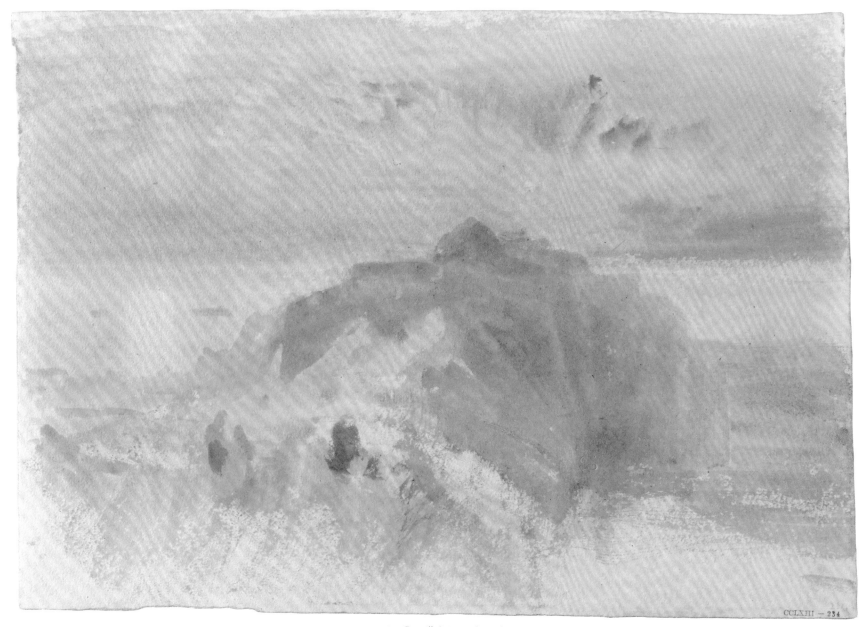

FIG 163 *Granville* ?1827–8 (cat.40)

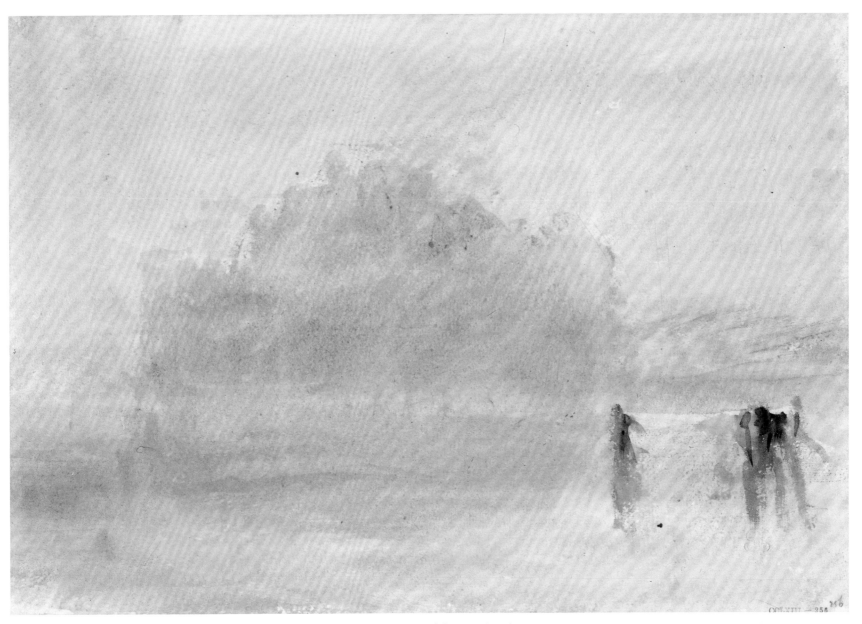

FIG 164 *Mont St Michel* ?1827–8 (cat.44)

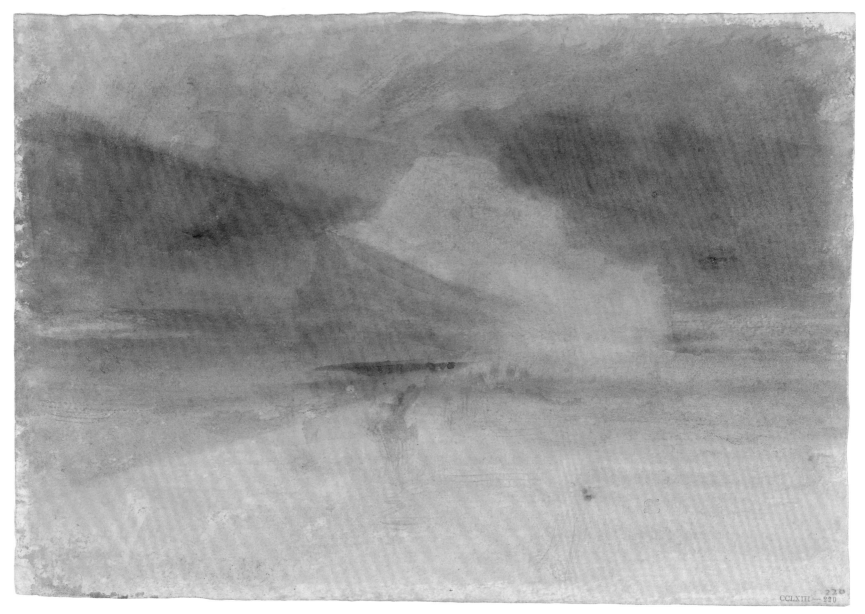

FIG 165 *Mont St Michel* ?1827–8 (cat.43)

The third potential *Channel* subject only recently came to light on the London art market, where it was correctly identified by Eric Shanes as a view of the fort at St-Vaast-la-Hougue, with the Fort de l'Ilet beyond and the town itself on the far left (fig.167).[23] In front of the tower that also forms the subject of fig.168, Turner staged a marine tournament in which sailors standing in different boats use long poles in an attempt to knock their opponents into the water. Even as men are hauled up into the boats, others continue the combat, occasionally falling backwards into the sea. Quite why Turner chose to introduce this friendly battle to the view of St-Vaast-la-Hougue is unclear, for there is nothing in his sketches of the site to make this connection. In view of the lack of any readily identifiable contemporary source, Eric Shanes has reasonably suggested that Turner may have remembered the battle that took place off the small port between 19 and 23 June 1692, when the English and Dutch fleets defeated the French. Alternatively, it is just as likely that the sport of the sailors in the foreground was invented, as it is far too light-hearted to commemorate an international conflict, an interpretation that is surely contradicted by the humour of the scene and its gently unifying sunlight. Stylistically this work resembles some of the *England and Wales* watercolours, such as *Aldborough, Suffolk* (w 795) or *Orford* (w 796), both of around 1826–7, although it has a much softer finish. It is probable that it was once a companion to the view of *Granville*, for when that drawing left the collection of Hannah Cooper on 13 February 1854, ironically as an exchange for some of the unpublished Loire views, it was part of a package of three works, one of which was listed in the family records as 'The Jute'.[24] Since it is not possible to trace a work by Turner with that title, it is most likely that this should mean 'The Joust', a title that relates directly to what the two sailors on the right are doing. Moreover, the French word for this activity, *la joute*, provides a clear link with the untraced work from the Cooper collection. Further support for this interpretation comes from the later provenance of the watercolour, which was presumably the work sold in 1861 from the collection of Edward Peddlar as 'Water Tournament. Drawing'.[25]

The possibility that there is an identifiable group of three finished French scenes for 'The English Channel' suggests that there may also be English subjects previously unconnected with any other series that should rightly belong here. Several works immediately suggest themselves as candidates, and, though one of these is a little larger than the rest of this group, they are of approximately comparable size to the French views.

The first is the view of *Fishing Boats on Folkestone Beach* in the collection of the National Gallery at Dublin, which has been associated both with the *Pic-*

FIG 166 *Granville* ?1827, watercolour. *Sotheby's (18 July 1970, lot 94; W 1050)*

turesque Views in England and Wales, although it is only about half the size of many of the compositions for that publication, and more realistically with the *Ports of England*.[26] Though it appeared in neither series, it was clearly intended for engraving. It may relate to an earlier pencil outline in the Turner Bequest that has been marked with notes to assist an engraver, but it is interesting to note a number of discrepancies in the presentation of the architecture between the two works.[27] As in the French subjects, the sun is placed at the centre of the composition, dazzling the viewer with its brilliance. Although no engravings specifically for *The English Channel* appeared in 1827, a print of this subject was afterwards produced by John Cousen, probably around 1844, although it was not published until 1867.[28] This small print was included in a volume entitled *Art and Song*, which seems to have been a way of mopping up watercolours begun for other, unrealised projects; two of the subjects included are likely to have been intended for the projected *East Coast* series.[29]

Another watercolour of almost the same dimensions as the Folkestone subject is a view of the cliffs at Hastings, which also entered the National Gallery of Ireland from the collection of Henry Vaughan.[30] As thunderous clouds brood over the head of Fairlight Cliff, a number of pieces of broken mast carry the survivors of a wreck towards the rocky shore. It is a design that Turner arrived at after working it out as one of his watercolour 'beginnings'.[31] There is a sharp

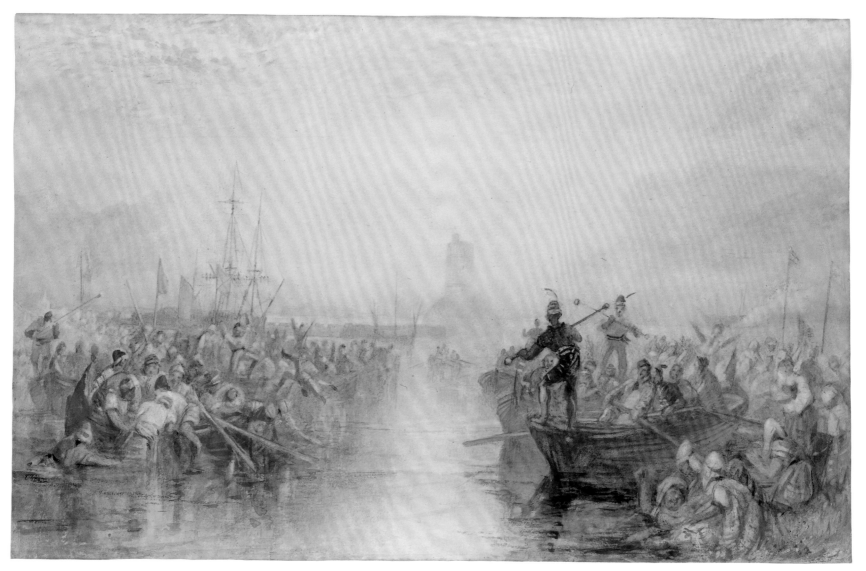

FIG 167 *The Jute: a jousting contest at St Vaast-la-Hougue, Normandy* ?1827, watercolour. *The Berger Collection, Denver Art Museum*

contrast between this dramatic subject and the sunny tranquillity of the other subjects linked here with *The English Channel*, but Turner presumably sought some variety in the group. This stirring shipwreck scene was unaccountably one of only two watercolours to be engraved for the posthumous volume *The Turner Gallery*, which was otherwise devoted to one hundred and twenty of the artist's most important paintings.[32] The engraver of the Hastings view was William Miller, who, as we have already seen, had actually been approached by the Arch brothers with a view to his participation in the making of *The English Channel*. It is quite possible, therefore, that he had accepted their offer and began work on this plate, only breaking off when the project was abandoned. *The Turner Gallery* plate may have been his way of capitalising on work undertaken forty years before.

A third, slightly larger watercolour shows Shoreham, which would have been an especially pertinent subject to include, as it was most probably where the 1826 tour had begun.[33] One of the smaller studies in cat.3 (fig.8) sets out the general composition of this scene, but there are also views of Shoreham in a sketchbook, perhaps recording a later visit which must have occurred before his 1828 trip to Italy.[34] These are more detailed and could suggest that the watercolour was not produced until somewhat after *The English Channel* group, although against this it should be noted that Turner frequently revisited and sketched intensively at sites he had already painted. But the real evidence lies in the watercolour itself and in the way the design is pivoted on its central burst of sunshine, which suggests most strongly its relationship to four of the other five watercolours in the group.

Sadly, no engravings were actually published, but the project is important in

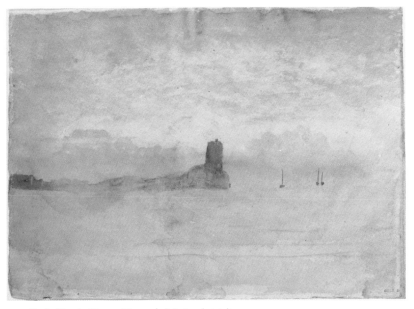

FIG 168 *St-Vaast-la-Hougue, Normandy* ?1826–7 (cat.37)

that it was the first time a group of Turner's views had been aimed directly at the French public, anticipating the later bi-lingual volume of *The Rivers of France* by a decade. In its outlined programme of an equivalent number of views of both sides of the Channel the project symbolised the many important cultural links between England and France during this period.

Painting The Banks of the Loire

hile *The English Channel* may have been the focus of Turner's attention for a brief time at the beginning of 1827, he had other commitments, the most important of which was the need to produce a handful of pictures for the forthcoming Royal Academy annual exhibition. One of these works was derived from the experience of the 1826 tour, but in order to understand the context in which this painting was produced it is necessary to examine a group of related works from 1825 and 1826.

In these two preceding years Turner had largely met with commercial success, eventually managing to sell nearly all of his exhibits, even though the critics had not always been kind. This was the period when the stock response to his paintings was to deride his use of yellow, a tendency that had first begun after 1810. Though conscious of these reservations about his work, Turner had continued to deploy increasingly vibrant colours in an attempt to give substance to his perception of the world. He apparently protested about the treatment he received from the press to Sir Thomas Lawrence during his stay in Rome in 1819, on an occasion when they were both looking at St Peter's, just then brilliantly lit by the noonday sun: 'Now, who says I paint too yellow?'[1] But his exasperation with his critics was powerless to stop the sport of poking fun at his preference for the warmer colours of the spectrum, which came to a head in the reviews of 1826. One writer complained: 'In all, we find the same intolerable yellow hue pervading every thing; whether boats or buildings, water or watermen, houses or horses, all is yellow, yellow, nothing but yellow, violently contrasted with blue.'[2] This year, at least, Turner was able to laugh along with his critics. In a letter to Holworthy he wrote: 'I must not say yellow, for I have taken it <u>all</u> to my keeping this year, so they say, and so I meant it should be.'[3]

One of the pictures to provoke this response in 1826 was *Cologne, the arrival of a packet boat. Evening* (fig.170), showing the waterfront of the great German river port. One of his largest canvases, it is of almost exactly the same size as the view of the *Harbour of Dieppe* that Turner had sent to the Academy the previous year, and was clearly intended as a companion work (fig.169). The French sub-ject was apparently commissioned by a Mr John Broadhurst, about whom little is known, even though he was obviously of great significance as a patron of Turner's work in the mid-1820s. As well as paintings by Turner, he acquired landscapes by George Vincent and William Linton.[4] He may have been the 'Mr Broadhurst, of the Theatre Royal English Opera House' depicted by Miss Mary Mainwaring in a portrait that was exhibited at the Royal Academy in 1822.[5] The connection certainly seems possible, because Turner had always retained a keen interest in the theatre and its performers as a result of his early work as a scene painter.[6]

Mr Broadhurst has also been associated with the Cologne view, which Turner painted as a result of his tour of 1825. But, though he did indeed acquire the picture, it is unlikely that Broadhurst actually commissioned it, as the painting was still in Turner's studio at the end of the summer of 1827, and it is not clear that he had definitely decided to buy it.[7] It was at this time that Broadhurst is known to have commissioned the classical subject *Dido directing the Equipment of the Fleet, or The Morning of the Carthaginian Empire* (B&J 241). What all these pictures have in common is their large size and the depiction of great ports, factors which provide some indication of Broadhurst's interests, as well as the scale of the house or gallery in which he intended to display them.

This brings us back to one of the paintings Turner exhibited in 1827, which is another work measuring about 170 x 224 cm (67 x 88 in). It appeared under the following title, *'Now for the Painter', (Rope.) Passengers going on Board*, and depicted the port of Calais, albeit as a distant group of towers on the horizon (fig.172). As was the case when he exhibited both *Dieppe* and *Cologne*, this was one of the places he had visited right at the end of the previous year's tour. He was, of course, very familiar with Calais, and would not necessarily have needed to draw on his most recent visit. There is, however, a colour study of Calais, dated here 1826–7, which seems to relate to the painting and which is part of a group of watercolours based on sketches from the 1826 tour (fig.171).

FIG 169 *Harbour of Dieppe (Changement de Domicile)* RA 1825, oil on canvas
The Frick Collection, New York (B&J 231)

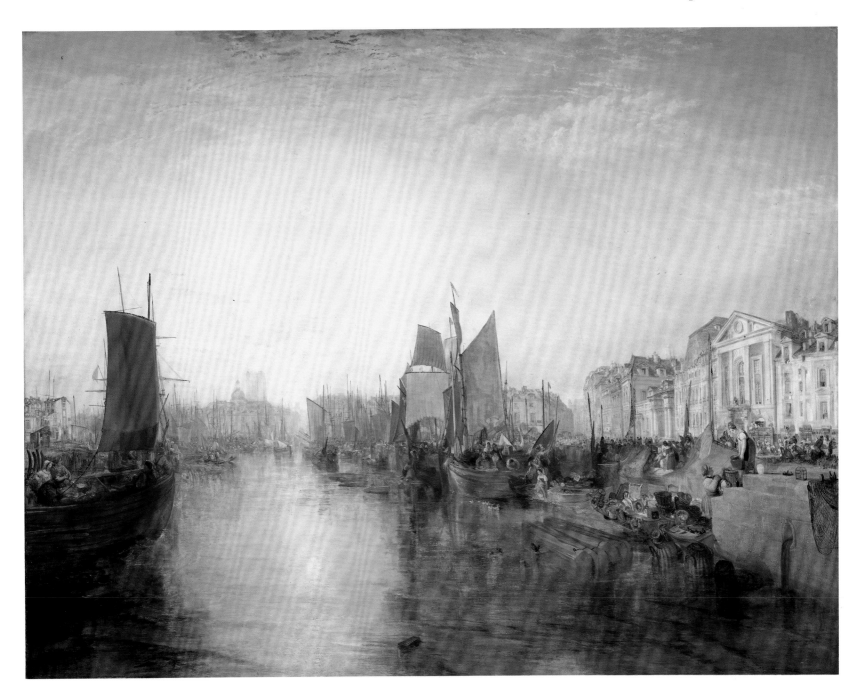

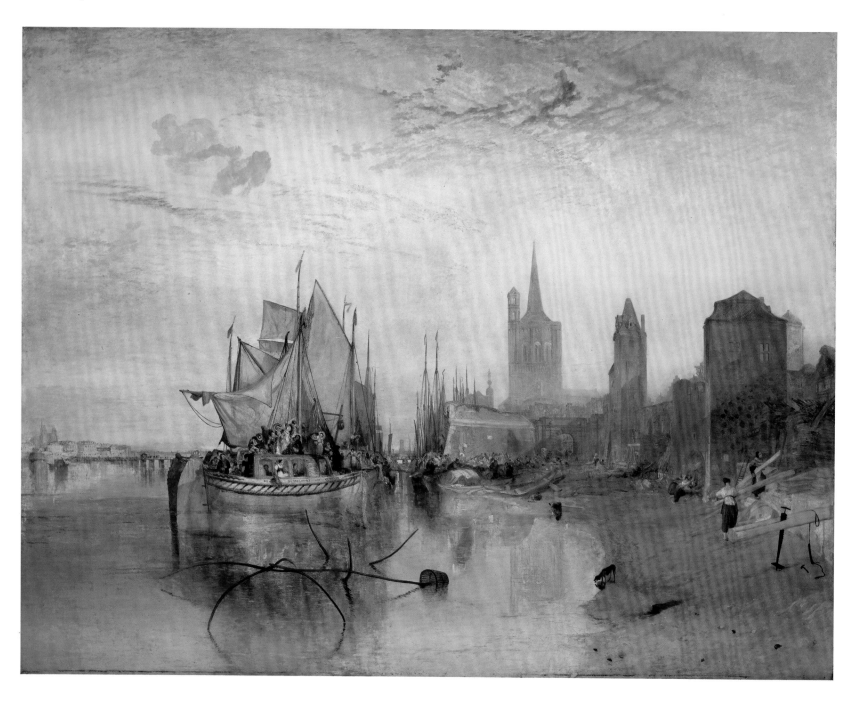

In many respects the topographical setting was incidental to the fun Turner was having with the ambiguity of his title, which was really no more than an in-joke among some of the Academicians. (For those unfamiliar with naval terms, a 'painter' is the rope attached to the bow of a boat for tying it to a quay.) Paintings with titles similar to Turner's had been prepared for the 1826 exhibition by both Augustus Wall Callcott and Clarkson Stanfield, and typically he could not refrain from squeezing the last bit of humour from the joke.[8] In the case of Turner's picture, the pun does not work very readily from a visual point of view because it is difficult to identify a figure among the groups in either boat who could be an artist. Could it be that the man in the dark jacket in the main vessel, with his right arm held up, is a self-portrait and that this painting is another in the series of works charting Turner's travels? If so, this reverses the logic of the title, but the only other possibility would be for one of the women in the smaller boat to be a painter.

Turner may have hoped that the picture would tempt Mr Broadhurst, but, if

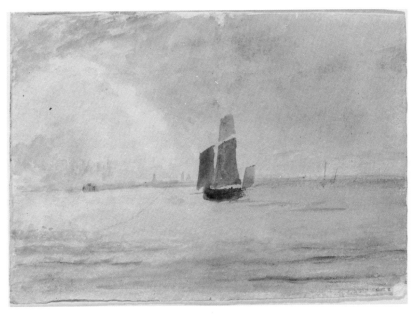

FIG 171 *Calais from the sea* ?1826–7 (cat.38)

FIG 170 *Cologne, the Arrival of the Packet Boat*, RA 1826, oil on canvas
The Frick Collection, New York (B&J 232)

so, he was to be disappointed. Instead, it was to languish in his gallery until 1851, when he sold it to John Naylor. Another picture that seems to have arisen from Turner's attempt to secure further patronage from Broadhurst was found in his studio after his death (fig.173). This has only been catalogued as part of the bequest since 1944, when it was rediscovered in the basement of the National Gallery among other overlooked rolls of canvas that had actually been worked on by Turner.[9] Though somewhat damaged as a result of neglect, both by Turner and the beneficiaries of his bequest, the unfinished harbour scene eventually emerged from its conservation treatment as a dazzling example of his mature work, directly comparable with either *Dieppe* or *Cologne* in size, handling and its restrained use of a yellow-orange palette over a warm white ground.

Since it was rediscovered, the only attempt to identify the subject of the painting was made by Andrew Wilton, who suggested that it shows the fortress of Namur on the River Meuse, relating it to the tour of that river dating from the 1820s.[10] But, in fact, this is a view of the harbour at Brest in Brittany, which is another of the subjects that Turner had sketched during the 1826 tour (fig.22). His sketches there were cursory and really only provided the basis for the left-hand half of the painting. The view is taken from the Quai Tourville, looking up at the impressive walls of the château, which had been modified in the seventeenth century by the great military engineer Sebastien le Prestre de Vauban, so the previous confusion with Namur, for which he was also responsible, was not altogether unwarranted.

Comparison with a nineteenth-century illustration shows how Turner has exaggerated the massiveness of the central tower (fig.174), but the general impression is true to the site as it can be seen today, with the exception of the houses on the left, which have since gone. Because the picture remained unfinished, some of the important details, such as the masting machine at the end of the quay, have been left indistinct. Similarly, the rather theatrical crowd of figures would surely have received more attention had Turner decided to present it at one of the Academy shows. They can, nevertheless, be seen to be wearing Breton head-dresses. The common observation that Turner clothed his scenes in an enveloping sunset effect could not be more apt for this picture. Just as Turner's contemporaries were surprised by his presentation of Dieppe, it is at first hard to equate the solid granite austerity of Brest with the place depicted by Turner. But the port was capable of stimulating a similar response in the writer Jean Genet, who noted that, 'If Brest seems less austere, it is when a feeble sun gilds the waterfront, where the facades are as noble and grand as those in Venice.'[11]

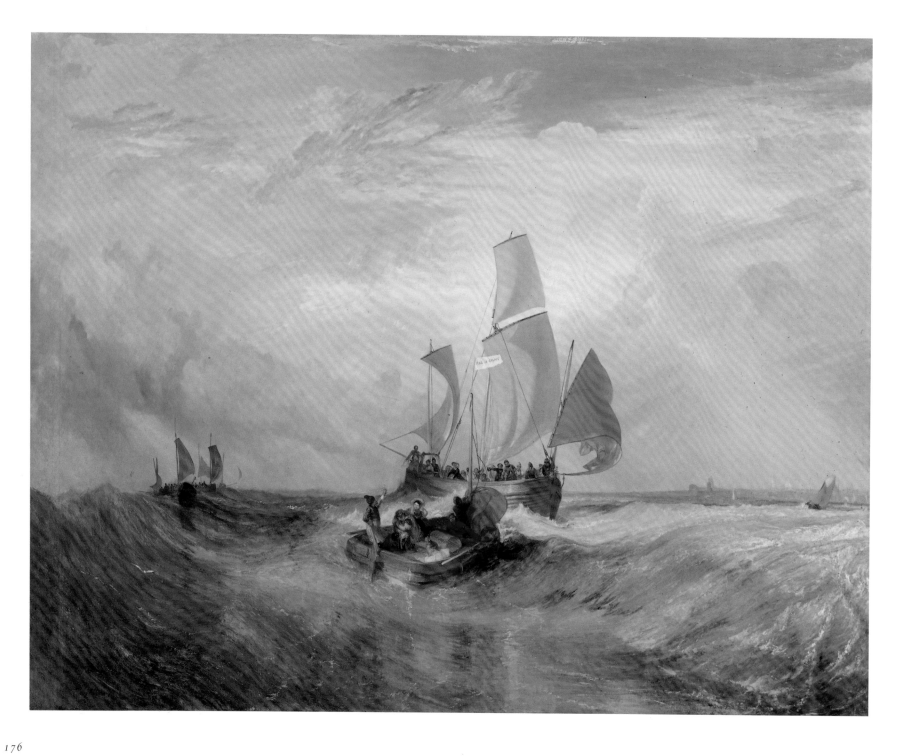

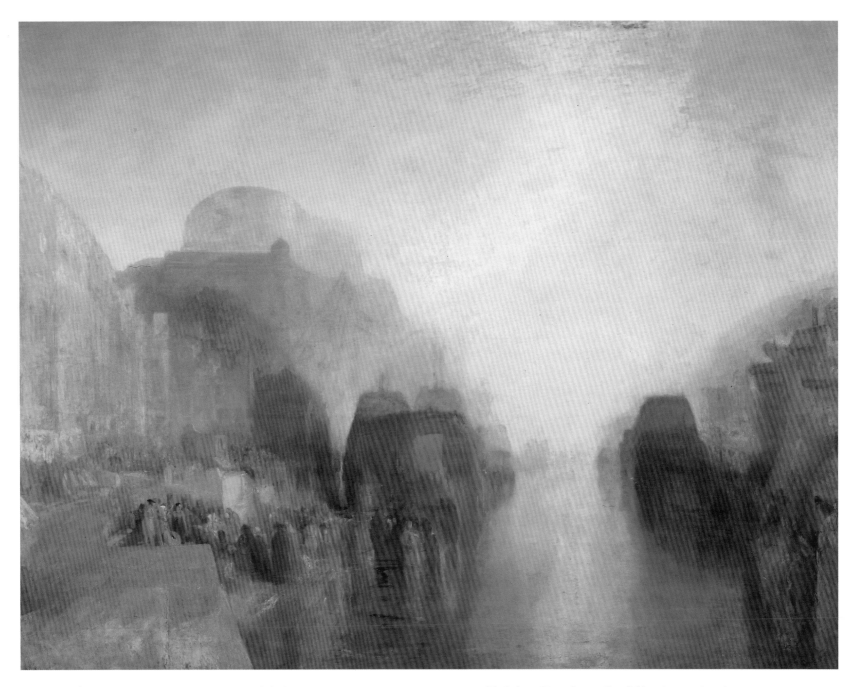

FIG 172 'Now for the Painter' (Rope), Passengers going on Board, also known as Pas de Calais RA 1827, oil on canvas. Manchester City Art Galleries (B&J 236)

FIG 173 The harbour of Brest: the quayside and château ?1826–8 (cat.99)

FIG 174 *Brest: L'avant-port au moment de l'arrivée d'un train de prisonniers insurgés,* mid-nineteenth century, engraving. *Département des Estampes, Bibliothèque Nationale, Paris*

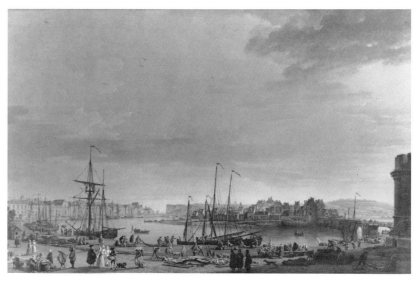

FIG 175 Claude-Joseph Vernet, *Dieppe,* oil on canvas
Musée de la Marine, Paris

In all of the pictures that Turner seems to have painted with Mr Broadhurst in mind there is either a direct or an underlying debt to Claude Lorrain's harbour scenes, which he had studied in the Louvre in 1821. But another model that Turner surely hoped to emulate was the set of paintings of *Les Ports de France* produced for Louis XV by Claude-Joseph Vernet.[12] Though the pictures were at that time still displayed in the Luxembourg Palace (fig.175), they were widely known through a set of engravings. As noted above, Turner had discovered Vernet's shipwreck scenes when he was an adolescent, and had surpassed them in his ability to produce sublime effects. There is, however, more than just an echo of the French artist's documentary approach to the views of Dieppe, Cologne and Brest. The consistent size of these views of European ports suggests that Turner envisaged them as a series, to be produced, just like Vernet's set, over a number of years. Furthermore, the first of these was begun at a time when Turner still seems to have hoped for the kind of royal recognition that Vernet had enjoyed. The details and popular myths of Vernet's life were clearly known to Turner, for he even parodied the famous incident where Vernet was strapped to a mast in order to study a storm at sea when talking about his late painting *Snow Storm – Steam-Boat off a Harbour's Mouth* (Tate Gallery, B&J 398).

The most likely time for Turner to have painted the view of Brest would have been in the spring of 1827, perhaps with the Academy show in mind. However, this proved to be an especially difficult few months for him, not only as a result of his rather desperate attempt to wound W.B. Cooke by starting his own 'Coast' project, but also because of the illness of his father. Quite probably he simply did not have time to finish the painting, and, once the deadline of the Academy opening had passed, he moved on to other things. At the very latest, he must have stopped working on it sometime before 16 July 1828. This was when the pictures of *Dieppe* and *Cologne* appeared in an auction at Phillips, apparently because of 'some distaste on the part of Mr Broadhurst'.[13] The sale took place only a few months after *Dido directing the Equipment of the Fleet* had received a warm reception from the critics on its exhibition at the Royal Academy, but although the painting had been commissioned by Broadhurst, he clearly did not want to buy the finished work. Shrewdly, Turner attempted to salvage something from this disaster by asking John Pye to engrave it, but the various costs of seeing this through would not

FIG 176 *View from the Terrace of a Villa at Niton, Isle of Wight, from sketches by a lady* RA 1826, oil on canvas. *Museum of Fine Arts, Boston* (B&J 234)

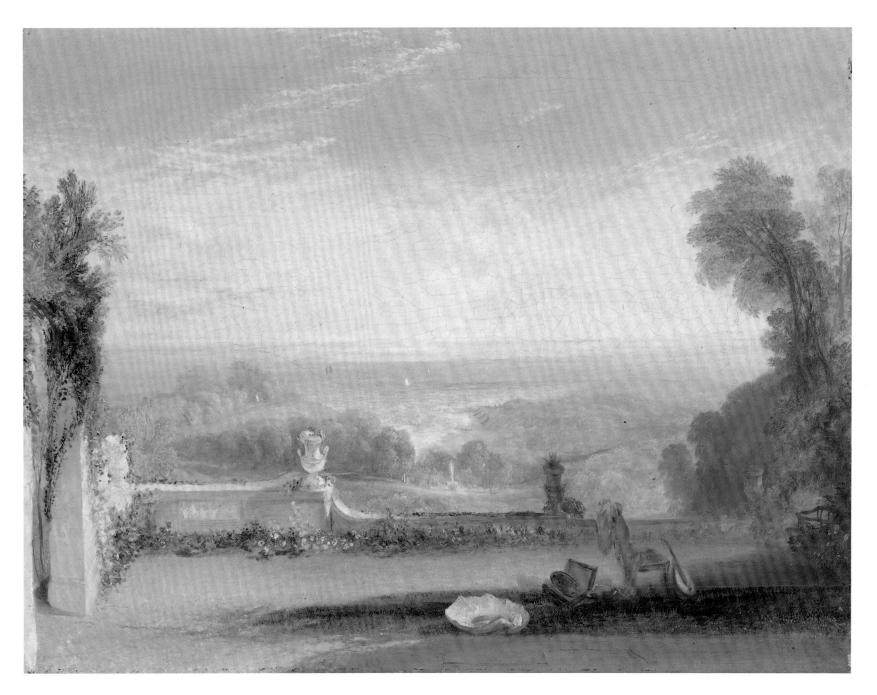

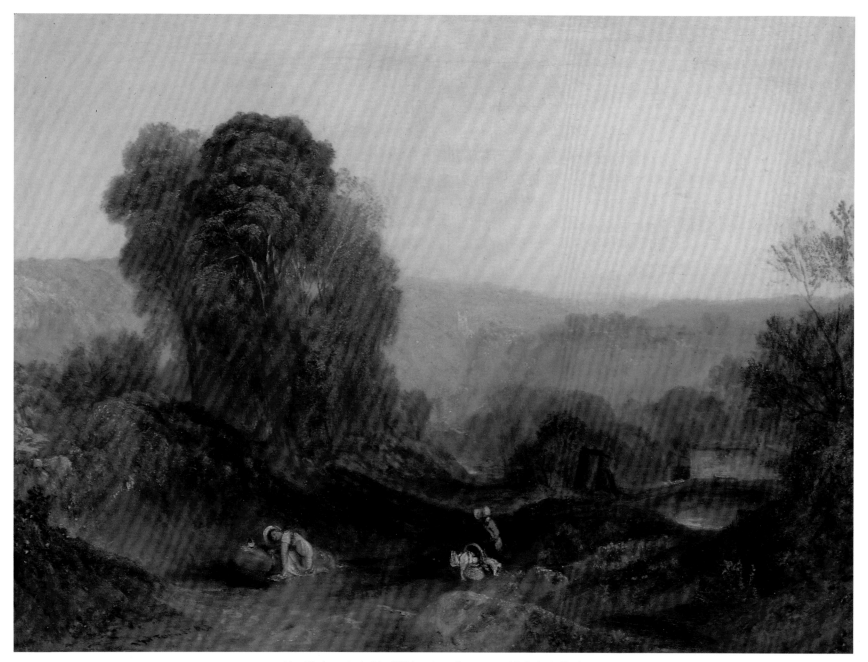

FIG 177 *Near Northcourt in the Isle of Wight* c.1827, oil on canvas. *Musée du Québec* (B&J 269)

have been as remunerative as an immediate sale, even if the print had actually been produced.[14] It is unlikely that Turner went along to Phillips to see his pictures again, for at the time of the sale he was preparing to make his second visit to Rome.

The first half of 1828 would have been the most likely time for him to have developed a group of gouache studies from his Loire material, following on from the sets he had produced at East Cowes Castle and Petworth in the autumn of 1827. This is supported by two facts. Firstly, some of the studies were worked on sheets of blue paper that have been found to have an 1828 water-mark. More importantly, one of these works provided the basis for an oil paint-ing called *The Banks of the Loire* that he exhibited at the Royal Academy in 1829, just two months after his return from his second trip to Italy. The short space of time between his arrival in London in February 1829 and the annual exhibition rules out the studies having been produced during these few weeks, as there was scarcely sufficient time for him to finish the two large paintings that were also shown that spring: *Ulysses deriding Polyphemus – Homer's Odyssey* (National Gallery, B&J 330) and *The Loretto Necklace* (Tate Gallery, B&J 331).

At the Royal Academy in 1829 attention inevitably focused on *Ulysses*, one of the most spirited and triumphant of Turner's classical subjects, which Ruskin later considered 'the central picture in Turner's career'.[15] The press coverage devoted to Turner's pictures that year focused almost exclusively on this and the Italian painting, thereby all but ignoring the view of the Loire. However, the critic of the *Athenaeum* noted that it was 'a gem of the first water, brilliant and beautiful', while a later review in the *Gentleman's Magazine* encouraged its readers to look from *Ulysses* to Turner's other 'specimen of aerial brilliancy of effect'.[16]

These few comments are all that can be found in contemporary records to suggest the limited impact made by Turner's only painting with a Loire subject. Once the Royal Academy show closed that summer, the picture disappeared and has remained untraced ever since. Attempts by previous scholars to relate the title to any of the unidentified views in the *catalogue raisonné* of Turner's work have been hindered by the vagueness of his title. Rather than suggesting a view of one of the main towns on the river, such as Blois or Tours, the title implies a less obvious spot, the name of which Turner had either forgotten or did not know, but which to him conveyed the essence of his visit there three years earlier.

One of the colour sketches in the Loire series has exactly this kind of char-acter and can be directly related to an oil painting in the Worcester Art

Museum in Massachusetts that has been catalogued under various titles, most recently as a view on the River Rhône, but which is here identified for the first time since 1829 as *The Banks of the Loire* (figs.67 and 179).[17] The subject of the design on blue paper is the group of follies constructed near Oudon by Maximilien Siffait, which were created as a means of employing local labourers and were not simply a monument to Siffait's vanity (see above, p.79). Although the pencil sketches Turner made on the spot reveal his interest in the follies, it is not possible to determine whether he knew anything of their history or the name of the local benefactor. If he had known the origins of the fanciful towers and terraces, he may have drawn a parallel between Siffait's public spirited generosity and that of Lord Egremont, for whom he had very recently painted the group of landscapes celebrating the earl's good works in the region around Petworth.[18]

The Loire canvas, however, was painted not for Egremont, but for another nobleman, with whom Turner had a long connection. This was Sir James Willoughby Gordon (1773–1851), who had commissioned the picture from Turner in 1828, prior to the artist's departure for Rome. Evidence of this can be found in one of Turner's sketchbooks, where he listed Gordon's name as part of a list of works he was planning to execute, followed by the measure-ments '28 Inches by 21 High'.[19] These are exactly the dimensions of the picture now at the Worcester Art Museum, which has a well-documented provenance all the way back to the Gordon family. The rare upright, or 'High', format of the painting was adopted for a very particular reason. This was because the Gordons had recently bought two smaller landscapes from Turner, both of which were depictions of properties they owned on the Isle of Wight (figs.176 and 177), and they presumably wanted a centrepiece so that the views could be hung as 'wings' on either side. The three works would have been in similar frames, but the design selected by the Gordons has been replaced in at least two of the three works.[20]

There is no readily discernible connection between the two Isle of Wight views and that of the Loire. One link may be simply that the earliest of the three works was exhibited at the Academy in 1826, the year of the Loire tour. This picture was effectively the result of a collaboration between Turner and Sir Willoughby Gordon's wife, Julia (1775–1867), who, as Julia Bennet, had been one of Turner's pupils in the late 1790s.[21] Without mentioning her name, his exhibition title for the 1826 picture suggests that Julia Gordon asked him to develop an oil painting from her sketches for the view from the family home at Niton (fig.178).[22] After Turner grew tired of teaching, she had continued paint-

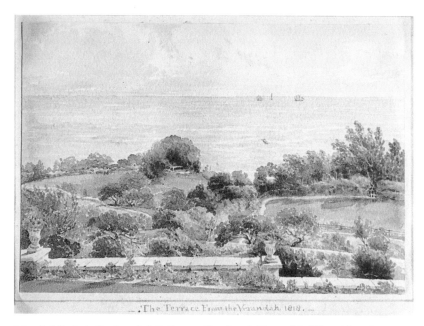

FIG 178 Julia, Lady Gordon née Julia Bennet, *View from the Terrace of the Villa at Niton* 1819, watercolour. *Private Collection*

ing under other drawing masters early in the nineteenth century.[23] There is no existing correspondence between Turner and the Gordons, but they must have stayed in touch over the years, since Sir Willoughby was a regular visitor to the Academy dinners, and the circle of artists from whom the Gordons bought pictures included men like Varley, Callcott, Wilkie and Stanfield, who were also among Turner's close associates.[24]

It is not known whether the Gordons had themselves visited the Loire, which would be an obvious reason for them to acquire such a scene, although the obscurity of the subject is puzzling if this was the case. They are more likely to have known the river at second-hand, learning about Turner's recent trip when he stayed with them in the summer of 1827, a visit that resulted in the second Isle of Wight picture.[25] Turner may even have produced some of his gouache designs for them to see by this date. They would surely have seen some of the colour studies resulting from the Loire tour before commissioning their painting a year later, perhaps selecting that of the Folies-Siffait and asking Turner to develop it as a comparative demonstration of how he transformed his own sketches, as he had done with Julia Gordon's drawing.

While the study of the follies had provided the actual subject matter for the glorious distances of the oil painting, Turner had to invent his own foreground. His gouache drawing was dependent on sketches taken from the middle of the river, where there is nothing but water between the viewer and the motif. So there was a need to provide a more conventional framework, which Turner created by suggesting a viewpoint from a sandy islet close to the north bank. On the left a receding path can be seen winding through the trees, while immediately in front are two dilapidated bridges, one of which links the island to the shore. The more distant bridge tapers off into a sandy spit, but its position has more to do with Turner's sense of design than the strict rules of perspective.

The inclusion of a stooping figure creates a visual link with the young woman turning towards the viewer in the painting of Northcourt, but in the case of *The Banks of the Loire* there is a more exotic feeling to her costume. Instead of a French peasant, it appears that Turner has portrayed an Italian woman. With her lustrous dark hair and red dress, she is reminiscent of the studio portraits of Italian peasant women by Corot. Not surprisingly, when Turner painted this scene in early 1829 after arriving back from Rome, his most immediate point of reference would have been Italian, rather than French, costume.

For these composition devices Turner was indebted to his usual master, Claude Lorrain. Only a year or so earlier, in 1828, Claude's idyllic *Landscape with Hagar and the Angel* had been presented by Sir George Beaumont to the newly formed National Gallery, then in Pall Mall.[26] Elements of this work are so close to *The Banks of the Loire* that it is difficult not to believe that Turner was attempting a direct pastiche. They share the same upright format, similar groups of framing trees, figures in boats, eye-catching bridges, but, significantly, Turner has transformed the gentle aerial perspective of Claude's painting into an intensely radiant sunrise. More pointedly, he omits a literary or historical reference from his foreground, perhaps at the request of the Gordons themselves, whose taste was not classical, although, if Turner knew of Siffait's kindness to the families near Oudon, he may have had his own underlying programme.

Although he had received his commission for the picture before departing for Italy, where he was also inevitably reminded of Claude, it is not possible to say whether he worked on this canvas there. According to Sir Charles Eastlake, he is known to have begun '7 or 8 pictures and finished three' during his stay, but these works did not arrive in England in time for the following year's Academy

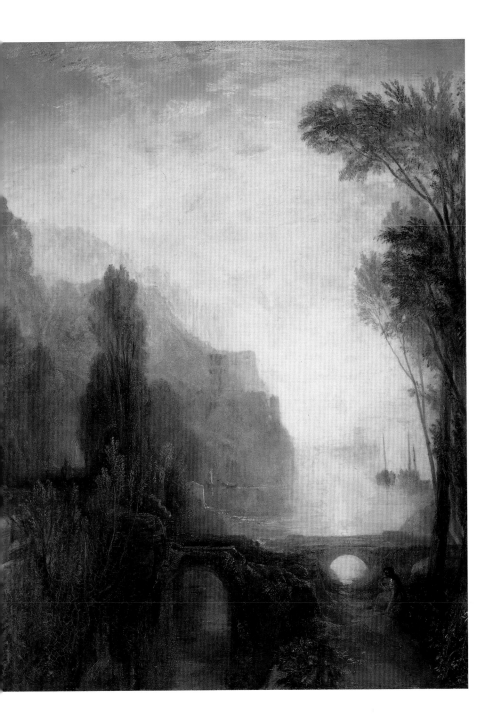

show.[27] Admittedly, the Loire subject is smaller than any of the finished works, and could perhaps have been carried back by Turner himself. However, its colouring and technique closely resemble those found in *Ulysses deriding Polyphemus*, which Turner worked on between February and April 1829.

While this date seems the most likely for the Loire picture, Turner may have worked on a version of the image during his time in Rome. This is suggested by the subject of one of the many unfinished 'Italian' sketches that was part of the cache rediscovered in 1944 at the same time as the view of the harbour at Brest (fig.173). Hitherto called *Landscape with a Castle on a Promontory* and dated uncertainly to the 'middle of Turner's career', this work sets out the basic composition of the Loire painting on a piece of canvas somewhat smaller than the finished work (Tate Gallery, B&J 281) Here the outline of the follies is made more prominent by drawing the mass of this headland upwards, but the trees on the left are in much the same place. That Turner had a request for a picture with specific measurements implies he did not intend to complete his work for the Gordons on this canvas, unless it was cut down subsequently. Another possibility is that he sketched out the subject in the manner of a colour 'beginning' before leaving for Italy, with the intention of using it to develop the final work, but was distracted by the more immediate desire to finish the group of three pictures that he exhibited at the Palazzo Trulli in an unsuccessful attempt to silence his critics in Rome.[28]

There are clear connections between the Loire scene and the Italian canvases, and in many ways it is a potted version of the features found in the view of *Palestrina* (Tate Gallery, B&J 295). However, in contrast with the grandeur and theatricality of the three Italian exhibition pieces, *The Banks of the Loire* is a work of much greater restraint, its charms deriving from the shady glade, with its invented tributary stream, and the golden warmth of the sky. Given the distinctly Turnerian character of this latter feature, it is amusing to discover that the authenticity of the picture was briefly questioned by the *Daily Telegraph*'s critic in 1912, when the picture was last exhibited in this country.[29] Eighty-five years later, there is no longer any doubt that this is one of Turner's works, but for the first time since 1829 it is at last possible to link the painting with its original title.

FIG 179 *The Banks of the Loire* RA 1829 (cat.100)

The Loire in Black and White

Designs for The Keepsake Annual

Two images of the Loire by Turner that achieved a much wider currency than his 1829 oil painting were printed in the 1831 edition of *The Keepsake* annual. This publication was one of about a dozen volumes of this type, which first began to appear in the early 1820s and included the *Forget-me-not*, *The Friendship's Offering*, and *The Amulet*. Each of these exquisitely produced pocket-books was published once a year just before Christmas. The annuals aimed to produce a broad and popular mixture of material to suit the increased interest in literature in the middle-class market. The product was usually a heady broth made up of a miscellaneous assortment of poems, essays and short stories, generally of a sentimental nature, which was supplemented by a handful of illustrations that included landscapes and fetching portrayals of young women (who were essentially the 'pin-ups' of the 1820s).[1] The general character was titillating not taxing, and it is hardly surprising that from certain quarters there was considerable disdain for the annuals, even though the editors managed to extract pieces from an impressive list of prominent literary names, such as Sir Walter Scott, Coleridge, Wordsworth, Mary Shelley, Tennyson, Ruskin and Thackeray.[2] Indeed, in spite of the involvement of these figures, it was generally agreed that the phenomenon of the annuals 'did more for arts than letters'.[3] The huge sales figures for any of these volumes brought an artist's work to a far wider audience than any of the London exhibitions.

Turner had contributed designs to annuals since 1826, when both *The Bijou* and *The Literary Souvenir* reproduced his work (R 313–14). But his most sustained association with any of the annual publications took the form of seventeen landscape and vignette designs that he made expressly for *The Keepsake* (R 319–35). This annual was published by Charles Heath, with whom Turner had begun to work on the set of *Picturesque Views in England and Wales* in 1825. A year later Heath was so encouraged by the continuing popularity of the first group of annuals that he set out to produce his own, initially hoping to secure Sir Walter Scott as his editor. The first volume of *The Keepsake* appeared at the end of 1827 and included Turner's view of Florence from San Miniato.[4] In the following years there was usually a pair of views by Turner in each edition, with complementary subjects.

In most of the sets of engravings for which Turner created watercolours, he had tended to select a standard size for the designs. This is also the case with the landscapes for *The Keepsake*, with one exception.[5] For some of his other serial publications the paper size was of roughly the same dimensions as the plate on which the design was to be produced. However, the expansive and lavishly detailed watercolours for *The Keepsake* are about three times larger than the diminutive prints based on them, and it was clearly intended that they could be exhibited and sold to publicise each new volume.

Although when first introduced it was more expensive than any of its rivals, *The Keepsake* sold consistently well during its first decade, averaging between 7,000 and 15,000 copies every year.[6] Heath employed many of the same engravers that he also used for the *England and Wales* series, and these men were also to become involved in the ensuing Loire project.

Two Loire subjects appeared in the 1831 *Keepsake*, but the engraving work would have been finished during the autumn of 1830, and Turner must therefore have created the watercolours on which they are based in either 1829 or early 1830 (figs.180 and 181). Both are reworkings of views he had recorded on blue paper during the 1826 tour, which he had later partly painted in colour, probably in 1828 (see figs.38 and 103). There are slight differences of interpretation between the studies and the finished watercolours, but by and large these are typical of the kinds of exaggeration Turner deployed when developing architectural subjects. The buildings on the left in the view of Nantes, for example, are given an extra storey and the central pediment is relocated, while the whitened form of the cathedral appears much more imposing, especially as its bulk is strengthened by the tail-end of a mass of swirling cloud. In both works it is the foreground that has been enhanced by the introduction of figures engaged in nursing children, plying the river or selling their wares. The long receding towpath in the view of Saumur provides a natural setting for these actions, but in the view of Nantes Turner has had to realign the flight of steps in order to create a wider quayside on which to place his characters. The

skies in both works are magnificent realisations of aerial perspective and were probably invented by Turner as part of the process of making separate experimental studies in his studio.[7]

Some idea of the kind of studies he was making for finished works at this period can be gained from a small group of watercolours that depict subjects related to the 1826 tour. Although these were probably begun with *The Keepsake* in mind, it is also possible that Turner first considered painting his series of engraved Loire views in pure watercolours on white paper. The first of these studies sets out the composition of one of the views of Tours from the west, but it is not clear whether it follows the blue paper design, as is the case in the engraved *Keepsake* subjects, or if it was a preliminary idea for that work (figs.112 and 182). The handling of paint on the left is unresolved and choppy, showing where wet colours have been worked into earlier washes that were not yet dry. In the distance the silhouette of Tours is barely suggested by the three or four stumps at the end of the bridge, but, though less important topographically, Turner has already brushed in the poplars on the island in the centre of the river. He has also indicated where he planned to introduce a figure in a boat. That this subject should be one of the few works to exist as a watercolour study is of special interest. It could be that a finished watercolour was also produced. But, more intriguingly, the view of Tours from the west was treated by F.C. Lewis as one of two undated aquatints, which may have been produced prior to the line engravings in *Turner's Annual Tour*, perhaps as a means of investigating ways of engraving the series.[8]

Another colour study has been identified as a view of Angers by Nicholas Alfrey (fig.183), and, although the forms in this watercolour are insufficiently precise to be easily related to any of the pencil sketches of the city, the solid round towers and the outline of a church or cathedral spire could suggest his identification is correct.[9] The top sketch in fig.96 is perhaps the closest to the general composition, but, if this is so, Turner has attempted to compress the information in his source material. Certainly, the extensive survey Turner made at Angers deserved to be given more tangible form in at least one watercolour, but there do not appear to have been any finished works in the records of early collectors.

The third 'beginning' is on a much larger sheet and must have been painted some time after 1829, since that is the date of its watermark (fig.184). It seems likely that it was created between 1830 and 1833, during the period when Turner was actively involved with the Loire. As in the case of the view of Tours, the composition can be linked to a design on one of the sheets of blue paper, this time for one of the works that was not afterwards engraved

(fig.63).[10] Which came first is a matter of speculation, but it is most probable that the large watercolour was based on the blue paper scene. Firstly, the 1829 watermark indicates a later date than the simple treatment of the motif on blue paper, which may have been produced around 1828, before the published set of Loire views was conceived. Furthermore, the large unfinished study has the same use of colour and seems to be a careful reworking rather than a newly created image. Even if this order is correct it remains unclear what function Turner hoped it would serve. Perhaps he initially envisaged a set of large views of the Loire based on the gouache studies he had painted before leaving for Italy. Another possibility is that he came back to the wonderfully tranquil image a number of years later and reworked its potent stillness in much the same way that he returned to some of his *Liber Studiorum* subjects.[11]

Turner's Annual Tour *for 1833*

By the time that the two Loire subjects were published in the 1831 *Keepsake*, Turner and Heath had decided to embark on a volume of views entirely devoted to the river, which was to appear under the title *Turner's Annual Tour*. In many ways this was an obvious decision led by market forces, as one or two of the annuals had already recognised and begun to cater for the public interest in foreign topography. Heath himself had created his own *Landscape Annual*, the 1830 edition of which was written by Thomas Roscoe and illustrated by Samuel Prout.

Another reason for the collaboration between Turner and Heath lay in the commercial success of the 1830 edition of Samuel Rogers's poem *Italy*. As even Rogers must have been forced to concede, the popularity of the volume arose almost exclusively from Turner's powerfully atmospheric distillations of Italian scenery. His engraved vignettes were widely admired and encouraged other publishers to seek his participation in their own projects. A set of landscape illustrations of places associated with Byron was undertaken in 1830, and other commissions followed.[12] In short, Turner's was suddenly the most desirable name in the publishing world.

It was as a result of these factors that at the end of January 1831, in its survey of the recent annuals, the *Athenaeum* reported the news that Turner was 'about to engage with Charles Heath in the production of Views on the Loire'. Because of his steady involvement with *The Keepsake* over the preceding years, neither his association with Heath nor the annual-like format of the projected volume would have been news of great moment for most readers, but the jour-

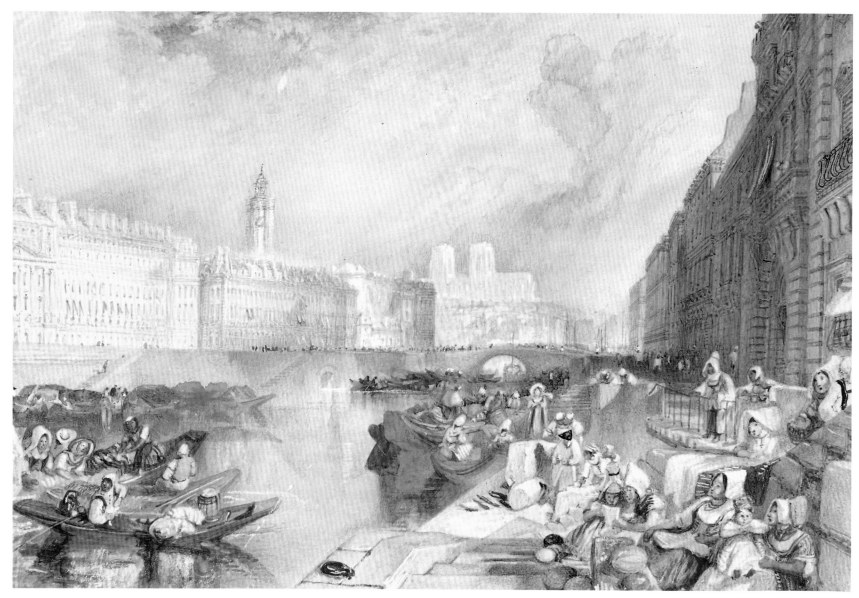

FIG 180 *Nantes* (for the *Keepsake, 1831*) *c*.1829–30 (cat.104)

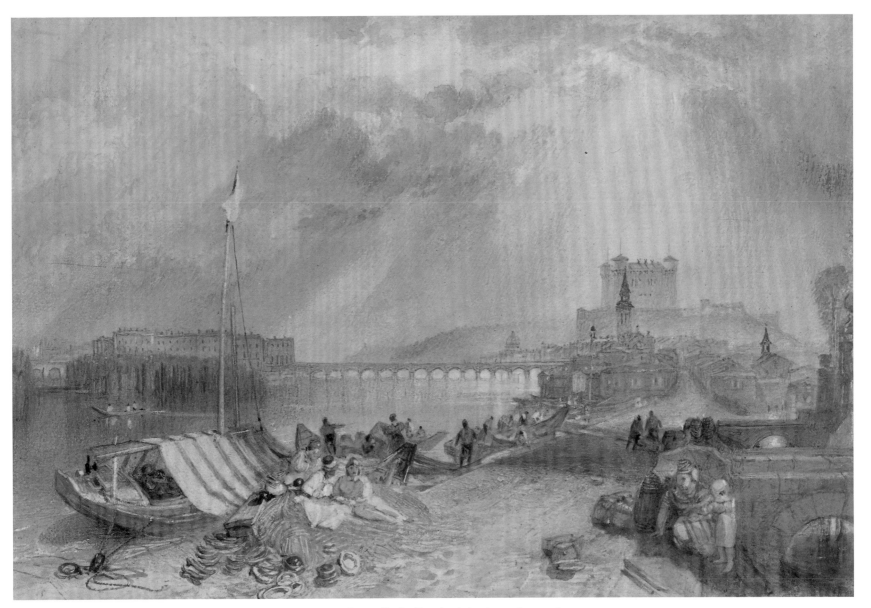

FIG 181 *Saumur* (for the *Keepsake, 1831*) *c.*1829–30 (see p.225)

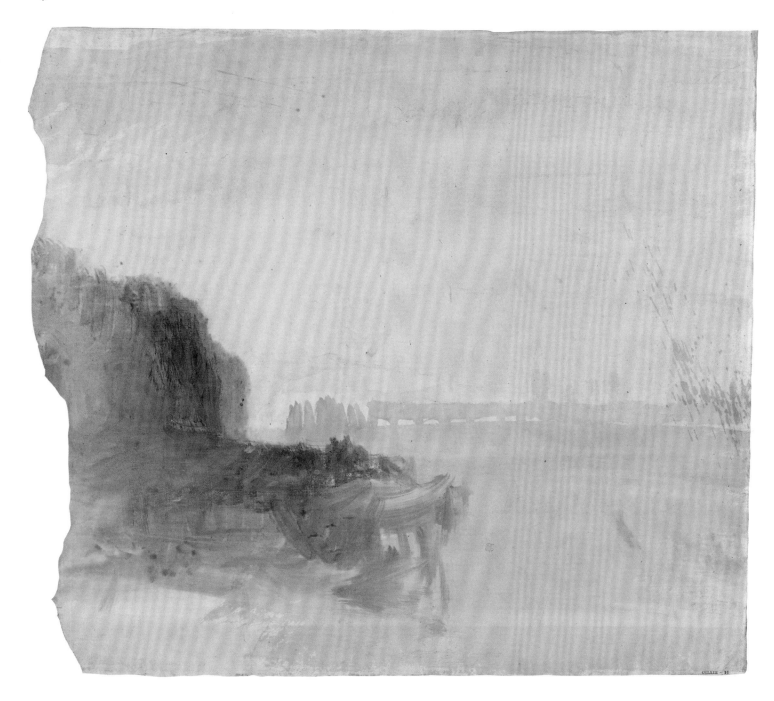

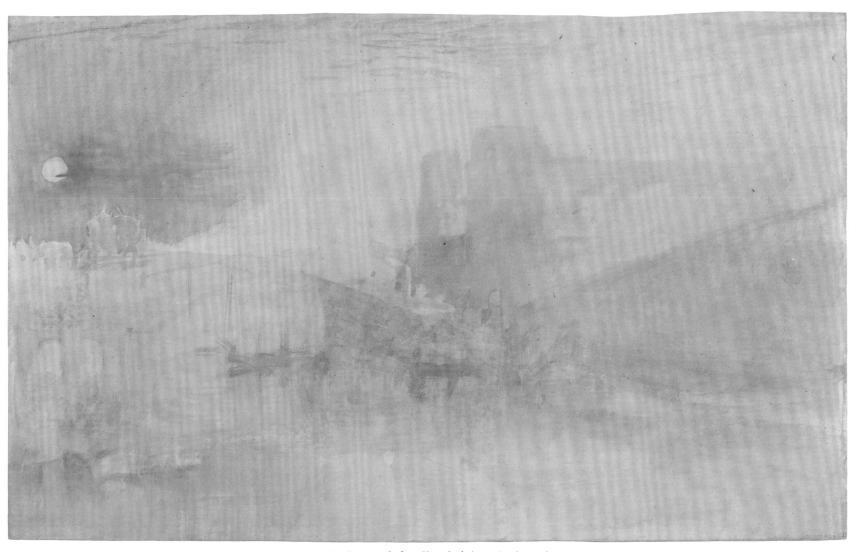

FIG 183 *Angers,* study for a *Keepsake* design *c.*1829 (cat.101)

FIG 182 *Tours from the west,* ?study for a *Keepsake* design *c.*1829 (cat.102)

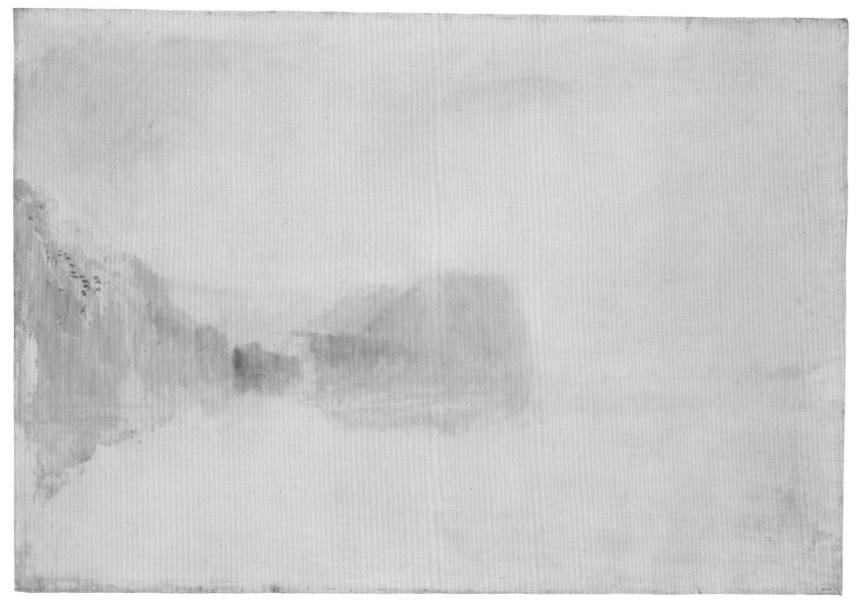

FIG 184 *Scene on the Loire, near the Château de Clermont c.*1829–33 or later (cat.103)

nalist used the new scheme as a means of making a dig at Turner's expense: 'We recollect to have heard this eminent artist anathematise the whole race of Annuals, as ruining art, and deluging the public with steel impressions.'[13] One might add '*cheap* steel impressions', for this was clearly an underlying concern for Turner. After the long years of seeing his designs produced on copper plates, which allowed only limited runs before the plate needed careful reworking, the sudden introduction of the more durable steel plates in the first years of the 1820s must have appeared to represent a loss of control. He did experiment privately with steel plates for some of the designs known as the 'Little Liber', and his *Rivers of England* may have been the first landscape series to be engraved on steel, so that by the time of his work for the annuals and for Rogers he had effectively assimilated the new technology. But even at this date it appears that he had some reservations about the much larger quantity of impressions that the new plates permitted. Though this meant his work could reach a much wider audience, he obliquely expressed his fears about the long-term significance of mass reproduction, apparently suspecting that if his creations could be sold cheaply by vendors from baskets there must be an inevitable tainting of his original art work.[14] Nevertheless, it was from steel plates that the Loire subjects were eventually printed.

Regrettably, there appear to be no records of the terms of the contract that Turner and Heath drew up between them. A few years earlier Heath had paid the artist thirty guineas for each of the *England and Wales* watercolours, which the publisher had then sold for a profit alongside the engravings at the 1829 exhibition in the Egyptian Hall in Piccadilly. The watercolours for that series were considerably larger and more detailed than the Loire views, and Turner would not have hoped for a comparable figure. However, rather than selling his Loire designs to Heath, he most probably rented them out in much the same way he had done when working on the illustrations for Samuel Rogers, who had eventually paid five guineas to borrow each vignette, after first proposing to buy them for fifty pounds a time.[15] Unfortunately, there is no entry recording a payment to Turner in Heath's account books to confirm this assumption.

Nevertheless, the high level of Turner's commitment to the project cannot be doubted and was reflected in the overall title: *Turner's Annual Tour*, or *Turner's Landscape Annual*, as it was sometimes known before publication. Luke Herrmann has made the valuable point that, whilst there were other landscape publications, Turner's was the only annual 'named after the artist whose work appeared in the engravings',[16] and it was with the aim of consolidating Turner's success in the field of book illustrations that work on the Loire engravings began.

By January 1831, when news of the project became public, Turner had probably already completed the set of gouache designs, or was shortly to do so. As always, the first few months of the year were his busiest time because of the demands of the forthcoming Academy exhibition, and, if he did allow his Loire work to carry on into 1831, he would have finished it prior to the opening of this annual event in May or, at the very latest, before departing for Scotland at the end of July. Presumably he and Heath would have agreed the group of twenty-one subjects before sending works off to individual engravers. Since some of the proofs are actually dated '1831', they must have received the original compositions by the end of the first quarter of that year; most publishers allowed their engravers six months or longer to translate a design, depending on its complexity.

How Turner and Heath determined on the selection of subjects is worth some consideration, as the twenty-one engraved views of the Loire are not really a balanced presentation of the entire river. Apart from the glut of seven scenes between Nantes and Angers, there are four views of Tours (figs.112, 113, 115 and 121) and two each of Blois (figs.129 and 134), Amboise (figs. 124 and 126) and Nantes (figs.29 and 34). Most surprisingly, the river is absent altogether from four of the set, which instead concentrate on the facades of churches, cathedrals or châteaux. Because of the impetuosity of his journey, which was more like a race from town to town, there was very little spare material of the places in between that could later provide substance for finished designs. The greatest flexibility lay in the sketches made on the steamer journey between Nantes and Angers, which is reflected in the prominence of this material. One obvious gap was a view of Angers, but the self-imposed limits of the 'Rivers' project seems to have confined Turner and Heath exclusively to subjects actually on the Loire. Few of the unpublished colour studies are of the same quality as the finished set, although they may have considered using the alternative views of Amboise (fig.125), Blois (fig.130) or a riverside vista of Orléans. The two views of Tours from the west offer different foregrounds but show essentially the same prospect of the city (figs.112 and 113). Furthermore, the first of the two (later referred to as *Tours looking backwards*) is similar in the structure of its composition to the work engraved as *Rietz, near Saumur* (fig.107), a factor that may have induced Heath to break the topographical sequence of the plates by placing the general view of Saumur before the more easterly subject, which should precede it if the course of the river is followed literally.

The names of the subjects as they appeared under the engraved image have been inscribed on the back of some of the finished subjects (see cats.111 and

117). However, for the most part, the Loire drawings in the Ashmolean Museum remain stuck to their mounts, so it has not proved possible to carry out a thorough survey. These annotations may have been added by Turner, who must have supplied the confused titles of *Château Hamelin* (fig.72) and *Rietz, near Saumur* (fig.107). Similar notes appear on the backs of the drawings for the Seine series, where it is apparent from the numbers also inscribed there that a sequence had been identified before engraving work began.

All of the nine men who engraved the Loire views had worked with Turner before, but this was the first time they had been asked to work from images painted in gouache on blue paper. Even to those with long experience of translating his generalised and indistinct effects, this new technique called for a period of adjustment and required Turner's supervision at every stage of their work to ensure that each subject was realised according to his intentions. There are, as a result, a number of touched proofs of most images in the series on which Turner has revised the nuance of a lighting effect or changed details to give greater force and clarity. Sadly, the scope of this publication does not allow these intricate transformations to be illustrated in detail, but the changes for each plate are set out in Appendix C.

Robert Wallis (1794–1872) was probably the most experienced of the group, having previously engraved nearly thirty watercolours, including the view of *Saumur* for *The Keepsake*. It is on the proofs of two of his four Loire subjects that the date '1831' can be found. These were the views of the *Coteaux de Mauves* and of *Tours* from the west (figs.211 and 202), both of which have rugged, angular foregrounds that recede into airy distances. The early completion of *Tours* may be contemporary with Turner's attempt to develop a large watercolour of the subject (fig.182).

An expenses ledger recording Heath's payments to his team of engravers still exists as part of the Longmans archive at Reading University and is reprinted here for the first time (fig.185).[17] This makes plain that Wallis received the standard rate for finishing a plate, which was £52 10s. Robert Brandard (1805–62), on the other hand, had negotiated the more substantial rate of £57 15s. for each of his six subjects, which was the largest group produced by any of the engravers. Like the other men, he also received interim payments for revisions and continuing work on plates. Surprisingly, in comparison with Wallis or the majority of the team, Brandard had previously engraved very few of Turner's watercolours, which make his higher fees and his dominance of the Loire set all the more noteworthy. He would have been around twenty-five when he started work on the project and clearly benefited, as did so many young

Heath's Turner's Annual Tour

1832

Jany 14	To Brandard for 2 plates	115.10.–	[? / ?]	
25	" Robert Wallis for 2 plates	105.	[figs.202 and 211]	
Feb. 17	" Willmore for a plate	52.10.–	[?]	
18	" Brandard for 2 plates	31.10.–	[revisions]	
22	" Wilmore [sic] for a plate	52.10.–	[?]	
March 3	R. Wallis on acct of 3 plates	63 –	[revisions]	
April 16	To Brandard for a plate	42 –	[?]	
28	To Radclyffe for a plate	52.10.–	[fig.201]	
May 4	To R. Wallis for a plate	52.10.–	[?]	
11	To Brandard for a plate	57.15.–	[?]	
	To W.R. Smith for a plate	52.10.–	[fig.198]	
June 20	To Allen for a plate	52.10.–	[fig.197]	
	To Brandard for a plate as pfolio 164	57.15.–	[fig.194]	
Aug. 3	To Carter for a plate [deleted] see 164 [★]	42	[deleted]	
	To Miller for 2 plates	126.–	[figs.207 and 212]	
4	To Higham for pl of Orleans	63.–	[fig.193]	
20	To Wallis on acct of a plate	26.5.–	[revisions]	
31	To Willmore on acct of a plate	20.–	[revisions]	
Sept 14	To Jeavons for a plate	52.10.–	[fig.199]	
18	To Brandard for a plate	57.15.–	[?]	
27	Miller for Vignette	36.15.–	[fig.192]	
29	Willmore for a plate	43.–	[?]	
	R. Wallis for a plate	52.10.–	[?]	

Carrd to 4C 225 £1265.5.0.

Carrd over

★ See also p.164 of the Ledger for a payment to Brandard, which was mistakenly entered under Heath's Picturesque Annual for 1833

FIG. 185 *Record of Payments made to the engravers of the twenty-one illustrations to 'Turner's Annual Tour, 1833'* (transcribed from page 157 of the Publications Expenses Ledger, Longman Archive, University of Reading)

engravers, from Turner's exacting scrutiny of each detail. He was clearly quick to learn and went on to produce many more designs after Turner, including seven of those for *Turner's Annual Tour, 1834*.

Two other young engravers both executed a plate each. The older of the two was James Baylis Allen (1802–76), who had worked on numerous topographical partworks for other artists but had only engraved Turner's *England and Wales* view of *Stonyhurst* (W 820; R 244) before he began work on the technically accomplished view of the *Château of Amboise* (fig.197). Thomas Jeavons (1806–67) was the youngest engraver but was already a fixture of the *England and Wales* series. His black and white version of *The Canal of the Loire and Cher, near Tours* brilliantly evokes the glorious sunset effect in Turner's original (see figs.121 and 199).

Among the older generation, to which Wallis also belonged, were William Radclyffe (1780–1855), Thomas Higham (1795–1844) and William Raymond Smith (*fl*.1818–48), who each engraved one plate. As the choice of subjects they were given suggests, their individual strengths lay in their ability to translate architectural scenes. Prior to the Loire illustrations, Smith and Higham had worked on many topographical volumes, including J.P. Neale's set of *Views of the Seats of Noblemen* (1818–24), and all three, together with some of the other Loire engravers, had completed engravings for a series of views that was published in 1829 as *Metropolitan Improvements*, based on watercolours by Thomas Hosmer Shepherd. Of their three Loire subjects, Radclyffe's realisation of the moonlit depiction of *St Julian's, Tours* is generally agreed to be one of the finest of the group (fig.201).

Almost as prolific as Wallis was James Tibbetts Willmore (1800–1863), for whom the Loire project also represented the beginning of a long association with Turner. Like Wallis, he had produced a Loire subject for *The Keepsake* in 1831. His three plates for the later volume made a distinctive contribution to the presentation of the lower reaches of the Loire. Above all, his subtle engraving of the view of the château of Clermont was unanimously agreed by the early critics to be the most evocative of the entire series (fig.210).

Perhaps the most talented of the team was the Scotsman William Miller (1796–1882), who had first sought work as an engraver of Turner's designs around 1820, when he reproduced one of the already published designs for the *Picturesque Views on the Southern Coast of England* as an example of his skill (R 99a). Turner was quick to appreciate Miller's abilities and remarked to one of his publishers, 'There is so much good work about Miller and it would [be] but justice to tell him so from me if you like.'[18] As we have already seen, he immediately turned to Miller when embarking on his project to illustrate

The English Channel, and repeatedly requested his services as an engraver, so that by 1851 Miller had produced seventy prints based on works by Turner. After training with George Cooke in London, he had returned to Scotland in 1821, which meant that watercolours and corrected proofs were sent backwards and forwards up the Great North Road until the finished plates were ready. In August 1832, when he was nearing the end of his work on the vignette of *Nantes* (figs.29 and 192), he had hoped to receive comments on the proofs, but Turner was then in Paris. This was not a matter of great concern to Charles Heath, who obviously had faith in Miller's abilities and simply encouraged him to 'do as well as you can without his touches'.[19]

As the entries in Heath's ledger reveal, Miller's vignette was almost the last work to be completed and paid for. All the plates were finished by the end of September 1832 and the long print runs must have already begun, so that reviewers were able to see copies of the completed portfolio towards the end of November. The two printing companies of McQueen, and Perkins and Bacon were involved, and the engravings were officially published by Longman, Rees, Orme, Brown, Green and Longman. Although the prints were available separately as proofs on India paper, they were intended to form a volume in the manner of the other annuals specialising in landscape.

To accompany the illustrations, Heath commissioned Leitch Ritchie (?1800–1865) to write an account of a journey down the Loire, which gives the volume its alternative title, *Wanderings by the Loire* (this appears on the spine, but the frontispiece carries the title 'Turner's Annual Tour. 1833'). Ritchie was then one of the most popular writers of the kind of companionable fare offered by the annuals, and was to become best known as the editor of the *Library of Romance*, which was published for the first time in 1833. The *Atlas* pronounced him 'the Scott of the short, picturesque, bold, and dramatic story', and his skills were described as follows by the *London Weekly Review*: 'The power of fascinating the reader, of chaining him down as it were, while his fancy is tormented by terrible imaginings, is the principal characteristic of Mr. Leitch Ritchie's fictions.'[20] He had been born in Scotland at Greenock but had moved to Normandy in 1829, where he subsequently published a history of France. His only previous work for Heath seems to have been the text of the 1832 edition of the *Picturesque Annual*. As with Turner, Heath's account books do not record how much Ritchie received to cover the cost of making his trip down the Loire, nor the fee paid for his text.

In his narrative he describes the Loire as it would be seen if travelling from Orléans to Nantes. This was how visitors from Britain tended to approach the

In the Wake of the 1826 Tour

river, but it meant reversing the order in which Turner had made his sketches. In the published volume the order of the plates does not follow the exact course of the Loire, but darts backwards and forwards within Ritchie's framing structure.[21] Ritchie's achievement in the resulting text was his ability to knit together his own experience with Turner's views in a way that proposes they were as one in their responses to the scenery, reacting simultaneously with pen and pencil. One or two of the first critics to see the volume were unwittingly taken in and stated that Ritchie had travelled with Turner in their reviews, a mistake that soon become an established fact. But though Turner had mounted the Loire during the first weeks of October 1826, Ritchie could not have made his journey until the summer of 1832. This is clear because he travelled with 'a few of the beautiful engravings of this volume', which had only begun to be paid for as they were completed in the first part of that year.[22] According to his text, he was at Tours on the Sunday after the Fête Dieu (i.e. Corpus Christi), which in 1832 fell on 24 June.[23] Because of the attempt by the Duchesse de Berry to rouse the Vendée a few weeks earlier, this was a momentous and dangerous time to be travelling through the region, but Ritchie omitted any reference to the disturbing events, preferring to evoke a country rich in historical interest, rather than one involved in the bloody events of making history. His text is peppered with romantic short stories, dealing with troglodytes, pirates and Blue Beard, which one critic suspected were introduced to 'relieve the sober monotony of mere description'.[24]

At Beaugency, soon after the beginning of his tour, Ritchie met with a mishap that could have prevented him travelling any further. He was obviously aware that the town had been painted by Turner, even if he did not actually have a copy of the finished print with him. Leaving his belongings in the diligence, he hoped to discover the riverside view before the coach horses were changed over. Perhaps inevitably, when he returned to the staging post, the vehicle had already departed, taking his possessions with it. This included a bundle of the Loire engravings, made up of perhaps nine completed subjects, although there may also have been proofs of some of the other views.[25] As he ruefully noted later, this was the 'treasury of the journey, [which] was merely inscribed with our name'.[26] Fortunately, he was able to recover the package once he had walked most of the way to Blois.

Although Ritchie was at great pains to stress the beauties of the illustrations in his text, the opportunity of being one of the first to follow in Turner's footsteps alerted him to factual inaccuracies and exaggerations perpetrated in the finished views. He told Alaric Watts much later how he had been 'frequently surprised to

find what a forcible idea [Turner] conveyed of the place without a single correct detail', although this charge smacks somewhat of hyperbole on his part.[27]

The first chance for others to assess Turner's new work came at the beginning of December 1832, when Heath started to advertise the portfolio of engravings.[28] Various types of proof were available from Moon, Boys and Graves in Pall Mall, as well as from other printsellers, at £2 2s. for standard proofs, £3 3s. for India proofs, and £4 4s. for proofs before letters, prices that are fairly comparable with proofs of other recent prints after Turner.

There had already been some excitement at the idea that Turner was about to add to the ever-increasing number of annuals with his own volume. The *New Monthly Magazine and Literary Journal*, for example, remarked on their imminent publication in its December edition, published at the beginning of the month, and noted that it was likely to be 'the most excellent of the whole race' of annuals.[29] It went on to praise the engravings in the highest possible terms: 'They are of surpassing beauty… Indeed it is scarcely possible to conceive greater excellence in art, either of design or execution. They have all the magic of Turner's pencil – and the several engravers have done justice to the effects of the British Claude.'[30]

In fact, this was just the beginning of an overwhelmingly positive response to the new illustrations, something that has not been appreciated before, as this is the first time the reviews have been collated (see Appendix D). Those with their suspicions about the Byzantine workings of the publishing world (then and now) might suspect that some of these reviews could be merely 'puffs' written by friends of the artist or publisher. But what is remarkable is that the favourable reviews came from an astonishingly wide range of papers and periodicals, in which the critics were more usually quite hostile to the oil paintings Turner exhibited at the Royal Academy. The positive comments are, however, not simply part of the trend to favour his works on paper, since other contemporary sets of engravings met with adverse criticism. Those undertaken to illustrate Byron, for example, did not always meet with the approval of the press.[31]

Typical of this reversal in Turner's critical fortunes were the comments of the critic of the *Literary Gazette*, who attempted to make amends for his former rudeness:

We are sure that none of our readers will suppose, because we have occasionally indulged in a laugh at some of Mr. Turner's extraordinary vagaries as an artist, that we are insensible to his merits. There is no man living – are there many of the dead? – entitled to rank with him in the highest qualities of that branch of the arts which is his peculiar vocation. When he is in his proper element, and when he chooses, no man has ever

communicated more of the most refined poetic feeling to the productions of his pencil. Others are landscape-painters: Mr Turner is much more.[32]

Turner's illustrations were published at the same time as another of Heath's new annuals, *The Book of Beauties*, which was not so well received. Several reviews made the point that it was badly titled, including that focusing on the Loire illustrations in the *Athenaeum*, which proclaimed, 'THIS is the true Book of Beauty; all others are spurious. We have sometimes seen individual landscapes of great loveliness from the hand of Turner, but we never saw at once so many truly excellent.'[33] It was unanimously agreed that the engravings far surpassed those produced for any other annual. One critic wrote, 'Accustomed as we are to most beautiful design and splendid execution in productions of this class, we cannot but think that the present publication excels all that have preceded it.'[34] The range of subjects selected for the set met with approval in the newspaper review in the *Atlas*: 'He has committed to his portfolio nothing that was not worthy of its place; he has chastened the exuberance of his imagination, and avoided much of the mannerism that defaced his former works.'[35]

The fullest and most considered discussion of the series appeared in the *Spectator* on 8 December. This unsigned review examined the illustrations at great length, and set out to demonstrate how Turner's works met the standards of good landscape painting. It was a sensitive and didactic piece that in many ways foreshadowed the approach the young John Ruskin was later to pursue so successfully. Surprisingly, the critic was not especially impressed with the scenery of the Loire as presented by Turner, deciding that 'the country is not prolific in scenes of beauty or grandeur'.[36] The critic was also attentive to the occasional distortions resorted to by Turner when composing the images, which provoked the following observation: 'He often sacrifices literal fidelity to his feeling for the beautiful, by aggrandising the peculiar features of a scene, so as to give it a grander and more romantic character; but he never outrageously violates truth, and is always consistent.'[37]

It was not only Turner that received commendation. The engravers were given due attention as individual works were discussed by various critics. Three designs were especially singled out for praise by the critics, with a consensus forming that Willmore's *Clairmont* was the finest. The *Spectator* pointed out how different Radclyffe's treatment of *St Julian's* was 'from the coarse, cold, theatrical effect of common moonlight scenes!',[38] while the *Atlas* noted the subtlety of J.B. Allen's view of the château and bridge at *Amboise*: 'There is much skill displayed, particularly in the indistinct background. Too much detail is often TURNER'S fault; here a few touches produce an extraordinary effect.'[39] The

deftness of Miller's work was also noted by the *Spectator*, which commented that he translated Turner's works 'better than almost any other engraver'.[40]

All of these reviews had been published before the bound version of *Turner's Annual Tour* was actually issued and available. The date of publication was announced as being Tuesday 18 December in an advertisement in the *Literary Gazette* on the preceding weekend, but it was first included in the *Morning Chronicle*'s list of 'Books Published this Day' on Wednesday 19 December.[41] Heath must have spent a considerable sum advertising the new volume, as the standard details about the book were widely printed in journals during the following week.[42] Though his accounts for December 1833 reveal what he spent promoting the second volume of the *Annual Tour* (the first of two devoted to the Seine), no amount has been traced for the Loire volume a year earlier.[43]

It is important to note that this was the first time a set of Turner's views had been published complete in one volume. Previously they had only been stitched together as a book after having been published over a number of years in parts. As a bound volume, issued in a deep purple binding with the edges of the paper decorated in gold, the new annual was certainly stylish. In its review the *Gentleman's Magazine* appealed to the latent snobbery of the buyers of the annuals by remarking, 'Its very appearance is aristocratic, and may be considered as the Lord of the ascendant in the present family of Annuals.'[44] But one was clearly expected to pay for such quality. Significantly, the book was double the price of any of its rivals, selling for the rather expensive sum of two guineas. The *Morning Chronicle* was quick to attribute this to Turner's fondness for money, but astutely considered it likely to be an injury to the publishers: 'Swift said that "twice two does not always make four"; and what is true in finance, as it regards the State, is, we believe, equally so with respect to bookselling – especially in works like this, which every one covets the possession of, and brought within their means, would have.'[45]

These were practical criticisms, for the 1832 season had already seen the deaths of two annuals – *The Gem* and *The Winter's Wreath*. At the beginning of December the *New Monthly Magazine* had warned:

It is clear, however, there are too many of the class; and that, although there may be a hundred thousand purchases of such works, if the market be overstretched, the chance of profit is very small. We believe the general opinion is that the gains bear no proportion to the expense and risk attending such costly publications; and that, consequently, the appearance of a new competitor is but another step towards the downfall of the race.[46]

If the sales of the Loire volume were perhaps affected by its costliness, there

was also a number of rival publications competing for the public's sudden interest in Loire scenery. Presumably the announcement that Heath and Turner intended to produce a set of views of the river, which had appeared in the *Athenaeum* at the beginning of 1831, had allowed others to anticipate the likelihood that they too could capitalise on the popularity of the Loire.

The first of these publications was a set of lithographs by a Brighton-based artist called Louis Parez, who had made his tour during the summer of 1831, probably only months after the note in the *Athenaeum*. His work appeared as *A series of Views illustrating the most interesting and beautiful Scenes on the Loire and its environs* and was reviewed alongside Turner's set of views in January 1833. The periodicals and newspapers issued on either side of Christmas 1832 also included reviews of the latest literature, including the frequently controversial notices of Tennyson's 1832 volume of poems, which included 'The Lady of Shalott' and 'The Lotos-Eaters'. A less important work in the history of English letters, but one that adopted an epic scale, was Thomas Mountford's volume *The Loire*. Despite its topicality, this was roundly dismissed in the *Gentleman's Magazine* as 'a poem written, if not in imitation of, at least in the manner of [Byron's] Beppo and others'.[47]

Though these works did not, perhaps, constitute a serious threat to *Turner's Annual Tour – Wanderings by the Loire*, there was a volume that directly confronted the work of Turner and Ritchie. This was published anonymously at the end of January under the rather twee title *Six Weeks on the Loire, with a Peep into La Vendée*. The author was actually someone called Elizabeth Strutt, who had already written a number of books based on her travels, including *A Spinster's Tour in France, the States of Genoa, &c. during the year 1827*. Her new volume on the Loire was similar to Ritchie's model, starting at Orléans and ending at Nantes, but her text was frequently more interesting because of the intense curiosity she had about the country she was passing through, and the directness of her style. We do not know whether she was inspired to undertake her journey by news of Turner's project, but it is clear from her text that she was well informed about contemporary art in general, and that she knew at least one or two artists personally, so she could well have known of it.[48] In fact, her journey predates Ritchie's by a couple of weeks, for when he was witnessing the procession of the Fête Dieu at Tours, she was watching a similar display further downstream at Angers.[49] Her earlier departure meant that she was sometimes embroiled in the repercussions of the Vendée uprising during the summer of 1832, but this unexpected dimension to her tour makes it all the more fascinating.

Perhaps the most unexpected feature of her volume, however, is its inclusion of four etchings of Loire subjects – Clermont, St-Florent, Montjean and Angers (fig.186) – the first three of which are directly based on Turner's published views of the same places. The book does not attribute them to anyone, and surprisingly none of the press noticed their relationship to the recently reviewed series by Turner. Ironically, the critic for the *Athenaeum* even went so far as to remark that 'the embellishments are better than ordinary'.[50] The illustrations seem to have been based on the engravings in *Turner's Annual Tour*, rather than on Turner's drawings, and it is most probable that they were quickly etched at the end of 1832, within weeks of the first publication of the original portfolio. That of the château of Clermont blends Willmore's acclaimed view (fig.210) with Miller's plate *Between Clairmont and Mauves* (fig.207) but in the process misinterprets the distant tower of Oudon as the sail of a Loire barge. Most intriguing is the source of the view of Angers, which perhaps coincidentally replicates a view on the back of page 30 of the *Nantes, Angers, Saumur* sketchbook (fig.88). If Turner knew of this plagiarism of his designs, he did nothing to check it, although, if the view of Angers is based on his pencil sketch, as is possible, he may in any case have been a party to the production of these plates. Support of a kind for the idea that the illustrations appeared with his consent comes from a lawsuit that Turner took out later this very year against Charles Tilt. This concerned three of Turner's designs for the *Provincial Antiquities and Picturesque Scenery of Scotland*, which Tilt intended to publish from his own engravings, rather than from those Turner had overseen and approved. As Turner attempted to prove, this was an infringement of his copyright, which he was keen to defend. If he had not been involved in some way with the plates for the Strutt book, it is remarkable that he did not also feel compelled to defend his more recent Loire scenes in the same way.[51] Clearly, further information is required about Elizabeth Strutt to clarify this connection.

Sales of Turner's Loire *Tour*, whether as a result of competition, or because of its high price, were not as good as expected.[52] Only six months after it was first published, the book was relaunched in June 1833 at the cheaper price of one guinea, half its original price. It was at that time that Heath began to promote the book as the first in a series called 'Great Rivers of Europe', covering 'The River Scenery of Europe'.[53] It was already known that the second volume was to focus on the Seine, but reactions to this news had not been greatly appreciative. The *Atlas*, in particular, had been blunt: 'The choice is not very good, although there are many points of grace and beauty in the Seine. We could point out more fertile materials elsewhere.'[54]

Precise figures for the number of copies of the Loire volume sold cannot be

FIG 186 *St Florent* and *Angers*, two of four illustrations from *Six Weeks on the Loire with a Peep into La Vendée* 1833

readily established from the documents in the Longmans archive. However, John Heath has conclusively shown that the number of copies printed of either of the succeeding Annual Tours was, as a result, lower than the seventeen hundred or so sets of the Loire.[55] In an attempt to recoup some of the costs of the Rivers project only a few years later, Heath appears to have reprinted the plates through the original publishers Longmans, but, according to the publication line on the prints, they worked in collaboration with Rittner and Co. in Paris, and Asher in Berlin.[56] Some of the impressions are dated 1835, suggesting Heath's commitment to the project was already in trouble at the time of the publication of the second group of Seine views. He seems to have sold the plates for the Loire and the two Seine sets to the publisher John McCormick, who operated from the Strand. This resulted in the first edition of *The Rivers of France* in 1837,[57] which presented in one volume all sixty-one river views, accompanied by edited versions of Ritchie's texts, for the reasonable sum of a sovereign, as was noted by the young Ruskin, who had acquired a copy by 1840, when he recommended it to his friend Edward Clayton.[58] The Loire images were subsequently reprinted many times – in 1853, 1857, 1886 and 1895 – and in varying formats (see p.00). After McCormick the plates later passed on to Henry Bohn, and then to J.S. Virtue and Co., but it is not known if they have survived.

The perception of Turner in France in the 1830s was quite different, and it is surprising to discover, as a result of the diligent research of Olivier Meslay, that

Turner's engravings of the Loire were reviewed in neither the *Journal des Artistes* nor its more progressive rival *L'Artiste*. Nevertheless, it is important to note that the designs must have been admired there, though perhaps not always in the form Turner had overseen. Several of them were re-engraved as lithographs by Edouard Hostein and published in 1834 by the Paris firm of François and Louis Janet, in collaboration with Baily, Ward and Co. of New York (i.e. based on figs.112, 113 and 126). At least one or two of the images were also reproduced by Ferdinand Perot and Frederick Salaté (derived from figs.100, 149 and 180). Although these impressions are greatly inferior to the original set, they did ensure that Turner's images were well known to the next generation of landscape artists on both sides of the Channel and on the other side of the Atlantic.

Back in January 1833, the *Morning Chronicle* had considered Turner's first *Annual Tour* the 'most extraordinary collection of landscapes ever published in a body', claiming that 'a more gorgeous work has not been witnessed in this country'.[59] By replacing Ruskin's well-known endorsements of the Loire series with a more immediate setting of this kind, it is once again possible to see the true significance of this ground-breaking publication. For Turner this was also a landmark. The volume created a new pattern in which he could present his work, providing an ambitious 'Napoleonic' framework for his continental explorations that was not limited solely to the rivers of France but could be used, he hoped, to conquer Europe.

The Later History of Turner's Loire Views

This concluding essay is concerned with the subsequent history of the Loire drawings, and the influence that the volume of engraved views had on Turner's contemporaries and on the following generations of artists. Though strictly speaking an amateur artist, John Ruskin was the chief figure among the second group. But the later history of the Loire illustrations is also inextricably bound up with Ruskin the collector and critic, partly because he owned many of the published set for a time but, more importantly, because he gave that group to the museum in Oxford, where he encouraged others to see them as one of the high points in British landscape painting.

Though the sales of the published volume of Loire views may not have been as encouraging as Turner or Heath had perhaps anticipated, the set does seems to have had an immediate resonance among contemporary artists, at least in terms of the subject matter. For, by the time that the engravings were published at the end of 1832, the Loire was already becoming a popular goal for artist-visitors.

David Cox (1783–1859) had intended to make a trip down the Loire in 1829, but had confined himself to Paris after an injury to his leg.[1] More successful was Samuel Prout (1783–1852), who visited the Touraine region for the first time in 1826 and possibly returned there again in 1830, but more certainly in 1833.[2] However, it was only from 1834, a year after the publication of Turner's Loire set, that Prout began to exhibit watercolours reflecting his own travels in the area. The majority of these works focused on the architecture of Tours (fig.187), but he also completed views of Orléans, Blois and Amboise.[3] In 1834 he published the set of lithographs *Interiors and Exteriors*, which included subjects entitled *At Blois* and *At Tours*. Though Prout was clearly able to find purchasers for Touraine scenes, numbering Ruskin and his father among them, the area never assumed the same importance in his repertoire as northern France or Venice.

Another artist who sought out the Loire a few years after the appearance of the views in *Turner's Annual Tour* was William Callow (1812–1908), who made the first of two visits to the region in June 1836.[4] His tour began at Orléans, but he left the river close to Saumur, thereby avoiding Angers and the other sites Turner had recorded to the west. On the basis of the sketches made on the

1836 journey, he was able to produce a large group of Loire subjects over the next sixty years, several of which incidentally echo Turner's compositions of the same places (fig.188).

Although the publication of Turner's engravings may well have contributed to a turning point in the perception of the river, a great measure of its new-found popularity came from the improvement in travel facilities due to the regular steamboat services from Orléans, via Tours, to Nantes. From 1829 onwards guidebooks were available for those travelling on the steamers. Victor Hugo was among those who enjoyed studying the river from a steamer during his 1834 journey, as was Stendhal three years later.[5]

For British visitors of this period the attractions of the river are perhaps best summed up by Leitch Ritchie, who considered it alongside the Rhine and the Rhône: 'The Loire, to an Englishman, is the most interesting of the three. It waters those famous countries of Touraine and Anjou, where the bones of his ancestors are found to this day. Its banks are connected with numberless associations both of history and romance.'[6] This special combination of 'history and romance' was the chief quality craved by the generation after Turner, and it was these elements, instead of pure topography, they sought on their visits to Touraine. Thomas Allom (1804–72) and William James Müller (1812–45), for example, both attempted to recreate the glories of the age of François I in their depictions of Blois, Chambord and Azay-le-Rideau.[7]

While all of these artists were able to sell their views of Loire scenery, it is unlikely that Turner ever attempted to part with his group of finished drawings until around 1850. Significantly, there is no evidence to suggest that they were offered for sale at the time that the prints were first published, so that they continued to remain in Turner's possession, unlike the finished drawings for most of his other sets of engraved views. This is in marked contrast to the watercolours for the contemporary series of *Picturesque Views in England and Wales*, which were actively promoted through a number of exhibitions, where they were shown with their engraved versions.[8] It should, however, be noted that, although they do not seem to have actually been exhibited in 1832–3, it is likely that the Loire set was available on request for the public to compare with

FIG 187 Samuel Prout, *The Corn Hall, Tours*, formerly a church, *c.*1834–8, pen and brown ink, watercolour and bodycolour. *Whitworth Art Gallery, University of Manchester*

the newly published prints in the show rooms of Moon, Boys and Graves. This was certainly the case a year later with the first group of Seine subjects, a fact that one of the critics drew to the public's attention.[9] Quite why the Loire drawings remained unsold for so long is not known. It could be because there

was no interest from collectors, or because Turner declined altogether to part with them, or, most probably, that he refused to break the group up through individual sales. If it is easy now to see the appeal of Turner's understated, economic technique, this characteristic alone would have made the drawings less appealing to collectors of the more finished watercolours of the *England and Wales* series. Similarly, the use of brilliant gouache on the small sheets of cheap blue paper, may have deterred those looking for a conventional example of watercolour painting to enliven their drawing rooms. Though the designs were definitely conceived as fully finished works, one can imagine contemporary viewers feeling slightly equivocal about their appearance, perhaps thinking of them merely as 'studies' for the engravings. And so, for over fifteen years, the drawings were stored among the other unseen treasures in Turner's studio, bundled in a parcel with the Seine views. However, there was eventually to be a fit audience for the group.

This was, of course, Ruskin, but he was not the first to own the Loire drawings, even though Turner apparently offered them to him in the first instance, most probably about 1848–9 or in April or early May 1850.[10] The precise date of the incident is not known, as Ruskin did not record it in his diary, but he later gave an account to George Allen. In this Turner came to him 'with a bundle in a dirty piece of brown paper under his arm. It contained the whole of his drawings for the *Rivers of France*.' Turner then proceeded to say, '"You shall have the whole series, John, unbroken for twenty-five guineas apiece,"' a rate that, when petitioned by his son, Ruskin's overly prudent father declined.[11] The emphasis here should presumably fall on the word 'unbroken', since Turner was clearly concerned to keep the set of sixty-one drawings together. As noted above, the three groups of French views were the first of his engraved watercolours to have been published simultaneously in one volume, undiluted by the work of other artists, a fact that had led him to create links between images, so that they benefit from being seen in relation to one another. But despite this underlying anxiety to keep the group united, Turner ultimately does not seem to have insisted on it himself. Until his death he retained the two groups of Seine views (with a few exceptions), but by mid-May in 1850 he had passed the Loire series to his dealer Thomas Griffith.[12]

The Ruskins were not the only active collectors of Turner at this time, although this is sometimes the impression given in the younger Ruskin's writings.[13] A patron and friend of much longer standing was the stockbroker Charles Stokes (1785–1853), who combined his antiquarian interests, particularly in geology, with a zealous philanthropy and a love of the visual arts.[14]

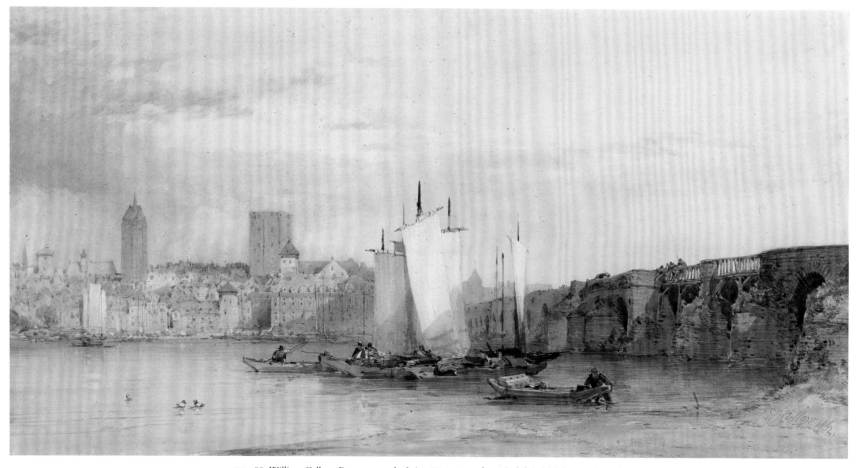

FIG 188 William Callow, *Beaugency on the Loire* 1862, watercolour, *Sotheby's (16 July 1992, lot 111)*

Although he is not thought to have met Turner until the early 1820s, when he began to acquire examples of designs for the *Southern Coast* series, he owned a large number of early watercolours dating from the 1790s. This could suggest a much earlier connection, although it may be that, as a result of his instinct to classify and order things, Stokes later attempted to create a rounded collection, setting out the history of Turner's development, which he complemented with works by formative influences such as Cozens, Malton, Hearne, Dayes and Girtin.[15] His important collection is documented in a series of notebooks, put together by his niece Hannah Cooper, which were rediscovered by Kurt

Pantzer in 1968 but have yet to be fully transcribed and properly edited.[16] They are now in the Indianapolis Museum of Art.

It was to Stokes that Griffith offered the set of Loire drawings, concluding the sale on 31 May 1850. According to the Cooper notebooks, Stokes paid six hundred guineas for a package that included the twenty-one subjects engraved in *Turner's Annual Tour*, plus three related Loire scenes (figs.70, 130 and the missing view of Tours, see p.121).[17] The drawings were, therefore, twenty-five guineas each, which is the same sum that Turner had asked Ruskin to pay. He may, however, have had second thoughts about the appropriateness of this price once

news of Griffith's success reached him, for there is an undated letter from him to Stokes, in which the desperate tone of the missive cannot be mistaken: 'I have the impression *wholly wrong* about the River Drawings – they are Fifty Guineas.'[18] This inflated price could suggest the disputed works referred to were watercolours from *The Rivers of England* series, for which the fifty guineas would easily have been appropriate in the 1850s. But the available evidence links Stokes only with the drawings of the River Loire, and, if his niece's account book is to be believed, it was he, rather than Turner, who got his way over the price.

Stokes lived for only a little over three years after purchasing the series, during which time he 'parted with & exchanged' seven of the group, including four of the engraved subjects (figs.65, 75, 100, and 112).[19] The remaining seventeen Loire views were inherited by Hannah Cooper, the wife of the Rev. James Cooper, who was one of the masters at St Paul's School. She appears to have admired the Loire views and was keen to reunite the larger group with its missing pieces. She gives clear evidence of her motives in one of the notebooks: 'Being desirous if possible to make the set complete I exchanged 3 drawings by Turner for 5 more of the blue paper drawings on 13th Febr. 1854.'[20] Three of the latter group were Loire subjects (figs.51, 63 and 125). Two months later Mrs Cooper made further progress in her quest by acquiring on 15 April, a view of the 'Town of Blois' (fig.130).[21] But her attempt to reunite the engraved group continued to be thwarted, as their new owner seems to have refused to part with them.[22] Later that year, on 6 October, she conducted another exchange, which resulted in the acquisition of the view of the market place at Orléans (fig.150) and a scene listed as 'Sunset fortified town', which is probably the view of Nantes (fig.32).[23] Some indication of the seriousness of her intent can be gauged from the fact that, in order to achieve her ends, she was prepared to relinquish in exchange a *Southern Coast* watercolour and two of the sepia drawings related to the *Liber Studiorum*, which were then very highly regarded among Turner collectors.[24] Her final Loire acquisition (fig.49) was one of a group of five blue paper drawings she obtained in July 1856, after parting with three of the watercolour landscapes engraved by the Findens for the 1834 publication of Bible scenery.[25] The identity of her sources requires more detailed investigation in order to establish how so many of the unpublished Loire designs became separated from the main group in the Turner Bequest. The most likely legal source is Thomas Griffith, but it is somewhat improbable that Turner would have considered these studies, and the other blue paper views of Genoa and Ehrenbreitstein that passed through Mrs Cooper's hands, readily saleable in the late 1840s. So, until further evidence is discovered

about Griffith's stock, it remains a vague possibility that a portfolio of these less finished works left Turner's studio by other means shortly after his death.

By 1856 the long Chancery court case considering the future of the massed contents of the artist's house had been resolved in favour of the nation, which meant that work could begin on arranging the pictures for public display. The immense collection of watercolours and sketches was to prove a more intractable problem, but by late 1857 Ruskin had completed a display that presented an overview of Turner's draughtsmanship in a series of one hundred and fifty frames containing over three hundred sketches.[26] Many of the colour studies for the Loire series were included in this selection (see figs.25, 35–8, 47–8, 50, 69, 78, 80, 82, 85, 98–9, 123, 142, 147). As Ruskin had spent so much time considering what was the best way of presenting Turner's studies, his advice was regularly sought by other collectors, one of whom appears to have been Mrs Cooper. By early 1858 they had become acquainted, and during that spring he made suggestions about how her collection should be preserved.[27] However, he was still very much a collector himself and must have looked covetously at the twenty-four Loire subjects she had amassed.

After her various negotiations Mrs Cooper was fully briefed on the market value of her collection, carefully listing the 'Lowest valuation' she would consider alongside the entries in her notebooks.[28] She, therefore, proved a shrewd woman to do business with, recognising in Ruskin someone with her own genuine love for the drawings. She must also have seen his hunger for her covetable group of Loire subjects and was happy to exploit this to her own advantage, although Ruskin later noted that she had been forced to part with the drawings 'sorrowfully', because she needed to purchase a commission in the army for one of her sons.[29] As an initial foray, she made him pay fifty guineas for each of the four Loire studies that he bought on 10 February 1858 (figs.49, 125, 130 and 150).[30] But on the following day he was induced to part with nearly sixty guineas for each of the engraved subjects, paying a total of one thousand guineas for the seventeen finished drawings. His elderly father, no doubt, was made to see the error of not buying the works straight from Turner a decade earlier when they had been only twenty-five guineas each, but the entry in Ruskin's diary for this day gives no sense of what he felt about the transaction, other than marking the event: 'Grey. Day of getting the Loire.'[31]

The date Ruskin acquired the remaining three Loire subjects in Mrs Cooper's collection is not given in his diary, his father's account book or in her notebooks (figs.32, 51, and 63). They are, however, listed in an undated note on one of the enclosures to the Cooper notebooks, where they appear below a

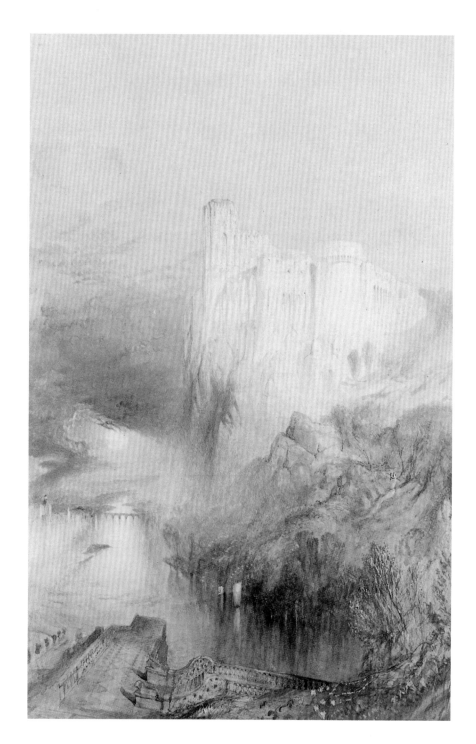

FIG 189 John Ruskin, *Amboise*, pencil and
watercolour with some scratching out
Sotheby's (30 March 1983, lot 197)

couple of exchanges that seem to have taken place between the two during 1858, and it is fairly safe to assume that they must have been in Ruskin's collection before 1859.[32]

In many respects Ruskin had a long claim to the images, as they had, in their engraved form, cast a spell over his early appreciation of the artist. In fact, the power of the set was just as potent as the illustrations to Samuel Rogers's *Italy*, which had first fired Ruskin's imagination and caused him to devote so much of his life to celebrating Turner's powers.

In early October 1840 he and his parents had visited Blois, Amboise and Tours, so that he could see the places depicted by Turner as well as sketch them for himself. He wrote of the significance of Turner's views much later, claiming the engraved images had become 'the criterion of all beauty to me'.[33] Later in 1840 he included the Loire views in the list of those engravings he told his friend Edward Clayton he ought to consult in order to appreciate Turner's unique qualities. He wrote, 'Take them to bed with you, and look at them before you go to sleep, till you dream of them; and when you are reading and come to anything that you want to refer to often, put a little Turner in to keep the place, that your eye may fall on it whenever you open.'[34]

A year after the first celebrated meeting of Ruskin and Turner in June 1840 (the details of which were afterwards greatly embellished before being transformed into the account given in *Praeterita*), Ruskin was inspired by the Loire engravings to paint a watercolour view of 'the Chateau of Amboise at sunset, with the moon rising in the distance, and shining through a bridge' (fig.189).[35] As he was the first to admit, the scale was even more exaggerated than anything Turner had produced, 'representing the castle as about seven hundred feet above the river', when in fact 'it is perhaps eighty or ninety'. However, the design neatly brought together what he had learnt from the Loire series with features found in Turner's illustrations to the two volumes of Rogers's poems.[36] Ruskin was especially pleased with his work on the chapel of St-Hubert, considering it 'perhaps a little better than Turner'.[37] He subsequently engaged Edward Goodall, who had worked on both sets of the illustrations to Rogers, to engrave the drawing to illustrate his poem 'The Broken Chain' (1839–42), which is set in the château of Amboise. It appeared in the *Friendship's Offering* in instalments between 1840 and 1843, when the engraving was also published.[38] But he was soon dissatisfied with this type of drawing. Like his parallel aspirations to become a great poet, it was later to seem a false step.[39]

A more confident Ruskin materialised two years later with the publication of the first volume of *Modern Painters*. This extended eulogy of Turner's work included several references to the Loire series, and in one section they were upheld as examples for others to study how Turner had realised chiaroscuro in his works.[40] It may be that his praise of these works had led Turner to offer him the Loire drawings in the first instance before consigning them to Griffith.

Since Ruskin had long admired the group, and paid well over the going rate to acquire them, one might assume that he would have then cherished them as one of the centrepieces of his collection. This was, however, the period during which he became more actively political, teaching at the Working Men's College in London and taking on social issues in the lectures that were published as *Unto this Last*. Through his friend Dr Henry Acland he was also involved in the teaching of drawing at Oxford, which alerted him to the need for students to have good examples of contemporary art to examine closely. By the beginning of March 1861 he had begun to envisage a study collection for Oxford and was already proposing to offer them the Loire series and other works, which he had at one stage thought of leaving to the National Gallery.[41] There were already many important drawings in the collection of the Oxford University Galleries in Beaumont Street (known as the Ashmolean Museum from 1908), including works by Raphael and Michelangelo, but, in making his decision to present the group of forty-eight Turner watercolours, Ruskin was giving substance to his attempt in *Modern Painters* to place Turner alongside such Renaissance masters.[42]

He valued the gift at over £2000 and insisted only on the museum paying for adequate frames and cabinets in which to store the drawings. But an entry in his father's account book records that he also paid for these, commissioning similar cabinets to those the maker Foord had created for Ruskin's own collection.[43] It was in these that they were presented throughout the late nineteenth century in what is now the Founder's Gallery on the first floor but was then designated the 'Turner Room'. One of Ruskin's letters to Acland concerning the gift dwelt at length on the discrepancies between the perceived market value and the real aesthetic interest of several of the Loire subjects. This was especially notable in the case of fig.49, which 'though containing hardly half-an-hour's work is so first rate that I would have given *anything* for it – I gave 50, but of course in the market it would bring only 30 or 35.' Generally, he preferred the less obviously finished subjects:

No.21 [fig.60], the best of the Loire series, is priceless, and 24 [fig.113] nearly so. 28 [fig.138] and 29 [fig.107] entirely magnificent in their own quiet way. 35 [fig.72] is inferior owing to a repentir [*pentimento*] in the left corner –

Turner never recovered after a repentir. 25 [fig.121] has two repentirs if not more – one in the sun: the other in the flags – but has high qualities here and there – 30 and 36 [figs.129 and 81] are full of repentirs and are entirely bad; but I sent them with the rest – lest it should be thought I had kept the two best – many people might think them so – They are instructive as showing the ruin that comes on the greatest men when they change their minds wantonly.[44]

Though the seventeen engraved subjects were complemented in the gift by four of the unpublished studies, he retained three studies, sending two of them to the Fitzwilliam Museum later in the year, in a parallel gesture to his Oxford gift (figs.32 and 150).[45] But it was not until 1870, when he gave his first lecture as Slade Professor, that he presented the 'Blue Loire', which was his favourite of the group (see p.75, fig.63).

In that lecture he plainly stated what he hoped others would gain from the 'simple and at first unattractive drawings of the Loire series'. He had encouraged others to copy them in order to understand how Turner placed distinct colours next to each other, but he claimed his chief motives lay in the 'infallible decision' and the 'extreme modesty in colour' of the group. 'They are', he said, 'beyond all other works that I know existing, dependent for their effect on low, subdued tones; their favourite choice in time of day being either dawn or twilight, and even their brightest sunsets produced chiefly out of grey paper.'[46]

Though the selfless philanthropy of his gift was widely recognised, Ruskin seems to have suffered some regrets. He noted in one of the letters in *Fors Clavigera* that 'when I gave away my Loire series of Turner drawings to Oxford, I thought I was rational enough to enjoy them as much in the University gallery as in my own study. But not at all! I find I can't bear to look at them in the gallery, because they are "Mine" no more.'[47] In spite of such emotions, he continued to work for the collections at Oxford, negotiating the loan of a large group of previously uncatalogued watercolours and sketches, which he selected from the Turner Bequest in London. These works were despatched in 1879 and included many of the Loire studies (figs.40, 42, 43, 46, 76 and 104). Sadly, when they were eventually returned to London in 1916, they had been irreparably damaged as a result of being continually displayed in sunlight, as was also the case with those shown in London during the late nineteenth century. Apparently, neither Ruskin nor the staff at either the National Gallery or at Oxford can have paid much attention to the widely held apprehensions about the fading of works on paper.

Ruskin's final connection with the Oxford group also occurred in 1879,

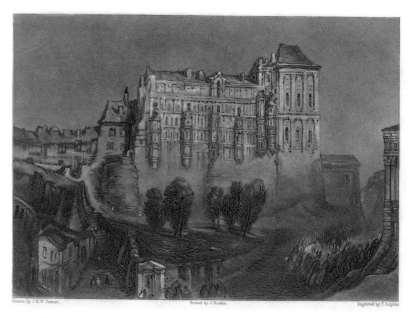

FIG 190 John Ruskin and Thomas Lupton, *Château de Blois* (cat.132)

when he requested the temporary loan of the northern view of the château of Blois (fig.134). This was because he wanted to 'finish an old drawing from it'.[48] His frequent exhortations on the benefits of copying Turner's works had given rise to numerous versions of the studies in the Turner Bequest by William Ward, Alexander Macdonald (fig.191), Isabella Lee Jay and others. On this occasion Ruskin's copy was used as the basis of an etching he produced, which was afterwards engraved in mezzotint by Thomas Lupton and published in the 1888 edition of volume V of *Modern Painters* (fig.190).[49]

He was not the only writer to analyse the character of Turner's 'French Rivers' series. The year 1879 also saw the publication of Philip Hamerton's biography of Turner, which included three etchings of some of the less well-known Loire studies by the Frenchman Alfred Louis Brunet-Debaines.[50] Hamerton's account is influenced by his preference for the recent trends in French painting and is sometimes harsh, but on the whole he is generally acute about Turner's presentation of French scenery. As a representative of a new generation of viewers, he sometimes seemed to find Turner's small, bustling scenes of towns and châteaux too much like travellers' hasty snapshots. But his comparison with the works of the Barbizon School or the Impressionists is not

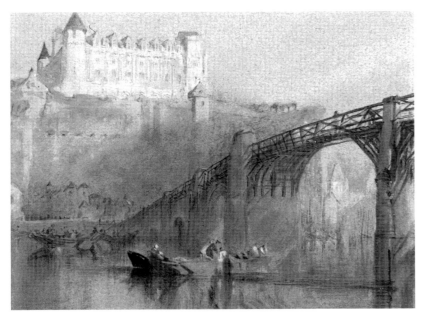

FIG 191 Alexander Macdonald after J.M.W. Turner, *Château of Amboise* (cat.133)

really valid because of the difference of media, scale and purpose. A more effective comparison would be made with the French topographers of Turner's own period, such as Dagnan, Deroy and Asselineau. It is nevertheless interesting to note that by the early 1880s Turner's views had begun to assume the charm of evocations of a former age, and it may have been for this very reason that they continued to find an audience. Indeed, there were several new editions in the last two decades of the nineteenth century.

In our own century, although *The Rivers of France* engravings were reprinted only as recently as 1990, it has generally been Turner's watercolours that have drawn most attention. The Loire studies, like nearly all of Turner's works on paper, speak directly to viewers and provide an invitation into the private world of the artist, where brushstrokes have sometimes been interrupted and ideas only partly resolved, allowing us, very tangibly, to see his mind at work. An indication of the continuing potency of the Loire scenes arose at the time of the bicentenary of Turner's birth in 1975, when the Royal Mail decided to issue a commemorative set of stamps. After much deliberation, four images were at last selected: two oil paintings and two watercolours.[51] These were not a representative selection of the trajectory of Turner's career but were instead drawn from roughly the last twenty years of his working life, reflecting the shift in taste for these formerly problematic works. The inclusion of the 'unfinished' view of St-Florent-le-Vieil (fig.76), with its mood of tranquil revelation, provided the perfect antidote to the bold tumult of the other images in the group, and demonstrated Turner's power even in apparently slight subjects. It is remarkable, in the light of our greater knowledge of Turner's fleeting visit to St-Florent and the other towns on the river, to find such peace and stillness in this scene, which appears so untroubled by the modern world. However, the reflective mood in the St-Florent study is characteristic of the Loire series as a whole and is arguably only surpassed in the deeply felt late watercolours of the Swiss lakes.[52]

Turner's journey up the Loire in 1826 may have been brief and hurried, but at its heart lay powerful experiences which lived on for years once he got back to London, stimulating him in many different ways. The episode in some very real sense provoked a transformation, changing both his technique and his way of presenting the world. Not only did it mark the beginning of his protracted use of gouache on blue paper, but it also allowed him to expand his knowledge, to explore remote regions of France and to develop new ways of presenting his work to the public. Perhaps for the first time, as a result of tracing Turner's progress through France, and seeing the repercussions of his journey in the finished and unfinished work that ensued, it is now possible to understand that this was a crucial journey of transition, in its own way as important as the more obviously significant tours of Italy.

Notes

Introduction

1 *Gentleman's Magazine*, vol.CII, pt II, December 1832, pp.549–50. The full text of this review can be found in Appendix D, below.
2 Where I have come across copies of specific Loire scenes I have recorded them in the individual catalogue entries below.
3 Finberg 1939, 1961, pp.297–8
4 Alfrey 1977.
5 See, for example: D. Delouche 1977, pp.59–61; Hervouet 1989, pp.12–23; David Brown, 'Turner et la Seine', in Louveciennes 1995, pp.14–30; and Lévêque-Mingam 1996. The last item was being prepared at the same time as the present volume, with neither author aware of the other's project. Monsieur Lévêque-Mingam's text is usefully complemented by detailed notes on the towns that Turner visited, written by local historians.

Part One

Turner and France in the 1820s

1 See David Bindman, *The Shadow of the Guillotine: Britain and the French Revolution*, exh. cat., British Museum, 1989.
2 See Jeremy Black, *The Grand Tour in the Eighteenth Century*, 1992, or Andrew Wilton and Ilaria Bignamini, *Grand Tour: The Lure of Italy in the Eighteenth Century*, exh. cat., Tate Gallery, 1996. Both of these volumes have extensive bibliographies on the subject.
3 In his *Wilson* sketchbook of *c*.1796 Turner made a copy of an unidentified Vernet shipwreck (TB XXXVII pp.104–5; see Tate Gallery facsimile, 1988, with text by Andrew Wilton).
4 I am grateful to Pierre Leveel for confirming my identification of the view of Tours, and for his attempts to locate the source of Turner's image. Sylvain Bellenger and Bruno Guignard at the Château et Musée des Beaux-Arts de Blois have suggested that the highest spire in the view is that of St-Sauveur, which was destroyed in the 1790s, so that the source of Turner's design must date from somewhat earlier, as one might also conclude from the style of Turner's work, which can be dated to the mid-1790s.
5 Black, op. cit., p.24.
6 See David Hill, *Turner in the Alps: The Journey through France & Switzerland in 1802*, 1992.

7 This tour is covered in the catalogues for both of the exhibitions curated by Cecilia Powell at the Tate Gallery (i.e. 1991 and 1995).
8 The development of these resorts and of Dieppe is discussed at length in Alain Corbain's study, *The Lure of the Sea: The Discovery of the Seaside 1750–1840*, 1988. See also the catalogue of the exhibition at Brighton Museum and Art Gallery in 1992.
9 At the Royal Academy alone, during the first half of the 1820s, there were numerous exhibits of both places. Those artists who exhibited views of Rouen are as follows: W. Collins (1818, no.80), H. Edridge (1819, no.644; 1820, nos.539, 582, 603; 1821, nos.475, 492, 500), J. Fudge (1821, no.597), J. Fuge (1828, nos.652, 958), Rev. R.H. Lancaster (1822, no.341), S.A. Rayner (1828, no.227), D. Roberts (1826, no.221), E.V. U. (1828, no.527), J. Walton (1827, no.542). Views of Dieppe and Château d'Arques were exhibited during the same period by the following: J. Fahey (1826, no.797), C.V. Fielding (1817, no.448), G. Jones (1822, no.10), Miss Kirkman (1825, no.388), Turner (1825, no.152), J.H. Wilkins (1821, no.197), J. Wilson (1825, no.351).
10 William Hazlitt, *Notes of a Journey through France and Italy*, 1826 (vol.10 of *The Complete Works of William Hazlitt*, ed. P.P. Howe, 1930–34, pp.92–3.
11 See Ian Warrell, 'J.M.W. Turner in Brighton', in *Brighton Revealed through Artists' Eyes, c.1760–c.1960*, exh. cat., Brighton Museum and Art Gallery, 1995–6, ed. David Beevers.
12 See, for example, TB CCLVIII f. 28 verso (Paris 1981, p.161, fig.278). See also *Soane and Death: The Tombs and Monuments of Sir John Soane*, exh. cat., Dulwich Picture Gallery, 1996, ed. Giles Waterfield, p.82, nos.III.6 and 7.
13 TB CCLVIII f. 32 verso and 34. These are reproduced and discussed in Paris 1993, pp.83–4.
14 TB CCXI f.37 verso (Paris 1981, p.162, fig.286). Views of Abbeville began to appear at the Royal Academy from 1819. Exhibits there by the following artists in the early 1820s depicted the town: H.W. Burgess (1821, no.529), H. Edridge (1820, no.614), J. Fudge (1821, no.620), G. Jones (1819, no.189; 1824, no.34).
15 TB CCXI ff. 19 verso, 20, 22.
16 For Turner's interest in Watteau, see the article in two parts by Selby Whittingham: 'What You Will; or some notes regarding the influence of Watteau on Turner and other British Artists', *Turner Studies*, vol.5, no.1, pp.2–24, and vol.5, no.2, pp.28–48.

17 The confusion over the date of this tour was resolved by Cecilia Powell in the catalogue for the Tate Gallery exhibition (1991b, pp.36–45).
18 This important event is discussed in the following: Basil Long, 'The Salon of 1824', *Connoisseur*, February 1924, pp.66–76; by Patrick Noon in New Haven 1991, pp.31–34; and Olivier Meslay, 'Le Salon de 1824', in Louveciennes 1995, pp.49–51.
19 Alfred Cobban, *A History of Modern France, Volume 2: 1799–1871*, 2nd ed., 1965, p.115.
20 For a detailed discussion of Constable's involvement with the French dealers, see Beckett 1966, pp.177–211.
21 Views of Boulogne can be found in the *Holland, Meuse and Cologne* sketchbook (TB CCXV ff.10–20, 77 verso–78, 79 verso–81 verso; see Paris 1981, pp.169–70, figs.295–301). Turner sketched at Calais in the *Holland* sketchbook (TB CCXIV ff.237 and ?239 verso).
22 See Guy Antonetti, *Louis-Philippe*, Paris 1994; H.A.C. Collington, *The July Monarchy: A Political History of France, 1830–48*, 1988; or André Castelot, *Louis-Philippe*, Paris 1994.
23 See either Shanes 1981 or Shanes 1990.
24 Shanes 1990, pp.13–15.
25 One of these was the 'View of Calais Harbour, to be engraved for Mr T.F. D'Ostervald's work of the Coasts and Ports of France, now publishing' (no.193). That year's exhibition also included Nash's designs for D'Ostervald's Work of French Palaces (nos.328, 329, 330).
26 *Examiner*, 21 January 1827 (quoted in Finberg 1961, p.300).
27 See Andrew Wilton and Rosalind Mallord Turner, *Painting and Poetry. Turner's 'Verse Book' and his Work of 1804–1812*, exh. cat., Tate Gallery, 1990. A detailed study of Turner's work on the Thames can be found in David Hill's book, *Turner on the Thames: River Journeys in the Year 1805*, 1993
28 Simon Schama, *Landscape and Memory*, 1995. See Part Two, 'Water', pp.245–382.
29 This point is made by Andrew Hemingway in his full study, *Landscape Imagery and Urban Culture in Early Nineteenth-Century Britain*, Cambridge University Press 1992, p.224. This is a fascinating survey of the developing fashion for views of rivers (and coastal resorts), setting Turner's pictures against the contemporary background of similar paintings by Constable and the Norwich School.

30 A number of the 1817 Rhine watercolours were included in the 1991 exhibition at the Tate Gallery (1991b, nos.4–11). In the catalogue of that show Cecilia Powell also discussed the failed attempt to create a set of engraved Rhine scenes; pp.34–6.
31 Shanes 1990, p.10.
32 Shanes 1981 and 1990, pp.11–12.
33 See *Vues de l'orléannais et de la Touraine d'après nature et lith. par Dagnan*, 1819. The French guidebooks of the Loire published in the early 1820s were by Edouard Richer, *Voyage pittoresques dans le departement de la Loire Inferieure*, 1823, and A.J. Noël, *Souvenirs Pittoresques de la Touraine*, Paris 1824. One of the few English guidebooks to cover the Loire was the volume by Mrs Charles Alfred Stothard, *Letters written during a Tour through Normandy, Brittany, and other parts of France in 1818: including local and historical descriptions; with remarks on the manners and characters of the people. With numerous engravings, after drawings by Charles Stothard, FSA*, Longmans, 1820.
34 The fullest account of George Jones's career is the article by Joany Hichberger, 'Captain Jones of the Royal Academy', *Turner Studies*, vol.3, no.1, pp.14–20. Other views from the 1817 journey along the Loire, also in the Ashmolean Museum in Oxford, are as follows: *Loire. Nr Orleans* (no.55); *Chateau Amboise on the Loire* (no.217); and *Chateau à Blois* (no.241). Jones made studies of figures in France that year, including a study of two women with a child, inscribed 'Amboise. Novr.17. 1817' (A-1, 230 (8) 4J, f.1). Jones also painted a view of Orléans in oils, which was in the Woburn Abbey collection until it was sold at Christie's, 19 January 1951, lot 183. Another exhibitor at the Academy, albeit an honorary one who is only listed as E.V. U., had visited the Loire in 1823. This resulted in two views at the 1827 exhibition (no.500, *The Cathedral at Tours, from the place de l'Arche Veché – Sketched in 1823*, and no.580, *Old building at Blois, on the river Loire; said to have been the baths of Catherine de Medicis*).
35 Jones was almost as regular a traveller as Turner, but his possible influence on Turner's travels has hitherto not received much attention. He was, for example, one of a party of friends who met Turner at Greenwich on 19 August 1835, on the eve of Turner's expedition to Denmark, Prussia, Saxony, Bohemia and Bavaria (see Jones's sketch of a group of figures seated under a tree, which was annotated with the words, 'Greenwich' and 'Dined with J.M.W. Turner';

Fitzwilliam Museum, Cambridge, Vol. XV, no. 23). The area covered by Turner's 1835 tour was a region that Jones had visited eight years earlier, in 1827, which would have qualified him to offer advice about which places were worth visiting, especially since he was often one of the few people to be trusted with knowledge of Turner's comings and goings (see Cecilia Powell's comments in Tate Gallery 1995b, p.46, where she suggests that more likely sources of information were David Wilkie and the Callcotts). Jones could also have influenced the direction of Turner's 1833 journey through Austria, having visited many of the same places on his way to Rome in 1829; the route south undertaken by Jones, with its detour to Salzburg, would have been known to Turner through their regular correspondence at that date. Turner may have even included Ghent on his itinerary because he had seen Jones' depiction of the city (see Tate Gallery 1995b, p.36, where the playful rivalry between Turner and Jones at the Academy exhibition preceding the 1833 tour is described).

36 *The Letters of Sir Walter Scott*, ed. H.J.C. Grierson, VII, pp.283–4; quoted by Susan Manning in her useful introduction to the Oxford University Press edition of *Quentin Durward*, 1992, p.xxix.

37 See Stendhal 1837, p.266, or Henry James 1884, pp.14–15.

38 See Gerald Finley 1980, pp.49–68.

39 See Noon in New Haven 1991, pp.162–3, nos.59–60, and p.274, no.143. See also Finley 1980. There were various other attempts to portray characters or scenes from *Quentin Durward* at the Royal Academy beginning with a picture by Miss E.E. Kendrick in 1824, the year after the book was first published, *Isabel de Croye, vide Quentin Durward*, no.621. This was also a subject adopted by Miss Heaphy in 1828 for her *Portrait of Elizabeth, eldest daughter of John Heaphy, Esq., as Isabella de Croye – Vide Quentin Durward*, b.i.p.71, no.865. George Cattermole sent his depiction of the *Murder of the Bishop of Liege* from the novel to the Old Water Colour Society in 1836 (no.125).

40 See Lee Johnson, *Eugène Delacroix (1783–1863): Paintings, Drawings, and Prints from North American Collections*, exh. cat., Metropolitan Museum, New York 1991, pp.142–77. Delacroix produced a number of works based on *Quentin Durward* (see P. Noon in New Haven 1991, p.162 n. 1).

41 *The Letters of Henry Wadsworth Longfellow*, ed. Andrew Hilen, Cambridge, Massachusetts, 1966, I, pp.182–5, 197–204.

42 Gage 1980, pp.102–3, no.119

43 Finberg 1961, pp.297–8

44 See the reports in *The Times* for 22 September 1826, p.2, and 23 September 1826, p.2.

45 Gage 1980, p.102.

46 *Hull Advertiser and Exchange Gazette*, Vol. XXXII, no.1689, Friday 20 October 1826, p.2, column d. The newspaper had reported the explosion at Ostend

almost a month earlier (29 September 1826, p.2, column e).

Preparing for the 1826 Tour

1 Turner's two applications for passports in London can be found in the Public Record Office at Kew. That for 1802 is dated 12 July (no.550 in FO 610/1); while the only other passport request by Turner that has been preserved was made in 1840 (no.6232 in FO 610/2). I am grateful to Mrs H.E. Jones in the Reader Services Department for her help in establishing that Turner made no attempt to get a passport before leaving London in 1826.

2 Ritchie 1833, pp.105–6; Strutt 1833, p.71; 'Diary of a Walking Tour, 1836', in Jan Reynolds, *William Callow, R.W.S.*, 1980, pp.20–53.

3 See the *Dolbadarn* sketchbook (TB XLVI, inside front cover), which has a list of French pronouns and a note on the conjugation of French verbs.

4 See Norwich 1975, p.4.

5 I am grateful to Debbie Hall of the Royal Geographical Society for providing information about the makers of this map.

6 Guidebooks were increasingly linked to details of the diligence service. See, for example, *Guide Pittoresque* 1837.

7 TB CCLV, the *Rouen* sketchbook; see also TB CCCXLIV 56, 57, 58, 59, 60, 61, 62, 145, 173, 174, 175, 176.

8 He may have taken with him the paper on which TB CCXX A–L are painted. He also took the rough sheets that he used on the way to Tours (TB CCCXLIV 242–5) and around Paris (TB CCCXLIV 82–3, 84–5).

9 See the forthcoming article by Peter Bower, 'Innovative and Unsung: George Steart's Development of Artist's Watercolour and Drawing Papers 1805–1832', to be published in *The London Papers*, Studies in British Paper History, vol.3, due for publication in 1998.

10 See Powell 1987, p.44, and figs.35–7, 40, and 56. See also Tate Gallery 1991b, nos.39 and 40.

11 There is no single survey of Turner's use of blue paper: for East Cowes Castle, see Graham Reynolds, 'Turner at East Cowes Castle', *Victoria and Albert Museum Yearbook*, I, 1969, pp.67–79; for Petworth, see Butlin, Luther and Warrell, *Turner at Petworth*, 1989; for the east coast of England, see Shanes 1990, pp.151–159, pls.121–130 (see also Piggott 1993, pp.49–50, where these works are linked with an edition of George Crabbe's poems); for a selection of the views made on the south coast of France in 1828, see Paris 1981, nos.73–5, or Tate Gallery 1991a, nos.81–4, (although some of these probably relate to an, as yet, undocumented tour in the 1830s); there are also some sketches on blue paper of scenes in Italy, which date from the 1828 tour; for the Seine, see Paris 1981; for the Rhône, see Paris 1981; for the Meuse, the Mosel and Luxembourg, see Tate Gallery 1991b, nos 47–127.

12 In his essay in the catalogue for the 1983 Turner exhibition in Paris, Nicholas Alfrey related a group of three sketchbooks to the first part of the 1826 tour (Paris 1983, p.37). The first, the *Meuse and Mosel* sketchbook, has now been convincingly redated to 1824 (as we have seen above). But Alfrey also suggested that the *Caen and Isigny* (TB CCLI) and the *Coutances and Mont St Michel* (TB CCL) sketchbooks were used on this tour, which is confirmed in the new research presented here. Alfrey's redating of these two books has not until now met with support from other Turner scholars; see, for example, Wilton 1987, p.168, where both books are dated 1829.

13 Ritchie 1833, pp.157–8.

14 Ibid., p.106.

15 TB CCXLIX inside back cover.

16 See Alfrey 1977, p.4 (which agrees with Finberg's coupling of the Loire and the Meuse tours); Paris 1981, p.197; Paris 1983, p.37; Lévêque-Mingam 1996, p.16. In Paris 1983 (p.313) Turner's tour was dated as late as November, by which time he would almost certainly have been back in London.

17 TB CCXLVII f.86 verso.

18 Andrew Wilton suggested a date of 1831–2 in the catalogue for the bicentenary exhibition at the Royal Academy (1974, p.113), but revised this to *c*.1826–30 (or 'shortly after the tour') in his 1979 book (p.409). Nicholas Alfrey, in the 1981 Paris exhibition catalogue, opted for a date near 'the end of the 1820's', and the individual entries carry the date '*c*.1830' (p.198). In the catalogue for the *Fourth Decade* exhibition (Tate Gallery 1991a) I suggested that some of the colour studies must have been executed before 1829 (see p.50, no.46).

19 Butlin, Luther and Warrell 1989, p.62.

20 See Eric Shanes in Tate Gallery 1997, p.23.

21 Paris 1981, pp.188–9.

22 The exception is the group of east coast subjects; Shanes 1990, pp.151–7, pls.121–9 (R 305–12).

23 An early example of this tendency is the watercolour of 1791–2 of the *Old Hot Wells House, Bristol* (Private Collection, W 19). See also *Magdalen Tower and Bridge* (Whitworth Art Gallery, Manchester, W 69, or British Museum, W 70), *Norham Castle on the Tweed, Summer's Morn* (Mr Brian Pilkington, W 225), *Rheinfels looking to Katz and Goarhausen* (Yale Center for British Art, New Haven, W 650).

24 Hamerton 1879, p.237.

25 Hamerton 1879, p.250.

Part Two

Turner's Route

As well as the nineteenth-century guidebooks cited in the notes below, I have made frequent use of many recent travel books and histories of the Loire châteaux. To save repeated reference to these works, they are listed here as follows: Baedeker's *Northern France from Belgium*

and the English Channel to the Loire, excluding Paris and its Environs (3rd ed., 1899); John McNeill, *The Blue Guide to the Loire Valley* (1995); Michelin guides to *Normandy* (1994), *Brittany* (1991), *Châteaux of the Loire* (1988); Guides Gallimard to *Manche, Normandie*, (Paris 1995), *Loire-Atlantique, Bretagne*, (Paris 1992), *Brittany* (English edition by Everyman Guides, 1994). The best complete, up-to-date survey of the great châteaux of the Touraine region in English is Marcus Binney's book, *Chateaux of the Loire*, published as part of the Architectural Guides for Travellers series (1992).

1 See reports in *Sussex Weekly Advertiser* and the *Brighton Gazette & Lewes Observer* for August 1826.

2 See below, note 30.

3 For those of 1821, see TB CCLVIIII (Paris 1981, p.149, figs.244–59) and TB CCXI f.25 verso (Paris 1981, p.168, fig.294). The 1824 sketches occupy most of the latter quarter of the *Meuse and Mosel* sketchbook, TB CCXVI.

4 Finberg 1909, II, p.776.

5 For the 1824 views of Château d'Arques, see TB CCXVI ff.237–43.

6 Royal Academy 1826, no.221, hanging in the School of Painting, was bought from the exhibition by Lord Northwick (exh. *The Victorian Painter Abroad*, Trafalgar Galleries, 1965, no.25, as in the collection of Capt. E.G. Spencer-Churchill, M.C.). See Finberg 1961, p.296.

7 See Norwich 1975, no.33, pl.36.

8 Turner could very easily have known the engravings of Cotman's work that illustrated Dawson Turner's book, *Account of a Tour in Normandy; undertaken chiefly for the purpose of investigating the Architectural Antiquities of the Duchy, with observations on its History, on the Country, and on its inhabitants*, 2 vols., 1820. This book was published by John and Arthur Arch, who by 1826 were involved with the production of the *Picturesque Views on the Southern Coast of England* after Turner's watercolours. They were also among those to buy watercolours from the sale of two hundred and fifty of Cotman's works at Christie's on 1 May 1824, which included several of his recent views of Normandy. Views by Cotman of Rouen and Louviers were included in the Old Water Colour Society displays in 1825 (no.105) and 1826 (no.192).

9 The only other attempt to relate this book to the 1826 tour was made by Nicholas Alfrey in Paris 1983, p.37.

10 Although I have no doubt that the book is connected to the 1826 tour, I feel it needs further discussion and plan to publish a more detailed article in the near future.

11 TB CCLI ff.4 verso, 13.

12 TB CCLI ff.11 verso, 12, 24, 25, 26 verso, 28 verso, 29, 33.

13 See, for example, the report from Boulogne in the *Times* on Tuesday 12 September 1826, p.2: 'We have had a terrific gale here during the last four days.'

14 TB CCLI f.14 verso.

15 See, for example, TB CCLI ff. 18–23.

16 I am grateful to Jean-Paul Pasquette for locating this reference in the Archives Municipales at Cherbourg (Document, 1I 35).

17 See TB CCL ff.2, 2 verso, 3, 59 verso. Two of the pen-and-ink and gouache studies were identified by Finberg as Cherbourg (TB CCLIX 87, 88), to which small group another work should also be added, TB CCLIX 49. Stylistically these studies look later than those related to the 1826 Loire tour. They may instead relate to a later visit at the time of Turner's trip to Guernsey.

18 TB CCL f.58.

19 TB CCLV f. 14v (see Paris 1981, p.357, fig.733, where identified as 'Evreux').

20 See TB CCL ff.8, 9, 10, 12, 16, 28, 31, 32 verso, 33, 45 verso, 51 verso, 52, 52 verso, 53, 55 verso, 58 verso, 59; see also TB CCCXLIV 145 (Paris 1981, p.516, fig.1032). For Cotman's views of Coutances, see Norwich 1975, no.17, pl.27 and no.19, pl.14.

21 For example, see the engraving by Skelton (reproduced in Guide Pittoresque 1837, opposite p.250) or the similar view dating from the later 1830s (Bibliothèque Nationale: Va.50, Manche, T2: H131675).

22 TB CCLI ff.2, 3, 4, 17 verso, 24, 28 and TB CCL ff.22, 23 verso, 27, 34 verso.

23 See Norwich 1975, no.10, pl.24.

24 Among the many who depicted Mont-St-Michel were Bonington, Cotman and Stanfield.

25 TB CCLV f.17. This sheet was not part of the original Rouen sketchbook, which contained only '15 leaves' (see executors' endorsement), and was added at a later point. For a reproduction, see either Paris 1981 p.356, fig.729, or Tate Gallery 1991a, p.70, no.87.

26 Thornbury's biography reports various stories related to him by Mr Thomas Rose of Jersey, including the following: '[Turner] remarked that, should I cross over to St. Malo, I was to be sure to proceed by the Rance to Dinan, as that river afforded many picturesque scenes, and the views were the most pleasant in that neighbourhood.' (Thornbury 1862, II, p.94). Philip Stevens has kindly provided me with biographical information about Mr Rose, and suggested that the period of their connection was most probably in the first half of the 1830s. Another area that Mr Rose suggests Turner visited is the Pyrenees (see Thornbury 1862, II, p.94), but a tour to that region has yet to be identified.

27 TB CCXLVII ff.1–10 verso.

28 TB CCXLVII f.11. A painting by A.J. Noël of the view from the Quai up towards the church of St-Mélaine is in the Musée des Beaux-Arts de Quimper (Une rue à Morlaix en 1830, 1870).

29 An impression of Ozanne's published view of Le Port de Landerneau can be found in the Bibliothèque Nationale (Va 29, Finistère, T 4: H1211400).

30 Register of travellers in the Archives Municipales de Brest, Cote 1 I 10.2. The record for the day Turner left

Brest lists another Britain named John Dobson, immediately next to his name, which could suggest that they travelled together. This document was located in the Archives by the curators Mme Annie Henwood and René Le Bihan.

31 See Louis-Nicolas Van Blarenberghe, Le Port de Brest, 1774 (Musée Municipal, Brest), and Jean-François Hue, Le Port de Brest, 1793 (Musée de la Marine, Paris). The design for one of Nicholas Ozanne's engraved views of Brest was sold at Sotheby's, Monaco, 20 February 1988, lot 274.

32 I am grateful to René le Bihan for confirming the identity of this sketch.

33 TB CCXLVII ff.19–21.

34 TB CCXLVII f.66 verso.

35 TB CCXLVII f.71 (b) verso.

36 See, Ferdinand Perrot (Bibliothèque Nationale, Va.29 Finistère. T7: H121637), Michel Le Tendre, Retour de la fête donnée au bas de la rivière par le principal du collège de Quimper (Musèe Departmental Breton, Quimper), Boudin, Vue du port de Quimper, 1857 (Musèe des Beaux-Arts de Quimper), Miles Birket Foster, Quimper (Laing Art Gallery, Newcastle, TWCMS, D2684; there are also a number of studies for this watercolour in the Victoria and Albert Museum, E.1379–1481.1954).

37 TB CCXLVII f.25 verso.

38 See the Scotch Figures book of 1801 (TB LIX) or the Swiss Figures book of 1802 (TB LXXVIII).

39 See Butlin, Luther and Warrell 1989, ch.4, pp.61–70.

40 Spectator, 8 June 1833, p.529.

41 TB CCXLVII ff.26–8, 64 verso, 65, 83 verso, 87–8.

42 Le Port de Lorient en 1792, after J.-F. Hue (Musée de la Compagnie des Indes, Citadelle de Port-Louis).

43 See, for example, the illustrations of Carnac by Jorand, engraved in 1823 for Monumens Druidiques or Celtiques (examples of these lithographs are in the Bibliothèque Nationale: Va.56, Morbihan, T1: H136570 etc).

44 There are sketches of Stonehenge in the following books: TB LXIX ff.79, 80 verso (based on engravings); TB CXIII ff.211–12; and the Stonehenge sketchbook, TB CXXV(b). Turner completed three watercolours of the famous landmark: an unpublished design for the Liber Studiorum (Private Collection; RL 81); a frontispiece executed for Walter Fawkes (Private Collection) and the England and Wales watercolour (Salisbury and South Wiltshire Museum, w 811). See Tate Gallery 1997, pp.15–16, where the latter two works are discussed and reproduced.

45 Turner's sketches of La Roche-Bernard are TB CCXLVII ff.28 verso, 29, 85 verso, 86. Stendhal 1837, II, p.6.

46 TB CCXLVII f.86 verso.

47 See Tate Gallery 1993.

48 In his biography Hamerton considers the three French Rivers vignettes 'amongst the most beautiful which Turner ever produced' (1879, p.236)

49 The study was presented to the museum as a view of Amboise. This identification was corrected to Nantes by Malcolm Cormack, but recently questioned by Jane Munro. See p.218.

50 A number of comparisons of this subject, as depicted by other artists, can be made from Nantes 1978, pls.XXII–XXIII.

51 Tate Gallery 1992–3, p.82.

52 See Alfrey 1977, pp.4–5, or Paris 1981, p.250, no.59.

53 See Nantes 1978, pl.XLI, and pl.XXXIII. No.378, by Jules Noël, shows the circus later built below the Tour à Plomb.

54 TB CCXLVII f.44.

55 See Nantes 1986.

56 Guide Pittoresque 1837, pp.460–61.

57 Stendhal 1837, II, pp.298 and 310.

58 See the Feuille Commerciale de Nantes, 1 October 1826. I am grateful to Bertrand Guillet for locating this reference. Curtis Price has demonstrated that Turner was involved in painting scenery in the early 1790s, an experience which instigated a lifelong love of the theatre (see 'Turner at the Pantheon Opera House, 1791–2', Turner Studies, vol.7, no.2, pp.2–8). Many of Turner's pictures have theatrical connections, and he clearly followed the ups and downs of the principal actors during his lifetime (see, for example, Tate Gallery 1995a, p.142, no.95).

59 TB CCXLVII f.48. See also the outline sketches in the Nantes, Angers, Saumur sketchbook, TB CCXLVIII f.1 and 3 verso.

60 The balustrade on the left is reminiscent of similar features in the vignettes made in 1826–7 for Samuel Rogers's Italy. For comparative views of the theatre, see Nantes 1986, p.28 (no.71) and p.76 (no.72). In both of these there is a tower to the right, but it is not topped off with a peaked roof, as in Turner's study. The form of Turner's tower resembles the way he has painted the steeple of the church of La Trinité at Angers (see fig.94).

61 TB CCXLVII ff.31–2, 48 verso, 60 verso, 61, 62 verso.

62 TB CCXXIV 206, 207.

63 See, for example, Strutt 1833, p.281.

64 Quoted in Herrmann 1968, p.33.

65 For comparable views of the Pont Pirmil, see Nantes 1978, pls.LI–LIII.

66 Herrmann accepted the identification as Angers and rather improbably attempted to relate the design to a sketch on f.30 of the Nantes, Angers, Saumur sketchbook (1968, p.74, no.37). Alfrey rightly rejected this sketch as Turner's source and instead linked the colour study with f.31 verso of the Morlaise to Nantes sketchbook, without making a firm identification (Paris 1981, p.221, no.42).

67 In his commentary on the Nantes, Angers, Saumur sketchbook Maurice Guillaud suggested that the sketches were 'taken from the coach window', a strange assertion given that the majority are obviously views from the river itself (Paris 1981, p.210).

68 William S. Rodner, 'Turner and Steamboats on the Seine', Turner Studies, vol.7, no.2, p.36. Rodner is currently preparing a fuller study documenting Turner's interest in steamers.

69 Patrick Villiers and Annick Senotier 1996, p.41. My discussion of the Loire steamers owes much to chapter 2 of Patrick Villiers' book. The following useful publications were brought to my attention by Bertrand Guillet: Félix Libaudière, 'La Navigation à Vapeur 1822–1825', Les Origines de l'Industrie Nantaise au XIXe Siècle, Nantes, 1909; H.E. Williamson, Les Bateaux à Vapeur sur la Loire 1822–1852 [?1985]; Françoise de Person, Bateliers sur la Loire, XVIIe, XVIIIe siècles. La vie à bord des chalands, Tours, 1995.

70 See Eric Shanes, 'Turner's "Unknown" London Series', Turner Studies, vol. 1, no.2, pp.39–45. The watercolour was untraced until 1990, when it was sold at Christie's (13 November, lot 118). It is reproduced in colour on the back cover of Turner Studies, vol.11, no.1.

71 See Ritchie 1833, pp.26–7.

72 Villiers and Senotier 1996, p.41; Williamson, p.13.

73 I am grateful once more to Bertrand Guillet for conducting a thorough, if ultimately fruitless, search on my behalf.

74 By 1832 Elizabeth Strutt was able to note that they passed twice a day; see Strutt 1833, p.271.

75 The steady passage past the sites along the riverside was noted critically by Miss Strutt (1833, p.274).

76 Those used in 1824 are discussed in Tate Gallery 1991b, while examples of Turner's sketching method in the 1825 books can be found in Tate Gallery 1994, p.68 (NB: the dating of the 'Sketchbooks with Dutch Place Names' on p.26 of that catalogue should be used with caution).

77 In both his 1977 study and in the catalogue of the 1981 exhibition in Paris Nicholas Alfrey considered that the watercolours of the Loire below Angers resulted from the experience of an afternoon, rather than a morning, voyage on the river (1977, p.8; 1981, p.198). As a point of reference for the following discussion, The Almanach de Nantes et de la Loire-Inferieure Pour l'An 1826 lists the expected time of sunrise on 3 October as 6.13 a.m. and of sunset as 5.46 p.m. (p.18).

78 See, for example, Between Quilleboeuf and Villequier (Tate Gallery, TB CCLIX 104; w 968) or Confluence of the Seine and the Marne (care of Christie's; w 988).

79 TB CCXLVIII f.7.

80 Turner's views of Mauves, looking upstream, can be compared with the lithograph produced by Charpentier after a design by F. Aubry (Bibliothèque Nationale, Va.44, Loire-Atlantique, T.3: H129303). The cliff is less sheer in Aubry's image than in any of Turner's views.

81 Ruskin, Modern Painters, I, 1843 (Works, III, pp.547–8); see also Armstrong 1902, p.262, and Herrmann 1990, p.170. Turner's comments on his

preference for sunrises were reported by Mary Lloyd in *Sunny Memories*, 1880, which was reprinted in *Turner Studies*, vol.4, No.1, p.22.

82 Quoted in Herrmann 1968, p.33.

83 Alfrey 1977, pp.7–8; Paris 1981, p.198.

84 Ritchie 1833, p.158

85 Ruskin, *The Art of England*, 1883 (*Works*, XXXIII, p.348).

86 See Butlin, Luther and Warrell 1989, pls.77–79.

87 TB CCXLVIII ff.10 verso, 11.

88 See J. de la Robrie, *Le Chateau de Clermont* [n.d.]. For the details of Elizabeth Strutt's visit, see Strutt 1833, p.265 ff.

89 For associative readings of Turner's works, see Eric Shanes, *Turner's Human Landscape*, 1990. In all of his writings Shanes has demonstrated the value of looking for connections between Turner's staffage and the history of a specific site.

90 TB CCXLVIII f.11 (the sketch nearest the bottom edge of the sheet).

91 Ruskin, *Catalogue of the Drawings and Sketches by J.M.W.Turner, R.A. at Present Exhibited in the National Gallery*, 1881, p.386; Wilton 1982, p.47, no.46.

92 Ludovic Chapplain, *Panorama de la Loire – Voyage de Nantes à Angers et d'Angers à Nantes sur les bateaux à vapeur*, Nantes, 1829 (2nd ed., 1830). The follies are also mentioned in T. Adolphus Trollope, *A Summer in Western France*, 1841.

93 Strutt 1833, pp.260–63.

94 The history of the follies is set out in the following articles, which were kindly brought to my attention by Bertrand Guillet: 'Quelques Notes sur le Châteauguy (Les Folie Siffait) Le Cellier (Loire-Inférieure)', *Bulletin de la Société Archéologique et Historique de Nantes et de la Loire-Inférieure*, vol.63, 1924, pp.120–24; Marie-Paule Halgand, 'La Folie de Monsieur Siffait', *Revue 303*, no.14, 1987, pp.59–60; Jacqueline Guevenoux, 'Les Folies Siffait, un paradis perdu sur les bords de la Loire', *Monuments Historiques*, no.176, September–October 1991, pp.32–7; Guy-Jean Ravard, 'De Chateau-Guy aux Folies Siffait', *Histoire et Patrimonie au Pays d'Ancenis*, ?1994, pp.24–9. See also the texts referred to under note 69 for further references to Siffait's part in the development of a regular steamboat service on the Loire.

95 Ritchie 1833, p.176.

96 A comparison with Turner's view can be made from a sketch by Victor Hugo dating from his journey down the Loire in 1834. See *Dessins de Victor Hugo conservés à la Maison de Victor Hugo* (Jur.976), Paris 1985. The sketch is also reproduced in *Victor Hugo. Correspondance familiale et écrits intimes*, ed. J. Gaudon, S. Gaudon and B. Leuilliot, II, 1828–38, Paris 1991, pp.593–4. As well as the view of Oudon on fol.28 of the 1834 sketchbook, Hugo made a sketch of the belltower of the church at St-Florent (fol.29). It is unlikely that Hugo was induced to make his tour by the publication of

Turner's Loire engravings the preceding year, as there is no trace of the 1833 book in any of his libraries; I am grateful to Sophie Grossiord at the Maison de Victor Hugo for her assistance with this detail. A later depiction of the building at Oudon, showing it with its peaked towers, was completed by Victor Ruprich-Robert in 1870 (it is reproduced in the Gallimard guide to the *Loire-Atlantique* region, pp.364–5).

97 TB CCXLVIII ff.13–14 verso. A comparative view of the *péage* by Dagnan can be found in the Bibliothèque Nationale (Va.49, Maine et Loire, T1: H130989). The history of the château at Champtoceaux is set out in an undated brochure by Marie-Madeleine Denis.

98 Ritchie 1833, p.174.

99 Herrmann has interpreted the lighting effect as a late afternoon subject, with the château 'catching the last rays of the sun' (1990, p.170).

100 Ritchie 1833, p.155.

101 *The Victory Returning from Trafalgar*, ?exhibited 1806 (Yale Center for British Art, New Haven; B&J 59).

102 See the *Gentleman's Magazine* for April 1833, p.340.

103 Simon Schama, *Citizens: A Chronicle of the French Revolution*, 1989. See chapter sixteen, 'Sacred Hearts: The Rising in the Vendee', pp.690–705, and also pp.788–9.

104 Scott's translation of Victorine Donissin de Larochejaquelin's recollections of the events appeared as *Memoirs of the Marchioness de Larochejaquelin: With a map of the theatre of war in La Vendée*, 1816. This work was later used by Anthony Trollope as the basis for his historical novel, *La Vendée: An Historical Romance*, 1850.

105 For a comprehensive survey of the career of the sculptor Pierre-Jean David D'Angers, see Viviane Huchard, *Galerie David D'Angers*, Angers 1984, republished 1995. The sculpture of Bonchamps is discussed on pp.34–6. See Strutt 1833, pp.233–4, where it is claimed that the monument was not installed until 1828.

106 Tate Gallery 1997, p.11.

107 Ritchie 1833, pp.149–150.

108 See, for example, the print of 1837 after a design by P.Hawke, published by J. Sebire Père, Quai Brancas, Nantes (Bibliothèque Nationale, Va.49, Maine et Loire, T2: H131085).

109 Ritchie 1833, p.125.

110 Strutt 1833, p.216.

111 See the commentary on *Montjean* in Lévêque-Mingam 1996, p.50, fig.33.

112 For a survey of views of Angers, including the Pont de Treilles, see Angers 1984. The most important view of the bridge in its ruined state is the oil painting of about 1840, attributed to either a British artist or to J.-V. de Fleury, which was acquired by the Musée d'Angers in 1986. See also the watercolour by Clarkson Stanfield, dated 'Sep tr 22nd 1851', which was sold at Christie's, 19 July 1978, lot 154.

113 W. Müller's 1840 watercolour view of Angers from

the river, shows the northern spire missing (Victoria and Albert Museum), as does an oil painting, also by Müller (Leverhulme Sale, Anderson, New York, 17–19 February 1926, lot 201).

114 TB CCXLVIII f.28 verso.

115 TB CCXLVIII f.30; repr in Paris 1981, p.220, and Lévêque-Mingam 1996, pp.58–9.

116 Alfrey 1997.

117 See the lithographs by Dagnan (Bibliothèque Nationale, Va.49, Maine et Loire, T.4: H131284 and H131287).

118 The watercolour study, fig.183, implies that Turner considered making a finished work. Although it is discussed more fully later in this book, it should be noted here that the illustration of Angers included in Strutt 1833 could be based on an untraced drawing by Turner. See p.194. Finally, the bicentenary show at the Royal Academy included a pen-and-ink study which it identified as Angers (Royal Academy 1974, p.116, no.383; it then belonged to Dr Charles Warren but is now in a private collection in Britain). However, the view depicted is Vernon, a Seine subject. Turner made no other pen-and-ink studies that can be identified as Angers.

119 TB CCXLVIII f.27 verso. See also note 60 above.

120 Henry James 1884, p.70.

121 See, for example, his notes in the Louvre in 1802 (TB LXXII) and again in 1821 (TB CCLVIII), or his records of pictures in Italy (see Powell 1987, ch. 5, pp.65–71), Holland (TB CCXIV f.81; see Tate Gallery 1994, p.66) and Germany (TB CCCXI inside front cover, ff.1, 94 verso; TB CCCVII ff.6 verso, 7; see Tate Gallery 1995b, pp.116–17).

122 Ritchie 1833, p.115; Strutt 1833, p.143.

123 TB CCXLVIII f.37; that this sheet, with its views of Montsoreau and Saumur from the east, should fall outside the main group of views of Saumur is interesting, since it could indicate that Turner went back to the town again after his expedition along the south bank, and departed from there for Tours.

124 Figs.98 and 103. The lack of any related pencil sketches for either of these works suggests that the compositions ought to have been made directly on to the sheets of blue paper. However, Peter Bower has linked these sheets with a piece of the blue paper bearing an 1828 watermark, in which case Turner could not have used the paper until two years after his tour. He must therefore have either invented the scenes from memory, or used other sketches no longer in existence. A view of Saumur from the west was also painted some years later in 1872 by George Clarkson Stanfield. See *The Victorian Painter Abroad*, Trafalgar Galleries, 1965, no.36, reproduced and listed as *A View on the Rhine*.

125 The identifications of figs.98 and 99 modify those given in Joseph-Henri Denécheau's survey of 1995, pp.46–7.

126 Tate Gallery 1992–3, p.82.

127 TB CCXLVIII f.43; see Lévêque-Mingam 1996, repr. p.62.

128 Ibid., p.128.

129 Strutt 1833, p.212.

130 See Denécheau 1995.

131 The novel is set in the year 1819, so the references to *The Keepsake* are effectively anachronisms, relevant and topical to Balzac's fashionable readership but grafted on to the story itself (see Penguin edition, pp.73, 78). Balzac enthuses about the 'fanciful portraits of women drawn by Westall for English *Keepsakes*, and engraved by the Findens with a burin so skilful that you hesitate to breathe on the vellum for fear the celestial vision should disappear' (p.73). However, though Westall did contribute a number of designs to the volume, none of them was engraved by either Edward or William Finden: *Hebrew Melody* (for 1828) engr. by Charles Rolls; *Lucy on the Rock* (for 1829) engr. by Charles Heath; *Nestor and Tydides* (for 1831) engr. by Robert Brandard. Further information about Westall can be found in Richard J. Westall, 'The Westall Brothers', *Turner Studies*, vol.4, no.1, Summer 1984, pp.23–38.

132 See TB CCXLVIII ff.37, 41 verso, 42 verso, 44 verso, 45 verso to 48 verso.

133 For example, the humble dwelling depicted in TB CCLIX 28 (Paris 1981, p.165, fig.289) could be a Loire subject (it is painted in appropriately autumnal colours), while the woman in TB CCLIX 237 wears the type of headdress found in north-western France. It was around 1827 especially that Turner seems to have been most interested interested in producing these small figure studies on blue paper. Another interior scene, TB CCLIX 190 (Paris 1981, p.399, fig.844), may also date from this period, although it can be related to an earlier pencil sketch in the 1821 *Dieppe, Rouen and Paris* sketchbook (TB CCLVIII 24 verso; Paris 1981, p.152, fig.257).

134 This view was also described by Ruskin as a sunset; see *Modern Painters*, V, 1860 (*Works*, VII, pp.217–21).

135 Although Turner was happy to create beautifully graduated areas of sunlit water in his finished drawings, he tended to add boats, buoys, or other flotsam, when these works were engraved; see the earlier view of *Stangate Creek, on the River Medway* (TB CCVIII A and R 766; Tate Gallery 1991a, pp.32–4, nos.13 and 16), or *Beaugency* in the Loire group, figs.139 and 194.

136 This point and identification are also made in Joseph-Henri Denécheau's caption to this work in Lévêque-Mingam 1996, p.67, fig.48.

137 Turner painted views of the confluences of several rivers. See, for example: *The Junction of the Severn and the Wye* (c.1806, TB CXVII E); *Sheerness and the Isle of Sheppey, with the Junction of the Thames and the Medway from the Nore* (1807, National Gallery of Art, Washington D.C.; B&J 62); *The Confluence of the Thames and the Medway* (1808, Tate Gallery and Petworth

Notes

House; B&J 75); *Junction of the Greta and Tees at Rokeby* (1816–8, Ashmolean Museum, Oxford; W 566); *Confluence of the Seine and the Marne* (?1832, care of Christie's, W 988).

138 See note 123 above.

139 Ritchie 1833, p.39; Stendhal 1837, I, p.263; *Guide Pittoresque* 1837, p.152. See Tours 1979, p.47 ff.

140 See note 165 below for discrepancies in the presentation of the bridge at Blois. See also the watercolour of a bridge recently included in *Turner's Watercolour Explorations*, which is there identified by Eric Shanes as Barnstable (Tate Gallery 1997, no.39) but which could be a first idea for *The Keepsake* view of Saumur or for a view of Tours taken from near the abbey of Marmoutier. This is perhaps supported by the tall rectangular sails of the boats, which, though reddish brown, resemble those found on Loire barges.

141 Honoré de Balzac, *Sténie ou les Erreurs Philosophiques* (1819–22), quoted by Graham Robb in *Balzac: A Biography*, 1994, p.67.

142 Ritchie 1833, p.55; he was, however, stopped when trying to leave the city (see ibid., pp.105–7).

143 See *Snowstorm, Mont Cenis* (1820, Birmingham City Museum and Art Gallery, W 402) and *Messieurs les Voyageurs on their Return from Italy (par le Diligence) in a Snow Drift upon Mount Tarrar – 22nd of January, 1829* (British Museum, W 405). Both these watercolours are reproduced in Tate Gallery 1991a, p.25 and p.14.

144 Two views by, or attributed to, Prout appear to show the interior of St-Julien. The first, in a British Private Collection, is currently listed as *At Dieppe* in the Witt Library photographic archive (XXIV, 28). A second watercolour, probably showing the interior of the apse of the church, is in the Huntington Library, California, where it is catalogued as *Stable in the Eglise St-Laurent, Rouen*. Frederick Nash exhibited a drawing at the Old Water Colour Society in 1831 entitled *Interior of the Church of St.Julien, at Tours; now used as a Remise to the Hôtel de l'Europe* (no.170; whereabouts unknown) [note the hotel is here recorded as the Hôtel de l'Europe, whereas in Ritchie's text it is identified as the Hôtel d'Angleterre]. A lithograph by Noël of the church was issued *c*.1844 (see Bibliothèque Nationale, Va.37, Indre et Loire, T1: H126421).

145 For a full and stimulating discussion of *The Fighting Temeraire*, see the book by Judy Egerton, which accompanied the National Gallery's exhibition on the picture in its 'Making and Meaning' series, 1995.

146 It is interesting to see the image of St-Julien against the background of the struggle for Catholic emancipation at the end of the 1820s, a cause to which Turner seems to have been sympathetic. This issue is considered by Eric Shanes in relation to two watercolour views by Turner of Stonyhurst College; 'Deciphering Turner's Clues', *Turner Society News*, no.71, December 1995, pp.12–14.

147 Christie's, 30 April 1937, lot 64. The history of the

missing drawing is set out in the catalogue section below, p.223.

148 Among those who visited Plessis-lès-Tours were Longfellow (1826), Delacroix (1828), William Callow (1836), Stendhal (1837), James (1882).

149 See Tours 1979, pp.25–30.

150 Another watercolour of the Pont d'Eudes has been erroneously attributed to Turner. This work is now in the Glynn Vivian Art Gallery at Swansea (where it is currently catalogued as *Orleans Cathedral* instead of Tours). The rather dry, detailed style is more convincing as the work of someone like Thomas Allom. However, the drawing was accepted as an authentic Turner by Rawlinson, who included both an engraving (by H. Adlard, R 647a) and a chromolithograph (by J.C. Ogle, R 863) of the subject in his *catalogue raisonné*. Not surprisingly, Turner's name does not actually appear on the publication lines for either of these works. The chromolithograph (sometimes listed as 'Orleans Cathedral' but also correctly as 'Bridge of Tours') was produced after his death, probably around 1856, when there were many efforts to capitalise on public interest in Turner's works. According to the Cooper Notebooks at Indianapolis (see below, p.214, note 16), the Turner collector Charles Stokes seems to have owned an impression of the chromolithograph, although the entry implies that the work was made by R. Carrick (see Cooper Notebooks, V, p.33).

151 Comparable views by other artists of Marmoutier include that of 1817 by C. Bourgeois (Bibliothèque Nationale, Va.37, Indre-et-Loire, T5: H126245) and that by Deroy from a book entitled *France en Miniature*, lithographed by the Becquet brothers (Bibliothèque Nationale, Va 37, Indre-et-Loire, T.5: H126247). The history of the site is covered in Charles Lelong, *L'Abbaye de Marmoutier*, Tours [n.d.].

152 Neither Peter Bower nor myself have been able to examine this sheet properly, as it remains stuck to its mount, like most of those at the Ashmolean Museum in Oxford.

153 See Tours 1979, pp.64–5.

154 *Kirkstall Lock, on the River Aire* (TB CCVIII L; W 745), *Chichester Canal* (Tate Gallery and Petworth House; B&J 285 and 290; see Butlin, Luther and Warrell 1989, pp.82–3 figs.79–80, and pp.117–119).

155 Honoré de Balzac, *Cesar Birotteau*, 1838, Penguin ed., p.108.

156 TB CCLIX 101 (RA 1974, no.396, colour, p.90).

157 It has been variously suggested that the view depicted could be Tours, Rouen, Koblenz or Mainz, but none of these identifications has been conclusively supported. Although some of the details are different, the composition is similar to a view of Trier dating from 1839 (see Tate Gallery 1991b, p.130, no.47).

158 This was catalogued by Ruskin as *Tours? The Scarlet Sunset* and made accessible in the series of framed works stored in cabinets in the basement of the

National Gallery. The similarities between this view and Monet's famous painting *Impression, Sunrise* (1872, Musée Marmottan, Paris) have often been remarked on, but there is no absolute way of proving that Monet saw Turner's study. However, another blue paper scene, that of the West Front of Rouen Cathedral (TB CCLIX 109), makes a much clearer link between the two artists, and suggests a probable influence on Monet's choice of the same motif in the 1890s (see John House, *Impressionism, its Masters, its Precursors, and its Influence in Britain*, exh. cat., Royal Academy, 1974, p.26 no.19).

159 The mallard motif can be found in paintings and watercolours throughout his career and seems to have been used as a kind of signature (see especially the personalised stamp used on Turner's late correspondence; Gage 1980, pp.228 no.325, 231 no.329). Sometimes this produces startling effects, as in the maritime funeral of Sir David Wilkie depicted in *Peace – Burial at Sea* (1842, Tate Gallery, B&J 399), where a black bird rises from the foreground, perhaps implying Turner's spiritual presence at the scene. There are also numerous instances in his correspondence of this characteristic way of referring to himself. See, for example, his letter to Holworthy, 4 December 1826: 'In the summer I have to oil my wings for a flight.' (Gage 1980, p.103.)

160 See Graham Robb, *Balzac: A Biography*, 1994, pp.364–5.

161 TB CCXLIX ff.11 verso, 12, 16.

162 Strutt 1833, p.31.

163 For comparable views of Amboise from the Ile de St-Jean, see those by George Jones (1817, Ashmolean Museum, no.217), William Callow (1836, Private Collection, and 1894, Christie's, 14 June 1983, lot 103) and Deroy in *La Loire et ses Bords* (1843; Bibliothèque Nationale, Va.37, Indre et Loire, T1: H125775).

164 The snuff-box was given to Turner in return for a presentation set of the prints in the *Picturesque Views in England and Wales* series (see Wilton 1987, p.229, where the box is illustrated). Although no documentary evidence has, as yet, been published, it seems that the connection between French monarch and artist continued into the 1840s, even if it had been less close prior to the 1838 gift; see Tate Gallery 1995a, p.16 and pp.35–40 nos.1–5.

165 For example, the bridge depicted has only nine arches, instead of eleven (as in fig.131), and is probably based on the earlier drawing (fig.2), where this is also the case.

166 See TB CCXLIX ff.20 verso and 22. The extent to which Turner and Robert Wallis have imposed order on this facade in their print can be ascertained by comparing their combined efforts with the lithograph by Charles Pensée, *Façade de Francis 1e, prise des Jardins du Roi*, ?1846 (Bibliothèque Nationale, Va.41, Loir-et-Cher, T5: H128366).

167 Paris 1981, p.234.

168 See the commentary by Alain Guerrier in Lévêque-Mingam 1996, p.88, fig.68. I was also confused by Turner's placing of a tower beyond the facade when I catalogued this drawing in Tate Gallery 1991a, p.51, no.48, and wrongly thought it was the cathedral of St-Louis. See also Luke Herrmann (1990, p.169), who claims there are no sketches of the foreground or the facade of St-Vincent-de-Paul (but see here, fig.133).

169 Ritchie 1833, p.25.

170 See the drawings by George Jones (Ashmolean Museum, no.241) and Thomas Shotter Boys (Yale Center for British Art, New Haven, B.1977.14.4401).

171 See the note by Nicholas Alfrey in Paris 1981, p.232, no.45.

172 TB CCXLIX ff.29 verso–31, 32 verso–34 verso.

173 For contemporary views by other topographical artists, see, for example, C. Bourgeois, *Orléans en 1825*, lithograph by Senefelder (Bibliothèque Nationale, Va 45, Loiret, T.4: H130204), or C.Reiss, *Orleans*, engraved by Martini (Bibliothèque Nationale, Va 45, Loiret, T.4: H130225).

174 Paris 1981, p.258, under no.69.

175 Ruskin, *Catalogue of the Sketches and Drawings By J.M.W.Turner, R.A. exhibited in Marlborough House*, 1857 (*Works*, XIII, pp.312–13).

176 Ibid., pp.311–2.

177 See the view of the Place de l'Etape in the *Petit Musé Pittoresque et Monumental Composé de 72 vues: La Ville d'Orléans en Miniature*, published by Alphonse Gatineau, Orléans (Bibliothèque Nationale, Va.45, Loiret, T.4: H130308), or the lithograph of the Place de l'Etape, also issued by Gatineau (Bibliothèque Nationale, Va.45, Loiret, T.4: H130308).

178 TB CCCXLIV 82–3, 84–5; and TB CCXLIX ff.3 verso, 9 verso, 27 verso, 28, 31 verso, 35 verso–44 verso.

179 Beckett 1966, pp.152–65. See also the sketchbook in the Turner Bequest, listed as *Colnaghi's Account* by Finberg (TB CCXLII).

180 Ibid., p.153. The Colnaghi family does not appear as a source for any of the pictures catalogued by Butlin and Joll 1984. If the commission for a companion piece from Constable took place in 1821, the work by Turner would presumably have been somewhat earlier. However, without further information it is not possible to identify any likely candidates.

181 See Gage 1980, p.103. See pp.272–3 of that volume for an outline of Munro's life, which is supplemented by Selby Whittingham's entry to the *Dictionary of Art*, 1996, vol.22 , pp.314–15. The reference in the letter to Holworthy implies that 'Monro' has also returned from Paris, but does not necessarily mean they were both there at exactly the same time. It is also possible that the Monro referred to was not H.A.J. Munro, as has been generally assumed, but that it was one of Dr Thomas Monro's children, with whom Turner may have kept in touch.

182 In a sketchbook mistakenly catalogued by Finberg as *Oxford and Bruges* (TB CCLXXXVI), there are records

of payments listed under the heading 'John Soane & J.M.W. Turner Esqr. in Trust' (f.9). Two of the payments recorded fell in 1826: on the 10 and 25 October. Turner would certainly have been away for the first of these, but logistically could have been back in London in time for the second. Susan Palmer, the Archivist at Sir John Soane's Museum, has suggested that the payments relate to the Artists' General Benevolent Institution with which both men were involved throughout the 1820s. In a recent article Cecilia Powell has very properly questioned Finberg's title for the sketchbook, linking the book with a visit to Petworth House in 1834 because of a group of views of Chichester and the inscription on f.19 (see 'Turner, Tom and Tegid', *Turner Society News*, no.74, December 1996, pp.14–15). The book certainly seems to have been used in Sussex, for there is also a view of the Chain Pier at Brighton from the east (ff.44 verso–45). But Turner may also have made sketches in it of the Kent coast. For example, one of the sketches linked by Powell with Petworth due to its portrayal of children at play with a boat, is in fact a view of the harbour at Margate (ff.55 verso–56).

Part Three

Exploring *The English Channel*

1 See Shanes 1990, pp.13–15, where a group of landscapes and vignettes on blue paper are identified as the designs for the *East Coast* project (see pp.151–8, pls.121–30). The same works were recently linked by Jan Piggott with a scheme in the early 1830s to produce an illustrated edition of the poems of George Crabbe. Two of the watercolours in the group had apparently been in Munro of Novar's collection as 'Two Illustrations to Crabbe' (see Tate Gallery 1993, pp.49–50). Given that Munro was one of Turner's most important patrons, this information is clearly of some significance. If the blue paper subjects do relate to the proposed *East Coast* series, they would have to date from before the end of 1826, when negotiations between Turner and Cooke broke down irrevocably, at which point Turner pursued the coast project outlined in the main text here. However, the group of blue paper works are stylistically as accomplished as the best of the Loire series, which are dated 1828–30 here. Furthermore, as the blue paper was a relatively new material for Turner in 1826, it seems unlikely that he could have produced such sophisticated works so soon after taking up this unfamiliar medium. The view of *Whitby* (w 903; Shanes 1990, pl.129), in particular, seems to have more in common with works from the 1830s. No details of the watermarks in the blue paper have so far been established, which could help resolve the problem of dating this group of drawings more accurately. There are, however, two watercolours on white paper that could have been prepared as *East Coast* subjects; see below, note 29.

2 Cooke's letter of 1 January 1827 recounting this

incident was first published in Thornbury 1862, I, pp.400–403; it is also reprinted in Shanes 1981, p.153. The essentials of the conflict between Turner and W.B. Cooke are confirmed by a note, dated 2 March 1827, from George Cooke to William Miller, although in this letter the sum Turner is said to have asked for to continue the Coast series has risen to twenty-five guineas per drawing (quoted in Miller 1886, p.123).

3 Ibid.

4 Miller 1886, p.122, where the letter is dated 'London, 1st mo.16, 1826'. In view of the reference to the tour of the northern French coast, which it is possible to link with the summer of 1826 from other documentary evidence, the year 1826 in the date heading this transcription of the letter must be a mistake and should read 1827.

5 *Examiner*, 21 January 1827; quoted in Finberg 1961, p.300. A copy of the prospectus for *The English Channel* can be found in the Dawson Turner collection at the British Library (1879.b.1; p.148).

6 2 March 1827, quoted in Miller 1886, p.123.

7 Nicholas Alfrey, for example, suggested that some of the pen-and-ink studies of Calais could have been prepared in connection with *The English Channel* (See Paris 1981, p.413 no.104). The pen-and-ink works in question have not been securely dated, but seem to be later than the burst of activity at the beginning of 1827. Following Alfrey's suggestion, I have previously linked some of the gouache studies of Brighton with *The English Channel* project, but doubt that this was actually Turner's motive for making those spontaneous works (see, for example, Butlin, Luther and Warrell 1989, p.120 and p.123 n.114).

8 'Now for the Painter', (Rope.) Passengers going on Board (no.74; Manchester City Art Galleries; B&J 236), *Port Ruysdael* (no.147; Yale Center for British Art, New Haven; B&J 237), *Rembrandt's Daughter* (no.166; Fogg Art Museum, Harvard; B&J 238), *Mortlake Terrace, the Seat of William Moffatt, Esq., Summer's Evening* (no.300; National Gallery of Art, Washington, D.C.; B&J 239), *Scene in Derbyshire* (no.319; whereabouts unknown; B&J 240).

9 TB CCXX A–L.

10 The identification of this subject was made by Eric Shanes in conjunction with the rediscovered watercolour sold at Sotheby's (see note 23, below).

11 For example, the watercolour of the quayside (TB CCXX C; Paris 1981, p.185 fig.341) seems to be based on a conflation of the information gathered on ff.13, 16 and 32 of the *Dieppe, Rouen and Paris* sketchbook (TB CCLVIII; see Paris 1981, pp.150–52, figs.248, 251 and 253). The sketches of Château d'Arques are TB CCXVI ff.237–43. Though it could reasonably be thought that the watercolours of Dieppe relate to the 1825 painting (fig. 169) and should therefore be dated 1824–5, the Château d'Arques and St-Vaast subjects discussed below suggest the later date of 1826.

12 David Hill discusses this labelling process briefly in

Turner on the Thames, where he corrects his earlier hypothesis that Turner undertook this task in 1821 or 1822 (1993, p.152 and p.176 n. 79). I have prepared a short article on this important event, which awaits publication. As part of that piece, I have set out Turner's own order and titles for his sketchbooks.

13 The third is the watercolour in the Fitzwilliam Museum at Cambridge, catalogued by Andrew Wilton as *River landscape, with a distant hill, c.1811* (w 422).

14 In the Schedule drawn up by Turner's executors for the National Gallery in June 1854 these watercolours were listed as part of package number '32', which was a 'Parcel containing 20 slightly colored sketches (Dieppe)' (National Gallery Library).

15 Quoted in Finberg 1909, II, p.685.

16 Quoted in Butlin and Joll 1984, p.141 no.231.

17 This point is made by Eric Shanes in Tate Gallery 1997, p.12.

18 Wilton 1979, pp.413–14.

19 The watercolour of *Granville* is catalogued by Andrew Wilton as dating from *c.1830* (p.424, w 1050). The provenance given there is incomplete and can be traced back to Charles Stokes. This is clear from vol.2 of the Cooper Notebooks, now at the Indianapolis Museum of Art, where Hannah Cooper set out the drawings she had inherited from her uncle. *Granville* is listed there on p.14 and again on a separate sheet (Enclosure No.7). Both references to the drawing record that it was one of three watercolours that Mrs Cooper parted with on 13 February 1854 as part of an exchange for five blue paper subjects. (The other two watercolours in the package of three were *Ingleborough, from Hornby Castle Terrace* [w 576] and *The Jute* [fig.167; not in Wilton]. The five blue paper subjects were *Rouen* [not in Wilton; see *Turner Studies*, vol.7, no.1, pp.59–60, fig.2]; *Jumieges* [not in Wilton]; *Scene on the Loire* [fig.63], *Scene on the Loire, unengraved* [fig.51], and *Amboise by Moonlight* [fig.125].) The subsequent owner of *Granville* may have been the dealer D.T. White, since it was he who sold the watercolour on to the Ruskins towards the end of 1854 or at the beginning of 1855 (there is an undated entry in John James Ruskin's Account Book at the top of the entry for 1855, which includes *Granville* as one of five drawings he had bought from White for £630; MS 28, Ruskin Library, Lancaster). *Granville* was last seen in public when it was sold by Sotheby's on 18 June 1970, lot 94.

20 TB CCCXLIV 57.

21 w 1049, where catalogued as *c.1833*. The watercolour measures approximately 17.9 × 25.4 cm (7 × 10 in), and is derived from TB CCLI f.14 verso.

22 Armstrong 1902, p.257 first suggested that it was *The Keepsake* drawing, an assumption which was followed by others, until Edward Yardley identified another source for the engraving of *Le Havre* (see *Turner Studies*, vol.7, no.1, pp.59–60, fig.1).

23 See the entry in the Sotheby's sale catalogue, 14

November 1996, lot 163, as *Fisherfolk at St Vaast la Hougue, Normandy*.

24 See under note 19, above.

25 Graves, *Art Sales*, vol.3, 1921, p.222: the sale took place at Walton, Preston on 24 June 1861, the watercolour was lot 1296, eventually fetching £95. The buyer is not listed.

26 *A View of Folkestone, with beached fishing-boat, ?c.1830* (no.2415; w 884, where linked with the *England and Wales* watercolours). Barbara Dawson also identifies it as a probable *England and Wales* subject (1988, pp.82–4, repr. in col. pl.17 as '*c.1830*'). Eric Shanes, however, has written about the stylistic links with the series of *Ports* views (see Shanes 1981, p.39 no.83, or Shanes 1990, p.146, no.116; both as *c.1828*).

27 TB CCIII D (repr. in Dawson 1988, p.82, fig.29). Although this pencil drawing is clearly somewhat earlier than the watercolour at Dublin, dating most probably from about 1821, Turner may have come back to it for this composition subsequently. The sheet is annotated with a list of places on the south coast, most of which were illustrated in the series of *Picturesque Views on the Southern Coast of England*. There are also instructions to assist the process of engraving the design, but as this view was not published in the *Southern Coast* series, it is not clear what purpose these comments served.

28 R 643. For the illustrations intended for *Dr Broadley's Poems*, afterwards published in *Art and Song*, see Diane Perkins' entry in *Tate Gallery Illustrated Catalogue of Acquisitions 1986–88*, 1966, pp.227–8.

29 The views of *Whitby* (w 905; Shanes 1990, p.73, pl.49, where the possibility that this is a work for the *East Coast* is also considered) and *Tynemouth Priory* (w 545; Shanes 1990, p.149, pl.119); both are of similar dimensions to the *Southern Coast, Rivers* and *Ports* series.

30 *Shipwreck off Hastings* (no.2411; w 511, ?c.1825). See Dawson 1988, pp.80–81, pl.16, and Shanes 1990, p.145 pl.115.

31 There is a watercolour in the Fitzwilliam Museum at Cambridge (PD.114–195–; w 764) which seems to set out the composition of the Dublin shipwreck scene, sharing the same black-green washes for the waves in the foreground, and a similar build-up of storm forces, moving in a diagonal from the top left, across the design. There is also the suggestion that the light-orange washes for the cliffs to the right of the principal peak could have been developed in a way similar to the finished subject. According to Malcom Cormack, this work has had several titles in its history. His own suggestion that it shows *Shakespeare Cliff, Dover* has not previously been questioned (1975, p.48, no.21; the watercolour is reproduced in colour in Cambridge 1994, p.70).

32 For the *Turner Gallery*, see Rawlinson 1913, II, pp.356–9. The watercolour was engraved as *Wreck off Hastings* by William Miller for the *Art Journal* in 1866,

Notes

and later appeared in the 1875 edition of the *Turner Gallery* (R 740). The only other watercolour to be included in this set of prints was Robert Wallis's version of *The Lake of Lucerne* (R 749).

33 *Shoreham*, Art Gallery and Museum, Blackburn (W 883, as 'c.1830', measuring 21 × 31.2 cm[8¼ × 12½ in]; see Shanes 1990, p.148, pl.118, where the watercolour is dated 'c.1824'). The pencil sketches of the harbour at Shoreham in cat.3 could, incidentally, have also provided the inspiration for the oil painting *Port Ruysdael* (RA 1827; Yale Center for British Art, New Haven; B&J 237).

34 TB CCXXXVII ff.5 verso–6, 62 verso–66 verso. I am grateful to Eric Shanes for bringing these sketches to my attention. The book also includes sketches of Brighton (ff.3 verso–5, 61–2) and the Pleasure Grounds at Petworth (ff.56 verso–59 verso). This book seems to have been used on several different occasions. It is not impossible that the Shoreham sketches, which occur right at the beginning (or end) of the book, could actually date from 1826.

Painting *The Banks of the Loire*

1 Quoted in the *Spectator*, 17 November 1832, p.1096, in a review of an exhibition of Turner's watercolours.
2 Gage 1980, p.99, no.115.
3 Ibid., p.100, no.116.
4 See the advertisements for his sale in 1828, which identify the work by Linton as a 'Grand Composition, representing the Trojans landing at Delos' and the landscape by Vincent as a view of Pevensey Bay: *Morning Post*, 7 July; *Morning Herald*, 9 July; *Morning Post*, 11 July, 14 July, 16 July, on which day the sale took place at Phillips. See Tate 1991b, p.61 note 37, where Cecilia Powell records that Captain Robert Batty made sketches of the pictures in this sale. Broadhurst's name is included next to that of Nash in a list on the inside front cover of the *Roman and French* note book (TB CCXXXVII; this was mistranscribed by Finberg).
5 RA 1822, no.643. This work was engraved by H. Meyer, a copy of which is in the National Portrait Gallery Archive. The 1823 exhibition included a *Portrait of the son of J.Broadhurst, Esq.* by Mrs J. Robertson. It may be that a reference to the Mr Broadhurst living at Campden Hill, Kensington in May 1854 is to Broadhurst junior, rather than Turner's patron (see Tate Gallery 1991b, p.61 n. 37).
6 See above, p.208, note 58.
7 See Tate Gallery 1991b, p.44, where it is stated that Broadhurst commissioned the view of *Cologne*; see Gage 1980, p.108 no.123, and p.109 no.125.
8 See Butlin and Joll 1984, p.145 no.236.
9 This event is colourfully described by Kenneth Clark in *Another Part of the Wood: A Self-Portrait*, 1974, pp.276–7. The works accessioned as a result of this discovery were No5473–No5546 (73 in total; the catalogue numbers of these works in Butlin and Joll

1984 can be identified by using the Concordance in the text volume on pp.322–4).
10 See *The Turner Collection in the Clore Gallery: An Illustrated Guide*, 1987, pp.42–3, repr.
11 Jean Genet, *Querelle de Brest*, 1966, Faber edition, translated by Gregory Streatham, 1990, p.8.
12 See Laurent Manoeuvre and Eric Rieth, *Joseph Vernet: Les Ports de France*, Paris 1994. Vernet's set of port scenes is also discussed in Philip Conisbee, *Claude-Joseph Vernet 1714–1789*, exh. cat., Kenwood, 1976, and Michael Levey, *Painting and Sculpture in France 1700–1789*, 1972, pp.198–204.
13 See note 4 above. As well as *Dieppe* and *Cologne*, Mr Broadhurst sold a much earlier painting by Turner: *The Guardship at the Nore* (Private Collection, B&J 91). See comments under B&J nos.91, 231, 232, 241.
14 Gage 1980, pp.117–18, nos.138, 139.
15 Ruskin, *Notes on the Turner Gallery at Marlborough House 1856*, 1857 (*Works*, XIII, p.136).
16 *Athenaeum*, 27 May 1829; quoted in Butlin and Joll 1984, p.183, where it is claimed this is the only reference to the painting. However, see the *Gentleman's Magazine*, June 1829, p.537.
17 See Finberg 1961, pp.487–8, where the painting was linked with the still untraced *Scene in Derbyshire*, and Butlin and Joll 1984, p.183, no.329, which includes the following note: 'Martin Butlin suggests that it is just possible that this work [*The Banks of the Loire*] is the picture newly identified as *View on the Rhone* (no.328a).' The painting had been catalogued the previous year as a Rhône subject in an article by Cecilia Powell, although the connection between the painting and the gouache study is not made there (see Powell 1983, pp.56–8). Powell was, however, right to recognise the Italian character of the foreground, as is made plain below.
18 See Butlin, Luther and Warrell 1989, pp.71–7 and 105–23.
19 TB CCXXXVII f.11. The inscription on that page was mistranscribed by Finberg, but was correctly interpreted by Powell 1983. The *DNB* has Gordon's year of birth as 1773, as opposed to 1772 in Powell and Whittingham, *Turner Studies*, vol.5, no.1, 1985, p.20.
20 Cecilia Powell has suggested that the format owes something to Turner's earlier painting *Mercury and Herse* (B&J 114), which was owned by Sir John and Lady Swinburne, who were Julia Gordon's brother-in-law and sister. The *View from the Terrace of a Villa Niton, Isle of Wight, from Sketches by a Lady*, now at the Museum of Fine Arts in Boston, seems to have the more traditional early nineteenth-century frame, but this should be compared with those on pictures by other artists known to have come from the Willoughby-Gordon collection in order to establish whether a consistent style of frame was used for all of their paintings.
21 A.P. Oppé, 'Talented Amateurs: Julia Gordon and her

Circle', *Country Life*, vol.86, 1939, pp.20–21; H.F. Finberg, 'With Mr Turner in 1797', *Burlington Magazine*, vol.99, 1957, pp.48–51; J. Gage, *Colour in Turner*, 1969, p.264, note 132; R.V. Turley, 'Julia Gordon, Lithographer', *Wight Life*, August/September 1974, pp.41ff.; Gage 1987, p.157 and n.9, figs.234, 235. Oppé reproduces a view by Julia Bennet based on Turner's early watercolour of *West Cowes Castle* (TB XXVII F), which is inscribed 'First with Mr Turner, 1797' (Private Collection). Another watercolour by her of Llangollen Bridge, illustrated in Hilda Finberg's article, is also annotated with the date 1797. At the beginning of the *Smaller South Wales* sketchbook (TB XXV) there is a list of the names of Turner's pupils, one of which could read either 'Bennet' or 'Burnet'. If this is a reference to the young Miss Bennet, the list must date from at least two years later than the sketches in the book, which was used on Turner's Welsh tour of 1795.
22 I am grateful to both Raymond Turley and Evelyn Joll for help in locating these sketches, which are variously dated between 1815 and 1821.
23 Oppé (op. cit., p.20) suggested she may have had lessons from Girtin, and that she certainly did from David Cox. See Anne Lyle's entry in the catalogue of the Oppé collection (1997), now at the Tate Gallery, which includes a work by Lady Julia Gordon.
24 See Hamish Miles, 'Sir David Wilkie & Sir Willoughby Gordon', in *Fourteen Small Pictures by Wilkie*, exh. cat., Fine Art Society, 1981. The Tate Gallery collection includes a group of watercolours by Wilkie showing Sir Willoughby Gordon and his daughter Julia Emily Gordon (No1740, No1739, A01024).
25 The discussion of Turner's visit to the Isle of Wight in 1827 has tended to focus only on the work he did while staying with the architect John Nash at East Cowes Castle (see Reynolds 1969). During his stay he may have revisited Carisbrooke Castle. Although the composition is probably based on a sketch from his visit over thirty years earlier, the watercolour of c.1828 in the *England and Wales* series includes a fashionably dressed party on horseback. (There is also a figure sitting in the distance, who could be sketching the castle, perhaps a retrospective self-portrait?; W 815; Shanes 1990, p.192, pl.162). See also Tate Gallery 1991a, pp.65–6, nos.75–7.
26 See Felicity Owen, David Blayney Brown and John Leighton, *'Noble and Patriotic' The Beaumont Gift 1828*, exh. cat., National Gallery, 1988. See pp.38–9, no.4, National Gallery, no.61.
27 Quoted in Powell 1987, p.141. See there also p.166.
28 Ibid., p.141 ff.
29 *Daily Telegraph*, 2 February 1912, where the art critic questioned the authenticity of this, and the other two Gordon pictures (figs.176, 177), charges which were refuted by Mrs Disney Leith, a descendant of the Gordons.

The Loire in Black and White

1 Chapter 3 of John Heath 1993 gives a comprehensive account of the phenomenon of the Annuals. The connections between some of Turner's figure subjects and the Annuals are explored in Andrew Wilton's article, 'The "Keepsake" Convention: *Jessica* and Some Related Pictures', *Turner Studies*, vol.9, no.2, Winter 1989, pp.14–33. The importance of the Annuals in British life has also been explored in a number of quotations from contemporary novels in several editions of *Turner Society News*, including that in no.61 (August 1992, pp.8–9), which notes the impact they made on Flaubert and his characterisation of Madame Bovary.
2 Ibid., pp.33–5: Scott (8 contributions to Annuals between 1825 and 1853), Coleridge (five Annuals included his poems), Wordsworth (4 contributions), Mary Shelley (several contributions, including the 1831 edition of *The Keepsake*), Tennyson (3 contributions between 1831 and 1851), Ruskin (3 contributions) and Thackeray (3 contributions between 1831 and 1854).
3 Charles Knight, *Passages of a Working Life*, 1864, quoted in Heath 1993, p.27.
4 W 727, Herbert Art Gallery and Museum, Coventry (see Tate Gallery 1991a, pp.66–7, nos.79–80.
5 The watercolours for *The Keepsake* are not catalogued together in Wilton 1979. They are as follows: *Florence* [1828] (W 727; R 319); *Lake of Albano* [1829] (W 731; R 320); *Lago Maggiore* [1829] (W 730; R 321); *Virginia Water* I [1830] (W 519; R 322); *Virginia Water* II [1830] (W 520; R 323); *Saumur* [1831] (W 1046; R 324); *Nantes* [1831] (W 1044; R325); *St.Germain-en-Laye* [1832] (W 1045; R 326); *Marly* [1832] (W 1047; R 327); *Ehrenbreitstein* [1833] (W 1051; R 328); *Falls of the Rhine* [1833] (W 406; R 329); *Havre* [1834] (W 1005; R 330); *Palace of the Belle Gabrielle* [1834] (W 1049; R 331). The four remaining designs by Turner that were published in *The Keepsake* were all vignettes (see Tate Gallery 1993, p.100, nos.145–8). The only watercolour to differ from the standard dimensions is the view of *Havre*, which is also on blue paper (see E. Yardley, *Turner Studies*, vol.7, no.1, Summer 1987, pp.59–60).
6 See Heath 1993, p.36 and p.84.
7 The view of *Nantes* was engraved opposite a poem called 'The Return', by Miss E. Landon, which is prefaced with the note 'Nantz is a fair city, but it seemed the very fairest in the world to the traveller, for he had been absent years'. Turner's view of *Saumur* was accompanied by the short story, 'Saumur. A Tale of Real Life' by R. Bernal, M.P. Other tales by Bernal were published in later volumes of *The Keepsake* alongside views by Turner (see the view of *Ehrenbreitstein* in the 1834 edition), and he seems to have owned watercolours by the artist (see the view of *Ingleborough*, W 576, which was also owned by Charles Stokes; see below, p.214, note 20). Turner's method of

making watercolours of the sky is discussed in Tate Gallery 1997, p.27.

8 See Anne Lyles's entry for this subject in *Tate Gallery Illustrated Catalogue of Acquisitions 1986–88*, 1996, p.235, repr. However, it should be noted that the British Museum impression of Lewis's print has an 1878 watermark.

9 Paris 1981, p.527 no.160.

10 This identification was also made by Eric Shanes in Tate Gallery 1997, p.97.

11 See Butlin and Joll 1984, pp.298–304.

12 See the following: David Brown, *Turner and Byron*, exh. cat., Tate Gallery, 1992; Finley 1980; Tate Gallery 1993c.

13 *Athenaeum*, 29 January 1831, p.76.

14 Thornbury relates an anecdote in which Turner reported to Lawrence that he had seen the engraving of that artist's *Portrait of Mrs Peel* sold by hawkers from baskets at Hastings. Lawrence's portrait appeared in the 1829 edition of *The Keepsake*, so in spite of his increasing participation in this bustling new industry at that date, it appears that Turner had some reservations (Thornbury 1862, II, p.129).

15 See Cecilia Powell, 'Turner's Vignettes and the Making of Rogers' *Italy*', *Turner Studies*, vol.3, no.1, Summer 1983, p.3.

16 Herrmann 1990, p.167.

17 Publications Expenses Ledger, A2, p.157. I am grateful to Michael Bott at the University of Reading for making the Longmans material available to me.

18 Gage 1980, p.94, no.108.

19 From a letter dated 15 August 1832, quoted in Miller 1886, p.139.

20 Both comments appear in an advertisement in the *Spectator*, 29 December 1832, p.1240. See also the entry on Ritchie in the *DNB*.

21 This point has sometimes been missed by scholars. See, for example, Herrmann 1990, pp.167–8.

22 Ritchie 1833, p.106.

23 Ibid., pp.43–4.

24 *Gentleman's Magazine*, vol.CII. pt II, December 1832, pp.549–550.

25 This assumes that he left London after 11 May, when the ninth subject was paid for.

26 Ritchie 1833, p.17.

27 *Alaric Watts, Narrative of a Life*, 1884, II, pp.312–13.

28 *New Monthly Magazine*, December pp.526, 528; *Athenaeum*, 1 December, p.780; *Atlas*, no.342, vol.VII, 2 December, p.816; *Athenaeum*, 8 December, p.798; *Literary Gazette*, no.830, 15 December, p.798; *Morning Chronicle*, no.19,7324, 19 December, front page; *Athenaeum*, 22 December, p.800; *Spectator*, 22 December, p.1220; *Literary Gazette*, 22 December, p.814; *Atlas*, 23 December, p.862; *Examiner*, no.1299, 23 December, p.830; *Gentleman's Magazine*, December, pp.549–50.

29 *New Monthly Magazine*, December 1832, p.526. This comment was applied both to *Turner's Annual Tour* and the new *Book of Beauties*.

30 Ibid., p.528.

31 Although the view of the *Drachenfels* received the highest praises (R 412; see the *Gentleman's Magazine*, February 1833, pp.156–7, or the *Athenaeum*, 16 February 1833, p.107), the *Field of Waterloo* (R 425) and *Mount Parnassus* (R 424) were not considered good illustrations of Byron's verse (*Athenaeum*, 9 February 1833, p.86).

32 *Literary Gazette and Journal of the Belles Lettres*, no.830, 15 December 1832, p.795.

33 *Athenaeum*, 1 December 1832, p.780.

34 *Literary Gazette and Journal of the Belles Lettres*, no.828, 1 December 1832, p.762.

35 *Atlas: A General Newspaper and Journal of Literature*, 9 December 1832, p.829.

36 *Spectator*, 8 December 1832, p.1166.

37 Ibid., p.1167.

38 Ibid.

39 *Atlas*, op. cit., p.829.

40 *Spectator*, op cit., p.1167.

41 See the *Literary Gazette*, no.830, 15 December, p.798, and the *Morning Chronicle*, no.18,734, 19 December, front page. Herrmann (1990, p.167) states that it was published on 18 December.

42 See above, note 28.

43 See p.254 of the Commissions Ledger (C5) in the Longmans records at the University of Reading, where an entry at the end of December 1833 records that Heath had spent £64 13s. 1d advertising *Turner's Annual Tour 1834* (a much larger sum than he spent on the *Book of Beauties*, the *Picturesque Annual*, or *The Keepsake* for that year).

44 *Gentleman's Magazine*, December 1832, published 1 January 1833, p.549.

45 *Morning Chronicle*, no.19,787, 26 January 1833, p.3.

46 *New Monthly Magazine and Literary Journal*, Part the Third, December, p.526.

47 *Gentleman's Magazine*, Supplement to vol.CIII, pt I, 1833, p.620. Mountford's volume was also mentioned in the *Morning Chronicle*, 6 June 1833.

48 Strutt 1833. See pp.24 and 171.

49 Ibid., p.191.

50 *Athenaeum*, 23 February 1833, p.115. The book received several other prominent and lengthy reviews: *Spectator*, 2 March, p.188; *Examiner*, no.1309, 3 March, p.132; *Gentleman's Magazine*, April (published 1 May), p.340.

51 See Finley 1980, pp.229–31. Alternatively, the Scottish subjects, following so soon after the plagiarism of the Loire scenes could have been the last straw, sending Turner promptly to seek redress.

52 Heath 1993, p.43, estimates the sales of *Turner's Annual Tour 1833* at 1,617 copies, with the two subsequent *Annual Tours* selling even less. The information in the Longmans archive at Reading is sadly incomplete, but pp.253–8 of the Commissions Ledger No.5 carry useful information about individual sales of the book, copies of which seem to

have been sent to Paris and Philadelphia. There is a list of the price of some sets of proofs of *Turner's Annual Tour 1833*, apparently available from Moon, Boys and Graves, in the so-called *Oxford and Bruges* sketchbook (TB CCLXXXVI f.1).

53 *Athenaeum*, 15 May 1833, p.336; *Gentleman's Magazine*, May 1833, p.448; *Monthly Magazine*, vol.15, June 1833, p.718; *Morning Chronicle*, 6 June 1833; *Spectator*, 8 June 1833, p.532.

54 *Atlas*, 13 January 1833, p.23.

55 See the table compiled from the figures in the Longmans archive by John Heath (Heath 1993, p.84).

56 Records of Heath's association with Asher in the production of *Turner's Rivers of France*, beginning in August 1835, can be found on pp.593–4 of the Longmans Commissions Ledger at Reading. In Paris Rittner was still receiving copies of the 1833 volume in February 1834 (see p.255 of the Ledger, where 25 copies are recorded as having been despatched).

57 The Longmans archive concerning this publication requires a more detailed study. They can be found in the Commissions Ledger No.5 on pp.443–5, 593–4, 597–601.

58 John Ruskin, Letter to Edward Clayton, 3 December 1840 (*Works*, I, pp.428–9).

59 *Morning Chronicle*, 26 January 1833, p.3.

The Later History of Turner's Loire Views

1 See Nathaniel Neal Solly, *Memoir of the Life of David Cox*, 1873, reprinted 1973. For his watercolours of Paris and Northern France, *see David Cox 1783–1859*, by Stephen Wildman, Richard Lockett and John Murdoch, exh. cat., Birmingham Museums and Art Gallery, 1983.

2 See Richard Lockett, *Samuel Prout (1783–1852)*, 1985, pp.11, 15, 54, 74, 80 n.12.

3 At the Old Water Colour Society he exhibited the following Loire subjects: *La Halle au Blé, at Tours* (1834, no.370, bt by Miss Langston for 7 guineas); *At Orleans* (1835, no.212, bt by John James Ruskin for 8 guineas); *A la Barbe blanc at Tours* (1836, no.161, bt by the Duchess of Kent for 6 guineas); *Market Place at Tours* (1836, no.226, bt by Lady Rolle for 7 guineas); *St Symphorien, at Tours* (1837, no.194, unsold); *Chapel at Amboise* (1837, no.361, bt by F.G. Parry for 7 guineas); *La Halle au Blé, Tours* (1838, no.175, bt by D. Colnaghi for 8 guineas); *Part of the Castle at Blois* (1838, no.194, bt by John Ruskin for 10 guineas); *At Orleans* (1839, no.286, bt by Hobson for 8 guineas); *Church of St Symphorien, Tours* (1843, no.171, bt by Graves & Co. for 8 guineas); *A la Barbe Blanc, Tours* (1844, no.255, unsold, for 8 guineas); *Interior at Blois* (1845, no.240, bt by J.C.Sharpe for 6 guineas); *Tours, France* (1846, no.56, bt by Geo. Pownall for 18 guineas); *Church at Tours, France* (1846, no.314, bt by H.G. Simes for 14 guineas); *Desecrated Chapel of St Jacques, Orleans* (1849, no.113, bt by L.W. Collmann [Art Union] for 10

guineas); *La Halle au Blé, Tours* (1851, no.205, bt by – Brown for 8 guineas).

4 See *William Callow, R.W.S., F.R.G.S.: An Autobiography*, ed. H.M. Cundall, I.S.O., F.S.A., 1908, ch. III, pp.31–60. See also Jan Reynolds, *William Callow, R.W.S.*, 1980, where the journal of the tour is also reprinted, pp.19–64.

5 For Hugo, see note 96 on p.209 above; for Stendhal, see Stendhal 1837, I, pp.283–5, and the following account of his voyage.

6 Ritchie 1833, p.14.

7 See Thomas Allom's watercolour of the *Double Spiral Staircase at the Chateau de Chambord, near Blois* (with Spink, September 1987) and the series of lithographs, *Müller's Sketches of the Age of Francis 1st*, published in 1841 (Francis Greenacre and Sheena Stoddard, *W.J.Müller 1812–1845*, exh. cat., Bristol Museums and Art Gallery, 1991; see pp.133–41, nos.125–38).

8 See, for example, the exhibitions at the Egyptian Hall in Piccadilly in June 1829, and at the gallery of Moon, Boys and Graves at No.6, Pall Mall in 1832 and again in June 1833. These displays were widely reviewed, which, no doubt, greatly assisted the sale of the new engravings.

9 See *New Monthly Magazine and Literary Journal*, Part the Third, December 1833, p.508: 'We have seen, at the rooms of Messrs. Moon, Boys, and Graves, both the originals and the engravings, (and it will be easy for any of our readers to enjoy the same rich treat).'

10 Turner was a frequent visitor to the Ruskin household during 1848, often also keeping in touch by post that year (see Gage 1980, pp.219–21, nos.308–13). In 1849 Ruskin was away on the Continent with his parents for much of the first part of the year (April to September) and he then went to Venice with his wife Effie (October 1849 to April 1850). The offer of the *Rivers of France* drawings could have taken place before these tours or shortly before the drawings were offered to Stokes in May 1850. Against the latter conclusion it should be noted that, unlike Ruskin, Stokes seems only to have been offered the Loire subjects, suggesting the event occurred somewhat after the initial approach to Ruskin. Furthermore, on 23 April 1850 (which was incidentally Turner's birthday) Ruskin wrote the following critical note in his Diary: 'Turner. Errors in. See if he draws sunlight diverging to horizon.' (Joan Evans and John Howard Whitehouse, *The Diaries of John Ruskin*, 1958, II, p.465.) So, in such a mood, he would perhaps have been less likely to have wanted new examples of Turner's work, even if offered them.

11 See *Works*, .XIII, p.li, and XXXV, p.26. It is perhaps significant that at the time of Turner's death Ruskin did not actually name the group of Loire subjects among those works by Turner he most hoped to acquire (see the list of his desiderata in John Lewis Bradley (ed.), *Ruskin's Letters from Venice 1851–1852*, 1955, 2nd ed. 1978, pp.144–8). This could be because

his list focuses on watercolours already on the market, rather than works still in the Bequest, which he had recently learnt would not be available for sale. Similarly, their absence from his list could be because he knew that the set of engraved subjects had already been sold to Charles Stokes.

12 See Gage 1980, p.228, no.325. In this letter to Griffith Turner makes the following comment: 'respecting the Loire if it is inconvenient for you to come to Town I will bring them to Norwood perhaps a trip to do so may do me good.' The letter was written on 19 May at the Athenaeum. This reference only makes sense if the year in question is 1850, but the postmark listed in Gage is for 1851, which may be a misreading.

13 See, for example, Ruskin's autobiography, *Praeterita* (*Works*, XXXV, p.253).

14 Gage 1980, p.288.

15 Cooper Notebooks, pp.16–21.

16 See Herrmann 1970, p.696–9. I am grateful to Professor Luke Herrmann for allowing me to work from the set of photocopies of the Cooper Notebooks sent to him by Kurt Pantzer. As this catalogue was going to press, I learnt that Martin Krause at Indianapolis is shortly to produce a transcription of the Turner entries in the Notebooks.

17 The assumption that it was these three subjects is based on the fact that both the street scene in Tours and the second view of Champtoceaux (or 'Chateau Hamelin') were later part of the Lewis Lloyd collection, as were three of the four engraved subjects that left Stokes's collection. The atmospheric view of Blois was acquired from an unknown source by Mrs Cooper in 1854 but seems the most probable solution to the question of which was the third study in the original Stokes group of twenty-four works.

18 Gage 1980, p.224, no.317.

19 Cooper Notebooks, p.10.

20 Ibid., pp.10 and 14. See also Enclosure No.7. The three inherited watercolours that Mrs Cooper parted with were *Ingleborough* (w 576; Shanes 1990, p.93, pl.68), *Granville* (w 1050; fig.166) and *The Jute* (not in Wilton; fig.167). The exchange gained her the following works: *The Castle of Amboise by moonlight* (w 994; fig.125); *Scene on the Loire* (w 991; fig.63); *Scene on the Loire with brilliant effect of sunshine* (w 995; fig.51); *The Abbey of Jumieges* (unengraved) (not in Wilton); *Rouen* (not in Wilton; see *Turner Studies*, vol.7, no.1, pp.59–60, fig.2)

21 Ibid., pp.10, 14 and Enclosure No.7. In order to obtain this work, and the blue paper drawing called *Birth Place of Poussin* (w 1006), she parted with four watercolours 'from W. Scott', which were listed in the Enclosure as *Kenilworth* (w 1148), *Pirate* (w 1307; see E. Shanes in *J.M.W. Turner. The Foundation of Genius*, Taft Museum, Cincinnati, Ohio, 1986, pp.62–4, no.54), *Greenwich* (this title probably reflects a mistaken identification of the view of *Whitehall*, now

in Manchester City Art Galleries, w 1149) and *Lochmaben* (w 1150).

22 The identity of the collector to whom Stokes sold or exchanged four engraved and three unpublished subjects is not at present known. However, see above, note 17. Some of the negotiations seem to have involved Henry Vaughan.

23 Cooper Notebooks, pp.11, 14 and Enclosure No.7. The *Orléans* subject is listed consistently in both places in the Cooper records, but the view of Nantes appears as both *Sunset fortified town* and *Fortress*. For Orléans she parted with *Crowhurst* (TB CXVIII R; see Tate Gallery 1996, no.76) and *Sion House* (British Museum; see Tate Gallery 1996, p.16, fig.8). She had to relinquish the dramatic watercolour of the *Mew Stone* (w 454; see Dawson 1988, pp.69–71, pl.12) in order to gain the view of *Nantes*.

24 See Tate Gallery 1996.

25 Cooper Notebooks, p.11, and Enclosure No.7, pp.1 and 4. The five in this group were *River Scene Calm* (w 992; fig.49), *Moonlight with Steamer* (w 923), *Huy on the Meuse* (w 1024; Tate Gallery 1991b, p.152), *Namur* (w 1025; Tate Gallery 1991b, pp.157–8) and *Genoa* (?w 1015). The Bible watercolours in that exchange were *Jerusalem* (?w 1244, 1251, 1254, 1255, or 1261), *Lebanon* (w 1248) and *Valley of Sinai* (w 1238). Mrs Cooper had acquired these and other Bible illustrations through a series of earlier exchanges in 1854.

26 Ruskin, *Catalogue of the Sketches and Drawings by J.M.W. Turner, R.A. exhibited in Marlborough House in the year 1857–8, Accompanied with Illustrative Notes*, 1857 (*Works*, XIII, pp.227–316).

27 Herrmann 1970, pp.696–9; this information is taken from a letter from George Jones to Ruskin. Herrmann states in this article that Ruskin did not know Charles Stokes, but there are several references to Stokes in the critic's correspondence with his father in 1851–2, where he is seen as a favoured rival collector (see Bradley, op. cit., pp.124 and 210).

28 Cooper Notebooks, pp.22–6. As well as specifying the lowest figure that she would (or her heirs should) accept for individual works, she also firmly indicated where groups of works should not be broken up.

29 See *Works*, XIII, p.462 no.77 and note 4.

30 Cooper Notebooks, pp.9, 10, and 11. The four Loire works were *Amboise by moonlight* (w 994; fig.125), *Bridge at Blois* (w 993; fig.130), *Market place at Orleans* (w 997; fig.150) and *River scene Calm* (w 992; fig.49). Ruskin bought a further six blue paper drawings on the same day: *Tancarville* (w 999), *Jumieges* (not in Wilton; reacquired by Mrs Cooper by 1859, see Enclosure No.7), *Huy* (w 1024; Tate Gallery 1991b, p.152), *Namur* (w 1025; Tate Gallery 1991b, pp.157–8), *Baden* (?not identified) and *Mountains on Genoa Coast* (w 1015). See also John James Ruskin's account book, now in the Ruskin Library at Lancaster, which records these Loire drawings as part of a group of ten works for which he paid £500, presumably a mistake for 500 guineas.

31 Ibid., p.9 ('17 Engraved drawings of the Loire parted with / Feb^y 11^th 1858. to Mr Ruskin for 1,000.gs.') and pp.10 and 14. Ruskin Senior's account book simply notes '17 Drawings £1050'. See also Evans and Whitehouse, op cit., II, p.534.

32 See Cooper Notebooks, Enclosure No.7, p.2, where listed as follows (Mrs Cooper's works are listed first): 'Fortified town [w 996; fig.32] for Pont de Buzet [w 1008] / Blue Loire [?w 991; fig.63] for Green Mountains + 10 gs [?w 1036] / Shower on the Loire [w 995; fig.51] [for] Upright Pass [Sotheby's, 14 November 1991, lot 130]'. The view of the 'Pont de Buzet' that Ruskin passed on to Mrs Cooper as part of this exchange appears in the list of works still in her collection 'after exchange in 1858' at the end of that year (Cooper Notebooks, p.23, no.7). However, Ruskin must have bought or exchanged something else for it in 1859, because it drops off her list once more during that year, and it afterwards remained part of his collection until after it was exhibited at the Fine Art Society in 1878 (see *Works*, XIII, pp.448 no.52, 598).

33 See Ruskin, *Works*, I, p.xxxviii, and XXXV, pp.262–3 and 626–7.

34 Ruskin, *Works*, I, pp.428–9; Ruskin was not the only one to value the engravings highly. In 1856 William Morris presented Georgiana Macdonald with a copy of the *Rivers of France* as a present when she became engaged to Edward Burne-Jones (see her *Memorials of Edward Burne-Jones*, 2 vols., 1904, p.135).

35 See *Praeterita* 1885–9 (*Works*, XXXV, p.301). For the discrepancy between what Ruskin actually wrote in his diary about his first meeting with Turner, and his later account, see Tate Gallery 1995a, pp.11 and 29 note 12.

36 See, for example, *A Villa (Villa Madama – moonlight)* (TB CCLXXX 159; R 361; w 1165) and *A Farewell: Lake of Como* (TB CCLXXX 150; R 372; w 1176), both designed for Rogers' *Italy*; or *A Garden* (TB CCLXXX 162; R 373; w 1177) for Rogers' *Poems*.

37 *Praeterita* (*Works*, XXXV, p.302)

38 *Works*, II, pp.124–80, and illustrated between pp.170 and 171; see also XXXV, p.302 n.1.

39 Paul H. Walton, *The Drawings of John Ruskin*, 1972, p.45.

40 *Modern Painters*, I, 1843 (*Works*, III, pp.314–16).

41 See Ruskin's letter to Acland, 7 March 1861, quoted in Herrmann 1968, p.31.

42 This point is made by Robert Hewison in Oxford 1996, p.15.

43 See John James Ruskin's account book at Lancaster: '1861...July Oxford Turner frames Foord £68.11 / Cases £78.85 [next line] 147.96'.

44 Quoted in Herrmann 1968, p.33.

45 Herrmann 1968, p.35. An unaccounted for entry of £131 10s. 5d in John James Ruskin's account books (now at Lancaster) may suggest that Ruskin also paid for the frames and cabinets for those works in the gift to the Fitzwilliam Museum.

46 'Turner and his Works', 1854 (*Works*, XII, pp.51–2 and 55–6).

47 *Fors Clavigera*, February 1876 (*Works*, XXVIII, p.519).

48 Letter from Ruskin to Alexander Macdonald, 22 January 1879; quoted in Herrmann 1968, p.40.

49 *Modern Painters*, V, 1860 (*Works*, VII, p.85 opp. p.203; the work is not discussed there, but see under note 2). It was etched by Ruskin and engraved in mezzotint by Thomas Lupton. See *Tate Gallery Illustrated Catalogue of Acquisitions 1986–88*, 1996, pp.235–6, repr.

50 In Hamerton 1879 see the following: between pp.236 and 237 *City on one of the Rivers of France*, based on one of the views of Saumur, cat.79 (TB CCLIX 201); on pp.240–41 *French Boats near Shore, with Lowering Sky*, based on cat.73 (TB CCLIX 185); and on pp.254–5 *Old Town on the Loire*, based on cat.51 (TB CCLIX 204). A set of these etchings can be found in the print room at the Victoria and Albert Museum (E.551–1888; E.545–1888; E.547–1888).

51 The set of four was issued on 19 February 1975, and was made up of the following images: at 4½p, *Peace – Burial at Sea* (1842, Tate Gallery, B&J 399); at 5½p, *Snow Storm – Steam-Boat off a Harbour's Mouth* (1842, Tate Gallery; B&J 398); at 8p, *Venice: The Arsenal* (1840?, TB CCCXVI 27); and at 10p, *St-Laurent* [i.e., *St-Florent-le-Vieil*] (c.1826–8, TB CCLIX 9, fig.76). Perhaps the biggest surprise about this group is that the *Fighting Temeraire* was not selected.

52 See Tate Gallery 1995a.

Catalogue

All items included in the catalogue are on white wove paper, unless otherwise specified. Measurements are given in millimetres, followed by inches in brackets, height before width. Any watermarks or inscriptions have been transcribed where legible. The paper types referred to are set out in Appendix B on p.238.

Early Views of the Loire, *c.*1795

1 **Tours from the north-east**
*c.*1794–5 (fig.1)
Watercolour 242 × 340 (9½ × 13⅜)
EXH: British Museum display 1935–6; Tate Gallery display, 1937–52 (interrupted by the War); Tate Gallery 1978
LIT: Finberg 1909, I, p.54, 'View of River, with Bridge and Town in middle distance'
TB XXVII L; D00673

2 **Blois from the south-west**
*c.*1794–5 (fig.2)
Pencil and watercolour 245 × 345 (9⅝ × 13⅝)
EXH: Exhibited Drawings, no.698, as 'Town and Bridge' (Ruskin, *Works*, XIII, p.639). Part of a loan collection shown at the following venues: Towner Art Gallery, Eastbourne 1937; Graves Art Gallery, Sheffield 1946–7; Whitechapel 1953 (117); Wakefield Art Gallery 1960
LIT: Finberg 1909, I, p.54, 'Town and Bridge. Probably the same place as TB XXVII L'
TB XXVII M; D00674

The Sketching Materials Used on the 1826 Tour
(Excluding the sheets of blue paper which were afterwards worked in colour)

3 **Sheet folded into four, with studies of Shoreham church and harbour** 1826 (fig.8)
Pencil 231 × 367 (9 × 14⅜)
Watermark: IVY MILL / 1816
LIT: Finberg 1909, II, p.1123 (as 'Village on English coast', 'Church', 'Harbour', 'Harbour')
TB CCCXLIV 173, 174, 175, 176; D34556, D34557, D34558, D34559

4 **Château d'Arques from the east** ?1826 (fig.9)
Pencil on blue paper (type A; watermarked '1823') 128 × 188 (5 × 7⅜)
Related works: See other views of the château in TB CCXX and W 422; and cats.33–6 below
LIT: Finberg 1909, II, p.693, as 'Town on hill'
TB CCXXIV 26; D20316

5 **Rouen from Ste Catherine's Hill** 1826 (fig.10)
Rouen sketchbook
Pencil page size: 115 × 182 (4½ × 7⅛)
Watermark: IVY MILL / 1816
EXH: Paris 1983–4 (182, as 'vers 1826')
LIT: Finberg 1909, II, p.776 as '1830'; Paris 1981, pp.355–7 figs.728–35 bis, dated '1830★'
TB CCLV f.7 verso; D24088

6 **Views of Bayeux** 1826 (fig.11)
Rouen, Le Havre, Caen, Bayeux and Isigny sketchbook
Pencil page size: 98 × 123 (3⅞ × 4⅞) [tipped into a new binding]
Inscribed: 'Take all you Like Home with You all Normandy'
LIT: Finberg 1909, II, pp.762–3, as '1830★'; Paris 1981, pp.309–17 figs.600–627, where dated '1830★'; Alfrey in Paris 1983, p.37 note 14
TB CCLI ff.33 verso, 34; D23522, D23523

7 **The cathedral at Coutances from the south-west** 1826 (fig.15)
Cherbourg, Coutances and Mont St Michel sketchbook
Pencil page size: 133 × 91 (5¼ × 3⅝)
Watermark of an unidentified French maker: LMV
LIT: Thornbury 1862, I, p.360 (the reference to a sketchbook with the binding of a Bible could relate to this book); Finberg 1909, II, pp.759–61 as '1830★'; Paris 1981, pp.303–8 figs.580–99; Alfrey in Paris 1983, p.37 note 14
TB CCL ff.51 verso, 52; D23434, D23435

8 **A folded sheet with four views of Coutances** 1826 (fig.14, detail)
Pencil 230 × 363 (9 × 14¼)
Watermark: IVY MILL / 1816
LIT: Finberg 1909, II, p.1113–14, as 'views of Coutances'; Paris 1981, p.517, repr. as figs.1034–5 (nos.59 and 61)
TB CCCXLIV 59, 60, 61, 62; D34414, D34415, D34416, D34417

9 **View from Avranches, looking towards Mont-St-Michel** 1826 (fig.17)
Pencil 119 × 181 (4⅝ × 7⅛)
Watermark: IVY M[ILL] / 18[16]
LIT: Finberg 1909, II, p.1113, as 'Town on hill, with distant view of coast'
TB CCCXLIV 58; D34413

10 **Map of Western France**: *Carte Itinéraire de la Bretagne contenant le Départemens, du Finistere, du Morbihan, du Côtes du Nord, d'Isle et Vilaine et de la Loire Inférieure. Avec les Route de Postes et Autres Routes de Communications. Dressée par Dezauche, Géographe, successeur de Guil Delisle et Phil Buache, Géographes. A Paris, chez l'Auteur, Rue des Noyers, An.8* (1799–1800) (fig.6)
Engraved by Dezauche
Pencil annotations by Turner on front and back, as well as sketches of figures, and various views, including St-Malo and Dinan
515 × 690 (20¼ × 27⅛)
EXH: Royal Academy 1974 (B.93)
LIT: Finberg 1909, II, p.1149; Alfrey in Paris 1983, p.37 note 15; Gage 1987, repr. p.61
TB CCCXLIV 426; D34922

11 **Two views of Brest: the château and the Port Militaire** 1826 (fig.22)
Morlaise to Nantes sketchbook
Pencil page size: 108 × 168 (4¼ × 6⅝)
French laid paper
LIT: Finberg 1909, II, pp.751–3, as '1826–30'; Paris 1981, pp.199–208 figs.346–81; see below, Appendix A
TB CCXLVII ff.16 verso, 17; D23040, D23041

12 **Views of St Florent-le-Vieil; a steamer seen from three angles; a Loire barge; and a figure study** 1826 (fig.74)
Nantes, Angers, Saumur sketchbook
Pencil page size: 170 × 110 (6¾ × 4⅜)
Watermark: The top of the mark is visible, possibly 'La Croix'
EXH: Paris 1981 (36, pp.208–21 figs, 383–408)
LIT: Finberg 1909, II, pp.754–6; see below Appendix A
TB CCXLVIII ff.17 verso, 18; D23184, D23185 items

13 **Angers: the Haute Chaine, from the right bank of the Maine, looking across to the main part of the city** 1826
Pencil on faded blue paper (type A; the bottom edges of this sheet and cat.15 [TB CCLX 84] were formerly joined) 255 × 190 (10 × 7½)
EXH: Exhibited Drawings, no.30, a, as one of 'Two Studies at Boulogne, and Two Studies at Ambleteuse' (Ruskin, *Works*, XIII, p.610)
LIT: Finberg 1909, II, p.807, as 'At Boulogne'; Alfrey in Paris 1981, p.240, under no.54, as 'Angers'
TB CCLX 17; D24853

14 **Angers: the château from near the Basse Chaine (or walls of Angers)** 1826
Pencil on blue paper (type A; possibly once attached to the top edge of cat.15 [TB CCLX 84])
128 × 185 (5 × 7¼)
LIT: Finberg 1909, II, p.811, as 'Old walls of town'; Alfrey in Paris 1981, p.240, under no.54
TB CCLX 82; D24918

15 **Angers: buildings and ramparts close to the château** 1826
Pencil, with gouache highlights, on blue paper (type A; see under cats.13 and 14) 124 × 187 (4⅞ × 7⅜)
LIT: Finberg 1909, II, p.811, as 'Harbour, with old town walls'; Alfrey in Paris 1981, p.240, under no.54
TB CCLX 84; D24920

16 **Angers: the Basse Chaine, looking north up the Maine** 1826
Pencil, with gouache highlights, on blue paper (?type A) 131 × 184 (5⅛ × 7¼)
LIT: Finberg 1909, II, p.811, as 'Towers and château'; Alfrey in Paris 1981, p.240, under no.54
TB CCLX 83; D24919

17 **Angers: the towers of the château** 1826 (fig.92)
Pencil on blue paper (type A; watermarked: 'B.E.& S. / 1823') 128 × 186 (5 × 7½)
LIT: Finberg 1909, II, p.813; Alfrey 1977, p.73 n.7, where listed as TB CCLX 67
TB CCLXI 67; D25039

18 **Angers: the château from the south** 1826 (fig.95)
Pencil on blue paper (type A) 125 × 185 (4⅞ × 7¼)
LIT: Finberg 1909, II, p.813; Alfrey 1977, p.73 n.7, where listed as TB CCLX 68
TB CCLXI 68; D25040

19 **Angers: the Pont de Treilles, with the cathedral above** 1826
Pencil on blue paper (type A) 127 × 187 (5 × 7⅜)
LIT: Finberg 1909, II, p.813; Alfrey 1977, p.73 n.7, where listed as TB CCLX 65
TB CCLXI 65; D25037

20 **Two views of Angers: the Moulin tower of the château from below; and (upside down at the other end of the sheet) the Grand Pont, with the tower of La Trinité on the left** 1826 (fig.90)
Pencil on blue paper (type A; this sheet was formerly part of a larger sheet, and was attached to TB CCXXIV 204/205, which are views of Coutances – see above, cats.7 and 8) 256 × 190 (10⅛ × 7½)
LIT: Finberg 1909, II, p.694, part of a 'Bundle of similar sketches, mostly on double sheets. Unidentified. They were contained in a parcel endorsed by Mr Ruskin – 235/o – Rubbish'
TB CCXXIV 212, 213; D20525, D20526

21 **Angers from close to the Haute Chaine on the right bank of the Maine** 1826
Pencil on blue paper (?type A) 126 × 184 (5 × 7¼)
LIT: Finberg 1909, II, p.813; Alfrey 1977, p.73 n.7, where listed as TB CCLX 66
TB CCLXI 66; D25038

22 **Angers from the right bank of the Maine** 1826
Pencil on blue paper (type A) 128 × 188 (5 × 7⅜)
LIT: Finberg 1909, II, p.693, as 'Town, from river'
TB CCXXIV 28; D20318

23 **Angers: the ruins of the Pont des Treilles, with the cathedral, from the right bank of the Maine** 1826 (fig.91)
Pencil on blue paper (type A) 131 × 187 (5⅛ × 7⅜)
LIT: Finberg 1909, II, p.693, as 'Town, from river'
TB CCXXIV 27; D20317

24 **A folded sheet of sketches of châteaux, etc., between Saumur and Tours, including 'Usse', 'Chousay', and 'Langeais' (drawn on both sides)** 1826 (fig.108, detail)
Pencil (formerly attached to TB CCCXLIV 246; see cat.27 below) 173 × 241 (6⅞ × 9½)
Inscribed: 'Usse', 'Chousay', 'Langeais'
LIT: Finberg 1909, II, p.1131, as 'Views on river, a chateau'; Paris 1981, p.519 figs.1039, 1041 (listed as TB CCCXLIV 243) and 1042
TB CCCXLIV 244A, 245; D34680, D34682

25 **A sheet folded into three with sketches of the châteaux at Cinq Mars-le-Pile and Luynes, and a detailed study of Tours Cathedral** 1826 (fig.109, detail)
Pencil 172 × 363 (6⅞ × 14¼)
LIT: Finberg 1909, p.1131, as 'The Cathedral of Tours, with views of town, towers and the Loire'; Paris 1981, p.519 figs.1038, 1040

(detail), p.520 fig.1043; Lévêque-Mingam 1996, p.77 fig.59 (repr. of TB CCCXLIV 242)
TB CCCXLIV 242, 243, 244; D34677, D34678, D34679

26 **Views of the château at Blois** 1826 (fig.133)
Loire, Tours, Orleans, Paris sketchbook
Pencil page size: 130 × 174 (5⅛ × 6⅞)
French paper with grapes in the watermark
LIT: Finberg 1909, II, pp.756–8; Paris 1981, pp.224–31 figs.411–38; see below, Appendix A
TB CCXLIX ff.20 verso, 21; D23277, D23278

27 **Tours from the northern end of the Pont de Tours, with the cathedral and Tour de Guise beyond** 1826 (fig.111)
Pencil (formerly attached to TB CCCXLIV 244A and 245, cat.24 above; torn unevenly) 130 × 174 (5⅛ × 6⅞)
LIT: Finberg 1909, II, p.1131, as 'View, with distant cathedral'
TB CCCXLIV 246; D34684

28 **Tours: the Tour de l'Horloge from the Place du Grand Marché** 1826 (fig.117)
Pencil 125 × 176 (4⅞ × 6⅞)
Inscribed: 'Caffe du G^d Marche'
LIT: Finberg 1909, II, p.1131, as 'Street scene, with tower, &c.'
TB CCCXLIV 247; D34686

29 **Paris: the Grande Galerie in the Louvre** ?1826 (fig.152)
Pencil, with gouache, on blue paper 123 × 185 (4⅞ × 7¼)
Related works: See TB CCLX 90, 125
EXH: Tate Gallery 1988 (37, as '1821'); Paris 1993 (6, as '1821', repr.)
LIT: Finberg 1909, II, p.811, as 'In the Louvre: The Long Picture Gallery'
TB CCLX 88; D24924

Designs Related to 'The English Channel or La Manche', 1827

30 Dieppe from the east ?1826–7 (fig.153)
Pencil and watercolour (formerly attached at
right edge to cat.31) 170 × 238 (6¾ × 9⅜)
EXH: Graves Art Gallery, Sheffield, and
University of Nottingham Art Gallery
1964–5
LIT: Cook 1905, repr. p.46; Finberg 1909, II,
p.685, 'View of Dieppe Harbour'; Paris 1981,
p.182 fig.338, colour
TB CCXX A; D20207

**31 Dieppe: a view down the Grande Rue
from the quayside** ?1826–7 (fig.154)
Watercolour (formerly attached at left edge to
cat.30) 171 × 241 (6¾ × 9½)
LIT: Finberg 1909, II, p.686, 'Street Scene'; Paris
1981, p.184 fig.340 (col.)
TB CCXX D; D20210

32 Cliffs near Dieppe ?1826–7 (fig.155)
Pencil and watercolour 172 × 241 (6¾ × 9½)
LIT: Finberg 1909, II, p.837, as 'Cliffs by the sea';
Tate Gallery 1997, pp.94, 97, 102
TB CCLXIII 302; D25425

33 Château d'Arques from the north-east
?1826–7 (fig.156)
Pencil and watercolour 170 × 241 (6¾ × 9½)
Related works: See cat.4
LIT: Cook 1905, repr. p.22, as 'Besancon';
Finberg 1909, II, p.686, as 'Two Views of same
city [with cat.34]'; Wilton 1982, pl.42, as
'Domfront (?), c.1825'
TB CCXX G; D20213

34 Château d'Arques from the south-east
?1826–7 (fig.157)
Pencil and watercolour 174 × 238 (6⅞ × 9⅜)
LIT: Finberg 1909, II, p.686, as 'Two Views of
same city [with cat.33]'
TB CCXX H; D20214

35 Château d'Arques from the east
?1826–7 (fig.158)
Watercolour 167 × 228 (6⅝ × 9)
Related works: W 422, also at the Fitzwilliam
Museum, Cambridge
EXH: Cambridge 1994 (repr. in col. p.71)
LIT: Cormack 1975, no.24, repr.; Wilton 1979,
p.347, no.421, as 'River landscape, with a
castle on a hill, c.1811', repr.
Prov: …; P&D Colnaghi, 1895, bt T.W.Bacon,
by whom given to the museum, 1950
Collection: The Syndics of the Fitzwilliam
Museum, Cambridge (PD.112-1950)

36 Château d'Arques from the west
?1826–7 (fig.159)
Watercolour 153 × 227 (6 × 8⅞)
Related works: Turner may have used this
watercolour as the basis for the view of
Château d'Arques engraved in *Scott's Prose
Works* (W 1132; R 555)
EXH: Paris 1981 (34, p.181, repr. in col., p.180);
Brighton 1992 (83, repr.)
LIT: Wilton 1979, p.436, no.1147, as 'Château
d'Arques-la-bataille, near Dieppe, c.1834',
repr.
Prov: …; A.G.E.Godden, by whom bequeathed
to the gallery, 1933
Collection: Royal Pavilion, Art Gallery and
Museums, Brighton and Hove

37 St-Vaast-la-Hougue, Normandy
?1826–7 (fig.168)
Watercolour 170 × 241 (6¾ × 9½)
Preliminary sketches: TB CCL ff.50, 53 verso
LIT: Finberg 1909, II, p.686, as 'Castle (or
lighthouse) on rock, on the coast'
TB CCXX L; D20219

38 Calais from the sea ?1826–7 (fig.171)
Watercolour 171 × 240 (6¾ × 9½)
LIT: Finberg 1909, II, p.686, as 'Ship sailing off
coast'
TB CCXX K; D20218

39 Granville ?1827–8 (fig.162)
Watercolour 297 × 484 (11⅝ × 19)
Preliminary sketches: TB CCL f.5 verso, 15
EXH: New York 1966 (48)
LIT: Finberg 1909, II, p.821, as 'A rocky coast';
Wilkinson 1975, repr. colour p.142; Eric
Shanes in Tate Gallery 1997, pp.97–8
TB CCLXII 90; D25212

40 Granville ?1827–8 (fig.163)
Watercolour 190 × 273 (7½ × 10¾)
Watermark: 1823
Verso (D40140): Two figures coaxing a horse
over the sands near Mont-St-Michel
Preliminary sketches: TB CCL f.5 verso, 15
EXH: Tate Gallery 1995–6, where dated '?1830'
LIT: Finberg 1909, II, p.832, as 'Rock on coast';
Eric Shanes in Tate Gallery 1997, pp.97–8
TB CCLXIII 234; D25356

41 Granville ?1827–8 (fig.160)
Watercolour 196 × 280 (7¾ × 11)
Preliminary sketches: TB CCL ff.5 verso, 15
LIT: Finberg 1909, II, p.832, as 'Rock on coast.
Same view as 234, but different effect'; Eric
Shanes in Tate Gallery 1997, pp.97–8
TB CCLXIII 235; D25357

42 Granville ?1827–8 (fig.161)
Watercolour 174 × 244 (6⅞ × 9⅝)
Preliminary sketches: TB CCL f.7
LIT: Finberg 1909, II, p.834, as 'Sunset from the
cliffs'; Wilkinson 1975, repr. colour, p.143;
Eric Shanes in Tate Gallery 1997, pp.97–8
TB CCLXIII 264; D25387

43 Mont-St-Michel ?1827–8 (fig.165)
Watercolour 186 × 273 (7⅜ × 10¾)
Verso (D40173): An inky cloud effect
LIT: Finberg 1909, II, p.831, as 'Castle on rock,
from the sands'; Wilkinson 1975, repr. colour,
p.108; Eric Shanes in Tate Gallery 1997,
pp.97–8
TB CCLXIII 220; D25342

44 Mont-St-Michel ?1827–8 (fig.164)
Watercolour 178 × 258 (7 × 10⅛)
Watermark: Partly visible 'B [E & S]'
EXH: Graves Art Gallery, Sheffield, and
University of Nottingham Art Gallery
1964–5; Japan 1970–71 (95)
LIT: Finberg 1909, II, p.834, as 'On the sands';
Wilkinson 1975, repr. in col. p.108; Eric
Shanes in Tate Gallery 1997, pp.97–8
TB CCLXIII 256; D25379

Colour Studies of the Loire, c.1826–8

45 Breton peasants dancing
c.1826–8 (fig.25)
Watercolour and gouache, with pen, on blue
paper (type E) 132 × 190 (5¼ × 7½)
Related sketches: TB CCXLVII f.25 verso
EXH: Marlborough House 1857, frame 91,
no.199, as 'French Dance in Sabots' (Ruskin,
Works, XIII, p.293); Exhibited Drawings,
no.581, a (Ruskin, *Works*, XIII, p.636);
Paris/Vienna 1937 (99, a); British Council
Tour 1947–8 (55, a); British Council Tour
1950 (14, a); Australia 1961 (19, a);
Smithsonian Tour 1963–4 (38); British
Museum 1975 (160); Georgia / Houston
1982 (64); Paris 1983–4 (193, repr.); Tate
Gallery 1989 (50)
LIT: Holme 1903, repr. as W3; Finberg 1909, II,
p.801; Delouche 1977, p.61, repr.
TB CCLIX 197; D24762

**46 Nantes: the château and cathedral
from the river** c.1828 (fig.30)
Watercolour and gouache, with pen, on blue
paper (type C) 127 × 188 (5 × 7⅜)
Preliminary sketches: Similar to, but not
dependent on, TB CCXLVII f.61 verso
EXH: Exhibited Drawings, no.116, as 'Nantes:
Loire' (Ruskin, *Works*, XIII, p.612); Paris
1981–2 (35, p.208 as 'Nantes, c.1830', p.209
fig.382 in col.)
LIT: Finberg 1909, II, p.794, as 'Nantes';
Hervouet 1989, repr. p.20; Lévêque-Mingam
1996, p.41 fig.23
TB CCLIX 92; D24657

NOT EXHIBITED
Nantes: the château from the river
*c.*1826–8 (fig.32)
Watercolour and gouache, with pen, on blue
paper 142 × 193 (5½ × 7½)
Preliminary sketches: The closest sketch to this
viewpoint falls on TB CCXLVII f.38 (fig.31),
but the discrepancies between the
information recorded there and this gouache
sketch suggest the view may have either been
developed over a pencil outline or is perhaps
a later recollection of the scene
EXH: Fitzwilliam Museum 1959; Fitzwilliam
Museum 1975; Fitzwilliam Museum 1994
(p.73, as 'Nantes [?]', colour)
LIT: Cooper Notebooks, p.11 no.11 'Sunset
fortified town', p.14, Enclosure No.7, p.1, as
'Fortress', p.2, as 'Fortified town'; Ruskin
1861 list of gift to Cambridge (*Works*, XIII,
pp.558, no.14, as 'Amboise'); Armstrong 1902,
p.239, as 'Amboise, circa 1831–2'; unpublished
drawing for "Rivers of France"'; Cook and
Wedderburn 1904 (*Works*, XIII, p.598, listed
as 'Amboise'); Mauclair 1939, repr. p.15, as
'Amboise'; Wilkinson 1975, p.88, repr. colour
as 'Amboise'; Cormack 1975, p.55, no.27, as
'Nantes', repr.; Wilton 1979, pp.417–18,
no.996, repr.
PROV: ?Thomas Griffith; …; acquired by
Hannah Cooper, 6 October 1854, with
Orléans (fig.150) in exchange for the *Southern
Coast* watercolour of *The Mew Stone*
(National Gallery of Ireland, Dublin; W 454);
acquired from her by John Ruskin during
1858 in exchange for *Pont de Buzet* (Museum
of Art, Rhode Island; W 1008); presented to
the museum by Ruskin, 1861
Collection: The Syndics of the Fitzwilliam
Museum, Cambridge (reg. no.580)

47 **Nantes: the château from the east**
*c.*1826–8 (fig.33)
Watercolour and gouache, with pen, on blue
paper (type E) 129 × 183 (5⅛ × 7¼)
Preliminary sketches: There are no sketches for
the view, which Turner may have sketched
directly on to this sheet
EXH: Second Loan Collection (113, b, as one of
'Two Views in France (Colour on Blue)')

LIT: Finberg 1909, II, p.803, as 'Scene outside
city walls. Probably the walls of Fougères';
Alfrey 1977, p.73 n.7, where identified as
'Nantes'
TB CCLIX 236; D24801

48 **Nantes: promenade on the Cours St-
Pierre, near the château** *c.*1826–8 (fig.35)
Watercolour and gouache, with pen, on faded
blue paper (type E) 131 × 182 (5⅛ × 7⅛)
Preliminary sketches: There are no preparatory
studies relating to this scene
EXH: Marlborough House, 1857, frame 134,
no.297, as 'Nantes: Promenade near the
Château' (Ruskin, *Works*, XIII, pp.311–12);
Exhibited Drawings, no.618, b (Ruskin,
Works, XIII, p.637); ?Tate Gallery 1931–4;
British Council Tour 1947–8 (54, b); British
Council Tour 1950 (13, b); Australia 1961 (18,
b); Smithsonian Tour 1963–4 (37); Paris
1983–4 (179, repr.)
LIT: Finberg, II, p.801; Herrmann 1968, p.80;
Delouche 1977, p.70
TB CCLIX 200; D24765

49 **Nantes: promenade on the
Cours St-Pierre** *c.*1826–8 (fig.36)
Watercolour and gouache, with pen, on faded
blue paper (type E) 126 × 183 (5 × 7¼)
Preliminary sketches: There are no preparatory
designs for this work
EXH: Marlborough House 1857, frame 135,
no.298, as 'Promenade at Nantes' (Ruskin,
Works, XIII, p.312); Exhibited Drawings,
no.442, b, as one of 'Four French Subjects:
Promenade at Nantes' (Ruskin, *Works*, XIII,
p.630); British Council Tour 1947–8 (54, a);
British Council Tour 1950 (13, a); Australia
1961 (18, a); Smithsonian Tour 1963–4 (36);
Paris 1983–4 (178, repr.); Tate Gallery 1989
(54, repr. p.52)
LIT: Finberg 1909, II, p.800, as 'Promenade at
Nantes'; Mauclair 1939, p.63, repr.; Herrmann
1968, p.80
TB CCLIX 191; D24756

50 **Soldiers drinking in a café, possibly in
Nantes** *c.*1826–8 (fig.39)
Watercolour and gouache, with pen, on blue
paper (type E; formerly joined, at the bottom
edge, to TB CCLIX 270) 140 × 190 (5½ × 7½)
EXH: Third Loan Collection (111, b);
Paris/Vienna 1937 (99, b); British Council
Tour 1947–8 (55, b); British Council Tour
1950 (14, b); Australia 1961 (19, b);
Smithsonian Tour 1963–4 (39); British
Museum 1975 (159); Georgia / Houston
1982 (65); Paris 1983–4 (194, repr.); Tate
Gallery 1989 (61, repr. p.55)
LIT: Finberg 1909, II, p.805, as one of 'Two
figure compositions'
TB CCLIX 263 b; D40080

51 **Nantes: the Pont de l'Aiguillon,
looking across to the Quai Flesselles,
with the Tour du Bouffay above**
?1826 (fig.37)
Pencil, pen and ink, with gouache highlights,
on faded blue paper (type A) 130 × 185
(5⅛ × 7¼)
Preliminary sketches: This subject seems to
have been developed over a sketch made on
the spot
Engr: See the etching by Alfred Louis Brunet-
Debaines, which appeared in Hamerton
1879, opp. p.254, as 'Old Town on the Loire';
an impression of this image can be found at
the Victoria and Albert Museum
(E.547-1888); see also cats.73 and 79
EXH: Marlborough House 1857, frame 139,
no.311, as 'Study of Town on Loire' (Ruskin,
Works, XIII, p.313 (with note 1: 'Grey
outlines, glorious'); Exhibited Drawings,
no.620, a (Ruskin, *Works*, XIII, p.637); ?Tate
Gallery 1931–4
LIT: Finberg 1909, II, p.801, as 'Town on the
Loire'; Alfrey in Paris 1981, p.250, under
no.60; Davies in Tate Gallery 1992–3 (fig.110,
as 'Town on the Loire')
TB CCLIX 204; D24769

52 **Nantes, from the Ile Feydeau**
(the basis for *The Keepsake* watercolour; see
cat.104) ?1826–8 (fig.38)

Pencil, pen and ink, with watercolour and
gouache, on faded blue paper (type E) 127 ×
184 (5 × 7¼)
Verso: Pencil sketch of the view over rooftops,
chalk applied on the right, perhaps to suggest
the river
Preliminary sketches: This subject seems to have
been developed over a sketch made on the
spot
Copies: There is one by Alexander Macdonald
among the copies in the cabinet given by
Ruskin to Whitelands College (frame 50) (see
Works, XXX, p.354, no.50, as 'Town on the
Loire (I forget which)' and n.1). William Ward
made copies for sale of a view of Nantes, but
it is not known which subject his versions
were based on, although this view is perhaps
the most likely (see *Works*, XIII, p.575, no.27)
EXH: Marlborough House, 1857, frame 137,
no.306, as 'Study for a Drawing of (Saumur?),
made for the "Keepsake"' (Ruskin, *Works*,
XIII, p.312: 'infinitely beautiful'); Exhibited
Drawings, no.619, c (Ruskin, *Works*, XIII,
p.637); displayed at the Victoria and Albert
Museum 1920–1; Paris 1981–2 (60, p.250,
p.246 fig.452 in col., as 'Nantes')
LIT: Finberg, II, p.801, as 'Study for a
"Keepsake" drawing'; Hervouet 1989, repr.
p.15; Lévêque-Mingam 1996, p.39 fig.20
TB CCLIX 203; D24768

53 **Nantes; the banks of the River Erdre,
looking north** ?*c.*1826–8 (fig.40)
Pen and ink, with watercolour and gouache, on
blue paper (type E) 130 × 185 (5⅛ × 7¼)
Preliminary sketches: There are no preparatory
sketches for this subject
EXH: Oxford Loan Collection, 1878–1916, nos.
200-125, as 'Country town on stream'
(Ruskin, *Works*, XIII, p.565); ?Paris 1981–2
(possibly an ex.cat. item, as then mounted
with TB CCLIX 10, which was exhibited)
LIT: Finberg 1909, II, p.791, as 'Country town
on stream'; Finberg 1910, repr. opp. p.127,
pl.LXXVI; Alfrey 1977, p.73 n.7, where
linked with TB CCLIX 93, but its identity as
Nantes was questioned
TB CCLIX 16; D24581

54 Nantes: the banks of the River Erdre and the Pont Sauvetot ?*c.*1826–8 (fig.41)
Watercolour and gouache, with pen, on blue paper (type C) 128 × 182 (5 × 7⅛)
Preliminary sketches: There are no preparatory sketches for this subject, which could suggest that it was recorded on the spot. However, against this it should be noted that the piece of blue paper is part of a batch with an 1828 watermark (type C), which would not have allowed Turner to have used the sheet on his 1826 tour
EXH: Exhibited Drawings, no.117, as 'Nantes: Loire' (Ruskin, *Works*, XIII, p.612); Paris 1981–2 (59, p.250, as 'Country town on a stream, *c.*1830', p.246 fig.454 in col.)
LIT: Finberg, 1909, II, p.794, as 'Nantes: Loire'; Alfrey 1977, p.73 n.7, where the identitification of this and TB CCLIX 16 as a view of Nantes was questioned; Delouche 1977, fig.152; Hervouet 1989, repr. p.17 as 'Nantes'; Lévêque-Mingam 1996, p.34 fig.14
TB CCLIX 93; D24658

55 Nantes: the Place Graslin with the Grand Théâtre *c.*1826–8 (fig.42)
Watercolour and gouache, with pen, on faded blue paper (type B) 144 × 192 (5⅝ × 7½)
Preliminary sketches: There are various memoranda of the Théâtre Graslin in both of the sketchbooks used at Nantes (TB CCXLVII ff.48, 68 verso; TB CCXLVIII ff.1, ?2 verso, ?3 verso). The closest to this composition is that on TB CCXLVIII f.1, but Turner may also have made a pencil sketch actually on this sheet
EXH: Oxford Loan Collection, 1878–1916, nos.202–129, as 'Place du Carrousel' (Ruskin, *Works*, XIII, p.566); Tate Gallery 1993d, as 'Place du Carrousel'
LIT: Finberg 1909, II, p.790, as 'Place du Carrousel'
TB CCLIX 14; D24579

56 Nantes: the Théâtre and Place Graslin from the Rue de Breda Gresset *c.*1826–8 (fig.43)
Watercolour and gouache, with pen, on blue paper (type B) 143 × 195 (5⅝ × 7⅝)

Preliminary sketches: Based on a conflation of TB CCXLVII f.48 and TB CCXLVIII f.1
EXH: Oxford Loan Collection 1878–1916, nos.199–126, as 'Dijon' (Ruskin, *Works*, XIII, p.565). Part of loan collection shown at the following venues: Burton-on-Trent 1934; Luton 1935; National Museum of Wales, Cardiff 1935–6 (40); Isle of Man 1936; Eastbourne 1937; Todmorden 1938; Sheffield 1946–7; Whitechapel 1953 (184, as 'North Italian Town'); Barnsley 1959–60; Wakefield 1960
LIT: Finberg 1909, II, p.790, as 'Dijon (?)'
TB CCLIX 8; D24573

57 Nantes: the Quai de la Fosse, with the Bourse in the distance *c.*1826–8 (fig.46)
Watercolour and gouache, with pen, on blue paper (type E) 127 × 185 (5 × 7¼)
Preliminary sketches: see TB CCXLVII f.48 verso, which shows this quay, but not the houses. Two other sheets of blue paper have sketches made from near this spot, TB CCXXIV 206, 207.
EXH: Oxford Loan Collection 1878–1916, nos.201–122, as 'Quai du Louvre' (Ruskin, *Works*, XIII, p.565); Paris 1981–2 (67, p.254, as 'Nantes', p.246 fig.453 in col.)
LIT: Finberg 1909, II, p.790; Hervouet 1989, repr. p.16; Lévêque-Mingam 1996, p.40 fig.21
TB CCLIX 10; D24575

58 Nantes: the shipyards (or Salorges) *c.*1826–8 (fig.47)
Watercolour and gouache, with pen, on blue paper (type E) 132 × 184 (5¼ × 7¼)
Preliminary sketches: Although there are sketches of the quays to the west of Nantes, all of those focus on the view back to the city. This scene may have been sketched on the spot.
EXH: Marlborough House, 1857, frame 136, no.300, as 'Havre (?)' (Ruskin, *Works*, XIII, p.312); Exhibited Drawings, no.443, a (Ruskin, *Works*, XIII, p.630); National Gallery, Cape Town 1936–7
LIT: Finberg 1909, II, p.800, as 'Havre (?)'
TB CCLIX 193; D24758

59 A *chasse-marrée* and other vessels under a cloudy sky *c.*1826–8 (fig.48)
Watercolour and gouache on blue paper (type B) 142 × 195 (5⅝ × 7⅝)
Related works: This work is on the same type of paper as cats.64 and 73. All three works focus on shipping scenes
EXH: Marlborough House 1857, frame 79, no.159, as 'Havre (?)' (Ruskin, *Works*, XIII, p.289); Exhibited Drawings, no.428, a (Ruskin, *Works*, XIII, p.629); Paris 1981 (95, p.401, p.400 fig.846 in col.)
LIT: Finberg 1909, II, p.798, as 'Havre (?)'; Wilton 1982, pp.52–3, no.61, as 'Shipping off Havre, *c.*1830', repr. in col.
TB CCLIX 161; D24726

60 Calm on the Loire (to the west of Nantes) *c.*1826–8 (fig.49)
Watercolour and gouache, with pen, on blue paper 138 × 188 (5⅜ × 7⅜)
Preliminary sketches: See TB CCXLVII ff.32, 60 verso
EXH: Paris 1981–2 (68, p.254, p.255 fig.464 in col.)
LIT: Cooper Notebooks, p.11 no.12, as 'River Scene calm', Enclosure No.7, p.1, 4; John James Ruskin Account Books (Lancaster) '1858 Feb. Ten Drawings £500'; Ruskin's list of his 1861 gift to Oxford, no.17; Revised 1861 list, no.4, as 'Calm on the Loire, near Nantes' (Ruskin, *Works*, XIII, p.559); Armstrong 1902, p.262, but the description given under this title is for W 947; Cook and Wedderburn 1904 (*Works*, XIII, p.601); Herrmann 1968, pp.72–3, no.33, repr. pl.XXIV; Wilton 1979, p.417, no.992, repr.; Lévêque-Mingam 1996, p.35 fig.15, colour
Prov: Thomas Griffith; …; one of five blue paper subjects acquired by Hannah Cooper on 4 July 1856, in exchange for three of the watercolours intended to illustrate the Findens' Bible; bought from her by John Ruskin (as part of a group of ten blue paper subjects), 10 February 1858, for 50 guineas; given by him to the University of Oxford, March 1861
Collection: The Visitors of the Ashmolean Museum, Oxford

61 Nantes: the northern approach to the Pont Pirmil *c.*1826–8 (fig.50)
Pencil, watercolour and gouache, with pen, on faded blue paper (type E) 134 × 189 (5¼ × 7⅜)
Preliminary sketches: TB CCXLVII f.50
EXH: Marlborough House 1857, frame 138, no.308 (Ruskin, *Works*, XIII, pp.312–113); Exhibited Drawings, no.444, b, as one of 'Four Sketches in Colour on the Loire and Meuse' (Ruskin, *Works*, XIII, p.630); Liege 1939; Aberystwyth 1939
LIT: Finberg 1909, II, p.687, as one of 'Three sketches in colour; possibly on the Meuse' (originally framed with TB CCXX P [*Alkan and Burg Thurandt from the North*; see Tate Gallery 1991, no.76] and TB CCXX R [see below, cat.94])
TB CCXX Q; D20224

62 Nantes: the Pont Pirmil from the river, under a stormy sky *c.*1826–8 (fig.52)
Watercolour and gouache on blue paper 136 × 187 (5⅜ × 7⅜)
Preliminary sketches: Herrmann suggests TB CCXLVIII f.30 ('there is a very slight pencil sketch of the same view, without the boats or stormy sky, on folio 30 of the *Nantes, Angers, and Saumur Sketchbook*'). But a more realistic starting point for the drawing is TB CCXLVII f.31v, as noted by Alfrey in 1981
Copies: William Ward sold copies of a work he titled 'Boats, Sun, and Rain', which are likely to have been based on this work (see Ruskin, *Works*, XIII, p.575, no.22). One such copy, probably by Ward, is in a private collection in America (seen, care of Sotheby's, 1991).
EXH: Paris 1981–2 (42, p.221, as 'Bridge and tower on the Loire *c.*1830', repr. in col. p.251 [NB: 'The Bridge at Blois: fog clearing, *c.*1830' was also catalogued as no.42 on p.232])
LIT: Cooper Notebooks, p.10 no.2 'Scene on the Loire (unengraved)', p.14, Enclosure No.7, p.1, p.2 as 'Shower on the Loire'; Ruskin's list of his 1861 gift to Oxford, no.18; Revised 1861 list, no.19, as 'Angers' (Ruskin, *Works*, XIII, p.559); Armstrong 1902, p.239, as

'Angers (?). (Perhaps rather Saumur), circa 1831–2'; Cook and Wedderburn 1904 (*Works*, XIII, p.598, as 'Angers'); Herrmann 1968, p.74, no.37, repr. pl.XLVI, D; Wilton 1979, p.417, no.995, as 'Angers, c.1826–30', repr.; Lévêque-Mingam 1996, p.57 fig.39, as Angers, colour

Prov.: ?Thomas Griffith; …; acquired by Hannah Cooper as part of a group of five blue paper drawings (2 Seine; 3 Loire: i.e. this work and cats.65 and 89 below), 13 February 1854, in exchange for three watercolours she had inherited from Charles Stokes (*Ingleboro* [*sic*], W 576; *Granville*, fig.166, W 1050; *The Jute*, fig.167, not in Wilton); acquired from her by John Ruskin during 1858 in exchange for *Upright Pass* (Sotheby's, 14 November 1991, lot 130); given by him to the University of Oxford, March 1861

Collection: The Visitors of the Ashmolean Museum, Oxford

63 On the Loire, looking west towards Nantes *c.*1826–8 (fig.58)

Watercolour and gouache, with pen, on faded blue paper (type E) 128 × 184 (5 × 7¼)

Verso (D40134): Pencil sketch of buildings with towers; a large building with a pediment and a bridge, possibly at Nantes

Preliminary sketches: Based on the sketches on ff.7 and 8 of TB CCXLVIII

EXH: Second Loan Collection (113, a, as one of 'Two Views in France (Colour on Blue)'); Paris 1981–2 (40, p.216, repr. in col. p.246 fig.451, as 'On the Loire near Nantes')

LIT: Finberg 1909, II, p.803, as 'French river scene'; Hervouet 1989, repr. p.23; Lévêque-Mingam 1996, p.41 fig.22 (detail)

TB CCLIX 235; D24800

64 Near Nantes: Loire barges in a gust of wind *c.*1826–8 (fig.57)

Watercolour and gouache, with pen, on blue paper (type B) 140 × 192 (5½ × 7½)

Preliminary sketches: For sketches of the Loire barges (known locally as *chalands* or *gabares*) see TB CCXLVIII ff.4 verso, 8 verso, 16, 16 verso, 17, 17 verso, 19 verso, 22, 22 verso, 23

Related works: See cats.59 and 73

EXH: Exhibited Drawings, no.103, as 'Heavy Barges in a Gust' (Ruskin, *Works*, XIII, p.612); Paris 1981–2 (p.397, no.91, colour, p.401, as 'Heavy Barges in a Gust'); Tate Gallery 1995–6, as 'Barges on the River Loire in a Gust of Wind, c.1826–32'

LIT: Finberg 1909, II, p.793, as 'Heavy barges in a gust'

TB CCLIX 79; D24644

65 Scene on the Loire: a distant view of the Château de Clermont *c.*1826–8 (fig.63)

Watercolour and gouache on blue paper 140 × 191 (5½ × 7½)

Preliminary sketches: TB CCXLVII f.10 (fourth main sketch down)

Copies: Herrmann notes one by Alexander Macdonald at the Felstead Diocesan College, Banbury Road, Oxford (see Herrmann 1968, p.99). Another version, perhaps by another of Ruskin's assistants, is in Herrmann's own collection. A third copy was sold at Christie's (28 April 1987, lot 154, one of three copies after Turner; see also the views of 'Rietz', fig.107, and Blois, fig.129).

EXH: Berlin 1972 (80); Munich 1979 (201, repr. p.344); Paris 1981–2 (37, p.210, as 'Scene on the Loire, c.1830', repr. in col. p.211 fig.384); Phoenix Art Museum 1993 (fig.92, repr. p.128)

LIT: Cooper Notebooks, Vol.2, p.10 as 'Scene on the Loire with a brilliant effect of sunshine', p.11 as 'Blue Loire', and p.14 as one of '5 Blue Drawings', Enclosure No.7, p.1 as 'Scene on the Loire', p.2 as 'Blue Loire'; Ruskin, *Slade Inaugural Lecture*, 1870 (*Works*, XX, p.38); Catalogue of the Standard Series at Oxford, 1870–72 (*Works*, XXI, p.12 no.3, 249); *Lecture on Landscape*, 1871 (*Works*, XXII, pp.56: 'the loveliest of all, gives the warmth of a summer twilight with a tinge of colour on grey paper so slight that it may be a question with some of you whether any is there'); *The Art of England*, 1883 (*Works*, XXXIII, p.348); Armstrong 1902, p.262, as 'Loire, On the, circa 1830'; Cook and Wedderburn 1904 (*Works*, XIII, p.559, note 1, and p.602); Herrmann

1968, pp.98–9, no.82, repr. pl.XXII; Wilton 1979, p.417, no.991, repr.; Birch 1990, pp.74–7, repr. in col.; Hewison in Oxford 1996 (pp.69–70, under no.14); Lévêque-Mingam 1996, p.4 fig.1 (col.)

Prov.: ?Thomas Griffith; …; acquired by Hannah Cooper as part of a group of five blue paper drawings (2 Seine; 3 Loire: i.e. this work and cats.62 and 89), 13 February 1854, in exchange for three watercolours she had inherited from Charles Stokes (*Ingleboro*, W 576; *Granville*, fig.166, W 1050; *The Jute*, fig.167, not in Wilton); acquired from her by John Ruskin during 1858, in exchange for *Green Mountains & 10 guineas* (Indianapolis Museum of Art, W 1036); given by him to the Ruskin School of Drawing and Fine Art, Oxford, 1875; transferred to the museum, 1938

Collection: The Visitors of the Ashmolean Museum, Oxford (Ruskin School Collection; Standard Series, No.3)

66 The Folies-Siffait, with Oudon beyond, from the west *c.*1826–8 (fig.67)

Watercolour and gouache, with pen, on blue paper (type D) 143 × 194 (5⅝ × 7⅝)

Preliminary sketches: TB CCXLVIII ff.11 and 12 (for the principal design); f.11 verso (for the tower of Oudon)

EXH: National Gallery 1881, Group XIX, Finest Colour on Grey (Latest), no.444/194, as 'Coast of Genoa?' (Ruskin, *Works*, XIII, p.386: 'Highest quality'); Exhibited Drawings, no.194 (Ruskin, *Works*, XIII, p.616); Tate Gallery 1983; Australia 1985

LIT: Finberg 1909, II, p.797, as 'Coast of Genoa'; Wilton 1982, pl.46, as 'The Coast of Genoa, c.1828'

TB CCLIX 138; D24703

67 The Folies-Siffait from the east *c.*1826–8 (fig.68)

Watercolour and gouache, with pen, on blue paper (type D) 145 × 196 (5¾ × 7¾)

Preliminary sketches: TB CCXLVIII ff.11 verso, 12, and 12 verso

EXH: National Gallery 1881, Group XIX, Finest

Colour on Grey (Latest), no.443/193, as 'Coast of Genoa?' (Ruskin, *Works*, XIII, p.386: 'Good, but dull'); Exhibited Drawings, no.193 (Ruskin, *Works*, XIII, p.616); Tate Gallery 1983; Australia 1985

LIT: Finberg 1909, II, p.797, as 'Coast of Genoa'

TB CCLIX 137; D24702

68 The Tower at Oudon *c.*1826–8 (fig.69)

Watercolour and gouache, with red pen work, on blue paper (type F) 145 × 195 (5¾ × 7⅝)

Preliminary sketches: TB CCXLVIII f.12 verso

Copies: During his visit to London in 1867 the American artist Thomas Moran made a copy of this work (Gilcrease Museum, Tulsa). See cat.74 for a copy made the previous year.

EXH: Marlborough House, 1857, frame 85, no.186, as 'River Scene, with Tower' (Ruskin, *Works*, XIII, p.292); Exhibited Drawings, no.434, d (Ruskin, *Works*, XIII, p.629); Paris 1981–2 (38, p.216, as 'Oudon, c.1830', repr. p.249 fig.459)

LIT: Finberg 1909, II, p.800, as 'River Scene, with tower'; Alfrey 1977, p.73 n.7, where identified as 'Oudon'; Lévêque-Mingam 1996, p.46 fig.28 (detail)

TB CCLIX 186; D24751

69 Champtoceaux from the north-west *c.*1826–8 (fig.70)

Watercolour and gouache, with scratching out, on blue paper 133 × 183 (5¼ × 7¼)

Preliminary sketches: TB CCXLVIII f.13 verso

EXH: Manchester 1857 (370, from the collection of Lewis Loyd)

LIT: Wilton 1979, p.490, no.997a, repr.

Prov.: Thomas Griffith; probably one of the twenty-four Loire subjects acquired by Charles Stokes on 31 May 1850 for 600 guineas; by the time of his death, in December 1853, it had already left his collection; …; Lewis Loyd; Capt.E.N.F. Loyd, sold Christie's, 30 April 1937 (65, as 'Chateau Hamelin with a sailing vessel; a bridge and wooded hills on the left: sunset. Engraved by Brandard'); Thomson; Professor E. Harold Hughes

Collection: Private collection, U.K.

70 **The ruined *péage* at Champtoceaux, from the west** *c.*1826–8 (fig.71)
Watercolour and gouache, on blue paper (type B) 141 × 189 (5½ × 7½)
Verso: (D40078) Gouache study of the *péage* from the opposite side to the view on the recto, based on TB CCXLVIII f.14
Preliminary sketches: There are sketches of the ruined *péage* on the following four pages of the *Nantes, Angers, Saumur* sketchbook: TB CCXLVIII 13–14 verso. The closest to this subject is the middle sketch on TB CCXLVIII f.13 verso, but in his colour study Turner has made the side of the *coteau* as much a focus of interest as the architectural motif.
EXH: Exhibited Drawings, no.122, as 'Château Hamelin: Loire' (Ruskin, *Works*, XIII, p.612); Graves Art Gallery, Sheffield, and University of Nottingham Art Gallery 1964–5; Paris 1981–2 (62, p.250, as 'Chateau Hamelin, c.1830', repr. in col. p.217 fig.399); Tate Gallery 1983; Australia 1985; Tate Gallery 1991a (51, repr. p.53)
LIT: Finberg 1909, II, p.794, as 'Château Hamelin: Loire'; Wilton 1982, pl. 52, as 'Château Hamelin, on the Loire, c.1829'; Lévêque-Mingam 1996, p.45 fig.27
TB CCLIX 98; D24663

71 **St-Florent-le-Vieil** *c.*1826–8 (fig.76)
Watercolour and gouache on blue paper (type B) 144 × 193 (5⅝ × 7⅝)
Preliminary sketches: TB CCXLVIII ff.18 and 19
Other reproductions: This work was selected as one of the four stamps issued on 19 February 1975 to commemorate the bi-centenary of Turner's birth. It was used as the design for the most expensive stamp of the set (10p).
EXH: Oxford Loan Collection 1878–1916, nos.198-124, as 'River Scene' in first edition of the catalogue, revised to 'St Laurent' in subsequent editions (Ruskin, *Works*, XIII. p.565); Graves Art Gallery, Sheffield, and University of Nottingham Art Gallery 1964–5; New York 1966 (66); America 1977–8 (40, repr.); Paris 1981–2 (37, p.249 fig.457); Tate Gallery 1991 (50, repr. in col. p.52)
LIT: Finberg 1909, II, p.790, as 'St Laurent'; Davy 1979, repr. as 'St Florent'; Alfrey 1981,

p.216, no.37, as 'St Florent, c.1830'; Wilton 1982, pl.51, as 'St Florent le Vieil, Loire, c.1829'; Lévêque-Mingam 1996, p.48 fig.30 (where TB CCLIX 170 is reproduced instead of this work)
TB CCLIX 9; D24574

72 **The Château de la Madeleine, Varades** *c.*1826–8 (fig.77)
Watercolour and gouache, with pen, on blue paper (type B) 141 × 191 (5½ × 7½)
Preliminary sketches: TB CCXLVIII f.19 (this thumbnail sketch includes a boat as part of its composition)
Copies: A version by an unknown artist is in an American private collection
EXH: Exhibited Drawings, no.115, as 'The Gray Castle' (Ruskin, *Works*, XIII, p.612); Paris 1981–2 (39, p.216, no.39, as 'Castle on the Loire, c.1830', repr. in col. p.249 fig.460)
LIT: Finberg 1909, II, p.794, as 'The Grey Castle'
TB CCLIX 91; D24656

73 **Boats on the Loire, possibly near Ingrandes** *c.*1826–8 (fig.78)
Watercolour and gouache, with pen, on blue paper (type B) 140 × 195 (5½ × 7⅝)
Preliminary sketches: Possibly related to the landscape on TB CCXLVIII f.17. The boats are similar to those on f.4 verso of the same sketchbook
Related works: see cats.59 and 64
Copies: There is a copy of this work by Isabella Lee Jay (*fl.*1868–96) in the Ruskin Library at Lancaster (Bembridge cat.265). Jay, who was one of Ruskin's pupils, may also have been responsible for the copy in the Fogg Art Museum in Cambridge, Massachusetts (1926.33.34)
Engr: An etching of this subject by Alfred Louis Brunet-Debaines was reproduced in Hamerton 1879, opp. p.240, as 'French Boats near Shore, with Lowering Sky'. The Victoria and Albert Museum holds a separate impression of the print (E.551-1888). See also cats.51 and 79
EXH: Marlborough House 1857, frame 85,

no.185, as 'French River Boats' (Ruskin, *Works*, XIII, p.292); Exhibited Drawings, no.434, c (Ruskin, *Works*, XIII, p.629); Paris 1981–2 (p.423, no.112, repr. in col.)
LIT: Finberg, II, p.800, as 'French river boats'
TB CCLIX 185; D24750

74 **Montjean-sur-Loire** *c.*1826–8 (fig.80)
Watercolour and gouache, with pen, on faded blue paper (type B) 142 × 192 (5⅝ × 7½)
Preliminary sketches: TB CCXLVIII f.20
Copies: There is a copy of this work by the American artist Thomas Moran, dated 1866 (Gilcrease Museum, Tulsa)
EXH: Marlborough House 1857, frame 137, no.305, as 'Mont Jean' (Ruskin, *Works*, XIII, p.312: one of three Ruskin described as 'All first-rate'); Exhibited Drawings, no.619, b (Ruskin, *Works*, XIII, p.637); displayed at the Victoria and Albert Museum 1920–21
LIT:; Finberg 1909, II, p.801, as 'Mont Jean'; Lévêque-Mingam 1996, p.51 fig.34
TB CCLIX 202; D24767

75 **Montjean-sur-Loire** *c.*1826–8 (fig.82)
Watercolour and gouache on faded blue paper (type B) 141 × 197 (5½ × 7¾)
Preliminary sketches: TB CCXLVIII ff.21, 21 verso
EXH: Marlborough House 1857, frame 79, no.161, as 'St Germain (?)' (Ruskin, *Works*, XIII, pp.288–90); Exhibited Drawings, no.428, c (Ruskin, *Works*, XIII, p.629); Royal West of England Academy, Bristol, *British Painters in France*, 1953 (153, as 'Rouen')
LIT: Finberg 1909, II, p.798, as 'St Germain (?)'; Alfrey 1977, p.73 n.7, where identified as 'Montjen'
TB CCLIX 163; D24728

76 **La Pierre Bécherelle, near Epire** *c.*1826–8 (fig.85)
Watercolour and gouache on blue paper 141 × 195 (5½ × 7⅝)
Preliminary sketches: Based on a conflation of the sketches on TB CCXLVIII f.23 verso (second from bottom of the page) and f.24 (top sketch)

EXH: Marlborough House 1857, frame 85, no.183, as 'Scene on Loire (?)' (Ruskin, *Works*, XIII, pp.291–2); Exhibited Drawings, no.434, a (Ruskin, *Works*, XIII, p.629)
LIT: Finberg 1909, II, p.800, as 'Scene on Loire (?)'; Lévêque-Mingam 1996, p.49 fig.32, as 'Entre Nantes et Angers'
TB CCLIX 183; D24748

77 **A village with a tower beside the Loire, possibly Béhuard, close to Angers** *c.*1826–8 (fig.84)
Watercolour and gouache, with red pen work, on blue paper (type D) 141 × 195 (5½ × 7⅝)
Preliminary sketches: TB CCXLVIII f.23 verso (fourth from the top)
LIT: Finberg 1909, II, p.791, as 'Town on river, with boats'
TB CCLIX 31; D24596

78 **Angers: looking south down the Maine** *c.*1826–8 (fig.93)
Watercolour and gouache, with pen, on blue paper (type F) 130 × 183 (5⅛ × 7¼)
Preliminary sketches: There are no preparatory sketches for this work. It was presumably developed over a pencil study made on the spot (see cats.13–23)
Copies: There are likely to be versions of this work by William Ward, who advertised his copies of a subject listed as 'Building a Bridge' (see Ruskin, *Works*, XIII, p.575, no.21)
EXH: Exhibited Drawings, no.118, as 'Angers' (Ruskin, *Works*, XIII, p.612); Paris 1981–2 (54, p.240, as 'French town on a river, c.1830', repr. in col. p.245 fig.450 [but incorrectly captioned 'Montjen', which is reproduced opposite with the caption for this work])
LIT: Finberg, II, p.794, as 'Angers'; Alfrey 1977, p.73 n.7, who thought the traditional identification as 'Angers' unlikely; Lévêque-Mingam 1996, p.55 fig.37
TB CCLIX 94; D24659

NOT EXHIBITED

Angers: the walls of the Doutre, with the tower of the church of La Trinité
*c.*1826–8 (fig.94)

Watercolour and gouache on blue paper 138 × 190 (5½ × 7½)

Preliminary sketches: The composition can be found in the left-hand part of the sketch on TB CCXLVIII f.36 verso; Turner has omitted the château on the right in this colour work.

EXH: Royal Academy, *Exhibition of Works by the Old Masters and Deceased Masters of the British School, including a Collection of Water Colours*, Winter 1908 (245, as 'A River in France', as from the Roget collection); Paris 1981–2 (71, p.266 as 'Arles: castle and aqueduct, *c.*1828 (?)', repr. in col. p.266 fig.491)

LIT: Armstrong 1902, p.262, as 'On the Loire, circa 1830' (Armstrong recorded that the sheet showed 'Warm evening light on fortress and bridge'); Wilton 1979, p.419, no.1009 as 'Arles: Castle and Aqueduct', ?*c.*1828, repr. Prov: ?Thomas Griffith; …; Henry Vaughan (who claimed he had acquired it directly from Turner); bequeathed to J.L. Roget; by descent to his grandson, J. Romilly Roget, sold Sotheby's, 18 June 1970 (179, as 'A River in France: ?Vernon-sur-Seine', repr. p.62. The catalogue note provided the early history set out above) £1200 bt Agnew's, who sold it on to Kurt Pantzer, by whom given to the museum

Collection: Indianapolis Museum of Art

79 **Saumur from the Pont de la Croix-Verte** ?*c.*1828 (fig.98)

Pencil, watercolour and gouache, with pen, on faded blue paper (type C) 131 × 186 (5⅛ × 7⅜)

Preliminary sketches: There are no studies for this design, which would appear to have been sketched on the spot. This is belied by the paper on which it is made, which may have been part of a larger sheet with an 1828 watermark

Copies: There may be a version of this subject by Isabella Lee Jay, but Cook and Wedderburn are wrong to link this subject with Ruskin's comments on pp.530–31 of

Vol.XIII of the Library Edition (no.64, R, note 4). See instead cat.81

Engraved: An etching of this subject was made by Alfred Louis Brunet-Debaines, *c.*1878, and used to illustrate Hamerton 1879, where it appears opp. p.236, as 'City on one of the Rivers of France'. An impression of this print can be found in the Victoria and Albert Museum (E.551-1888). See also cats.51 and 73.

EXH: Marlborough House 1857, frame 137, no.304, as 'Saumur' (Ruskin, *Works*, XIII, p.312: 'first-rate'); Exhibited Drawings, no.619, a (Ruskin, *Works*, XIII, p.637); displayed at the Victoria and Albert Museum 1920–21; Tate Gallery 1992–3 (p.82 fig.111)

LIT:; Finberg 1909, II, p.801, as 'Saumur'; Lévêque-Mingam 1996, p.61 fig.41

TB CCLIX 201; D24766

80 **Saumur: the Ilot Censier from the Pont des Sept Voyes** *c.*1826–8 (fig.99)

Watercolour and gouache, with pen, on faded blue paper (type E) 131 × 184 (5½ × 7¼)

EXH: Marlborough House 1857, frame 136, no.303 (Ruskin, *Works*, XIII, p.312: 'of highest quality'); Exhibited Drawings, no.443, b (Ruskin, *Works*, XIII, p.630); National Gallery, Cape Town 1936–7

LIT: Finberg 1909, II, p.800, as 'Saumur'; Mauclair 1939, p.72, repr.

TB CCLIX 194; D24759

81 **Saumur from the west** (the basis for the *Keepsake* watercolour, see fig.181 and p.225) ?*c.*1828 (fig.103)

Watercolour and gouache, with pen, on blue paper (type C) 130 × 190 (5⅛ × 7½)

Verso (D40128): Interior of a cave dwelling, possibly related to cat.83; inscribed in pencil, 'Keepsake'

Preliminary sketches: There are no sketches of Saumur from the west in any of Turner's sketchbooks, which implies that this composition may have been recorded on the spot. But as with cat.79, which is also a view of Saumur, this sheet seems to date from 1828 or later, and could not have been carried with Turner on the 1826 tour. In this case, he may

have constructed the design from memory; note the inaccurate number of arches on the bridge

Copies: There is a copy by William Ward in the Fogg Art Museum, Cambridge, Massachusetts (1926.33.35). Another copy was made for Ruskin by Isabella Lee Jay: see *Works*, XIII, pp.530–31, no.64, R

EXH: National Gallery 1881, Group XVII – Various (Latest), no.383, as 'Saumur' (Ruskin, *Works*, XIII, p.384); Exhibited Drawings, no.383, as 'Saumur', one of a group of 'Various Sketches (Late Period)' (Ruskin, *Works*, XIII, p.626); Tate Gallery 1991 (46, repr. p.50)

LIT: Finberg 1909, II, p.797, as 'Saumur'; Wilton 1982, pl.49, as '*c.*1829'; Lévêque-Mingam 1996, p.64 fig.45

TB CCLIX 145; D24710

82 **A herd of sheep at Saumur; below the walls of the château, with the Tour de Papegault to the left** *c.*1826–8 (fig.104)

Watercolour and gouache, with pen, on blue paper (type D) 127 × 183 (5 × 7¼)

Preliminary sketches: Freely based on the sketch on the inside back cover of TB CCXLVIII

EXH: Oxford Loan Collection 1878–1916, nos.209-118, as 'Sheep in the trench' (Ruskin, *Works*, XIII, p.565). Part of loan collection shown at the following venues: Burton-on-Trent 1934; Luton 1935; National Museum of Wales, Cardiff 1935–6 (41); Isle of Man 1936; Towner Art Gallery, Eastbourne 1937; Todmorden 1938; Graves Art Gallery, Sheffield 1946–7; Whitechapel Art Gallery 1953 (185); Barnsley 1959–60; Wakefield Art Gallery 1960

LIT: Finberg, 1909, II, p.791, as 'Sheep in a trench'; Finberg 1910, repr. opp. p.128, pl.LXXVII

TB CCLIX 17; D24582

83 **The interior of a cave near Saumur** *c.*1826–8 (fig.105)

Watercolour and gouache, with pen, on blue paper 131 × 185 (5⅛ × 7¼)

Preliminary sketches: See the outline on the verso of cat.81. There is also a sketch of the interior of one of the caves near Saumur on f.46 of the *Nantes, Angers, Saumur* sketchbook (TB CCXLVIII).

LIT: Finberg 1909, II, p.805, as 'Among the rock dwellings of Touraine'

TB CCLIX 266; D24831

84 **Tours from above the Place de la Tranchée a the northern end of the Pont de Tours (now the Place Choiseuil)** *c.*1826–8 (fig.114)

Watercolour and gouache, with pen, on blue paper (type D) 130 × 185 (5⅛ × 7¼)

Verso (D40129): Gouache study, probably showing a distant château on headland (compare with cat.65)

Preliminary sketches: TB CCXLIX f.9

EXH: National Gallery 1881, Group XVII – Various (Latest), no.385, without a title (Ruskin, *Works*, XIII, p.384); Exhibited Drawings, no.385, as 'Town in France: Bridge and Barracks?' (Ruskin, *Works*, XIII, p.626)

LIT: Finberg 1909, II, p.797, as 'Town in France: Bridge and barracks'; Alfrey 1977, p.73 n.7, where identified as Tours

TB CCLIX 147; D24712

85 **Tours: the cathedral from the Place de l'Archevêché** *c.*1826–8 (fig.118)

Watercolour and gouache, with pen, on blue paper (type F) 128 × 187 (5 × 7⅜)

Preliminary sketches: Turner made a pencil sketch of the cathedral facade (see cat.25), but this colour study may have been developed over an on-the-spot sketch, for there is no other record of the gateway to the Bishop's Palace.

EXH: Exhibited Drawings, no.36, b, as 'Tours (colour on grey)' (Ruskin, *Works*, XIII, p.610); Graves Art Gallery, Sheffield; and University of Nottingham Art Gallery 1964–5

LIT: Holme 1903, W 29, as 'Church, Tours'; Finberg 1909, II, p.792, as 'Tours'; Lévêque-Mingam 1996, p.76 fig.58

TB CCLIX 72; D24637

NOT EXHIBITED OR ILLUSTRATED (see p.121)
Street in Tours *?c.*1826–30
Watercolour and gouache on blue paper
Dimensions unknown, but likely to be about
130 × 185 (5⅛ × 7¼)
EXH: Manchester 1857 (?373)
LIT: There is no entry for this work in Wilton
1979, but see there under no.940
Prov: Thomas Griffith; probably one of the
twenty-four Loire subjects acquired by
Charles Stokes on 31 May 1850 for 600
guineas; by the time of Stokes' death in
December 1853, this work had left his
collection; …; Captain Lewis Lloyd; Lewis
Lloyd; sold Christie's, 30 April 1937 (64, as
'Tours. A street scene, with a crowd of figures.
Bodycolour on grey paper 5½ × 7¼.
Manchester 1857 [no.373]. An unpublished
drawing for "Rivers of France"') 89½ guineas
bt Rayner MacConnell (or Mac Connal)
Collection: Whereabouts currently unknown

86 **Tours: the ruins of the Old Pont
Eudes, with the city beyond**
*c.*1826–8 (fig.119)
Pencil, watercolour and gouache on blue paper
(type C) 139 × 191 (5½ × 7½)
Preliminary sketches: TB CCXLIX f.10
EXH: British Museum, 4 Screens display,
March–Sept 1938; Georgia/Houston 1982
(56, as 'Trier on the Moselle'); Tate Gallery
1991a (49, as 'Tours from the River', repr.
p. 52)
LIT: Finberg 1909, II, p.689, as 'Bridge, with
trees'
TB CCXXI W; D20256

87 **The ruined abbey of Marmoutier, near
Tours** *c.*1826–8 (fig.120)
Watercolour and gouache, with pen, on blue
paper (type F) 140 × 192 (5½ × 7½)
Verso: inscribed in pencil, '18 – 410'
Preliminary sketches: TB CCXLIX f.11
EXH: As part of Loan Series B, shown at the
following places: Public Gallery and
Museum, Hove 1934–5; Ferens Art Gallery,
Hull 1948–9; National Museum of Wales,
Cardiff 1951

LIT: Cook 1905, p.21 as 'Sketch for "Rivers of
France"'; Finberg 1909, II, p.791, as 'The
ruined Abbey of Marmoutier, near Tours';
Lévêque-Mingam 1996, p.79 fig.61
TB CCLIX 18; D24583

88 **The lantern of Roche-Corbon, near
Tours** *c.*1826–8 (fig.123)
Watercolour and gouache on blue paper (type
B) 145 × 197 (5¾ × 7⅜)
Preliminary sketches: TB CCXLIX ff.15 and 15
verso
EXH: Marlborough House 1857, frame 81,
no.170, as one of 'Four French Subjects'
(Ruskin, *Works*, XIII, p.290); Exhibited
Drawings, no.430, b (Ruskin, *Works*, XIII,
p.629); ?Tate Gallery 1931–4; Paris 1981–2
(66, p.254, as 'Ruins on the Loire, *c.*1830',
where it is suggested the colour study is based
on TB CCXLVIII f.23 verso; repr. in col. p.196
fig.345, and again [also in col.] on p.435, as
fig.896 [among a group of Tancarville
subjects])
LIT: Finberg 1909, II, p.799, as 'Tancarville (?)';
Hervouet 1989, repr. p.21, where it is
suggested it may be a location near Montjean
TB CCLIX 168; D24733

89 **The bridge and château of Amboise**
*c.*1826–30 (fig.125)
Pencil, watercolour and gouache, with black
pen work, on blue paper 134 × 187
(5¼ × 7⅜)
Preliminary sketches: There is a basic sketch of
the château at Amboise on TB CCXLIX f.16
verso, which could have been the starting
point for this and the engraved view of
Amboise (fig.126). That sketch does not
include the bridge on the right, although
Turner could easily have added this feature
from memory
EXH: Paris 1981–2 (65, p.254, as 'The Bridge
and Château at Amboise', repr. in col. p.229
fig.426)
LIT: Cooper Notebooks, p.9 as '1, Amboise by
moonlight', p.10 as '1, The Castle of Amboise
by moonlight', p.14 as one of '5 Blue
Drawings', Enclosure No.7, p.1 as 'Amboise

by moonlight'; John James Ruskin Account
Book (Lancaster) '1858 Feb. Ten Drawings
£500'; Ruskin's list of his 1861 gift to Oxford,
no.14; Revised 1861 list, no.23, as 'Amboise
(the first thought of No.22)' (Ruskin, *Works*,
XIII, p.560); Armstrong, 1902, p.239, as
'Amboise Bridge: First thought for above
(fig.126, W 936), circa 1831–2'; Cook and
Wedderburn 1904 (*Works*, XIII, p.598 as
'Amboise, Bridge. Unpublished sketch for the
same'); Herrmann 1968, p.73, no.36, pl.XXVI;
Wilton 1979, p.417, no.994, repr.; Lévêque-
Mingam 1996, p.81 fig.62 (col.)
Prov: ?Thomas Griffith; …; acquired by
Hannah Cooper as part of a batch of five blue
paper drawings (2 Seine, 3 Loire; the others
were cats.62 and 65) in exchange for three
watercolours (*Ingleboro*, W 576; *Granville*,
fig.166, W 1050; *The Jute*, fig.167, not in
Wilton); sold to John Ruskin on 10 February
1858 as part of a group of ten blue paper
subjects, for which he paid 50 guineas per
design; given by him to the University of
Oxford, March 1861
Collection: The Visitors of the Ashmolean
Museum, Oxford

NOT EXHIBITED
The bridge at Blois: fog clearing
*c.*1828–30 (fig.130)
Watercolour and gouache, with red and brown
pen work, on blue paper 131 × 187
(5⅛ × 7⅜)
Preliminary sketches: TB CCXLIX ff.19, 19 verso
and 46
EXH: Germany 1972 (75); Paris 1981–2 (42,
p.232, as 'The Bridge at Blois: fog clearing,
*c.*1830', repr. in col. p.223 fig.410 (NB:
another watercolour is also catalogued in that
volume as no.42; see above here, cat.62])
LIT: Cooper Notebooks, p.9 as '2, bridge at
Blois', p.10 as '6, Town of Blois', p.14 one of
two blue paper drawings, Enclosure No.7,
p.1, 'Town of Blois'; John James Ruskin
Account Book (Lancaster) '1858 Feb. Ten
Drawings £500'; Ruskin's list of his 1861 gift
to Oxford, no.13; Revised 1861 list, no.24, as
'The Bridge of Blois. Fog clearing' (Ruskin,
Works, XIII, p.560, no.24); Armstrong 1902,

p.243, as 'Blois, The Bridge at: Fog clearing,
circa 1830'; Cook and Wedderburn 1904
(*Works*, XIII, p.598); Herrmann 1968, p.73,
no.34, repr. pl.XXV; Wilton 1979, p.417,
no.993, repr.; Warrell in Blois 1994, p.32, repr.
in col. pp.24–5 fig.4; Lévêque-Mingam 1996,
p.90 fig.70, colour
Prov: ?Thomas Griffith; ?C. Stokes, 1850; …;
acquired by Hannah Cooper (with *Poussin's
Birthplace*, W 1006) on 15 April 1854, in
exchange for '4 from W. Scott' (*Kenilworth*,
W 1148; *The Pirate*, W 1307; *Greenwich*
(confused identification of *Whitehall*), W 1149;
Lochmaben, W 1150); sold to John Ruskin on
10 February 1858, as part of a group of ten
blue paper subjects, for which he paid 50
guineas per design; given by him to the
University of Oxford, March 1861
Collection: The Visitors of the Ashmolean
Museum, Oxford

90 **Blois: the Façade des Loges of the
château from below** *c.*1828–30 (fig.135)
Watercolour and gouache, with pen, on blue
paper (type C) 138 × 191 (5⅜ × 7½)
Preliminary sketches: The main sketch is based
on TB CCXLIX f.21. For the distant church
tower, Turner mistakenly used his note of the
facade of St Nicholas de Paul at the bottom
of f.20 verso.
Copies: William Ward made a copy of this work
for the cabinet Ruskin presented to
Whitelands College (frame 52) (see *Works*,
XXX, p.354). Other versions, approved by
Ruskin, were available for sale at the Fine Art
Society (see *Works*, XIII, p.575, no.26)
EXH: National Gallery 1881, Group XVIII –
Finest Colour on Grey (Late) no.421 / 121, as
'Château de Blois' (Ruskin, *Works*, XIII,
p.385); Exhibited Drawings, no.121 (Ruskin,
Works, XIII, p.612); Graves Art Gallery,
Sheffield, and University of Nottingham Art
Gallery 1964–5; Paris 1981–2 (47, p.234, as
'Blois, *c.*1830', repr. in col. p.238 fig.444); Tate
Gallery 1983; Australia 1985; Tate Gallery
1991 (48, repr. p.51 and in col. p.22)
LIT: Finberg 1909, II, p.794, as 'Château de
Blois: Loire'; Wilton 1982, pl.48, as 'The
Chateau de Blois, *c.*1829'; Warrell in Blois

1994, p.32, repr. in col. pp.8–9 fig.1; Lévêque-Mingam 1996, p.88 fig.68
TB CCLIX 97; D24662

91 Beaugency from the south *c.*1826–30 (fig.137)
Watercolour and gouache, with pen, on blue paper (type C) 124 × 183 (4⅞ × 7¼)
Verso (D41435): Pencil sketch of the château at Beaugency
Preliminary sketches: TB CCXLIX f.26 verso (bringing together the two halves of the view sketched there). See also f.28, for a related study of the bridge.
Copies: See under cat.92
EXH: National Gallery 1881, Group XVIII – Finest Colour on Grey (Late), no.420 / 120, as 'Beaugency' (Ruskin, *Works*, XIII, p.385); Exhibited Drawings, no.120 (Ruskin, *Works*, XIII, p.612); Arts Council Tour 1974 (26, as 'c.1827', repr. p.33); Paris 1981–2 (43, p.232, as 'Beaugency, c.1830', repr. p.232 fig.439); Tate Gallery 1993 (42, repr. p.45)
LIT: Finberg 1909, II, p.794, as 'Beaugency'; Wilton 1988, pp.126–7, pl.56, as 'Beaugency, c.1830'; Lévêque-Mingam 1996, p.95 fig.74 (col.)
TB CCLIX 96; D24661

92 Beaugency from the north-east *c.*1826–30 (fig.139)
Watercolour and gouache, with pen, on blue paper (type C) 138 × 188 (5½ × 7½)
Preliminary sketches: TB CCXLIX f.25. Another similar view can be found on f.8 verso
Copies: William Ward made a copy of this work for the cabinet Ruskin presented to Whitelands College (frame 51) (see *Works*, XXX, p.354 and n.2). Ward sold versions of a view title 'Beaugency' at the Fine Art Society in 1878, which could be based on either this study or cat.91 (see *Works*, XIII, p.575, no.13). A copy of the latter was sold at Phillips on 22 December 1986 (72) and was apparently approved by Ruskin
EXH: National Gallery 1881, Group XVIII – Finest Colour on Grey (Late), no.419 / 119, as 'Beaugency' (Ruskin, *Works*, XIII, p.385);

Exhibited Drawings, no.119 (Ruskin, *Works*, XIII, p.612); Arts Council Tour 1974 (25, as 'c.1827', repr. p.32); Paris 1981–2 (45, p.232, as 'Beaugency, c.1830', repr. in col. p.233 fig.440); Tate Gallery 1989 (32, as 'c.1830', repr. p.41); Tate Gallery 1993b (21, as 'c.1826–30', repr. p.45 fig.42)
LIT: Finberg 1909, II, p.794, as 'Beaugency: Loire'; Wilton 1982, pl.47, as 'Beaugency, c.1829'; Lévêque-Mingam 1996, p.98 fig.78 (col.)
TB CCLIX 95; D24660

93 Orléans from the Quai Neuf *c.*1826–8 (fig.143)
Watercolour and gouache, with red pen work, on blue paper (type B) 141 × 196 (5½ × 7¾) (the lower left corner made up)
Watermark: '1824'
Preliminary sketches: TB CCXLIX ff.29 verso, 30
EXH: Exhibited Drawings, no.626, b, as one of 'Two Sketches at Orleans (colour on grey)' (Ruskin, *Works*, XIII, p.637); ?Tate Gallery 1931–4
LIT: Finberg 1909, II, p.801, as 'At Orleans'; Lévêque-Mingam 1996, p.109 fig.84
TB CCLIX 206; D24771

94 Orléans from the south side of the river *c.*1826–8 (fig.142)
Watercolour and gouache, with red pen work, on faded blue paper (type B) 135 × 188 (5¼ × 7½)
Preliminary sketches: TB CCXLIX f.29 verso
EXH: Marlborough House 1857, frame 138, no.309, as part of the group '307–310. Studies on the Loire and Meuse' (Ruskin, *Works*, XIII, pp.312–3); Exhibited Drawings, no.444, c, as part of the group 'Four Sketches in Colour on the Loire and Meuse' (Ruskin, *Works*, XIII, p.630); Liege 1939; Aberystwyth 1939
LIT: Finberg 1909, II, p.687, as one of 'Three sketches in colour; possibly on the Meuse', grouped with TB CCXX P and TB CCXX Q (cat.61), following the way the three items had been displayed by Ruskin; Wilkinson 1975, p.81, repr. in col.; Alfrey 1981, p.258

under no.69, where identified as a view of Orléans
TB CCXX R: D20225

95 The bridge and cathedral at Orléans *c.*1826–8 (fig.144)
Watercolour and gouache, with red and black pen work, on blue paper (type B) 126 × 196 (5 × 7¾)
Preliminary sketches: TB CCXLIX f.30
EXH: Exhibited Drawings, no.626, a, as one of 'Two Sketches at Orleans (colour on grey)' (Ruskin, *Works*, XIII, p.637); ?Tate Gallery 1931–4
LIT: Finberg 1909, II, p.801, as 'At Orleans'; Lévêque-Mingam 1996, p.108 fig.83
TB CCLIX 205; D24770

96 Orléans Cathedral from the left bank of the Loire *c.*1826–8 (fig.145)
Watercolour and gouache, with red pen work, on blue paper (type B) 141 × 193 (5½ × 7¾)
Preliminary sketches: TB CCXLIX ff.30 verso, 31 and, for the western tower of the cathedral, possibly also f.32 verso
EXH: Exhibited Drawings, no.36, a, as 'Orleans (colour on grey), 1833–1835' (Ruskin, *Works*, XIII, p.610); Graves Art Gallery, Sheffield, and University of Nottingham Art Gallery 1964–5; Paris 1981–2 (69, p.258, as 'Orléans, c.1830', repr. fig.472)
LIT: Finberg 1909, II, p.792, as 'Orléans'; Wilkinson 1975, p.88, repr. in col.; Lévêque-Mingam 1996, p.105 fig.82
TB CCLIX 71; D24636

97 Orléans: the west front of the cathedral *c.*1826–8 (fig.148)
Watercolour and gouache, with red penwork, on faded blue paper (type B) 141 × 196 (5½ × 7¾)
Preliminary sketches: TB CCXLIX f.33. The details of the transept, to the right, may have been culled from the sketch on f.33 verso
EXH: Fourth Loan Collection 1891–1916, frame no.19, as 'Exterior of a cathedral'
LIT: White 1896, pp.28–9, no.35, as 'West Front of Orleans Cathedral, 1830–35'; Catalogue for

the 1906 showing of the Fourth Loan Collection at Manchester, 1906, no.32, as 'Rouen Cathedral (about 1833) – Body colour'; Finberg 1909, II, p.805, as 'Part of Rouen Cathedral'; *Catalogue of Original Drawings in Water Colour, etc., by J.M.W.Turner, R.A., Lent by the Trustees of the National Gallery [the 4th Loan Collection]*, Laing Art Gallery, Newcastle, 1912, no.18, 'Rouen Cathedral'; Wilkinson 1975, p.95, repr. in col., as 'Rouen Cathedral'
TB CCLIX 260; D24825

98 Orléans: the Place de l'Etape, looking toward the Théâtre, the Hôtel Dieu and the cathedral *c.*1826–8 (fig.147)
Watercolour and gouache, with red pen work, on blue paper (type B) 143 × 194 (5¾ × 7¾)
Preliminary sketches: TB CCXLIX f.34, but imagined from a more northerly point in the Place de l'Etape.
EXH: Marlborough House 1857, frame 134, no.296, as 'Orleans: The Theatre and Cathedral' (Ruskin, *Works*, XIII, pp.311–2); Exhibited Drawings, no.618, a (Ruskin, *Works*, XIII, p.637); ?Tate Gallery 1931–4; Tate Gallery 1991 (47, repr. p.51); Tate Gallery 1993b (no cat.)
LIT: Finberg 1909, II, p.801, as 'Orleans: The theatre and cathedral'; Alfrey in Paris 1981, p.258, under no.69
TB CCLIX 199; D24764

NOT EXHIBITED
Orléans: twilight over the Place du Martroi *c.*1826–8 (fig.150)
Watercolour and gouache, with black and red penwork, on blue paper 140 × 195 (5½ × 7¾)
Preliminary sketches: TB CCXLIX f.34 verso
EXH: Fitzwilliam Museum 1959; Fitzwilliam Museum 1975; Fitzwilliam Museum 1994 (p.73, repr. in col.)
LIT: Cooper Notebooks, p.9 as '3, Market place at Orleans', p.11 as '10, Market Place at Orleans', Enclosure No.7, p.1 as 'Market Place at Orleans'; Thornbury 1862, I, p.239; Ruskin list of 1861 gift to Cambridge (*Works*,

XIII, p.558, no.13, as 'Orleans (Twilight)';
Armstrong 1902, p.269, as 'Orleans – Twilight.
circa 1830'; Cook and Wedderburn 1904
(*Works*, XIII, p.603); Mauclair 1939, p. 71,
repr.; Finberg, 1909, II, p.758, under TB
CCXLIX f.34; Herrmann 1970, p.696;
Cormack 1975, pp.53–4, no.26, repr.; Wilton
1979, p.418, no.997, repr.
Prov: ?Thomas Griffith; …; acquired by
Hannah Cooper, 6 October 1854, in
exchange for the unengraved *Liber Studiorum*
subjects, *Sion House* (British Museum; see Tate
Gallery 1996, p.16 fig.8) and *Crowhurst* (TB
CXVIII R; see Tate Gallery 1996, no.76); sold to
John Ruskin, 10 Februrary 1858, as one of a
group of ten blue paper subjects, for which
he paid 50 guineas per design; given by him
to the museum, May 1861
Collection: The Syndics of the Fitzwilliam
Museum, Cambridge (reg. no.579)

Oil Paintings Resulting from the 1826 Tour

99 The harbour of Brest: the quayside and château *c.*1826–8 (fig.173)
Oil on canvas 1725 × 2235 (68 × 88)
Preliminary sketches: TB CCXLVIII ff.16, 16 verso
EXH: Edinburgh 1968 (20)
LIT: Davies 1946, p.164; Reynolds 1969, repr.
p.152 fig.134; B&J 1977, no.527, as 'Harbour
with town and fortress, ?*c.*1830'; Wilton 1979,
p.224, repr. p.296; B&J 1984, no.527, col.
pl.528; Wilton 1987 (*Guide*), repr. in col. p.43,
as 'A fortress on the Meuse, *c.*1828'
T05514 (Accessioned *c.*1946)

100 The Banks of the Loire *c.*1828–9 (fig.179)
Oil on canvas 686 × 521 (27 × 20⅞)
Preliminary sketches: TB CCXLVII ff.11, 11 verso
and TB CCLIX 138 (cat.66); see also the oil
painting currently titled, *Landscape with a
Castle on a Promontory c.*1820–30? (Tate
Gallery, B&J 281; repr. pl.301), which sets out
this composition; it is discussed here p.181.
EXH: RA 1829 (19); RA 1912 (89); Memphis
1979 (2, repr. in col., as 'A View Looking

Over a Lake, *c.*1827'); Munich 1983 (139,
repr); Japan 1986 (29, as 'A View on the
Rhone?, *c.*1828–9', repr. in col. p.103)
LIT: John Burnet, *Turner and his Works* 1852,
p.115, no.147; Thornbury 1877, p.575;
Monkhouse 1879, p.111; Bell 1901, p.110,
no.160; Armstrong 1902, pp.167, 224; *Worcester
Art Museum Annual*, iv, 1941, pp.35–41, repr.
fig.6; H.F. Finberg 1957, p.51; Finberg 1961,
pp.313–14, 487, no.315, 488, no.322; *European
Paintings in the Collection of the Worcester Art
Museum*, British School catalogue by St John
Gore, 1974, pp.67–9, repr. p.550; B&J 1977,
no.270, *c.*1827; Powell 1983, pp.56–8, repr.;
Butlin and Joll 1984, p.182, no.328a, as 'A
View on the Rhone? *c.*1828–9', repr. in col.
pl.332; (see also Butlin and Joll 1984, p.183,
no.329, *The Banks of the Loire*, as 'Present
Whereabouts Unknown')
Prov: Painted for Sir Willoughby and Lady Julia
Gordon (see TB CCXXXVII f.11); by descent to
their grand-daughter, Mrs Disney Leith, and
then to her son, the fifth Lord Burgh; sold
Christie's 9 July 1926 (26) bt Langton
Douglas; Theodore T. Ellis by November
1927; bequeathed to the Worcester Art
Museum by his widow, Mary G. Ellis, in 1940
(Theodore T. Ellis and Mary G. Ellis
Collection)
Collection: Worcester Art Museum, Worcester,
Massachusetts, Theodore T. and Mary Ellis
Collection

Designs for *The Keepsake* Annual, 1829–31

101 Tours, from the west: ?study for a *Keepsake* design *c.*1829 (fig.182)
Watercolour 399 × 460 (15¾ × 18⅛)
Related works: See cat.117
LIT: Finberg 1909, II, p.816, as 'Sunshine on
river'; Tate Gallery 1997, p.97
TB CCLXIII 26; D25148

102 Angers; ?study for a *Keepsake* design *c.*1829 (fig.183)
Watercolour and gouache 302 × 496
(11⅞ × 19½)

Preliminary sketches: see TB CCXLVIII f.34 verso
EXH: As part of Loan Series B, shown at the
following venues: Public Gallery and
Museum, Hove 1934–5; Ferens Art Gallery,
Hull 1948–9; National Museum of Wales,
Cardiff 1951; Paris 1981–2 (160, p.527, as
'Angers, 1830?', repr. in col. p.529 fig.1055)
LIT: Finberg 1909, II, p.815, as 'Town, with
river. Possibly in the south of France';
Lévêque-Mingam 1996, p.56 fig.38; Tate
Gallery 1997, pp.95 and 99 as '?Sketch for an
England and Wales series view of the Pool of
London'
TB CCLXIII 13; D25135

103 Scene on the Loire, near the Château de Clermont *c.*1829–33, or later (fig.184)
Watercolour 579 × 861 (22¾ × 33⅞)
Watermark: J WHATMAN / TURKEY MILL
/ 1829
Verso: Inscribed in ink '138 × 4JT' and in
pencil 'C.L.E. / JPK', i.e. 138 ★ in the 1854
National Gallery schedule, which was 'A Roll
of 14 sheets (beginnings)'
Preliminary sketches: Based on cat.65
LIT: Finberg 1909, II, p.1214, as 'River scene
(?)'; Tate Gallery 1997, p.97, where linked
with 'Scene on the Loire', and dated '*c.*1832'
TB CCCLXV 31; D36322

104 Nantes (design for *The Keepsake* annual) *c.*1829–30 (fig.180)
Watercolour 298 × 439 (11¾ × 17 ×¼)
Preliminary sketches: Based on cat.52
(TB CCLIX 203)
Engr: By James Tibbetts Willmore, 1830, for the
1831 edition (R 325; see Appendix C, no.2,
and p.197)
EXH: Musée du Château de Nantes, *Nantes Ville
portuaire à travers les collections du musée*, 1995,
supplement to the main catalogue by Marie-
Hélène Jouzeau, repr. in col.
LIT: *The Art Union*, April 1839, no.3, 'No.12
Nantes'; Armstrong 1902, p.267, as 'Nantes.
1829' and '1830–35' (Armstrong lists two
views of Nantes: the one from the Dillon
collection, sold at Foster's in 1856, and a
second work that came from the sale of

Munro of Novar's collection in 1877, which
he dates slightly later. Both works have
roughly the same measurements. The chief
difference between them is that Armstrong
attributes an engraving of the second
watercolour to 'R. Wallis (?)', which does not
seem to exist. This could imply that this is a
confusion and duplication of the provenance
for one work, since the buyer at the Munro
sale was Mr Wallis, while the watercolour was
in fact engraved by Willmore [for a similar
confusion, see also cat.117]. Furthermore, the
1861 list of works in Munro's collection
[Thornbury 1862, II, pp.396–7] does not
include a watercolour of Nantes, implying
that this was acquired somewhat later);
Wilton 1979, p.424, no.1044, as '*c.*1829,
untraced'; S. Whittingham, *Turner Studies*,
vol.7, no.2, Winter 1987, p.33; Lévêque-
Mingam 1996, p.38, repr. in col. fig.19
Prov: B.G. Windus until at least 1840; John
Dillon, sold Foster 7 June 1856 (145); …; H.A.J.
Munro of Novar; sold Christie's 2 June 1877
(35) £819 bt Wallis; …; bt Pennell; by 1900 in
the collection of the family of the vendor who
sold it at Mellors and Kirk, Nottingham, 1
December 1994 (327, as 'The Property of a
Lady') bt for the museum at Nantes
Collection: Musée du Château, Nantes

NOT EXHIBITED

Saumur (design for *The Keepsake* annual) *c.*1829–30 (fig.181)
Watercolour 283 × 423 (11⅛ × 16⅝)
(TB CCLIX 145)
Engr: By Robert Wallis, 1830, for the 1831
edition (R 324; see Appendix C, no.1)
Copies: There is a version of this subject in oils
by an unknown artist, which takes the basic
composition, but adds trees to the river bank
and (more significantly) moves the château
across to the northern side of the Loire
(exported by C. Marshall Spink to a private
collector in Rome, 1958, and later to Paul
Mellon, 1962)
EXH: Guildhall 1899 (147, as 'Namur'); Agnew's
1951 (66); British Musuem 1975 (168, repr.
p.107)

Catalogue

LIT: Ruskin, *Works*, XIII, pp.530 and 604; Armstrong 1902, p.276, as 'Saumur. circa 1829'; *(Turner and Ruskin*, vol.1, p.88, repr.;) Wilton 1979, p.424, no.1046, repr.; Wilton 1982, pl.50, as 'c.1830'; S.Whittingham, *Turner Studies*, vol.7, no.2, Winter 1987, p.33; Lévêque-Mingam 1996 p.65 fig.46 (col.)

Prov: B.G.Windus, until at least 1840; (on the basis of a note in the Guildhall exhibition catalogue, Armstrong, Cooke and Wedderburn, and Wilton all say that Ruskin owned this watercolour between Windus and Munro, but this seems unlikely unless it involved a series of undocumented exchanges;) by 1855 with H.A.J. Munro of Novar, sold Foster 1855; J. Dillon, sold Foster 7 June 1856 (144); J.H. Maw, 1857; Hon W.F.D. Smith, M.P.; Sir Joseph Beecham, sold Christie's 4 May 1917 (153) bt in, sold Christie's 10 May 1918 (87); R.W.Lloyd, by whom bequeathed to the museum, 1958

Collection: British Museum (1958-7-12-430)

105 *The Keepsake* for 1831
Edited by Frederic Mansel Reynolds
Open at p.222; *Saumur*, engraved by Robert Wallis after Turner, 1830 (see Appendix C, no.1)
The print is inserted opposite 'Saumur. A Tale of Real Life' by R. Bernal, M.P. (see p.212, n.7)
Published at the end of 1830 by Hurst, Chance, and Co., and Jennings and Chaplin, London
Dr Jan Piggott

JAMES TIBBETTS WILLMORE AFTER J.M.W.TURNER

106 **Nantes**, 1830 (for *The Keepsake* 1831)
Line engraving on steel, engraver's proof (d) 87 × 130 (3⅜ × 5⅛) on wove paper, 283 × 406 (11⅛ × 16)
R 325; see Appendix C, no.2:
T04619

Drawings Engraved for *Turner's Annual Tour, 1833*
These are listed in topographical order and, unless otherwise stated, use the titles under which the images were engraved. Since most discussion of the images concerned the engraved versions, the reader should also consult Appendix C for literary references to these works.

107 **Nantes (vignette)** *c.*1830–31 (fig.29)
Watercolour and gouache, with pen, on blue paper 186 × 134 (7⅜ × 5¼)
Preliminary sketches: loosely based on TB CCXLVII f.61v
Engr: By William Miller, 1832 (R 432; Appendix C, no.3)
Copies: There is a version of this design, formerly attributed to Samuel Prout, in the Victoria and Albert Museum (E.1146.1948; see Richard Lockett, *Samuel Prout 1783–1852*, 1985, p.167, no.70, repr.)
EXH: Paris 1981–2 (58, p.250, as 'Nantes, c.1830', repr. in col. p.247 fig.455); Tate Gallery 1993c (28, repr. p.86)
LIT: Cooper Notebooks, pp.9, 10, 14; John James Ruskin Account Book (Lancaster), 1858, 'Feb 17 Drawings £1050'; Thornbury 1862, II, p.396, as one of 'Seventeen Drawings of the Loire Series (Rivers of France)' (reprinted in *Works*, XIII, p.557); Ruskin's list of his 1861 gift to Oxford, no.20; Revised 1861 list, no.17, as 'Nantes' (Ruskin, *Works*, XIII, p.559); Armstrong 1902, p.267, as 'Nantes. Upright. circa 1830'; Swinburne 1902, p.265; Cook and Wedderburn 1904 (*Works*, XIII, p.603); Herrmann 1968, p.71, no.29, repr. pl.XXXVI; Wilton 1979, p.409, no.930; Lévêque-Mingam 1996, p.33 fig.13 (col.)
Prov: Thomas Griffith; bought by Charles Stokes on 31 May 1850, as part of a group of twenty-four Loire subjects (the engraved set and three studies; probably cat.69, fig.130, and the missing view of a street scene in Tours), for which he paid 600 guineas (i.e. 25 guineas each); inherited by his niece Hannah Cooper on his death in December 1853 as one of a group of seventeen of the engraved Loire subjects (the other seven works from the

group of twenty-four having been sold or exchanged since 1850); this group was sold to John Ruskin, 11 February 1858, for 1,000 guineas; given by him to the University of Oxford, March 1861
Collection: The Visitors of the Ashmolean Museum, Oxford

108 **Château de Nantes** *c.*1828–30 (fig.34)
Watercolour and gouache, with pen, on blue paper 123 × 180 (4⅞ × 7⅛)
Preliminary sketches: There are no pencil sketches for this composition
Related works: There are two other views of the Cours St-Pierre (cats.48 and 49)
Engr: By William Miller, 1832 (R 452; Appendix C, no.23); this work was also engraved in aquatint by Frederick Christian Lewis, ?1830–32 (R.832; Appendix C, no.25)
Copies: There is a copy by Alexander Macdonald in the Ruskin Cabinet at Whitelands College (see *Works*, XXX, p.354, no.50, note 1)
EXH: Germany 1972 (79); Louisville, Kentucky 1977 (49, b, repr. p.73); Paris 1981–2 (53, p.240, as 'Chateau de Nantes', repr. in col. p.248 fig.456); Ashmolean Museum 1996 (ex. cat.)
LIT: Cooper Notebooks, pp.9, 10, 14; John James Ruskin Account Book (Lancaster), 1858, 'Feb 17 Drawings £1050'; Ruskin in Marlborough House catalogue 1857 (*Works*, XIII, pp.311–12, under frame no.134); Thornbury 1862, II, p.396, as one of 'Seventeen Drawings of the Loire series (Rivers of France)' (reprinted in *Works*, XIII, p.557); Ruskin's list of his 1861 gift to Oxford, no.34; Revised 1861 list, no.27, as 'Château de Nantes' (Ruskin, *Works*, XIII, p.560); Armstrong 1902, p.267, as 'Nantes, Chateau de:"Jour de Fete". circa 1830'; Cook and Wedderburn 1904 (*Works*, XIII, p.603); Herrmann 1968, pp.79–80, no.51, repr. pl.XLVII, C; Wilton 1979, p.412, no.950, repr.; Lévêque-Mingam 1996, p.37 fig.18 (col.)
Prov: See cat.107
Collection: The Visitors of the Ashmolean Museum, Oxford

109 **Scene on the Loire (near the Coteaux de Mauves)** *c.*1828–30 (fig.60)
Watercolour and gouache, with pen, on blue paper 140 × 190 (5½ × 7½)
Preliminary sketches: TB CCXLVIII f.9 and 9 verso (Herrmann suggested f.22 verso, which shows Montjean)
Engr: By Robert Wallis, 1831–2 (R 449; Appendix C, no.20)
Other Reproductions: One of a set of six images reproduced in a facsimile edition by Lawrence and Turner in 1989 (limited number of 5,000). See also cats.110, 111, 115 and figs.126–9
EXH: Germany 1972 (78); Louisville, Kentucky 1977 (49, a, repr. p.72); Paris 1981–2 (63, repr. in col. p.251 fig.461, as 'Scene on the Loire'); Paris 1983–4 (180, repr.); Ashmolean Museum 1996 (14, repr.)
LIT: Cooper Notebooks, pp.9, 10, 14; John James Ruskin Account Book (Lancaster), 1858, 'Feb 17 Drawings £1050'; Thornbury 1862, II, p.396, as one of 'Seventeen Drawings of the Loire series (Rivers of France)' (reprinted in *Works*, XIII, p.557]; Ruskin's list of his 1861 gift to Oxford, no.21; Revised 1861 list, no.14, as 'Near the Coteaux de Mauves' (Ruskin, *Works*, XIII, p.559, no.14); Armstrong 1902, p.262, as 'Loire, near Nantes, Calm on the, circa 1830', and again on p.266, as 'Mauves, near the Coteaux de, Loire. circa 1830'; Swinburne 1902, p.266; Cook and Wedderburn 1904 (*Works*, XIII, p.602); J. Rothenstein and M. Butlin, *Turner*, 1964, pl.69b; Herrmann 1968, p.79, no.50, repr. in col. pl.C; Wilton 1979, p.411, no.947, repr.; Birch 1990, p.75, repr. in col.; Lévêque-Mingam 1996, p.22 fig.8. (col.)
Prov: See cat.107
Collection: The Visitors of the Ashmolean Museum, Oxford

110 **Coteaux de Mauves** *c.*1828–30 (fig.61)
Watercolour and gouache, with pen and scratching-out, on slightly faded blue paper 138 × 187 (5⅜ × 7⅜)
Preliminary sketches: TB CCXLVIII ff.9 verso, 10. Herrmann suggested the composition was based on f.24 verso. This latter sketch

actually shows the cliffs overhanging the Maine near Angers, but it may have helped Turner resolve his ideas for structuring this image

Engr: By Robert Wallis, 1832 (R 451; Appendix C, no.22)

Other reproductions: One of a set of six images reproduced in a facsimile edition by Lawrence and Turner in 1989 (limited number of 5,000)

EXH: Paris 1981–2 (50, repr. in col. p.249 fig.458, as 'Coteaux de Mauves')

LIT: Cooper Notebooks, pp.9, 10, 14; John James Ruskin Account Book (Lancaster), 1858, 'Feb 17 Drawings £1050'; Thornbury 1862, II, p.396, as one of 'Seventeen Drawings of the Loire series (Rivers of France)' (reprinted in *Works*, XIII, p.557]; Ruskin's list of his 1861 gift to Oxford, no.23; Revised 1861 list, no.15 (Ruskin, *Works*, XIII, p.559); Armstrong 1902, p.266, as 'Mauves, Coteaux de, Loire, circa 1830'; Cook and Wedderburn 1904 (*Works*, XIII, p.602); Herrmann 1968, p.75, no.41, repr. pl.XXX; Wilton 1979, p.412, no.949, repr.; Lévêque-Mingam 1996, p.43 fig.25 (col.)

Prov: See cat.107

Collection: The Visitors of the Ashmolean Museum, Oxford

111 Between Clairmont and Mauves

*c.*1828–30 (fig.62)

Watercolour and gouache, with pen, and scratching-out, on blue paper (ruckled at the left hand side, creating texture on rocks) 138 × 189 (5⅜ × 7½)

Verso: Inscribed on lower edge in pencil 'Between Clairmont & Mauves'

Preliminary sketches: TB CCXLVIII f.9 verso, 10

Engr: By William Miller, 1832 (R 447; Appendix C, no.18)

Other reproductions: One of a set of six images reproduced in a facsimile edition by Lawrence and Turner in 1989 (limited number of 5,000)

EXH: Paris, 1981–2 (61, repr. in col. p.252)

LIT: Cooper Notebooks, pp.9, 10, 14; John James Ruskin Account Book (Lancaster), 1858, 'Feb 17 Drawings £1050'; Thornbury 1862, I,

p.241, II, pp.338, and 396, as one of 'Seventeen drawings of the Loire series (Rivers of France)' [reprinted in *Works*, XIII, p.557]; Ruskin's list of his 1861 gift to Oxford, no.22; Revised 1861 list, no.18 (Ruskin, *Works*, XIII, p.559); Armstrong 1902, p.246, as 'Clairmont and Mauves, between. On the Loire, circa 1830'; Swinburne 1902, p.266; Cook and Wedderburn 1904 (*Works*, XIII, p.599); Herrmann 1968, p.72, no.31, repr. pl.XLVI, c; Wilton 1979, p.411, no.945, repr.; Alfrey 1977, p.73 n.7, suggests a study for this work is TB CCLIX 77, but this seems unlikely; Lévêque-Mingam 1996, p.42 fig.24 (col.)

Prov: See cat.107

Collection: The Visitors of the Ashmolean Museum, Oxford

112 Château de Clermont (engraved for *Turner's Annual Tour* as Clairmont

*c.*1828–30 (fig.65)

Watercolour and gouache, with scratching-out, on blue paper 140 × 190 (5½ × 7½)

Preliminary sketches: TB CCXLVIII f.10 verso

Engr: By James Tibbetts Willmore, 1832 (R 450; Appendix C, no.21)

LIT: Cooper Notebooks, p.10; Thornbury 1862, I, p.241; Wilton 1979, p.411, no.948, repr.

Prov: Thomas Griffith; from whom bt by Charles Stokes on 31 May 1850, as part of a package of twenty-four Loire subjects, for which he paid 600 guineas (i.e. 25 guineas each); this drawing had left his collection before his death in December 1853; …; anon. sale Christie's 23 February 1920 (23) bt Sampson; …

Collection: Mr and Mrs Jerry Van Auken Kollig

113 Champtoceaux from the east (engraved as 'Château Hamelin, between Oudon and Ancenis')

*c.*1828–30 (fig.72)

Watercolour and gouache, with pen and scratching-out, on blue paper 137 × 189 (5⅜ × 7½)

Preliminary sketches: TB CCXLVIII ff.14 verso

Engr: By Robert Brandard, 1832 (R 448; Appendix C, no.19)

Copies: There is a copy of this work in watercolour on white paper in a French collection (seen, care of Christie's, 1996)

EXH: RA 1974 (385); Paris 1981–2 (41, p.216, as 'Chateau Hamelin, between Oudon and Ancenis, c.1830', and p.253 fig.463 in col.)

LIT: Cooper Notebooks, pp.9, 10, 14; John James Ruskin Account Book (Lancaster), 1858, 'Feb 17 Drawings £1050'; Thornbury, II, p.396, as one of 'Seventeen Drawings of the Loire series (Rivers of France)' (reprinted in *Works*, XIII, p.557); Ruskin's list of his 1861 gift to Oxford, no.35; Revised 1861 list, no.26 as 'Château Hamelin' (Ruskin, *Works*, XIII, p.560); Armstrong 1902, p.256, as 'Hamelin, Chateau. On the Loire, circa 1830'; Swinburne 1902, p.266; Cook and Wedderburn 1904 (*Works*, XIII, p.601); Herrmann 1968, p.74, no.39, repr. pl.XLVI, F; Wilton 1979, p.411, no.946, repr.; Lévêque-Mingam 1996, p.44 fig.26 (col.)

Prov: See cat.107

Collection: The Visitors of the Ashmolean Museum, Oxford

114 St-Florent-le-Vieil *c.*1828–30 (fig.75)

Watercolour and gouache, on blue paper 140 × 187 (5½ × 7⅜)

Preliminary sketches: TB CCXLVIII f.18

Engr: By Robert Brandard, 1832 (R 446; Appendix C, no.17)

EXH: Manchester 1857 (369, from the collection of Lewis Loyd)

LIT: Cooper Notebooks, p.10; Wilton 1979, p.411, no.944

Prov: Thomas Griffith; bt from him by Charles Stokes on 31 May 1850, as part of a group of twenty-four Loire subjects (all but three of which were the set of engraved views), for which he paid 600 guineas; by December 1853, when Stokes died, the drawing had already left his collection; …; Lewis Loyd; Capt. E.N.F. Loyd; sold Christie's 30 April 1937 (70) bt Capt. Loyd; by descent to the present owner

Collection: Private collection

115 Montjean-sur-Loire *c.*1828–30 (fig.81)

Watercolour and gouache, with pen and scratching-out, on blue paper 135 × 188 (5⅜ × 7⅜)

Preliminary sketches: TB CCXLVIII ff.20, 21

Engr: By James Tibbetts Willmore, 1832 (R 445; Appendix C, no.16)

Other reproductions: One of a set of six images reproduced in a facsimile edition by Lawrence and Turner in 1989 (limited number of 5,000)

EXH: Paris 1981–2 (56, p.240, as 'Montjen, c.1830', and repr. in col. p.244, as 'Montjen, c.1830', but incorrectly captioned as 'French town on a river', which is reproduced on the opposite page); Paris 1983–4 (181, repr.)

LIT: Cooper Notebooks, pp.9, 10, 14; John James Ruskin Account Book (Lancaster), 1858, 'Feb 17 Drawings £1050'; Thornbury 1862, I, p.241, II, p.396, as one of 'Seventeen Drawings of the Loire series (Rivers of France)' (reprinted in *Works*, XIII, p.557); Ruskin's list of his 1861 gift to Oxford, no.36; Revised 1861 list, no.8 (Ruskin, *Works*, XIII, p.559); Armstrong 1902, p.267, as 'Mont Jean, on the Loire, below Angers. circa 1830'; Cook and Wedderburn 1904 (*Works*, XIII, p.603); Herrmann 1968, p.75, no.40, repr. pl.XLVI, G; Wilton 1979, p.411, no.943, repr.; Lévêque-Mingam 1996, p.50 fig.33 (col.)

Prov: See cat.107

Collection: The Visitors of the Ashmolean Museum, Oxford

116 Saumur, from the Ile d'Offard, with the Pont Cessart and the château beyond *c.*1828–30 (fig.100)

Watercolour and gouache on blue paper 127 × 191 (5 × 7½)

Preliminary sketches: TB CCXLVIII f.43

Engr: By James Tibbetts Willmore, 1832 (R 443; Appendix C, no.14; and see p.197)

EXH: Manchester 1857 (372, from the collection of Lewis Loyd); Spink-Leger, annual spring display, 1997 (37, as '1826–30', repr. in col.)

LIT: Mauclair 1939, repr. in col. p.73; Wilton 1979, pp.410–11, no.941, repr.

Prov: Thomas Griffith; bt from him by Charles Stokes on 31 May 1850, as part of a group of

twenty-four Loire subjects (all but three were engraved views), for which he paid 600 guineas; by December 1853, when Stokes died, the drawing had already left his collection; …; by 1857 it was with Lewis Loyd, Monks Orchard, Beckenham; Capt. E.N.F. Loyd; by descent until sold at Christie's 30 April 1937 (68); Rayner MacConnell or Mac Connal), 1937; T.E. Fattorini, to 1967; A.R.Lusk, to 1981; Agnew's; John Madden, Colorado; Agnew's 1990–91; bt. by Leger from whom acquired by the current owner, 1996
Collection: Sir Edwin and Lady Manton

NOT EXHIBITED

The Junction of the Loire and the Vienne near Montsoreau and Candes St-Martin (engraved as 'Rietz, near Saumur') *c.*1826–30 (fig.107)
Pencil, watercolour and gouache, with black and brown pen work, on blue paper 124 × 181 (4⅞ × 7⅛)
Preliminary sketches: TB CCXLVIII f.37 and f.45 verso, top sketch. Turner could have conflated these two sketches for this composition, but it is also possible that he sketched the scene directly on to his sheet of blue paper
Engr: By Robert Brandard, 1832 (R 444; Appendix C, no.15); and etched by Ruskin, in reverse, to illustrate *Modern Painters*, V, plate 73, 'Loire Side' (*Works*, VII, opp. p.218)
Copies: By an unknown artist, perhaps William Ward, sold at Christie's, 28 April 1987, lot 154 (one of three copies; see also cat.65 and the engraved view of Blois, fig.129).
EXH: Paris 1981–2 (57, p.240, as 'Rietz, near Saumur, c.1830', repr. in col. p.241 fig.446)
LIT: Cooper Notebooks, pp.9, 10, 14; John James Ruskin Account Book (Lancaster), 1858, 'Feb 17 Drawings £1050'; Thornbury 1862, II, p.396, as one of 'Seventeen Drawings of the Loire series (Rivers of France)' (reprinted in *Works*, XIII, p.557); Ruskin's list of his 1861 gift to Oxford, no.29; Revised 1861 list, no.11 (Ruskin, *Works*, XIII, p.559); Ruskin, *Modern Painters*, V, 1860 (*Works*, VII, pp.217–21); Armstrong 1902, p.273, as 'Rietz, near Saumur. circa 1830'; Swinburne 1902,

p.261; Cook and Wedderburn 1904 (*Works*, XIII, p.604); Herrmann 1968, pp.78–9, no.49, repr. pl.XXXIV; Wilton 1979, p.411, no.942; Birch 1990, p.78, repr. in col.; Lévêque-Mingam 1996, p.67 fig.48 (col.)
Prov: See cat.107
Collection: The Visitors of the Ashmolean Museum, Oxford

117 **Tours (afterwards known as 'Tours – looking backwards')** *c.*1826–30 (fig.112)
Watercolour and gouache, with pen and brown ink, over pencil, on blue paper 122 × 186 (4⅞ × 7⅜)
Verso: Inscribed in pencil, 'Tours'
Preliminary sketches: There are many sketches of Tours from the west at the beginning of the *Loire, Tours, Orleans, Paris* sketchbook (TB CCXLIX), but none of them relate directly to this composition
Related works: See cat.101 (TB CCLXIII 26) for a watercolour beginning of this view, perhaps intended as the basis for a *Keepsake* subject.
Engr: By Robert Brandard, 1831–2 (R 442; Appendix C, no.13); the design was also reproduced in lithograph by Edouard Hostein in *France*, 1834 (see Bibliothèque Nationale, Va.37, Indre-et-Loire, T.6, H126347)
EXH: Manchester 1857 (?373); Agnew 1951 (28); Yale Center for British Art, New Haven, *English Landscape 1630–1850: Drawings, Prints & Books from the Paul Mellon Collection* 1977 (149, Tours: Sunset, ca.1830', pl.CXXXII; New Haven 1993 (167, repr.)
LIT: Wilton 1979, p.410, no.940
Prov: Thomas Griffith; bt from him by Charles Stokes on 31 May 1850, as part of a group of twenty-four Loire subjects (all but three were engraved views), for which he paid 600 guineas; by December 1853, when Stokes died, the drawing had already left his collection; …; by 1857 it was with Lewis Loyd of Monks Orchard, Beckenham; Capt. E.N.F.Loyd, by descent to 1937; sold Christie's 30 April 1937 (69 as 'Tours, looking backwards: sunset. Engr by Wallis [*sic*]'); … ; Mrs Jonas; T.E. Fattorini; Sir Steven Runciman; Dr P.G. McEverdy; sold Agnew's 1967 bt Paul Mellon

Collection: Yale Center for British Art, Paul Mellon Collection (1981.25.2705)

118 **Tours** *c.*1826–30 (fig.113)
Pencil, watercolour and gouache, with pen, on blue paper 122 × 183 (4¾ × 7¼)
Preliminary sketches: The distant outline of Tours can be found on the following pages of the *Loire, Tours, Orleans, Paris* sketchbook: TB CCXLIX f.1 verso, 6 verso. There are sketches of the shallow boats on f.3 of the same book
Engr: By Robert Brandard, 1832 (R 440; Appendix C, no.11); also reproduced as a lithograph by Edouard Hostein for the volume *France*, 1834 (see Bibliothèque Nationale, Va.37, Indre-et-Loire, T.6, H128349)
EXH: Tours 1978–9; Paris 1981–2 (52, p.240, as 'Tours', repr. in col. p.242 fig. 447 [incorrectly captioned as 'The Canal of the Loire and Cher, near Tours', which is reproduced on the opposite page]); Tours 1988, repr. p.20
LIT: Cooper Notebooks, pp.9, 10, 14; John James Ruskin Account Book (Lancaster), 1858, 'Feb 17 Drawings £1050'; Thornbury 1862, II, p.396, as one of 'Seventeen Drawings of the Loire Series (Rivers of France)' (reprinted in *Works*, XIII, p.557); Ruskin's list of his 1861 gift to Oxford, no.24; Revised 1861 list, no.2 (Ruskin, *Works*, XIII, p.559); Armstrong 1902, p.281, as 'Tours. circa 1830', repr. p.81, pl.43; Swinburne 1902, p.266; Cook and Wedderburn 1904 (*Works*, XIII, p.605); Herrmann 1968, pp.77–8, no.46, repr. pl.XXXIII, A; Wilton 1979, p.410, no.938, repr.; Lévêque-Mingam 1996, p.73 fig.53 (col.)
Prov: See cat.107
Collection: The Visitors of the Ashmolean Museum, Oxford

NOT EXHIBITED

St Julien's, Tours *c.*1826–30 (fig.115)
Pencil, watercolour and gouache, with pen, on blue paper 120 × 184 (4¾ × 7¼)
Preliminary sketches: This drawing may have been developed over a pencil sketch made on the spot. A different view of the southern entrance to the church can be found on TB CCXLIX f.45 verso (fig.116)

Engr: By William Radclyffe, 1832 (R 441; Appendix C, no.12)
EXH: Whitechapel 1953 (202); Germany 1972 (77); Paris 1981–2 (64, p.254, as 'St Julian's, Tours, c.1830', repr. in col. p.354 fig.727)
LIT: Cooper Notebooks, pp.9, 10, 14; John James Ruskin Account Book (Lancaster), 1858, 'Feb 17 Drawings £1050'; Thornbury 1862, I, p.240–41, and II, p.396, as one of 'Seventeen Drawings of the Loire Series (Rivers of France)' (reprinted in *Works*, XIII, p.557); Ruskin's list of his 1861 gift to Oxford, no.32; Revised 1861 list, no.1 (Ruskin, *Works*, XIII, p.559); Armstrong 1902, p.281, as 'Tours: St Julien. circa 1830'; Cook and Wedderburn 1904 (*Works*, XIII, p.605); Herrmann 1968, p.77, no.45, repr. pl.XLVII, A; Wilton 1979, p.410, no.939; Lévêque-Mingam 1996, p.74 fig.54 (col.)
Prov: See cat.107
Collection: The Visitors of the Ashmolean Museum, Oxford

NOT EXHIBITED

The Canal of the Loire and Cher, near Tours *c.*1826–30 (fig.121)
Watercolour and gouache, with pen, on blue paper 123 × 182 (4⅞ × 7⅛)
Preliminary sketches: None of the sketches made at Tours can be related to this scene, which could suggest that it was developed over an on-the-spot outline
Engr: By Thomas Jeavons, 1832 (R 439; Appendix C, no.10)
EXH: Whitechapel 1953 (200); RA 1974 (387); Tours 1978–9 (84, repr); Paris 1981–2 (55, p.240, as 'The Canal of the Loire and Cher, near Tours, c.1830', repr. in col. p.243 fig.448 (incorrectly captioned with the title 'Tours' [cat.118 here], which is reproduced on the opposite page); Tours 1988, repr. p.21
LIT: Cooper Notebooks, pp.9, 10, 14; John James Ruskin Account Book (Lancaster), 1858, 'Feb 17 Drawings £1050'; Thornbury 1862, II, p.396, as one of 'Seventeen Drawings of the Loire series (Rivers of France)' (reprinted in *Works*, XIII, p.557); Ruskin's list of his 1861 gift to Oxford, no.25; Revised 1861 list, no.10 (Ruskin, *Works*, XIII, p.559);

Armstrong 1902, p.281, as 'Tours: Canal of Loire and Cher. circa 1830'; Cook and Wedderburn 1904 (*Works*, XIII, p.599); Herrmann 1968, p.76, no.43, repr. pl.XLVI, H; Herrmann 1970, pp.696–9; Wilton 1979, p.410, no.937, repr.; Lévêque-Mingam 1996, p.72 fig.52 (col.)
Prov: See cat.107
Collection: The Visitors of the Ashmolean Museum, Oxford

119 **Amboise** *c.*1826–30 (fig.124)
Watercolour and gouache, with pen, on blue paper 132 × 187 (5¼ × 7⅜)
Preliminary sketches: None of the sketches in the *Loire, Tours, Orleans, Paris* sketchbook can be related directly to this composition
Engr: By William Raymond Smith, 1832 (R 437; Appendix C, no.9)
EXH: RA 1974 (384); Paris 1981–2 (44, p.232, as 'Amboise, *c.*1830', repr. in col. p.195 fig.344)
LIT: Cooper Notebooks, pp.9, 10, 14; John James Ruskin Account Book (Lancaster), 1858, 'Feb 17 Drawings £1050'; Thornbury 1862, I, pp.239, 241, and II, p.396, as one of 'Seventeen Drawings of the Loire series (Rivers of France)' (reprinted in *Works*, XIII, p.557); Ruskin's list of his 1861 gift to Oxford, no.26; Revised 1861 list, no.16, as 'Amboise' (Ruskin, *Works*, XIII, p.559); Armstrong, 1902, p.239, as 'Amboise, Chateau, circa 1831–2'; Cook and Wedderburn 1904 (*Works*, XIII, p.598, as 'Amboise, Château'); Herrmann 1968, p.74, no.38, repr. pl.XLVI, E; Wilton 1979, p.410, no.935, repr.; Lévêque-Mingam 1996, p.84 fig.65 (col.)
Prov: See cat.107
Collection: The Visitors of the Ashmolean Museum, Oxford

NOT EXHIBITED
Château of Amboise ?*c.*1826–30 (fig.126)
Watercolour and gouache, with pen, on faded blue paper 136 × 188 (5⅜ × 7⅜)
Preliminary sketches: Turner could have based this composition on the sketch on f.16 verso of TB CCXLIX, but he would then have had to

invent the bridge, and the right hand half of the view
Engr: By James Baylis Allen, 1832 (R 438; Appendix C, no.8); a lithograph by Edouard Hostein was published in Paris by François & Louis Janet, and in New York by Bailly, Ward & Co (Bibliothèque Nationale, Va.37, Indre et Loire, Cartes, généralités; communes, T.1: H12578)
Other reproductions: One of a set of six images reproduced in a facsimile edition by Lawrence and Turner in 1989 (limited number of 5,000)
Copies: Ruskin commissioned a copy of this work from Alexander Macdonald (1839–1921) for the cabinet he gave to Whitelands College, frame 57; see below cat.133. Another copy, by an unknown hand, is in a private collection in Sussex
EXH: Germany 1972 (76, repr. p.74 as fig.21a); Paris 1981–2 (49, p.234, as 'Château of Amboise, *c.*1830', repr. in col. p.237 fig.443)
LIT: Cooper Notebooks, pp.9, 10, 14; John James Ruskin Account Book (Lancaster), 1858, 'Feb 17 Drawings £1050'; Thornbury 1862, I, p.239–40, and II, p.396, as one of 'Seventeen Drawings of the Loire series (Rivers of France)' (reprinted in *Works*, XIII, p.557); Ruskin's list of his 1861 gift to Oxford, no.27; Revised 1861 list, no.22, as 'Amboise Bridge' (Ruskin, *Works*, XIII, p.560); Armstrong 1902, p.239, as 'Amboise Bridge, circa 1831–2'; Swinburne 1902, p.266; Cook and Wedderburn 1904 (*Works*, XIII, p.598, as 'Amboise, Bridge'); Herrmann 1968, p.73, no.35, repr. pl.XXVII; Wilton 1979, p.410, no.936, repr.; Lévêque-Mingam 1996, p.82 fig.63 (col.)
Prov: See cat.107
Collection: The Visitors of the Ashmolean Museum, Oxford

NOT EXHIBITED
Blois *c.*1826–30 (fig.129)
Watercolour and gouache, with pen, on blue paper 135 × 183 (5¼ × 7¼)
Verso: Inscribed in pencil, 'Blois'
Preliminary sketches: There are no sketches from the 1826 tour for this composition, but see cat.2 (TB XXVII M)

Engr: By Robert Brandard, 1832 (R 435; Appendix C, no.6)
Other reproductions: One of a set of six images reproduced in a facsimile edition by Lawrence and Turner in 1989 (limited number of 5,000)
Copies: A copy of this, perhaps by William Ward or another of Ruskin's pupils, was sold at Christie's, 28 April 1987, lot 154 (one of three copies, see also cat.65 and the view engraved as 'Rietz', fig.107). A copy of this subject in oils was sold incorrectly as an authentic work by Turner in the Nellis sale, American Art Association, New York, 8 April 1937, lot 61. It is now in the Hamburg Kunsthalle (Schwabe collection)
EXH: Whitechapel 1953 (198); RA 1974 (386); Paris 1981–2 (70, p.258, as 'Blois, *c.*1830', repr. in col. p.222 fig.409;); Blois 1994 (6, repr. in col. pp.32–3)
LIT: Cooper Notebooks, pp.9, 10, 14; John James Ruskin Account Book (Lancaster), 1858, 'Feb 17 Drawings £1050'; Thornbury 1862, I, p.239, and II, p.396, as one of 'Seventeen Drawings of the Loire series (Rivers of France)' (reprinted in *Works*, XIII, p.557); Ruskin's list of his 1861 gift to Oxford, no.30; Revised 1861 list, no.9 (Ruskin, *Works*, XIII, p.559); Armstrong 1902, p.243, as 'Blois, from the Loire, circa 1831–2'; Cook and Wedderburn 1904 (*Works*, XIII, p.598); Herrmann 1963, pl.13; Herrmann 1968, p.76, no.42, repr. pl.XXXI; Alfrey 1977, p.73 n.7, where TB CCLIX 192 is suggested as a related study, although this seems unlikely; Wilton 1979, pp.409–410, no.933, repr.; Warrell in Blois 1994, p.32; Lévêque-Mingam 1996, p.87 fig.67 (col.)
Prov: See cat.107
Collection: The Visitors of the Ashmolean Museum, Oxford

NOT EXHIBITED
Palace at Blois *c.*1828–30 (fig.134)
Pencil, watercolour and gouache, with pen, on blue paper 130 × 185 (5⅛ × 7¼)
Preliminary sketches: TB CCXLIX f.20 verso
Engr: By Robert Wallis, 1832 (R 436; Appendix C, no.7); and later etched by Ruskin and

engraved in mezzotint by Thomas Lupton for the 1888 edition of *Modern Painters*, Vol.V (see cat.132; *Works*, VII, pl.85, facing p.203, and footnote, pp.203–4)
EXH: Whitechapel 1953 (201); Germany 1972 (74); Paris 1981–2 (46, p.234, as 'Palace at Blois, *c.*1830', repr. in col. p.239 fig.445)
LIT: Cooper Notebooks, pp.9, 10, 14; John James Ruskin Account Book (Lancaster), 1858, 'Feb 17 Drawings £1050'; Thornbury 1862, I, pp.239, 241, and II, p.396, as one of 'Seventeen Drawings of the Loire series (Rivers of France)' (reprinted in *Works*, XIII, p.557); Ruskin's list of his 1861 gift to Oxford, no.31; Revised 1861 list, no.20, as 'Château be Blois' (Ruskin, *Works*, XIII, p.560); Amstrong 1902, p.242, as 'Blois, Chateau de, circa 1831–2'; Swinburne 1902, p.266; Cook and Wedderburn 1904 (*Works*, XIII, p.598); Herrmann 1968, pp.76–7, no.44, repr. pl.XXIX; Wilton 1979, p.410, no.934, repr.; Warrell in Blois 1994, p.32, repr. in col. pp.12–13; Lévêque-Mingam 1996, p.91 fig.71 (col.)
Prov: See cat.107
Collection: The Visitors of the Ashmolean Museum, Oxford

NOT EXHIBITED
Beaugency *c.*1826–30 (fig.138)
Watercolour and gouache, with pen, on blue paper 118 × 175 (4⅝ × 7⅜)
Preliminary sketches: TB CCXLIX f.27
Engr: By Robert Brandard, 1832 (R 434; Appendix C, no.5)
EXH: Paris 1981–2 (51, p.234, as 'Beaugency, *c.*1830', repr. in col. p.235 fig.441); Tours 1988, repr. p.39
LIT: Cooper Notebooks, pp.9, 10, 14; John James Ruskin Account Book (Lancaster), 1858, 'Feb 17 Drawings £1050'; Thornbury 1862, I, pp.239, 241, and II, p.396, as one of 'Seventeen Drawings of the Loire series (Rivers of France)' (reprinted in *Works*, XIII, p.557); Ruskin's list of his 1861 gift to Oxford, no.28; Revised 1861 list, no.13 (Ruskin, *Works*, XIII, p.559); Armstrong 1902, p.241, as 'Beaugency, circa 1831–2'; Cook and Wedderburn 1904 (*Works*, XIII, p.598); Herrmann 1968, p.78, no.47, repr. pl.XXXII;

Wilton 1979, p.409, no.932, repr.; Lévêque-Mingam 1996, p.96 fig.75 (col.)
Prov: See cat.107
Collection: The Visitors of the Ashmolean Museum, Oxford

NOT EXHIBITED
Orléans *c*.1828–30 (fig.149)
Watercolour and gouache, with red and black pen work, on blue paper 136 × 189 (5⅜ × 7⅜)
Preliminary sketches: TB CCXLIX f.34
Engr: By Thomas Higham, 1832 (R 433; Appendix C, no.4 and see p.197)
EXH: Paris 1981–2 (48, p.234, as 'Orléans, *c*.1830', repr. in col. p.236 fig.442)
LIT: Cooper Notebooks, pp.9, 10, 14; John James Ruskin Account Book (Lancaster), 1858, 'Feb 17 Drawings £1050'; Thornbury 1862, I, p.239, and II, p.396 as one of 'Seventeen Drawings of the Loire series (Rivers of France)' (reprinted in *Works*, XIII, p.557); Ruskin's list of his 1861 gift to Oxford, no.33; Revised 1861 list, no.12 (Ruskin, *Works*, XIII, p.559); Armstrong 1902, p.269, as 'Orleans. circa 1830'; Cook and Wedderburn 1904 (*Works*, XIII, p.603); Herrmann 1968, p.78, no.48, repr. pl.XLVII, B; Wilton 1979, p.409, no. 931, repr.; Lévêque-Mingam 1996, pp.102–3, repr. in col. with three details fig.80
Prov: See cat.107
Collection: The Visitors of the Ashmolean Museum, Oxford

Engravings from *Turner's Annual Tour, 1833*, and Other Reproductions of Turner's Published Loire Subjects

120 ***Turner's Annual Tour, 1833 / Wanderings by the Loire* by Leitch Ritchie**
Open at frontispiece: *Nantes*, engraved on steel by William Miller (R 432; Appendix C, no.3)
Published by Longman, Rees, Orme, Brown, Green, and Longman, Paternoster Row, London
Collection: Tate Gallery Library

THOMAS HIGHAM AFTER J.M.W. TURNER
121 Orléans 1832
Line engraving on steel 98 × 143 (3⅞ × 5⅝) on India paper laid on wove paper 304 × 436 (11¹⁵⁄₁₆ × 17³⁄₁₆) (Turner studio sale blind stamp)
R 433, first published state; Appendix C, no.4
T04679

ROBERT BRANDARD AFTER J.M.W. TURNER
122 Beaugency 1832
Line engraving on steel 92 × 138 (3⅝ × 5⁷⁄₁₆) on India paper laid on wove paper 303 × 437 (11¹⁵⁄₁₆ × 17³⁄₁₆)
R 434, first published state; Appendix C, no.5
T04680

ROBERT BRANDARD AFTER J.M.W. TURNER
123 Blois 1832
Line engraving on steel 94 × 137 (3¹¹⁄₁₆ × 5⁷⁄₁₆) on India paper laid on wove paper 223 × 305 (8¾ × 12)
R 435, engraver's proof (ab), touched by Turner; Appendix C, no.6
Yale Center for British Art, Paul Mellon Collection (B.1977.14.7472)

ROBERT WALLIS AFTER J.M.W. TURNER
124 Palace at Blois 1832
Line engraving on steel 97 × 142 (3¹³⁄₁₆ × 5⁷⁄₁₆) on India paper laid on wove paper 299 × 435 (11¾ × 17⅛) (Turner studio sale blind stamp)
R 436, first published state; Appendix C, no.7
T04682

JAMES BAYLIS ALLEN AFTER J.M.W. TURNER
125 (Château of) Amboise 1832
Line engraving on steel 94 × 144 (3¹¹⁄₁₆ × 5¹¹⁄₁₆) on India paper laid on wove paper 222 × 306 (8¾ × 12)
R 438, engraver's proof (a), touched by Turner; Appendix C, no.8
Yale Center for British Art, Paul Mellon Collection (B.1977.14.7483; mounted with the published state of the same image, B.1975.6.108)

THOMAS JEAVONS AFTER J.M.W. TURNER
126 The Canal of the Loire and the Cher 1832
Line engraving on steel 96 × 140 (3¾ × 5½) on India paper laid on wove paper 302 × 437 (11⅞ × 17³⁄₁₆) (Turner studio sale blind stamp)
R 439, first published state; Appendix C, no.10
T04685

ROBERT BRANDARD AFTER J.M.W. TURNER
127 Tours 1832
Line engraving on steel 94 × 137 (3¹¹⁄₁₆ × 5⅜) on India paper laid on wove paper 189 × 270 (7½ × 10⅝)
R 440, engraver's proof (?a/b), touched by Turner; Appendix C, no.11
Yale Center for British Art, Paul Mellon Collection (B.1977.14.7493)

WILLIAM RADCLYFFE AFTER J.M.W. TURNER
128 St Julian's, Tours 1832
Line engraving on steel 97 × 145 (3¾ × 5¹¹⁄₁₆) on India paper laid on wove paper 302 × 433 (11⅞ × 17)
R 441, engraver's proof (c), touched by Turner; Appendix C, no.12
Yale Center for British Art, Paul Mellon Collection (B.1977.14.7500)

ROBERT BRANDARD AFTER J.M.W. TURNER
129 Rietz, near Saumur 1832
Line engraving on steel 89 × 137 (3½ × 5⅜)

on India paper laid on wove paper 301 × 435 (11⅞ × 17⅛)
R 444, first published state; Appendix C, no.15
T04690

JAMES TIBBETTS WILLMORE AFTER J.M.W. TURNER
130 Clairmont 1832
Line engraving on steel 98 × 136 (3⅞ × 5½) on India paper laid on wove paper 300 × 439 (11¹³⁄₁₆ × 17¼)
R 450, first published state; Appendix C, no.21
T04695

FREDERICK CHRISTIAN LEWIS AFTER J.M.W. TURNER
131 Tours, Looking Backwards ?1830–32
Aquatint 130 × 189 (5⅛ × 7⁷⁄₁₆) on wove paper 299 × 451 (11¹⁵⁄₁₆ × 17¾)
R 831, engraver's proof; Appendix C, no.24
T05198

JOHN RUSKIN AND THOMAS LUPTON AFTER J.M.W. TURNER
132 Château de Blois (fig.190)
Etching and mezzotint 129 × 180 (5¹⁄₁₆ × 7¹⁄₁₆) on India paper laid on wove paper 204 × 286 (8 × 11¼) trimmed mainly within plate-mark
LIT: Published in the 1888 edition of *Modern Painters* (see Ruskin, *Works*, VII, opp. p.203); see here p.202 note 49.
T05199

ALEXANDER MACDONALD, AFTER J.M.W. TURNER
133 Château of Amboise *c*.1880–82 (fig.191)
Watercolour 130 × 180 (5⅛ × 7¹⁄₁₆)
Frame 57 of the set of framed copies after Turner from a cabinet given to Whitelands College by Ruskin. This work was a substitute for William Ward's copy of the 'Golden Avenue', i.e. *The Avenue, Farnley*, Bolton Art Gallery, W 600.
LIT: Ruskin (*Works*, XXX, p.354, n.8)
Collection: Whitelands College, Roehampton Institute, London

Turner's Loire Sketchbooks

As there is insufficient space to transcribe details of all the sketchbooks Turner used on his 1826 tour, only those with Loire subjects have been listed here. It is hoped that the contents of the other sketchbooks will be published at a future date; meanwhile my notes will be available for consultation in the Tate Gallery Study Room.

TB CCXLVII: *Morlaise to Nantes* **sketchbook 1826 (cat.11)**
168 × 98 (6⅝ × 3⅞)
Made up of French laid paper
The covers have now become detached from the sketchbook itself, but are still part of the Turner Bequest. They were made from skin, rather like that used on the books of the Italian tour of 1828. Turner's title for the book, inscribed in ink, appears on the front cover: 'Morlaise to Nantes'. National Gallery Schedule, 21 June 1854, No.400: 'Book containing 66 leaves of pencil sketches'. Inside the front cover Turner's executors have inscribed the following in ink: 'No.400 / Contains 66 Leaves / Pencil Sketches – / [Signed] H.S. Trimmer / C. Turner [and in pencil] C.L. E[astlake]. and JPK[night]'. Ruskin's endorsement on a wrapper was noted by Finberg: '400. Nearly valueless, but of late time, and having some bits of mountain interest'.
A loose leaf inside the covers, inscribed on verso, in pencil 'CCXLVII / Back Cover'. This sheet is covered with a series of views made in pencil. They have been annotated by Turner with what appears to say 'Cerverau', and other illegible words.

1 Morlaix; the Quai des Lances, looking south-east with the tower of St-Melaine above
Inscr. 'Morlaise'
LIT: Delouche 1977, p.60, repr.; Paris 1981, p.200, fig.348, as 'Row of Houses'

1v. Morlaix; part of the Quai des Lances

2 Morlaix; the port, with large vessels, and the distant tower of St-Melaine
LIT: Paris 1981, p.200, fig.347, as 'Harbour'

2v. Morlaix, from the river (a more distant view than f.2) [fig.19]

3 Morlaix; the Cigar Factory

3v. Outlines of a river scene, perhaps at Morlaix

4 View down the river near Morlaix, perhaps close to Locqénolé

4v. The Bay of Morlaix from near Locqénolé, with the Penn-al-Lann peninsula, the Ile Louêt and the Château de Taureau

5 Four sketches (from the top): [fig.20]
(a) another view over the Bay of Morlaix (see f.4v)
(b) the Phare de la Lande, with Carantec in the distance; inscr. 'Sail W B'
(c) a view looking up the Morlaix river, with Dourduff on the left
(d) [page turned ninety degrees] View of river near Morlaix; inscr. 'Black the River'

5v. The Carantec peninsula from the south-west

6 Three sketches:
(a) the Phare de la Lande from offshore
(b) islands in the Bay of Morlaix
(c) a headland

7 View of the Morlaix river with a church tower in the foreground

7v. View on the Morlaix river, looking north

8 Four sketches on the river near Morlaix:
(a) boats in front of houses
(b) a stretch of river
(c) a bend in the river; inscr. 'Red Sail the most colour / W'
(d) outlines of river banks
LIT: Paris 1981, p.201, fig.350, as 'River scenes'

8v. The estuary of the river near Morlaix
Inscr. 'Passage'

9 Four sketches on the river near Morlaix:
(a) building with steps; inscr. above 'Moon'
(b) a bend of the river where St-François-de-Cuburien can just be glimpsed; inscr. 'Francois'
(c) a closer view of St-François-de-Cuburien
(d) a bend in the river leading to a building; inscr. 'Gull'
LIT: Paris 1981, p.201, fig.351, as 'Four river

scenes'; Everyman Guide to Brittany, 1994, pp.116–17, repr. detail

9v. Three sketches:
(a) a bend in the river, with trees
(b) Maison de retraite, St-François-de-Cuburien
(c) a bend in the river, with the distant forms of Morlaix
LIT: Paris 1981, p.201, fig.352, as 'Three river scenes, one of a church'

10 Continuation of middle sketch on f.9v

10v. Morlaix from the port
Inscr. 'Brassin'
LIT: Paris 1981, p.202, fig.359, as 'Town with harbour and shipping'

11 Three sketches at Morlaix:
(a) the towers of the churches of St Matthew and of St-Melaine; inscribed so that that of St-Melaine relates to the note 'St Matthew / old…', whilst that of St-Melaine has a note above it reading 'St Martin / Body new'
(b) [upside down] interior of a church; inscr. 'Mor'
(c) [upside down] detail of gothic architecture; inscr. illegibly

12 Two peasants on a road, with the tower of a church in the distance, perhaps near St-Thégonnec

12v. Landerneau: the Pont de Rohan from the south side of the River Elorn, looking east, with the church of St-Thomas on the right (bell-tower reconstructed in 1847–9)
Inscr. 'fragments'
LIT: Paris 1981, p.201, fig.353, as 'L'Elorn à Landerneau (?)'

13 Landerneau: the church of St-Houardon, from the south side of the Elorn (the church was rebuilt further east by Bigot in 1858–61)

13v. Landerneau: looking east up the River Elorn, with the church of St-Houardon on the left, and the church of St-Thomas on the right [fig.21]
Inscr. 'Landerneau'
LIT: Paris 1981, p.201, fig.354

14 Brest: the church of St-Louis [fig.23]
LIT: Paris 1981, p.202, fig.355, as 'Church'

14v. Three sketches at Brest:
(a) the Rade de Brest
(b) military buildings, including the Bagne
(c) the Tour Tanguy

15 Blank

15v. Quick sketch of a two-masted boat

16 Brest: the château (two sketches)

16v. Brest: the château from the quayside, with the masting device [fig.22]. This view, and f.16, served as the basis for an oil painting, see cat.99, fig.173
Inscr. 'Folies / CL' (on hull of ship)

17 Brest; view of the port, with the arsenal on the right
Inscr. 'Glow 4'

18 Blank

18v. Three sketches:
(a) possibly a view over the Rade de Brest towards the Menez Hom
(b) sketch of the coast near Brest
(c) a line of coast with a building, perhaps at Le Conquet

19 The Pointe de St-Mathieu, with the ruins of the abbey of St-Mathieu

19v. View at Le Conquet

20 View from Le Conquet towards the island of Ushant (Ouessant)
Inscr. 'Raz + du 7 / Ushant / Ush'
LIT: Paris 1981, p.202, fig.356, as 'Ile de Batz'

20v. Two coast scenes with a church tower, perhaps at Le Conquet

21 Coast scene, looking across to Ushant

21v. Three sketches of distant coasts
Inscr. 'G [in top sketch] / Sea and Gul [bottom sketch]'
[Two pages have been torn out of the book at this point, leaving only part of the margin edge.

These are perhaps the same stubs referred to by Finberg, who placed them between ff.20v and 21, and noted 'Four leaves torn out'.]

22 Blank

22v./23 Quimper: the facade of the cathedral of St-Corentin [fig.24]

23v. Sketch of buildings at Quimper
Inscr. 'Bourse [?]' and 'Concarau… [?]'

24v. Quimper: the place in front of the cathedral
Inscr. 'Busine [?] / Concarneau / Entre… / Pour Lorient / Vannes Nantes / Rennes Paris / St Lauan… / Marlie Pont Royale / Dekeron… / … ./ Plorugu…'
LIT: Paris 1981, p.203 fig.361, as 'A Concarneau'

25 Quimper: figures at a market place, with the southern transept of the cathedral above
Inscr. 'Lichec Matte' under statue of the virgin and child
LIT: Wilkinson 1975, p.63, repr.; Paris 1981, p.203 fig.363, as 'Market Place, with figures'

25v. Sketches of figures and a building at Lorient (possibly the Magazin de l'Artillerie du Prohibe) See cat.45
Inscr. with notes on costumes, 'White or Blue / Black / Red'
LIT: Paris 1981, p.203 fig.368, as 'Britanny [*sic*] costumes'

26 Four views over the Rade de Lorient towards Port Louis
Inscr. 'Ex / Bat DE / Mados [?] / Ex Caus / STP'
LIT: Paris 1981, p.203 fig.362, as 'Views on coast'

26v. Port Louis

27 Port Louis
Inscr. 'Ex'

27v. Lorient; numerous views, including the lighthouse tower
Inscr. 'Lord Mayor's Barge / Plus / 15'
LIT: Paris 1981, p.203, fig.364, as 'Harbour'

28 Four views across the Rade de Lorient to Port Louis

28v. La Roche-Bernard from further up the River Vilaine

29 La Roche-Bernard, from the west

29v. Vannes: the Chapelle St-Yves [fig.27]
Inscr. 'Vannes / a Hotel Croix Verte Bureau de… / Chez Carli…'
LIT: Paris 1981, p.204 fig.369, as 'Hôtel de Ville "Vannes"'

30 Blank

31 Nantes: Quai de la Fosse, looking east
LIT: Paris 1981, p.203 fig.365, as 'Houses on quay'

31v. Nantes: a distant view of the Pont Pirmil
Inscr. 'Tranton'. See cat.62
LIT: Paris 1981, p.204 fig.366, as 'Bridge, with shipping'

32 Three views at Nantes:
(a) the Salorges looking east
(b) the Salorges looking east
(c) from the Salorges, looking west, inscr. 'sand'
LIT: Paris 1981, p.204 fig.367, as 'A harbour'

33 Nantes: the Pont Pirmil from the south-west (see Nantes 1978, pl.LI, no.96)
LIT: Paris 1981, p.205 fig.370, as 'Stone bridge'

33v. Nantes: sketches of the facades of the Bourse and the Théâtre Graslin
Inscr. 'Borse. 10 Co[lumns]'

34 Blank

34v. View across a valley towards a large religious building, with another tower to the right (?near Nantes)

35 Blank

36 Nantes: looking down from the hill above the Salorges

37 Blank

37v. Nantes: the Ile Feydeau from the east; also a detail of the château

38 Nantes: the château from the river [fig.31]

39–43 Blank

44 Nantes: the cathedral seen from the St-Similien quarter, with a bridge in the right foreground

45–7 Blank

47v. Two views over the Loire estuary
Inscr. 'Ev Loire'
LIT: Lévêque-Mingam 1996, repr. p.3 frontispiece (detail)

48 Nantes: looking towards the Théâtre Graslin from the Rue de Breda Gresset (the basis for cat.56); a second subsidiary sketch (at ninety degrees to the first) shows a group of clouds above the sea, with sailboats
LIT: Paris 1981, p.205 fig.371, as 'A street'

48v. Nantes: the Quai de la Fosse, looking east to the Ile Feydeau. Related to the view depicted in cat.57
Inscr. 'Pillend / Gordon Dealer [?] / Red / Swan [on boat]'
LIT: Paris 1981, p.206 fig.373, as 'Shipping'

49 Blank

50 Nantes: the Pont du Pirmil from the northern approach. The basis for cat.61
Inscr. 'Green / Ground with / Blanks'
LIT: Wilkinson 1975, p.63, repr.; Paris 1981, p.205 fig.372, as 'Bridge leading to town'

51 Blank

51v. Nantes: quick sketch showing the church of St-Similien
Inscr. 'St Similien'

52 Blank

52v. Slight sketches, perhaps at Nantes

53 An architectural detail, perhaps at Quimper or Nantes

53v. Quimper: the Bishop's Palace on the right, with the cathedral of St-Corentin beyond at the end of the Rue St-Catherine

54 Quimper: architectural details of a half-timbered house, and a fragment showing one of the porches of the cathedral of St-Corentin

55 Blank

55v. Nantes: the Bourse and the Ile Feydeau. Above this a second sketch extends this panorama, showing the Ile Feydeau, with the Bains Publics, and the quays of the Ile Gloriette beyond [fig.45]
LIT: Paris 1981 p.206 fig.374

56 Blank

56v. Nantes: the château from the north-west, with the Loire beyond to the left. Compare this view with the painting by Jean-Baptiste Lecoeur (*Le Cours Saint-Pierre et le Château de Nantes*, 1831, Musée du Château des ducs de Bretagne, Nantes)
Inscr. 'Nantes'

57 Nantes: the château from the river, with the cathedral behind, and the Ile Feydeau to the west

58 Blank

58v. Nantes: the eastern end of the Ile Feydeau, with the Bras de Bourse, and the Tour Bouffay on the right
Inscr. 'Wood Fuels [?] / Bran [?] / Pol' (or 'Pos' on boat; the building above was the Poissonnerie) and 'Angels' (on tower)
LIT: Paris 1981, p.206 fig.375, as 'Shipping'

59 Nantes: the château from the river, with the towers of the cathedral; a subsidiary sketch also shows the château walls
LIT: Paris 1981, p.207 fig.378; Lévêque-Mingam 1996, p.36 fig.17 (detail)

60 Blank

60v. Nantes: looking along the Quai de la Fosse to the cathedral; a smaller subsidiary sketch probably shows the view westwards. See cat.60
LIT: Paris 1981, p.200 fig.349, as 'River at Nantes'

61 Nantes: the Quai de la Fosse, looking east
LIT: Paris 1981, p.206 fig.377

61v. Nantes: the château, with the cathedral beyond; a second sketch of boats. See cats.46 and 107
LIT: Paris 1981, p.208 fig.381, as 'Ancient towers and church'

62 Nantes: the Pont de la Belle Croix [fig.52]
Inscr. 'a Merdur [?] / for Bees [?]'
LIT: Paris 1981, p.206 fig.376; Lévêque-Mingam 1996, p.36 fig.16 (detail)

62v. Nantes: looking east; thumbnail sketch of the towers of the cathedral from the south (before transept rebuilt); disc of the sun on right suggests this view was recorded in the early morning, soon after sunrise. There is a chimney emitting a plume of smoke at the centre of the image which may be a steamer
LIT: Paris 1981, p.207 fig.379

63 A windmill and church tower, perhaps near Nantes

64 Blank

64v. Lorient: the lighthouse

65 Four views at Lorient

66 Blank

66v. Quimper: timbered houses, with the towers of St-Corentin
Inscr. 'Rue de Bouchery / C Ralf [?] of…'

67–8 Blank

68v. Nantes: the facade of the Théâtre Graslin, in

profile and head on; also a barge with its mast and rigging folded up [fig.44]
Inscr. '10 / Ionic Col.', also '8' (Turner is here distinguishing between the number of columns on the Bourse and those on the Théâtre; see f.33 verso). Beside the boat there is the following note, 'Mast and Rigging curld up under Mats'

69 Faint continuation of the sketch of the Place Graslin on f.68v

70–71 Blank

71v. View over a fortified port, perhaps at Quimper or Lorient
LIT: Paris 1981, p.202 fig.357, as 'Harbour', and p.210 as Quimper

71b Blank

71b verso Quimper from the river
Inscr. '3 / Port of Quim'

72 Quimper; the Bishop's Palace
Inscr. '8'

72v./73 Quimper; the Bishop's Palace beside the River Odet, with the towers of St-Corentin above
Inscr. '4' for arches of bridge
LIT: Paris 1981, p.203 fig.360 (f.73 only)

74–83 Blank

83v. Lorient from the south

84–5 Blank

85v. La Roche-Bernard from the south-west [fig.28]

86 Two sketches at La Roche-Bernard: a view down river; and a view up the village street beside the rocks, with a diligence
Inscr. 'Roch Bernard'
LIT: Paris 1981, p.207 fig.380, and p.204

86v. A financial calculation and the following inscription: 'Nantes = 1 / 2 October'
The sum is as follows: 8 –
$$L \quad 4 \text{ [written on top of the 3]}$$
$$\begin{array}{r} 2 \quad 3 \\ 1 \quad 1 \\ \hline 8 \quad 10 \end{array}$$

87 Lorient [fig.26]
Inscr. 'open / Gal / Quay'
LIT: Paris 1981, p.202 fig.358, as 'Town with tower'

87v./88 Sketches across both pages in two horizontal bands: a hasty outline of a figure in a cloak

Inscr. 'P Evng on W of / all White Gamb wants / § 5 3 and 3 / Grand Causeway

88v. A view with a church, the tower of which could have one or two spires; also two female figures
Inscr. 'Green'

TB CCXLVIII: *Nantes, Angers, Saumur* sketchbook 1826 (cat.12)
168 × 108 (6⅝ × 4¼)
Made up of French laid paper, with evidence of a Lacroix watermark
Marbled covers, inscribed in ink by Turner, 'Nantes / Angers / Saumur'
National Gallery Schedule, 21 June 1854, No. 355: 'Book containing 48 leaves of pencil sketches, very slight, many leaves used on both sides'. The following note by Turner's executors appears inside the front cover: '355 / 48 leaves of pencil sketches / H.S. Trimmer / [and in pencil] C.L.E. / JPK'. The blue page numbers were added to each sheet by Ruskin, who went through the book in reverse order. Although there are forty-eight pages, Ruskin's pagination only runs as far as p.46, because he added two 'B' numbers (1–5B [f.43], 6–41B [f.6], 42–6).

1 Nantes: faint outline sketch of the Théâtre Graslin from the north-west corner of the Place Graslin. See cat.55
Inscr. '3 Dor[ic]'

1v. Thumbnail sketch of steps rising to a temple or some other building with a dome
Inscr. 'Horse & 4 Co...' referring to the heavily laden animal in the sketch

2 Loire barge under sail; faint outline of château of Saumur

2v. Nantes: details of the steps and columns of the Théâtre Graslin
Inscr. '12 Steps'

3 Nantes: the Ile Feydeau from the east

3v. Nantes: outline sketch of the Théâtre Graslin (or perhaps the Bourse); with a subsidiary sketch of the cathedral
Inscr. 'Salon / Robert Bor...che [?]'

4 Nantes: several sketches of parts of the château walls, seen from the river

4v. Three sketches of Loire boats

5 Nantes: the walls of the château

5v. A Loire Steamer: the *Louis Guibert* [fig.53]
Inscr. 'Louis Gaibur' (partly illegible at edge of page; but probably intended to read 'Guibert', for whom, see p.65)

6 Nantes: four levels of quick sketches of the cathedral and château

6v. Nantes: quick outline of the cathedral towers

7 Five views from the river near Nantes:
a) the château and cathedral
[the sheet was turned the other way for the following four sketches]
b) looking upriver to the east; inscr. 'Sun rise'
c) view back towards Nantes, with the towers of the cathedral; inscr. '10' for arches of the Madeleine bridge, and 'Curious effect of... [?] crimson / on the Ca[thedral]'. See cat.63
d) another, more distant view back towards Nantes
e) ?outline of a boat

7v. Three sketches on the river near Nantes:
a) view of Nantes, from the cathedral on the right across to the Pont de la Madeleine; inscr. '10' over bridge, and 'Red Hs' over the Prairie de la Madeleine
[the book was turned the other way for the other two sketches]
b) the Pont Pirmil, with the Hôpital St-Jacques
c) general view of Nantes from the east

8 Three sketches on the river at Nantes:
a) panorama from the cathedral towers on right to the Hôpital St-Jacques on left. See cat.63. As on f.7v, the following details have been noted: '10 arches' and 'Red H'
[the book was rotated to make the following sketches]
b) faint sketch of boats on the river, with Nantes beyond
c) sketch of Loire barges

8v. Seven sketches on the river near Nantes:
a) Ruined building with a boat, inscr. 'Sheep fog. the... sun vapour / House standing like a tower white [?]'
b) sketch of Loire barges under sail
c) distant view of Nantes; inscr. 'Ca[thedral] above the Fog'
d) quick sketch of a boat, perhaps a steamer; inscr. 'Red top'
[remaining sketches upside down]
e) view on the river; inscr. 'S.Courots'
f) view on the river

9 Four sketches near the Coteaux de Mauves (see cat.109):
a) the Coteaux de Mauves
b) Mauves, with the Coteaux de Mauves beyond

[the page was turned over for the remaining sketches]
c) view upriver towards the east, beyond the Coteaux de Mauves
d) the left bank near the Coteaux de Mauves

9v./10 Thirteen sketches of the Coteaux de Mauves, sketched across both pages. The Château de Clermont appears distantly in those looking along the coteaux to the east [fig.59]. See cats.65, 109–111
Inscr. 'Mauves / Sand Bank'

10v. Three sketches of the Château de Clermont, from below to the west [fig.64]. See cat.112
Inscr. 'Clearmont / Clermont'

11 Nine sketches of the coteaux between the Château de Clermont and the Folies-Siffait, close to Oudon. See cats.66, 100
Inscr. 'Sand / Clermont / Fo [for *Folies*]'
LIT: Paris 1981, p.213 fig.391, as 'Several views of Château de Clairmont'

11v. Four sketches [fig.66] (see cats.67, 100):
a) distant view of the Folies-Siffait, from the east
b) the tower at Oudon, from the west
[page turned upside down for the following sketches]
c) the Folies-Siffait from the east
d) a more distant view of the Folies-Siffait from the east, with the Château de Clermont beyond; inscr. 'C' above

12 Three sketches [fig.66]:
a) a distant view of the Château de Clermont from the east. See cat.67
b) the Folies-Siffait from the west; with a subsidiary sketch of a detail. See cat.66
c) the Folies-Siffait from below to the east; inscr. above 'Folls' and, to the left of the form meant to suggest Clermont, Turner has also inscribed the letter 'C' on the facing page.

12v. Six sketches:
a) small slight sketch of left bank of the river
b) the Folies-Siffait (and the Château de Clermont) from the east. See cat.67
c) the tower at Oudon, with windmills seen beyond; inscr. 'Do' (above Oudon in the sketch below)
d) another sketch of Oudon; inscr. 'Oudon' [upside down]
e) (at left) continuation of the sketch on f.13, showing the view downriver
f) the tower at Oudon. See cat.68.
LIT: Paris 1981, p.213 fig.389; Lévêque-Mingam 1996, p.47 fig.29 (detail)

13 Five sketches:
a) Champtoceaux from the west
b) distant view of the Folies-Siffait and the Château de Clermont from the east; inscr. above 'Folls'
c) the tower at Oudon, with the windmills behind the village
d) Champtoceaux from the river, with the *péage* in the foreground, directly below the château [upside down]
e) view downriver from near Champtoceaux, with distant 'Chatx' on the left bank of the Loire [continued across onto f.12v]
LIT: Paris 1981, p.213 fig.390, as 'Château Hamelin'; Lévêque-Mingam 1996, pp.8–9 figs.3 (details)

13v. Three sketches from below Champtoceaux near the ruined *péage*. See cat.69; [upside down] two sketches of the view downriver

14 Six sketches:
a) Champtoceaux, the ruined *péage* from the east, looking back to the Folies-Siffait. See cat.70 verso. Inscr. 'Folies'
b) slight sketch of Champtoceaux; inscr. '2' and '3'
c) Champtoceaux from below to the east. See cat.113. [upside down]
d) the right bank of the river near Champtoceaux, with the Coteau de Pierre Meslière
e) distant view of Champtoceaux from the east; inscr. 'Drain'
f) distant view of Ancenis from the west, inscribed 'Ancenis from W'

14v. Two views of Champtoceaux, looking west, the first of which also includes the tower at Oudon. Also a subsidiary sketch of the river bank above. See cat.113

15 Six sketches:
a) the hillside near St-Géréon
b) boats in front of the hillside at St-Géréon; inscr. 'St Gerran'
c) windmills near St-Géréon [upside down]
d) distant view of Ancenis from the west; inscr. 'Ancenis'
e) another more distant view of Ancenis
f) detail of buildings at Ancenis

15v. Four sketches at Ancenis [the book has been turned upside down to make the last] [fig.73]
Inscr. 'Landing Place' (in third sketch) and 'Ancenis'
LIT: Paris 1981, p.213 fig.392

16 Seven sketches near Ancenis [fig.73]:
a) Ancenis from the east
b) a distant view of Ancenis from the east
c) the Château de Juigné from the west [upside down]
d) slight sketch of a tower, possibly the Château de Juigné
e) the Château de Juigné, from the west, with Loire barges under sail
f) the Château de Juigné from the east
g) a small, distant view of St-Florent-le-Vieil, with Loire barges
LIT: Paris 1981, p.213 fig.393

16v. Six sketches of the distant outline of St-Florent-le-Vieil, with a great number of Loire barges
Inscr. 'The First Boat guides the rest.and / the rudder of the last over… [?] / Florin / Florent'

17 Four sketches:
a) a distant view of St-Florent-le-Vieil
b) a Loire barge in profile
c) two Loire barges under sail [parallel with the centre margin (or gutter) of the sketchbook]
d) a distant view of Ingrandes. See cat.73
LIT: Paris 1981, p.212 fig.388, as 'View of town, also boats sailing'

17v. Various sketches [clockwise from the figure] [fig.74]
a) a woman wearing local costume; inscr. 'Gr' for her bodice
b) faint study of ?a boat
c) three sketches of a steamer, possibly the *Maine*, (from left to right) retreating, advancing, and in profile
d) two Loire barges; inscr. 'Cargo covered with Mats and Cloths'
LIT: Paris 1981, p.210 fig.383, detail fig.385; J.Egerton, *Turner, The Fighting Temeraire*, 1995, p.144, as 'circa 1826–30' (detail); Lévêque-Mingam 1996, pp.16, 18, 19, all fig.7 (details)

18 Six views at St Florent-le-Vieil, mostly from the west, including a detail of the cupola of the abbey church [four of the six views are upside down] [fig.74]. See cats.71 and 114
LIT: Paris 1981, p.214 fig.394; Lévêque-Mingam 1996, p.48 fig.31 (detail)

19 Four views of St-Florent-le-Vieil, charting Turner's progress past the town to the east (see cat.71); also (fourth sketch from the top of the page) a view of the Château de la Madelaine at Varades. See cat.72
Inscr. 'C Voral [?]'

19v. Sketches of Loire barges under sail

20 Eleven distant views of Ingrandes and Montjean-sur-Loire [the page turned upside down for the lowest two]. See cats.74 and 115
Inscr. 'Ingrande / Montjen / Dry black in the Sand / [and upside down] 2a. 40 / from Sarr [?]'
LIT: Paris 1981, p.214 fig.395; Gage 1987, p.70 fig.94 (misidentified as a leaf of TB CCXLVII); Lévêque-Mingam 1996, p.29 fig.11 (detail), and p.52 fig.35

20v. Five views at Montjean-sur-Loire, from the east [fig.79]
Inscr. 'Mont Jeane / Sand B'

21 Six sketches at Montjean-sur-Loire from the west and north; in the top sketch the sun or, less probably, the moon can be seen above the group of buildings [fig.79]. See cats.75 and 115
Inscr. '10, 5, 4'

21v. Four sketches at Montjean-sur-Loire, from the east. See cat.75
LIT: Lévêque-Mingam 1996, p.53 fig.35

22 Sketches of Loire barges

22v. Four studies of Loire barges under full sail, with distant views of Montjean-sur-Loire from the east [fig.55]
Inscr. 'Mt Jean / Ex light [?] S and Rt'
LIT: Paris 1981, p.212 fig.386

23 Sketches of a convoy of Loire barges [fig.55]
Inscr. 'Old Van'
LIT: Paris 1981, p.212 fig.387; Hervouet 1989, repr. p.18; Lévêque-Mingam 1996, p.85, fig.66, and p.138 (detail)

23v. Seven sketches on the Loire [fig.83]:
a) river side; inscr. 'S E of P'
b) Possonière from the river, with a windmill; inscr. 'Poffoniere'
c) Savennières; inscr. 'Savunnier'
d) closer view of Savennières. Possibly related to cat.77
[page turned upside down for remaining three sketches]
e–g) three sketches of rocks beside the Loire, with windmills above, probably La Pierre Bécherelle at Epire. See cat.76

24 Six sketches [fig.83]:
a) La Pierre Bécherelle at Epire; inscr. 'Sand'
b) distant view of ?Bouchemaine
c) town beside the river, with a tower. See cat.77
d) distant view of ?Bouchmaine
e–f) cliffs on the Loire below Angers

24v. Six views on the River Maine below Angers
a) Cliffs near the mouth of the Maine (not Coteaux de Mauves, as listed elsewhere)
b) the village of la Pointe; inscr. 'Point [?]'
c) distant view upriver towards Angers
d) cliffs on the right bank of the Maine; inscr. 'Merron [? or Maine]'
e) Angers, seen beyond cliffs on the right bank of the Maine; inscr. 'Angers'
f) Angers from the south-west
LIT: Paris 1981, p.214 fig.396, as 'Coteaux de Mauves'

25 Six views charting the approach to Angers [fig.86]:
a–b) the convent of La Baumette; inscr. 'Bayume'
c) the left bank at Angers; inscr. above the cathedral of St-Maurice 'St Mer'
d) the Manufacture de toiles peintes, with Angers beyond
e) the Doutre at Angers from the south
f) the château and spires of Angers

25v./26 Slight sketch of the walls of Angers (partly continued on f.26)

26v. Angers: the Tour St-Aubin, with a continuation of the sketch on f.27 [fig.87]

27 Angers: the west front of the cathedral of St-Maurice. Part of the Bishop's Palace is continued onto f.26v [fig.87]
Inscr. 'Parvis / St Maurice / 4 figures on col and 7 Small'

27v. Angers: the tower of the church of La Trinité in the Doutre

28 Angers: detail of the Tour de Guillou and Basse Chaine from the left bank; the main sketch showing the view upriver towards the tower of the church of La Trinité

28v. Angers: the Hotel du Roi de Pologne from the south, with the Basse Chaine beyond
LIT: Paris 1981, p.220 fig.402

29 Angers: boats near the quayside, with the towers of Doutre on the opposite bank
LIT: Paris 1981, p.219 fig.401, as 'Town, with shipping'; Hervouet 1989, repr.

29v. Angers: the château and *cité* from downstream on the left bank, with a detail of the tower of La Trinité
LIT: Paris 1981, p.220 fig.403

30 Angers: panorama of the city from down river, continuing to the left of the view recorded on f.29 verso. Top sketch, from right, château across to right bank of the Maine; middle sketch, from

right, the Basse Chaine and the tower of La Trinité up to the ramparts; lower sketch, slight memorandum of a building close to the Basse Chaine
Inscr. 'Inner Wall' over sketch of the Doutre area
LIT: Paris 1981, p.220 fig.405; Lévêque-Mingam 1996, pp.58–9 figs.40 (details)

30v. Angers: the river front of the château from the north-west; a subsidiary sketch of the view downstream from the Doutre [fig.88]. Possibly used as the basis for an etching in *Six Weeks on the Loire* by Elizabeth Strutt (1833; see fig.186)
Inscr. 'Cloth [?]'
LIT: Paris 1981, p.220 fig.404

31 Two sketches at Angers: upper sketch, the main bridge at Angers; lower (main) sketch, the Pont des Treilles from the left bank, with the tower and church of La Trinité [fig.89]
Inscr. above, 'Trinity'
LIT: Paris 1981, p.220 fig.406

31v. Angers: the left bank, with the spires of the cathedral, from the Doutre; a subsidiary sketch of part of the bridge
Inscr. '…from Walls [?]'
LIT: Paris 1981, p.220 fig.407

32v. Angers: La Tour de le Haute-Chaine, with the Tour St-Aubin and the cathedral on the opposite bank beyond
LIT: Paris 1981, p.221 fig.408, as 'View of town'

33 Angers: La Tour de la Haute-Chaine with the city beyond (faint outline)

33v. Angers: the Porte Lyonnaise through the ancient ramparts, with the cathedral above

34 Angers: the Porte St-Nicolas through the ancient ramparts, with the towers of the city above
Inscr. 'Port S Nicolo [?]'

34v. Three views at Angers [fig.96]:
a) the left bank, with the château and the cathedral spires. See cat.102
b) (bottom left) near the Porte St-Nicolas with the tower of La Trinité
c) (bottom right) the left bank with the Tour St-Aubin beyond

35v. Angers: from the Tour de Guillou and the Basse Chaine, looking across to the château on the left bank

36v. Angers: a view upriver, with the Tour de Guillou and the Basse Chaine, with La Trinité on the left, and the château on the right; also a sketch along the southern walls of the château,

with the roofs of houses to its right. The left-hand details are probably related to the gouache study of Angers in the Indianapolis Museum of Art (fig.94)

37 Three views near Saumur:
a) Saumur from the east, from the dome of Notre-Dame des Ardilliers to the Pont Cessart
b) Montsoreau and Candes St-Martin from the west; the basis of fig.107
c) an unintelligible sketch of a hillside town?
LIT: Lévêque-Mingam 1996, p.26 fig.9 (detail)

37v. Angers: the château from the right bank

38 Angers: the south-west corner of the château. Turner recorded much the same view on a sheet of blue paper (see cat.18).

38v. Angers: the Tour de Guillou and the Basse-Chaine, with the château beyond

39 Angers: the Place St-Croix, with the spires of the cathedral above
Inscr. 'Place St Croix / Ru / Cheb / Roiux'
LIT: Wilkinson 1975, p.63, repr.

39v. Angers: Maison d'Adam [fig.97]
Inscr. illegibly

40 Angers: hasty sketch of the Pont des Treilles from the north-east, with the tower of La Trinité beyond

40v. Two sketches at Angers:
a) (main sketch) the market place, with the twin towers of the cathedral
b) (side sketch) quick sketch of a church and bridge, perhaps at Angers

41v. A distant view of Saumur from the east, with a subsidiary sketch of the Château de Souzay [fig.101]

42 Sketches at Saumur, showing the view east towards Notre-Dame des Ardilliers, the Hôtel de Ville and the château [fig.101]
Inscr. 'Bains Public / 10 / 3'

42v. Saumur from Notre-Dames des Ardilliers
LIT: Paris 1981, p.218 fig.400, as 'The Castle, Saumur'; Lévêque-Mingam 1996, p.63 fig.44 (detail)

43 Saumur from the Ile d'Offard, with the Pont Cessart (see cat.116); a subsidiary sketch along the top edge of the sheet showing the other buildings on the left bank to the right of the main sketch, concluding with the church of St-Nicholas
Inscr. '12' under bridge
LIT: Lévêque-Mingam 1996, p.64 fig.42

43v. Saumur; the château and steeple of St-Pierre, from the Ile d'Offard [fig.102]
LIT: Lévêque-Mingam 1996, p.63 fig.43 (detail)

44 Saumur: a view from the east with Notre-Dame des Ardilliers in the mid-distance; two partial studies of architecture, one of which shows the château [fig.102]

44v. Four sketches near Saumur:
a) interior of a troglodyte dwelling [continued on to f.45]
[page turned ninety degrees for remaining three sketches]
b) buildings on the cliffs near Saumur
c) troglodyte dwellings near Saumur
d) distant view of Saumur from the east
LIT: Wilkinson 1975, p.63, repr.

45 Saumur: the château from below, with Papegault's Tower on the right; also continuation of top sketch on f.44v

45v. Four sketches near Saumur:
a) thumbnail sketch of view down the river, with a large building. Related to the left-hand part of the composition of fig.107
b) street scene at Candes St-Martin
c) cave interior
d) the château at Montsoreau or Souzay
LIT: Lévêque-Mingam 1996, p.66 fig.47

46 Inside of a troglodyte cave, near Saumur. See cat.83

46v. Three sketches of troglodyte dwellings at Souzay, near Saumur
Inscr. 'Sou' twice

47 Two sketches of windmills near Saumur, one of which is the Moulin de la Herpinière
LIT: Paris 1981, p.216 fig.398

47v. Parnay; the church, looking west towards Saumur; a smaller view, along the top of this sketch, also shows the view towards Saumur [fig.106]
Inscr. 'C Par'

48 Three sketches at Parnay:
a) the church from the west; inscr. 'Parrasol'
b) a view over the Loire Valley from near Parnay
Inscr. 'Card'
c) Parnay church from the east; inscr. 'Pourne'

48v. Four sketches between Parnay and Saumur:
a) the church at Parnay, from the west; inscr. 'Poussell [?] / Souze [?]'
b) cavern interior
c) windmill with cavern below
d) Saumur, the château

Inside back cover
Saumur: Papegault's Tower, with the château above on the right. See cat.82
Inscribed, in ink, 'Saumur'

TB CCXLIX: *Loire, Tours, Paris, Orléans sketchbook 1826 (cat.26)*
152 × 101 (6 × 4)
Made up of French laid paper with a watermark showing a bunch of grapes
Marbled covers, inscribed in ink by Turner: 'Loire / Tours / Orléans / Paris'
National Gallery Schedule, 21 June 1854, no.266, 'Book containing 44 leaves with pencil sketches, most of the leaves used on both sides'. The following note by the executors appears in ink inside the front cover: 'No 266 / 44 sketches in pencil / H.S. Trimmer [and in pencil] JPK' and 'C.L.E.'. Ruskin seems to have removed some of the pages, placing them in an envelope marked, '266. Inferior leaves' (these were identified by Finberg as ff.5, 13, 14, 25, 28, 33, 41, 44, plus another unnumbered sheet). All the sheets seem to have been tipped in, but, with the exception of two sheets (ff.45 and 46), the order is consistent with Ruskin's pen numbers in the top right-hand corner. Ruskin hoped to exhibit some of the sketches as part of the group that went to Oxford in 1879, selecting them to demonstrate the type of material from which Turner was able to develop his colour studies; but ultimately they were dropped from the selection. There are two types of additional number sequences within the book which relate to this process: one in pencil and the other in blue ink. The pencil numbers were added when Ruskin was working on the Oxford selection and are as follows: 128 [f.22], 129 [f.21], 130 [f.27], 131 [f.26], 132 [f.34], 133 [f.30], 134 [f.9], 135 [f.20]. The group of sheets annotated with ink numbers is much larger, and may relate to the earlier arrangements of the Bequest in the 1850s: 1385 [f.9], 1386 [f.20], 1387 [?f.34], 1388 [f.30], 1389 [f.21], 1390 [f.22], 1391 [f.26], 1392 [f.27], 1393 [f.19], 1394 [f.10], 1395 [the ink number on f.16 is now illegible, but it may have fallen here in Ruskin's sequence], 1396 [f.11], 1397 [f.6], 1398 [f.37], 1399 [f.7], 1400 [f.8].

1 Fragmentary sketches of the church of St-Laumer/St-Nicholas at Blois from the south and the west [upside down]
Inscr. 'Blois / Fog'

1v. Distant view of Tours, from the west; figures, possibly nuns from the nearby convent of the Soeurs de la Presentation

LIT: Paris 1981, p.225 fig.413; Lévêque-Mingam 1996, p.15 fig.6 (detail), and p.72 fig.6 (detail)

2 Buildings on the right bank of the Loire to the west of Tours, near St-Cyr
LIT: Paris 1981, p.228 fig.422, as 'Buildings on river bank'

2v. Distant view of Tours, from the heights of St-Cyr
Inscr. '6' under arches of the bridge

3 Sketches of boats
Inscr. 'Mast and C... cov with / Mats and Some of / Willow'
LIT: Paris 1981–2, p.226 fig.417

3v. Paris: Pont-au-Change, with the Palais de Justice, and the outline of the Louvre beyond
LIT: Paris 1981, p.256 fig.470

4 Distant view of Tours from the west close to a bridge, perhaps the Pont Mort (see f.4 verso); subsidiary sketch of troglodyte dwelling above

4v. Distant view of Tours from the west
Inscr. 'Pont Mort' and 'Loire'

5 Sketch of a Loire boat
Inscr. 'Gabor'

5v. View over the Loire to the west from St-Cyr

6 Tours, from St-Cyr
Inscr. '16 arches' by bridge
LIT: Lévêque-Mingam 1996, p.70 fig.50 (detail)

6v. The church of St-Cyr, with Tours in the distance; a subsidiary sketch of the towers of Tours [fig.110]
Inscr. 'loopins [?] / Saint Sear / St Cyr'

7 Tours, from St-Cyr, with the towers of the old cathedral of St-Martin above the Ile Simon

7v. Tours: (from left to right) the church of St-Julien, the Hôtel de Ville, the Tour Charlemagne and the Tour de l'Horloge
LIT: Paris 1981, p.226 fig.416

8 Two views of Tours from St-Cyr: (upper sketch) the church of St-Symphorien on the right bank and the Pont de Tours, inscr '15'; (lower sketch) Tours, with the Tour de Guise (on the left), the cathedral of St-Gatien, and the church of St-Julien, with the Pont de Tours outlined in front
LIT: Paris 1981–2, p.226 fig.416 bis, as 'Canal de la Loire au Cher'

8v. A distant view of Tours from above the rooftops of St-Cyr; and [upside down] Beaugency from the east on the road to Orléans, inscr. 'Boujancy'

9 Tours: the bridge from its northern approach. See cat.84.
LIT: Paris 1981, p.226 fig.414; Lévêque-Mingam 1996, p.71 fig.51

9v. Paris: the facade of Notre-Dame Cathedral
Inscr. 'N.Dame / Hotel Dieu'
LIT: Paris 1981, p.257 fig.471

10 Tours: the ruins of the bridge of Eudes, with the cathedral beyond, from St-Symphorien (see cat.86); a subsidiary sketch at the upper level shows the right bank at Tours, looking towards the eighteenth-century bridge
Inscr. 'Saint Symphorien'
LIT: Paris 1981, p.226 fig.415

10v. A distant view of Tours from the right bank near St-Symphorien, with the ruins of the Pont de Eudes and the Pont de Tours in the distance; also a subsidiary sketch of the right bank, with St-Symphorien
Inscr. 'Simphorien'

11 The Portail de la Crosse at the abbey of Marmoutier (see cat.87); slight sketch above of the right bank to the east of Tours
LIT: Lévêque-Mingam 1996, p.78 fig.60

11v. Three sketches:
a) quick sketch of the Château de Moncontour; inscr. 'Montcontour'
b) the church tower at Vouvray [upside down]
c) Blois: the view across the Pont Jacques-Gabriel to the Quartier Vienne

12 Four sketches:
a) ?Château de Moncontour
b) view across the river to a château; inscr. 'Porte Royale'
c) more distant view of château across river [upside down]
d) the river front at Blois

12v. Distant view of Tours from Marmoutier, with the spire of St-Symphorien on the right
Inscr. 'Marmotier / Constant... [?]'

13 Interior of the church of St-Julien, Tours: the chancel, with a diligence
LIT: Lévêque-Mingam 1996, p.75 fig.57 (detail of carriage)

13v. Interior of the church of St-Julien, Tours: the nave and transepts
LIT: Lévêque-Mingam 1996, p.75 fig.56

14 Faint outline sketch of the interior of St-Julien, Tours

14v. Interior of the church of St-Julien, Tours, with a carriage
LIT: Paris 1981, p.227 fig.419

45 Interior of the church of St-Julien, Tours
Inscr. 'Stalls' [? or 'Stables']

45v. The church of St-Julien, Tours; the entrance to the church with a diligence [fig.116]. Compare with fig.115
Inscr. '...[?] Royal ou Moly [?]'
LIT: Lévêque-Mingam 1996, p.75 fig.55

15 Several sketches of the lantern at Roche-Corbon

15v. Several sketches of the lantern at Roche-Corbon [fig.122]. See cat.88
Inscr. 'Loire / ROCH CO...' (the rest unintelligible)

16 Five sketches of the banks of the Loire near Mont-Louis and Chouzy [fig.122]
Inscr. 'Cheval Blanc / Chouzy H'

16v. Amboise; main sketch of the château from the Ile d'Or (perhaps the basis for cat.89 and fig.126); subsidiary sketches of the repaired bridge (bottom) and of the bridge over the northern branch of the river (top); also detail of a house, with a dormer window
LIT: Paris 1981, p.228 fig.423; Lévêque-Mingam 1996, p.83 fig.64

17 Five views of Amboise from the north bank
Inscr. 'Amboise' (four times) and 'Place Tronchee'

17v. Outline sketch of the Château de Chaumont, from the west; a woman carrying baskets; also an unintelligible outline
Inscr. 'Chomont /' and '[?...] with 2 [?]'

18 Blois; the Pont Jacques-Gabriel, from the Quartier Vienne, with the cathedral beyond
LIT: Lévêque-Mingam 1996, p.94 fig.72

18v. Blois from the left bank, with the Pont Jacques-Gabriel and the cathedral; possibly seen in fog (see the squiggle to the right of cathedral spire)

19 Blois; the Pont Jacques-Gabriel, with the Prefecture; a subsidiary sketch of the apse of the cathedral and the Bishop's Palace. See fig.130
LIT: Paris 1981, p.228 fig.424; Lévêque-Mingam 1996, repr. p.93 fig.73

19v. Blois; the Pont Jacques-Gabriel; the obelisk at the centre of the bridge sketched separately [fig.131]. The basis for fig.130

Inscr. at top 'v. warm Pink Haze' and in the drawing 'Sun shine / on the Pont warm Pink / Glorious Effect of Sun Rise and Fog / warm tos' with the numbers '11' and '6' under the bridge (the latter under the central arch with the obelisk)

20 Blois; sketches of buildings on the right bank: the church of St-Laumer/St-Nicholas, the château and the cathedral
Inscr. 'Water green'
LIT: Lévêque-Mingam 1996, p.89 fig.69

20v. Blois; the Façade des Loges of the château; subsidiary sketch, bottom right, of the church of St-Vincent-de-Paul [fig.133]; the basis for fig.134
LIT: Paris 1981, p.228 fig.421

21 Blois; a view to the west along the Façade des Loges of the château; the basis for cat.90
LIT: Paris 1981, p.228 fig.425

21v. Blois; faint outline of the Gaston d'Orléans wing of the château

22 Blois; details of the balconies on the Façade des Loges of the château

22v. Blois; the church of St-Laumer/St-Nicholas and other buildings at Blois

23 Blois; general sketch of buildings near the cathedral
Inscr. with various numerals and 'Hotel Novedler / Cafe Moku / Cafe Gaillard / C... Lorne / a la File F... [?] / Cafe du Grandarc [?] / a la B... [?]'

23v. Two sketches at Blois:
a) the right bank of the Loire, with the Bishop's Palace and the cathedral above on the right and the Pont Jacques-Gabriel beyond
b) a view over the Loire to the east, with a windmill; inscr. 'High water [?]'
LIT: Paris 1981, p.230 fig.427; Lévêque-Mingam 1996, p.7 fig.2

24 Blank

24v. Seven sketches [fig.136], beginning from the bottom of the sheet:
a) the Château de Chaumont from the east; inscr. 'Chomomt'
b) the Château de Menars from the west, with the pagoda beyond
c) ?Château de Chambord; inscr. 'Chambor' (possibly another sketch of Menars)
d–e) two sketches of groups of *Mariniers* [upside down]
f) church tower beside a road or the river; inscr. 'Terrace ofV'

g) the church at Montlivault; inscr. 'Monlivois'
LIT: Paris 1981, p.227 fig.418; detail fig.412; Lévêque-Mingam 1996, p.11 fig.4 (detail), and p.25 fig.4 (details of figures)

25 Several sketches, chiefly of wagons and figures, but also including one of Beaugency (the study for cat.92); and a detail of the ?Tour St-Jacques in Paris
LIT: Paris 1981, p.230 fig.429; detail fig.411

25v. Sketches of buildings / walls, perhaps at Beaugency or Meung-sur-Loire
Inscr. 'Church / Cafe de Borse [?] / Hotel d Monselle… [?]'

26 Landscape with a road near Cléry-St-André; inscr. 'Cleri'

26v. Beaugency; two sketches of the same panoramic view (the top image joins up on its right edge with the left-hand side of that below). Used as the basis for cat.91.
LIT: Lévêque-Mingam 1996, p.99 fig.79 (detail)

27 Beaugency. The basis for the view engraved in *Turner's Annual Tour* (fig.138); inscr. 'Boujancy'
LIT: Paris 1981, p.230 fig.432; Lévêque-Mingam 1996, p.97 fig.76

27v. Several sketches: (from the top) towers at Beaugency; inscr. 'Boujacie-Gancis.;' walls of Beaugency; [page turned upside down for the other sketches] the Conciergerie, Paris; a road with a tower

28 Beaugency from the south, with the bridge stretching across the page; inscr. '12'; a second sketch of Notre-Dame, Paris, has been fitted into the space left for the sky in the main view [fig.140]
Inscr. 'Notre Dame'

28v. Four sketches [fig.141]:
a) ?the towers of Meung-sur-Loire; inscr. 'Meun [?]' and 'KAKY [?]'
b) towers of Meung-sur-Loire
c) the basilica of Cléry-St-André; inscr. 'Cleri'
d) ?the church and château at Meung-sur-Loire

46v. Blank [bound in here, though not numbered in the Ruskin sequence]

46 Blois; outlines of the buildings on the river front to the east of the Pont Jacques-Gabriel, with a more detailed study above of the cathedral and the Bishop's Palace [fig.132]. This detail may have contributed to the composition of fig.130

29 Distant views of the towers of Orléans; tower of the church of St-Paul in lowest sketch
Inscr. '9' over arches of the Pont Neuf

29v. Four sketches at Orléans; see cats.93 and 94:
a) the Pont Neuf, with the Quai Neuf on the right; inscr. '9' under the bridge
b) the right bank, a panorama from the *hôpital* to the towers of the cathedral
c) the church of St-Laurent
d) sketch of a building
LIT: Paris 1981, p.230 fig.428; Lévêque-Mingam 1996, p.97 fig.77, as Beaugency (detail)

30 Orléans; the view from the left bank as far as St-Aignan, with additional details above of the towers of Notre-Dame de Recouvrance and St-Paul, and of the buildings on the Quai Neuf
LIT: Paris 1981, p.230 fig.430; Lévêque-Mingam 1996, p.28 fig.10 (detail), and p.101 fig.10

30v. Orléans: the buildings of the right bank, broken down into three sketches, spanning the distance from Notre-Dame de Recouvrance to St-Aignan

31 Orléans: the cathedral and St-Aignan from the opposite side of the river; the second sketch shows the rest of Orléans from the same spot, looking downstream
LIT: Lévêque-Mingam 1996, p.104 fig.81

31v. Two views at Paris:
a) the view east to the Louvre, with the Pont de la Concorde
b) the Palais Bourbon; inscr. 'Rive de Bas…[?]'
LIT: Paris 1981, p.231 fig.435

32 Blank

32v. Details of the architecture of Orléans Cathedral: the spire over the crossing and the southern tower [fig.146]
LIT: Paris 1981, p.227 fig.420; Lévêque-Mingam 1996, p.13 fig.5 (detail), and p.107 fig.5

33 Part of the facade of Orléans Cathedral [fig.146]. See cat.97
LIT: Wilkinson 1975, p.64, repr.

33v. The southern transept of Orléans Cathedral
LIT: Lévêque-Mingam 1996, p.30 fig.12 (detail) and p.106 fig.12 (detail)

34 Orléans: the Théâtre, the Hôtel Dieu and the cathedral, from the Hôtel Groslot. See cat.98 and fig.119
Inscr. 'Caff / Firills [?]' and below 'Cafe du Loiret / Caffe a Cabroke [?]' and 'MAIRE'
LIT: Paris 1981, p.230 fig.431

34v. Orléans: the Place Martroi, with the spire of the church of St-Pierre and the towers of the cathedral. The basis for fig.150
Inscr. illegibly, top left

35 Blank

35v. Paris: the Pont au Change, the Conciergerie and Tour de l'Horloge, above which are the outlines of the towers of Notre-Dame (see also f.27v)
LIT: Wilkinson 1975, p.64, repr.; Paris 1981, p.256 fig.468

36 Paris: the Quai du Louvre, looking west to the Pont Royal
LIT: Paris 1981, p.256 fig.469

37 Paris: the Quai du Louvre, looking east to the Pont Neuf and the Ile de la Cité
LIT: Paris 1981, p.256 fig.467

37v. Paris: the Pont des Invalides from the east, with the dome of Les Invalides on the left
LIT: Paris 1981, p.231 fig.438

38 Paris: the Pont des Invalides from the west, looking across to Les Invalides
LIT: Paris 1981, p.231 fig.436

38v. Two views of Paris:
a) looking through the Pont des Invalides to the Louvre, with Les Invalides on the right
b) the Pont du Passy; inscr. 'Paffy'
LIT: Paris 1981, p.231 fig.437

39 Paris: sketch of the Pont du Passy [page turned upside down]
Inscr. 'Paffy'

39v. Looking west from Paris, near the Barrière du Passy
Inscr. 'Cuyp' in the sky

40 Blank

40v. Several sketches of Paris from the heights of Passy, looking both back upriver and across to Les Invalides, with the windmills of Montmartre beyond
Inscr. 'Maison Sands' (? or 'Lamb' as in Hotel de la Princesse de Lamballe) and 'PL 15' (?Palace of Louvre)
LIT: Paris 1981, p.231 fig.433

41 Hasty sketch of domes near the river, probably including Les Invalides

41v. Two sketches of the environs of Paris to the west; inscr. 'Mt Calvaire' and 'Wong… Cloud'. Also a study of cloud [page turned sideways]; inscr. 'Effect of… / Grey / Blue' and along gutter of page 'Cou… st…'

42 Paris: the Pont Neuf and the Ile de la Cité, with the towers of Notre-Dame, from the Quai Conti.
LIT: Paris 1981, p.256 fig.466

42v. Paris: the Pont au Change leading to the Colonne du Châtelet, the Pont Notre-Dame with the Pump, and the Tour St-Jacques above
LIT: Paris 1981, p.231 fig.434

43 Paris: the Pont Neuf, with the statue of Henri IV and the Tour St-Jacques beyond
LIT: Paris 1981, p.256 fig.465

43v. Outline of the interior of the Grande Galerie, in the Louvre

44 Blank

44v. Several outlines, possibly connected with the lighting in the Grande Galerie
Inside back cover
A pencil scribble. Inscr. in ink, upside down from general order, '1826 / 23 Aug.ᵗ Colnaghi Junʳ set of Libers'

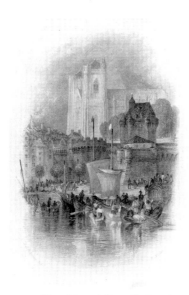

FIG 192 *Nantes* (vignette) (Appendix C, no.3)

following institutions have impressions: British Museum
(1949.5.12.696); Tate Gallery (T04678, Turner studio sale blind
stamp, inscribed '1st pub. state ?different lettering'; and T05727);
Yale (B.1977.14.13569)

Second state: 'Proofs on India Paper'. Colombier 4to. Title added in
centre in ital., and below, 'London Published for the Proprietor, by
Moon, Boys, and Graves, 6 Pall Mall', in slender rom. caps. At top,
'Turner's Annual Tour, 1833', in open caps. (i.e. Tate Gallery,
T06192)]

Third state: 'Proofs'. Size and lettering as in second state, but on plain
paper. [i.e., ?Tate Gallery (T06191);Yale (B.1977.14.13570)]

Later states: In book form, 8vo, large and small. Lettering as Second
State, except that in pub. line, 'Longman and Co., Paternoster
Row', takes the place of 'Moon, Boys, and Graves'.

LIT: *Athenaeum*, 1 December 1832; *Spectator*, 8 December 1832; *Atlas*,
9 December 1832; *Literary Gazette*, 15 December 1832; *Gentleman's
Magazine*, December 1832; Ritchie 1833, frontispiece; Ritchie
1837; Hamerton 1878, p.236; Herrmann 1990, p.167; Tate Gallery
1996, p.149; Lévêque-Mingam 1996, p.112, fig.85.

4 Orléans (fig.193)
Based on fig.149 (see p.230)
Engraved by Thomas Higham, for which he was paid on 4 August
1832 (see fig.185)
R 433
Image size: 98 × 142 (3⅞ × 5⅝)

Open etching: Yale (B.1977.14.7465). This could be the etching
included in the Turner studio sale on 25 April 1873 as part of lot 681.

Engraver's proof: Earlier than the following impressions – before
light clouds added to sky above theatre. Yale (B.1977.14.7466).

Engraver's proofs: W.a.l. Completed. India paper. Rawlinson lists
three impressions: British Museum (1868.8.22.4144, formerly in
the Felix Slade collection); one in the H.S. Theobold collection;
and his own, now at Yale (B.1977.14.7464, with Rawlinson and
dragon collector's stamps; see also B.1977.14.13571 at Yale, which is
presumably the H.S. Theobold impression).

First published state: 'Proofs before letters'. India, Colombier 4to
(11½ × 17). Art. names in small rom. type. 'Printed by McQueen'
low on right, in small ital. Before title and pub. line. (i.e. Tate
Gallery: T04679, with Turner studio sale blind stamp; and
T05574).

Second state: 'Proofs on India Paper'. Same, with title added in centre
in ital., and below, 'London, Published for the Proprietor by Moon,
Boys, and Graves, Pall Mall' in small rom. type.

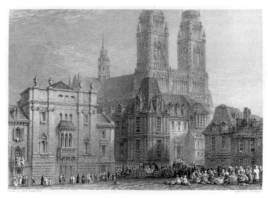

FIG 193 *Orléans* (Appendix C, no.4)

NB: This state is rarely found in its original form. Probably, as
explained below, the unsold impressions were cut down and used
for the Large Paper edition of the book.

Third state: 'Proofs'. Same size and lettering, but on plain paper.
Fourth state: In book form (see list).

LIT: *Spectator*, 8 December 1832; *Atlas*, 9 December 1832; *Literary
Gazette*, 15 December 1832; *Gentleman's Magazine*, December
1832; Ritchie 1833, pp.10–12, repr. opp. p.11; Ritchie 1837;
Ruskin, *Modern Painters*, I, 1843 (*Works*, III, p.314); Herrmann 1990,
pp.167–8; Tate Gallery 1996, p.149, repr. of T04679; Lévêque-
Mingam 1996, p.138 fig.105.

Details of cathedral towers refined and more accurate in engraving,
probably based on pencil sketch (TB CCXLIX f.32 verso). Procession
clearer at each side.

5 Beaugency (fig.194)
Based on fig.138 (see also p.229)
Engraved by Robert Brandard; presumably completed by him before
3 August 1832 (see below), possibly that paid for on 20 June
R 434
Image size: 92 × 138 (3⅝ × 5⅞)

Open etching: Yale (B.1977.14.7468)

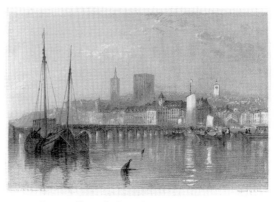

FIG 194 *Beaugency* (Appendix C, no.5)

Engraver's proof: Early, before overhanging cloth on side of boat was
added and before second buoy introduced in the centre of river.
Yale (B.1977.14.7469). Acquired from the Hawkins sale.

Touched proofs: The Turner studio sale on 25 April 1873 included
two touched proofs of this subject in lot 684. One of these could
be the work now in the Victoria and Albert Museum. This has
pencil annotations introducing the second, more distant buoy, the
reflections under the boats on the right, and the cloth hanging
from the boat on left. Also changes to architecture of bridge
(E.4081–1946). The other has not been traced.

Engraver's proofs: W.a.l. Completed. Rawlinson listed three: one in
the British Museum (1868–8–22–4145; and see below); one in the
H.S. Theobold collection; and his own, now at Yale
(B.1977.14.7467). There is also an impression in the Victoria and
Albert Museum which is inscribed 'Turner [?Own] 3 Aug 1832 /
Brandard' (E.4082–1946).

First state: Examples can be found at the Tate Gallery (T04680,
T05575).

Late proofs: One inscribed '1835' under the boat in front of its sail
can be found in the British Museum (1868.8.22.4145, formerly
Felix Slade collection). This suggests the image may have been
reworked before the 1837 edition.

LIT: *Athenaeum*, 1 December 1832; *Spectator*, 8 December 1832; *Atlas*,
9 December 1832 ; *Literary Gazette*, 15 December 1832; Ritchie
1833, repr. opp. p.15; Ritchie 1837; Ruskin, *Modern Painters*, I, 1843
(*Works*, III, pp.315, 421); Herrmann 1990, p.168; Tate Gallery 1996,
p.150; Lévêque-Mingam 1996, p.137 fig.104.

Light clouds added to sky. A second, more distant buoy added in middle
of image. Cloth spilling over side of left-hand boat introduced.
Houses to the right of distant boats given greater structure.

6 Blois (fig.195)
Based on fig.129 (see p.229)
Engraved by Robert Brandard
R 435
Image size: 94 × 137 (3¹¹⁄₁₆ × 5⁷⁄₁₆)

Touched Engraver's Proofs. listed as (ab) (cat.123). Pencil shading to

the towers of the church. Formerly in J.E. Taylor's collection, now at Yale (B.1977.14.7472)

Engraver's proofs:

1. Rawlinson (b), where he rightly noted that this did possibly precede state (a) In centre, in ital. writing, 'Engd by R. Brandard from a Drawing by J.M.W. Turner R.A.' Formerly in the H.S. Theobold collection, now at Yale (B.1977.14.7471).

2. Rawlinson state (ab) See under 'Touched proofs' above.

3. Rawlinson (a) W.a.l. He lists two impressions: that at the British

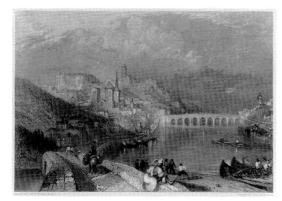

FIG 195 *Blois* (Appendix C, no.6)

Museum (1868.8.22.4147, formerly Felix Slade collection) and his own, now at Yale (B.1977.14.7470).

4. Yale (B.1977.14.13574).

First published state: Tate Gallery (T04681, Turner studio sale blind stamp; and T05576); Yale (B.1977.14.13575).

LIT: *Spectator*, 8 December 1832; *Atlas*, 9 December 1832; *Literary Gazette*, 15 December 1832; Ritchie 1833, opp. p.24; Ritchie 1837; Ruskin, *Modern Painters*, I, 1843 (*Works*, III, p.315); Herrmann 1990, p.168, repr fig.134 (proof at Birmingham Museum and Art Gallery); Tate Gallery 1996, p.150; Lévêque-Mingam 1996, p.135 fig.102.

The obelisk appears to be on this, the downstream side of the bridge.

7 Palace at Blois (fig.196)
Based on fig.134 (see p.229)
Engraved by Robert Wallis
R 436
Image size: 97 × 142 (3¹⁵⁄₁₆ × 5⁹⁄₁₆)

Open etching: Yale (B.1977.14.7474)
Engraver's proofs: On India paper

(a) Unfinished. W.a.l. No smoke from houses on extreme left. Formerly in the collection of Alaric Watts. There are two existing impressions of this state, but I am not sure which is the one Rawlinson saw in the Watts' collection: Victoria and Albert Museum (E.4087–1946; formerly J.E. Taylor collection) or Yale (B.1977.14.7475).

(ab) Generally darker than preceding state – see especially the

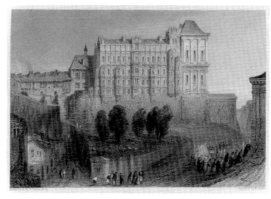

FIG 196 *Palace at Blois* (Appendix C, no.7)

garments of the cleric in the foreground. Via Hawkins sale, to Yale (B.1977.14.7476).

(b) Completed. W.a.l. Rawlinson lists three impressions: British Museum (1868.8.22.4146, formerly Felix Slade collection); his own, now at Yale (B.1977.14.7473, stamped with both Rawlinson's and the dragon collector's mark); and one in the H.S. Theobold collection.

First published state: Tate Gallery (T04682, Turner studio sale blind stamp). Another impression of this state can be found in the collection at Yale (B.1977.14.13576).

Title variants: The title on the plate is given as 'Palais de Blois' in *Liber Fluviorum* (1853/7), *Turner's Rivers of France* (1886), and *The Seine and the Loire* (1895). The list of plates for the first two of these volumes gives the title as 'Castle of Blois', while in *The Seine and the Loire* it appears as 'Blois. The Castle'.

LIT: *Spectator*, 8 December 1832; *Atlas*, 9 December 1832; *Gentleman's Magazine*, December 1832; Ritchie 1833, repr. opp. p.25; Ritchie 1837; Ruskin, *Modern Painters*, I, 1843 (*Works*, III, pp.315 336n, 340n, 423), Ruskin *Modern Painters*, V, 1860 (*Works*, VII, pl.85 opp. p.203); Herrmann 1990, p.169; Tate Gallery 1996, p.150; Lévêque-Mingam 1996, p.136 fig.103.

Architecture generally given greater precision, not always following what is in the drawing. For example, in the centre of the facade the projecting bay is made to rise up five storeys whilst this is not clear in drawing (or reality). Much more of the facade of the church of St-Vincent-de-Paul is included on the extreme right. The coffin in the procession is much clearer, as is a figure of a priest in the central group of figures. A couple of stars have begun to appear in the sky to the right of the château.

8 [Château of] Amboise (fig.197)
Based on fig.126 (see p.229)
Engraved by J.B. Allen, for which he was paid on 20 June 1832
R 438 (this image preceded the general view of Amboise [no.9, R 437] in *Turner's Annual Tour, 1833* and should have been catalogued first)
Image size: 94 × 144 (3¹¹⁄₁₆ × 5¹¹⁄₁₆)

Open Etching: Victoria and Albert Museum (E.4094–1946).

Engraver's proofs: Art. names in ital., often very faint. The sale of Turner's studio contents included two touched proofs of this subject (25 April 1873, lot 677). These are possibly those listed under 1(a) and 4(bc) below. The order here slightly modifies that given by Rawlinson.

1. Rawlinson state (a) (cat.125) Nearly completed. Touched by Turner in pencil, and with the following instructions referring to the wall not in shadow below the castle on the left: 'This wants more cross-work [a series of pencil lines made to indicate how it could be achieved] not the little black bits [insertion – 'they do much harm'] behind the light pieces of paper which must be all put dark [a line followed by a circle to suggest the support of the bridge; Rawlinson reads the last word as 'down']'. Below, referring to pier of bridge: 'The same [sketch of brickwork area under bridge] more like layers of stone'. Also, an arrow to annotations on the third arch of the bridge: 'too dark'. Referring to the struts of the bridge: 'too distinct'. Top right (referring to sky, hitherto quite plain): 'This is so much of a dividing line that if the same cannot be rendered more gradated, some [insertion 'light'] clouds must be put, burnished out' [horizontal lines of light clouds are scraped out in upper sky]. Bottom right: 'Pray send me back all my touched proofs'. Turner studio sale blind stamp. Formerly Rawlinson's

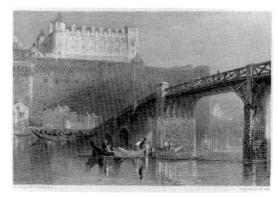

FIG 197 *Château of Amboise* (Appendix C, no.8)

collection, now at Yale (B.1977.14.7483); see New Haven 1993, no.160, repr. p.42.

2. Rawlinson state (b) Names in ital. No sky. Formerly H.S. Theobold collection, now at Yale (B.1977.14.7484).

3. Rawlinson state (c) Light clouds added in upper sky. Completed. Rawlinson lists three impressions: British Museum (1868–8–22–4149); his own, now at Yale (B.1977.14.7485; inscribed 'To Robert Wallis Esqr with James B Allen's every honour R'); and one in the H.S. Theobold collection.

4. Rawlinson state (bc) On plain paper. Pencil shading to indicate that the shadow should fall in a harder line across the surface of the wall under the bridge (to darken it) and in recesses of wall, at left. Detail of architecture in pencil above plate mark (sketch). Names erased. Turner studio sale blind stamp; subsequently Rawlinson collection (his collector's stamp), now at Yale (B.1977.14.7487).

5. Rawlinson state (bc/c) On India. Names erased. From Hawkins sale, now at Yale (B.1977.14.7486).
6. Rawlinson state (d) On India. Art. names erased, but tops of letters showing. Harder lines of shadow. Rawlinson's own impression is now at Yale (B.1977.14.7488); another is in the British Museum (1868.8.22.4149, formerly Felix Slade collection).

First published and later states: Tate Gallery (T04684, with Turner studio sale blind stamp; and T05578). There is another version of the first state at Yale (B.1977.14.13595).

Title variants: Simply 'Amboise' in *Turner's Annual Tour, 1833*, where the list of plates refers to it as 'Amboise'. In the subsequent reprintings of the Loire series it was generally distinguished from the general view in no.9 by the title 'Chateau of Amboise'.

LIT: *Athenaeum*, 1 December 1832; *Spectator*, 8 December 1832; *Atlas*, 9 December 1832; *Literary Gazette*, 15 December 1832; Ritchie 1833, repr. opp. p.34; Ritchie 1837; Ruskin, *Modern Painters*, I, 1843 (*Works*, III, p.315); Ruskin, *The Elements of Drawing*, 1857 (*Works*, XV, p.76n); Hamerton 1879, pp.242–5; Herrmann 1990, p.169; Tate Gallery 1996, p.150; Lévêque-Mingam 1996, p.134 fig.101.

Much greater clarity given to foreground, including reflections, especially where they recede through the arch. The underside of the bridge is more regular, with six supports instead of five. Light introduced to the turrets of two buildings at far end of bridge.

9 Amboise (fig.198)
Based on cat.119 (fig.124)
Engraved by W.R.Smith, for which he was paid on 11 May 1832

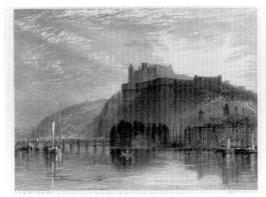

FIG 198 *Amboise* (Appendix C, no.9)

R 437
Image size: 103 × 142 (4 × 5⁹/₁₆)

Open etchings:
1. Yale (B.1977.14.7481). Only the basic suggestion of sky and clouds.
2. Yale (B.1977.14.7480). More clouds added.
Engraver's proofs:
(a) W.a.l. Before rays behind château, and lights clouds on left. Rawlinson's own impression is now at Yale (B.1977.14.7477). There

is also another, unrecorded impression in the Victoria and Albert Musuem (E.4090–1946).
(b) W.a.l. Touched by Turner. Scratching to the large turret at the centre of the image. Light clouds added on left (not in the original image, but this completes the composition). Formerly in the H.S. Theobold collection, now at Yale (B.1977.14.7478)
(bc) On plain paper. Yale (B.1977.14.7482).
(c) Rays added. Completed. Art. names in ital. writing. Rawlinson lists three impressions of this state: British Museum (1868.8.22.4148); his own, now at Yale (B.1977.14.7479); and one in the H.S. Theobold collection.
First published state: Tate (T04683, with Turner studio sale blind stamp). There is also an impression of this state at Yale (B.1977.14.13577)

Title variants: In *Turner's Annual Tour, 1833* where given in the list of plates as 'Amboise (Another view)'.

LIT: *Athenaeum*, 1 December 1832; *Spectator*, 8 December 1832 ; *Atlas*, 9 December 1832; *Literary Gazette*, 15 December 1832; Ritchie 1833, repr. opp. p.35; Ritchie 1837; Ruskin, *Modern Painters*, I, 1843 (*Works*, III, pp.315, 423 ['Sunsetting. Detached light cirri and clear air']; Hamerton 1879, pp.242–5; Herrmann 1990, p.169; Tate Gallery 1996, p.150; Lévêque-Mingam 1996, p.133 fig.100.

Sky is transformed into an erupting sunrise. Loire barges, with sails hoisted, introduced alongside the quays on the right, and a rowing boat in the centre, below the copse of trees.

10 The Canal of the Loire and Cher, near Tours (fig.199)
Based on fig.121 (see p.228–9)
Engraved by Thomas Jeavons, for which he was paid on 14 September 1832
R 439
Image size: 96 × 140 (3¾ × 5½)

Engraver's proofs:
NB: A touched proof was listed in the Turner studio sale (25 April 1873, as part of lot 681).
1. Earlier than Rawlinson state (a) Much darker in the clouds than later states. Less defined. Towers of St-Gatien unfinished. Smaller sun. Yale (ex Hawkins sale; B.1977.14.7490).

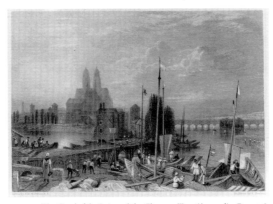

FIG 199 *The Canal of the Loire and the Cher, near Tours* (Appendix C, no.10)

2. Rawlinson state (a) Completed. Art. names in ital. writing, sometimes very faint. Rawlinson lists two impressions: his own, now at Yale (his collector's stamp; B.1977.14.7489); and one in the H.S. Theobold collection, probably that now in the British Museum (1928.4.17.54).
3. Rawlinson state (b) Names erased, but faint traces visible. Two impressions were listed by Rawlinson: British Museum (1868.8.22.4153) and his own, now at Yale (collector's stamps of Rawlinson and dragon; B.1977.14.7491).
NB: There are three proofs in the V&A: one from Rawlinson's collection; one with the artist's name in italics; one on plain paper (E.4100–1946; E.4098–1946; E.4099–1946).
First published and later states: Tate Gallery (T04685 – Turner studio sale blind stamp) (T05579). There is also an impression at Yale (B.1977.14.13596)

LIT: *Spectator*, 8 December 1832; *Atlas*, 9 December 1832; *Literary Gazette*, 15 December 1832; Ritchie 1833, opp. p.38; Ritchie 1837; Herrmann 1990, p.169; Tate Gallery 1996, p.150, repr. of to T04685; Lévêque-Mingam 1996, p.132 fig.88, and p.119 (detail).

Foreground activities clarified. Figures added to the sandbank on the right.

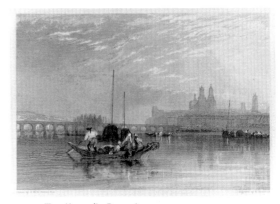

FIG 200 *Tours* (Appendix C, no.11)

11 Tours (fig.200)
Based on cat.118 (fig.113)
Engraved by Robert Brandard
R 440
Image size: 94 × 137 (3¹¹/₁₆ × 5⅜)

Engraver's proofs:
1. Rawlinson state (a) W.a.l. Before light streaks on water on right, and many light clouds in sky. Rawlinson lists one in the Ward collection.
2. Rawlinson state (a/b) (cat.127) There is a touched proof of this state at Yale, which has the Turner studio sale blind stamp. This could relate to lot 678 in the sale on 25 April 1873. This impression has pencil annotations to the masts for lines of rigging; reflections of arches under the bridge suggested (and improved in subsequent

states); ripples expanded even further. Foreground right scratched out to create lights on water. Sky extensively scratched out. Subsequently in the Hawkins sale. Yale (B.1977.14.7493).

3. Rawlinson state (b) Completed. W.a.l. India paper. Two impressions listed by Rawlinson: British Museum (1868.8.22.4150; ex Felix Slade collection); and Rawlinson's own, now at Yale (B.1977.14.7492).

4. Rawlinson state (c) Art. names added in centre, in ital. writing. Two impressions listed: Rawlinson's own, now at Yale (B.1977.14.7494; collector's stamps of Rawlinson and dragon); and one then in the H.S. Theobold collection, now British Museum (1928.4.17.55).

First published and later states: Tate Gallery (T04686, with Turner studio sale blind stamp; and T05580 – Turner's name on bottom line not fully printed). There is also the following impression at Yale (B.1977.14.13597).

Title variants: listed as 'Tours, I' in *The Seine and the Loire* (1895)

LIT: *Spectator*, 8 December 1832; *Atlas*, 9 December 1832; *Literary Gazette*, 15 December 1832; Ritchie 1833, pp.47–8, repr. opp. p.47; Ritchie 1837; Herrmann 1990, p.169; Tate Gallery 1996, pp.150–51; Lévêque-Mingam 1996, p.131 fig.99.

The cathedral towers depart from the watercolour in the suggestion that they are irregular, when in fact they are largely the same. The Tour de Guise, beyond the bridge on the left of the towers of St-Gatien, looks more like a pedimented facade of a Venetian church, such as the Gesuati on the Zattere. The towers of the old cathedral have been introduced, inaccurately drawn, on the right.

12 St. Julian's [Tours] (fig.201)
Based on fig.115 (see p.228)
Engraved by William Radclyffe, for which he was paid on 28 April 1832
R 441
Image size: 97 × 145 (3¾ × 5¹¹⁄₁₆)

Open etching: There are two known impressions of this state: Victoria and Albert Museum (E.4104–1946); and one formerly in the collection of J.E. Taylor, now at Yale (B.1977.14.7496).

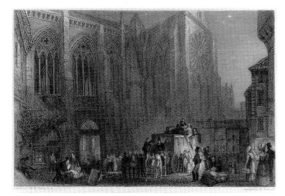

FIG 201 *St Julian's, Tour* (Appendix C, no.12)

Engraver's proofs: Rawlinson noted that the exact sequence of these proofs was difficult to establish with certainty and perhaps needed reordering.

1. Earlier than Rawlinson state (a). India paper. No light in window, on left. Many stars. Ex Hawkins sale, now at Yale (B.1977.14.7498).

2. Rawlinson state (c) (cat.128) Engraver's name erased. Touched by Turner: pencil annotations to darken areas, i.e. the foreground to the right of the horses, in front of the group at far right, under eaves of arch on left. The pencil diagram of the rose window was made to indicate the pattern at the end of each piece. Also note about area of sky close to the building at right: 'Lighter generally within this [pencil arch to mark out area in print] towards the House'. With Turner studio sale blind stamp; this may be the touched proof recorded in the sale on 25 April 1873, lot 679. Formerly in Rawlinson's own collection, now at Yale (B.1977.14.7500).

3. Still earlier than Rawlinson state (a) Small stars in the sky. Yale (B.1977.14.7499).

4. Rawlinson state (a) Nearly completed. 'W.Radclyffe Sct' in ital. on right. Only one large star on right. Rawlinson's own impression, now at Yale (B.1977.14.7495).

5. Rawlinson state (b) More stars added. 'W.Radclyffe Sct' in ital. on right. Rawlinson listed three impressions: British Museum (1868.8.22.4151; ex Felix Slade collection); his own, now at Yale (B.1977.14.7497); and one in the H.S. Theobold collection.

First published and later states: Tate Gallery (T04687, with Turner studio sale blind stamp; and T05581), Victoria and Albert Museum (4th state, with Longmans name on bottom line, E.4108–1946), Yale (B.1977.14.13598).

Title variants: 'Saint Julian's' in *Turner's Annual Tour, 1833*; *Liber Fluviorum* (1853/7) has the correct spelling of 'St Julien' in its list of plates, while in the list of plates in *The Seine and the Loire* (1895) the title is given as 'Tours. St Julian's'.

LIT: *Athenaeum*, 1 December 1832; *Spectator*, 8 December 1832; *Atlas*, 9 December 1832; *Literary Gazette*, 15 December 1832; Ritchie 1833, p.48, repr. opp. p.48; Ritchie 1837; Ruskin, *Modern Painters*, I, 1843 (*Works*, III, pp.315, 423, as 'An hour after sunset. No moon'); Hamerton 1879, p.254; Herrmann 1990, p.169; Tate Gallery 1996, p.151; Lévêque-Mingam 1996, p.130 fig.98, and p.118 (detail).

The changes here are slight and largely amount to the refining of details to increase the idea of a nocturnal scene. Stars are introduced above and to the right of St Julien's.

13 Tours [Looking Back] (fig.202)
Based on cat.117 (fig.112)
Engraved by Robert Wallis
R 442
Image size: 94 × 143 (3⁹⁄₁₆ × 5¹¹⁄₁₆)

Open etching: 'Robert Wallis 1831' in ital. writing on right below. Yale (B.1977.14.7502). Another impression in the British Museum, may be slightly later than this state. Before dark tones added. No sky other than outline of sun (1893.7.31.90).
Touched proofs: Lot 680 of the Turner studio sale on 25 April 1873 included a touched proof and an etching of this view of Tours (see above).
Engraver's proofs: Completed.

1. Earliest. On plain paper. Formerly J.E. Taylor collection, now at Yale (B.1977.14.7503).

2. On plain paper. Slightly darker. Water more heavily worked. Yale (B.1977.14.7504).

3. On India paper. Women in boat by shore darkened. Yale (B.1977.14.7505).

4. On India paper. Shadow of balustrade added. Yale (B.1977.14.7506).

5. Rawlinson state (a) W.a.l. 'Wallis' erased. Three impressions were listed by Rawlinson: British Museum (1868.8.22.4152); his own, now at Yale (B.1977.14.7501; dragon and Rawlinson collector's stamps); and one in the H.S. Theobold collection.

6. Rawlinson state (b) 'Robt Wallis 1831,' on right in ital. writing. Formerly in the Ward collection, perhaps that now in British Museum, see above.

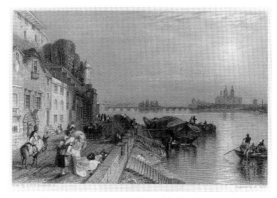

FIG 202 *Tours* (looking backwards) (Appendix C, no.13)

First published and later states: British Museum (trimmed, 18787.5.11.986), Tate Gallery (T04688, with Turner studio sale blind stamp; and T05583), Yale (B.1977.14.13599).

Title variants: while the title given on the plate itself is simply 'Tours', the list of plates in *Turner's Annual Tour* attempted to distinguish between this and no.11 above by adding the parenthesis, 'Tours (looking back)'. When the plate appeared in *Liber Fluviorum* (1853/7) a more topographical title was appended in the list of plates: 'Tours (from the fauxborg St.Symphorien)'. This was followed in *Turner's Rivers of France*, where it was listed as 'Tours (from the faubourg St Symphorien)'. In *The Seine and the Loire* it appeared merely as 'Tours II'.

LIT: *Spectator*, 8 December 1832; *Atlas*, 9 December 1832; *Literary Gazette*, 15 December 1832; *Gentleman's Magazine*, December 1832; Ritchie 1833, repr. opp. p.106; Ritchie 1837; Herrmann 1990, p.169; Tate Gallery 1996, p.151, repr. of T04688; Lévêque-Mingam 1996, p.129 fig.97.

The circle of the sun is made much more distinct, as is the serpentine effect it produces across the water. The foreground is made much more precise, which is especially noticeable in the architecture. The bridge is clearly given thirteen arches (instead of its sixteen).

14 Saumur (fig.203)
Based on cat.116 (fig.100)
Engraved by James Tibbetts Willmore
R 443
Image size: 97 × 145 (3¹³⁄₁₆ × 5⅝)

Engraver's proofs: Completed. W.a.l. On India paper. Rawlinson lists three impressions: British Museum, ex Felix Slade collection (1868.8.22.4154); Rawlinson's own, now at Yale (B.197.14.7507; dragon and Rawlinson collector's stamps); and that in the H.S. Theobold collection.

First published and later states: Tate Gallery (T04689, with Turner studio sale blind stamp; and T05583), Yale (B.1977.14.13600).

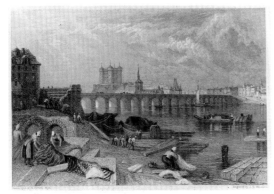

FIG 203 *Saumur* (Appendix C, no.14)

Title variants: Erroneously listed as 'Saumur (second view)' in *Turner's Rivers of France*, where it was confused with *The Keepsake* view. In *The Seine and the Loire* it was listed as 'Saumur from the North Bank'.

LIT: *Spectator*, 8 December 1832; *Atlas*, 9 December 1832; *Literary Gazette*, 15 December 1832; Ritchie 1833, repr. opp. p.112; Ritchie 1837; Herrmann 1990, p.169; Tate Gallery 1996, p.151; Lévêque-Mingam 1996, p.128 fig.96.

General sharpening of detail in translation of Turner's image.

15 Rietz, near Saumur (fig.204)
Based on fig.107, *The Junction of the Loire and the Vienne, near Montsoreau and Candes St-Martin* (see p.228)
Engraved by Robert Brandard
R 444
Image size: 89 × 137 (3½ × 5⅜)

Touched proof: The Turner studio sale on 25 April 1873 included a touched proof of this subject as lot 682. This presumably included the boats missing from the early proofs.
Engraver's proofs:
1. Earliest. On plain paper. Sun less distinct, no distant white spot. No boats. Yale, ex Hawkins sale (B.1977.14.7510).
2. Next. On plain paper. Oblique shadows on water. Yale (B.1977.14.7509).

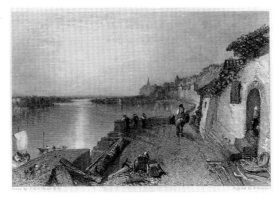

FIG 204 *Rietz, near Saumur* (Appendix C, no.15)

3. Completed. W.a.l. On India paper. Three impressions were recorded by Rawlinson: British Museum (1868.8.22.4156); Rawlinson's own, now at Yale (B.1977.14.7508); and that in H.S. Theobold's collection.
First published and later states: Tate Gallery (T04690 cat.129 and T05584), Yale (B.1977.14.13601).
?Third to fifth state: Tate Gallery (trimmed, T06206), India paper, italics under image: 'Engd by R. Brandard from a Drawing by J.M.W.Turner, R.A.'

Title variants: The list of plates in *Turner's Annual Tour, 1833* gives the title of this subject as 'View near Saumur'. This form was largely adopted in both the *Liber Fluviorum* and *Turner's Rivers of France*, which list the scene as 'View near Saumur (Rietz)'.

LIT: *Spectator*, 8 December 1832; *Atlas*, 9 December 1832; *Gentleman's Magazine*, December 1832; Ritchie 1833, repr. opp. p.114; Ritchie 1837; Ruskin, *Modern Painters*, V, 1860 (*Works*, VII, pp.217–21, pl.73, etching by Ruskin, in reverse, of Turner's image); Herrmann 1990, p.169; Tate Gallery 1996, p.151; Lévêque-Mingam 1996, p.127 fig.95.

Boats introduced to the left, and a building on the opposite bank becomes clearer (if it is not also another invention). White sail introduced between the silhouette of Montsoreau and the patch of sunlight on the water. The carpenter's work is made clearer.

16 Montjen (fig.205)
Based on cat.115 (fig.81)
Engraved by James Tibbetts Willmore
R 445
Image size: 96 × 137 (3¹³⁄₁₆ × 5⅜)

Touched proofs: The catalogue for the Turner studio sale lists two touched proofs of this subject (25 April 1873, lot 683). These have not been traced, but at least one of them may have been concerned with the introduction of the moon to the left of the château.
Engraver's proofs: W.a.l. On India paper.
(a) Before moon and reflection, and many bright lights on chateau. Right-hand sky much less animated with cloud. Bird flying over water on left. Formerly in the collection of H.S. Theobold, now at Yale (B.1977.14.7512).

(b) Moon added, but only partly obscured. Formerly owned by H.S. Theobold, now at Yale (B.1977.14.7513).
(c) Moon brightened and reflection added. Bird removed. Lights heightened on château, sails, etc. Completed. Two impressions listed by Rawlinson: British Museum, ex Felix Slade collection (1868.8.22.4157); and his own, now at Yale (B.1977.14.7511).
First published and later states: Tate Gallery (T04691, on India paper, with Turner studio sale blind stamp; and T05585), Yale (B.1977.14.13602; with dragon and Rawlinson collector's stamps).

Title variants: The list of plates in *Turner's Annual Tour* gives this work as 'Montjen'. In *Liber Fluviorum* the correct spelling of 'Montjean' is used.

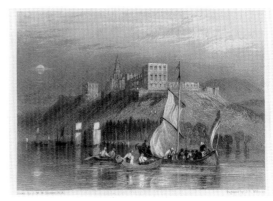

FIG 205 *Montjen* (Appendix C, no.16)

LIT: *Spectator*, 8 December 1832; *Atlas*, 9 December 1832; *Literary Gazette*, 15 December 1832; *Gentleman's Magazine*, December 1832; Ritchie 1833, pp.124–5, repr. opp. p.124; Ritchie 1837; Ruskin, *Modern Painters*, I, 1843 (*Works*, III, p.423); Herrmann 1990, p.169; Tate Gallery 1996, p.151; Lévêque-Mingam 1996, p.126 fig.94.

Moon introduced to the sky on the left of the town, with its reflection in the river. Clouds on right.

17 St Florent (fig.206)
Based on cat.114 (fig.75)
Engraved by Robert Brandard
R 446
Image size: 95 × 137 (3¾ × 5⅜)

Engraver's proofs:
(a) W.a.l. On plain paper. Before rays striking downwards. One white figure only below clump of trees. No boats on the right. No highlights on distant buildings beyond church (on right). Formerly owned by R. Wards, now at Yale (B.1977.14.7514).
(ab) On plain paper. Only one boat on right hand side (that nearest front shore). Formerly owned by Rawlinson (his stamp), ex Hawkins sale, now at Yale (B.1977.14.7515).

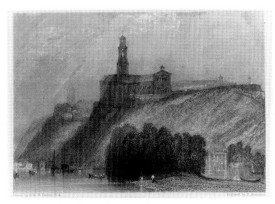

FIG 206 *St Florent* (Appendix C, no.17)

(b) Rays and second figure added. Completed. Art. names in centre in faint ital. writing (that at Yale reads 'Engd by R.Brandard from a Drawing by J.M.W.Turner RA 1832'). On India paper. Rawlinson listed three impressions: British Museum, ex Felix Slade collection (1868.8.22.4158); Rawlinson's own (with his stamp), now at Yale (B.1977.14.7516); and that owned by H.S.Theobold.
First published and later states: Tate Gallery (on India paper, T05586), Yale (B.1977.14.13603).

Title variants: 'Saint Florent', rather than the abbreviated form, is used in the list of plates in *Turner's Annual Tour, 1833*.

LIT: *Spectator*, 8 December 1832; *Atlas*, 9 December 1832; Ritchie 1833, repr. opp. p.150; Ritchie 1837; Herrmann 1990, p.169; Lévêque-Mingam 1996, p.125 fig.93.

Two boats added in foreground on right, and a second figure on the island. Rays of light slanting from sky more pronounced.

18 Between Clairmont and Mauves (fig.207)
Based on cat.111 (fig.62)
Engraved by William Miller, for which he was paid on 3 August 1832
R 447
Image size: 99 × 135 (3⅞ × 5⁵⁄₁₆)

Engraver's proofs:
1. Early. Sails of ship on the right unresolved. Yale, ex Hawkins sale (B.1977.14.7518).
2. Completed. Art. names in ital. Three impressions listed by Rawlinson: British Museum, ex Felix Slade collection, also bearing the stamps of 'JDF' and 'G' (1868.8.22.4159); Rawlinson's own (with his stamp), now at Yale (B.1977.14.7517); and that of H.S. Theobold.
First published and later states: British Museum (trimmed to image – 1878.5.11.974), Tate Gallery (T04692, with Turner studio sale blind stamp; and T05587), Yale (B.1977.14.13604).

Title variants: Listed as 'Scene between Clairmont and Mauves' in *Liber Fluviorum*.

LIT: *Atlas*, 9 December 1832; *Literary Gazette*, 15 December 1832; Ritchie 1833, pp.157–8, repr. opp. p.157; Ritchie 1837; Ruskin,

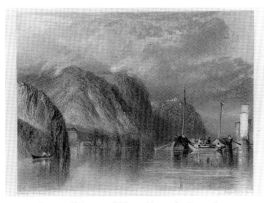

FIG 207 *Between Clairmont and Mauves* (Appendix C, no.18)

Modern Painters, I, 1843 (*Works*, III, p.466); Ruskin, *Modern Painters*, IV, 1856 (*Works*, VI, p.302); Herrmann 1990, p.170; Tate Gallery 1996, p.151; Lévêque-Mingam 1996, p.123 fig.91.

Sky made more cloudy. Outline of the Château de Clermont on the most distant coteau made more distinct. Pennant added to the mast of barge.

19 Château Hamelin, between Oudon and Ancenis (fig.208)
Based on cat.113 (fig.72, *Champtoceaux from the east*)
Engraved by Robert Brandard
R 448
Image size: 92 × 131 (3⅝ × 5⅛)

Engraver's proofs:
1. Earliest. Yale, ex Hawkins sale (B.1977.14.7520).
2. Same state – Touched. Pencil shading to indicate the need for further reflections and shadows in the group of timbers, lower right; and on back of boat, on right; also in bushes immediately below château. Yale, ex Hawkins sale (B.1977.14.7521).

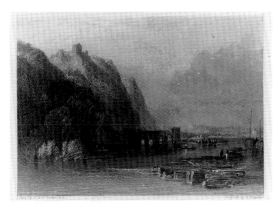

FIG 208 *Château Hamelin, between Oudon and Ancenis* (Appendix C, no.19)

3. Rawlinson state (a) W.a.l. Sky unfinished; before lights on top of *coteaux* on extreme left. Formerly H.S.Theobold collection, now at Yale (B.1977.14.7519).
4. Rawlinson state (b) Lights added and sky completed. Three impressions listed by Rawlinson: British Museum, ex Felix Slade collection (1868.8.22.4160); Rawlinson's own, now at Yale (B.1977.14.8442; with dragon and Rawlinson collector's stamps); and that belonging to H.S.Theobold.
(c) Art. names in centre in faint ital. writing. Rawlinson listed an impression then in the collection of Ward.
First published and later states: British Museum (trimmed to image, 1947.1.16.19), Tate Gallery (T04693; and T05588), Yale (B.1977.14.13605/6)

Title variants: 'Chatrau Hamelin' appears on some impressions of the first published state. In the list of plates for *Turner's Annual Tour*, and in Ritchie's text, the image is identified as 'Chatoceau'. In the *Rivers of France* volume it is listed as 'Chateau Chantoceau', but was thereafter generally referred to as 'Chantoceau (Chateau Hamelin)' in the later publications, with the exception of *The Seine and the Loire*, which reverted to the publication line title.

LIT: *Spectator*, 8 December 1832; *Atlas*, 9 December 1832; *Literary Gazette*, December 1832; Ritchie 1833, p.174, repr. opp. p.158 as 'Chatrau [sic] Hamelin'; Ritchie 1837; Herrmann 1990, p.170, as 'a sunset scene'; Tate Gallery 1996, p.152; Lévêque-Mingam 1996, p.124 fig.92

The only noticeable difference is the addition of the birds flying in a V-formation downstream.

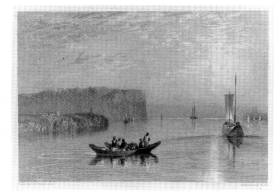

FIG 209 *Scene on the Loire* (Appendix C, no.20)

20 Scene on the Loire (fig.209)
Based on cat.109 (fig.60)
Engraved by Robert Wallis
R 449
Image size: 95 × 144 (3¾ × 5¹¹⁄₁₆)

Engraver's proofs:
1. Earliest. Possibly open etching. Before sky added. Sun outlined. No name or date. British Museum (1893.7.31.88).

2. Rawlinson state (a) Burin work only commenced. 'Robt Wallis 1832' on right, in faint ital. Formerly owned by H.S. Theobold, now at Yale (B.1977.14.7524).

3. Rawlinson state (b) Completed. Faint traces of 'Robert Wallis 1832'. Formerly belonging to Rawlinson (his stamp), now at Yale (B.1977.14.7522).

4. Rawlinson state (c) Engraver's name erased. Three impressions known to Rawlinson: British Museum, ex Felix Slade collection (1868.8.22.4164); Rawlinson's own, now at Yale (B.1977.14.7523); and that of H.S. Theobold.

First published and later states: Tate Gallery (T04694, on India paper, with Turner studio sale blind stamp; and T05589), Yale (B.1977.14.13607).

Title variants: This image was listed as 'View on the Loire' both in *Turner's Annual Tour*, and in the *Liber Fluviorum*.

LIT: *Athenaeum*, 1 December 1832; *Spectator*, 8 December 1832; *Atlas*, 9 December 1832 ; Ritchie 1833, repr. opp. p.173; Ritchie 1837; Ruskin, *Modern Painters*, I, 1843 (*Works*, III, pp.547–8); Herrmann 1990, p.170, as 'effect of sunset on a calm day', repr. fig.135 (proof in Birmingham Museum and Art Gallery); Tate Gallery 1996, p.152; Lévêque-Mingam 1996, p.114 fig.86.

Church towers added on far right above barge sails. Light catches the tops of *coteau* more dramatically.

21 Clairmont (fig.210)
Based on cat.112 (fig.65)
Engraved by James Tibbetts Willmore
R 450
Image size: 97 × 136 (3⅞ × 5⅜)

Engraver's proofs: W.a.l.
1. Early. No distant white light near sail. Yale (B.1977.14.7526).
2. Completed. Three impressions listed by Rawlinson: British Museum, ex Felix Slade collection (1868.8.22.4161); Rawlinson's own, now at Yale (B.1977.14.7525, with the stamps of Rawlinson and dragon); and that of H.S. Theobold.

First published and later states: Tate Gallery (T04695, on India paper, cat.130; and T05590, on India paper), Yale (B.1977.14.13608).

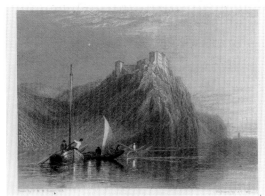

FIG 210 *Clairmont* (Appendix C, no.21)

LIT: *Athenaeum*, 1 December 1832; *Spectator*, 8 December 1832; *Atlas*, 9 December 1832; *Literary Gazette*, 15 December 1832; *Gentleman's Magazine*, December 1832; Ritchie 1833, p.177, repr. opp. p.177; Ritchie 1837; Ruskin, *Modern Painters*, I, 1843 (*Works*, III, p.423, as 'Sun half an hour set'); Hamerton 1879, p.254 (as an evening scene); Herrmann 1990, p.170; Tate Gallery 1996, p.152; Lévêque-Mingam 1996, p.120 fig.89.

Suggestion of a morning star made more pronounced in print. Tower of Oudon on far right, with flash of white between it and *coteaux*.

22 Coteaux de Mauves (fig.211)
Based on cat.110 (fig.61)
Engraved by Robert Wallis
R 451
Image size: 97 × 145 (3⅞ × 5¹¹⁄₁₆)

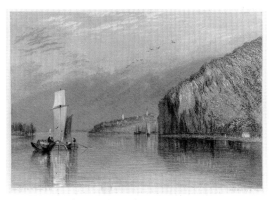

FIG 211 *Coteaux de Mauves* (Appendix C, no.22)

Engraver's proofs:
1. Rawlinson state (a) 'Robt Wallis, 1831' on right in ital. writing. Sails of boat on left, dark. Formerly owned by J.E. Taylor, ex Hawkins sale, now at Yale (B.1977.14.7528).
2. Rawlinson state (b) Sails light and light reflections added. Before cottage by river. Formerly owned by Mr. A. Wallis, probably now at Yale (B.1977.14.7529), although there is also an impression at the British Museum (1893.7.31.89). This latter impression still has evidence of engraver's name and date on a trimmed sheet, and may be the proof listed by Rawlinson as (e).
3. Rawlinson state (c) Cottage drawn in white by Turner, with pencil sketch outside plate mark of cottage roof. British Museum (1949.5.12.710).
4. Rawlinson state (bd) Cottage added. On plain paper. Yale (B.1977.14.7530).
5. Rawlinson state (d) Cottage engraved. Completed. Two impressions listed by Rawlinson: his own (with his stamp), now at Yale (B.1977.14.75727); and that of H.S. Theobold, now in the British Museum, ex Felix Slade collection (1868.8.22.4162).

First published and late states: Tate Gallery (T04696, on India paper, Turner studio sale blind stamp; and T05591, on India paper), Yale (B.1977.14.13609).

Title variants: In the *Liber Fluviorum* this image was listed as 'Chateau de Mauves'.

LIT: *Athenaeum*, 1 December 1832; *Spectator*, 8 December 1832; *Atlas*, 9 December 1832; Ritchie 1833, p.177, repr. opp. p.177; Ritchie 1837; Herrmann 1990, p.170; Tate Gallery 1996, p.152, repr. of T04696; Lévêque-Mingam 1996, p.117 fig.87.

White house added on right below *coteaux*, and barge under sail immediately under tip of cliff. Barge on left has been given an oar.

23 Château de Nantes (fig.212)
Based on cat.108 (fig.34)
Engraved by William Miller, for which he was paid on 3 August 1832
R 452
Image size: 95 × 135 (3¾ × 5⁵⁄₁₆)

Engraver's proofs: Completed. Art. names in ital. Rawlinson lists three impressions: British Museum, ex Felix Slade collection (1868.8.22.4163); his own (with his stamp), now at Yale (B.1977.14.7531); and that of H.S. Theobold.

First published and later states: Tate Gallery (T04697, on India paper, with Turner studio sale blind stamp; and T05592, on India paper), Yale (B.1977.14.13610).

Title variants: In the list of plates in *Turner's Annual Tour* this view is referred to simply as 'Nantes', which causes some confusion with the vignette subject (no.3 above) in early discussions of both works.

FIG 212 *Château de Nantes* (Appendix C, no.23)

LIT: *Spectator*, 8 December 1832; *Atlas*, 9 December 1832; *Literary Gazette*, 15 December 1832; Ritchie 1833, p.186, repr. opp. p.186; Ritchie 1837; Herrmann 1990, pp.170–71, repr. fig.136 (proof in Birmingham Museum and Art Gallery); Tate Gallery 1996, p.152; Lévêque-Mingam 1996, p.122 fig.90.

Made crisper and more precise – foreground figures especially.

The Loire engravings appeared
in the following published forms:

1 ***Turner's Annual Tour, 1833,*** or '***Wanderings by the Loire*** by Leitch
Ritchie, Esq., Author of Heath's Picturesque Annual, Romance of
French History, &c., with Twenty-One Engravings from Drawings
by J.M.W. Turner, Esq. R.A.'
Fourth state: Large Paper copies (issued in morocco gilt)
Published by Longman and Co. (Longman, Rees, Orme, Brown,
Green, and Longman), Paternoster Row
Printed by McQueen★ and Perkins and Bacon+

★: *Nantes (vignette); Palace at Blois; Amboise; Rietz, near Saumur; Between
Clairmont and Mauves; Chatrau Hamelin. between Oudon and Ancenis;
Clairmont*
+: *Tours, St Julian's, St Florent,* and *Coteaux de Mauves*

Order of plates
Nantes (vignette title-page)
Orléans (opp. p.11)
Beaugency (opp. p.15)
Blois (opp. p.24)
Palace at Blois (opp. p.25)
Amboise (opp. p.34)
Amboise ['Amboise, Another view' in list of plates] (opp. p.35)
The Canal of the Loire and Cher, near Tours (opp. p.38)
Tours (opp. p.47)
St Julian's (opp. p.48)
Tours ['Tours (looking back)' in list of plates] (opp. p.106)
Saumur (opp. p.112)
Rietz, near Saumur ['View near Saumur' in list of plates] (opp. p.114)
Montjen ['Montjan' in list of plates] (opp. p.124)
St Florent ['Saint Florent' in list of plates] (opp. p.150)
Between Clairmont and Mauves (opp. p.157)
Chatrau [sic] *Hamelin. between Oudon and Ancenis* ['Chatoceau' in list
of plates'] (opp. p.158)
Scene on the Loire ['View on the Loire' in list of plates] (opp. p.173)
Clairmont (opp. p.177)
Coteaux de Mauves (opp. p.177)
Château de Nantes ['Nantes' in list of plates] (opp. p.186)

2 Fifth state. Small Paper copies (plain morocco)
Published by Longman and Co. (sometimes in association with
Rittner and Co., Paris, and Asher, Berlin)
Order of plates: As under no.1

3 ***The Rivers of France, 1837***
Reprint A (with the all the forty Seine views), 8vo, with new text in
English and French Lettering as in Fifth State, with the exception
of the publication line.
Published by J. McCormick, 147 Strand
NB: The publication line of seven of the plates also bears the words,
'& Asher, Berlin'; see 'Tours (looking back)', 'Rietz', 'Montjen', 'St
Florent', 'Between Clairmont and Mauves', 'Clairmont' and 'Scene
on the Loire'.

Three of the plates – 'Beaugency'; 'Amboise'; and 'Saumur' – are
dated 1835 in their publication lines

Reprinted in facsimile, 1990, by Adam Biro, introduced by Eric Shanes

Order of plates
Orléans
Blois
Palace at Blois
Beaugency
Amboise
Château of Amboise
St Julians, Tours
Tours
The Canal of the Loire and Cher, near Tours
Tours, looking backward
Saumur
Rietz, near Saumur
Montjen
St. Florent
Between Clairmont and Mauves
Château Hamelin, between Oudon and Ancenis ['Chateau Chantoceau'
in letterpress]
Clairmont
Scene on the Loire
Coteaux de Mauves
Château de Nantes
Nantes, vignette

4 ***Liber Fluviorum, or River Scenery of France, Depicted in Sixty-
One Line Engravings from Drawings by J.M.W. Turner, R.A., with
Descriptive Letter-press by Leitch Ritchie; and a Biographical
Sketch by Alaric Watts,*** 1853 and 1857
Reprint B, large 8vo. Same lettering as in Reprint A
No publication line, except on title-page and on *Chateau Gaillard* (R
473), but without the vignettes of *Nantes* (R 432) and *Light-towers of
the Heve* (R 453), which have been replaced by *The Keepsake* views
of *Saumur* (R 324; Appendix C, no.1) and *Havre* (R 330)
Published by Henry G. Bohn, York Street, Covent Garden, London

Order of plates
II, *Orléans* (opp. p.2)
III, *Beaugency* (opp. p.7)
IV, *Palais de Blois* ['Castle of Blois' in list of plates] (opp. p..9)
V, *Blois* (opp. p.10)
VI, *Amboise* ['Amboise (the Château)' in list of plates] (opp. p.12)
VII, *Chateau of Amboise* (opp. p.15)
VIII, *Tours* (opp. p.18)
IX, *St Julian's, Tours* ['St Julien' in list of plates] (opp. p.21)
X, *Tours* ['Tours (from the fauxborg St. Symphorien)' in list of plates]
(opp. p.31)
XI, *The Canal of the Loire and Cher, Near Tours* (opp. p.33)
XII, *Saumur* (opp. p.36)
XIII, *Saumur* ['Saumur, second view' in list of plates: *Keepsake* subject]
(opp. p.38)
XIV, *Rietz, near Saumur* ['View near Saumur (Rietz)' in list of plates]
(opp. p.40)
XV, *Montjen* ['Montjean' in list of plates] (opp. p.44)
XVI, *St Florent* (opp. p.47)
XVII, *Between Clairmont and Mauves* ['Scene between Clairmont and
Mauves' in list of plates] (opp. p.51)
XVIII, *Chateau Hamelin between Oudon and Ancenis* ['Chantoceau
(Chateau Hamelin)' in list of plates] (opp. p.52)

XIX, *Clairmont* (opp. p.55)
XX, *Coteaux de Mauves* ['Chateau de Mauves' in list of plates] (opp.
p.56)
XXI, *Château de Nantes* (opp. p.58)
XXII, *Scene on the Loire* ['View on the Loire' in list of plates] (opp.
p.63)

5 ***Turner's Rivers of France, with an Introduction by John Ruskin. A
Series of Sixty-One Steel Engravings from the Originals of J.M.W.
Turner, R.A., described by Leitch Ritchie, the companion of Turner
during his tour through France, with a Biography of the Artist by
Alaric Watts***
(For which the original plates were reworked by J.C. Armytage, who
had worked with Turner, and published under the supervision of
Marcus Huish in a folio volume)
Reprint C. Impressions on India on pub. line. Plates R 432 and R 453
again omitted
Published by J.S. Virtue and Co. Limited, 26 Ivy Lane, Paternoster
Row, London 1886: the volume described is supposedly 'Vol.1'

Order of plates
Tours [R 440] (frontispiece)
Orléans (opp. p.2)
Beaugency (opp. p.7)
Palais de Blois ['Castle of Blois' in list of plates] (opp. p.9)
Blois (opp. p.10)
Amboise (opp. p.12)
Chateau of Amboise (opp. p.15)
St Julian's, Tours (opp. p.21)
Tours ['Tours (from the faubourg St Symphorien)' in list of plates]
(opp. p.31)
The Canal of the Loire and Cher, near Tours (opp. p.33)
Saumur [*Keepsake* subject] (opp. p.35)
Saumur ['Saumur (second view)' in list of plates] (opp. p.38)
Rietz, near Saumur ['View near Saumur (Rietz)' in list of plates] (opp.
p.40)
Montjen (opp. p.46)
St Florent (opp. p.47)
Between Clairmont and Mauves (opp. p.51)
Chateau Hamelin between Oudon and Ancenis ['Chantoceau (Chateau
Hamelin)' in list of plates] (opp. p.52)
Clairmont (opp. p.55)
Coteaux de Mauves (opp. p.56)
Château de Nantes (opp. p.58)
Scene on the Loire (opp. p.63).

6 Reprint D. A later issue of Reprint C in 4to form, the plates
printed on plain paper. Titles in heavy italics, 1890

7 ***The Seine and the Loire, Illustrated after Drawings by J.M.W.
Turner, R.A., with Introduction and Descriptions by M.B. Huish,
LLB***
New edition. Published by J.S. Virtue & Co. 1895

Order of plates
Orléans (no.41)
Beaugency (no.42)
Palais de Blois ['Blois. The Castle' in list of plates] (no.43)
Blois (no.44)

Amboise (no.45)

Chateau of Amboise ['The Chateau of Amboise' in list of plates, and
 'Amboise' in letterpress] (no.46)

Tours ['Tours I' in list of plates (R 440)] (no.47)

Tours ['Tours II' in list of plates (R 442)] (no.48)

St Julian's, Tours ['Tours. St Julian's' in list of plate] (no.49)

The Canal of the Loire and Cher, near Tours (no.50)

Saumur ['Saumur from the North Bank' in list of plates] (no.51)

Saumur ['Saumur from the South Bank' in list of plates; i.e. *Keepsake*
 view] (no.52)

Rietz, near Saumur (no.53)

Montjen (no.54)

St Florent (no.55)

Between Clairmont and Mauves (no.56)

Chateau Hamelin, between Oudon and Ancenis ['Chateau Hamelin' in
 list of plates] (no.57)

Clairmont (no.58)

Coteaux de Mauves (no.59)

Château de Nantes (no.60)

Scene on the Loire (no.61)

II Variations of the Loire 'Annual Tour' Subjects in Aquatints, c.1830

The following unpublished aquatints may have been created by
 Frederick Christian Lewis in the early 1830s, perhaps as an
 experiment before the designs were engraved on steel. Turner
 worked most closely with Lewis towards the end of the 1820s and
 in the early 1830s. There are two other aquatints based on subjects
 in the *Rivers of France* series – both views of Rouen from the 1834
 volume of *Turner's Annual Tour* – but they were engraved by
 someone called Himely, who may have been French, and are
 significantly larger than those created by Lewis.

24 Tours, Looking Backwards
Based on cat.117, fig.111; see also no.13 of this Appendix
Engraved in aquatint by Frederick Christian Lewis
R 831
Image size: 130 × 189 (5⅞ × 7½)

Engraver's proofs: W.a.l. British Musuem (1879–5–10–229: NB This
 impression has an 1878 watermark), Rawlinson's own copy, now at
 Yale, plain impression (B.1977.14.8393); a second coloured
 impression is also at Yale, exh. Ward collection (B.1977.14.13934);
 and Tate Gallery (T05198; cat.131)
LIT: *Tate Gallery Illustrated Catalogue of Acquisitions*, 1986–8, p.235

25 Promenade on the Ramparts of Nantes
Based on cat.108 (fig.34); see also no.23 of this Appendix
Engraved in aquatint by Frederick Christian Lewis
R.832
Image size: 125 × 181 (4¹⁵⁄₁₆ × 7⅛)

Engraver's proofs: 'F.C.Lewis sc' etched in right corner of margin.
 N.o.l. One impression. Rawlinson's own, now at Yale
 (B.1977.14.8394).

Reviews of the Illustrations to Turner's Annual Tour, 1833

The following is a selection of the fullest reviews of *Turner's Annual Tour*, concentrating on those discussing the illustrations rather than Ritchie's text, which was sometimes reviewed separately. None of these reviews has been republished, or quoted, in the recent Turner literature. A full overview of the contemporary criticism of Turner's work is being prepared by Marjorie Munsterberg.

I Reviews of the portfolio of illustrations available at the end of November, prior to the official publication of *Turner's Annual Tour* on 18 or 19 December 1832

The New Monthly Magazine and Literary Journal, December edition (Part the Third, p.532):
Turner's Annual Tour.
We have seen the greater number of the Illustrations to this Annual, which has not yet appeared. They are of surpassing beauty, – and leave all the other works of the prolific family [of Annuals] behind. Indeed it is scarcely possible to conceive greater excellence in art, either of design or execution. They have all the magic of Turner's pencil – and the several engravers have done justice to the effects of the British Claude. We shall introduce them to our readers at greater length, when we have examined the whole.

The Athenaeum, 1 December 1832 (no.266, p.780):
Turner's Annual Tour for 1833.
THIS is the true Book of Beauty [allusion to Heath's *Book of Beauties*]; all others are spurious. We have sometimes seen individual landscapes of great loveliness from the hand of Turner, but we never saw at once so many truly excellent. Here are one-and-twenty scenes happily delineated and happily engraved; there is not one common-place composition among them. Those who engrave for this painter seem to go with heart and hand to the task; the admiration which they bear for him makes the labour light; they cannot but be under the influence of something akin to inspiration, when they look at his truly poetic works. Beautiful as all these landscapes are, there are some which excel all others; we shall name our favourites – 1 'Nantes'; whenever Turner touches on water he is unrivalled.

2 'Clairmont'; water again, with a small tower perched on a lofty rock overlooking it. 3 'Amboise', with the sun shining from behind the castle, and dropping his rays on the boats lying quiet on the stream. 4 'Scene on the Loire', full of tranquil beauty. 5 'St Julian's', a night view of a splendid abbey, with a coach and lights, and the bustle of inside and outside passengers. 6 'Beaugency', a fine city and broad river, with bridge and shipping. 7 'Coteaux de Mauses [*sic*]', a steep hill and a deep stream. 8 'Amboise', a strong castle, a lofty bridge, and a noble river – forming the finest scene we ever beheld; the view beneath and beyond the arch of the bridge may be compared with any work of modern times. There are some nearly as good as the best of these, for which we must refer to the work itself. We have seen nothing like these illustrations of Turner's tour hitherto.

The Literary Gazette and Journal of the Belles Lettres, 1 December 1832 (no.828, p.762):
Twenty-one Illustrations to Turner's Annual Tour for 1833. London. Moon and Boys.
The proofs of this work are before us, and we want words to express our admiration of them. Accustomed as we are to most beautiful design and splendid execution in productions of this class, we cannot but think that the present publication excels all that have preceded it. But we must reserve a detailed examination for our next No., and be contented for the present with stating, that the portfolio could not contain a richer treasure than Mr. Turner and his engravers have here supplied.

The Spectator, 8 December 1832 (pp.1166–7):
TURNER'S ANNUAL TOUR.
It is as we wished it to be. TURNER'S is the last of the Annuals. We could not have enjoyed the sight of the others after it; and it is as well for them as for us that they came first, for they must have been seen to great disadvantage in comparison with TURNER'S TOUR. Like the grand attraction of a gorgeous pageant, it appears after the glittering show that preceded, eclipsing all by its real splendour, and leaving the spectators no eyes for other objects. Yet, rich as are these Views on the Loire in the beauties of nature and of art, we dare say that but for the name of TURNER many of the plates might be glanced at superficially by the listless eye, without exciting much interest; for the country is not prolific in scenes of beauty or grandeur – its general features

are by no means extraordinary. There are, however, a few striking objects; and TURNER has made up any deficiency, by his genius. There are, however, no hard, cutting outlines – none of those startling contrasts of black and white which catch the vulgar sense. The skill of the artist is so refined that the most simple and natural results are produced by its most wonderful exercise. These plates will afford the highest gratification to two classes of persons – the genuine lovers of nature, and the enlightened admirers of art. TURNER looks as sober in black and white as he does intoxicated in colours; and those who are only astonished at his brilliant colouring may perchance see little to attract in this modest garb. The divinity that dazzles them with his splendours, is likely to be passed by unheeded now that they are veiled.

The most remarkable quality in TURNER'S Landscapes is the truth and variety of his effects. And here we will take occasion to explain, for popular use, the meaning of this and other terms of art which we have so frequent occasion to employ, but which, we are reminded, may be little better than slang to the general reader.

Let us trace, for example, the progress of a view. An architect designs a mansion, and draws a set of ground-plans and elevations of the building. The *elevation* is a mere outline of the form and details of each side, and conveys no idea of the building in the aggregate as it will appear to the sight when erected. He accordingly combines the parts in a *perspective* view; and adds the colour of the building and the shadows thrown by the projecting parts: we have then a view of the structure as it would be seen from some given point, with its *local colour* and the *local effects* of light and shade. All this is done by rule, and is so far mechanical. At this point the artist of genius steps in, and flings over the scene the charm of *effect*, – invests it with the poetry of art; and whether it be a palace or a stack of warehouses, a stately pile or a tasteless heap of brick and mortar, it is made beautiful by the effects of light, shade, and colour, and by its combination with other objects, – which last is termed the *composition* of the picture. Effect, then, in painting, means that arrangement of light, shade, and colour, which pervades the whole scene, and modifies local appearances so as to produce a harmonious and beautiful *coup d'œil*. Effects are *natural* where they are shown to be the evident result of the position of the luminary of the picture, and of other objects partially intervening. They are said to

be *arbitrary* where their cause is not evident: in this case, it is merely a trick of art, and one that is employed very extensively. Natural effects are also imitated by recipe, by the great majority of artists; who, in this respect, like cooks who can make but one sauce, steep all their views in the one effect – which becomes as mechanical as rule-and-compass-work. TURNER is a splendid exception, – we were going to say the only one. Not only are his effects various and true in the main, but they are brilliant and appropriately chosen; and in his imitation he follows them into all the subtleties of detail, blending these by almost imperceptible gradations into one broad, pure, and harmonious whole. The *breadth* of his effects – that is, the absence of any little points or spots of light and shade to stop the eye and prevent it taking in the whole scene at once, or to annoy the sight and interfere with the general effect – is another of his great merits. The tender and aerial tone of his distances, which gives such appearance of space to his views; and the effect of atmosphere in his pictures, which preserves the *keeping* of the various objects – that it to say, not only shows them to be in their proper places, but does not allow a more distant object to meet the eye before one that is nearer, – are also among his excellencies. All these are the result of a quick, observant, and retentive eye, and an apprehensive sense of the more subtle and delicate appearances of nature, as well as a large and comprehensive perception of her beauties and sublimities in the aggregate. TURNER'S study of nature must be a series of enjoyments combining the most vivid sensual perceptions with imaginative feelings, and the nicest exercise of the judgment. He is an epicurean painter. He both feels the poetry of his art and understands its philosophy.

Of the twenty-one views before us, the most striking, considered with reference to the objects introduced, are the following. The Cathedral and Château of Nantes; two of TURNER'S extraordinary combinations of figures and perspective, which, though engraved with great feeling and skill by MILLER, who translates TURNER better than almost any other engraver, must be received with allowance for the difficulty of the subjects; the view of the Château is admirable in its general effect, and the sky is beautiful; but the vignette of the Gate and Cathedral wants keeping. The Town of Blois is a very striking composition, and, excepting a general heaviness, is well engraved by BRANDARD. The Palace at Blois, a stately and

picturesque structure on an elevation, is a noble object; and the subject is treated with great power and simplicity. The calm, clear, evening effect, is beautifully rendered in the engraving by WALLIS. This and the Château and Bridge of Amboise are two of the grandest scenes in the collection. Amboise is a calm but brilliant effect of sunset; the breadth, transparency, and purity of which are preserved with great skill in the engraving by J.B. ALLEN. The Cathedral of Orléans is partly concealed by what appears to be the Hôtel de Ville, before which a procession is stopping; but the two western towers, of the richest Gothic, give us an idea of its magnificence. It is well engraved by HIGHAM.

We can only allude *en passant* to the beautiful effects which adorn the more simple but pleasing views. The tranquil loveliness of "Rietz", with the river reflecting the evening sun-light; the transparency and breadth of "Tours", seen from the river under a calm but bright sunset; and the more brilliant evening effect of "Beaugency", are beautifully rendered by BRANDARD; in the view of "St. Florent", where an almost vertical sun pours down its rays over the cathedral, he has only been less successful on account of the extreme difficulty and almost impossibility of the task; but we see what TURNER meant, and can fancy what he accomplished, which is something. The engraving by this artist of "Château Hamelin" is somewhat feeble; but the sombre effect is well conveyed. The bright effects of evening sunlight in "Tours" and a river scene "on the Loire", are rendered with great purity and truth by R. WALLIS; and "Château des Mauves" [sic], by the same, is a chaste piece of excellence. The dazzling effect of sunrise, in a general view of "Amboise", is brilliantly managed by W.R. SMITH; though the plate is otherwise black and scratchy. Perhaps the most poetical scene is "Clairmont", with the château crowning its steep cliff, and the last rays of the sinking sun gilding its walls, and glancing on the sail of a boat beneath. The whole effect is perfectly conveyed in the engraving by WILLMORE; the distant sky has almost colour; and the misty appearance of twilight is well indicated. "Montjeu" [sic], by the same, is brilliant, but not so perfectly in keeping; and "Saumur" is so black and hard, that we should not have supposed it to be the work of the same engraver. A scene on "The Canal of the Loire, near Tours", with boats and figures in the foreground, is well engraved by JEAVONS. "St. Julian's"; a cathedral at Tours, by faint moonlight, with effects of lamplight introduced in the foreground, which is the scene of the departure of the diligence, is admirably engraved by RADCLYFFE. What a solemn grandeur there is in the gloom that enshrouds the ruined pile! How beautifully the two lights are blended in one harmonious effect, by means of the delicate gradations of tone! How different from the coarse, cold, theatrical effect of

common moonlight scenes! TURNER'S sombre effects have all the imaginative character of REMBRANDT; his glowing atmospheres more than the brilliancy with all the subtlety of CLAUDE; and his foregrounds all the lavish richness of RUBENS. We have noticed more in detail than we are in the habit of doing the engraving of these plates, because not only are TURNER'S drawings the most trying to imitate in black and white, but because being so truly natural in their effects, we can better judge of the engraver's skill – in so far as the effect is concerned at least. As specimens of engraving they are beautiful; but their value is enhanced a hundred fold by the charm they derive from the originals. We do not know which to admire most in TURNER'S works, the beauty of the scene or the truth of his imitation – his taste in selection or his skill in production. Let those who deem TURNER extravagant, and who erroneously think that his eccentricities are the greatest proofs of his genius – they may be very striking marks of it – look at the majority of these views, and then say it they are not of that opinion. TURNER'S thorough knowledge of the science of perspective often tempts him to give impossible views of places; he delights to work its most difficult problems – it would be presumption in us to insinuate that he sometimes does so without satisfying himself of his correctness. A sense of this extraordinary command over the difficulties of his art lends him to indulge in the boldest exercise of his skill, both in combinations of forms and colours to excess. He often sacrifices literal fidelity to his feeling for the beautiful, by aggrandizing the peculiar features of a scene, so as to give it a grander and more romantic character; but he never outrageously violates truth, and is always consistent. His freaks of fancy are the revellings of a god – he soars with daring wing to heights that others cannot attempt. He tracks, as it were, the footsteps of the sun, "when his bright sandals sweep the blue of heaven". He seems to live in the face of nature, watching the ever-varying aspects she assumes, from the first uplifting of the veil of morning twilight to the spreading out of the spangled pall of night; gazing with eagle eye upon the burning radiance of her noontide smile, and dwelling on the tender hue that invests her lovely countenance, when with closed eyes she sinks to rest, and the ruddy smiles of day are succeeded by the pale melancholy of evening. But enough of this. The truth is, that we are as much lovers of TURNER'S beauties as he is of those of Nature; and we are apt to forget that our rhapsodies may be deemed by some to be most uncritical. Only one word more, and that is to call attention to the distance, the space, the appearance of atmosphere in these plates. Ordinary views are crowded or very limited in their extent; in these, we see as far as we do in nature, and through a medium almost as pure and as transparent.

The Atlas. A General Newspaper and Journal of Literature, 9 December 1832 (no.343, vol.VII, p.829):
Twenty-One Illustrations to Turner's Annual Tour. London, 1832.
This truly poetical painter can bear better than most artists to have his subjects softened down at the burin of the engraver. His colours mock the rainbow and all nature; but he has an eye and a hand of miraculous discrimination and power. These talents are proved in the results of this tour. He has committed to his portfolio nothing that was not worthy of its place; he has chastened the exuberance of his imagination, and avoided much of the mannerism that defaced his former works.

Approaching Tours, he is struck by the picturesque point of the canal of the Loire and Cher. Beneath a warm sky – the haze of which lies like a veil on the cathedral towers, and softens the light through the arches of the interminable bridge – is grouped a fleet of river boats bristled with masts, fluttering with penons, and all alive with animated crews. He then changes his position, and all the bridge and town assume a new and tranquil character. Another removal brings us to the quay, with all its comic characteristics. From the blaze of noon we change to the deep of night, and are gathered in a crowd around the diligence beneath the beautiful walls of St Julian's. All the light proceeds from an unseen lantern in the midst of a group of passengers, and the contrast of deep shadow and brilliant yet subdued light, is exquisite. This engraving is one of the gems of the collection, and the execution does as great credit to Mr. RADCLYFFE, as the design does to the genius of the painter.

In the view of Amboise, from beneath the wooden bridge, there is much skill displayed, particularly in the indistinct background. Too much detail is often TURNER'S fault; here a few touches produce an extraordinary effect: the lofty battlements, lowering in shadow over the winged batteaux beneath, are in gloomy contrast to the mass of silvery white that soars above them. Another view of Amboise sparkles beneath the splendours of a brilliant sunset.

We must proceed at once to Nantes. Its lofty minster and sullen battlemented walls have acquired a new interest by the capture of the "Regente de France" [the Duchesse de Berry]. The romantic incidents of that extraordinary history have excited such deep interest that we were prepared to appreciate the scenery. TURNER shows us, that no place could be more suited to be the stage of extraordinary events. The view of the chateau, with a parade in the foreground on the wall, is rich in beauty, and particularly remarkable for the antique statues which grace the entrance to the square.

There are two views of Blois, one looking up to its acropolis and citadel (for they are worthy of the

names); another, in which the palace is the principal feature, relieved, however, by a religious procession, and the steep accesses to the streets, dotted with groups and individual figures.

The next trio begins with Clairmont, seated like an eagle's eyrie, on the summit of a precipitous cliff, rising abruptly from the soft bosom of the water. Between Clairmont and Mauves, is another lake-like scene of a Cumbrian character, and the painter has not omitted to detain the fleeting mist-cloud, as it flits along the summit of the mountain. There is something hard and thin in the Coteaux de Mauves, but the reflected lights on the water are extremely beautiful. The same quality is remarkable in a scene on the Loire, which has nothing in it but the skill of the artist. Rietz has a very Spanish look; and the view of Saumur is remarkable for its softness, as well as for the building exactly like the Temple at Paris, which forms the donjon of the fortress.

Of the solitary scenes which remain, one is the crowded street beneath the gorgeous west front of the Cathedral of Orléans. The bridge of Beaugency, skirting the town, is a second; the Loretto-like church of St. Florent, is a third; Montjen, a fourth; and the fifth, an engraving of great beauty, is a view of the Chateau Hamelin, between Ouden [sic] and Ancenis. We have been highly delighted in accompanying Mr. TURNER on his tour, and, wishing them the same pleasure, we cordially recommend the work to our readers.

The Literary Gazette and Journal of the Belles Lettres, 15 December 1832 (no.830, p.795):
Twenty-one Illustrations to Turner's Annual Tour for 1833. Moon, Boys, and Graves.
We are sure that none of our readers will suppose, because we have occasionally indulged in a laugh at some of Mr. Turner's extraordinary vagaries as an artist, that we are insensible to his merits. There is no man living – are there many of the dead? – entitled to rank with him in the highest qualities of that branch of the arts which is his peculiar vocation. When he is in his proper element, and when he chooses, no man has ever communicated more of the most refined poetic feeling to the productions of his pencil. Others are landscape-painters: Mr. Turner is much more. By his profound knowledge, and by his masterly management of effect, he frequently imparts to an ordinary view a character of beauty, or of grandeur, with which many in vain endeavour to invest the finest scenery in the world. What then must be the result, when the character of his subjects corresponds with that of his genius? We answer, by referring to the fascinating little collection of plates under our notice; on every one of which the eye and the mind may dwell long and often, without satiety. It is evident that the engravers, Messrs. J.B. Allen, R. Brandard, T. Higham, T. Jeavons, W. Miller, W. Radcliffe, W.R. Smith, R. Wallis, and J.T. Willmore, have executed themselves to the utmost to do justice

to Mr. Turner's conceptions; and while they have bestowed the most exquisite finish on the various details, have never forgotten that much more valuable and important consideration, the *tout ensemble*. Were we to select some of those which appear to us to be the brightest stars of the constellation, we should name – "Amboise", "Clairmont", "St. Julian's, Tours", "Between Clairmont and Mauves", "Saumur", "Tours", "Nantes", "Blois", "Montjen", "Beaugency", "Orleans", "The Canal of the Loire and Cher", "Chateau Hamelin"; but we must check ourselves, or we shall go through the whole portfolio.

II Reviews following the publication of *Turner's Annual Tour* on 18 or 19 December 1832

The Gentleman's Magazine, December 1832 edition, published 1 January 1833 (vol. CII, pt II, pp.549–550):
Turner's *Annual Tour*
When the 'Keepsake' and 'Landscape Annual' first made their appearance, they so far surpassed their predecessors in costliness and splendour, as to be considered the ne plus ultra of *annualism*; but, as if the march of improvement was never to stand still, even those splendid productions are now partially eclipsed by the superbly beautiful volume before us. It is printed in super-royal size, and richly decked in purple and gold. Its very appearance is aristocratic, and it may be considered as the Lord of the ascendant in the present family of Annuals. The Work is entitled "Wanderings of the Loire", and the engravings (twenty-one in number) are from drawings by the celebrated artist J.M.W. Turner, esq. R.A. The letter-press descriptions are from the pen of Leitch Ritchie, author of Heath's Picturesque Annual, &c. who, during a tour along the River Loire, commencing at Orléans and terminating at Nantes, has finely described the various scenes as they arose, particularly those which have been the subject of the artist's pencil.

[A quote from Ritchie's text about the Loire, taken from pp.189–190, follows here.]

To relieve the sober monotony of mere description, the writer has occasionally interwoven some very curious and amusing narratives connected with the historical or traditional recollections of the places he is describing. Among these may be particularly noticed 'The Subterranean', 'The Unknown', 'The Pirate of the Loire', and 'Blue Beard'.

Of the splendid engravings which adorn this costly volume, it is scarcely possible to speak with adequate praise. These alone, in our judgment, would

be sufficient to raise the character of British art to the highest pinnacle of fame. The genius of the painter and the skill of the engraver, have here united to produce the realization of perfection in the pictorial and graphic arts. The views of Nantes, engraved by Miller; of Orléans, by Higham; Palace at Blois, and Tours, by Wallis; Rietz, Montjen, and Clairmont, by Willmore, – are all inexplicably beautiful, picturesque, and romantic. If any fault is to be found, it is with the style, so peculiar to Turner's poetic pencil, of sometimes circumveloping all objects in hazy vapours, and throwing his aerial perspective into "shadows, clouds, and darkness"; as if the genius of Turner, despising the ordinary scenes of common life, always delighted to sport the misty morn or dewy eve.

This volume being the first of a series which is intended to illustrate, with the pencil and pen, all the most celebrated rivers of Europe, the second, as the Editor informs us, will be devoted to the river Seine and its localities.

The Atlas, 13 January 1833 (no.348, vol. VIII, p.23):
Wanderings by the Loire. By Leitch Ritchie. London, 1833
This is the letter-press title of *Turner's Annual Tour*, the spirited and splendid engravings of which we recently noticed. Mr. LEITCH RITCHIE's part, which, as usual, is an agreeable fire-side mixture of legend, description, and rumination, is executed in the same graphic style for which that gentleman's sketches are already celebrated. We know not who could perform this sort of task better than Mr. RITCHIE, for his mind is constantly running upon that class of topics that is best calculated to make a tour in a picturesque country delightful to a traveller. If any man could talk in a steam-boat or post-chaise as Mr. RITCHIE writes, he would be an inestimable companion, a protection against low spirits and blue devils, and one in whose presence it would be impossible to grumble at ordinary inconveniences. The *manner* of this book is – without reference to the illustrations – highly pictorial. The tourist composes like an artist, and pictures grow under his pen with as much certainty as if he worked on a stretch of the canvas with the richest pencils. There is a remarkable felicity in the adaptation of means to ends, and in bringing home the design so completely to the feelings of the reader, that there is nothing incomplete to the eye or the understanding. We feel every thing but the motion, the breath of the river-airs, and the descent of the blue-mists from the tower-crowned hills. But these – the living elements and the component particles of the nature that is here painted by two arts – are supplied by the mind; and to say that LEITCH RITCHIE leaves little else to be supplied, is to say no more than he merits. The present volume is announced as the first of a series in illustration, by pen and pencil, of the

river scenery of Europe. The next volume will be dedicated to the Seine. The choice is not very good, although there are many points of grace and beauty in the Seine. We could point out more fertile materials elsewhere.

The Morning Chronicle, 26 January 1833 (number 19,787, p.3):
TURNER AND HEATH.
We have here the combined exertions of the most imaginative Landscape Painter, and the most skilful Engraver in certain departments of his art, at the present period of our history. Although in "Turner's Landscape Annual" and "The Book of Beauties", Mr Heath may not have employed his hand directly, and it is to be regretted, his taste and masterly superintendence is everywhere visible.

[There follows a brief discussion of *The Book of Beauties*, of which the critic complained that it was inappropriately named, as he did not consider many of the ladies included truly beautiful.]

"Turner's Landscape Annual" would have better deserved the name of the "Book of Beauties". It is redolent of them. Some, indeed, may wish that there had been another hand or so employed for the sake of variety and the effect of contrast, or, as in this case it would probably have been, the relief of repose. A change is agreeable in some instances, even when the change is for the worse, so that it is not too bad, as it certainly would not have been had the pencil of Calcott, Stanfield, Stanley, and two or three others been engaged, but a variety of the most agreeable kind. "On n'aime guères d'etre empoisonné même avec esprit de rose".

It is the vice of Turner to be too fond of money, and to make the most of the market which runs in his favour; he renders himself too common – he fritters away his genius – and his little things are to be found every where, even in the meanest portfolios. This attempt to get all the eggs at once is killing the goose, and will ultimately prove the killer to be the greater goose of the two. The Sybill's leaves increased in value as they decreased in number – such would be the case with Mr. T.'s, which now –
"Fall fast and thick as the autumnal leaves,
That strew the ground in Vallambrosa,"
were they reduced to half the quantity. "Eximis", says Pliny, "raritate commendat naturae" – but his "Beauties", he seems to think, bound by no such law, and that, though Nature heightens the value by the rarity of the thing, Art may accomplish the same by its profusion. This is the mistake of an over anxiety to pocket. Were diamonds as plentiful as pebbles, we should pass them with as little admiration as we tread our way over a gravel walk.

Mr. T. has, also, by employing himself so much *pour la tripe* on these numberless little drawings, done mischief to his style in oil-painting, and he may be

aptly described in the words of Pasquin: – "It has been objected to him that he was slovenly, inasmuch as he painted more for effect than precision; and to become grand, forgot or disdained the littleness of the art. He was mighty and charming, though negligent. When he committed his thoughts to canvas, he may be rather said to have *dashed* in his objects than accurately defined them; yet he managed the combination with such oddness, as to delude the observant into a belief, that its nature was not exactly as he had poutrayed, it would be better if she were" – Hist. of the Professors, &. p.122.

With two or three exceptions, these twenty-one engravings form the most extraordinary collection of landscapes ever published in a body. It is a great triumph of art in all that appertains to fancy and masterly handling, in which latter merit the engravers, Miller, Brandard, Wallis, Higham, Wilmore, Jeavons, Allen, and Radclyffe, largely share. A more gorgeous work has not been witnessed in this country, and it well deserves the splendid manner in which it has been got up.

These *"Wanderings by the Loire"* are by Mr. Ritchie – so he terms the remarks he made during his tour with Mr. T.; and though he holds fast by "the painter", which keeps his head gallantly above the waters, he has distinguished himself with more than usual skill in his struggles through the Loire. His position by the side of the painter was, in the highest degree, spirit-stirring – almost amounting to inspiration; but the task was difficult, and he has met it with much tact, ingenuity, and adroitness.

Although we have no hesitation in saying that two guineas bear [so]me fair proportion to the value of a single copy, we have a doubt as to the policy of the charge. The injury, in our view of the matter, is exclusively to the publishers. Swift said that "twice two does not always make four"; and what is true in finance, as it regards the State, is, we believe, equally so with respect to bookselling – especially in works like this, which every one covets the possession of, and, brought within their means, would have – the result in profit of such a sale at half the price (and here the saying of Hesiod, that "half is more than the whole", would be manifest), printsellers and bibliopolists can calculate without our assistance. We are confident that all the other parties concerned felt this, but were over-ruled by the grasp-all principle of "the Goose".

Bibliography

All books published in London unless otherwise stated.

N.J. Alfrey, 'Turner and the French Rivers', unpublished MA report, University of London, 1977

N.J. Alfrey, 'Turner and the Loire' (and individual catalogue entries) in *Turner en France*, exh. cat.; see Paris 1981

Sir Walter Armstrong, *Turner*, 1902

R.B. Beckett (ed.), *John Constable's Correspondence: Vol IV, Patrons, Dealers and Fellow Artists*, Suffolk Records Society, X, 1966

Dinah Birch, *Ruskin on Turner*, 1990

Martin Butlin and Evelyn Joll, *The Paintings of J.M.W. Turner*, 1977, revised ed. 1984

Martin Butlin, Mollie Luther and Ian Warrell, *Turner at Petworth*, 1989

E.T. Cook, *Hidden Treasures at the National Gallery*, 1905

E.T. Cook and A. Wedderburn (eds.), *The Works of John Ruskin* (Library Edition), 39 vols., 1903–12; see there, vol. XIII for 'List of Pictures, Drawings, Sketches, and Studies by Turner at any time in the collection of Ruskin', pp.597–606

Cooper Notebooks. Containing notes by Mrs Cooper, the niece of Charles Stokes, covering the watercolours, pencil sketches, sepia drawings, mezzotints and other engravings in her collection. Manuscript: vol.2 unless stated otherwise. Indianapolis Museum of Art

Malcom Cormack, *J.M.W. Turner 1775–1851: A Catalogue of Drawings and Watercolours in the Fitzwilliam Museum, Cambridge*, Cambridge 1975

Martin Davies, *National Gallery Catalogues: The British School*, 1946, 2nd ed. 1959

Pierre A. Davy, 'Autour d'une aquarelle de J.M.W. Turner', in *Science, Lettres, Arts*, 1982

Barbara Dawson, *Turner in the National Gallery of Ireland*, Dublin 1988

James S. Dearden, 'The Ruskins as Collectors of Turner: A review of Luke Herrmann, *Ruskin and Turner*', *Connoisseur*, vol.172, no.691, Sept. 1969, p.40

Denise Delouche, *Peintres de la Bretagne, découverte d'une province*, Rennes 1977

Joseph-Henri Denécheau, *Saumur en dessins*, Longué (Maine-et-Loire) 1995

Anthony Dyson, *Pictures to Print: The Nineteenth-Century Engraving Trade*, 1984

A.J. Finberg, *A Complete Inventory of the Drawings of the Turner Bequest*, 2 vols., 1909

A.J. Finberg, *Turner Sketches and Drawings*, 1910

A.J. Finberg, *The Life of J.M.W. Turner, R.A.*, 1939, revised, 2nd ed., Oxford 1961

H.F. Finberg, 'With Mr Turner in 1797', *Burlington Magazine*, vol.99, 1957, pp.48–51

Gerald Finley, *Landscapes of Memory: Turner as Illustrator to Scott*, 1980

John Gage (ed.), *Collected Correspondence of J.M.W. Turner … with a Memoir by George Jones*, Oxford 1980

John Gage, *J.M.W. Turner: 'A Wonderful Range of Mind'*, New Haven and London 1987

Guide Pittoresque Portatif et Complet du Voyageur en France Contenant L'Indication des Postes et la Description des Villes, Bourgs, Villages, Chateaux, et Généralement de Tous les Lieux Remarquables qui se trouvent sur les Grandes Routes de Poste qu'à Droite et à Gauche de Chaque Route, Paris 1837, 1838

Philip Gilbert Hamerton, *The Life of J.M.W. Turner, R.A.*, 1879

Andrew Hemingway, *Landscape Imagery and Urban Culture in Early Nineteenth-Century Britain*, Cambridge 1992

Luke Herrmann, *J.M.W. Turner 1775–1851*, 1963

Luke Herrmann, *Ruskin and Turner: A Study of Ruskin as a collector of Turner, based on his gifts to the University of Oxford; incorporating a Catalogue Raisonné of the Turner drawings in the Ashmolean Museum*, 1968

Luke Herrmann, 'Ruskin and Turner: A riddle resolved', *Burlington Magazine*, vol.112, no.811, Oct. 1970, pp.696–9

Luke Herrmann, *Turner Prints*, 1990

Hubert Hervouet, 'J.M.W. Turner: images de Loire', *Arts de l'Ouest: Artistes Étrangers à Pont-Aven, Concarneau et Autres Lieux de Bretagne*, ed. Denise Delouche, Rennes 1989, pp.12–23

Charles Holme (ed.), *The Genius of Turner, R.A.*, special Winter no., *Studio*, 1903

Basil Hunnisett, *An Illustrated Dictionary of British Steel Engravers*, revised ed., Cambridge 1989

Henry James, *A Little Tour in France*, 1884 (Oxford University Press 1984)

Paul-Jacques Lévêque-Mingam, *Turner et la Loire* [with historical and topographical notes by Sylvain Bertholdi, Jacques Debal, Joseph-Henri Denécheau, Chantal Fromont, Sophie Gillot, Alain Guerrier, Marie-Hélène Jouzeau and Pierre Leveel], Tours, 1996

Camille Mauclair, *Turner*, 1939

W. Cosmo Monkhouse, *Turner*, 1879

Cecilia Powell, 'Picture Note: *A View overlooking a Lake*', *Turner Studies*, vol.2, no.2, Winter 1983, pp.56–8

Cecilia Powell, *Turner in the South*, 1987

W.G. Rawlinson, *The Engraved Work of J.M.W. Turner*, 2 vols., 1908, 1913

Graham Reynolds, *Turner*, 1969

Leitch Ritchie, *Wanderings by the Loire – Turner's Annual Tour. 1833*, 1833

Leitch Ritchie, *Liber Fluviorum or, River Scenery of France Depicted in Sixty One Line Engravings*, 1853/7

John Ruskin, *The Complete Works* [*Works*]; individual volumes can be found within the Library Edition as listed under Cook and Wedderburn, above

Eric Shanes, *Turner's Rivers, Harbours and Coasts*, 1981

Eric Shanes, *Turner's England 1810–38*, 1990

Eric Shanes (ed.), *Turner: Les Fleuves de France / The Rivers of France*, Paris 1990; introductory essay to a reprinting of the sixty-two engravings first published in one volume in 1837

Stendhal [Henry Beyle], *Mémoires d'un Touriste*, Paris 1837

Elizabeth Strutt, *Six Weeks on the Loire, with a Peep into La Vendée*, 1833

Charles Algernon Swinburne, *Life and Work of J.M.W. Turner, R.A.*, 1902

Tate Gallery, *Tate Gallery Illustrated Catalogue of Acquisitions 1986–1988*, 1996 (entries on prints after Turner by Anne Lyles and Diane Perkins)

Walter Thornbury, *The Life of J.M.W. Turner, R.A. Founded on Letters and Papers Furnished by His Friends and Fellow Academicians*, 2 vols., 1862, revised, 2nd ed., 1877

Patrick Villiers and Annick Senotier, *Une Histoire de la Marine de Loire*, Tours 1996

William White, *Notes on a Biographical Series of Fifty Drawings and Sketches by J.M.W. Turner, R.A.,*

*belonging to the National Gallery Collection, selected
and arranged from hitherto unmounted material* [to
accompany the showing of the Fourth Loan
Collection at Newcastle], 1896

Gerald Wilkinson, *Turner's Colour Sketches,
1820–1834,* 1975

Andrew Wilton, *The Life and Work of J.M.W. Turner,*
1979

Andrew Wilton, *Turner Abroad: France, Italy,
Germany, Switzerland,* 1982

Andrew Wilton, *Turner in his Time,* 1987

Andrew Wilton, *The Turner Collection in the Clore
Gallery: An Illustrated Guide,* 1987 (with later,
revised editions)

Andrew Wilton, *Turner Watercolours in the Tate
Gallery,* 2nd ed., 1988

Exhibitions

Manchester 1857
*Art Treasures of the United Kingdom Collected at
Manchester in 1857*

Marlborough House 1857
See Ruskin, *Catalogue of the Sketches and Drawings
by J.M.W. Turner, R.A., Exhibited in Marlborough
House in the Year 1857–8,* 1857 [*Works,* XIII,
pp.229–316]

Second Loan Collection (1869–1931)
For a full list of venues visited by this group of
watercolours, see Ian Warrell, 'R.N. Wornum and
the First Three Loan Loan Collections: A History
of the Early Display of the Turner Bequest Outside
London', vol.11, no.1, *Turner Studies,* 1991,
pp.36–49

Oxford Loan Collection 1878–1916
*Catalogue of Sketches by Turner Lent by the Trustees of
the National Gallery to the Ruskin Drawing School,
Oxford.* Catalogue notes by John Ruskin (see
Works, XIII, pp.560–68; a manuscript draft of this
selection is in the National Gallery Library); the
two sets of numbers listed refer to the two editions
of the catalogue; the first in each case is the
number in the first edition.

Exhibited Drawings (1881)
See Ruskin, *Catalogue of the Drawings and Sketches
by J.M.W. Turner, R.A., at Present Exhibited in the
National Gallery, revised and cast into progressive
Groups, with explanatory Notes,* 1881 (*Works,* XIII,
pp.349–88, 609–46; and for concordance,
XXXVIII, pp.385–90)

Fourth Loan Collection (1891–1916)
Ruskin Art Museum, Sheffield (1891–5); Leeds
City Art Gallery (1896); National Gallery (1897);
Glasgow Art Gallery (1898–9); National Gallery
(1900); Newport Free Library and Museum
(1901–4); Wolverhampton (1905); Municipal
School of Art, Manchester (1906–8); Nottingham
Art Gallery (1909–11); Laing Art Gallery,
Newcastle (1912); York Art Gallery
(May–Sept.1913); Corporation Art Gallery, Bury
(1913); Art Gallery, Swansea (1914); Castle
Museum, Merthyr Tydfil (1915); returned to the
Tate Gallery (National Gallery of British Art) 1916

Paris/Vienna 1937
Aquarelles de Turner: Oeuvres de Blake. Catalogue by
Laurence Binyon and Cambell Dodgson.
Bibliothèque Nationale, Paris (Jan.–Feb.1937);

*Ausstellung von englische Gemälden und Aquarellen, W.
Blake und J.M.W. Turner.* Verein de Museumfreunde,
Vienne (March–May 1937)

British Council Tour 1947–8
Turner 1775–1851. Catalogue by John Rothenstein
and Humphrey Brooke. An exhibition circulated
by the British Council: Stedelijk Museum,
Amsterdam (?Nov.1947); Bernere Kunstmuseum,
Berne (Dec.1947–Feb.1948); Palais voor Schone
Kunst, Brussels (March–April 1948); Museum vor
Schone Kunsten, Liege (?May–June 1948); British
Pavilion, XXIV Venice Biennale (?July–Aug.1948);
Palazza Venezia, Rome (?Sept.1948)

British Council Tour 1950
British Painting from Hogarth to Turner. Organised by
the British Council: Kunsthalle, Hamburg;
Kunsternernes Hus, Oslo; Nationalmuseum,
Stockholm; Statens Museum for Kunst,
Copenhagen (1949–50)

Whitechapel 1953
*J.M.W. Turner, R.A. 1775–1851. An Exhibition of
Pictures from Public and Private Collections in Great
Britain.* Catalogue by Sir John Rothenstein.
Whitechapel Art Gallery, London (Feb.–March
1953)

Australia 1961
*Paintings by J.M.W. Turner, R.A. 1775–1851. Lent by
the Tate Gallery, London.* National Gallery of South
Australia, Adelaide (March–April); Art Gallery of
New South Wales, Sydney (April–May); National
Gallery of Victoria, Melbourne (June–July);
Queensland National Art Gallery, Brisbane
(July–Aug.); Art Gallery of Western Australia, Perth
(Aug.–Sept.1961)

Smithsonian Tour 1963–4
*Turner Watercolours from the British Museum. A Loan
Exhibition Circulated by the Smithsonian Institute.*
National Gallery of Art, Washington (Sept.–Oct.
1963); Museum of Fine Arts, Houston (Nov. 1963);
M.H. de Young Memorial Museum, San Francisco
(Dec.1963–Jan.1964); Cleveland Museum of Art
(Jan.–March 1964); William Rockhill Nelson
Gallery of Art, Kansas City (March–April 1964);
Brooklyn Museum, New York (May 1964);
National Gallery of Canada, Ottawa (June–July
1964)

New York 1966
Turner: Imagination and Reality. Catalogue by
Lawrence Gowing. Museum of Modern Art, New
York (March–June 1966)

Edinburgh 1968
J.M.W. Turner (1775–1851). National Gallery of
Scotland, Edinburgh (1968)

Japan 1970–71
*English Landscape Painting in the 18th and 19th
centuries.* National Museum of Western Art, Tokyo
(Oct.–Nov. 1970); National Museum of Modern
Art, Kyoto (Dec.1970 – Jan.1971)

Germany 1972
J.M.W. Turner – Gemälde. Aquarelle. Catalogue by
Werner Haftmann, Andrew Wilton, Henning
Bock, Ursula Prinz, William Vaughan and Andreas
Haus. Gemäldegalerie Neuer Meister, Dresden
(July–Aug.1972); Nationalgaleries Staatliche
Museen Preussischer Kulturbesitz, Berlin
(Sept.–Nov.1972)

Arts Council Tour 1974
*Turner and Watercolour: An Exhibition of Watercolours
Lent from the Turner Bequest at the British Museum.*
Catalogue by John Gage. Circulated by the Arts
Council (April–Sept.1974)

Royal Academy 1974
*Turner 1775–1851: Bicentenary Exhibition Celebrating
the Artist's Birth.* Catalogue by Martin Butlin, John
Gage, Evelyn Joll and Andrew Wilton. Royal
Academy, London (Nov.1974–March 1975)

British Museum 1975
*Turner in the British Museum: Drawings and
Watercolours.* Catalogue by Andrew Wilton. British
Museum (May 1975 – Feb. 1976)

Norwich 1975
John Sell Cotman Drawings of Normandy. Catalogue
by Miklos Rajnai and Marjorie Allthorpe-Guyton.
Norwich Castle Museum (July–Oct.1975)

Louisville, Kentucky 1977
British Watercolours: A Golden Age 1750–1800.
Catalogue by Stephen Somerville. J.B. Speed Art
Museum, Louisville, Kentucky (Oct.–Nov.1977)

America 1977–8
*Turner Watercolours: An Exhibition of Works Loaned by
the Trustees of the British Museum.* Catalogue by
Andrew Wilton. Circulated by the International
Exhibition Foundation: Cleveland Museum of Art
(Sept.–Nov. 1977); Detroit Institute of Arts
(Dec.1977–Feb.1978); Philadelphia Museum of Art
(March–April 1978)

Nantes 1978
Iconographie de Nantes. Catalogue by Claude
Cosneau. Musée Dobrée, Nantes 1978

Bibliography

Tours 1978–9
Ponts de Tours. Traversée des fleuves et des riaux du Moyen-Age à nos jours. Catalogue by Marie-Noîlle Pinot de Villechenon, Benard Toulier and Véronique Miltgen. Musée des Beaux-Arts de Tours

Munich 1979
Zwei Jahrhunderte Englische Malerei. Haus der Kunst, Munich (Nov.1979–Jan.1980)

Memphis 1979
Joseph Mallord William Turner. Dixon Gallery and Gardens, Memphis, Tennessee (March–April 1979)

Paris 1981
Turner en France: Aquarelles, Peintures, Dessins, Gravures, Carnets de Croquis. Catalogue by Jacqueline and Maurice Guillaud, Andrew Wilton, David Hill, Nicholas Alfrey, John Gage, Lindsay Stainton, Michael Kitson and Robin Hamlyn. Centre Culturel du Marais, Paris (Oct.1981 – Jan.1982)

Georgia/Houston 1982
J.M.W.Turner: Watercolours from the British Museum. Catalogue by Lindsay Stainton. Georgia Museum of Art (March–May 1982); Houston Museum of Fine Arts (May–July 1982)

Munich 1983
Im Licht von Claude Lorrain. Haus der Kunst, Munich (March–May 1983)

Tate Gallery 1983
Turner Abroad: France, Italy, Germany, Switzerland. Display to celebrate the publication of Andrew Wilton's book of the same title. Tate Gallery (June–Dec.1983)

Paris 1983–4
J.M.W.Turner. Catalogue by John Gage, Jerold Ziff, Nicholas Alfrey, Evelyn Joll and Andrew Wilton. Grand Palais, Paris (Oct.1983–Jan.1984)

Angers 1984
Angers: Images d'Histoire. Catalogue by Francois Lebrun. Musée des Beaux-Arts, Angers 1984

Australia 1985
Turner Abroad: France, Italy, Germany, Switzerland (see also Tate Gallery 1983). National Gallery of Victoria, Melbourne (May–June 1985); Queensland Art Gallery, Brisbane (July–Aug.1985); Art Gallery of New South Wales, Sydney (Sept.–Oct.1985)

Nantes 1986
Mathurin Crucy 1749–1826: Architecte Nantais Néo-Classique. Catalogue by Claude Cosneau and Daniel Rabreau. Musée Dobrée, Nantes 1986

Japan 1986
Turner. Catalogue by Martin Butlin, Evelyn Joll, Ian Warrell and Andrew Wilton. National Museum of Western Art, Tokyo (Aug.–Oct 1986); Kyoto Municipal Museum of Art (Oct.–Nov.1986)

Tours 1988
Peintres et Poètes de La Loire. Association des Amis de la B.C.P., D'Indre-et-Loire, Tours 1988

Tate Gallery 1988
Turner and Architecture. Catalogue by Ian Warrell and Diane Perkins. Tate Gallery (March–July 1988)

Tate Gallery 1989
Turner and the Human Figure. Catalogue by Ann Chumbley and Ian Warrell. Tate Gallery (April–July 1989)

Tate Gallery 1990
Colour into Line. Turner and the Art of Engraving. Catalogue by Anne Lyles and Diane Perkins. Tate Gallery (Oct.1989 – Jan.1990)

Tate Gallery 1991a
Turner: The Fourth Decade 1820–30. Catalogue by Ian Warrell. Tate Gallery (Jan.–May 1991)

Tate Gallery 1991b
Turner's Rivers of Europe: The Rhine, the Meuse and Mosel. Catalogue by Cecilia Powell. Tate Gallery (Sept.1991–Jan.1992)

New Haven 1991–2
Richard Parkes Bonnnington, 'On the Pleasure of Painting'. Catalogue by Patrick Noon. Yale Center for British Art, New Haven (Nov.1991–Jan.1992)

Tate Gallery 1992–3
Turner as Professor. The Artists and Linear Perspective. Catalogue by Maurice Davies. Tate Gallery (Oct.1992–Jan.1993)

Phoenix Art Museum 1993
John Ruskin and the Victorian Eye. Catalogue by Susan P.Casteras, Susan Phelps Gordon, Anthony Lacy Gully, Robert Hewison, George P.Landow and Christopher Newall. Phoenix Art Museum (March–May 1993); Indianapolis Museum of Art (June–Aug.1993)

Paris 1993
Copier Créer. De Turner à Picasso: 300 oeuvres inspirées par les maîtres du Louvre. Catalogue by Jean-Pierre Cuzin and Marie-Anne Dupuy. Musée du Louvre, Paris (April–July 1993)

Brighton 1992
The Dieppe Connection. The Town and its Artists from Turner to Braque. Catalogue by John Willett, Anna Gruetzner Robins and Sophie Bowness. Brighton Museum and Art Gallery (May–June 1992)

New Haven 1993
Translations: Turner and Printmaking. Catalogue by Eric.M.Lee. Yale Center for British Art, New Haven (Sept.–Dec.1993)

Tate Gallery 1993a
Turner's Urban Landscape. Selected by David Brown. No catalogue. Tate Gallery (June–Sept.1993)

Tate Gallery 1993b
Turner's Painting Techniques. Catalogue by Joyce Townsend. Tate Gallery (June–Oct.1993)

Tate Gallery 1993c
Turner's Vignettes. Catalogue by Jan Piggott. Tate Gallery (Sept.1993–Feb.1994)

Tate Gallery 1994
Turner's Holland. Catalogue by Fred G.H. Bachrach. Tate Gallery (July–Oct.1994)

Blois 1994
Blois – un Amphithéâtre sur la Loire. Catalogue by Sylvain Bellenger *et. al.*, with a commentary on Turner's views of Blois by Ian Warrell. Musée des Beaux-Arts du château de Blois (Sept.1994–Jan.1995)

Fitzwilliam 1994
British Landscape Watercolours 1750–1850. Catalogue by Jane Munro. Fitzwilliam Museum, Cambridge 1994

Tate Gallery 1995a
Through Switzerland with Turner. Ruskin's First Selection from the Turner Bequest. Catalogue by Ian Warrell. Tate Gallery (Feb.–May 1995)

Louveciennes 1995
Peindre le Ciel de Turner à Monet. Catalogue included essays by David Brown, Richard Hearn, Christine Kayser, Olivier Meslay, Arlette Sérullaz, Barthélemy Jobert, Richard Kendall, Béatrice Porte and Emmanuelle Loizeau. Musée-Promenade, Marly-le-Roi, Louveciennes (8 April–9 July 1995)

Tate Gallery 1995b
Turner in Germany. Catalogue by Cecilia Powell. Tate Gallery (May–Sept.1995)

Tate Gallery 1995–6
Sketching the Sky. Watercolours from the Turner Bequest. Selected by Ian Warrell. No catalogue. Tate Gallery (Sept.1995–Feb.1996)

Ashmolean 1996
Ruskin and Oxford. The Art of Education. Catalogue by Robert Hewison. Ashmolean Museum, Oxford (May–Sept.1996); City Museum and Mappin Art Gallery, Sheffield (Sept.–Nov.1996)

Tate Gallery 1997
Turner's Watercolour Explorations 1810–1842. Catalogue by Eric Shanes. Tate Gallery (Feb.–June 1997)

Concordance

Topographical Index

Lenders